The British monarchy on screen

Manchester University Press

The British monarchy on screen

Edited by
Mandy Merck

Manchester University Press

Published by Manchester University Press
Altrincham Street, Manchester M1 7JA
www.manchesteruniversitypress.co.uk

British Library Cataloguing-in-Publication Data
A catalogue record for this book is available from the British Library

Library of Congress Cataloging-in-Publication Data applied for

ISBN 978 07190 9956 4 hardback

First published 2016

Typeset by Out of House Publishing
Printed in Great Britain
by TJ International Ltd, Padstow

CONTENTS

Contents

FIGURES

The images in this book are reproduced here under the fair dealing guidelines relating to criticism and review, as suggested by the Intellectual Property Office (published 12 June 2014).

CONTRIBUTORS

Ruth Adams has worked as Lecturer in Cultural and Creative Industries at King's College London since 2003, where she convenes a Masters programme and teaches courses on Heritage, Youth Subcultures and Culture and Commerce. She has written about museum culture and punk rock, and is currently interested in the interplay between high art and popular culture and how perceptions of the past shape our understanding of the present.

Erin Bell is Senior Lecturer in History at the University of Lincoln, and previously worked with Professor Ann Gray on the AHRC-funded project 'Televising History 1995–2010'. The co-authored monograph based on the project's findings, *History on Television*, was published by Routledge in 2013. Her current research interests include the representation of the past on television and other audio-visual media, and early modern religious, gender and cultural history.

Elisabeth Bronfen is Professor of English and American Studies at the University of Zurich. A specialist in nineteenth- and twentieth-century literature, she has also published widely in gender studies, psychoanalysis, film, cultural theory and visual culture. Her most recent books include an introduction to the writings of Stanley Cavell as well as a collection of essays on visual culture, both of which appeared in German in 2009, *Specters of War: Hollywood's Engagement with Military Conflict* (Rutgers University Press, 2012) and *Night Passages: Philosophy, Literature, Film* (Columbia University Press, 2012). Current research projects include a study of Elizabeth I as the first political diva.

Ian Christie is a film and media historian, curator and broadcaster. He has written and edited books on Powell and Pressburger, Russian cinema,

Scorsese and Gilliam, and contributed to exhibitions ranging from 'Film as Film' (Hayward, 1979) to 'Modernism: Designing a New World' (V&A, 2006). A Fellow of the British Academy, he is Professor of Film and Media History at Birkbeck, University of London, 2006 Slade Professor of Fine Art at Cambridge University, director of the London Screen Study Collection and past president of Europa Cinemas. Recent publications include *The Art of Film: John Box and Production Design* (Wallflower, 2009) and the edited collection *Audiences* (Amsterdam University Press, 2012) and articles on Patrick Keiller, early film copyright, film in the museum and stereoscopy.

Jude Cowan Montague works in the Reuters Archive at ITN Source. She has a PhD in the History of Film and Visual Media from Birkbeck, University of London and has conducted research on early British cinema. She is a writer, artist and composer and the author of *For the Messengers* (Donut Press, 2011), a collection of poetry about Reuters Television news stories during 2008.

Glyn Davis is Chancellor's Fellow and Reader in Screen Studies at the University of Edinburgh. He is the author of *Superstar: The Karen Carpenter Story* (Columbia University Press, 2008) and *Far from Heaven* (Edinburgh University Press, 2011) and co-editor with Gary Needham of *Queer TV: Theories, Histories, Politics* (Routledge, 2009) and *Warhol in Ten Takes* (BFI, 2013).

James Downs is currently conducting doctoral research on nineteenth-century photography at the University of Exeter. His published work on photographic history has appeared in *The Innes Review* and *Studies in Photography: The Journal of the Scottish Society for the History of Photography* and he is the editor of *A Carnal Medium: Fin-de-siècle Essays on the Photographic Nude* (Callum James Books, 2013). Current research projects include a book on nineteenth-century Hungarian photographer Ivan Szabo and a biography of Anton Walbrook.

Victoria Duckett teaches film history in the Centre for Ideas, Victorian College of the Arts, University of Melbourne. She has published broadly in early cinema, has programmed films for Cinema Ritrovato, Bologna, and convened the 2013 'Women and Silent Screen' conference in Melbourne as well as a related film programme at the Australian Centre for the Moving Image. She is currently completing *'A Little Too Much is Enough for Me': Sarah Bernhardt and the Silent Film* for the University of Illinois Press.

Steven Fielding is Professor of Political History and Director of the Centre for British Politics at the University of Nottingham. He is especially interested in the representation of politics in television and film in the UK and US. He has presented BBC Radio 4 documentaries on screen representations of New Labour and political conspiracies. His book *State of Play: British Politics on the Screen, Stage and Page since Trollope* was published by Bloomsbury in 2013.

Deidre Gilfedder is Senior Lecturer in English at the University of Paris-Dauphine. She specialises in Australian cultural studies and has published on First World War commemoration, the visual culture of Australia and Australian indigenous issues of testimony. Her forthcoming book is titled *Se souvenir des Anzacs: la mémoire de la Grande Guerre en Australie.*

Basil Glynn is Lecturer in Film and Television at Middlesex University. Together with James Ashton and Beth Johnson he co-edited the collection *Television, Sex and Society* (Bloomsbury / Continuum, 2012) and has published on topics including body horror and popular drama, transnational television, East Asian television drama and Korean pop music.

Ann Gray is Emerita Professor of Cultural Studies at the University of Lincoln. She was Principal Investigator on the AHRC-funded 'Televising History 1995–2010' project. In addition to her co-authored monograph with Erin Bell, *History on Television* (Routledge, 2013), she has published on television documentary, methods for memory studies, research practice and the history of cultural studies. She is a founding editor of the *European Journal of Cultural Studies.*

Andrew Higson is Greg Dyke Professor of Film and Television at the University of York, UK, where he is Head of the Department of Theatre, Film and Television. He has published widely on British cinema, national / transnational cinema and heritage cinema. His books include *Film England: Culturally English Filmmaking since the 1990s* (I.B.Tauris, 2011), *English Heritage, English Cinema: The Costume Drama since 1980* (Oxford University Press, 2003) and *Waving the Flag: Constructing a National Cinema in Britain* (Oxford University Press, 1995). He is currently leading a collaborative European research project, 'Mediating Cultural Encounters through European Screens' (www.mecetes.co.uk).

Jane Landman is Senior Lecturer at Victoria University in Melbourne, where she teaches media studies. An editor of the forthcoming Wiley-Blackwell *Companion to Australian Cinema*, she explores representations of Australia and the Pacific in film history. She is the author of *'The Tread of a White Man's Foot': Australian Pacific Colonialism and the Cinema* (Pandanus Books, ANU, 2006). Recent work includes editing (with Felicity Collins) a theme issue of *Studies in Australasian Cinema* focusing on 'decolonising screens'.

Karen Lury is currently Dean of Research for the College of Arts at the University of Glasgow and an editor of the film and television journal *Screen*. She has published widely on children and film, on screen performance and on television. Her most recent monograph is *The Child in Film: Tears, Fears and Fairy Tales* (I.B.Tauris, 2010). Research for her chapter in this collection draws upon her recently completed AHRC-funded project on 'Children and Amateur Media in Scotland 1927–2010'. With Ryan Shand, Karen is writing a co-authored monograph based on the project titled *Show and Tell: Children and Amateur Media* (Edinburgh University Press, forthcoming).

Mandy Merck is Professor of Media Arts, Royal Holloway, University of London. She is the author of *Perversions: Deviant Readings* (Virago / Routledge, 1993), *In Your Face: Nine Sexual Studies* (New York University Press, 2000) and *Hollywood's American Tragedies: Dreiser, Eisenstein, Sternberg, Stevens* (Berg, 2007). Among her edited collections are *After Diana: Irreverent Elegies* (Verso, 1998), *America First: Naming the Nation in US Film* (Routledge, 2007) and, most recently, *Further Adventures of the Dialectic of Sex* (co-edited with Stella Sandford, Palgrave Macmillan, 2010). Her next book is provisionally titled *The Melodrama of Celebrity: Personal Worth and Public Attention*.

Nicola Rehling has taught film and literature at Aristotle University of Thessaloniki and CITY College, International Faculty of the University of Sheffield. Her research interests include feminist film theory, popular cinema, gender theory and critical race theory. She is the author of *Extra-Ordinary Men: White Heterosexual Masculinity in Contemporary Popular Cinema* (Lexington, 2009) and is currently researching the relationship between cinema and cultural memory.

Jo Stephenson is a PhD candidate in Film at Queen Mary University of London. Her doctoral research is on the use of British film to promote the

branding of the nation and its fashion industry, ranging from the 1940s British Pathé Cinemagazine to the films of the Central Office of Information in the 1960s.

Barbara Straumann is Senior Lecturer in the English Department of the University of Zurich. She is the co-author, with Elisabeth Bronfen, of *Die Diva: Eine Geschichte der Bewunderung* (Schirmer/Mosel, 2002) and the author of *Figurations of Exile in Hitchcock and Nabokov* (Edinburgh University Press, 2008). She is currently completing a monograph on female performer voices in narrative fiction in the nineteenth century and, with Elisabeth Bronfen, a study of Queen Elizabeth I as the first political diva. Her new research focuses on debt in the Victorian novel.

ACKNOWLEDGEMENTS

This volume originated in 'The British Monarchy on Screen', a conference held on 23–24 November 2012 at Senate House, University of London. The conference was convened by the University of London Screen Studies Group; the Institute of English Studies of the School of Advanced Study, University of London; the Department of Media Arts and the Centre for International Theatre and Performance Research at Royal Holloway, University of London. Their support for this event is gratefully acknowledged.

'Melodrama, celebrity, *The Queen*' by Mandy Merck was originally published in *Women: A Cultural Review*, Volume 24, Numbers 2/3 (Summer/Autumn 2013), 'Women in Politics'. The permission of the Editors to reprint this article is gratefully acknowledged. Support for the research of this article was generously provided by a fellowship from the Leverhulme Foundation.

Introduction

Mandy Merck

This volume is the culmination of a project begun in the sixty-first year of the reign of Queen Elizabeth II, Head of the Commonwealth and Queen Regnant of the United Kingdom, Canada, Australia and New Zealand, as well as several Caribbean countries, Papua New Guinea, the Solomon Islands and Tuvalu. Among the many public celebrations that marked that Diamond Jubilee year, the Queen opened the 2012 Summer Olympics in partnership with the current James Bond. As BBC viewers looked on, Daniel Craig's 007 arrived at Buckingham Palace and briskly climbed the stairs to the Queen's private receiving room, where she worked at her desk in a dress of pink velvet. From there, trailed by two faithful corgis, he escorted her to a waiting helicopter that glided above Big Ben, St Paul's and the Tower of London to the illuminated Olympic stadium, into which the MI6 agent and his monarch, signature handbag on arm, duly parachuted to the surf-rock riffs of the James Bond theme.

The collaboration of the longest-reigning British sovereign with one of the longest-running film series in history raises issues that will be considered in this study. Central to them is the continuing role of royal representation in film and television as patriotic signifier and entertainment commodity. What political meanings – of Crown and Parliament, Empire and Commonwealth, sovereign and subject – do these moving images convey? How are these meanings assimilated to the commercial significance of royalty? Or indeed to the commercial imperatives of the media industries that portray them?

If, as many commentators and the British Council itself maintain, the Olympic opening ceremony was a triumphant celebration of the nation's cultural influence, what relation does this 'soft power'[1] have to the harder version personified by the muscular Bond? What connection does this charmingly self-mocking monarch have with the purviews of British intelligence, or indeed

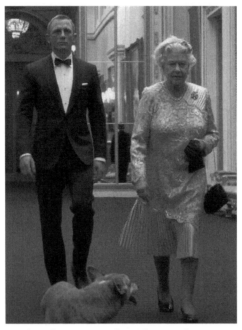

1 Elizabeth II is escorted to the 2012 London Olympics by James Bond (Daniel Craig), as filmed for the BBC by Danny Boyle.

the other institutions represented by the London landmarks over which her helicopter flew – parliament, the established church, and the punitive power of the state? How have film and television, British and international, masked or made manifest the political power of the British monarchy?

In what way is the significance of that institution inflected by the key genres – action adventure, costume drama, the 'biopic' and melodrama – with which it is portrayed in fiction film? How do these understandings shift with the international production and consumption of such fictions? What connections are drawn between royal celebrity and movie stardom? How is the deference with which the British royal family has historically been portrayed in its national media affected by the greater informality of contemporary social relations – or indeed by their own intermarriage with their social subordinates? Do the richly brocaded broadcasts of royalty on state occasions contradict their more critical coverage in history documentaries and current affairs programmes? What happens when the spectators enter the ceremonial scene?

Happy and Glorious, as Danny Boyle's dramatisation of the Queen's arrival at the Olympic stadium is titled, is only one example of the countless screen

appearances of this particular monarch on television, in cinema newsreels and in her more recent portrayals in feature films. A superstar in her own right, Elizabeth II has reigned for over half of the entire history of the cinema, as was pointed out on her Jubilee visit to the British Film Institute. The screening for her at the BFI predictably included excerpts from British classics such as *Lawrence of Arabia* and popular comedies like *Carry On Camping*, but also scenes from the royal home movies in the Institute's archive, reaching backward from footage of the Queen as a young mother holding Prince Charles in 1949 to film of her great-great-grandmother Victoria in 1896.

Moving images of the British monarchy, in fact and fiction, are almost as old as the moving image itself. In 1895 the Edison Manufacturing Company released an eighteen-second Kinetoscope film titled *The Execution of Mary Stuart*. Directed by Alfred Clark, it may be the first film with trained actors and one of the first to use editing for special effects. In this dramatic vignette, the blindfolded Queen of Scots (played by an uncredited actress) is led past a contingent of armed guards to kneel with her neck on the block. Watched by two women attendants, the executioner (Robert Thomae) raises his axe, brings it down and then holds the severed head aloft. The shocking decapitation was created by stopping the camera, replacing the actress with a mannequin and cranking it up again.

One year later a living monarch, Queen Victoria, was filmed at Balmoral riding in an open chaise attended by a Highlander. The Queen's last years were repeatedly filmed, whether in a procession to the May 1897 opening of Sheffield's Town Hall, or in a much grander parade through the streets of London to celebrate her Diamond Jubilee a month later. By her death in January 1901, the commercial value of royal 'actualities' had become apparent, and several film companies took up positions on the route of her funeral cortège, along which Victoria's crowned coffin was borne on a gun carriage. From these early examples alone, it is easy to perceive the appeal of royal movies – costumes, carriages and national celebration vie with martial display, violence and, as we shall see, romance. And, not incidentally, the prominence of Britain's queens, from the Celtic Boudicaa (played by Alex Kingston in 2003) to Elizabeth II (played by Helen Mirren in 2006), offers plentiful leading roles to women as representatives of an institution deemed to have become increasingly feminised. Long before the 2012 legislation ending male primogeniture in the royal succession, the longevity of Victoria and Elizabeth II, the idealisation of the maternal wife and her influence and the presumed amenability of

women contributed to this feminisation, and to the potential 'depoliticisation' of the royal role.[2] It also provided rich narrative opportunities for royal screen fictions in the genres of romance, costume drama and melodrama, with their ready-made female following.

The reign of the current British monarch is as foundational to the history of television as that of her great-great-grandmother Victoria is to the cinema. The 1953 coronation is famously cited as a milestone in the adoption of the new medium, doubling the number of UK TV licence holders as Britons bought sets for the first time in order that they and their neighbours could watch it. (Some 20 million did so, as well as the 100 million North Americans who viewed a recording of the ceremony in the days before satellite transmission.) Other blockbusters in royal broadcasting would follow, including the 1981 marriage of Prince Charles to Lady Diana Spencer (750 million viewers worldwide) and Diana's funeral sixteen years later (2.5 billion). In addition to Stephen Frears's Oscar-winning 2006 drama of the week of that funeral, *The Queen*, this ill-fated relationship prompted a remarkable number of US television biopics, including *Charles and Diana: A Royal Love Story* (1981), *The Royal Romance of Charles and Diana* (1981), *Charles and Diana: Unhappily Ever After* (1992), *The Women of Windsor* (1992), *Diana: Her True Story* (1993), *Princess in Love* (1996), *Charles and Camilla: Whatever Love Means* (2005) and *Last Days of a Princess* (2007).[3]

As a depiction of the life of a named historical person, the biopic is one of the venerable forms of film and television drama, and an obvious genre for royal representation. Often based on popular biography, this generic designation overlaps that of historical fiction more generally and costume drama less historically. Yet the plethora of US-made biopics about Charles and Diana exposes the comparative reluctance of British producers to portray living members of the royal family in dramatic works until recently. As John Snelson observes, any such depiction of a living monarch was 'unthinkable' at the time of Elizabeth II's coronation, and it took a further fifty-three years for Frears's film to make history as the first full-length cinematic representation of a reigning British sovereign.[4]

The numerous film adaptations of Shakespeare's histories and those of later royal dramatists such as Friedrich Schiller, whose 1800 play *Mary Stuart* provided a precedent for the Edison short as well as Katherine Hepburn's *Mary of Scotland* (1936) and Vanessa Redgrave's *Mary, Queen of Scots* (1971), suggest the range of generic possibilities for such portrayals. When fictionalised accounts of British monarchs emphasise the painful struggle between public duty and

personal desire, they enter the terrain of melodrama, with its focus on the intimate life of a suffering individual. As this collection will demonstrate, all these genres have been plundered for royal representation, both in film and television fiction, in single and series form. Indeed, the media representation of the British royal family's crises and celebrations, as successive generations pass through birth, childhood, courtship, marriage, procreation and death, has long been described, in the term originally used for serial dramas sponsored by manufacturers of household cleansers, as soap opera.

When Malcolm Muggeridge denounced the 'orgy of vulgar and sentimental speculation' over Princess Margaret's relationship with a divorced Royal Air Force officer as a 'royal soap opera' in 1955,[5] he failed to consider the success of the narrative form he was invoking. By that date, the cinema had already produced a lengthy roster of melodramatic British monarchs, beginning with Sarah Bernhardt's *Queen Elizabeth* (*Les Amours de la Reine Elisabeth*) in 1912 and given the Hollywood treatment with Bette Davis's two portrayals of the same Queen in 1939 and 1955. The theme, in these and similar pictures, was the suffering of a royal woman torn between romantic fulfilment and official obligation, a box-office formula that persists in films such as 1997's *Mrs. Brown*. Moreover, in comparing 'the running serial' of tabloid coverage of controversial romances like Margaret's and that of her abdicating uncle Edward VIII to *The Archers*, Muggeridge underestimated the longevity of both. Today the BBC radio serial and the British monarchy are more popular than ever. Unlike the feature melodrama, which comes, however ambiguously, to a conclusion, the soap opera can go on and on. And thus it has readily contributed to the identification of the Crown's continuity with that of the nation, as endorsed by the writer himself.

VICTORIAN INVENTIONS

Malcolm Muggeridge suspected that the royal family had developed 'a taste for the publicity which, in theory, they find so repugnant',[6] but this again was no new phenomenon. As Ian Christie recounts in this collection, Queen Victoria and her consort Prince Albert were not only early enthusiasts of photography but their own family archivists, installing a darkroom in Windsor Castle and having their nine children schooled in the medium. In addition to the albums compiled by the family, the royal parents and their offspring had their portraits taken by professionals such as the famed Crimean War photographer Roger Fenton. For her Diamond Jubilee in 1897, Victoria chose a photograph by

William Ernest Downey as her official portrait and encouraged its wide circulation without copyright control, so long as the Downey studio was credited. A decade later her daughter-in-law Queen Alexandra, wife of Edward VII, would publish a *Christmas Gift Book* of family photographs, the proceeds going to charity.

This interest in photography extended to the moving image, with British cinematographer Birt Acres following up his 1895 film of the Queen's grandson Kaiser Wilhelm with an 1896 study of the Prince and Princess of Wales opening the Cardiff Exhibition. A few months later Victoria herself agreed to be filmed at Balmoral by J. Downey, son of William Ernest. The *Lady's Pictorial* later reported that the resulting vignette, together with lantern slides of royal photographs and Robert Paul's film of the Prince of Wales's horse winning the Derby, were exhibited at Windsor to the delighted Queen and her household on 23 November 1896. If Downey's 'animated photographs' of the monarch were intended for private consumption, they were soon followed by royal films designed for the public. At the initiative of Colonial Secretary Joseph Chamberlain, Victoria's June 1897 Diamond Jubilee procession was staged as a spectacle of imperial splendour of and for her (inter)national subjects, marching in the massed ranks of the colonial troops, watching in person on the streets of London or later in the new film theatres of Belfast and Melbourne and Quebec. Nor were Victoria's family unwilling to exhibit their social life on screen. The summer of 1897 saw the filming of three generations of them at *Afternoon Tea in the Gardens of Clarence House*, followed in 1900 by the very popular *Children of the Royal Family of England* showing the future Edward VIII 'at play' with his young siblings.

Victoria was not only the first British monarch to be filmed; her reign became talismanic for producers eager to invoke its power and prosperity as the Empire was threatened with war, rebellion and economic collapse. On the eve of the Great War, G. B. Samuelson's *Sixty Years a Queen* celebrated *The Life and Times of Queen Victoria* in an exceptionally expensive epic of nearly two hours' length, now lost except for a 46-foot fragment depicting the moment in which the young Princess is told that she will become Queen. Recreating it through the surviving press-book's scene list and production stills, a tie-in biography and the trade papers, Jude Cowan Montague describes the painstaking production and ecstatic reception of this 'great patriotic film'. Casting three actresses to represent the Queen from youth to old age, *Sixty Years a Queen* employed the infrastructure and techniques of theatrical history dramas as well as their tableau

style. Events as varied as the monarch's proposal to Albert, the annexation of British Columbia, the Indian Mutiny and a visit of 'Victoria the Good' to the military hospital she had established in Hampshire were carefully researched and designed using illustrations from the weekly pictorials. Authenticity became the watchword of films about this royal personage, not least in this case because some of its spectators had lived through the events represented. But authenticity did not rule out hagiography, and the Queen was portrayed as a saintly, if well-dressed, head of a national community reconsecrated by viewing the film.

The production of films about Victoria did not abate with the deaths of those who remembered her. On the contrary, as Steven Fielding points out in this volume, she has persisted as the central protagonist of features stretching to the 2009 *The Young Victoria*. Acknowledging a 2012 British survey whose respondents believed that the current Queen was more concerned about their problems than were their elected representatives, Fielding reads her predecessor's biopics in the light of 'an idea almost as old as history' recorded by George Orwell, that the monarch and the common people share 'a sort of alliance against the upper classes'.[7] After a hiatus enforced by George V's prohibition of filmed portrayals of his grandmother, British producer-director Herbert Wilcox released *Victoria the Great* in 1937, the year of the coronation of George VI and the centennial of Victoria's own accession to the throne. So successful was this picture that Wilcox immediately followed it with *Sixty Glorious Years* in 1938. Both films star the producer's wife Anna Neagle and Anton Walbrook as a romantic royal couple, and both emphasise the Queen's concern for the well-being of her subjects in the face of her dilatory, bellicose or uncaring prime ministers. Even the Queen's favourite, Benjamin Disraeli, is shown opposing the repeal of the Corn Laws before embracing the beneficent Victorian agenda in the 1930s films. (In a notable exception, their postwar sequel *The Mudlark* (1950), it is the Prime Minister who convinces the mourning monarch to end her seclusion and join him in social reform.) As Fielding observes, recent Victorian films have been even more negative in their evocation of the country's political leadership, with *Mrs. Brown* (1997) portraying Disraeli as a cynical manipulator of his grieving sovereign and *The Young Victoria* drawing implicit parallels between the reforming Queen's struggles with a recalcitrant Lord Melbourne and Princess Diana's with an unsympathetic male establishment. Both regal characterisations, of the distraught older monarch (played by Judi Dench) and the idealistic *ingénue* (Emily Blunt), invite an identification that disavows the immense distance between the sovereign and her subjects.

In a rare discussion of the actor made famous by his casting as Prince Albert, James Downs compares the Viennese actor Anton Walbrook's ambiguous relation with his adopted country to that of Albert himself. Originally trained as a classical actor, the then Adolf Wohlbrück played sophisticated heroes in popular German films, anticipating his royal role in the 1933 musical *Walzerkrieg* by portraying composer Johann Strauss on a visit to Victoria's court. But his screen success could not withstand the dangers posed by his homosexuality and Jewish ancestry as the Nazification of the German film industry proceeded, and he seized the opportunity of an RKO contract to work in Hollywood. While he was filming there in 1936, the British ban on dramas about Victoria was lifted and rival producers began to plan films of her life. When Wilcox prevailed, Walbrook's resemblance to Prince Albert brought him to England early in 1937.

The question of resemblance was crucial in a period in which the Windsors' reticence about filming their forebears was only beginning to relax. Wilcox's team sought the royal household's advice on Victorian architecture and costume to render their production a faithful record, but the vogue for the Viennese waltz film required the movie couple to perform a dance that would have been impossibly intimate for the real Queen. The resulting hybrid of period detail and popular convention proved a huge success, with Walbrook's rendition of an intelligent and ironic Prince judged brilliant. In the 1937 *Victoria the Great* Albert confronts accusations of spying for Germany, but with war approaching, the film's sequel, *Sixty Glorious Years*, omits even its predecessor's reference to Victoria's German-speaking childhood. Only a few months later, as a German national, Walbrook himself would have his radio and car confiscated when war was declared. The origins that had supported his casting as Prince Albert consigned him to similar suspicions of disloyalty long before his burial in England as the ultimately beloved performer of his royal role.

THE ELIZABETHAN DIVA

Film portraits of Victoria follow the lead of the Queen herself in emphasising the happiness and stability of the royal *family*. 'A family on the throne is an interesting idea', the nineteenth-century political journalist Walter Bagehot enthused, comparing its popular appeal to the dull machinations of little-known parliamentarians.[8] But the family values espoused in the Victorian canon are a world away from the themes explored in films portraying her greatest screen rival, Elizabeth I. Unencumbered by the reserved image of an English gentlewoman,

8

the Virgin Queen enters the cinema as the diva of royal representation – magnificent, passionate, singular. Fittingly, her most notable early film incarnation is by Sarah Bernhardt, then the world's most famous actress, if something of an intruder in the cinema. In 1912 Bernhardt revived her stage failure *Queen Elizabeth* in a multiple-reel feature in which the stricken Queen dies of remorse after executing the man she loves. On the heels of her highly successful screen version of *La Dame aux camélias*, it too became an international success, drawing other theatre stars to the cinema and helping to inaugurate the longer-playing narrative film. Yet scholars and historians have long denounced *Queen Elizabeth* as anachronistic and stagey, proof of its star's inability to engage with film. Reconsidering the much-denigrated theatricality of this melodrama, Victoria Duckett praises the spectacular appeal of its pictorial composition, expressive gestures and capacity to animate the static pose. Not for the last time, the regal role is seen to confirm the star performer's own majesty.

In establishing her political power, the real-life Elizabeth made exceptionally effective use of her public self-display in rich apparel, stately 'progresses' through her realm and commissioned portraits, so becoming an iconic figure. Monarchy, in Ernst Kantorowicz's influential theory of medieval and early modern culture, exists in the sovereign's natural body and persists in the body political, guaranteeing the institution's immortality.[9] As a female monarch, Elizabeth I was constituted by a normatively masculine symbolic body and a feminine natural one, a duality that is also marked in the relations of gender to power in her cinematic representation. Addressing the conflict between private person and public persona particular to female sovereignty, Elisabeth Bronfen and Barbara Straumann explore the diverse enactments of the Queen by four film stars (Flora Robson, Bette Davis, Jean Simmons and Cate Blanchett) in eras of impending war, ambivalent domesticity and political spin-doctoring. As the Queen's two bodies bring together her physical being and her symbolic mandate, the mediality of this screened embodiment becomes conspicuously foregrounded.

In 1992, Quentin Crisp appeared on cinema screens as Elizabeth I in Sally Potter's adaptation of Virginia Woolf's *Orlando*; the following year he provided the 'Alternative Queen's Message' on Britain's Channel 4 television on Christmas Day, in direct competition with Elizabeth II's own holiday address. The late 1980s and early 1990s had heralded a shift away from the lesbian and gay politics that had arisen in the 1970s towards a more confrontational queer activism. With it came a 'new queer cinema' which transgressed received history in a

pointedly artificial *mise-en-scène* (Isaac Julien's 1989 *Looking for Langston*, Derek Jarman's 1991 *Edward II*, Tom Kalin's 1992 *Swoon*). *Orlando* can be seen as a prime example of queer cinema, given its play with gender and sexuality and the choice of Jarman collaborator Tilda Swinton for the title role. In casting the arch-diva Crisp as the quintessence of queenliness, Potter's film takes its lead from Woolf's novel, a fictional biography whose hero turns into a heroine. But as Glyn Davis points out, the film's *lèse-majesté* can also be traced back to Woolf's ambivalent musings about monarchy in her other writings, which both marvel at and ridicule the custom of 'bowing and curtseying to people who are just like ourselves'.[10]

IMAGES OF EMPIRE

Remarking in her diary on the shock caused by the revelation that Edward VIII was considering abdication in order to marry a twice-divorced American socialite, Virginia Woolf noted the widespread view that if royalty was in peril, 'empires, hierarchies – moralities – will never be the same again'.[11] But both royalty and imperial loyalty have persisted long beyond the 1936 abdication crisis, sustained by the ties of the Commonwealth of Nations and the geopolitical forces that this organisation of former British territories represents. Founded as decolonisation and the Cold War took hold in 1949, its head continues to be the British monarch, who is also monarch of sixteen of its member states, including Australia. Where her namesake consolidated her hold on the crown with her spectacular progresses through England, the modern Elizabeth's periodic tours of the Commonwealth, together with those of her royal relations, have also been politically purposeful, calculated to strengthen economic and military alliances. Exploring a much-heralded colour film of one such visit, *The Queen in Australia* (1954), Jane Landman considers the dramaturgy with which the Griersonian documentarist Stanley Hawes renders the first visit to Australia by a ruling monarch, the climax of the 1953–54 Royal Tour of the Pacific. Shooting 60,000 feet of film on a tour of 10,000 miles, Hawes crafted an explicit assertion of settler colonialism – 'a new nation, flexing its muscles, filling its spaces, inheriting its own'. Arriving as Queen of the 'free world', the regal young mother is an ideal representative of both renewal and tradition. Her happy family – white crowds climbing trees to catch sight of the sovereign, white flower girls presenting their tributes, and the occasional Indigenous dancer – are played by Australians in a striking performance of imaginary unity.

Fifty-six years later, both social hierarchy and imperial loyalty were con-firmed in the highly successful dramatisation of Elizabeth's father, the soon-to-be George VI, and his treatment by Australian actor-turned-speech therapist Lionel Logue. *The King's Speech* (2010) takes the imperial story back to the abdi-cation, which results in Prince Bertie's reluctant ascent to the throne. Opening with his agonised stammering at the British Empire Exhibition of 1925 and clos-ing at the declaration of war in 1939 with a BBC radio address to his imperial subjects, the film portrays the healing of the monarchy by its loyal, if imper-tinent, colonial vassal. As Deidre Gilfedder observes, *The King's Speech* follows the Shakespearean tradition of the 'trusted fool' as the irrepressible Logue (Geoffrey Rush) insists on equality with his royal patient (Colin Firth) in seek-ing to cure his stammer. This dose of democracy propels the stuffy sovereign into modernity, enabling him to meet the new media demands of monarchy and speak into the microphone. An all-purpose therapist, drama coach and spin doctor, Logue effectively ushers Britain's last emperor into the less deferential, but still stratified, world of the film's spectators, where in 2014 the Australian government reintroduced the titles of Knight and Dame. Commenting on the film's challenge to republicanism, the English journalist Jonathan Freedland has argued that the concluding emphasis on the Second World War confirms that it 'has now become our nation's defining narrative, almost its creation myth', with the briefly seen Princess Elizabeth 'the last public figure anywhere in the world with a genuine tie' to it and her royal descendants 'Kate and Wills' now on first-name terms with the far-flung denizens of the former Empire.[12]

POPULAR PARTICIPATION IN ROYAL REPRESENTATION

The dramatic and documentary films so far described are designed for the dynamics of traditional cinematic spectatorship, with the (on- and off-screen) commoner as onlooker and the monarch as the object of the gaze. But this rela-tionship has been modified in other modes of screen representation, enabling the spectator to enter the scene. As Karen Lury demonstrates, the Scottish ama-teur film archive offers fascinating examples of this process, with home movies of royal visits accidentally breaching the fourth wall between the royal entou-rage and the crowd to capture the smoking, chatting, fidgeting spectators them-selves. Analysing amateur films from 1932 and 1952, she observes the way they expose the clumsy choreography of such visits and the fragile formality of the monarch's performance. The recurring figure of the child is central to Lury's

analysis. In royal visit films, the little girl who proffers her posy is a figure of social inferiority, an inferiority that conveniently can be attributed to her status as a child rather than as a member of a subordinate population. But in another type of amateur film, those in which schoolchildren parade as make-believe queens, they are the intended spectacle, together with the crowd who watch them. Dressed in a fanciful approximation of ceremonial robes, they proceed in awkward imitation of regal poise and again reveal its performative character. However loyal in intention, these amateur films insidiously expose the illusory nature of royal superiority.

Where the children in amateur films copy the monarch in homemade costumes, this mimetic impulse has long been commercialised in the fashion industry's mass production of royal couture. Paramount in this process is the royal wedding, in Bagehot's famous description, 'the brilliant edition of a universal fact'. Reflecting on its screen history, Jo Stephenson traces the orchestrated anticipation of the bridal gown back to a British Pathé newsreel of the 1935 wedding of Prince Henry to Lady Alice Scott. Employing the present-tense narration later adopted for live broadcast, the commentator excitedly describes the wait for the bride and the international rejoicing at the marriage. Another Pathé film supplements this coverage by showing a mannequin modelling Lady Alice's honeymoon trousseau and naming its designer, royal couturier Norman Hartnell. The 1947 wedding of Princess Elizabeth was preceded by weeks of publicity about her Hartnell dress, taking in the rationing coupons required for its Essex-spun silk fabric. On the day of the ceremony replicas were ready for sale in the US. Two generations later, in addition to her much-acclaimed Alexander McQueen wedding gown, Catherine Middleton appeared in high-street dresses that had only to be worn to sell out. As Stephenson concludes, this democratisation of royal fashion is central to both its political and financial impact, sustaining the appeal of an apparently accessible national institution while promoting a national industry.

If by donning these clothes the public seek to join in the royal spectacle, this impulse is even more evident in the remarkable popularity of ceremonial broadcasts on giant outdoor screens. Despite the ubiquity of domestic TV, thousands chose to watch the 2011 royal wedding in Hyde Park and Trafalgar Square and an estimated million congregated to view the Golden Jubilee concert on screens along the Mall. Here the traditional norms of home viewing gave way to those of active social participation, in which the audience became a considerable part of the spectacle. This was evident in the news broadcasts

after Diana's death in 1997, when the mourners who brought their tributes to the Palace were the whole show until the Queen belatedly arrived.[13] Similarly, during Diana's funeral, it was the applause of the crowds viewing it on the big screen outside that prompted the very unconventional clapping within the Abbey. Canvassing the experiences of interviewees who had joined the al fresco audiences for the wedding of Diana's son in 2011 and his grandmother's Jubilee celebrations a year later, Ruth Adams explores how these public viewings created a co-presence with the events screened, via the spectators' co-presence with one another and the images of that presence included within the live broadcast. The reported result was a profound sense of being 'part of history'. Instead of the potentially destabilising performance of royalty afforded by imitative dress, the participatory dynamic was an immersive experience of the real time and screen space of the royal ceremony, in the process legitimating its public significance.

<center>TELEVISION'S CONTESTED HISTORIES</center>

Echoing the claim that state ceremonial elevates the prestige of British royalty even as that of Britain declines, David Cannadine maintained in 1978 that while the nation's 'television has cut politicians down to size, so that the grand manner in parliament or Whitehall is no longer effective, it has continued to adopt the same reverential attitude toward the monarchy which radio pioneered in the days of Reith'.[14] In response to the criticism of the BBC's populist coverage of the Jubilee celebrations thirty-four years later, Erin Bell and Ann Gray consider the current affairs and history programmes that framed these events in the years 2007–13. Comparing those broadcast by the BBC and Channel 4, they measure the differences in historical emphasis and interpretation generated by the two very different British channels. Three issues discussed in them illustrate the variation in their approaches to the past and future of the monarchy – Prince Charles's adultery with Camilla Parker-Bowles, Catherine Middleton's working-class ancestry and the possible abdication of the ageing Queen or her heir. Effectively interrogating the moral exemplarity, social superiority and future competence of the royal family, these programmes and their associated websites offer perspectives that cannot be described as 'reverential', however cautious their articulation. Whether they outweigh the iconic power of the broadcast ceremonials in which these individuals star is a different question.

With the relaxation of censorship in the era of cable, boxed sets and streamed television, historical drama has escaped the confines of family-centred broadcasting.

The graphic depiction of sex and violence in series such as *Rome* and *The Borgias* flouts the high-mindedness, as well as the factual pretensions, of previous historical dramas. In the case of Britain's most filmed king, the private life of Henry VIII provided *The Tudors* (Showtime, 2007–10) with a loose pretext for a dramatic update in screen persona, exchanging the ageing fatty in the feathered hat for a punk potentate with pectorals. Chronicling the long history of Henry films, Basil Glynn charts the international appeal of an English monarch impervious to the English virtue of 'fair play'. *The Tudors'* abiding allure of murder and multiple marriages, as enacted by a multi-national cast against a computer-generated background, attracted British and North American investment, as well as tax incentives provided by the Irish and Canadian governments. Discarding the expensive trappings of stage knights and castle locations, it was freed by writer-producer Michael Hirst to portray the Henry its audience wanted to see – a sadistic pop star working his way through a bevy of doomed damsels in an open-necked shirt. Post-national and post-historical as he undoubtedly is, this king upholds a tradition that has only intensified as British sovereigns have been subjected to screen mediation – one in which the monarchy and its moving image increasingly merge in a spectacle whose dominant meaning is the power of spectacle itself.

MONARCHY IN CONTEMPORARY ANGLOPHONE CINEMA

The 'heritage film' is less a generic category than a political accusation. Since the 1990s, many British-made period dramas have so been labelled to criticise the nostalgic travelogue of the imperial past that they are accused of propounding. Reflecting on the Thatcherite marketing of this fantasy history in tourism and the arts, Andrew Higson initially employed the term to characterise a cycle of 'quality' films with a late nineteenth- or early twentieth-century setting, conspicuous *mise-en-scène* and a concentration on a narrow band of privileged characters in picturesque locations.[15] If that description fits *Chariots of Fire* or the Merchant-Ivory adaptations of the novels of E. M. Forster, it also fits many films featuring British monarchs. But as Higson has also observed, the style of these films is often at odds with their narratives, overwhelming them with decor or admitting the double registration of 'repression and feeling'[16] characteristic of melodrama. This opens them to more complex analyses, and he has since elaborated his commentary on the heritage designation.

Turning in this volume to anglophone monarchy films made in the ensuing decades, Higson acknowledges their continuing role as profitable productions

of an imaginative construction of British national identity. Achieving this requires both the restatement of continuity between the past and present and the modernisation of the monarchy to make it relevant to contemporary concerns. In an increasingly transatlantic industry, films that depict Scottish and English kings and queens are often UK/US co-productions, working in a variety of genres. These can be roughly divided between the action adventure characteristic of representations of medieval monarchs in Mel Gibson's *Braveheart* (1995) or the *Robin Hood* films directed by Kevin Reynolds (1991) and Ridley Scott (2010); the costume dramas that typically display the ornamentalised rulers of Renaissance England in films like *Shakespeare in Love* (1998) and *The Other Boleyn Girl* (2008); and the dramas of late modern royal family life from *The Madness of King George* (1994) to *Hyde Park on Hudson* (2012). As Higson points out, this withdrawal from action to interiority reflects the reduction of royal power from warrior kingship to constitutional monarchy, from hard power to soft. In this reading the meaning of the Crown diminishes from physical force to visual splendour to model family. With the representation of the later royals, however, there is a necessary counterpoint, the faux-antique traditions largely instituted in Victoria's reign to distinguish the bourgeois sovereign from her subjects.[17] Here recent films have also exploited the royal duality of symbolic performer and private person identified by Kantorowicz, but where representations of Tudor monarchs eroticise the royal body to match its public decoration, those of modern kings and queens emphasise their physical restraint.

The tension in these characters as feeling individuals and ceremonial figureheads is the central theme of two highly successful melodramas. Both cast stars as monarchs, but they play down their glamour to emphasise George VI's and his daughter Elizabeth II's difficulties with their royal roles. *The Queen* depicts the fateful week after the death of Diana with actual as well as fabricated news footage and an intermittently documentary style. But, as Mandy Merck points out, despite its portrayal of real people and events, docudrama in this film is trumped by melodrama's pathos, appeal for moral recognition and highly expressive *mise-en-scène*. So doing *The Queen* became what David Thomson called 'the most sophisticated public relations boost HRH had had in 20 years'.[18] In its opposition of the Queen of hearts to the Queen of the nation, the film echoes Friedrich Schiller's 1800 proto-melodrama *Mary Stuart*, with its own meditation on a sovereign confronted with a female rival and the fluctuating loyalties of her subjects. Two centuries later, melodrama renders the modern monarch more vivid and affecting than the much-mourned Princess. Much of this triumph can

be attributed to Helen Mirren, bringing her star persona to a monarch in danger of being overshadowed by the fame of her rival. In an unusually forthright discussion of royalty and celebrity, *The Queen* draws the two regimes of power together in a single figure, who finishes the film with a declamation on 'glamour and tears'. Accepting her Academy Award for this performance, the soon-to-be Dame Helen consolidated Hollywood's long complicity with the Crown in a recitation of the loyal toast: 'Ladies and Gentlemen, I give you the Queen.'

The King's Speech is paradigmatic of the contemporary representation of the British monarchy through a mode that traditionally sides with the powerless. As Nicola Rehling demonstrates, the Prince who becomes George VI (Colin Firth) is a melodramatic figure whose integrity is underscored, in Linda Williams's phrase, by 'the literal suffering of an agonized body'. His speech impediment embodies the psychic wounds caused by both the demands of royalty and his austere father. Like his nickname 'Bertie', his stammering renders him the object of popular identification, despite his self-confessed ignorance of his common subjects. Melodrama, in Peter Brooks's influential formulation, offers moral legibility in a secular era, but only in individualised terms. Bertie's hysterical symptoms confirm his virtue and that of the monarchy as institution via a relentless focus on the private realm, with the spectre of class antagonism and republican protest evoked only to be dismissed. The King's stammering speaks the burden of royalty, while also providing a vehicle for exploring the reterritorialisation of the public/private distinction in the wake of the new mass media. His final broadcast unites the nation, reinvigorating the national body ailing from his brother's abdication, triumphantly readying it for war.

Both films climax with their monarchs' speeches broadcast to the nation, a mediated assertion of the increasing importance of the mass media to royal authority. As royal biographer William Shawcross wrote of *The Queen*'s portrayal of the monarch's reaction to the death of Diana in 1997, 'Since the film was released she has had many more letters, some of the writers saying that before the film they had never quite understood what she had been through, others saying how glad they were that the film had finally tried to tell the truth they had always accepted.'[19] In the Olympic opening, the real Queen replaced Mirren in the fictional frame. Reportedly delivered in one take, her 'Good evening, Mr Bond' was a sly reference to the historical interchange between motion pictures and the Palace. For a reserved woman who had complained as a young princess of the harsh lighting of her photographers,[20] the Queen's embrace of movie bondage was an overdue acknowledgement

of a *fait accompli*. Her model was of course 'M', Bond's boss in the film series, played from 1995's *Golden Eye* to the 2009 *Skyfall* by Judi Dench. In 1998 Dame Judi also played, in *Mrs. Brown*, the Queen's great-great-grandmother Victoria, and in 1997 her namesake, Elizabeth I, in *Shakespeare in Love*. As Philip French wrote in his review of *Skyfall*, 'M seems now a code letter for majesty.'[21] Its literalisation three years later was an Olympian achievement of updated loyalty, media reflexivity and reciprocal product placement – in the tradition of British screen monarchs.

NOTES

1 See Joseph Nye, *Soft Power: The Means to Success in World Politics* (New York: PublicAffairs, 2004); and John Holden assisted by Chris Tryhorn, *Influence and Attraction: Culture and the Race for Soft Power in the 21st Century* (London: British Council, 2013), www.britishcouncil.org/.../files/influence-and-attraction-report. pdf.

2 Andrzej Olechnowicz, 'Historians and the modern British monarchy', in Andrzej Olechnowicz (ed.), *The Monarchy and the British Nation, 1780 to the Present* (Cambridge: Cambridge University Press, 2007), pp. 29–31.

3 See Giselle Bastin, 'Filming the ineffable: biopics of the British royal family', *Auto/Biography Studies* 24:1 (Summer 2009).

4 See John Snelson, 'Royalty on stage: famous examples and struggles with royal censorship', *Royal Opera House* (18 June 2013), www.roh.org.uk/famous-examples-and-struggles-with-censorship; and Mark Lawson, 'One is ready for one's close-up', *Guardian* (8 September 2006), www.theguardian.com/film/2006/sep/08/3.

5 Malcolm Muggeridge, 'The royal soap opera', *New Statesman* (first published in the *New Statesman*, 22 October 1955), republished by the *New Statesman* (30 May 2012), www.newstatesman.com/lifestyle/2012/05/royal-soap-opera.

6 *Ibid.*

7 George Orwell, 'The English people', in *The Collected Essays, Journalism and Letters of George Orwell*, vol. 3, *As I Please, 1943–1945*, ed. Sonia Orwell and Ian Angus (London: Secker & Warburg, 1968), p. 17.

8 Walter Bagehot, *The English Constitution* (1867) (London: Fontana Library, 1963), p. 85.

9 Ernst H. Kantorowicz, *The King's Two Bodies: A Study in Mediaeval Political Theology* (Princeton, NJ: Princeton University Press, 1957).

10 Virginia Woolf, 'Royalty' [1934], in Michèle Barrett (ed.), *Women and Writing* (New York: Harvest, 2003), p. 139.

11 Virginia Woolf, *The Diary of Virginia Woolf*, vol. 5, *1936–1941*, ed. Anne Olivier Bell (London: Hogarth Press, 1984), pp. 12–13.

12 Jonathan Freedland, '*The King's Speech* lays bare the sheer scale of the republican challenge', *Guardian* (18 January 2011), www.theguardian.com/commentisfree/2011/jan/18/kings-speech-republican-challenge-war-queen.

13 See Mandy Merck, 'Introduction', in Mandy Merck (ed.), *After Diana: Irreverent Elegies* (London: Verso, 1998), p. 7.

14 David Cannadine, 'The context, performance and meaning of ritual: the British monarchy and the "invention of tradition", *c.* 1820–1977', in Eric Hobsbawm and Terence Ranger (eds), *The Invention of Tradition* (Cambridge: Cambridge University Press, 2000), p. 158.

15 See Andrew Higson, 'Re-presenting the national past: nostalgia and pastiche in the heritage film', in Lester Friedman (ed.), *British Cinema and Thatcherism* (London: Routledge, 1993).

16 For a detailed commentary see Belén Vidal, *Heritage Film: Nation, Genre and Representation* (London: Wallflower, 2012), p. 19.

17 See Cannadine, 'The context, performance and meaning of ritual', pp. 101–64.

18 David Thomson, 'Biographical dictionary of film, number 99 (Stephen Frears)', *Guardian* (3 September 2010), p. 14.

19 William Shawcross, 'Portrait in majesty', *Vanity Fair* (June 2007), p. 106.

20 Ben Pimlott, 'Monarchy and the message', *Political Quarterly* 69:B (1998), p. 94.

21 Philip French, 'Skyfall', *Observer* (28 October 2012), www.theguardian.com/film/2012/oct/28/skyfall-james-bond-review.

BIBLIOGRAPHY

Bagehot, Walter, *The English Constitution* [1867] (London: Fontana Library, 1963).

Bastin, Giselle, 'Filming the ineffable: biopics of the British royal family', *Auto/Biography Studies* 24:1 (Summer 2009).

Cannadine, David, 'The context, performance and meaning of ritual: the British monarchy and the "invention of tradition", *c.* 1820–1977', in Eric Hobsbawm and Terence Ranger (eds), *The Invention of Tradition* (Cambridge: Cambridge University Press, 2000).

Freedland, Jonathan, '*The King's Speech* lays bare the sheer scale of the republican challenge', *Guardian* (18 January 2011), www.theguardian.com/commentisfree/2011/jan/18/kings-speech-republican-challenge-war-queen.

French, Philip, '*Skyfall*', *Observer* (28 October 2012), www.theguardian.com/film/2012/oct/28/skyfall-james-bond-review.

Higson, Andrew, 'Re-presenting the national past: nostalgia and pastiche in the heritage film', in Lester Friedman (ed.), *British Cinema and Thatcherism* (London: Routledge, 1993).

Holden, John, assisted by Chris Tryhorn, *Influence and Attraction: Culture and the Race for Soft Power in the 21st Century* (London: British Council, 2013), www.britishcouncil.org/.../files/influence-and-attraction-report.pdf.

Kantorowicz, Ernst H., *The King's Two Bodies: A Study in Mediaeval Political Theology* (Princeton, NJ: Princeton University Press, 1957).

Lawson, Mark, 'One is ready for one's close-up', *Guardian* (8 September 2006), www.theguardian.com/film/2006/sep/08/3.

Merck, Mandy, 'Introduction', in Mandy Merck (ed.), *After Diana: Irreverent Elegies* (London: Verso, 1998).

Muggeridge, Malcolm, 'The royal soap opera', *New Statesman* (first published in the *New Statesman*, 22 October 1955), republished by the *New Statesman* (30 May 2012), www.newstatesman.com/lifestyle/2012/05/royal-soap-opera.

Nye, Joseph, *Soft Power: The Means to Success in World Politics* (New York: PublicAffairs, 2004).

Olechnowicz, Andrzej, 'Historians and the modern British monarchy', in Andrzej Olechnowicz (ed.), *The Monarchy and the British Nation, 1780 to the Present* (Cambridge: Cambridge University Press, 2007).

Orwell, George, 'The English people', in *The Collected Essays, Journalism and Letters of George Orwell*, vol. 3, *As I Please, 1943–1945*, ed. Sonia Orwell and Ian Angus (London: Secker & Warburg, 1968).

Pimlott, Ben, 'Monarchy and the message', *Political Quarterly* 69:B (1998).

Shawcross, William, 'Portrait in majesty', *Vanity Fair* (June 2007).

Snelson, John, 'Royalty on stage: famous examples and struggles with royal censorship', *Royal Opera House* (18 June 2013), .www.roh.org.uk/famous-examples-and-struggles-with-censorship.

Thomson, David, 'Biographical dictionary of film, number 99 (Stephen Frears)', *Guardian* (3 September 2010).

Vidal, Belén, *Heritage Film: Nation, Genre and Representation* (London: Wallflower, 2012).

Woolf, Virginia, *The Diary of Virginia Woolf*, vol. 5, *1936–1941*, ed. Anne Olivier Bell (London: Hogarth Press, 1984).

———'Royalty' [1934], in Michèle Barrett (ed.), *Women and Writing* (New York: Harvest, 2003).

Part I

Victorian inventions

'A very wonderful process': Queen Victoria, photography and film at the *fin de siècle*

Ian Christie

Queen Victoria's Diamond Jubilee, celebrated in 1897, is generally agreed to have been the ceremonial climax to her reign, marking an unexpected return to public appearance after decades of self-imposed seclusion following the death of Prince Albert in 1861. Yet how much its impact owed to being the first major state event to be comprehensively filmed, with records of the procession being shown throughout Britain and the British Empire, as well as elsewhere, has hardly been assessed. Nor has the relationship between Victoria's long-standing interest in photography, still very much in evidence at the time of the Jubilee, and her response to 'animated photography'. While John Plunkett has argued convincingly for seeing Victoria as 'media made', his focus is primarily on 'the tremendous expansion of the market for newspapers, books, periodicals and engravings' that her reign witnessed.[1] And despite agreeing with Plunkett's claim that 'the royal image itself became photographic', at least one of his critics has drawn attention to an apparent lack of agency in his portrayal of Victoria's relationship to this process.[2]

My purpose here is not to adjudicate the degree of Victoria's involvement in her photographic or filmic representation – especially in view of the limited and somewhat selective evidence available from royal archives. Rather, it is to connect the scattered fragments of evidence, in order to offer an account that does not underestimate Victoria's active interest in the new photographic media, or create a false hiatus between still and moving pictures, while broadly agreeing with the many writers who have stressed how these reshaped the image of monarchy at the turn of the century.

A PASSION FOR PHOTOGRAPHY

In one of the most vivid accounts of Victoria's involvement with photography, a pioneer historian of the medium, Bill Jay, claims that the Queen was viewing

the first specimens of the daguerreotype to reach England on the very occasion that she effectively proposed to Prince Albert: 15 October 1839.[3] The story that Jay traces is one of a shared enthusiasm for the new medium in its earliest formats, with Albert photographed by daguerreotypist William Constable in Brighton in 1842 and Victoria by her former drawing master, Henry Collen, who had taken up the calotype negative-positive process invented by William Fox-Talbot, and produced a miniature portrait of her in 1844 or 1845.

By the early 1850s, Victoria and Albert were recognised patrons and practitioners of photography. A private darkroom had been established at Windsor Castle, and the royal couple were reported by the *Illustrated Magazine of Art* as 'well known to be no mean proficients in photography'.[4] As patrons of the newly formed Photographic Society of London, they visited its first major exhibition in January 1853 and Victoria's journal entry reveals how engaged she was with the personalities and varieties of early photographic work:

> It was most interesting & there are 3 rooms full of the most beautiful specimens, some, from France, and Germany, & many by amateurs. Mr Fenton, who belongs to the Society, explained everything & there were many beautiful photographs done by him. Profr Wheatstone, the inventor of stereoscope, was also there. Some of the landscapes were exquisite, & many admirable portraits. A set of photos of the animals at the Zoological Gardens by Don Juan, 2nd son of Don Carlos, are almost the finest of all the specimens.[5]

Roger Fenton, the Society's first Secretary, would soon become closely involved with the royal family, photographing their children in early 1854 and taking formal studies of the couple, including the well-known double portrait in court dress of 1854. Later that year, he left for the Crimea, apparently at the prompting of Prince Albert (if not the Queen herself) to photograph the war, in the hope that his record would counteract reports appearing in the press about the poor management of the war. Also significant is Victoria's recognition of the polymath Charles Wheatstone, Professor of 'Experimental Philosophy' at King's College London, inventor of the telegraph and much else, whose explanation of binocular vision in 1838 introduced stereoscopy.[6] A commercial version of his stereoscope had been launched at the Great Exhibition in 1851, which was very much Albert's project, and the royal couple acquired their own early example of what would soon become a hugely popular instrument – although one often passed over in many histories of 'Victorian photography', in favour of the carte-de-visite craze of the 1860s.[7] Likewise, Victoria's reference to Don Juan,

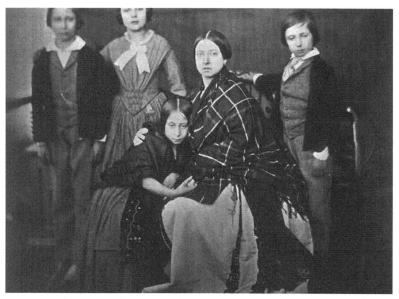

2 An early image from the royal collection: Queen Victoria with four of her children, photographed by Roger Fenton in February 1854.

son of the Carlist claimant to the Spanish throne and known as the Count of Montizón, indicates how widely photography was practised by the aristocracy by the 1850s.[8]

Victoria and Albert took steps to have their children given instruction in photography, with all the princes and princesses encouraged to use cameras and learn the still-complex 'wet' process.[9] Prince Alfred took his equipment on a tour of South Africa in 1860 and was backed up by a professional photographer, Frederick York. Albert, the Prince of Wales (known as Bertie, and later Edward when he became King), also learned photography, and was accompanied on a tour of the Middle East in 1862 by another professional, Francis Bedford. All the princesses practised photography, and made up albums, like their parents, while Albert's wife, Princess Alexandra of Denmark, eventually exhibited her work, and published a *Christmas Gift Book* of family photographs in 1908 to aid charities.

Two major exhibitions have recorded the depth of Victoria and Albert's shared interest in photography: 'Victoria and Albert: Art & Love' (Queen's Gallery, 2010) included photographs among the other art they collected, while 'A Royal Passion: Queen Victoria and Photography' (Getty Center, 2014) focused on Victoria's lifelong preoccupation with the medium, as a family photographer

herself, a collector and also in her extensive use of photography to memorialise Albert after his death. Jay notes that:

> Few days passed without Victoria sending for one volume [of photographs] or another, all of which were methodically catalogued with their contents arranged in systematic order. Photographs for these albums were commissioned, bought at auction, exchanged with related royal families abroad, or simply requested. The Queen even had a standing order with her favourite photographers for one print of every picture they made.

Even after Victoria's death, when Bertie undertook a draconian house-clearing exercise and 'thousands of loose photographs were burnt', what remained would illustrate 'the extent of the Royal passion for photography – over 100,000 photographs survived in 110 albums'.[10]

'Passion' is also used by Anne Lyden in the title of her Getty exhibition, and for once it seems to be deserved – this was far from a routine amassing of family photographs, even if many of the subjects were members of Victoria and Albert's extended family. It amounted to a serious and also passionately motivated collecting ambition. The technical-cum-aesthetic novelty that photography offered, which appealed to Victoria and Albert alike, led them to take a scientific interest in research to improve the fixing of the photographic image. (Jay cites Albert supporting several lines of inquiry into fading, and Victoria later 'having her most treasured prints copied by the stable carbon process'.)[11] After Albert's death, the multiplication of his image in a wide variety of photographic formats, on ceramic and enamel as well as in coloured prints, clearly served her mourning need, recalling one of the earliest drives that helped popularise photography.

But Lyden also cites another facet of Victoria's passion, which points towards a shrewd understanding of the power and status of the photographic image by the 1890s. In 1897, as the Diamond Jubilee approached, the Queen chose a photograph made some four years earlier and nominated it her 'official portrait', under specific conditions:

> She has the copyright removed from the photograph. The only stipulation being that whoever reproduces the image has to credit the photographer by name. Well, you can imagine what this does; it means that her image is on everything from biscuit tins to tea towels.[12]

In his contribution to a 1997 television documentary on Victoria's Diamond Jubilee, David Cannadine insisted on her reluctance to take part in such

ceremonial, and also paints a portrait of the elderly Victoria retreating into a romanticised imperial fantasy, with exotic décor inspired by India created at her Isle of Wight residence Osborne House, and a fondness for 'native' servants. What this account ignores is the evidence of Victoria's almost encyclopaedic collecting, and her deliberate amassing of photographic evidence, beginning with the extent of suffering in the Crimean War, all carefully recorded in albums:

> She had amazing albums compiled of the severely injured and maimed soldiers after they had returned. She met them and the photographs become a personal record of her interaction with these men. She had the photographers compile the soldier images for her with very detailed captions.[13]

Even earlier, Albert had pioneered the use of photography to create a visual inventory of all of Raphael's known paintings and drawings, as an adjunct to cataloguing the Royal Collection, and had urged the Photographic Society to establish a reference collection of exemplary works.[14] Long before Albert Kahn's 'Archives of the Planet' project in the early twentieth century,[15] Victoria and Albert clearly understood the documentary as well as the personal value of photography – a fact that apparently still needs to be asserted against the sentimentalising account of 'royal amateurs' recording their leisured lives.[16] In view of this long history of growing up with the medium, Victoria's overseeing an approved Jubilee image of herself, knowing this would become an essential imperial icon in the era of expanding 'mechanical reproducibility', seems like a far-sighted recognition of the role of image in the interactive system that imperialism had become.[17]

THE MOVING IMAGE

We have seen that both Victoria and Albert were well aware of innovation in photography from the 1850s onwards. So it would hardly be surprising that Victoria should show an interest in a subsequent development, which was widely advertised as 'animated photography'.[18] Equally, pioneer filmmakers, like many other inventors, were well aware of the potential value of royal 'patronage', which had already been conferred on many photographers during previous decades.[19] Birt Acres was the first British photographer to seek royal permission for moving pictures. His partnership with Robert Paul had produced a workable moving picture camera before they split acrimoniously in

the spring of 1895, whereupon Acres travelled to Germany and filmed Kaiser Wilhelm (Victoria's grandson) opening the Kiel Canal, and in August took more films of the Kaiser reviewing troops in Berlin. This was before film projection had been developed, so they would have been seen on Kinetoscopes before the end of that year, when first the Lumières, then Paul, took up projection (some of the Paul–Acres 1895 films were shown by Edison in New York in April 1896, at the launch of his projection system, the Vitascope).

During 1896, Acres continued to seek royal patronage, and gave a screening for the Prince of Wales at Marlborough House on 21 July 1896 'by royal request', where he was assisted by the future producer Cecil Hepworth. This resulted from Acres having filmed a visit by the Prince and Princess of Wales to the Cardiff Exhibition on 27 June, which he wanted permission to exhibit publicly.[20] According to the official British Monarchy account, 'before giving his permission, The Prince of Wales asked Acres to bring the film to Marlborough House for inspection'.[21] There had been press reports of Acres having made a hole in the exhibition wall to gain a better view of the visitors – allegedly with permission, although not from the royal party – and in this (lost) film, the Prince of Wales was seen scratching his head. Despite this 'indiscretion', the royal couple were apparently happy to invite him to show the film, along with some twenty other subjects, in a marquee at Marlborough House, before forty specially invited guests.

The future Edward VII seems to have been aware of film's ability to capture the moment from an early stage, and visited the Alhambra Music Hall in June 1896 to see what had become the first major success of British 'animated photography': Robert Paul's film of the Derby, won by the Prince's horse, Persimmon. Having filmed the finish of the race at Epsom, when an enthusiastic crowd surged onto the course, Paul hurried back to London to develop and print the film, which he was able to show the following evening as a novel addition to his regular Animatographe programme:

> [A]n enormous audience at the Alhambra Theatre witnessed the Prince's Derby all to themselves amidst wild enthusiasm, which all but drowned the strains of 'God Bless the Prince of Wales', as played by the splendid orchestra.[22]

Another report confirmed that the film was encored at the Alhambra, and also at another music hall which Paul supplied with a regular programme, the Canterbury.[23] Paul filmed the public procession that accompanied Edward's

daughter Princess Maud marrying Prince Charles of Denmark on 22 July (another lost film), and it is likely that Paul's 'animated photograph film' would have offered a considerably livelier image than the formal group photograph published in the *Illustrated London News*.[24] It almost certainly offered a better view of the procession of carriages and Life Guards than many lining the procession route would have had, just as Acres's earlier film had offered unusual intimacy with royal personages.[25]

Queen Victoria's own initiation into moving pictures came in early October 1896, when J. Downey was summoned to Balmoral to take photographs of a visit by the Tsar and his wife, Alexandra, who was Victoria's granddaughter and a frequent visitor to Britain in her youth before marrying Nicholas. This Downey was a son of William Ernest Downey, proprietor of the leading portrait studio W. & D. Downey in London, and already an official photographer to the Queen,[26] which helps explain why an otherwise obscure South Shields firm, J. & F. Downey, was given this commission. One of Downey's assistants, T. J. Harrison, had been working on a film camera of his own design, and Downey junior took the camera to Balmoral, along with his normal still equipment, and asked if he might also take some animated photographs. The Queen agreed, recording her own reaction in her journal:

> At 12 went down to below the terrace ... & were all photographed by Downey by the new cinematograph process, which makes moving pictures by winding off a reel of films. We were walking up & down & the children jumping about. Then took a turn in the pony chair.[27]

Victoria would not see the result until the following month, when an elaborate screening was arranged at Windsor Castle, probably as a treat to mark the tenth birthday of a grandson, Prince Alexander. The show on 23 November included lantern slides 'from some of the old Royal Photographs and the modern Art Studies', and a selection of ten films drawn from the Lumières' and Paul's catalogues, finishing with the now celebrated 'Prince's Derby', as it had become known.[28]

According to a report in the *Lady's Pictorial* in December, the audience at Windsor included 'the Duchess of Saxe-Coburg, the Duke and Duchess of Connaught and their children, Princess Christian and Princess Henry of Battenberg and her children', together with 'some forty or fifty ladies and gentlemen of the Royal household'. The Queen viewed the show with her

opera-glass, and was 'delighted with the animated photographs, wondering if it were possible to repeat the views'. When told that this would take time – since films were not wound onto take-up spools at this date – she 'was pleased to withdraw her request'.[29] Later, she wrote in her journal:

> After tea went to the Red Drawingroom where so called 'animated pic-tures' were shown off, including the groups taken in September [*sic*] at Balmoral. It is a very wonderful process, representing people, their move-ments & actions, as if they were alive.[30]

After she left, according to the *Lady's Pictorial*, 'some of the young Royal chil-dren came behind the screen and displayed much curiosity as to the working of the views and the lighting of the same by electric light and oxy-hydrogen'.

What the Windsor audience had seen was in fact an unusual and complex presentation, making use of two film projectors – one for the 70mm Balmoral films (only completed on the morning of the show) and a Paul Theatrograph for the others – with a magic lantern for photographs from the royal collection, many of which would have been taken by Downey senior. Three Balmoral films are listed in the programme, and presumably these are the source of three shots now extant: one of the donkey carriage, which had become Victoria's preferred vehicle in old age, turning; a second extended shot of the carriage amid a crowd of parents, children and dogs, including the Queen holding a white dog in her carriage; and a third of the carriage coming towards the camera, with guests walking alongside.[31] This appears to be the sole surviving footage of Victoria among her extended family, similar in form and content to the conventional family film that stretches from Louis Lumière to the present day; and it is surely significant that Victoria recorded the audience as including 'we 5 of the fam-ily'.[32] Spanning three generations, from the matriarch to her grandchildren, it conveys a strong sense of the relative informality of life within the court family circle. And knowing that it was seen first by many of those who appeared in it brings it within the defining form of all family film – intended to be seen pri-marily or exclusively by those who appear in it.[33]

What differentiates the Balmoral film from other family records of the period, of course, is that it shows Victoria, Queen of Britain and Empress of India, in a 'domestic' setting, and to our eyes strongly reinforces the image that Victoria and Albert had created of a 'bourgeois' rather than a courtly lifestyle. It also makes visible the interconnectedness of European monarchy at this time, with Nikolai ('Nicky' in Victoria's journal), the recently crowned Tsar of Russia,

wearing plain country dress and walking respectfully alongside his wife's grand-mother. Nikolai had married Victoria's granddaughter, Alix, Princess Alexandra of Hesse-Darmstadt, in 1894, the same year that his father Alexander III died, but was not crowned Tsar until 1896. Downey and Paul were both quick to advertise that they had 'exhibited before Her Majesty at Windsor Castle',[34] but there is no evidence that this intimate family footage was widely, if ever, seen outside the royal family until modern times.[35]

Five months before the Balmoral film, in May 1896, Nikolai had his own first encounter with the new medium, which showed its power both to cele-brate and embarrass. Two days after the coronation, which was filmed exclu-sively by Charles Moisson and Francis Doublier for Lumière, the new Tsar was to be presented to the ordinary people of Russia at Khodynka Field, a military parade ground outside Moscow. Some half-million people gathered from early in the morning to receive a souvenir package of food and gifts from the Tsar, but in the afternoon a rumour began to spread that there would not be enough for all. Panic spread as people began rushing towards the food and drink tables and over 1,300 were trampled to death – some estimates have claimed up to 5,000 – with another 1,300 injured. Nicholas had left the scene by this time, but when he was informed of the tragedy decided not to attend a banquet that night at the French Embassy, before being persuaded to do so by his uncles.[36]

The disaster had been filmed by Moisson and Doublier, but the film was taken from them and never seen again.[37] However, in July, another Lumière trav-elling operator, Alexandre Promio, managed to present a programme before the Tsar and Tsaritsa; and in the following year, Boleslaw Matuszewski, a Pole who had moved from Paris to Warsaw, became 'photographer to Tsar Nicholas' (although apparently only on a commercial basis), and took both still photo-graphs and film of the imperial family, including the state visit by President Félix Faure of France in 1897.[38] When the former German Chancellor Otto Bismarck accused Faure of not showing respect by removing his hat in the pres-ence of the Tsar, this slur was effectively refuted by Matuszewski showing his films of the visit in a special presentation at the Elysée Palace in Paris in January 1898.[39] Later in the same year, Matuszewski would publish two pamphlets argu-ing for the value of films as a 'source of history', now widely regarded as among the earliest documents to advocate film archiving.[40]

Compared with the short royal films of 1896, Victoria's Diamond Jubilee in June 1897 provided the first major spectacle of the film age, on a par with

the passion plays and boxing matches that pioneered extended filmic presentation as a commercial proposition. The Jubilee was also credited, nearly forty years later, with helping to develop or revive interest in moving pictures, after film companies' operators lined the route of the procession and subsequently promoted their films.[41] Unlike Victoria's earlier Golden Jubilee, focused on the Queen herself and attended by fellow crowned heads of Europe, this was conceived by the dynamic new Colonial Secretary Joseph Chamberlain as a 'festival of the British Empire'. With the aid of Reginald Brett, then Secretary of the Board of Works, who had become close to both the Queen and the Prince of Wales, he ensured that

> the diamond jubilee of 1897 was showier, more triumphal, and more imperial than previous London ceremonies. The jubilee organizers also persuaded the queen to drive south of the river through Kennington. They were attempting to bring the monarchy into closer contact with both the empire abroad and the newly enfranchised working classes at home.[42]

Governors and heads of state of the dominions and colonies were summoned to make up a great procession, which took the Queen from Buckingham Palace to St Paul's and back. But the major coup which made the Jubilee spectacular in a new way – and eminently filmable – was the massive cast of 50,000 servicemen, both mounted and on foot, many wearing exotic 'colonial' uniforms, that accompanied the royal party and dignitaries in open carriages. A journalist, G. W. Steevens, summed up what the organisers had achieved in this procession:

> Up they came, more and more, new types, new realms at every couple of yards, an anthropological museum – a living gazetteer of the British Empire. With them came their English officers, whom they obey and follow like children. And you begin to understand, as never before, what the Empire amounts to. Not only that we possess all these remote outlandish places ... but also that these people are working, not simply under us, but with us.[43]

There were, of course, dissenting views, from the likes of Beatrice Webb, Keir Hardie and other anti-imperialists.[44] But during the heady days of the Jubilee, when even the warm sunshine became known as 'the Queen's weather', much of the country seemed to enter into a delirium of self-congratulation and identification with the aged Queen, so little seen since the death of her beloved Albert in 1861. And If Victoria was initially reluctant to take part in a public

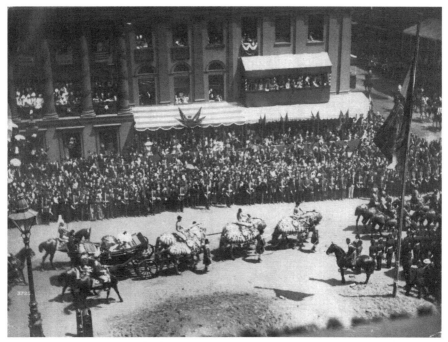

3 The Diamond Jubilee procession on 22 June 1897 provided an unprecedented spectacle for crowds lining the route, and for the many film companies who had secured vantage points.

celebration of her sixty-year reign, she could hardly doubt the affection of her people. She wrote in her journal:

> No-one ever I believe, has met with such an ovation as was given to me, passing through those 6 miles of streets, including Constitution Hill. The crowds were quite indescribable, & their enthusiasm truly marvellous & deeply touching. The cheering was quite deafening, & every face seemed to be filled with real joy. I was much moved & gratified.[45]

To which a recent historian of the Jubilee year adds: '[A]t times the response overwhelmed her, and keen observers noted that she frequently wiped away tears as she received this thunderous ovation.'[46]

The Lumière coverage, by its star cameraman Promio, began with two films, taken on Sunday 20 June, as Victoria arrived at Paddington from Windsor and her cortège was followed by crowds. Two days later, the Jubilee procession was filmed by cameramen stationed at many points along the

route, among crowds that were estimated to total 3 million. Robert Paul recalled that:

> Large sums were paid for suitable camera positions, several of which were secured for my operators. I myself operated a camera perched on a narrow ledge in the Church yard. Several continental cinematographers came over, and it was related of one that, when the Queen's carriage passed he was under his seat changing film, and of another, hanging on the railway bridge at Ludgate Hill, that he turned his camera until he almost fainted, only to find, on reaching a dark room, that the film had failed to start.[47]

Contemporary commentators foresaw that film would carry this spectacle to wider audiences. The showman's paper *The Era* urged:

> Those loyal subjects of her Majesty who did not witness the glorious pageant of the Queen's progress through the streets of London … should not miss the opportunity of seeing the wonderful series of pictures at the Empire, giving a complete representation of the Jubilee procession … by the invention of the Cinématographe … our descendants will be able to learn how the completion of the sixtieth year of Queen Victoria's reign was celebrated.[48]

Throughout Britain, a variety of new exhibitors of moving pictures made the Diamond Jubilee the centrepiece of their programmes throughout the second half of 1897 and into the following year. Producers and distributors experienced a boom in sales, and even resorted to renting the most popular items to secure maximum returns. One pioneer itinerant exhibitor, William Slade from Cheltenham, had no prior entertainment experience, but toured throughout England and Scotland in 1897, featuring in all his shows five Diamond Jubilee subjects, with the Queen at St Paul's always considered the highlight.[49] A writer who interviewed Paul about his films of the Jubilee introduced his article in *Cassell's Family Magazine* with an eye to the value of moving pictures as a chronicle:

> This automatic spectator, who is destined to play an important part in life and literature by treasuring up the 'fleeting shows' of the world for the delight of thousands in distant countries and in future ages.[50]

The processions had indeed been organised like a pageant or 'gazetteer' of the Empire, with highly recognisable figures from the dominions and detachments of their armed forces. In Ireland, with its already long history of home-rule and

independence campaigns, the Jubilee films inevitably provided a focus for different factions to demonstrate their positions. While they played for substantial seasons in Dublin and Belfast, there were reports of vociferous hostility at the latter's Empire Theatre in November when the orchestra played 'God Save the Queen', after which a diarist wrote that he 'thought the angry gods and balconyites would tear down the house in their exceeding wrath'.[51]

Elsewhere across the Empire, the recorded responses seem to have been mainly appreciative, and often rapturous in the most distant countries. Six weeks after the Jubilee, the Melbourne showman Harry Rickards, who had first presented animated photographs a year earlier, advertised on Friday 13 August that 'an enormous attraction will be announced tomorrow'. Monday's edition of the Melbourne *Herald* enthused about

> one of the most thrilling spectacles ever witnessed, the appearance of Her Most Gracious Majesty on the Royal Carriage, drawn by six cream ponies, causing a perfect blizzard of LOYAL and Acclaimative ENTHUSIASM, the vast audience rising EN MASSE, cheering incessantly until the picture was reproduced.[52]

As the screenings continued in Melbourne, 'the waving arm of Sir George Turner', the Australian Prime Minister, was reported to be 'loudly applauded every evening'.[53] In Canada, where there were also no doubt mixed responses, especially in Quebec, the dominion's first premier of French ancestry, Sir Wilfred Laurier, was appreciatively recognised by local audiences, who would also have known that he had been knighted on the morning of the Jubilee procession.

Perhaps unsurprisingly, then, the Jubilee films provided a focus for displays of pro- as well as anti-British sentiment across the sprawling Empire, with these demonstrations most vociferous where there were active independence movements, and equally strong loyalist communities. We might wonder how aware the participants in the Jubilee procession were of these reactions? One of the earliest presentations of the Jubilee films to those who had taken part in the procession must have been the royal command performance at St James's Palace on 20 July, when the British Mutoscope and Biograph Company was invited to give a 'special exhibition' after a banquet celebrating the Prince of Wales's appointment as Grand Master of the Order of the Bath. On show were the Diamond Jubilee procession, along with the associated naval review at Spithead and military review at Aldershot, all filmed in Biograph's impressive 68mm format: an appropriately ceremonial and martial programme for this all-male company.

However, in November, a selection of Lumière films was presented to a mixed audience at Windsor by H. J. Hitchens, the manager of the Empire, with the theatre's full orchestra accompanying, conducted by Leopold Wenzel. The Queen recorded the occasion in her journal:

> After tea went with the children to the Green Drawingroom, where the Ladies & Gentlemen were assembled, & where we saw Cinematograph representing parts of my Jubilee Procession, & various other things. They are very wonderful, but I thought them a little hazy & rather too rapid in their movements.[54]

Victoria's comment on the quality of the presentation, which suggests that the projector set-up was less than ideal, and that the films were shown too fast, demonstrates that the seventy-eight-year-old Queen was still a photographic enthusiast, as well as a shrewd judge of quality.

The British Mutoscope and Biograph, an offshoot of the original American company, started operations early in 1897, and appears to have adopted a deliberate policy of courting royal relationships, possibly in order to counteract the dubious reputation of its Mutoscope subjects, which often featured titillating images of glamorous women.[55] In the summer of 1897, their record of *Afternoon Tea in the Gardens of Clarence House* showed three generations of the royal family at a garden party with what Richard Brown and Barry Anthony term 'startling informality'.[56] British Bioscope's relationship with the royal family continued to bear fruit after the St James's Palace showing. They filmed the Queen laying the foundation stone of the Victoria and Albert Museum on 17 May 1899, while a Biograph show was given at Sandringham on 29 June.[57] And in the summer of 1900, Biograph filmed what is probably the most important of the early 'intimate' royal films, *Children of the Royal Family of England*, which showed 'our future king at play' – namely Prince Edward of York, later Edward VIII.[58] This two-part film, made over two mornings, was a major success for the company, becoming an extremely popular item in Biograph programmes at the Palace Theatre, and later on their home-viewing system, the Kinora.[59] And Biograph's relationship with the future king, Prince Albert, soon to be Edward VII, would continue, as they filmed many events throughout his reign.

The Diamond Jubilee was the last great public occasion of the Queen's long reign. However, the outbreak of the Anglo-Boer War late in 1899 led to Victoria not visiting France, as was her springtime custom, but instead travelling in April to Ireland, where at least four companies filmed her procession in Dublin and reception by the city's Corporation, followed by a review of

troops in Phoenix Park and a large children's party.[60] With various currents of nationalist and home-rule sentiment running high, following the centenary of the 1798 United Irishmen uprising, there were inevitably protests during the visit. As Kevin and Emer Rockett note, some members of the Corporation boycotted the Queen's reception, while the nationalist leaders Maud Gonne and James Connolly 'organised a nationalist riposte, the "patriotic children's treat", for 15,000 poor children'.[61] If the extant footage of the visit does not register the dissent it provoked among Irish nationalists and home-rule campaigners (although a man visibly appealing to the crowd near the Queen's carriage could conceivably represent some protest in progress[62]), neither does it reveal the equivalent enthusiasm that greeted the films in loyalist quarters. One of the two Belfast-based cameramen who filmed Victoria's visit to Dublin, John Walter Hicks, who also carried on his film activities as 'Professor Kineto', improved on Paul's Derby coup by having his coverage of the Queen's arrival ready to show by the same evening a hundred miles away at the Empire Theatre in Belfast, where it was reportedly 'cheered to the echo' – in striking contrast to the Jubilee response three years earlier.[63]

By Christmas Victoria's health had begun to decline and she died at Osborne on 22 January 1901. She had left detailed instructions for the detail of her funeral (to include mementoes of Albert and of her loyal Scottish retainer John Brown), but the actual procession followed a similar pattern to the Jubilee after her coffin reached London, with many film cameramen seeking the same camera positions they had used for the Jubilee. The funeral films were also widely shown, although the grey winter weather made them considerably less striking than those of the Jubilee.

Two anecdotes from early in the new century reveal how rapidly awareness of the role of film in portraying royal ceremonial was advancing. The best known of these comes from the memoir by the pioneer producer Cecil Hepworth, who had positioned three cameras along the route of Victoria's funeral procession. He operated one of the cameras, positioning himself inside the railings of Grosvenor Gardens, opposite Victoria station. As the procession approached, headed by the new King, Edward, Hepworth began to crank his camera, and was horrified by the noise this made in the prevailing silence. He later wrote: 'If I could have had my dearest wish, then the ground would certainly have opened at my feet and swallowed me and my beastly machine.'[64] However, the noise of the camera attracted Edward's attention, and he halted the procession for a moment so that a 'cinematograph record' of the procession

could be preserved for posterity. Another anecdote appears in the memoirs of an ex-India civil servant, J. H. Rivett-Carnac, who had been an aide-de-camp to Victoria, and rode in the procession for her son Edward's coronation in 1903. Rivett-Carnac recalled how 'a pipe band suddenly struck up nearby, so that the good horse stood straight up on his hind legs and it was quite as much as I could do to keep my seat'. He added: 'Although it was interesting enough to see one-self and show oneself to one's friends in the "living pictures" riding along in the procession, one did not want to be handed down to posterity coming off one's horse in an undignified attitude.'[65]

Edward's coronation was extensively covered by all the leading film com-panies, in marked contrast to the relatively modest occasion of his mother's, sixty-four years earlier, on the threshold of the era of photography. An indica-tion of the level of filmic interest was also provided by one enterprising produc-er's decision to commission a fake film of the Westminster Abbey event. Charles Urban, manager of the Warwick Trading Company in London, commissioned Georges Méliès, already known for his trick films, to solve the problem of not being able to film inside Westminster Abbey by staging a film of it in Paris in time for the scheduled date of the coronation, 26 June. However, due to Edward's illness, the coronation was delayed until 9 August, when the film played as a headliner at the Alhambra Music Hall (where the Persimmon Derby had been shown six years earlier) before touring the world as the first 'royal doc-umentary'.[66] Urban's investment in this coverage, and that of the other compa-nies, confirm that the advent of the photographic image, both still and moving, had made the British monarchy a highly marketable spectacle.

POSTERITY

What we can discover in the filming of Victoria and her children between 1896 and 1900 are two primordial film genres in their earliest form. One is the 'fam-ily film' that would become central to amateur practice during the twentieth century – even if Victoria's family films were very different from those of her subjects. For the British branch of the 'family' of Hanover (later changed to Saxe-Coburg and Gotha), film 'could break down barriers of social etiquette … and present a vivid glimpse of their private life to their subjects'.[67] That such glimpses were contrived could hardly be doubted, even if the journalistic con-text surrounding *Children of the Royal Family* was at pains to stress the 'courtesy and thoughtfulness of the Royal trio', as well as their 'unaffectedness', during

the two mornings that they were filmed by Biograph, after being shown several of the company's Mutoscope subjects as an induction into what filming would involve and produce.[68] These are the prototypes of what would become the British royal family's most potent mode of communication with its subjects: the occasional and partial 'glimpse' of informal family life, away from the official news media, yet communicated by these same media in 'special' documentaries.[69]

The other genre, raised to a new level by the large-scale filming of the Diamond Jubilee, is the ceremonial procession. While processions quickly became a staple of early film programmes, usually structured around military formations passing the camera, the Diamond Jubilee procession also brought together a number of significant narratives, which help explain its wide popularity.[70] One was the intended 'gazetteer' of the British Empire, with its exotic diversity made visible in the ethnic variety of those processing, condensing into a dynamic yet disciplined image of the very concept of the Empire.[71] A second, however, was the appearance, after long seclusion, of the sovereign at the centre of this mighty web. The contrast between Victoria's small, elderly figure, in simple widow's clothing, and the vast spectacle surrounding her struck many spectators at the time. One observer was the American writer Mark Twain, hired for the occasion by the *New York Journal*, who offered an intriguing comparison between processions as 'shows' and 'symbols', comparing the Jubilee procession with Henry V's London victory procession after Agincourt, and describing it as 'a symbol, and allegory of England's grandeur'.[72] While criticising the composition of the procession for what it omitted – the sources of British power and prosperity – Twain also concluded that the Queen 'was the procession itself, all the rest was mere embroidery'.[73] This seems to express what many contemporaries also felt, that the figure of Victoria somehow eclipsed the pageantry all around it. Through film this microcosmic image of the Queen, always seen distantly by the lenses of the time, circulated globally. The contrast between such an image and the 'official' Jubilee close-up portrait photographs could not be greater.

Before 1896, Victoria had already lived through fifty years of still photography, as an early adopter and connoisseur of the successive processes and formats, an important collector, and patron of the leading photographic society in Britain. Encountering 'animated photography' in her old age, she seems to have retained her earlier interest in new techniques and subject matter, and a willingness to assess their quality. As Twain observed, she had witnessed almost every

technology of modern life develop during her reign; and on the morning of the Jubilee, she pressed a button that sent a telegraphic message around the world.[74] Seeing and sharing the response to these first family and procession films, she may well have guessed that animated photography was about to create a new paradigm by 'representing people and their actions as if they were alive' far into the future.

NOTES

1 John Plunkett, *Queen Victoria: First Media Monarch* (Oxford and New York: Oxford University Press, 2003), p. 3.

2 Margaret Homans, 'Review: *Queen Victoria: First Media Monarch*', *Victorian Studies* 46:3 (Spring 2004), p. 520.

3 Bill Jay, 'Queen Victoria's second passion: royal patronage of photography in the 19th century' (1988), in Jay's articles online, www.billjayonphotography.com/QnVictoria2ndPassion.pdf. The date of her proposal is corroborated by Christopher Hibbert in *Queen Victoria: A Personal Biography* (London: HarperCollins, 2000), pp. 108–9, and other biographies, and in Victoria's journal, although this makes no mention of daguerreotypes.

4 Jay, 'Queen Victoria's second passion', p. 3.

5 Queen Victoria, *Journals* (3 January 1854).

6 Charles Wheatstone, 'On some remarkable, and hitherto unobserved, phenomena of binocular vision', *Proceedings of the Royal Society* 128 (1838).

7 Victoria records 'Stereoscope' in her draft journal entry for 25 August 1855, implying private time spent viewing stereographs while travelling in France. See *Journals* online: www.queenvictoriasjournals.org/search/displayItemFromId.do?ResultsID=2779406415851&FormatType=fulltextimgsrc&QueryType=articles&ItemID=qvj08274&volumeType=DRAFT#zoomHolder.

8 Juan, Count of Montizon came to England after the uprisings of 1848 and was a founder member of the Photographic Society. After renouncing his claim to the Spanish throne, he lived for the rest of his life in Worthing and Hove. One of his London Zoo photographs, of a hippopotamus, illustrates his Wikipedia entry, http://en.wikipedia.org/wiki/File:The_Hippopotamus_at_the_Regents_Park_Zoo,_ca._1855.jpg.

9 The Collodion process, invented by Frederick Archer in 1851, involved a glass plate being coated, exposed and developed within less than fifteen minutes, often requiring a portable darkroom. It remained the preferred photographic process until the 1880s.

10 Jay, 'Queen Victoria's second passion', pp. 5–6.

11 *Ibid.*, p. 7.

12 Her choice was apparently not the Gustav Mullins portrait taken on the day of the Jubilee, but an earlier image, which is now listed as 'photographer unknown'. Anne

Lyden, quoted in interview by Barry Keevins, 'Picture pioneer: Queen Victoria's passion for photography', *Sunday Express* (24 January 2014).

13 *Ibid.*

14 Jay, 'Queen Victoria's second passion', p. 7.

15 On Kahn's collection, see Teresa Castro, '*Les Archives de la planète*: a cinematographic atlas', *Jump Cut* 48 (Winter 2006).

16 An attitude still apparent in much documentation of Victoria's photographic collecting. See for instance the online *Diamond Jubilee Scrapbook*, a website supported by the official British monarchy website: www.queen-victorias-scrapbook.org/.

17 Cannadine quotes P. D. Morgan on the need to reach a 'synoptic view' of the imperial system in his *Ornamentalism: How the British Saw Their Empire* (London: Allen Lane, 2001). The source is Philip D. Morgan, 'Encounters between British and "indigenous" peoples, *c.* 1500–*c.* 1800', in Martin Daunton and Rick Halpern (eds), *Empire and Others: British Encounters with Indigenous Peoples, 1600–1850* (London: Routledge, 1999), p. 68.

18 See, for instance, Robert Paul's catalogues, 1897–1901, British Film Institute Special Collections.

19 Jay records the earliest of these Royal Warrants as William Edward Kilburn being appointed 'Photographist to Her Majesty and His Royal Highness Prince Albert' in 1847, while later appointments were more specific, referring to 'Her majesty's photographer on paper' (Nicolaas Henneman, 1848) and 'Royal Photographer for Scotland' (George Washington Wilson, 1860). 'Queen Victoria's second passion', p. 5.

20 *Prince and Princess of Wales Arriving in State at the Cardiff Exhibition* (Northern Photographic Works [Acres], 40ft). Dennis Gifford, *The British Film Catalogue, 1895–1985: A Reference Guide* (Newton Abbott: David & Charles, 1986), p. 6.

21 *Official website of the British Monarchy*, www.royal.gov.uk/LatestNewsandDiary/Pressreleases/2002/TheRoyalFilmPerformance2002.aspx.

22 As reported in an article in the *Strand Magazine* (August 1896), p. 140.

23 *The Era* (6 June 1896), p. 16.

24 *Illustrated London News*, supplement on the royal wedding (1 August 1896).

25 *Princess Maud's Wedding* (Paul's Theatrograph, a two-part film of 80ft), released on 8 August. Gifford, *The British Film Catalogue*, p. 6.

26 Michael Pritchard, 'Downey' entry in John Hannay (ed.), *The Encyclopedia of Nineteenth-Century Photography* (London: Routledge, 2013), p. 436.

27 Queen Victoria, *Journals* (3 October 1986), www.queenvictoriasjournals.org/search/displayItem.do?ItemNumber=1&FormatType=fulltextimgsrc&QueryType=articles&ResultsID=2785135291831&filterSequence=0&PageNumber=1&ItemID=qvj23243&volumeType=PSBEA.

28 The printed programme is reproduced in John Barnes, *The Beginnings of the Cinema in England, 1894–1901*, vol. 1, *1894–1896* (Exeter: University of Exeter Press, 1998), p. 144.

29 *Lady's Pictorial* (December 1896), quoted in Barnes, *Beginnings*, pp. 213–15.

30 Queen Victoria, *Journals* (23 November 1896), www.queenvictoriasjournals.org/ search/displayItem.do?FormatType=fulltextimgsrc&QueryType=articles&Results ID=2785136687191&filterSequence=0&PageNumber=1&ItemNumber=2&ItemI D=qvj23294&volumeType=PSBEA.

31 This material was originally very unsteady, no doubt due to the improvised camera, but has been effectively stabilised and tinted by the BFI National Archive. Accessible on YouTube as *Scenes at Balmoral* (1896) at www.youtube.com/watch?v=E10c50DNhHY.

32 Queen Victoria, *Journals* (23 November 1896).

33 Collette Piault, 'Films de famille et films sur la famille', in Natalie Tousignant (ed.), *Le Film de famille* (Brussels: Facultés universitaires Saint-Louis, 2004), p. 57. See also Roger Odin (ed.), *Le Film de famille. Usage privé, usage public* (Paris: Méridiens-Klincksieck, 1999), p. 6. Odin insists that the family film, whatever its technical qualities, has a unique significance and adequacy for its subjects.

34 Barnes, *Beginnings*, p. 215.

35 The Balmoral film is now in the BFI National Archive, and has been included in documentaries. It has not proved possible to establish when it was first seen publicly.

36 An album of photographs recording the coronation and Khodynka Field, before and after the stampede, is online at www.angelfire.com/pa/ImperialRussian/royalty/ russia/corphotoalbum.html.

37 Jay Leyda recorded an account of the disaster, as told to him by Doublier, in his *Kino: A History of the Russian and Soviet Film* (London: George Allen & Unwin, 1960), p. 19.

38 For the most complete account of Matuszewski's somewhat mysterious career, see Magdalena Mazaraki, 'Boleslaw Matuszewski: photographe et opérateur de cinéma', *1895* 44 (2004).

39 Reported in *Le Figaro*, 'A travers Paris' (12 January 1898), pp. 1–2, quoted in Mazaraki, 'Boleslaw Matuszewski'.

40 Boleslaw Matuszewski, *Une Nouvelle Source de l'histoire; La Photographie animée* (both Paris, 1898).

41 Reminiscing about his early career as a film pioneer in 1936, Robert Paul recalled that 'in [the] year before the Jubilee, public interest in animated pictures seemed to be on the wane'. R. W. Paul, 'Before 1910: kinematograph experiences', *Proceedings of the British Kinematograph Society* 38 (1936), p. 5.

42 William M. Kuhn, 'Brett, Reginald Baliol', *Oxford Dictionary of National Biography*, www.oxforddnb.com/templates/article.jsp?articleid=32055&back.

43 G. W. Steevens, 'Up they came', *Daily Mail* (23 June 1897). The fullest account of the Jubilee and its filming is in Luke McKernan, 'Queen Victoria's Diamond Jubilee' (2012), accessible online: http://lukemckernan.com/wp-content/uploads/queen_ victoria_diamond_jubilee.pdf.

44 For a survey of opinion on the Jubilee, see Niall Ferguson, *Empire: The Rise and Demise of the British World Order and the Lessons for Global Power* (New York: Basic Books, 2008), pp. 130–6.

45 Queen Victoria, *Journals* (22 June 1897), www.queenvictoriasjournals.org/search/displayItem.do?FormatType=fulltextimgsrc&QueryType=articles&ResultsID=2824165630308&filterSequence=0&PageNumber=1&ItemNumber=1&ItemID=qvj23505&volumeType=PSBEA.

46 Greg King, *Twilight of Splendor: The Court of Queen Victoria during her Diamond Jubilee Year* (Hoboken: John Wiley, 2007).

47 Paul, 'Before 1910'.

48 *The Era* (27 June 1896).

49 Patricia Cook, PhD research on William Slade's touring exhibition, Birkbeck College.

50 'Living pictures of the Queen', *Cassell's Family Magazine* (August 1897), p. 327.

51 Joseph Holloway, 'Diary', quoted in Kevin Rockett and Emer Rockett, *Magic Lantern, Panorama and Moving Picture Shows in Ireland, 1786–1909* (Dublin: Four Courts, 2013), p. 231.

52 *Melbourne Herald* (16 August 1897).

53 *Melbourne Herald* (23 August 1897).

54 Queen Victoria, *Journals* (23 November 1897) www.queenvictoriasjournals.org/search/displayItemFromId.do?FormatType=fulltextimgsrc&QueryType=articles&ResultsID=2824167480910&filterSequence=0&PageNumber=1&ItemID=qvj23659&volumeType=PSBEA and www.queenvictoriasjournals.org/search/displayItemFromId.do?FormatType=fulltextimgsrc&QueryType=articles&ResultsID=2824167480910&filterSequence=0&PageNumber=2&ItemID=qvj23659&volumeType=PSBEA.

55 Richard Brown and Barry Anthony argue that this was a deliberate strategy in their study, *A Victorian Film Enterprise: The History of the British Mutoscope and Biograph Company, 1897–1915* (Trowbridge: Flicks Books, 2001), pp. 57–8.

56 *Ibid.*

57 *Ibid.*, pp. 59, 71n.

58 The films are also known as *Children of the Royal Family Playing Soldiers*, a title hardly suited to the second year of the Anglo-Boer War.

59 Brown and Anthony, *A Victorian Film Enterprise*, pp. 59–60.

60 Surviving footage from this visit is in the British Pathé collection, viewable on YouTube at www.youtube.com/watch?v=q9gwnKH15Xo. This appears to show only the procession, although a man is seen on the road appealing to the waving crowd who occupy the foreground.

61 Rockett and Rockett, *Magic Lantern, Panorama and Moving Picture Shows in Ireland*, p. 235.

62 This footage from British Pathé can be accessed on YouTube at www.youtube.com/watch?v=q9gwnKH15Xo. A man waving his hat and shouting at the crowd in a grandstand abruptly disappears, as a result of a jump-cut in the shot. This is most likely due to the fragmentary state of the film material, but could conceivably have recorded some disruptive behavior at this moment in the ceremony, subsequently cut.

63 Rockett and Rockett, *Magic Lantern, Panorama and Moving Picture Shows in Ireland*, p. 235.

64 Cecil Hepworth, *Came the Dawn: Memoirs of a Film Pioneer* (London: Phoenix House, 1951), p. 56. A photograph of the moment described appears on p. 24.

65 J. H. Rivett-Carnac, *Many Memories of Life in India, at Home, and Abroad* (Edinburgh and London: William Blackwood, 1910), p. 410.

66 After this unconventional success, Urban would go on to play a leading part in organising the filming of both the Delhi Durbar and the coronation of George V.

67 Brown and Anthony, *A Victorian Film Enterprise*, p. 57.

68 The *Harmsworth Magazine* carried extensive coverage, with illustrations, of the making of *Children of the Royal Family* under the heading 'Our future king at play' in October 1900. Quoted in Brown and Anthony, *A Victorian Film Enterprise*, p. 59.

69 Such documentaries include: *Royal Family* (1969), *Elizabeth R* (1992), *Windsor Castle – A Royal Year* (2005), *Monarchy: The Royal Family at Work* (2007).

70 On the aesthetics of procession films, and especially the stereoscopic effect of filming processions from an oblique angle, see Gerry Turvey, 'Panoramas, parades and the picturesque: the aesthetics of British actuality films, 1895–1901', *Film History* 16:1 (2004).

71 David Cannadine has written of the 'interconnected pageants and mutually reinforcing ceremonials [with which], the British Empire put itself on display, and represented itself to itself', in his *Ornamentalism*, p. 111. See also my discussion of his thesis about the primacy of the 'ornamental', in ' "The captains and the kings depart": imperial departures and arrivals', in Lee Grieveson and Colin MacCabe (eds), *Empire and Film* (London: Palgrave Macmillan, 2011).

72 Twain's eye-witness account of the Jubilee first appeared in two installments in the *New York Journal* on 20 and 23 June 1897, and in a slender volume, privately printed in only 195 copies in 1910, entitled *Queen Victoria's Jubilee 1897*, subtitled *The great procession of June 22 … reported both in the light of history and as a spectacle*. The text is now available in Mark Twain, *A Tramp Abroad, Following the Equator, Other Travels* (New York: Library of America, 2010). See also discussion of this essay in Randall K. Knoper, *Acting Naturally: Mark Twain in the Culture of Performance* (Berkeley and Los Angeles: University of California Press, 1996), pp. 144–7.

73 Twain, *A Tramp Abroad*, p. 1051.

74 Victoria had sent a message to the American President in 1858, when the first transatlantic telegraph cable was successfully laid, after which telegraphic communication had become a major new communication medium, especially for Britain's global interests. See http://atlantic-cable.com/Books/Whitehouse/DDC/index.htm.

SELECT BIBLIOGRAPHY

Barnes, John, *The Beginnings of the Cinema in England, 1894–1901*, vol. 1, *1894–1896* (Exeter: University of Exeter Press, 1998).

Brown, Richard and Barry Anthony, *A Victorian Film Enterprise: The History of the British Mutoscope and Biograph Company, 1897–1915* (Trowbridge: Flicks Books, 2001).

Cannadine, David, *Ornamentalism: How the British Saw Their Empire* (London: Allen Lane, The Penguin Press, 2001).

Castro, Teresa, '*Les Archives de la planète*: a cinematographic atlas', *Jump Cut* 48 (Winter 2006).

Christie, Ian, '"The captains and the kings depart": imperial departures and arrivals', in Lee Grieveson and Colin MacCabe (eds), *Empire and Film* (London: Palgrave Macmillan, 2011).

The Era (6 June 1896 and 27 June 1896).

Gifford, Dennis, *The British Film Catalogue, 1895–1985: A Reference Guide* (Newton Abbott: David & Charles, 1986).

Hepworth, Cecil, *Came the Dawn: Memoirs of a Film Pioneer* (London: Phoenix House, 1951).

Hibbert, Christopher, *Queen Victoria: A Personal Biography* (London: HarperCollins, 2000).

Homans, Margaret, Review of *Queen Victoria: First Media Monarch*, *Victorian Studies* 46:3 (2004).

Illustrated London News, supplement on the royal wedding (1 August 1896).

Jay, Bill, 'Queen Victoria's second passion: royal patronage of photography in the 19th century' (1988), in Jay's articles online, www.billjayonphotography.com/writings.html.

King, Greg, *Twilight of Splendor: The Court of Queen Victoria during her Diamond Jubilee Year* (Hoboken, NJ: John Wiley, 2007).

Knoper, Randall K., *Acting Naturally: Mark Twain in the Culture of Performance* (Berkeley and Los Angeles: University of California Press, 1996).

Lady's Pictorial (December 1896).

Leyda, Jay, *Kino: A History of the Russian and Soviet Film* (London: George Allen & Unwin, 1960).

'Living pictures of the Queen', *Cassell's Family Magazine* (August 1897).

Lyden, Anne M., *A Royal Passion: Queen Victoria and Photography* (Los Angeles: Getty Publications, 2014).

———Interview by Barry Keevins, 'Queen's photographic passion revealed', *Sunday Express* (24 January 2014), www.express.co.uk/entertainment/books/453394/ART-Queen-s-photographic-memories-revealed.

Mazaraki, Magdalena, 'Boleslaw Matuszewski: photographe et opérateur de cinéma', *1895* 44 (2004).

Melbourne Herald (16 August 1897).

Morgan, Philip D., 'Encounters between British and "indigenous" peoples, *c.* 1500–*c.* 1800', in Martin Daunton and Rick Halpern (eds), *Empire and Others: British Encounters with Indigenous Peoples, 1600–1850* (London: Routledge, 1999).

Odin, Roger (ed.), *Le Film de famille. Usage privé, usage public* (Paris: Méridiens-Klincksieck, 1999).

Paul, R. W., 'Before 1910: kinematograph experiences', *Proceedings of the British Kinematograph Society* 38 (1936).

Piault, Collette, 'Films de famille et films sur la famille', in Natalie Tousignant (ed.), *Le Film de famille* (Brussels: Facultés universitaires Saint-Louis, 2004).

Plunkett, John, *Queen Victoria: First Media Monarch* (Oxford and New York: Oxford University Press, 2003).

Rivett-Carnac, J. H., *Many Memories of Life in India, at Home, and Abroad* (Edinburgh and London: William Blackwood, 1910).

Rockett, Kevin and Emer Rockett, *Magic Lantern, Panorama and Moving Picture Shows in Ireland, 1786–1909* (Dublin: Four Courts, 2013).

Turvey, Gerry, 'Panoramas, parades and the picturesque: the aesthetics of British actuality films, 1895–1901', *Film History* 16:1 (2004).

Twain, Mark, *Queen Victoria's Jubilee 1897*, in *A Tramp Abroad, Following the Equator, Other Travels* (New York: Library of America, 2010).

Victoria [Queen], *Journals*, online at www.queenvictoriasjournals.org/home.do.

Wheatstone, Charles, 'On some remarkable, and hitherto unobserved, phenomena of binocular vision', *Proceedings of the Royal Society* 128 (1838), online at http://rstl.royalsocietypublishing.org/content/128/371.full.pdf+html.

Sixty Years a Queen (1913): a lost epic of the reign of Victoria

Jude Cowan Montague

When *The Life Story of David Lloyd George* (Maurice Elvey, 1918) was screened in 1996 it was greeted as a rediscovered masterpiece. Discovered in the house of Lloyd George's grandson, it was as if it had sprung from nowhere. But there was a precedent for this incipient biopic, a high-budget long feature which also juxtaposed mass scenes with an intimate focus on the private life of a famous political figure. This earlier film played at the new picture palaces of 1913 and 1914 throughout the UK to packed audiences. It received substantial media acclaim. The epic portrayed the most revered 'star' of recent British history. Its subject was the life and times of the monarch who had presided over an age of imperial expansion, a reign associated with progress in science, education, industry and European diplomacy. The film was *Sixty Years a Queen* (1913), alternatively titled *The Life and Times of Queen Victoria*. Its two producers were William George Barker, an experienced filmmaker and the owner-manager of a flourishing studio at Ealing, and George Berthold Samuelson, a successful film agent and the driving force in bringing the royal story to the screen.

Sixty Years a Queen has so far attracted only perfunctory comment in British film histories so this essay will outline aspects of its production, exhibition, distribution and reception. Although the film is lost, various primary materials survive including a single fragment (46 feet) of the early scenes of the film held by the National Film and Television Archive (NFTVA), a book of the film and a souvenir programme or press-book. The press-book contains a menu of scene headings, which list a chronological sequence from the death of William IV on 20 June 1837 to Victoria's death, divided into seven parts. The film book contains fifty-five photographic illustrations described as 'taken from the cinematograph film'.[1] These appear to be production stills, an inference supported by examining another film book from the same series. The film from this second

book, *Hamlet* (Cecil Hepworth, 1913), is mostly extant and it is clear that the illustrations have been directly printed from the film stock. These books were luxury items, retailing at one shilling. The text of the book for *Sixty Years a Queen* was written by May Wynne (aka Mabel Winifred Knowles), an unreliable historian but a popular storyteller. Writing within a conventional if increasingly old-fashioned approach, Wynne treats Victoria's life as exemplary. Despite these creative liberties, her book offers useful contextualising information and presumably reflects the film's presentation of Victoria as a shining example of domestic virtue and a dutiful monarch.

The surviving footage, rediscovered by film historian Luke McKernan, depicts the moment in which Victoria receives the news that she is to be Queen, a narrative which found particular favour in the late period of her reign. In this sequence a young Victoria calls for divine blessing on her accession to the throne by raising her arms to heaven in the kind of gestural acting used to communicate meaning in nineteenth-century theatre. This fragment exemplifies the film's portrayal of Victoria's reign with the hagiographic attitude forged at the end of the nineteenth century, celebrated and codified in the souvenir material created for her Silver and Diamond Jubilees.

As an enthusiastic royalist Samuelson had developed his pitch into a script by commissioning playwright Arthur Shirley to 'delve into the history of the early, middle and late Victorian periods to find a suitable set of incidents to develop in pictorial form'. He reused this three-act approach to periodisation in later projects.[2] Seeking an experienced filmmaker he approached Will Barker, whose studios at Ealing had already produced many prestige films, most notably a cinematic version of Herbert Beerbohm Tree's extravagant stage version of Shakespeare's *Henry VIII*. Having experienced the financial benefits of a royal subject, Barker embraced the project. Despite describing himself as a patriotic republican he expressed respect for the British monarch as the head of his nation state.[3]

Research for the film drew on illustrated newspapers of Victoria's reign. Julian Wylie, Samuelson's older brother, described how he, Samuelson and Barker had visited the second-hand bookshops on Charing Cross Road, where 'we got volumes of the illustrated papers of the period, we got books on the life of the Queen'.[4] Respectful stories of royalty were a popular subject for the *Illustrated London News* (*ILN*), a weekly pictorial launched on 14 May 1842 and aimed at an educated readership.[5] From 1873, 'special numbers' of the magazine were issued for commemorative occasions, the first commemorating the death of Emperor Napoleon III of France.[6] Some of the original images were

recycled for later retrospective editions to accompany Victoria's jubilees in 1887 and 1897, and were again recycled for obituary issues on her death in 1901.[7] These souvenir editions of the *ILN* mediated the representation of the Queen for readers in the early 1900s.

Reflecting Samuelson's three-part chronology, three different actors played Victoria at three different ages. Ina Kastner acted the young Victoria and appears in the surviving fragment; Ida Heath played the Queen in her middle years; and Mrs Henry Lytton played the older Queen.[8] The surviving press-book lists the incidents from the film in chronological order, divided into seven acts. Part I, on Victoria's accession to the throne, offers a flavour of the full programme:

PART I

THE KING IS DEAD, LONG LIVE THE QUEEN

1837, June 20th, 2am Windsor. The Marquis Conyngham and the Archbishop of Canterbury are present at the death of William IV. – The Archbishop and Lord Conyngham set out for Kensington Palace – 5am. The early awakening at Kensington Palace. We are come on business of state to the Queen, and even her sleep must give way to that. – Long live the Queen. – The young Queen holds her first Council at Kensington Palace. – 'I shall promote to the utmost of my power the happiness and welfare of my subjects.' – 1837, Sept 28th, Her Majesty holds her first review in Windsor Great Park. – The Duke of Wellington parades the Waterloo Veterans – 1838, June 27th. Coronation of Queen Victoria.

Ceremonial scenes appeared throughout the film and typify how *Sixty Years a Queen* represented early Victorian events through the filter of later attitudes. The generation of cinema had seen actuality film of royal events, notably Victoria's impressive Diamond Jubilee procession in 1897. A crop of popular 'actualities' depicted the coronation of George V in 1911, and although camera operators had not been allowed inside Westminster Abbey, the processions filmed by Barker and others were viewed at cinemas up and down the country. These records of lavish ceremonials influenced the painstaking recreation of Victoria's coronation in *Sixty Years a Queen*. This scene was staged with care, most unlike the infamously shambolic proceedings of Victoria's 'shabby coronation'.[9] It was performed in front of an invited audience, reflecting contemporary traditions of royal ceremonial which had been influenced by the opulence of theatres during the reign of Edward VII.[10]

Samuelson's memoirs discussed the filming of the coronation scene.[11] It reportedly lasted twenty minutes and Barker tried to record it without an interruption, drawing on his experience of filming the stage production of *Henry VIII*, which was performed and recorded in a special event at Ealing.[12] The anecdotal evidence suggests it was recorded as a single take. The *Bioscope* journalist who witnessed the filming of the play reported that all scenes were performed exactly as on stage, the characters speaking their parts throughout.[13] The first attempt was thwarted as a result of 'insufficient light', a hazard of filming in late November, but when the effort was repeated in February 1911, the result was successful enough for release.[14] To achieve these long scenes in one take, Barker may have used the cameras he reputedly pioneered that could accommodate magazines of 1,000ft of film.[15] However, the extended duration of the shot exacerbated the usual problem inherent in achieving consistent and sufficient lighting with a combination of variable sunshine and arc lamps.

Samuelson's autobiography recalls that the first take was ruined at a crucial moment by someone passing a teacup in front of the camera. By this time, cloud cover had reduced the natural light. To avoid the expense involved in rescheduling such a major scene for another day – and perhaps the presence of an audience of 'nobility' influenced this decision – Barker decided to try again before nightfall, compensating for the diminished daylight by increasing the lighting in the studio. Much of the scene had been successfully filmed before changeable weather once more threatened the shoot; but at the point when 'the Queen received the spurs and sword and the Dean of Westminster placed the "Armill" around the Sovereign's neck', the clouds parted and the sun shone through the glass roof, over-exposing the film stock.[16] In a concerted attempt to complete the scene, Barker instructed his staff to turn off the top lights, but for some reason the interior light still grew brighter. After a vigorous intervention by Barker, partly censored in Samuelson's anecdote (' "If you don't switch those so-and-so lights off I'll come and knock your b— head off!" '), it was revealed that the extra illumination was due to a fire in the studio.[17] There being no obvious reference to this fire elsewhere, presumably the blaze was safely contained.

Such physical hazards were accompanied by financial risk, with the final bill for the production cited as £12,000.[18] The scale of the production and the immense efforts made to accurately reconstruct events applied the West End theatre tradition of combining well-researched design with historical drama. The filmmakers benefited from the London theatre infrastructure, such as the suppliers then profiting from the fashion for historical romantic pictures.[19]

Barker could supplement what was available through these companies with the props and costumes of the Empire Theatre (noted as the largest stage wardrobe in the world), to which he had unique access as 'special artist' to the venue.[20] The sets for *Sixty Years a Queen* were created by the in-house scenery department at Ealing and reports suggest no expense was spared. When visiting the studios in January 1914, one reporter noted that 'every spare corner was blocked up with properties and scenery relative to the great patriotic film' that included some very special and expensive pieces:

> Pointing to some massive columns standing on one side, the manager explained that the firm had specially engaged an artist to visit Westminster Abbey day after day and work upon an exact replica of the age-worn pillars in the noble sacred fane. These pillars, the manager remarked, were used in the stately Abbey scenes. 'But,' he went on, showing the trouble they took with the film, 'although we paid such a big sum for them, I don't suppose we shall ever have [a use] for them again.'[21]

Other carefully reconstructed props still present in the grounds in January 1914 included 'the hurdles used in the Sebastopol scenes, and the charred remains of the gate at Cashmere'.[22]

The number of different settings required for the varied film scenes demanded the exploitation of several indoor and outdoor spaces. The grounds of Barker's Ealing studios and the wider surrounds were remodelled to resemble sites from around the world. International and imperial locations featured 'the shade of impenetrable forests' which formed a backdrop to the celebrations of the Crown's annexation of British Columbia, Khartoum and the siege of Ladysmith, as well as Sebastopol and the Cashmere Gate.[23] The back lot represented Hyde Park, with the construction of a road for the carriages; studio buildings which had a 'shed-like' structure set the scene for the Anglo-Boer War conflict; and events from the Sudan and the Crimea were staged inside the studio grounds. Barker's team managed to suggest a much larger location in a limited area, as in the staging of the Delhi Durbar.[24] The process amazed one journalist: 'Never have men and women worked harder, and certainly never have the studios and grounds been put to such good use and undergone such rapid and remarkable changes.'[25]

Ealing provided the majority, if not all, of the locations for the film, and about two-thirds of the actors were local.[26] This assisted with managing crowd scenes, an important consideration as many extras were required to represent popular Victorian spectatorship. For the later part of the chronology, 'supers'

4 Queen Victoria (Ina Kastner) proposes to Prince Albert in a photographic illustration from the May Wynne book accompanying *Sixty Years a Queen* (William Barker, 1913).

were involved in re-enacting scenes that would have evoked personal memories in 1913, and which consequently sometimes produced an emotional response; one old lady was reported as believing that she was actually having tea with Victoria: '[T]he old lady's "acting" is perfectly natural, for she was, tremendously flustered and nervous at having the honour of drinking tea with the "Queen".'[27]

Victoria's betrothal story offered an intimate peep at royal private life behind the public show. Many were fascinated by its apparent gender reversal as it was understood that Victoria had proposed to Prince Albert, forced by her status to go against the convention that it was the man's duty to pop the question. But the young Queen was portrayed as a romantic figure, and the lace, satin, pearls and velvet of her costume added spectacle to the scene. Victoria is shown in the off-shoulder fashion and flowers associated with 1840s women's fashion. More formal dresses were utilised for the public betrothal scene of Victoria and Albert at a palace ball. Following soon after, the marriage scene was replete with rich fabrics, medals, wigs, ribbons and flowers.

The film alternated between public and private events and between imperial and domestic scenes. The battle of Sebastopol was filmed in Walpole Park with special effects of snow and explosions; local children were reportedly 'deafened

with the booming of the guns of the Crimean War'.[28] The Indian Mutiny was represented as a time of horror and heroism through a scene of the storming of the Cashmere Gate. These images of war were succeeded by scenes of Victoria mourning the death of her husband before famously going into seclusion. The challenge her retreat presented to retaining her relevance to public events was solved by showing the Queen in audience with important figures of her age, such as David Livingstone, Charles Dickens and Benjamin Disraeli. For example, she is seen alongside Disraeli sending the first telegraphic message to President Lincoln.

Imperial scenes without the Queen continued, notably the regime-rocking last stand of General Gordon at Khartoum, which irreparably damaged Prime Minister Gladstone's reputation. The final pictures in the book depict Victoria visiting the veterans at Netley Hospital in Hampshire. These scenes reinforced the hagiography of 'Victoria the Good', with the hospitalised men standing to attention in the presence of their Queen. When viewing the film, past and present British subjects seem to have colluded in a collective homage. The respectful behaviour of the film's characters showed its spectators how to behave when witnessing Victoria; like those portrayed on the screen they should gaze respectfully and with interest at her person, the veterans possibly even saluting her presence as do her old soldiers at Netley. This fostered the illusion of a cross-generational membership of an imaginary community working harmoniously towards a common goal. It seems to have given a therapeutic power to the film, which offered a new kind of opportunity for those inclined to celebrate and mourn recent ancestors in the emerging communal venue of the cinema.

The release of *Sixty Years a Queen* coincided with the opening of a new generation of high-investment cinemas. Immediately after its London launch at the New Gallery Kinema, Samuelson personally toured the film to trade audiences in cities around the United Kingdom. The shows offered an exemplary experience of the new era of long feature film; it provided a full performance of nearly two hours, eschewing any need for supplementary shorts, and offered a standardised musical accompaniment. Industry discussion of the appearances of *Sixty Years a Queen* on the UK cinema circuit of 1913 and 1914 indicates a new level of attention for a British long film. Although detailed information on audience statistics is not available, the film was often mentioned in the *Bioscope*'s regional reports such as 'Events at Ealing', 'Exeter echoes', 'Northern notes', 'Novel lines at Leicester', 'Happenings at Hull', 'Movements at Morecambe' and 'Trawlings from Grimsby'. The reports in these columns and in local newspapers repeatedly claim that the film was breaking or threatening to break

box-office records between November 1913 and June 1914. Comments included 'this film is going strong for creating a record', 'very big business has been done with *Sixty Years a Queen*', '*Sixty Years a Queen* has met with a record reception', 'packed houses thrice daily and receipts constituted a record for the Palace'.[29] Some stressed the relative popularity of the film compared with other fare:

> [T]here are not many films which can successfully run for a fortnight, but such has been the success of *Sixty Years a Queen* at the Mechanic's Large Hall that the management decided to retain the production during the whole of this week.[30]

In Teesside the management warned after the success of its first night that no seats were guaranteed unless booked in advance.[31] It seems that the film was achieving a special level of popularity at the British box-office, with positive reports emerging from Wales and Scotland as well as from England.[32]

The pre-publicity for *Sixty Years a Queen* stated that tunes from the 1830s, 1840s, 1850s and 1860s were arranged specially by the musical director of a West End theatre.[33] But, outside the controlled environment of the trade show, cinemas would vary in their chosen accompaniment. Sometimes this was simply an adaptation of the music suggested by the distributors, as at the Strand Cinema de Luxe in Grimsby, Lincolnshire, where 'an organ lent the requisite effect to the solemn music'.[34] Highly regarded local musicians took the opportunity to perform their specialities, as in the following extracts from reports of screenings at the Picture Palace in Southport and the Corn Exchange in Alnwick, Northumberland: 'Praiseworthy musical selections were given by the famous Southport Abbey Prize Quartette';[35] 'Miss Pearl Grey, a highly cultured soprano vocalist, charmed the large audience with her admirable renderings of "The Prima Donna", "Comin' thro' the rye" and other lyric gems.'[36] 'The Prima Donna' and 'Comin' thro' the Rye' were popular pieces; perhaps the latter setting of a Robert Burns poem would have accompanied the Balmoral sequence. At other screenings there might have been a choral accompaniment, following on from the example set by the male choir at the New Kinema trade show.[37] At Stockton-on-Tees 'the excellent orchestra was supplemented by a full choir and the Albion Prize Quartette, the music and vocal accompaniments being greatly enjoyed'.[38] Choral music was a novelty for cinema, but was a common entertainment of the Victorian era. The metaphor of the choir underpinned the interpretation of *Sixty Years a Queen* as depicting the progress achieved through the combined efforts of all the social ranks. Choral music is a democratic exercise in the sense that that no expensive instruments are necessary; vocalists could perform the different parts and come together to create a communal whole.

Most cities and towns screened the film at their most prestigious cinemas. Record profits were announced for the Grand on Smithdown Road in Manchester, which achieved its greatest box-office return on Easter Monday.[39] In Bradford patriotic decorations and themed costumes for the staff were reported to have stimulated memories of the era for elderly spectators who recalled the distinctive costumes of the Victorian past:

> The hall was lavishly decorated with flags and bunting, and the attendants were dressed in costumes of the early Victorian period. The crinolines, especially, brought back memories to many old folks who attended. An invitation had been extended to all Army and Navy veterans and old age pensioners in the city to attend the afternoon performances.[40]

Sixty Years a Queen achieved unprecedented box-office success by exploiting what Eric Hobsbawm has described as the 'twilight zone' of recent history.[41] For older audiences, the film was particularly poignant in re-enacting scenes which they could remember seeing in the pictorial press. Younger audiences could witness stories from the lives of their parents and grandparents through trips arranged by school and youth organisations. Group visits of schoolchildren were strongly encouraged, with special matinees and performances at the New Picture House, Halifax; the Princes Cinema, Edinburgh / Paisley; the Sun Hall, Bootle; the Corn Exchange, Alnwick; and the Quay Picture House, Lincolnshire. The boy scouts marched in procession to the performance at the Picture Coliseum in Harlesden.[42]

This combination of cinema with civic duty was a late flowering of the Victorian philanthropic event. Victoria was known for her support for charitable and public works through her visits around the country, a pattern which was set up in the opening years of her reign: 'Assuredly the reign of Victoria will be known as the reign of royal visits; it seems to have established an era of royal and imperial sociability.'[43] These visits exemplify the social contact of Victoria with her subjects that historian John Plunkett has called 'civic publicness'.[44] Victoria established this royal patronage during her lifetime, and posthumously her screen representation continued this tradition. Local politicians associated themselves with the monarch's civic virtues and her regime's reputation for progress by making personal appearances at special performances. This process was triumphantly realised in the capital on 8 December at the film's premiere, which Barker remembered as attended by 'the Lord Mayor of London [and] supported by several Mayors of greater London, together with a very imposing

list of celebrities'[45]. For *The Times*, this screening marked a positive change in its reviewers' attitudes towards cinema, claiming that '[A] public production of an important cinematograph film is rapidly becoming as interesting a social function as a theatrical "first-night".'[46] As well as Councillor Will Phillips's lectures accompanying the film at two Manchester cinemas, mayors and their entourages patronised performances in Plymouth, Beverley and Bristol, and education committees officially approved the performance in Exeter and Bootle.[47] Samuelson colluded with this appropriation of the film's kudos by the higher echelons of regional government when he presented an inscribed casket containing a duplicate of the film to the Lord Mayor of Bristol.[48] This official approval of the newly prestigious medium coincided with the building of attractive cinemas targeting higher-income groups. Regional mayors formally opened several of these; for example, in January 1914 the Lord Mayor of Manchester inaugurated the Deansgate Picture House and café, was built for the Alliance Cinematographic Company.[49]

Samuelson used his special relationship with *Sixty Years a Queen* to introduce a new form of distribution that had been successful for the high-investment film in the USA, but which had not yet been seen in Britain – the road show. Adolph Zukor had toured *Queen Elizabeth* (*Les Amours de la Reine Elisabeth*, Henri Desfontaines and Louis Mercanton, 1912)[50] in America along similar lines to a stage production, which allowed him relatively strong control of the auditorium experience, and assisted in avoiding the many vagaries of local cinema exhibition. This was extremely attractive to producers of the large-budget long film in the UK as well as in the USA. Samuelson's road show emulated Zukor's approach and, in some instances, went beyond the trade into public screenings. He personally showed the film at various venues while it was still fresh. These screenings were family-run events: Fred Wainwright, the family chauffeur, was engaged to drive Samuelson and the reels of *Sixty Years a Queen* from venue to venue; Samuelson's mother was the cashier; his sister Rahleen and family friend Harry Lorie (soon to be Samuelson's brother-in-law) acted as ushers; Wainwright was general assistant to the project, while Samuelson himself was presenter. With costs saved by minimising outsourced labour, this operation maximised profits for the family. Box-office receipts were divided 60 per cent to Samuelson and 40 per cent to the exhibitor.[51]

These screenings of *Sixty Years a Queen* violated the principle of exclusive distribution when exhibition took place within an area for which his agency had

already disposed of the rights. The official body of exhibitors, the Cinematograph Exhibitors Association (CEA), complained. The controversial screenings that provoked the criticism were organised by Samuelson at the Colston Hall in Bristol and opened with a charity gala at which the Lord Mayor presided. The attendance of the Bristol Crimea and India Mutiny Veterans was felt to add a commemorative and community air to the evening. Despite the evening's takings being donated to the Lord Mayor's Hospital Fund, the event was a sound investment for Samuelson as the Colston Hall bookings continued for at least five weeks.[52] The Bristol and West of England branch of the CEA objected to these shows, proposing to take action 'against such manufacturing and renting firms as engaged large halls for the purpose of exhibiting special films in opposition to the exhibitors'.[53] But although the regional initiative was considered important enough to be backed by the central body of the CEA, no mention is made of such any action in the trade pages and the 'strong action' may have simply consisted of a written condemnation of the actions of the Royal Film Agency.[54] This opposition had no serious impact on Samuelson's income, his business or his standing within the trade press. Barker remembered the reasoning behind the Colston Hall performances not as a deliberate attempt to undermine exhibitors but simply one of meeting demand: 'At Bristol, the success was so great that the Colston Hall had to be taken, as no other place in the city would hold the crowds.'[55]

Although *Sixty Years a Queen* was made for a domestic market it was released at an opportune moment to succeed in the United States.[56] A generally upward trend for imports in terms of footage was recorded in 1913, spearheaded by the European spectaculars *Dante's Inferno* (Francesco Bertolini, Adolfo Padovan and Giuseppe De Liguoro, 1911) and *Queen Elizabeth*.[57] In August 1912, when the US government brought a suit against the Motion Picture Patents Company under the Sherman Act for exclusive monopolisation of commerce, the American market was perceived as opening a little to foreign imports. In April 1913, the *Bioscope* asserted that it was time to export good product to secure the future of British film in America:

> [T]he absolute closing of the door against foreign competition killed, for the time being, all hopes of placing British films on the American market. But that time has long since passed, and the policy of the 'open door' is rapidly developing. Whatever may have happened in the past only confirms our belief that the time has come for the British manufacturer to enter the lists against his American competitors on their own ground.[58]

While it had been Samuelson who had presented the British road shows, it was Barker, with his enthusiasm for transatlantic trade, who took the film to the USA.[59] Barker maintained his East Coast connection by launching the American distribution at the Astor Hotel ballroom, Times Square, New York on 21 December 1913. Reviewer Louis Reeves Harrison noted that Barker's commentary won over the American audience with his 'decided accent'.[60] Barker remembered selling the film before it was half over 'for a sum which will make the mouths water of some of today's producers'.[61] On this promotional trip he was accompanied by promoter Edward Laurillard of the New Gallery Kinema, who selected *Sixty Years a Queen* as one of the main films to help establish a sister venue in New York to support the exchange of European and American productions. This enterprise, known as the Anglo-American Film Corporation, was incorporated with American businessman George Lederer, who intended to use the organisation as a platform for exporting his own films into Europe.[62] The New York Theatre was acquired and *Sixty Years a Queen* showed at this venue in April.

Despite the transatlantic hopes for this exchange of 'high-class' films, the *Variety* review of the screening showed the limitations of this subject in the United States, even in the Anglophile community of New York theatre-goers.[63] Citing its lack of appeal for the American audience, *Variety* panned the film. The review was by 'Sime', the pseudonym of Simon J. Silverman, known for coining the motto 'Bury the puff and give me the fact.' In his characteristically brusque style, Sime gave *Sixty Years a Queen* short shrift. He did not find fault with the film's production, recognising the unusually high levels of investment: 'The indications early in the reels were that this film had been very expensively made, almost extravagantly so.'[64] But Sime felt that the original concept and the chronological structure undermined the storytelling and editing qualities that he associated with a good movie: 'The film is merely the exposition in action of a series of incidents concerning England and Victoria during her royal life. There is no continuity except in the passing of years.'[65] The critic confessed to leaving after only two or three reels. He felt the film to be inappropriate for America on national grounds, claiming that Victoria for the English was as Napoleon for the French, characters that may be a great draw for their respective colonies and expatriates but of no interest to Americans. 'The *Victoria* film for America should be sent through Canada. It was probably built for England. England and her possessions are where this feature belongs.'[66]

The US release of *Sixty Years a Queen* showed that such patriotic product was not going to reap box-office success in America and change the fortunes of British cinema in the overseas market, whereas in the territories of the British Empire the film netted an impressive £35,000. Even before the distribution of *Sixty Years a Queen* had run its course, Samuelson was able to position himself as a major film manufacturer. As early as 23 April 1914 the *Bioscope* announced that he had purchased Worton Hall in Isleworth and commenced work on creating a modern studio. On 30 May 1914 he incorporated the Samuelson Film Manufacturing Company Ltd.[67]

With *Sixty Years a Queen* Samuelson and Barker tested a new formula for the long film that would be revisited and renewed in 1918 for *The Life Story of David Lloyd George*. In the earlier film British royalty demonstrated its box-office power to kick-start the inchoate feature film industry, and it was this model that was later adapted for the biographical film of a living British prime minister. On the eve of the First World War, many settled comfortably in the plush seats of the newly opened picture palaces to take in this lengthy pageant of Queen Victoria's life and times, celebrating the supposedly golden days of imperial peace and progress.

NOTES

1 May Wynne, *The Life and Reign of Victoria the Good, Produced in Conjunction with the Cinematograph Film 'Sixty Years a Queen': Cinema Books No. 2* (London: Stanley Paul & Co., 1913).

2 'Our view', *Bioscope* (21 August 1913), p. 553.

3 'Faking the coronation: interview with Mr Will G. Barker', *Bioscope* (2 February 1911), p. 9; Presumably the film to which Barker was referring was Georges Méliès's *The Coronation of Edward VII* (1902).

4 Julian Wylie, 'Confessions of a star maker: queen to-day and super to-morrow', *Sunday Graphic and Sunday News* (1 January 1933), p. 7.

5 Lucy Brown, *Victorian News and Newspapers* (Oxford: Clarendon Press, 1985), p. 30.

6 'Death of Emperor Napoleon III of France', *Illustrated London News*, Special Number (undated, 1873).

7 'Victoria: Queen and Empress. A Jubilee memorial', *Illustrated London News*, Special Number (13 June 1887); 'Her Majesty's glorious Jubilee 1897: the record number of a record reign', *Illustrated London News*, Record Number (21 June, 1897); 'The life and death of Victoria, Queen of Great Britain and Ireland and Empress of India', *Illustrated London News*, Special Number (30 January 1901).

8 BFI Special Collections, London, Brunel Collection, Box 21, Item 2, letter from W. G. Barker to the editor of the *Sunday Dispatch* (undated).

9 See Dorothy Thompson, *Queen Victoria: Gender and Power* (London: Virago, 2001), pp. 27–8.

10 David Cannadine, 'The context, performance and meaning of ritual: the British monarchy and "invention of tradition", *c.* 1820–1977', in Eric Hobsbawm and Terence Ranger (eds), *The Invention of Tradition* (Cambridge: Cambridge University Press, 1983), pp. 120–39.

11 G. B. Samuelson, 'From 15/- to £100,000 and back to 15/-', quoted in Harold Dunham and David W. Samuelson, *Bertie: The Life and Times of G. B. Samuelson* (London: Published by the Samuelson Family and available at the BFI National Library, 2005), p. 32.

12 *Ibid.*

13 'The filming of *Henry VIII*: a wonderful spectacle', *Bioscope* (16 February 1911), p. 5.

14 'My view of things', *Bioscope* (24 November 1910), p. 7; 'The filming of *Henry VIII*', pp. 5–7.

15 'The Bioscope at home: the wide-awakeness of Ealing's "Sleepy Hollow" ', *Middlesex County Times* (10 September 1910), p. 6.

16 Samuelson, 'From 15/- to £100,000 and back to 15/-', p. 33.

17 *Ibid.*

18 Charles F. Ingram, 'Film gossip', *Illustrated Films Monthly* 1 (September 1913–February 1914), p. 210.

19 'The picture pianist', *Bioscope* (13 November 1913), p. 615.

20 'The Bioscope at home', p. 6.

21 'Ealing's cinematograph masterpiece – how *Sixty Years a Queen* was produced', *Middlesex County Times* (17 January 1914), p. 2.

22 *Ibid.*

23 Wynne, *The Life and Reign of Victoria the Good*, p. 33.

24 'Ealing's cinematograph masterpiece', p. 2.

25 *Ibid.*

26 *Ibid.*

27 '*Sixty Years a Queen*', *Picturegoer* (3 January 1914), pp. 392–3.

28 'Ealing's cinematograph masterpiece', p. 2.

29 'Northern notes', *Bioscope* (23 April 1914), p. 431; 'Edinburgh and Paisley notes', *Bioscope* (29 January 1914), p. 451; 'Northern notes', *Bioscope* (30 April 1914), p. 485; 'Bits from Bedford', *Bioscope* (22 January 1914), p. 308.

30 'Nottingham and district notes', *Bioscope* (29 January 1914), p. 417.

31 'Teesside topics', *Bioscope* (12 March 1914), p. 107.

32 'Welsh notes', *Kinematograph and Lantern Weekly* (1 January 1914), p. 30; 'Edinburgh and Paisley notes', p. 451.

33 'Our view', p. 553.

34 'Trawlings from Grimsby', *Bioscope* (29 January 1914), p. 417.

35 'Snippets from Southport', *Bioscope* (8 January 1914), p. 148.

36 'Cinema in the Corn Exchange', *Alnwick and County Gazette* (14 March 1914), p. 5.

37 'Sixty Years a Queen: a very remarkable film illustrating the long reign of Queen Victoria', *The Cinema* (6 November 1913), p. 70.

38 'Success at Stockton', *Bioscope* (8 January 1914), p. 110.

39 'Round Manchester and Liverpool', *Bioscope* (23 April 1914), p. 429.

40 'Veterans see *Sixty Years a Queen*', *Bioscope* (29 January 1914), p. 421.

41 Eric Hobsbawm, *The Age of Empire 1875–1914* (London: Abacus, 2001).

42 *Bioscope* (22 January 1914), p. 329; 'Bits from Bedford', p. 451; 'Big juvenile party', *Bioscope* (19 February 1914), p. 752; *Bioscope* (12 March 1914), p. 1213, *Bioscope* (2 April 1914), p. 89. 'In the Metropolitan District', *Bioscope* (2 April 1914), p. 82.

43 *Illustrated London News* (June 1844), p. 361, quoted in John Plunkett, *Queen Victoria: First Media Monarch* (Oxford: Oxford University Press, 2003), p. 14.

44 Plunkett, *Queen Victoria: First Media Monarch*, pp. 13–67.

45 Letter from W. G. Barker to the editor of the *Sunday Dispatch*.

46 'Sixty Years a Queen: a pictorial record of the Victorian era', *The Times* (9 December 1913), p. 10.

47 'Round Manchester and district' *Bioscope* (5 February 1914), p. 553; 'Big juvenile party', p. 752; 'Echoes from Exeter', *Bioscope* (12 March 1914), p. 1135.

48 *Bristol Times and Mirror* (20 January 1914), p. 3.

49 Brian Hornsey, *Ninety Years of Cinema in Manchester: A Chronological Essay in Celebration of the Cinema* (Stamford: Fuchsiaprint, 1998), p. 9.

50 Review, *Bioscope* (22 August 1912), p. 547.

51 Dunham and Samuelson, *Bertie*, pp. 39–40.

52 *Bristol Times and Mirror* (10 March 1914), p. 7.

53 'Bristol and West of England District Branch and *Sixty Years a Queen*', *Bioscope* (19 February 1914), p. 839.

54 *Ibid.*

55 Letter from W. G. Barker to the editor of the *Sunday Dispatch*.

56 The US government's 1917 case against the MPCC for monopoly practices offered new commercial opportunities to foreign film exporters. The case was followed avidly in the British press

57 Kristin Thompson, *Exporting Entertainment: America in the World Film Market 1907–1934* (London: BFI, 1985), p. 26.

58 'The future of English films: a brighter prospect', *Bioscope* (24 April 1913), p. 234.

59 Letter from W. G. Barker to the editor of the *Sunday Dispatch*.

60 Louis Reeves Harrison, 'Sixty Years a Queen: life and times of Queen Victoria illustrated in an educational multiple reel of W. G. Barker', *Moving Picture World* (3 January 1914), p. 51.

61 Letter from W. G. Barker to the editor of the *Sunday Dispatch*.

62 'Maybe New York Kinema', *Variety* (23 January 1914), p. 15.

63 'Sixty Years a Queen', *Variety* (24 April 1914), p. 21.

64 *Ibid.*

65 *Ibid.*

66 *Ibid.*

67 The National Archives, Kew, Board of Trade papers, BT 31/22323.

BIBLIOGRAPHY

Besas, Peter, *Inside Variety: The Story of the Bible of Show Business 1905–1987* (Madrid: Ars Millenii, 2000).

'Big juvenile party', *Bioscope* (19 February 1914).

'The Bioscope at home: the wide-awakeness of Ealing's "Sleepy Hollow"', *Middlesex County Times* (10 September 1910).

'Bits from Bedford', *Bioscope* (22 January 1914).

'Bristol and West of England District Branch and *Sixty Years a Queen*', *Bioscope* (19 February 1914).

Brown, Lucy, *Victorian News and Newspapers* (Oxford: Clarendon Press, 1985).

Cannadine, David, 'The context, performance and meaning of ritual: the British monarchy and "invention of tradition", *c.* 1820–1977', in Eric Hobsbawm and Terence Ranger (eds), *The Invention of Tradition* (Cambridge: Cambridge University Press, 1983).

'Cinema in the Corn Exchange', *Alnwick and County Gazette* (14 March 1914).

'Death of Emperor Napoleon III of France', *Illustrated London News*, Special Number (undated, 1873).

Dunham, Harold and David W. Samuelson, *Bertie: The Life and Times of G. B. Samuelson* (London: Published by the Samuelson Family and available at the BFI National Library, 2005).

'Ealing's cinematograph masterpiece – how *Sixty Years a Queen* was produced', *Middlesex County Times* (17 January 1914).

'Echoes from Exeter', *Bioscope* (12 March 1914).

'Edinburgh and Paisley notes', *Bioscope* (29 January 1914).

'Faking the coronation: interview with Mr Will G. Barker', *Bioscope* (2 February 1911).

'The filming of *Henry VIII*: a wonderful spectacle', *Bioscope* (16 February 1911).

'The future of English films: a brighter prospect', *Bioscope* (24 April 1913).

'Her Majesty's glorious Jubilee 1897: the record number of a record reign', *Illustrated London News*, Record Number (21 June, 1897).

Hobsbawm, Eric, *The Age of Empire 1875–1914* (London: Abacus, 2001).

Hobsbawm, Eric and Terence Ranger (eds), *The Invention of Tradition* (Cambridge: Cambridge University Press, 1983).

Hornsey, Brian, *Ninety Years of Cinema in Manchester: A Chronological Essay in Celebration of the Cinema* (Stamford: Fuchsiaprint, 1998).

'In the Metropolitan District', *Bioscope* (2 April 1914).

Ingram, Charles F., 'Film gossip', *Illustrated Films Monthly* 1 (September 1913–February 1914).

'The life and death of Victoria, Queen of Great Britain and Ireland and Empress of India', *Illustrated London News*, Special Number (30 January 1901).

'Maybe New York Kinema', *Variety* (23 January 1914).

'My view of things', *Bioscope* (24 November 1910).

'Northern notes', *Bioscope* (23 April 1914).

'Northern notes', *Bioscope* (30 April 1914).

'Nottingham and district notes', *Bioscope* (29 January 1914).

'Our view', *Bioscope* (21 August 1913).

'The picture pianist', *Bioscope* (13 November 1913).

Plunkett, John, *Queen Victoria: First Media Monarch* (Oxford: Oxford University Press, 2003).

Reeves Harrison, Louis, '*Sixty Years a Queen*: life and times of Queen Victoria illustrated in an educational multiple reel of W. G. Barker', *Moving Picture World* (3 January 1914).

'Round Manchester and district' *Bioscope* (5 February 1914).

'Round Manchester and Liverpool', *Bioscope* (23 April 1914).

'*Sixty Years a Queen*', *Picturegoer* (3 January 1914).

'*Sixty Years a Queen*', *Variety* (24 April 1914).

'*Sixty Years a Queen*: a pictorial record of the Victorian era', *The Times* (9 December 1913).

'*Sixty Years a Queen*: a very remarkable film illustrating the long reign of Queen Victoria', *The Cinema* (6 November 1913).

'Snippets from Southport', *Bioscope* (8 January 1914).

'Success at Stockton', *Bioscope* (8 January 1914).

'Teesside topics', *Bioscope* (12 March 1914).

Thompson, Dorothy, *Queen Victoria: Gender and Power* (London: Virago, 2001).

Thompson, Kristin, *Exporting Entertainment: America in the World Film Market 1907–1934* (London: BFI, 1985).

'Trawlings from Grimsby', *Bioscope* (29 January 1914).

'Veterans see *Sixty Years a Queen*', *Bioscope* (29 January 1914).

'Victoria: Queen and Empress. A Jubilee memorial', *Illustrated London News*, Special Number (13 June 1887).

'Welsh notes', *Kinematograph and Lantern Weekly* (1 January 1914).

Wylie, Julian, 'Confessions of a star maker: queen to-day and super to-morrow', *Sunday Graphic and Sunday News* (1 January 1933).

Wynne, May, *The Life and Reign of Victoria the Good, Produced in Conjunction with the Cinematograph Film 'Sixty Years a Queen': Cinema Books No. 2* (London: Stanley Paul & Co, 1913).

3

The heart of a heartless political
world: screening Victoria

Steven Fielding

When British politicians complain that television dramatists have failed to produce a native equivalent of *The West Wing* – that is, a series about politics that presents its practitioners as noble and effective – they forget one vital detail.[1] President Jed Bartlet, the central protagonist in the NBC series, which in the United States ran from 1999 to 2006, is a head of state, and like all other occupants of the White House – real or imagined – embodied his country in ways that no other elected representative could. Perhaps for that reason Hollywood has produced few 'bad' fictional Presidents, for to criticise the head of state is like attacking the United States itself.[2] Certainly, in the hands of his creator Aaron Sorkin, Bartlet personified the heroic promise of the United States constitution.[3]

Despite the supposed 'presidentialisation' of the role of British prime minister, those residing at Number 10 are still merely heads of government, closely tied to a political party, which usually holds a majority of seats in the House of Commons.[4] Therefore, those who want British politicians depicted in the same noble manner as Bartlet are not comparing like with like. Britain's screen politicians – variously incompetent, corrupt, evil or a combination of the three – are prime ministers (notably Jim Hacker in the 1980–88 BBC satire *Yes, Minister/Prime Minister* or Francis Urquhart in the 1990 BBC political thriller *House of Cards*), ministers (such as Hugh Abbot and Nicola Murray in the 2005–12 BBC comedy series *The Thick of It*) or MPs (infamously Alan B'Stard in the even broader 1987–92 ITV comedy *The New Statesman*). The country's head of state – its hereditary monarch – rarely makes a showing in Britain's contemporary political dramas.

One reason for the monarchy's absence is that, compared to the American presidency, many consider its formal function to be barely 'political'. Indeed,

according to one of Britain's leading constitutional experts, Vernon Bogdanor, the main virtue of the monarchy is that it stands above party politics, which is, he argued in 2000, 'of inestimable value in an age when politics has come to invade almost every aspect of our national life, choking all too many activities in its unnatural embrace'.[5] Certainly most surveys of British politics deal with the monarchy very succinctly: one 700-page tome covers the subject in little more than a page, while another almost as thick gives it even less space.[6] For most students of British politics the monarchy is a minor detail, whose modest right to be consulted, to encourage and to warn is strictly bounded by conventions established as long ago as 1867, when Walter Bagehot first made that claim in *The English Constitution*.

As there is little point discussing the monarchy if virtually all power lies with those whom Britons elect to the Commons, political experts consequently focus on apparently more important issues, such as why so few participate in Westminster elections or think so little of those for whom they do vote. Indeed, it might be thought that, in the first decades of the twenty-first century, the monarchy is the one part of British public life that needs no fixing. If MPs are forced to admit they have lost the people's 'trust', the monarchy is popular, certainly more so than members of the Commons. A 2012 survey discovered for example that a plurality of those who expressed an opinion thought the Queen was more concerned about problems facing ordinary Britons than were senior politicians and government ministers.[7]

The monarchy's favoured status is largely due to most recent incumbents refraining from being openly involved in controversial political issues, although behind the scenes they have assiduously tried to protect their own interests.[8] As a result most Britons associate the institution with, as Bagehot put it, only the 'dignified' aspect of the constitution. The official website of the British monarchy is happy to reinforce that impression by claiming that:

> Although the British Sovereign no longer has a political or executive role, he or she continues to play an important part in the life of the nation.
>
> As Head of State, The Monarch undertakes constitutional and representational duties which have developed over one thousand years of history. In addition to these State duties, The Monarch has a less formal role as 'Head of Nation'. The Sovereign acts as a focus for national identity, unity and pride; gives a sense of stability and continuity; officially recognises success and excellence; and supports the ideal of voluntary service.[9]

Yet, the monarch's 'representational duties' as 'Head of Nation' have subtle political consequences, inflecting how people perceive their country and their own place within it. Situating a hereditary monarch at the centre of regular national ceremonials helps to propagate a particular way of thinking about history, politics and the people's subordinate position within a quasi-paternalistic rather than fully democratic order.[10] To illustrate that point Tom Nairn quotes Charles de Gaulle's 1961 address in which he told Elizabeth II that she was 'the person in which your people perceive their own nationhood'. As a critic of monarchy, Nairn believes the 'enchanted glass' it holds up to Britons is socially regressive and politically reactionary; but, he has to concede, it is a beguiling, comforting – and highly popular – national fantasy.[11] In promoting such a vision of the nation, the monarch's ceremonial role is an example of what Joseph Nye referred to as 'soft power', that is 'the ability to get what you want through attraction rather than coercion or payment'.[12] In this instance it mobilises popular feeling towards a conservative conception of national history by placing the monarchy at its centre. This is no accidental outcome. As David Cannadine suggests, the elite's desire to temper the radical consequences of democracy was a crucial reason for their invention of so many royal rituals since the later nineteenth century.[13]

PERIOD DRAMA POLITICS

The ways in which monarchs have been dramatised on the screen matter because, like the real rituals in which they take a leading part – and which such dramas spend much time restaging – fictional representations tell us something about what Britons think about their politics. Those working in a variety of academic disciplines certainly believe that the imagination plays an inescapable role in shaping perceptions of the real. Margaret Somers writes that all claims to knowledge 'are transmitted *via* some kind of cultural schema; they are culturally embedded – that is, mediated through symbolic systems and practices, such as metaphors, ritualized codes, stories, analogies, or homologies'.[14] Murray Edelman argues that the role of the imagined is especially important in politics, if only because so few people have direct experience of it, beyond voting. Thus, Edelman claims, 'art is the fountainhead from which political discourse, belief about politics, and consequent actions ultimately spring'.[15] Thanks to a number of studies we know the kind of effect screen dramas have on audiences' political dispositions, the most relevant of which discovered that, after

watching episodes of *The West Wing*, American viewers were better disposed towards Presidents Clinton and Bush.[16] Some even claim that idealised fictional Presidents, like Jed Bartlet, have made a notable contribution to what they call the 'cult of the Presidency'.[17] To be sure, Jeff Smith contends that 'The stories that Americans tell and have told about presidents' have played a critical part in forming how they think about their elected heads of state.[18]

As noted above, Britain's monarchs mostly appear in historical narratives, often described as period or costume dramas, one of the most popular of fictional genres.[19] Some cultural theorists believe dramas about the past exert an overwhelming influence over audiences. Michel Foucault went so far as to say that French films depicting the Resistance could 'reprogramme … popular memory'.[20] If Foucault provided no evidence, one survey suggests that even one of the most fallacious of Hollywood's historical dramas – *Braveheart* (1995) – shaped how audiences regarded the distant past, even after they had read reliable academic accounts.[21] This is also true of those who actually participated in events depicted on the big screen. Less than twenty years after its end, many American veterans of the Vietnam War were unable to distinguish their own recollection of the conflict from Hollywood's version.[22]

Having reshaped the past, Foucault argues, historical films then 'impose on people a framework in which to interpret the present', or as Pierre Sorlin puts it, to 'reorganise' it.[23] Writing about film versions of British history, James Chapman suggests, however, that such movies are also shaped by their context, tending to endorse narratives that accord with popular views of history. Reinforcing that generalisation, on the basis of five decades' experience starring in countless historical plays and movies, the British actor George Arliss, who won an Oscar for playing Disraeli in 1929, wrote: 'Cinema, and even theatre, audiences have a very superficial idea of most historical characters – when they have any idea at all.' History, so far as this renowned thespian was concerned, was an adornment for a good story; but he still believed it vital that dramas adopted audiences' 'preconceived ideas' of the past, no matter how limited they were.[24] Working with the grain of popular opinion, commercial cinema has generally reinforced, as Chapman puts it, 'narratives of national greatness'.[25] Reflecting the central role monarchs enjoy in most renditions of the British national story, they are far more popular big screen subjects than their prime ministers – Winston Churchill apart (see Table 1).[26]

Queen Victoria was Britain's second longest-reigning monarch, and the one most represented: just over 100 films and television programmes. As the author

Table 1 *Top ten screen (film and television) depictions of Britain's heads of state and government*

Heads of state		Heads of government	
Victoria	106	Churchill	137
Elizabeth I	85	Wellington	47
Elizabeth II	82	Thatcher	41
Henry VIII	79	Lloyd George	36
Charles II	55	Blair	31
Richard I	46	Disraeli	26
Cromwell	40	Gladstone	25
Richard III	40	Pitt the Younger	17
George III	36	Chamberlain	16
Edward VII	34	Eden	16

Source: Data from Internet Movie Database, www.imdb.com/.

of *A State of Play*, an exploration of fictional representations of British politics since the late nineteenth century, I will focus on this screen monarch, concentrating on eight film dramas in which she is the central protagonist or a significant figure.[27] Stretching from *Victoria the Great* (Herbert Wilcox, 1937) to *The Young Victoria* (Jean-Marc Vallée, 2009) by way of *Sixty Glorious Years* (Herbert Wilcox, 1938), *The Prime Minister* (Thorold Dickinson, 1941), *The Mudlark* (Jean Negulesco, 1950), *Mrs. Brown* (John Madden, 1997) and *Victoria and Albert* (John Erman, 2001), these dramas aimed to be popular entertainments, and many were. They also ostensibly aspired to historical authenticity, something that proved much more elusive.

Certainly, thanks to their props, costumes and locations, dramas about Victoria *looked* authentic. Other stratagems were also mobilised. Most baldly, and fallaciously, *Victoria the Great* begins with an intertitle declaring that the film was based on 'actual events and happenings' in the Queen's life; and that 'every incident is founded on historic fact and the political utterances by various statesmen are authentic'. The *Daily Mirror* critic pronounced *Sixty Glorious Years* so accurate, he argued it should be shown in schools throughout the Empire. Julian Fellowes, who wrote *The Young Victoria*, also asserted that everything in his script was 'based entirely on fact'. That was true, but only up to a point. A madman *did* fire a shot at Victoria. But Prince Albert *did not* – as Fellowes has it – take the bullet in the chest to prevent the Queen's assassination, thereby

finally convincing Victoria of his love for her.[28] Thanks to its staging, the scene none the less *looks* 'authentic'.

Historical dramas seek to give audiences a view of the past with which they are already familiar, however inaccurate that may be. Perceptions are reshaped in so far as filmmakers reflect back – and thereby reinforce while reordering – beliefs they consider suitable for representation. In other words, there are grounds for believing that the screen dramas in which monarchs appear, in a similar way to national ceremonials, 'mobilise bias', by luring audiences in directions many were already predisposed to take, subsequently making them less likely to accept alternative points of view.[29] Screen dramas about Queen Victoria did not by themselves make monarchy well liked – the production of such works suggests monarchy was already that – but they certainly helped make it more popular than it would otherwise have been, while revealing the reasons why so many looked upon the institution with favour.

VARIOUS VICTORIAS

Many of Victoria's screen appearances consist of her being used to establish period authenticity, being the historical figure – at least as the elderly matron in black who is 'not amused' – which even the most historically ignorant audiences might recognise. Her earliest outings were reverential. Perhaps the only critical depiction was in *Ohm Krüger* (*Uncle Kruger*, Hans Steinhoff, Karl Anton, 1941), a Nazi account of the Anglo-Boer War, which shows the Queen as greedy and duplicitous. This was not a characterisation found in films produced within the anglophone world. Hollywood's *The Little Princess* (Walter Lang, 1939), for example, presents Victoria as a sweet old lady who intercedes on behalf of a distressed Shirley Temple trying to find her father, wounded in the defence of Mafeking. In the musical *Annie Get Your Gun* (George Sidney, 1950) she benignly grants royal prestige to Buffalo Bill's travelling Wild West show.

After the 1960s these cameos were more often made for comic effect. *Lèse-majesté* was certainly evident when Peter Sellers played Victoria in *The Great McGonagall* (Joseph McGrath, 1974), while *The Adventures of Sherlock Holmes' Smarter Brother* (Gene Wilder, 1975) established its irreverent credentials by having the elderly Queen issue an expletive. These appearances, however, said little about Victoria or the monarchy but more about the stuffy Victorian ethos ridiculed by such permissive comedies. More recently Victoria has become – like a number of other historical heads of state such as Lincoln

in *Abraham Lincoln: Vampire Hunter* (Timur Bekmambetov, 2012) and Roosevelt in *FDR: American Badass!* (Garrett Brawith, 2012) – a free-floating signifier, to be used in a variety of self-consciously anachronistic ways. The 2004 remake of *Around the World in 80 Days* (Frank Coraci, 2004) has Victoria intervene on behalf of Phileas Fogg against her power-mad Minister of Science to ensure the triumph of progress over tradition. In a 2006 episode of *Dr Who* the Queen becomes a gun-toting alien killer who later establishes Torchwood to protect Britain from future extra-terrestrial invasions.[30] Very unusually, the animated comedy *The Pirates! In an Adventure with Scientists!* (Peter Lord, 2012) casts the Queen as a sinister figure who together with other world crowned heads wants to eat animals on the verge of extinction.

For much of the interwar period, however, stage and screen depictions of Victoria were banned as a result of objections from George V. As Jude Cowan Montague indicates in this collection, however, before that prohibition could be enforced, *Sixty Years a Queen* (Will Barker, 1913) told the story of the Queen's life, in glowing terms and to great acclaim. Victoria also made a brief appearance in the 1916 film version of Louis Napoleon Parker's 1910 play *Disraeli*. In the final scene of Parker's play the Prime Minister attends a reception at which it is announced the Queen will honour those who helped him purchase shares in the Suez Canal. Victoria is, however, not depicted and the play ends with Disraeli leading her guests stage left, toward what Parker's directions describe as a 'great blaze of light'. The 1916 film, directed by Charles Calvert and Percy Nash, does not survive, but as Victoria is depicted it is likely it portrayed the Queen in the same way as its 1929 Hollywood remake, which concludes with the Prime Minister and colleagues processing respectfully towards a distant, silent and static figure sitting on a throne.

George V's death allowed Herbert Wilcox to produce the first talking – and royally sanctioned – Victoria.[31] His *Victoria the Great* (1937) was one of the most popular films in the year of its release, with cinemagoers in proletarian Bolton declaring it their favourite movie.[32] In response to such acclaim Wilcox rushed out *Sixty Glorious Years*, a kind of off-cut of his earlier film – which was again well liked, especially by working-class audiences.[33] Wilcox's two films covered the monarch's private and public life, but mostly focused on Victoria's happy relationship with her beloved consort Albert: the *Daily Mirror* welcomed *Victoria the Great* as 'a beautifully told royal romance'.[34] They did not, however, avoid politics, and associated Victoria with policies which audiences were presumed to support, having her embody the imperial consensus of the time. In contrast,

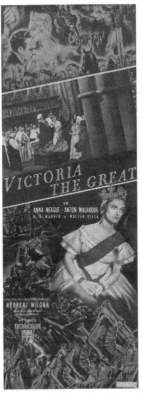

5 A poster for *Victoria the Great* (Herbert Wilcox, 1937).

films made after the outbreak of the Second World War – *The Prime Minister* (1941) and *The Mudlark* (1950) – presented the widowed Victoria as more concerned with her people's domestic welfare, an interest appropriate to the People's War and the postwar social democratic consensus that succeeded it.

More recent dramas pushed formal politics further into the background and concentrated even more on Victoria's emotional life. They certainly give audiences an unprecedentedly intimate view of the Queen – the mini-series *Victoria and Albert* (BBC1, 2001), for example, shows the Queen abed with her Consort and in the midst of the agony of childbirth: it is a long way from Parker's discrete 'great blaze of light'. Wilcox's films had highlighted the tensions inherent to the monarch being a public figure and a private individual. But these later movies emphasised much more strongly the extent to which Victoria was – as Princess Diana was popularly thought to be – a victim of tradition. *Mrs. Brown*

(1997) has Victoria trapped by protocol: only John Brown talking to her directly, like a woman, saves the Queen from her own morbidity. As *The Young Victoria* (2009) has it: 'Even a Palace can be a prison.'

AN AMERICANISED MONARCH

There has always been a market for British period dramas in the United States. Indeed, Anglophilia was a defining aspect of American national identity and for much of the twentieth century the high-school curriculum stipulated that students be taught British history as a precursor to their own.[35] As a consequence, historical dramas with upper-class settings such as television's original *Upstairs, Downstairs* (London Weekend, 1971–75, revived by the BBC, 2010–12) and *Downton Abbey* (ITV, 2010–) have had significant American followings.

The huge rise of this potential market across the Atlantic meant that, for financially obvious reasons, British filmmakers shaped their content to make it amenable to American as well as British audiences. *Victoria the Great* (1937), which did very well in the United States, for example, emphasised how keenly Victoria and Albert sought to prevent war with the Union during the Civil War. Lincoln is even shown praising their intervention in a scene *The Times* critic declared 'evidently designed to appeal to American sentiment'.[36] By the late 1930s Hollywood studios wishing to exploit this transatlantic interest had also started to produce films with British subjects in Britain. *The Prime Minister* might have had a native cast and crew, but the script was written for Warner Brothers in California, albeit by British writers.[37]

The Mudlark had even stronger transatlantic origins. Based on a 1949 novel by American writer Theodore Bonnet, the film was financed by Twentieth Century Fox, whose executives insisted the American actor Irene Dunne play Victoria. The casting of Dunne irritated some British critics, who expressed disdain for the film's 'Anglo-American view of Queen Victoria'.[38] In the *Daily Express* Leonard Mosley claimed its transatlantic provenance meant the movie was 'as deferential and embarrassing as the doffed cap of a new gamekeeper to an old squire'.[39] Despite that, the film was chosen for the Royal Film Performance of 1951. In truth *The Mudlark* was no more obsequious than other drama about Victoria: Mosley's reaction had more to do with sensitivities provoked by Britain's postwar imperial decline and Washington's international dominance. Indeed, in 1975 the *Observer* deemed Dunne's 'bland' Queen to be 'the definitive Victoria'.[40]

Later productions were also 'Americanised' to varying degrees. *Mrs. Brown* was produced on a low budget for BBC Scotland, but when Harvey Weinstein of Miramax saw it he bought the US distribution rights. *Victoria and Albert*, like most BBC period dramas, was jointly financed with a US partner. Finally, while Sarah Ferguson (who claimed the movie was all her idea) was credited as a co-producer and the future Baron Fellowes of West Stafford (and *Downton Abbey*) wrote the script, *The Young Victoria* was wholly financed by Hollywood.[41] To some extent therefore, and certainly latterly, it was American interest in Victoria that helped give the Queen such a prominent screen presence.

VICTORIA AND POLITICS: THE EARLY FILMS

Victoria the Great and *Sixty Glorious Years* focused on Victoria *and* Albert, presenting them, according to one critic, as 'a lonely, often bewildered man and woman in unique partnership – doing their best, going resolutely and often painfully on'.[42] Both films depicted Victoria as preoccupied with her subjects' prosperity and security, presenting the Queen, the *Manchester Guardian* believed, as 'an actively beneficent constitutional force'.[43]

It is certainly true that in these films Victoria has a strongly implied political agency. Thus, in *Sixty Glorious Years* England is said to be on the verge of revolution when Victoria becomes Queen and her accession inaugurates a period of stability. Precisely what contribution Victoria made to this transformation is never established. Similarly, reviewing her reign in 1877, a caption refers to the Queen's 'innate sense of ruling', which leads to Disraeli declaring to Victoria:

> [F]or many years now, with untiring energy, with the widest sympathy and with an indomitable sense of duty you have applied yourself to government with greater ardour and greater industry than any of your predecessors. ... You have watched England grow. ... You have seen the worst horrors of poverty disappear ... [and] under your own kindliness has been born a greater kindliness between rich and poor.

The implication is clear: Victoria has had a beneficent effect on these outcomes. Closer inspection (something of course denied the cinema audience), however, reveals that the verbs betray her lack of agency – she 'watched', she 'saw' – and even the origin of the alleged greater 'kindliness' between the classes is obscure.

Victoria is, moreover, the films' central figure: politicians have little more than a variety of walk-on parts. One critic even claimed that in *Victoria the Great*

prime ministers 'succeed one another like patient dogs' and complained of their 'ludicrous inadequacy' as portraits in *Sixty Glorious Years*. As a consequence Gladstone was reduced to 'the man who left Gordon to his fate' and Disraeli boiled down to 'the man who bought the Suez Canal'.[44] Such brevity none the less meant that Wilcox's movies outlined in striking terms the normative role expected of Victoria's prime ministers: to facilitate their monarch's wishes, wishes dictated purely by her love for her people.

Most notably, *Victoria the Great* suggests that in repealing the Corn Laws, which kept the price of grain artificially high, Conservative Prime Minister Robert Peel was merely doing his monarch's work. This is because repeal is instigated immediately after Victoria is shown becoming aware of the people's suffering – through reading *Oliver Twist*. At the precise moment she first appreciates the unfortunate position of her subjects the royal couple are disturbed by a demonstration outside Buckingham Palace, the placards for which establish that the Corn Laws are the main reason for the mob's misery. The film then cuts to a scene in which Albert praises Peel for demonstrating 'true loyalty' to his monarch by putting her people's interests before those of his own party, many of whose members benefited from the high price of corn.[45]

Not all political leaders were presented in such terms. Gladstone, as *The Times* reviewer noted, was 'unkindly treated' in *Sixty Glorious Years*, which had the great Liberal as, in the words of the *Manchester Guardian* critic, a 'shifty, dilatory politician', castigated by a righteous Victoria for failing to pay heed to her demand that troops be immediately sent to save the besieged Gordon.[46] If Gladstone was merely late in acting on his monarch's wishes, Lord Palmerston is shown actively opposing them in *Victoria the Great*. The royal couple are unhappy with Palmerston's reckless, warlike attitude towards the United States. Only Albert's intervention saves the day. In *Sixty Glorious Years* Palmerston is again shown promoting conflict, this time with Russia, conflict the royal pair believe unnecessary. In this instance the Foreign Secretary prevails – but the wisdom of their counsel is confirmed when the Crimean War proves to be a pointless waste of life. This senseless sacrifice provokes the Queen to tears when she visits wounded soldiers, showing even her most sceptical subjects that she truly cares for them.

All these early films focus on Victoria's relationship with Disraeli as critical to the fate of the country. Reflecting his 'special place in the Imperial portrait gallery', Disraeli was a figure the interwar cinema portrayed in numerous positive ways.[47] *Victoria the Great* unusually shows him opposing the repeal

of the Corn Laws. But the film explains this away when an avuncular Peel notes his 'youth': he was in fact forty-two at the time, but the movie makes him look much younger. In any case, at its climax Disraeli makes Victoria Empress of India. Furthermore in *Sixty Glorious Years* Disraeli and monarch are in complete agreement over Suez. His youthful indiscretion apart, therefore, audiences are meant to think well of the mature Disraeli, but only because he has seen the error of his ways and is articulating the monarch's imperialist agenda.

The Prime Minister even suggests monarch and Prime Minister formed part of a unique political marriage. It has Disraeli watch Lord Melbourne inform the young Victoria that she has become Queen and hear her vow to bring peace and prosperity to all her people, which inspires him to enter politics and 'work for England'. On the death of Disraeli's wife, Victoria dissuades the despairing widower from resigning and encourages him to stand up to Russia and Germany. Indeed she is complicit in Disraeli's secret – and highly unconstitutional – sidestepping of his appeasing Cabinet to ensure Britain emerges out of the 1876 Balkan crisis at peace – but also with honour. Putting a seal on this relationship the film concludes with both on the balcony of Buckingham Palace, waving to crowds singing the national anthem in joy at his diplomatic success, one which – again – saves the Empire.

Victoria's relationship with Disraeli was made to fit the different postwar 'consensus', one built around greater concern for the people's social and economic welfare.[48] Thus, 1950 saw in *The Mudlark* the emergence of a Disraeli who talked only of reforms to improve the condition of Victoria's 'poorest and weakest' subjects. Disraeli, however, needs the Queen to show her support for his programme by resuming her public duties. While Victoria is enthusiastic for reform she is still mourning Albert and afraid of how her people will receive her. When a poor orphan breaks into Windsor Castle he convinces her that the people still love her – in his case like a mother. The film ends with the Queen casting off her widow's weeds and enabling Disraeli's ambitious – if exceptionally hazy – legislation to sail through the Commons.

VICTORIA AND POLITICS: THE LATER FILMS

Even while Wilcox's films praise Victoria's 'innate sense of ruling' they show politics intruding, painfully, into her private life. Both depict Albert's mortification

at the hands of disrespectful MPs when he attends a Commons debate on the repeal of the Corn Laws so he may become informed about the issue and help his wife be a better Queen. The MPs none the less demand he leaves the gallery, humiliating Albert and upsetting Victoria in the process. Indeed, it is even suggested that Palmerston's desire for war with the United States ultimately kills Albert, forcing him to expend his failing energies drafting a telegram to Lincoln that will help avoid war. Otherwise politics – as articulated through Victoria's relationship with Disraeli – is presented in predominantly positive terms in all the early Victoria films. This perspective is sustained on the small screen in the four-part biographical serial *Disraeli* (ITV, 1975) and the 'Dizzy' episode in the historical drama series *Number 10* (ITV, 1982), both of which reproduce the familiar picture of two figures enjoying a genuine rapport and sharing the same desire for imperial expansion and domestic reform.

In 1997 *Mrs. Brown* – produced in the era of 'Tory sleaze' and of political 'spin' – breaks that mould.[49] It transforms Victoria's relationship with the Conservative Prime Minister; and critics rightly saw Anthony Sher's Disraeli – in contrast to the idealistic John Gielgud in *The Prime Minister* or the benevolent Alec Guinness in *The Mudlark* – as 'beady-eyed, silken-tongued', 'cunning and supercilious'.[50] With no mention of Suez, or legislation to improve the condition of the people, the film instead shows Disraeli cynically appreciating the political value of associating himself with monarchical tradition. But, given the secluded Victoria's unpopularity, he is unprincipled enough to wonder 'do we need her?', determining to 'see which way the wind blows'. It is only when his government comes under pressure from the Liberals that Disraeli finally decides that 'it's time to wheel her out' and travels to Balmoral to persuade Victoria to end her isolation. His motives are, however, purely selfish and he seeks to emotionally manipulate Victoria for his own ends.

Mrs. Brown therefore marks a significant shift in representations of Victoria's relationship with her prime ministers. The 2001 made-for-TV film *Victoria and Albert* and the 2009 feature *The Young Victoria* continue this process by focusing on the early part of the Queen's life, evoking parallels with the fate of Princess Diana, who died the week *Mrs. Brown* was released. Victoria is consequently shown, as Graham King, the executive responsible for *The Young Victoria*, put it, as a 'feisty, passionate young woman ... an amazing, dynamic, romantic personality'.[51] She is, moreover, like Diana was supposed to be, surrounded by older men – kings, prime ministers, advisers – who want to control her life, and that of the callow Albert.

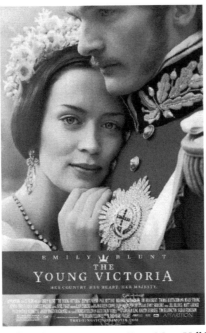

6 A poster for *The Young Victoria* (Jean-Marc Vallée, 2009).

If the older Victoria's relationship with Disraeli is recast in *Mrs. Brown* these two dramas transform the young Victoria's relationship with Lord Melbourne. An avuncular figure in earlier films, as well as the series *Edward the Seventh* (ITV, 1975), which all show him guiding the inexperienced Queen in the ways of ruling before making way for Albert, *Victoria and Albert* suggests he exploited Victoria's dependence on his experience so he could remain Prime Minister. *Young Victoria* even presents Melbourne as discouraging the Queen's desire to improve her people's lot. Thus, while she refers to 'the suffering that needs my help', he says 'we must reform when we can', a formula designed to leave things as they are. When Victoria and Albert marry it is a partnership intent on reform. As Albert asks, 'There are people who are lost, and whose business is it to see to their welfare?' Not the politicians, it seems.

These later dramas are, however, no more specific than were the early ones in regard to Victoria's agency. Thus, at the end of *The Young Victoria* a caption has it that: 'Among their accomplishments, Victoria and Albert championed reforms in education, welfare and industry.' To what purpose and to which effects, the audience is never told.

CONCLUSION

Filmmakers have crafted their respective 'Queen Victorias' to match what they presumed audiences wanted to see so that they could, to be crude, make money. That meant they gave them what they presented as insights into Victoria's private life: the 1938 *Sixty Glorious Years* announced that it was 'an intimate diary of Queen Victoria and her beloved Consort'. This not only satisfied many people's desire to gain a glimpse into the lifestyle of one of British history's rich and famous. It also gave them what the Hollywood producer Darryl F. Zanuck called a 'rooting interest'.[52] It was hard for most to identify with 'Her Majesty Victoria, by the Grace of God, of the United Kingdom of Great Britain and Ireland Queen, Defender of the Faith, Empress of India', to give Victoria her full title. But many undoubtedly saw echoes of their own lives in her devotion to Albert and love for their children. As its star, Emily Blunt, said of *The Young Victoria*, it was 'a very intimate portrait of a girl, rather than a Queen', continuing:

> I don't know what it's like to be the Queen of England. Hardly anyone does. But, at the end of the day, there's a human side to everyone. She was a young girl who was in love for the first time, in a job where she felt completely intimidated and over her head, and a lot of people can relate to that. A lot of people remember what it's like to be in love for the first time.[53]

This of course eviscerated the many differences – of wealth, status and class – that separated the real monarch from her actual people, and associated the monarchy with a marital fidelity to which not every modern British monarch has adhered.[54] Ideological and historical distortions of the reality of monarchy they undoubtedly were but, dramatically and commercially, the films tended to work.

In regard to the politics of the monarchy these films demonstrate a remarkable continuity. Since 1937 Victoria has been shown exhibiting a maternal preoccupation with her people's welfare. How she manifested this concern has always been left vague: it is never clear what she does with those red boxes she is shown opening and closing. Even so her beneficent impact on her people's lives is, according to these movies, not to be doubted. This continuity contrasts with how they present Victoria's ministers. In the early dramas a politician's worth was measured by the extent to which they followed the Queen's wish to safeguard her people's interests. Disraeli's uniquely positive depictions were due to his purported identification with that aim. In more recent films, however, the political class has undergone a transformation, one that better accords with the

prejudices of the times in which they were produced. They are consequently shown to be interested only in maintaining their own hold on power.

Victoria remains the same caring, selfless figure, one all the more admirable as the statesmen around her are diminished. By the beginning of the twenty-first century, the people's only hope of salvation is shown to ultimately lie in her hands. For if their politicians cannot be trusted the people lack the agency necessary to act on their own behalf. Ordinary Britons – apart from servants attending to Victoria in her various palaces – are either absent or seen in long shot, reduced to faceless, cheering crowds. If this is a democracy, it is one in which the people are infantilised.

In these films, Victoria's ministers are all men, at least one detail that reflects historical reality. If that is a necessary constant, there is an intriguing shift in how they render their gender politics. In Wilcox's dramas, Albert's male rationality tames Victoria's female emotionalism and he eventually enjoys predominance in the relationship. Indeed, the *Daily Express* critic claimed of *Victoria the Great*, that 'Albert really is the film'.[55] After her Consort's death it is very much as Albert's Victoria that the Queen continues her reign. This remained the narrative as late as the 1975 television series *Edward the Seventh* (ATV). In the later films, and reflecting changed assumptions about relations between the sexes, the Queen is, however, cannier and more of an equal in what is presented as – in the case of *The Young Victoria* – 'a very modern marriage'.[56] This progressive couple is nonetheless now ranged against untrustworthy, self-interested men who want to tell them what to do, just as modern-day politicians are popularly imagined.

Screenwriters like to present Victoria and her successors as the heart of a heartless political world, the only figures within the constitution wanting to put the people's interests first – unlike the politicians, those whom the people elected to do that job. In the case of films about Victoria discussed here, all of which were written by men, they addressed what were presumed to be the preferences of a largely female audience. Period dramas have historically been disproportionately popular with women: surveys of those watching various 1970s BBC series set in the past and a recent study of audiences for historically themed movies suggest as much.[57] It was certainly assumed that the films discussed here had a special feminine appeal: as one popular critic claimed, *Victoria the Great* was so fine, 'no woman – or her escort – dare admit she has not seen it'.[58] That the three most represented British screen monarchs are women – and the next two are men whose lives are popularly associated with affairs of the

heart as much as of state – suggests a certain bias (see Table 1). In promoting the position of female royal protagonists, presented as seeking private happiness but often thwarted in their endeavours by powerful male political figures, these film histories evoke, and so reinforce, a female distance from contemporary electoral politics, while at the same time offering very rare representations of a powerful British woman. For even after all adult women gained the vote in 1928, the British parliament remained a male domain: it wasn't until 1997 that women formed more than 10 per cent of the House of Commons.[59] The continued predominance of men at Westminster is one reason given for women's continued low participation in, ignorance about and antagonism to formal politics.[60]

It is, to say the least of it, ironic that the monarchy, that part of the constitution immune to popular sovereignty, is at the start of the twenty-first century represented in the terms outlined in this chapter. To those with an interest in the health of Britain's democracy such tales, which entertainingly encourage audiences to disparage representative democracy and admire the hereditary principle, might be thought worrying, for they have profoundly anti-democratic implications. In these fantastic narratives Victoria is the only figure who truly wishes to put British people's interests first. Perhaps it is time for students of British politics investigating the current 'crisis of politics' to start asking why that is.

NOTES

1 See, for example, Hazel Blears, 'Reinvigorating communities: the role of active citizenship in building a better neighbourhood', Lecture, 25 November 2008, Smith Institute, London, p. 6.
2 See Jeff Smith, *The Presidents We Imagine* (Madison: University of Wisconsin Press, 2009).
3 See, for example, Trevor Parry-Giles and Shawn J. Parry-Giles, *The Prime-Time Presidency. The West Wing and U.S. Nationalism* (Urbana: University of Illinois Press, 2006).
4 On the concept of 'presidentialisation', see Richard Heffernan and Paul Webb, 'The British Prime Minister', in Thomas Poguntke and Paul Webb (eds), *The Presidentialization of Politics: A Comparative Study of Modern Democracies* (Oxford: Oxford University Press, 2005).
5 Vernon Bogdanor, 'The *Guardian* has got it wrong', *Guardian* (6 December 2000), www.theguardian.com/uk/dec/06/monarchy.comment8.
6 Ian Budge, Ivor Crew, David McKay and Ken Newton, *The New British Politics* (Harlow: Longman, 2001), pp. 188–90, and Dennis Kavanagh, David Richards, Martin Smith and Andrew Geddes, *British Politics* (Oxford: Oxford University Press, 2006).

7 Bonnie Gardiner, 'The monarchy vs government', *YouGov UK* (15 June 2012) http://
 yougov.co.uk/news/2012/06/15/monarchy-vs-government/.

8 See, for example, Antony Taylor, *'Down with the Crown'. British Anti-Monarchism and
 Debates about Royalty since 1790* (London: Reaktion, 1999), p. 212.

9 *Official Website of the British Monarchy*, www.royal.gov.uk/monarchuk/howthemon-
 archyworks/howthemonarchyworks.aspx.

10 On the politics of ceremonials in general see Eric Hobsbawm, 'Introduction: invent-
 ing traditions', in Eric Hobsbawm and Terence Ranger (eds), *The Invention of Tradition*
 (Cambridge: Cambridge University Press, 1983); and Steven Lukes, 'Political ritual
 and social integration', in *Essays in Social Theory* (London: Macmillan, 1977).

11 Tom Nairn, *The Enchanted Glass. Britain and its Monarchy* (London: Radius/
 Hutchinson, 1988), pp. 9–10.

12 Joseph S. Nye, *Soft Power. The Means to Success in World Politics* (New York: PublicAffairs,
 2004), pp. 5–11.

13 David Cannadine, 'The context, performance and meaning of ritual: the British
 monarchy and the "invention of tradition", *c.* 1820–1977', in Hobsbawm and Ranger
 (eds), *Tradition*.

14 Margaret R. Somers, 'The privatization of citizenship', in Victoria E. Bonnell and
 Lynn Hunt (eds), *Beyond the Cultural Turn* (Berkeley: University of California Press,
 1999), p. 125.

15 Murray Edelman, *From Art to Politics* (Chicago: University of Chicago Press, 1995),
 pp. 2–7.

16 R. L. Holbert, O. Pillion, D. A. Tschida, G. G. Armfield, K. Kinder, K. Cherry and
 A. Daulton, *'The West Wing* as endorsement of the American presidency: expanding
 the domain of priming in political communication', *Journal of Communication* 53:3
 (2003). For a survey of this evidence as a whole, see Steven Fielding, 'New Labour,
 "sleaze" and television drama', *British Journal of Politics and International Relations*
 16:2 (2014).

17 Gene Healy, *The Cult of the Presidency* (Washington, DC: Cato Institute, 2008),
 pp. 76–7, 276–8.

18 Smith, *Presidents We Imagine*, p. 9.

19 See Marcia Landy, *British Genres. Cinema and Society, 1930–1960* (Princeton,
 NJ: Princeton University Press, 1991), pp. 53–86.

20 Michel Foucault, 'Film and popular memory', *Radical Philosophy* 11 (Summer
 1975), p. 28.

21 Andrew Butler, Franklin M. Zaromb, Keith B. Lyle and Henry L. Roediger III, 'Using
 popular films to enhance class room learning', *Psychological Science* 20:9 (2009).

22 Marita Sturken, *Tangled Memories: The Vietnam War, the AIDS Epidemic, and the Politics
 of Remembering* (Berkeley: University of California Press, 1997), pp. 6, 20.

23 Foucault, 'Film and popular memory', p. 28; Pierre Sorlin, *The Film in History*
 (Oxford: Oxford University Press, 1980), p. 80.

24 George Arliss, *My Ten Years in the Studios* (Boston: Little, Brown, 1940), pp. 155, 204,
 223, 275.

25 James Chapman, *Past and Present. National Identity and the British Historical Film* (London: I.B.Tauris, 2005), pp. 7–8.

26 Taylor, *'Down with the Crown'*, p. 13.

27 Steven Fielding, *A State of Play. British Politics on the Screen, Stage and Page, from Anthony Trollope to 'The Thick of It'* (London: Bloomsbury, 2014).

28 *Daily Telegraph Magazine* (31 January 2009).

29 For the concept of the 'mobilisation of bias', see Steven Lukes, *Power. A Radical View* (London: Palgrave, 2005), pp. 1–13.

30 'Queen Victoria's Torchwood', *The Doctor Who Site*, www.thedoctorwhosite.co.uk/torchwood/themes/Queen-victoria-torchwood/.

31 Herbert Wilcox, *Twenty-Five Thousand Sunsets* (London: The Bodley Head, 1967), p. 111.

32 Jeffery Richards and Dorothy Sheridan (eds), *Mass-Observation at the Movies* (London: Routledge & Kegan Paul, 1987), p. 39.

33 John Sedgwick, 'Cinema-going preferences in Britain in the 1930s', in Jeffrey Richards (ed.), *The Unknown 1930s. An Alternative History of the British Cinema, 1929–1939* (London: I.B.Tauris, 1998), pp. 30 and 34; J. Poole, 'British cinema attendance in wartime: audience preference at the Majestic, Macclesfield, 1939–1946', *Historical Journal of Film, Radio and Television* 7:1 (1987), pp. 18 and 21–2.

34 *Daily Mirror* (17 September 1937).

35 Elisa Tamarkin, *Anglophilia: Deference, Devotion, and Antebellum America* (Chicago: University of Chicago Press, 2008), pp. 87–177; Andrew Campbell, *Unlikely Allies. Britain, America and the Victorian Origins of the Special Relationship* (London: Hambledon Continuum, 2007), p. 240.

36 *The Times* (17 October 1937).

37 Jeffery Richards, *Thorold Dickinson. The Man and His Films* (London: Croom Helm, 1986), p. 88. More generally, see H. Mark Glancy, *When Hollywood Loved Britain: The Hollywood British Film* (Manchester: Manchester University Press, 1999).

38 *The Times* (31 October 1950).

39 *Daily Express* (31 October 1950).

40 *Observer* (13 April 1975).

41 *Daily Telegraph Magazine* (31 January 2009).

42 *Observer* (19 September 1937).

43 *Manchester Guardian* (20 October 1938).

44 *New Statesman* (25 August 1937 and 2 October 1938).

45 This might also have been a subtle endorsement of Ramsay MacDonald, who, in the face of economic difficulties, broke with the Labour Party to form a National Government in 1931, a coalition some contemporaries believed George V had engineered: see Herbert Morrison, *Government and Parliament. A Survey from the Inside* (Oxford: Oxford University Press, 1959), pp. 77–80.

46 *The Times* (17 September 1937); *Manchester Guardian* (20 October 1938).

47 Jeffery Richards, *Visions of Yesterday* (London: Routledge & Kegan Paul, 1973), p. 142. For more on Disraeli, see Steven Fielding, 'British politics and cinema's historical dramas, 1929–38', *Historical Journal* 56:2 (2013).

48 For the most influential view of the postwar 'consensus', see Paul Addison, *The Road to 1945* (London: Quartet, 1977).

49 For more on that context, see Fielding, 'New Labour'.

50 *Guardian* (5 September 1997); *Daily Telegraph* (5 September 1997).

51 *The Times* (22 March 2007).

52 George F. Custen, *Bio/Pics. How Hollywood Constructed Public History* (New Brunswick: Rutgers University Press, 1992), p. 18.

53 Sara Wayland, 'Emily Blunt interview, *The Young Victoria*', *Collider* (16 December 2009), http://collider.com/emily-blunt-interview-the-young-victoria/.

54 Taylor, *'Down with the Crown'*, p. 225.

55 *Daily Express* (17 September 1937).

56 *Daily Mail Weekend Magazine* (28 February 2009).

57 BBC Written Archives, Reading, Audience Research Reports for *Nicholas Nickelby*, VR/77/246, *The Onedin Line*, VR/77/477 and *Marie Curie*, VR/77/505; Claire Monks, *Heritage Film Audiences* (Edinburgh: Edinburgh University Press, 2012), ch. 3.

58 *Daily Mirror* (17 September 1937).

59 Library of the House of Commons, London, SN/SG/1250, 'Women in Parliament and Government', January 2012.

60 Cathy Newman, ' "British women know less about politics than men" – but why?', *Telegraph* (3 July 2013), www.telegraph.co.uk/women/womens-politics/10154822/British-women-know-less-about-politics-than-men-but-why.html.

BIBLIOGRAPHY

Addison, Paul, *The Road to 1945* (London: Quartet, 1977).

Arliss, George, *My Ten Years in the Studios* (Boston: Little, Brown, 1940).

Blears, Hazel, 'Reinvigorating communities: the role of active citizenship in building a better neighbourhood', Lecture, 25 November 2008, Smith Institute, London.

Bogdanor, Vernon, 'The *Guardian* has got it wrong', *Guardian* (6 December 2000), www.theguardian.com/uk/2000/dec/06/monarchy.comment8.

Budge, Ian, Ivor Crew, David McKay and Ken Newton, *The New British Politics* (Harlow: Longman, 2001).

Butler, Andrew, Franklin M. Zaromb, Keith B. Lyle and Henry L. Roediger III, 'Using popular films to enhance class room learning', *Psychological Science* 20:9 (2009).

Campbell, Andrew, *Unlikely Allies. Britain, America and the Victorian Origins of the Special Relationship* (London: Hambledon Continuum, 2007).

Cannadine, David, 'The context, performance and meaning of ritual: the British monarchy and the "invention of tradition", *c.* 1820–1977', in Eric Hobsbawm and Terence Ranger (eds), *The Invention of Tradition* (Cambridge: Cambridge University Press, 1983).

Chapman, James, *Past and Present. National Identity and the British Historical Film* (London: I.B.Tauris, 2005).

Custen, George F., *Bio/Pics. How Hollywood Constructed Public History* (New Brunswick: Rutgers University Press, 1992).

Edelman, Murray, *From Art to Politics* (Chicago: University of Chicago Press, 1995).

Fielding, Steven, 'British politics and cinema's historical dramas, 1929–38', *Historical Journal* 56:2 (2013).

———'New Labour, "sleaze" and television drama', *British Journal of Politics and International Relations* 16:2 (2014).

———*A State of Play. British Politics on the Screen, Stage and Page, from Anthony Trollope to 'The Thick of It'* (London: Bloomsbury, 2014).

Foucault, Michel, 'Film and popular memory', *Radical Philosophy* 11 (Summer 1975).

Gardiner, Bonnie, 'The monarchy vs government', *YouGov UK* (15 June 2012).

Glancy, H. Mark, *When Hollywood Loved Britain: The Hollywood British Film* (Manchester: Manchester University Press, 1999).

Healy, Gene, *The Cult of the Presidency* (Washington, DC: Cato Institute, 2008).

Heffernan, Richard and Paul Webb, 'The British Prime Minister', in Thomas Poguntke and Paul Webb (eds), *The Presidentialization of Politics: A Comparative Study of Modern Democracies* (Oxford: Oxford University Press, 2005).

Hobsbawm, Eric, 'Introduction: inventing traditions', in Eric Hobsbawm and Terence Ranger (eds), *The Invention of Tradition* (Cambridge: Cambridge University Press, 1983).

Holbert, R. L., O. Pillion, D. A. Tschida, G. G. Armfield, K. Kinder, K. Cherry and A. Daulton. '*The West Wing* as endorsement of the American presidency: expanding the domain of priming in political communication', *Journal of Communication* 53:3 (2003).

Kavanagh, Dennis, David Richards, Martin Smith and Andrew Geddes, *British Politics* (Oxford: Oxford University Press, 2006).

Landy, Marcia, *British Genres. Cinema and Society, 1930–1960* (Princeton, NJ: Princeton University Press, 1991).

Lukes, Steven, 'Political ritual and social integration', in *Essays in Social Theory* (London: MacMillan, 1977).

———*Power. A Radical View* (London: Palgrave, 2005).

Monks, Claire, *Heritage Film Audiences* (Edinburgh: Edinburgh University Press, 2012).

Morrison, Herbert, *Government and Parliament. A Survey from the Inside* (Oxford: Oxford University Press, 1959).

Nairn, Tom, *The Enchanted Glass. Britain and its Monarchy* (London: Radius/Hutchinson, 1988).

Newman, Cathy, ' "British women know less about politics than men" – but why?', *Telegraph* (3 July 2013), www.telegraph.co.uk/women/womens-politics/10154822/British-women-know-less-about-politics-than-men-but-why.html.

Nye, Joseph S., *Soft Power. The Means to Success in World Politics* (New York: PublicAffairs, 2004).

Official Website of the British Monarchy, www.royal.gov.uk/monarchuk/howthemonarchyworks/howthemonarchyworks.aspx.

Parry-Giles, Trevor and Shawn J. Parry-Giles, *The Prime-Time Presidency. The West Wing and U.S. Nationalism* (Urbana: University of Illinois Press, 2006).

Poole, J., 'British cinema attendance in wartime: audience preference at the Majestic, Macclesfield, 1939–1946', *Historical Journal of Film, Radio and Television* 7:1 (1987).

'Queen Victoria's Torchwood', *The Doctor Who Site*, www.thedoctorwhosite.co.uk/torchwood/themes/Queen-victoria-torchwood/.

Richards, Jeffrey, *Visions of Yesterday* (London: Routledge & Kegan Paul, 1973).

———*Thorold Dickinson. The Man and His Films* (London: Croom Helm, 1986).

Richards, Jeffrey and Dorothy Sheridan (eds), *Mass-Observation at the Movies* (London: Routledge & Kegan Paul, 1987).

Sedgwick, John, 'Cinema-going preferences in Britain in the 1930s', in Richards, Jeffrey (ed.), *The Unknown 1930s. An Alternative History of the British Cinema, 1929–1939* (London: I.B.Tauris, 1998).

Smith, Jeff, *The Presidents We Imagine* (Madison: University of Wisconsin Press, 2009).

Somers, Margaret R., 'The privatization of citizenship', in Victoria E. Bonnell and Lynn Hunt (eds), *Beyond the Cultural Turn* (Berkeley: University of California Press, 1999).

Sorlin, Pierre, *The Film in History* (Oxford: Oxford University Press, 1980).

Sturken, Marita, *Tangled Memories: The Vietnam War, the AIDS Epidemic, and the Politics of Remembering* (Berkeley: University of California Press, 1997).

Tamarkin, Elis, *Anglophilia: Deference, Devotion, and Antebellum America* (Chicago: University of Chicago Press, 2008).

Taylor, Antony, *'Down with the Crown'. British Anti-Monarchism and Debates about Royalty since 1790* (London: Reaktion, 1999).

Wayland, Sara, 'Emily Blunt interview, *The Young Victoria* ', *Collider* (16 December 2009), http://collider.com/emily-blunt-interview-the-young-victoria/.

Wilcox, Herbert, *Twenty-Five Thousand Sunsets* (London: The Bodley Head, 1967).

4

Walbrook's royal waltzes

James Downs

On Monday 15 February 1937 *The Times* announced that 'a Viennese actor' had been secured to play the part of Prince Albert in a forthcoming film about Queen Victoria.[1] Over the following months the British public learned a great deal more about Anton Walbrook through press conferences, newspaper interviews, magazine features and screenings of films he had made on the continent as Adolf Wohlbrück. Publicity for the film was aided by the serendipitous timing of George VI's coronation, which provided a further, contemporary, layer of comparisons between real events and their cinematic representation. Adolf Anton Wilhelm Wohlbrück, as *The Times* rightly noted, was born in Vienna on 19 November 1896, but most of his life had been spent in German cities such as Berlin, Dresden and Munich. In several respects his life would mirror that of the Prince Consort, with continual ambiguities about national identity, loyalty and belonging. As the star of both German and English depictions of the Victorian court, his career offers a unique double perspective on the representation of the British monarchy.

Although his father Adolf Wohlbrück (1864–1940) was a clown, a family tradition of acting stretched back for several generations. Almost incredibly, young Adolf grew up unaware of his distinguished ancestors, as his father had joined the circus as a child after the death of both parents. The future actor was educated in Vienna and Berlin, where he left the Gymnasium at the age of fifteen to enter Max Reinhardt's theatre school next door to the Deutsches Theater. Once the drama students proved their abilities, they were given minor roles in productions at either the Deutsches Theater or the smaller, more intimate Kammerspiele. Fittingly, the British monarchy provided the setting for his first stage role – as a young page-boy in Friedrich Schiller's *Mary Stuart*. A few years

later he played the part of Mortimer in the same play in Munich, with Hermine Körner playing Elizabeth I.[2] Mortimer – a creation of Schiller's rather than a real historical figure – is a passionate young admirer of the Scottish queen who conspires to free her from prison, but commits suicide when his love proves unrequited and the escape plan is foiled. Schiller's portrayal of the Queen as a tragic heroine, driven by passion and opposed by cold-reasoning foes, rehearsed the tension between private feeling and public office that would feature in *Victoria the Great*.

Wohlbrück's acting career, however, was interrupted by the First World War. He saw action on both the eastern and western fronts before being captured in 1917. He spent the rest of the war in a POW camp in France where he whiled away the time organising dramatic performances. The productions were ambitious and included works by Rilke and Strindberg, as well as a performance of Georg Büchner's satirical comedy *Leonce und Lena* with Wohlbrück reading the text while a fellow soldier operated puppets.

After the war, he returned to the stage and soon become a leading player in theatre companies in Munich (1920–26), Dresden (1927–30) and Berlin (1930–35). His technique owed an enormous debt to his early formation under Max Reinhardt's direction and the accomplished actors and actresses with whom he worked as a youth. He later said that Hermine Körner taught him 'what a lift of the eyebrow or a turn of the wrist could mean on stage'.[3] As an actor, he became a master of subtle gestures: viewers of his films will often be rewarded for keeping their eyes on his hands, and the 'Victoria' films are no exception.

Wohlbrück first appeared on the screen in 1915, and had minor roles in three more silent films before starring opposite Anna Sten in *Salto Mortale* (E. A. Dupont, 1931), a romantic thriller set in a circus. Over the next few years he appeared in some twenty films, mainly romantic comedies and musicals, establishing his reputation as a player of suave, sophisticated heroes. He had not abandoned the theatre, either, and by the mid-1930s he had appeared in over 200 productions. These included several adaptations of English-language works, such as Oscar Wilde's *The Ideal Husband* and *The Importance of Being Earnest*, Shakespeare's *Twelfth Night*, *As You Like It*, *Midsummer Night's Dream* and *King Lear*, as well as George Bernard Shaw's *Candida*. In another play about the British monarchy he played the part of Essex in Ferdinand Bruckner's *Elisabeth von England*.

He already had a sound knowledge of English literature and drama, plus extensive experience of performing the role of the English gentleman, before

his first screen encounter, so to speak, with the British monarchy, the 1933 musical comedy *Walzerkrieg* (Ludwig Berger). This light-hearted film is based upon several real-life incidents in the life of Johann Strauss the Elder, centring on his visit to England and the court of Queen Victoria in 1838 – an event referred to in *Victoria the Great*. The film's comedy relies on a series of misunderstandings. Firstly, Victoria's court ball director is sent to Vienna to learn about the new waltz, witnesses a drunken brawl involving orchestra and dancers and presumes this riotous behaviour to be part of the dance. This uproar is a consequence of the intense rivalry between Strauss and fellow waltz composer Joseph Lanner, who led his own orchestra in Vienna. When Lanner demonstrates the waltz with his daughter Katti in the presence of Victoria, they have a heated discussion and the young Queen mistakes their gestures for dance steps. When she later replicates these at a court ball, the rest of the dancers feel obliged to follow suit. No attempt was made at historical authenticity in the appearance of the royal couple: slim, fair-haired Hanna Waag plays the Queen, while Heinz Max von Cleve plays Prince Albert without moustache. Wohlbrück, on the other hand, was persuaded to grow one for the part of Strauss.

Moustaches provide a source of comedy when a drummer tries to impersonate Strauss with a fake moustache dyed black, which then smudges the Queen's glove when he kisses her hand. The composer later bursts in and confronts his doppelganger – an amusing version of a more sinister image Wohlbrück would explore in *Der Student von Prag* (*The Student of Prague*, Artur Robison, 1935). Underlying these farcical scenes there runs a current of gentle mockery of the British, who are portrayed as being as pompous and rigid as they are gullible.

These same characteristics recur in another Wohlbrück comedy, *Die englische Heirat* (*The English Marriage*, Reinhold Schünzel, 1934), in which he was again paired with Renate Müller. Here, he plays an English lawyer, Warwick Brent, who is drawn into a series of misunderstandings caused by a secret marriage. The scenes of English society life depicted in the film appear to date from long before the 1930s. The women dress in elaborate costumes laden with pearls and carry oversize fans; at their centre is the matriarchal figure of Lady Mavis, whose appearance seems modelled on that of Queen Victoria. The men are portrayed as weak and foolish, dominated by the women, and overawed at the sight of Müller's stylish car as it sweeps up the driveway bringing German modernity into the ancient mansions of England. Later on she rescues Lady Mavis from a road accident with a hay wain, driven by a peasant whose costume might have been lifted from a Constable painting.

Müller and Wohlbrück co-starred in four films, the last one being the sparkling comedy *Allotria* (Willi Forst, 1936) with Jenny Jugo and Heinz Rühmann. While they were filming this in February 1936, *Mädchenjahre einer Königin* (*Girlhood of a Queen*, Erich Engel) was released, starring Jugo as the young Victoria. In addition to comic scenes, such as the tiny queen struggling to lift a sword in order to knight Lord Aberdeen, there are imaginative embellishments to the familiar story of the royal courtship: while away from the palace, Victoria meets a charming young man at Dover with whom she falls in love, only to discover – by an extraordinary coincidence – that he is in fact her cousin Prince Albert, who has been sent against his will and (like her) resents the machinations of their respective families. This sympathetic portrayal of Victoria is perhaps due in part to the fact that its Jewish playwright, Geza Silberer, lived in London in the early 1900s and had a warm appreciation of English personalities and history.[4] The actor who played Prince Albert, Frederick Benfer, actually married Jenny Jugo a few years after the war.

At the time *Mädchenjahre einer Königin* was showing on German screens, rumours were already starting to circulate among cinemagoers about Wohlbrück's departure from Germany.[5] As a homosexual and a *Mischling*, or half-Jew, he was in a dangerous position and it remains unclear as to why he did not leave sooner. The Nazification of the film industry began immediately after Hitler came to power. Anyone working in the industry was required to hold membership of the Reichsfachschaft Film (RFF), which could only be obtained after completing detailed questionnaires about racial descent. The Nazi authorities seemed doubtful about the Jewish-looking surnames 'Lewien' and 'Kohn' on his mother's side, and pressed Wohlbrück for further documentary evidence of his Aryan credentials. This investigation lasted for over a year.[6]

However, he continued to work, and by late 1935 had completed the filming of *Der Kurier des Zaren* (Richard Eichberg), an adaptation of Jules Verne's swashbuckling adventure *Michel Strogoff* in which he played the eponymous hero, wrestling with bears and fighting off Tatars as he galloped across Siberia with a vital message for the Russian Tsar. A French-language version was also made, and when RKO offered Wohlbrück a contract to come to Hollywood and make an English version, he saw an opportunity to leave Nazi Germany behind. He slipped out of Berlin just as the Olympic Games began in August 1936, and sailed for America in the early autumn, arriving in Hollywood in October. Here, he changed his name to Anton Walbrook.

On 3 December 1936, while Walbrook was filming *Michael Strogoff* in Hollywood, the following notification appeared in the British press:

> The Lord Chamberlain is authorised to announce that, by permission of His Majesty the King, plays dealing with the life of Queen Victoria can now be considered for production after the 20th June 1937, subject to the usual regulations for the licensing of stage plays. This date has been scheduled as being the centenary of Queen Victoria's appointment to the throne.[7]

The initiative for this seems to have come from Victoria and Albert's third son, Prince Arthur, the Duke of Connaught (1850–1942), who spoke to the Lord Chamberlain about the 'inevitable necessity for lifting the ban on plays dealing with the life of Queen Victoria'. Although this ban was a matter of protocol rather than law, as Licenser of Plays the Lord Chamberlain used his power to veto any public representations of the late Queen.[8] Connaught was 'naturally anxious that the impersonation of Queen Victoria should be by a British actress and not by a foreign one'.[9] According to Herbert Wilcox, however, the original impetus came from Wallis Simpson, who had seen Laurence Housman's play *Victoria Regina* in New York and asked Edward VIII why there was no film about his great-grandmother.[10] Within twenty-four hours of the Lord Chamberlain's proclamation no less than three British producers announced their intention to make a film about the life of Victoria: Alexander Korda, Michael Balcon and Herbert Wilcox.

Korda was still basking in the success of his direction of a previous royal biopic, *The Private Life of Henry VIII* (1933), which had provided Charles Laughton with his first Oscar and saved Korda's London Film Company from financial ruin. Although the film's popularity owed much to strong performances and shrewd marketing, Korda had proved that historical dramas could bring in huge box-office returns: this would have significant impact upon the course taken by the British film industry. Simon Callow has argued that much of the credit should go to Laughton, for 'It was he who instigated the passionate quest for authenticity; he who dragged Korda down to Hampton Court again and again. Such texture as the film possesses derives from his research and drive.'[11] Certainly, Korda was unable to replicate the success of *The Private Life of Henry VIII*, and the disappointing returns for *Rembrandt* at the end of 1936 may have made the prospect of another royal project look appealing. In a series of lavish advertisements, Korda boasted that his film on Queen Victoria was already in 'active preparation'.[12] This was a characteristically bold move designed to discourage

competitors such as Michael Balcon, who staked his claim by announcing that MGM-British were adapting Silberer's play *Girlhood of a Queen* and had already secured seventeen-year-old Nova Pilbeam for the role of Queen Victoria.[13] Pilbeam had just appeared as Lady Jane Grey in *Tudor Rose* (1936), directed by Robert Stevenson from a screenplay by Miles Malleson. Stevenson began work on the film as a scenarist, but was promoted by Balcon to the director's chair because of his 'deep-seated respect for accuracy'.[14] For the production of films on the British monarchy, 'authenticity' and 'accuracy' were already recognised as being of critical importance.

Korda's film was never made, but then he was notorious for announcing projects that were little more than aspirations; the trade papers at the time were full of such mirages, so much so that the editor of *Film Weekly* had recently urged him to 'dream in private, not in public.'[15] After Balcon's film fell through because of financial problems at Gaumont-British, the way was clear for Herbert Wilcox to proceed without fear of competition.[16] He may well have enjoyed some advantage because of his relationship with King Edward, as the two men had been on good terms for many years; early in his career, Wilcox had made a short documentary film about the Prince of Wales.

According to Anna Neagle, it was she who drew Wilcox's attention to Walbrook after watching him in *The Student of Prague*, when she was struck by his physical resemblance to Prince Albert.[17] This may be so, but it is almost certain that Wilcox knew about Walbrook, as he had been in Hollywood negotiating a distribution deal with RKO while *Strogoff* was in production. Walbrook was unhappy in Hollywood and as soon as filming was completed in January 1937 he left America, arriving in England on the same day that Anna Neagle's casting as Queen Victoria was announced. When *The Times* announced that he had been given the role of Prince Albert, production of *Victoria the Great* had already begun.

On 11 February Lawrence Williams, the film's art director, wrote to Buckingham Palace seeking photographs or measured drawings of the royal residences of Kensington, Osborne and Balmoral, for the purpose of constructing accurate sets at Denham Studios. The appearance of many of the buildings, both interior and exterior, had changed dramatically since Victoria's reign, and strenuous efforts were made to research and reconstruct these in detail. Thus began a lengthy and convoluted exchange of correspondence with the royal household. Williams visited Windsor Castle, as did Charles de Grandcourt, who had been commissioned to co-write the screenplay with Miles Malleson.

Grandcourt's letter to Norman Gwatkin, Assistant Comptroller at the Lord Chamberlain's Office, reveals much about how Wilcox's team regarded the film. He referred to his

> very considerable efforts ... for over a year in petitioning the authorities to enable this tribute to the Crown to be made by a British company, with British artistes, on the actual sites with which it deals. ... I am speaking not merely of a piece of motion picture entertainment, but of what is potentially the greatest piece of British Empire propaganda that has yet been attempted by the cinema.

Grandcourt proceeded to stress the patriotic appeal of the film, asking for royal co-operation 'to enable this production to be not only an outstanding piece of patriotic entertainment, but an historical record worthy of being revived again and again in the years to come'.[18] He was not alone in his aspiration to historical accuracy. Gwatkin, reporting back on his meeting with Grandcourt in a memo to the Lord Chamberlain (the 2nd Earl of Cromer), shared this concept and believed 'that the film should not only be a commercial enterprise, but should be regarded as a historical representation, accurate in every detail'.[19] The ambition is proclaimed in the film's opening intertitle, which proudly announces: 'Every incident is founded on historic fact, and political utterances by various statesmen are authentic.'

The defensive tone of these claims was tactical. The question of historical accuracy had been debated in the House of Lords in December 1936, a few days after the Lord Chamberlain's announcement. Viscount Mersey proposed a motion calling for 'some form of control over the historical accuracy of films produced or shown in this country'.[20] He criticised Laughton's portrayal of Henry VIII as 'a comic buffoon' in Korda's film, as well as the historical inaccuracies in John Ford's RKO flop, *Mary of Scotland* (1936), which had been released shortly before Walbrook's arrival at the studio. Lord Mersey seems to have been particularly offended by the film's inclusion of an entirely fictitious meeting between Queen Mary (Katherine Hepburn) and Queen Elizabeth (Florence Eldridge), but the same fantasy had been entertained by Schiller in *Mary Stuart*, and the Marquess of Dufferin wisely pointed out that cinema's presentation was little different from the romantic stories passed on by Shakespeare, Scott and Dumas. Lord Mersey withdrew his motion.

Wilcox was already well aware of such sensitivities. He had directed Anna Neagle in two earlier costume dramas, *Nell Gwyn* (1934) and *Peg of Old Drury* (1935),

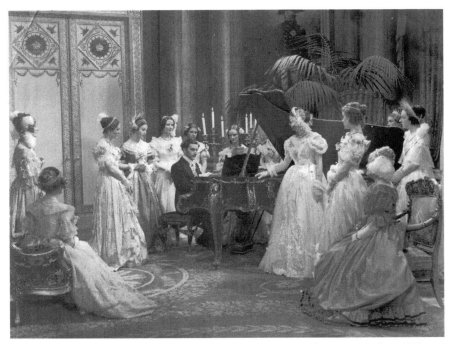

7 Anton Walbrook as Prince Albert at the piano in *Victoria the Great* (Herbert Wilcox, 1937). Copyright © STUDIOCANAL Films Ltd.

and knew the value of historical pretensions for increasing a film's market appeal. Promotional material for *Nell Gwyn* followed the same pattern as the *Victoria* press books, emphasising the time spent on historical research and the care taken to model the sets and costumes on architectural plans and paintings in the National Portrait Gallery.[21] Walbrook's casting can be seen as part of the programme of verisimilitude pursued by Wilcox and his team. Press coverage and promotional materials made constant reference to Walbrook's resemblance to Prince Albert in matters of height, age, appearance and accent. Not all of these claims were true. Albert was probably two inches shorter than Walbrook, who was actually twice as old at the time of filming as Albert was when he met Victoria.[22] British cinemagoers were now getting more familiar with Walbrook's appearance. *Michael Strogoff* had been shown in London since mid-February, fuelling interest in Walbrook and strengthening public perception of him as a romantic hero. Until then, he was known best for his performance in the Viennese comedy *Maskerade* (Willi Forst, 1934), which had proved popular with 'arthouse' audiences.

Films evoking 'old-time Vienna' were very much in vogue at this time. *The Times* had emphasised Walbrook's Viennese origins and there had been a spate of similarly titled films. Lilli Palmer, another émigrée from Nazi Germany who also starred in a Wilcox production – *Sunset in Vienna* (1937) – referred in her autobiography to the popularity of 'Viennese schmaltz':[23] Anna Neagle's first big film was *Goodnight, Vienna* (Herbert Wilcox, 1932), then there was *Reunion in Vienna* (Sidney Franklin, 1933) starring Walbrook's later co-star Diana Wynyard, and even a Hitchcock musical called *Waltzes in Vienna* (1934). Walbrook's films *Walzerkrieg* and *Maskerade* were marketed in English as *Waltz Time in Vienna* and *Masquerade in Vienna* respectively.

Both Walbrook's associations with romantic old Vienna and Neagle's background as a dancer contributed to the prominence given in both films to magnificent ballroom scenes and numerous references to the waltz. In reality, protocol had prohibited Victoria and Albert from dancing the waltz together – their high status, combined with the physical intimacy of the dance, meant that this was considered improper.[24] These were not the only liberties taken with historical details. Prior to their engagement Victoria appears with Albert, showing him photographs of herself and her mother in an album. In October 1839 no photographs of the Queen had ever been taken: the first photographic portrait of a member of the royal family was a daguerreotype of Prince Albert, taken in 1842 by William Constable.

While their representation of photography may have been anachronistic, the designers used genuine photographs to ensure the accuracy of the interior sets for the ballroom scenes. On the first day of filming, Tuesday 13 April 1937, photographs were taken of Grand Reception Room at Windsor Castle. Although Wilcox often claimed that filming was completed in five weeks (i.e. by 18 May 1937), it is clear from press reports that shots were still being taken at the end of the month.[25] According to cameraman Freddie Young, this was a tactic of Wilcox's to fool his bankers that he had finished: ongoing filming was disguised as 'inserts' being added to existing footage.[26] It was unsurprising that production costs were high, given the visual splendour of the coronation scenes that were filmed on 3 May on the vast Stage Four at Denham.

Nine days later, the real coronation of George VI took place, filmed for BBC television by Jack Cardiff, who would later shoot Walbrook in Michael Powell and Emeric Pressburger's *The Life and Death of Colonel Blimp* (1943) and *The Red Shoes* (1948). The occasion was marked by numerous royal documentaries, including Paramount's *Crown and Glory* (director unknown), John Drinkwater's

The King's People and Fred Watts's *House of Windsor*. Coronation week also saw the premiere of *The Prince and the Pauper* (William Keighley) starring Errol Flynn. Audiences were not watching *Victoria the Great* in a vacuum: it was released into a market already awash with royal films.

Victoria the Great premiered on 16 September 1937 at the Leicester Square Theatre, a cinema originally opened in 1930 as a venue for Anna Neagle's former dance partner Jack Buchanan. The first film shown there, appropriately enough, was *Viennese Nights* (Alan Crosland, 1930). Vast crowds besieged the theatre for the premiere, filling the square and blocking the adjacent streets, while inside an audience studded with celebrities and aristocracy watched the film, offering rapturous applause for individual scenes. Afterwards, Walbrook took the stage along with Wilcox and Neagle, using microphones to address the audience. The enthusiasm at the premiere was echoed by both critics and the general cinema-going public. Aided by an energetic publicity campaign that saw Wilcox and Neagle travel to America and Canada, the film proved a huge success at home and abroad. German cinema audiences, however, had to wait until after the war to see *Königin Victoria* on their own screens.[27]

There is no doubt that the film was a triumph – it even won that year's Venice Trophy at the Venice Film Festival – but its weaknesses are more apparent to modern audiences. Conceived and promoted as a 'panorama of the reign of Queen Victoria', the film needed to sacrifice depth in order to achieve the long perspective. Lacking sufficient time to provide a nuanced treatment of complex historical events and social issues, it became in essence a series of short tableaux – an impression underscored by the use of captions to introduce important scenes. Reports of audiences applauding individual scenes indicates that the film was experienced in episodic form. In contrast to these presentations of public office, the private lives of Victoria and Albert provided a much-needed depth of feeling and dynamism.

The success of these scenes depended heavily upon the acting talent of Neagle and Walbrook, but there seems little doubt that the latter's performance was the superior one. As *The Times* critic noted:

> In so uninquisitive a film, there is little room for close inspection of character, and only the Prince Consort is allowed to emerge as a complete human being. Mr. Walbrook makes the most of his opportunity and contributes an original and accomplished study, suggesting a man of real intelligence, capable of detachment and irony.[28]

Intimate scenes between Walbrook and Neagle, such as the royal couple
lying beneath the trees at Windsor or singing together at the piano, provide
a series of domestic vignettes to break up the more formal episodes of state
business. Critic Lionel Collier noted that this portrayal of the couple's private
relationship 'lifts the picture above the purely documentary', adding that 'Anton
Walbrook is brilliant as the Prince Consort. His performance in a large measure
ensures the success of the piece.'[29] The image of Walbrook playing the piano
for his wife would reappear in *Gaslight* (Thorold Dickinson, 1940) and *Dangerous
Moonlight* (Brian Desmond Hurst, 1941), making use of the actor's renowned
musical skill: one British journalist reported that 'Almost as soon as he could
walk he was able to play the piano by ear.'[30] Music plays a significant role in the
film's presentation of Albert's life with Victoria, often providing a medium for
the Prince to communicate powerful feelings that words cannot articulate.[31]
When Victoria insists that Albert play music rather than discuss politics with
Peel, he gets revenge by drawing all the ladies across the room to listen to him
singing at the piano. Likewise in Wilcox's *Sixty Glorious Years* (1938), after argu-
ing with his wife about the appointment of a private secretary, he storms off to
play the organ at full volume. Such scenes ring true to what Albert's biographer
recorded: 'In [music] he found a vent for all that world of deeper emotion, for
which it is given to few to find an adequate expression in words ... to [the organ]
he could speak out his heart, with no fear of being misunderstood.'[32]

Albert faced another obstacle to finding 'adequate expression in words' and
Walbrook's accent throughout the film is a constant reminder of the Prince
Consort's foreign origins. Victoria is shown correcting Albert on his pronunci-
ation of 'waltz', just as Valerie Hobson would chasten Captain Hardt (Conrad
Veidt) for his pronunciation of 'butter' in *The Spy in Black* (Michael Powell,
1939). Such scenes must have resonated with the real experiences of the émi-
gré actors. Walbrook knew only a few words of English when he left Germany,
and kept a dialect coach with him on the set of *Victoria the Great*.[33] Modern
audiences are probably less aware of the strong Germanic strain in Queen
Victoria's ancestry and upbringing: she spoke only German until the age of
three and was surrounded by German-speaking relatives throughout her youth.
While Helen Hayes was preparing for her stage role in *Victoria Regina*, Gilbert
Miller arranged for her to meet the Queen's granddaughter, the Marchioness of
Milford Haven. Concerned about her American accent, Hayes asked if Victoria
had spoken with a German accent. The marchioness shook her head. 'No, no.
My grandmutter spoke chust as gut Anglish as I do.'[34]

8 Anton Walbrook and Anna Neagle as the royal couple in *Victoria the Great*.
Copyright © STUDIOCANAL Films Ltd.

As if in reaction to playing the part of a prince, Walbrook's next role took him as far down the social ladder as it was decent to go, doubtless in a deliberate move to stress his acting range and versatility. *The Rat* was a romantic melodrama set in the Paris underworld, in which Walbrook played jewel thief Pierre Boucheron. Despite exchanging the ballrooms of Windsor for the bars of Montmartre, the film was produced along very similar lines: Wilcox delegated direction to Jack Raymond, but it was made at Denham Studios under the auspices of Imperator Productions, for RKO distribution, featuring many of the same actors – such as Felix Aylmer, Gordon McLeod and Hugh Miller – with dialogue provided again by Miles Malleson. Walbrook was involved in filming during the summer, finishing at the end of September 1937. A few days later his former UFA co-star Renate Müller, who had been hounded by the Gestapo, was found dead after a mysterious fall from a hospital window; it was a dark reminder of the fate that might have awaited Walbrook had he remained in Germany.

The Rat was released on 11 November 1937, but with the success of *Victoria the Great* confirmed, Wilcox pressed ahead with his plans to make another film about the Queen that would emphasise different aspects of her reign. This time, he asked Sir Robert Vansittart, just ousted from his post as Permanent Secretary at the Foreign Office because of his implacable hostility to Chamberlain's appeasement policy, to co-write the screenplay with Miles Malleson. Sir Robert already had strong links to the film industry, including personal friendships with Basil Dean and Alexander Korda. He helped the director with dialogue and song lyrics for films including *Burmese Silver* (another of Korda's abandoned projects), *Elephant Boy* (Zoltan Korda and Robert Flaherty, 1937), *The Four Feathers* (Zoltan Korda, 1939) and *The Thief of Baghdad* (Alexander Korda, 1940).[35] Before his political career developed Vansittart had dabbled with poetry, novels and plays – Miles Malleson had acted in a production of his verse play *Foolery* – and the loss of his position at the Foreign Office encouraged him to return to his literary pursuits.

In addition to writing the dialogue, Vansittart acted as a mediator between King George and Wilcox, managing to obtain royal permission to use the properties of Osborne, Balmoral, Buckingham Palace and Windsor Castle. The royal household appears to have been under the impression that Vansittart was in charge. Lord Cromer referred to the film being made 'under the auspices of Sir Robert Vansittart of the Government Propaganda Bureau'.[36] A few days later he wrote to Sir George Crichton, again emphasising Vansittart's role, asking if Crichton would like to be employed by Wilcox as an official adviser. He enlarged upon this in June 1938:

> The way in which you could be of service to them is to prevent them either in dress, make-up or other details from introducing foolish and inappropriate things such as are apt to be introduced when these pictures are made in America, where they are wholly ignorant about such details.[37]

Further support was provided by passing a series of questions to Princess Helena Victoria (1870–1948), granddaughter of Albert and Victoria. The Princess sent a handwritten letter on 6 June 1938, in reply to a list of eleven questions on royal protocol. The first two concerned Walbrook's portrayal of Albert. Would the Prince Consort's secretary deliver a despatch box to him at Windsor Castle, and would the Prince unlock the box himself? Secondly, would the Prince Consort have worn 'Windsor dress' to a state ball around 1845? The Princess replied to these questions in the affirmative, having checked with her

uncle, the aforementioned Duke of Connaught. Extra information was added, probably by Crichton, describing exactly what Windsor dress looked like: 'blue cloth tail-coat, scarlet collar and cuffs, brass buttons, worn with knee breeches and white waistcoat'.[38]

The scene in which Walbrook wore the tail-coat was actually set in 1857, rather than 1845, and depicts the ball following the engagement of their daughter, Princess Victoria, to the Prussian Prince Frederick, later Frederick III. It occurs almost an hour into the film and mirrors a similar scene at the beginning of the film that uses almost identical dialogue. These two waltz scenes are thus used to frame the entire life of Victoria and Albert in *Sixty Glorious Years*, for the second one is followed immediately by his collapse and subsequent death. Despite the fact that Albert was married to Victoria for only twenty of these years, Walbrook is on the screen for most of the film's ninety minutes. The prominence of his performance in the film is reflected by a programme from the Birmingham Paramount cinema, which devotes much more space to him than to Anna Neagle.[39]

Sixty Glorious Years does without the screen titles of *Victoria the Great*, adopting a slightly more fluid and natural mode of narrative, rather than the pop-up book tableaux of the first film. As before, however, many scenes are modelled closely on famous paintings. In a contemporary article in *Photoplay Studies*, H. E. Fowler invited students to compare stills from the film with nineteenth-century portraits and decide 'which of these parallels you consider the closest'.[40] The visit of Albert and Victoria to a military hospital, for example, is a shameless attempt to recreate Jerry Barrett's 1856 oil painting *Queen Victoria's First Visit to her Wounded Soldiers*.

Elsewhere there are intriguing differences between the versions of events presented in the two films. In *Victoria the Great*, the royal couple's support for repealing the Corn Laws originates with Victoria, whose fireside reading of Charles Dickens arouses her concern for the poor. In the second film, however, it is Albert who has been reading Dickens, and he tells Victoria about the novelist's social concerns while playing a long sequence on the piano. Dickens inspires him to do something useful with his life, and this fusion of music and literature then leads into a display of Albert's cultural achievements and the contribution he made to the arts in Britain. Walbrook's Prince Albert, like the Polish pianist Radetzky he played in *Dangerous Moonlight*, represents a noble tradition of European high culture suggested to be not only worth fighting for, but with the power to transcend national boundaries as an almost mystical force for unity.

However, both Walbrook and Albert learned that the possession of culture offers scant protection against national prejudice. Shortly after the triumphant sequence on the Great Exhibition, a mob of misguided and poorly educated patriots is shown attacking the Palace, daubing walls with graffiti that read 'Albert the Traitor. Down with the Cobug [*sic*]'. Lord John Russell then reports rumours to the Queen that Albert is 'a foreign agent, an avowed enemy of this country'.

Likewise, despite his highly acclaimed contribution to this patriotic 'Empire film', within eighteen months Walbrook had his car and radio confiscated as a result of suspicions about German nationals in wartime Britain.[41] Unlike Conrad Veidt, who chose to support British propaganda by playing Nazi villains, Walbrook consistently avoided such roles. Prince Albert was the first in a series of 'good Germans' he would play on both screen and stage: his role as the pacifist Peter in Powell and Pressburger's *49th Parallel* (1941) was followed by that of anti-Nazi Theo Kretschmar-Schuldorff in *The Life and Death of Colonel Blimp*, which was filmed while he was playing another anti-Nazi campaigner, Kurt Müller, at the Aldwych Theatre in Lillian Hellman's *Watch on the Rhine*. Vansittart, whose contribution to *Sixty Glorious Years* had arguably done so much to enhance Walbrook's reputation, became increasingly hostile to Germany and attacked *Watch on the Rhine* with harsh words:

> For nearly a year [the English] have been flocking to see a play called *Watch on the Rhine*, under the deliberate delusion that just Germans, as portrayed in that play, are flocking back from the security of the United States to fight Hitler underground. No such thing has ever happened, even once ... the underground movement in Germany has produced no substantial evidence of its existence. Yet the London critics reviewed *Watch on the Rhine* as a moving play instead of as a well-constructed delusion. I like delusion – we all do – and I like nonsense, even flagrant nonsense, but not about Germany. It is too expensive.[42]

Walbrook and his co-star Walter Rilla did in fact use their acting skills to support the fight against Germany. Rilla worked on the 'black operations' project at Woburn Abbey, broadcasting misleading information on German airwaves, while Walbrook played a German major in an RAF training film, *Information Please* (1944), that prepared pilots for interrogation in the event of capture. A letter written by Walbrook's secretary to a fan described him as being busy with making 'propaganda *films*'[43] (author's italics) and there may have been other contributions that he made to the British war effort in addition to the

substantial financial assistance he gave to the Red Cross and the Association for Jewish Refugees.

Changing attitudes to Germany are evident between the two films, but it is more subtle than Vansittart's later belligerence might suggest. The scene in *Victoria the Great* where the royal couple sing together in German was absent from *Sixty Glorious Years*, as is Victoria's statement that she spoke German until the age of nine.[44] By beginning with her engagement to Albert, the 1938 film avoids showing the young Queen's early life, when German relatives were prominent. It was therefore easier to imply that Britain was different from Germany, with its own independent traditions and national identity that needed defending. The Queen's warning about 'doing nothing' before the Crimea crisis might be interpreted as a condemnation of appeasement.

Walbrook played Albert as a strong character with a degree of political maturity and wisdom that exceeds that of his wife, so the weight he gives to the peace process cannot be dismissed. His reference to talk of the inevitability of war as 'like living in a madhouse' is based on an actual letter from Albert.[45] The films constantly link the Prince Consort's name to work for peace: his aim for the 1851 Great Exhibition was 'a greater understanding between all peoples', he would 'pursue peace and conciliation to the end' and he watches his daughter's courtship with the observation 'Princess Victoria of England, Prince Frederick of Prussia ... with those two children, so much could be done for the peace of the future.'

As in the earlier film, a strong link is made between Albert's tireless work for peace and his death from typhoid fever brought on by exhaustion and overwork. Victoria's servant John Brown (played by Gordon McLeod), however, sees things differently:

'Aye, he's sick of something more than the fever.'

'Mr Brown, what's that?'

'The English. Aye, they can be a cold, stand-offish lot if they want to. They dinna ken that he's always been working for them. They've never taken him to their hearts – that's what's brought this.'

Such a sympathetic alliance between the Scots and the Germans against the cold-hearted English was conveyed in *Das Herz der Königin* (*The Heart of the Queen*, Carl Froehlich, 1940), which starred Zarah Leander as Mary, Queen of Scots. A blatant propaganda movie, the film laid strong emphasis on the contrast

101

between the emotional Mary Stuart, who is guided only by her heart, and the ruthlessness of the loveless English queen, the figurehead for British cruelty and greed. The part of Riccio, incidentally, was played by Frederick Benfer, who played Prince Albert in *Mädchenjahre einer Königin*.

Unsympathetic portrayals of Queen Victoria and John Brown appeared in another German propaganda film released shortly after *The Heart of a Queen*. A harsh condemnation of British conduct during the Anglo-Boer War, *Ohm Krüger* (*Uncle Krüger*, Hans Steinhoff, 1941) presents historical events as a commentary on the present, taking special care to demonise the actions of Winston Churchill. Joseph Chamberlain is also cast as a villain, and played by Gustaf Gründgens, an actor who worked closely with Walbrook on the stage in the 1930s and was responsible for his return to German theatres in 1951. Krüger and his wife were both played by former co-actors of Walbrook: Emil Jannings was another of Reinhardt's students and Lucie Höflich (1883–1956) was Walbrook's mother in *Der Kurier des Zaren* (*The Czar's Courier*, Richard Eichberg, 1936). Sixty-five-year-old Hedwig Wangel played Queen Victoria, who is shown with John Brown at her side, filling her glass from a whisky bottle. Brown of course died in 1883, long before the Anglo-Boer War. Despite these inaccuracies *Ohm Krüger* was a brilliant piece of propaganda, directly countering the claims about Britain's colonial heritage that Korda and Vansittart had presented in *Elephant Boy* and *The Four Feathers*.

Sixty Glorious Years was premiered on 14 October 1938 with Queen Mary, the Duke of Kent and the Countess of Antrim (a former Lady-in-Waiting to Queen Victoria) in attendance. It anticipated successor films' provision of a sympathetic screen portrayal of the British monarchy in return for the film's use of prestigious iconography and brand names as part of its marketing. Ever the showman, Wilcox embellished his material to such an extent that the line between reality and representation was blurred. Both films were made by his own company, 'Imperator Film Productions', which he registered in March 1937 with £100.[46] He had special notepaper printed for official correspondence relating to the film, which was headed with a broad red band and gold crests containing a cartouche with a miniature portrait of Anna Neagle as Queen Victoria. The image was doctored in such a way to match precisely the popular 1837 portrait of the Queen by Alfred Chalon.[47] Cinema programmes for *Sixty Glorious Years* were emblazoned with gold-leaf covers and heraldic crests.

Despite his role in all this patriotic pageantry, almost a decade would pass before Walbrook took British citizenship, swearing allegiance to King George

VI, the great-grandson of Prince Albert, on 7 January 1947. And although he received great acclaim for his performances in *The Red Shoes* (1948) and *Queen of Spades* (1949), Walbrook failed to settle in Britain and spent a large part of his later years in Europe. The world had changed, and he seemed oddly rootless, his postwar career characterised by a restless wandering that took in French film studios and German theatres, stage musicals, non-singing operatic parts and German made-for-television dramas.

It is easy to see parallels with Prince Albert, struggling to find an outlet for his talents, seeking a sense of belonging in a country of adopted citizenship that never really felt like home. None the less, it was Walbrook's final wish that he be buried in England, and after his death in Germany his remains were interred in a Hampstead churchyard. When *The Times* published news of his death they identified him exclusively with the role they had announced forty years earlier: 'Anton Walbrook: Prince Albert of *Sixty Glorious Years*'.[48]

NOTES

1 *The Times* (15 February 1937), p. 14.
2 Amy Smith, *Hermine Körner* (Berlin: Kranich-Verlag, 1970), p. 102.
3 *Daily Express* (13 August 1952).
4 'Sil-Vara' was the pseudonym of an Austrian author and journalist, Gustav A. 'Geza' Silberer (1876–1938). His *Englische Staatsmänner* (Berlin: Verlag Ullstein & Co., 1916) contained character sketches of sixteen public figures including Joseph Chamberlain, Lord Kitchener and Churchill.
5 *Filmwelt* (2 February 1936), p. 26. A staff member reassured an anxious reader, 'C.M.G.' from Chemnitz: 'Haben Sie nur keine Sorge. Wohlbrück filmt natürlich wieder.' ('Have no worries, of course *Wohlbrück will make more films.' Author's translation.)*
6 Wohlbrück completed the RFF form on 25 September 1933 but the RFF did not profess themselves satisfied until October 1934. Bundesarchiv, Berlin, Reichsfilmkammer file on Wohlbrück, Mitgleids-Nr.1063.
7 *Western Daily Press* (Thursday 3 December 1936), p. 7.
8 In 1909 Lawrence Housman gave evidence before the Joint Select Committee on Stage Plays (Censorship), criticising this 'autocratic power' and the risk of abuse. *Report from the Joint Select Committee of the House of Lords and the House of Commons on Stage Plays (Censorship)* (London: HMSO, 1909), paragraphs 2530–41.
9 Royal Archives, Windsor Castle, RA/PS/PSO/GV/PS/MAIN/39402, Lord Chamberlain to Private Secretary, 19 November 1936. I would like to express my gratitude to staff at the Royal Archives for assistance in accessing this material.
10 Herbert Wilcox, *Twenty-Five Thousand Sunsets* (London: The Bodley Head, 1967), p. 111. Housman's play opened in New York on 26 December 1935 with Helen

Hayes playing Victoria. The Lord Chamberlain's ban was sidestepped by holding a private performance at the Gate Theatre, London, around the same time. It finally opened in the West End on 21 June 1937.

11 Simon Callow, *Charles Laughton* (London: Methuen, 1987), p. 58.

12 *Daily Film Renter* (4 December 1936), pp. 8–9.

13 *Motion Picture Herald* (19 December 1936), p. 53.

14 Sue Harper, *Picturing the Past: The Rise and Fall of the British Costume Film* (London: BFI, 1994), p. 34.

15 Herbert Thompson, 'Korda the Dreamer', *Film Weekly* (20 June 1936), p. 3.

16 Film production at Lime Grove was scaled down in 1936 because of financial difficulties, and the studio was shut down from March 1937 for over two years. Nigel Ostrer, *The Ostrers and Gaumont British* (No place of publication given: Nigel Ostrer, 2010), pp. 256–60.

17 Anna Neagle, *There's Always Tomorrow* (London: W. H. Allen, 1974) p. 91. There are minor discrepancies between the chronology of events as remembered by Neagle and Wilcox and the dates recorded in contemporary press reports.

18 Royal Archives, RA/LC/LCO/MAIN/110/1937, file re: *Victoria the Great*, Grandcourt to Gwatkin, 15 February 1937.

19 Royal Archives, RA/LC/LCO/MAIN/110/1937, file re: *Victoria the Great*, Gwatkin to Lord Chamberlain, 17 February 1937.

20 *Hansard*, House of Lords debates, 9 December 1936, vol. 103, cc. 699–708.

21 Sarah Street, *Transatlantic Crossings: British Feature Films in the USA* (London: Continuum, 2002) pp. 73–7. Neagle, *There's Always Tomorrow*, pp. 76–7.

22 T. R. Hooper states that Prince Albert stood at around 5ft 10in in *The Memoirs of Ebenezer and Emma Hooper, 1821–1885* (Guildford: Billing & Sons, 1905), p. 186, while Walbrook was 6ft tall ('Sixty Glorious Years', *Cinegram 39*, p. 14).

23 Lilli Palmer, *Change Lobsters – and Dance* (London: W. H. Allen, 1976), p. 66.

24 At the Windsor state ball for the visit of Grand Duke Alexander of Russia on 27 May 1839, '[S]he danced with vigour and enjoyment a number of quadrilles, but not waltzes, neither she nor the Grand Duke, owing to their high status, being permitted to waltz.' Cecil Woodham-Smith, *Queen Victoria: Her Life and Times*, vol. 1, *1819–61* (London: Hamish Hamilton, 1972), p. 176. Victoria's journal entries for October 1839 confirm that she danced only quadrilles with Albert.

25 The final sequence in Technicolor appears to have been shot at the end of May, according to 'Tatler', writing in the *Daily Film Renter* (28 May 1937), p. 2.

26 Freddie Young, *Seventy Light Years. A Life in the Movies* (London: Faber, 1999), p. 38.

27 *Illustrierter Film-Bühne*, no. 836, *Königin Victoria*.

28 *The Times* (17 September 1937), p. 10.

29 Lionel Collier, review of *Victoria the Great* in the *Picturegoer* (25 December 1937), p. 23.

30 'The Life Story of Anton Walbrook', *Picture Show & Film Pictorial* (28 August 1943), p. 11.

31 This understanding of music was a tenet of German Romanticism. See Wilhelm Wackenroder, 'The marvels of the musical art', in M. H. Schubert (ed.), *Wackenroder's*

Confessions and Fantasies (Philadelphia: University of Pennsylvania Press, 1971), pp. 178–81.

32 Theodore Martin, *The Life of His Royal Highness, the Prince Consort*, vol. 1 (London: Smith, Elder & Co., 1876), p. 85.

33 In his biography of his grandfather, Kevin Macdonald states that Walbrook had his English governess from Vienna, Edith Williams, on set with him. *Emeric Pressburger: The Life and Death of a Screenwriter* (London: Faber & Faber, 1994), p. 218.

34 Kenneth Barrow, *Helen Hayes: First Lady of the American Theatre* (New York: Doubleday & Co., 1985), p. 128.

35 Norman Rose, *Vansittart: Study of a Diplomat* (London: Heinemann, 1978), p. 218.

36 Royal Archives, RA/LC/LCO/110/file re: *Sixty Glorious Years*, Cromer to Michael Adeane (27 May 1938).

37 Royal Archives, RA/LC/LCO/110/file re: *Sixty Glorious Years*, Cromer to Crichton (3 June 1938).

38 The Windsor coat worn by Walbrook matches this description faithfully; it is now in the author's possession.

39 *Sixty Glorious Years*, Birmingham Paramount cinema, February 1939.

40 H. E. Fowler, 'A guide to the appreciation of the historical photoplay *Victoria the Great*', *Photoplay Studies* 3:8 (1937), pp. 8–9.

41 Christopher Robbins, *Empress of Ireland. A Memoir of Brian Desmond Hurst* (London: Scribner, 2004), p. 320.

42 Robert Vansittart, *Lessons of My Life* (London and New York: Hutchinson & Co., 1943), pp. 18–19.

43 Letter from Arthur Dreyfuss, 22 September 1943. Original in possession of author.

44 The chief exchange of German dialogue in *Sixty Glorious Years* occurs between Albert and Baroness Lehzen, played by native German actress Greta Wegener, who starred in *Nosferatu* (F. W. Murnau, 1922). Walbrook had appeared alongside her first husband Ernst Matray in the silent film *Marionetten* (Richard Löwenbein, 1915).

45 Albert wrote to Stockmar on 23 December 1853, 'One almost fancies oneself in a lunatic asylum.' Martin, *The Life of His Royal Highness*, vol. 2, p. 534.

46 Rachael Low, *Film-Making in 1930s Britain* (London: HarperCollins, 1985), p. 249.

47 See, for example, Royal Archives, RA/LC/LCO/MAIN/110/1937, file re: *Victoria the Great*, letter to Col. Nugent (15 December 1937).

48 *The Times* (10 August 1967), p. 8.

SELECT BIBLIOGRAPHY

Barrow, Kenneth, *Helen Hayes: First Lady of the American Theatre* (New York: Doubleday & Co., 1985).

Callow, Simon, *Charles Laughton* (London: Methuen, 1987).

Charlot, Monica, *Victoria: The Young Queen* (Oxford: Blackwell, 1991).

Fowler, H. E., 'A guide to the appreciation of the historical photoplay Victoria the Great', *Photoplay Studies* 3:8 (1937).

Harper, Sue, *Picturing the Past: Rise and Fall of the British Costume Film* (London: BFI, 1994).

Holl, Werner, *Das Büch von Adolf Wohlbrück* (Berlin: Hermann Wendt, 1935).

Hooper, T. R. (ed.), *The Memoirs of Ebenezer and Emma Hooper, 1821–1885* (Guildford: Billing & Sons, 1905).

Housman, Laurence, *Victoria Regina: A Dramatic Biography* (London: Jonathan Cape, 1935).

Kemp, Peter, *The Strauss Family, Portrait of a Musical Dynasty* (Tunbridge Wells: The Baton Press, 1985).

Longford, Elizabeth, *Victoria* (London: Abacus, 2011).

Loup, Karl, *Die Wohlbrücks: eine deutsche Theaterfamilie* (Düsseldorf: Claasen, 1975).

Low, Rachael, *Film-Making in 1930s Britain* (London: HarperCollins, 1985).

Macdonald, Kevin, *Emeric Pressburger: The Life and Death of a Screenwriter* (London: Faber & Faber, 1994).

Martin, Theodore, *The Life of His Royal Highness, the Prince Consort*, vols 1 and 2 (London: Smith, Elder & Co., 1876).

Moor, Andrew, 'Dangerous limelight: Andrew Walbrook and the seduction of the English', in Bruce Babington (ed.), *British Stars and Stardom. From Alma Taylor to Sean Connery* (Manchester: Manchester University Press, 2001).

Neagle, Anna, *There's Always Tomorrow* (London: W. H. Allen, 1974).

Ostrer, Nigel, *The Ostrers and Gaumont British* (No place of publication given: Nigel Ostrer, 2010).

Palmer, Lilli, *Change Lobsters – and Dance: An Autobiography* (London: W. H. Allen, 1976).

Report from the Joint Select Committee of the House of Lords and the House of Commons on Stage Plays (Censorship) (London: HMSO, 1909).

Robbins, Christopher, *Empress of Ireland. A Memoir of Brian Desmond Hurst* (London: Scribner, 2004).

Rose, Norman, *Vansittart: Study of a Diplomat* (London: Heinemann, 1978).

Sil-Vara [Geza Silberer], *Englische Staatsmänner* (Berlin: Verlag Ullstein, 1916).

Smith, Amy, *Hermine Körner* (Berlin: Kranich-Verlag, 1970).

Street, Sarah, *Transatlantic Crossings: British Feature Films in the USA* (London: Continuum, 2002).

Vansittart, Robert, *Lessons of My Life* (London and New York: Hutchinson & Co., 1943).

Wackenroder, Wilhelm, 'The marvels of the musical art', in M. H. Schubert (ed.), *Wackenroder's Confessions and Fantasies* (Philadelphia: University of Pennsylvania Press, 1971).

Wechsberg, Joseph, *The Waltz Emperors: The Life and Times and Music of the Strauss Family* (London: Weidenfeld & Nicholson, 1973).

Weintraub, Stanley, *Albert. Uncrowned King* (London: John Murray, 1997).

Wilcox, Herbert, *Twenty-Five Thousand Sunsets* (London: The Bodley Head, 1967).

Williams, Michael, 'Anton Walbrook: the continental consort', in Tim Bergfelder and Christian Cargnelli (eds), *Destination London. German-Speaking Emigrés and British Cinema, 1925–1950* (Oxford: Berghahn Books, 2012).

Woodham-Smith, Cecil, *Queen Victoria: Her Life and Times*, vol. 1, *1819–61* (London: Hamish Hamilton, 1972).

Young, Freddie, *Seventy Light Years. A Life in the Movies* (London: Faber, 1999).

Part II

The Elizabethan diva

Her Majesty moves: Sarah Bernhardt, *Queen Elizabeth* and the development of motion pictures

Victoria Duckett

Sarah Bernhardt, the greatest theatrical star of the late nineteenth century, enabled and even promoted the association of early film with the British monarchy. She did this literally, by playing the role of Queen Elizabeth in *Queen Elizabeth* (*Les Amours de la Reine Elisabeth*, Henri Desfontaines and Louis Mercanton, 1912). Bernhardt also promoted the association of the cinema with monarchy symbolically, making the medium a new empathetic vehicle for the development of celebrity mystique and global power. In *The Royal Touch: Sacred Monarchy and Scrofula in England and France*, Marc Bloch explains that in the Middle Ages through to at least the seventeenth century, royal power was associated with physical contact. English and French kings were believed to possess magical powers of healing; through their sacred touch they were thought to cure their subjects of epilepsy and tuberculosis. Distributing so-called cramp rings that they consecrated through their touch, these monarchs sought to heal the sick even beyond the boundaries of their own state.[1] Bernhardt's *Queen Elizabeth* tells the story of a royal ring's failure to deliver the Queen's favourite from death. The Earl of Essex sends back a ring given to him by Elizabeth in order to gain her pardon from the charge of treason. The ring, however, is never received and he is consequently executed. Anguished by the loss of her favourite subject, the Queen dies of remorse. At the opening of the twentieth century, Bernhardt's film functioned symbolically as a royal ring. It circulated widely, changing the ways audiences engaged with and experienced celebrity mystique and power. In this changed order, it is Bernhardt's capacity to move audiences through the nascent medium of film that confirms her already established status as a theatrical diva. Film accords her the symbolic status of queen.

Bloch explains that his history of monarchy offers a new way to investigate a subject that is otherwise formalised into accounts of political developments

and dynastic power. His aim is to explore the mystique of royalty, the objects that accompany it and the beliefs and fables that often go ignored, forgotten and overlooked.[2] Where Bloch reconsiders monarchy in relation to folklore, beliefs and fables, Bernhardt's *Queen Elizabeth* allows me to reconsider early film history in relation to its own folklore, beliefs and fables. Prime among these is the idea that Bernhardt's *Queen Elizabeth*, coming on the heels of her film adaptation of *Camille* (*La Dame aux camélias*, André Calmettes, 1911) is, like its predecessor, 'too theatrical' for film.[3]

I am not alone in arguing that our reluctance to embrace a figure such as Bernhardt is part of film history's own myth, born of the need to separate and identify the medium as a unique and popular art form. David Mayer has long and eloquently argued that the late nineteenth- and early twentieth-century stage and early film were mutually interdependent fields, together marking 'a fluid period of explorations and experimentations, developments, borrowings, and mutual rip-offs'.[3] Jon Burrows, in his book *Legitimate Cinema: Theatre Stars in Silent British Films, 1908–1918*, also debunks what he calls the 'dismissive judgment' of the merit and significance of early films featuring stars from the legitimate stage. Arguing that film was a hybrid form dependent on other established media practices, he explores on a national scale the ideas that I will instead present in microcosm.[4]

Bernhardt's marginalisation as a theatrical intruder in early film relates, I believe, to her very importance. *Queen Elizabeth* was one of the first multiple-reel feature films released in America. A transnational production, it was produced in London by J. Frank Brocliss, the European representative of the Lubin Company, for the Histrionic Film Company (established by Bernhardt for the film), and features Bernhardt with her French cast and the costumes and sets of its stage version. Accompanied by a score composed by Jacques Breil, the film drew middle-class audiences after its lavish opening at the Lyceum Theatre in New York, with its remarkable profits eventually enabling Adolph Zukor to develop Famous Players into the company that became Paramount Pictures.[5] In this way, *Queen Elizabeth* became precursor to a major Hollywood studio and helped inaugurate a new category of spectacle in the cinema. Indeed, the success of the film drew other theatrical stars to film, helping to develop the longer playing narrative film.

As the Italian *Enciclopedia dello spettacolo* notes, however, Bernhardt's indirect participation in the development of Paramount is one of the 'most paradoxical cases in the history of the film industry'.[6] Her cinema performances are criticised for being gestural, melodramatic and physically excessive.[7] Dismissed as 'filmed

9 Sarah Bernhardt as Elizabeth I in the final scene of the film version of *Queen Elizabeth*. National Film and Sound Archive of Australia.

theatre', *Queen Elizabeth* is characterised by a still camera, action introduced by lengthy intertitles, elaborate costumes and a gesticulating, silent Bernhardt who mimes her lines.[8] The final scene, in which the dying queen falls to the ground in an extraordinary gown with long, bell-shaped sleeves, is often said to epitomise visual display rather than narrative in the development of the film.[9]

Queen Elizabeth is a spectacular film, whose players are indeed theatrical in a manner that appears unusual today: they are separately introduced at the opening of the film, they mouth words we can not hear, they are elaborately costumed and it is they (rather than a mobile or fluid camera) who articulate narrative meaning. Moreover, Bernhardt's final descent onto a pile of cushions is excessive, and can even seem comical. The fact that she immediately returns to this set (now cleared and cleaned) in order to acknowledge applause from her unseen spectators reinforces the potential humour of the film's conclusion. At the same time, however, questions remain. How did a Tudor Queen renew Bernhardt's hold not just on Empire (now newly conceived in terms of film), but on the affection and loyalty of an international public?[10] What have we overlooked in our analysis of *Queen Elizabeth* that might reveal something of the film's pioneering appeal?

It is not just the formal language of Bernhardt's film but the very performance of British monarchy on screen that prompts *Queen Elizabeth*'s ongoing

association with an *haute bourgeois* theatrical culture that had no place in early film. The irony, of course, is that it is only on screen that it might be argued that Bernhardt was legitimate. We know – as her own public knew through the many references and anti-Semitic caricatures of her in the popular press – that Bernhardt was Jewish and that in the late nineteenth century this meant that she was cast as an outsider to legitimate French culture.[11] Moreover, Bernhardt was the daughter of an established Parisian courtesan whose profession she also followed in her youth. In these and other ways, her behavior and choices ran counter to established social and theatrical mores: she had a son out of wedlock, was rumoured to be bisexual and disregarded theatrical convention. Even the public who first made her a star were on the margins of Parisian society: they were the *Saradoteurs*, the modest workers and students of the Left Bank who were vocal and demonstrative in their support of her and who clashed with the older and more established patrons of the Odéon theatre.[12] When the constantly touring Bernhardt appeared forty years later on film in *Queen Elizabeth*, her public had expanded to include legions of spectators in both American continents and the Antipodes. She had become the first global star, with a cross-class following of similar proportions who witnessed her performances of classics and melodramas in an extraordinary range of venues. On her 1905 tour to America she played, for example, in a circus tent that seated 6,000 people as well as in conventional halls, skating rinks and a combined swimming pool-auditorium in Tampa.[13] *Queen Elizabeth* is not, therefore, a film documenting the legitimate theatrical culture that was fast disappearing at the opening of the twentieth century. It is instead a popular spectacle that is combative, even imperious, in the way that it makes a role that had been associated with other actresses on the international stage Bernhardt's own.

Bernhardt's *Queen Elizabeth* is implicated in a history of performance and patronage that, like Bloch's discussion of the royal touch, extends over centuries. The dramatic depiction of Elizabeth I can be traced back to Thomas Heywood's 1605 play *If You Know Me Not: The Troubles of Queen Elizabeth*. The staging of her relationship to Essex reaches back to 1681, with John Banks's *The Unhappy Favorite, or The Earl of Essex*.[14] At the turn of the twentieth century, the role had acquired new importance for anglophone audiences. The American actress Nance O'Neil successfully toured *Queen Elizabeth*, a 'five-act classical tragedy written around the life of Elizabeth, Queen of England, by Paolo Giacometti', to audiences in America, Australia and New Zealand in 1901 (she also took it to London in 1902).[15] She returned with the play to Australia and

New Zealand in 1905 and to America in 1906. When O'Neil first played *Queen Elizabeth* in Australia, note was taken of the fact that it was new to audiences. Still, readers were reassured that '*Queen Elizabeth* will seem as an old friend to many from the mere fact of its historical foundation.'[16]

Giacometti's play was written for the nineteenth-century Italian tragedienne Adelaide Ristori. When Ristori first brought *Queen Elizabeth* on tour to America in 1866 the *New York Times* noted the familiarity that audiences had with its narrative, stating:

> The story of the plot is an old one. It has been served in many forms and always successfully. It is simply that of Essex who, receiving a ring from the Queen in her favor, and knowing that it will give him pardon, freedom and life, refuses these boons … in his indignation at her coquettish cruelty.[17]

It was the international renown of Ristori, even more than Bernhardt's contemporary Nance O'Neil, that explains her choice of *Queen Elizabeth* in 1912. The Italian diva had crowned her career with *Queen Elizabeth* in England in 1883 and performed it again on her farewell tour to America in 1884–85.[18]

In essaying one of Ristori's main roles and bringing this to the screen, Bernhardt was able to embark on her own, far more extensive, world tours. Reaching audiences Ristori could never reach via steamships and railways, and replacing Giacometti's script with her own commission from Emile Moreau, Bernhardt invited comparison between herself and Ristori, competing with a star who had been described half a century earlier on her American debut in the role as 'the living, breathing Queen … Queen of art and hearts!'.[19]

A further explanation for Bernhardt's adoption of Ristori's role is their mutual use of an emotionally expressive style of acting. A contemporary marvelled that in Bernhardt's performance of the Queen the 'subtlest moments of craft and cunning give place in brutal suddenness – which yet seems natural – to paroxysms of rage and grief or to times of delirium'.[20] Ristori's own account stressed the need to incorporate character transitions in her depiction of Elizabeth.[21] It is also in accordance with the reception Ristori enjoyed on her American debut: 'So majestic in action, so graceful in motion, no attitudinizing, no statuesque poses, but the living, breathing Queen. … The subtle expounder of the human passions in their varied phazes [*sic*].'[22] Again, the criticisms levelled by film scholars at Bernhardt's theatrical anachronism are paradoxical since she, like Ristori, abandons formal theatrical choreography for more emotionally spontaneous and impulsive action.

Adolphe Brisson, writing in *Le Temps* in 1912, argues that Bernhardt's acting provides the focus of the play and keeps the improbability of Moreau's plot at bay:

> We do not understand a lot about the grievances [against Essex]. ... But what does it matter? We watch Sarah Bernhardt. And Sarah is extraordinary. The incomplete and confused tragedy becomes concentrated and precise in her, in her attitudes, in her gesture, in the trembling of her hands, in her anxious eyes, in her breathless, trembling, broken voice. We are not interested in anything about Essex, about whom we know but little. But the pain of this amorous and betrayed woman, the emotion of this queen torn between the feelings of her heart and her duties as head of State stir us. In the play's dénouement, Sarah Bernhardt is even more admirable. ... Elizabeth is inconsolable, devoured by remorse. ... Terrible, the face of the artist, her bewilderment, her dread, and in her eyes the terror of her recent hallucinations ... [on learning of Lady Howard's betrayal] Sarah utters some marvellous cries of hatred and offers us a spectacle of sublime agony [...] She translates with an extreme truthfulness the entire gamut of human sentiments, she expresses vehemence as much as sweetness; her acting is sincere, it is even realist on occasion.[23]

It is clear that Bernhardt's performance of the English queen was a powerful and emotive one. Yet Moreau's play was performed only twelve times at the Théâtre Sarah Bernhardt in Paris in 1911 and became one of the biggest failures in the actress's career.[24] Nevertheless, Bernhardt's decision to film the drama was a canny one: the role allowed her to play an older woman and to develop her existing repertoire of death scenes. It also exhibited a range of emotions (joy, love, jealousy, fury, pain, terror, remorse) made intelligible through physical acting. Bernhardt's expressive gestures were a celebrated aspect of her performance style, one which enabled its subsequent cinematic success. They allowed audiences to empathetically engage with a figure (the Tudor queen but also the star who played her) often regarded as literally and symbolically removed from the public and the trials of quotidian life.

W. Stephen Bush, commenting in *The Moving Picture World* on Bernhardt's capacity to make the role emotive and compelling, states:

> This great artist had her own conception of the character of Elizabeth. It was not the traditional Elizabeth, crafty, calculating and not at all emotional.
>
> So superb is the art of Sarah Bernhardt that she made her conception, which is that of a passionate woman, dominated wholly by her affections, seem not impossible. No student of history could pay a greater tribute to her art than to

say that she successfully defied a well-known historical fact. Throughout the play, which consists of three reels, she exhibited her best powers and won from her audience such keen sympathy and compassion as the real Elizabeth could never have expected.[25]

If *Queen Elizabeth* allowed Bernhardt to compete with an eminent predecessor, it also allowed her to incarnate a role she already played as a public person. Indeed, while Ristori had been called 'the living, breathing Queen', it was Bernhardt who uniquely adopted the trappings of monarchy and made these an integral and visible part of her public life. She travelled, for example, in a personal railway carriage.[26] She commissioned craftsmen such as Lalique to make jewellery for her and was admired for the headdresses, bracelets, rings and brooches she wore. She bought a fort on an island in Brittany and here met, greeted and supported local inhabitants as though meeting and supporting her own subjects. Like many other famous singers and performers on the stage, she was known as 'the Divine'. She was carried regally in a sedan chair after the amputation of her right leg in 1915. Finally and perhaps most famously, Bernhardt designed a letterhead with a tendrilic monogram that featured her initials, SB, with the motto *Quand même* woven through it.[27] Meaning 'in any case', or 'nevertheless', this challenge to adversity played itself out both seriously and satirically against the ER of Elizabeth Regina, as well as against Elizabeth's own famous motto, *Semper eadem* or 'Always the same'.

Queen Elizabeth associated Bernhardt with monarchy. It also engaged an object – the Queen's ring – that was still topical. A report in *The Times* published the same year that Bernhardt brought the play to the stage (1911) explains under the heading 'Queen Elizabeth's Ring' that among the items auctioned at Christie's was 'the Essex ring'. Explaining that this is the 'identical ring given by Queen Elizabeth to Essex', that it had been handed down from Essex's daughter in unbroken succession from mother to daughter, and that it sold for the enormous sum of 3,250 guineas, the article presumed general knowledge of the ring's significance. The article also mentioned that the ring had been exhibited at the Tudor exhibition of 1890. Clearly, readers had an ongoing engagement in this queen and her epoch.[28] As proof of this – at least (again) within London but this time circulating in the American press – is a report in 1913 of Shakespeare's England being reproduced at Earl's Court, replete with narrow streets, wooden houses, the Globe Theatre (showing the relevant Elizabethan plays), as well as Queen Elizabeth dining 'in state in a banqueting hall, with all her courtiers about her'.[29]

Queen Elizabeth tells the story of Elizabeth's relationship with her young subject, the Earl of Essex. A court favourite, he helps defeat the Spanish at sea and later introduces the Queen to Shakespeare. Told by a gypsy that he will be beheaded, the Queen gives Essex a ring with the promise of a royal pardon should he ever need it. And he does indeed need this pardon after the jealous Count of Nottingham sees him and his wife in an embrace and realises that Essex is romantically involved with both her and the Queen. After witnessing his wife's liaison, Nottingham writes an anonymous letter accusing the Earl of treason. When Essex returns suddenly to court from Ireland, he is seen by the Queen as he embraces the Countess. As the intertitle states: 'The Queen discovers Lord Essex is unfaithful. She then believes the anonymous letter and orders his arrest.' Sentenced to death, Essex gives his ring to the Countess in the hope that he will be saved. But on her way to the Queen she is intercepted by her jealous husband, who ensures Essex's death by throwing the ring into the Thames. After Essex has been beheaded – and we see the Queen watching him walk past her on his way to the scaffold, as well in the moments before his death – the Queen visits his corpse and finds the ring missing. A confession is extracted from the Countess and the Queen refuses to forgive her. Finally the distraught Elizabeth falls dying to the ground.

This narrative, like the many long-standing tales of Elizabeth and Essex, associates the Queen with romantic passion, enabling and even facilitating spectatorial empathy. Presented against a rich panoply of implied and even re-enacted paintings, prints and popular lore, Bernhardt's performance gave audiences the tools with which to interpret and be emotionally moved by film. Martin Meisel's suggestion that it was in 'the studios, laboratories, and movie houses' of the twentieth century that the nineteenth-century tension between picture and motion was finally synthesised is crucial to understanding the success of this film.[30] Unlike the live stage, where Bernhardt held poses for up to seventeen seconds,[31] and certainly in contrast to painting or print, a static pose could not be contemplated on film. In this sense, Bernhardt invites cinema audiences to engage with her performance on film in a new and challenging way. She asks for an involvement that is at once empathetic and emotional as well as historically and textually dense. It is in this sense that I speak of the moving pictures: not as proof of the camera's newfound mobility, but of film's capacity to animate and electrify the static pose and, with this, to emotionally engage and move a watching audience.

The opening and closing scenes of *Queen Elizabeth* reference a variety of sources. These sources include the 'Dresses, Armor and Furniture from the

Sarah Bernhardt Theatre, Paris' that were publicised in the opening credits of the film, the *mise-en-scène* that was designed by Emile Bertin for Bernhardt's original stage production in Paris, accounts of Elizabeth's famous speech given at Tilbury before her troops on 7 August 1588, seventeenth-century descriptions of gesture and court chivalry, as well as the re-enactment of famous paintings and prints.

The variety of sources that are restaged by Bernhardt and her cast in *Queen Elizabeth* give depth and nuance to the historical characters presented on film. The film animates well-known moments of Elizabeth's life and does this by suggesting and even re-staging well-known paintings and prints associated with the Queen. For example, in the opening shot of the film we see Lou Tellegen (playing Essex) fling a cloak at Bernhardt's feet when she enters the screen. Tellegen then takes his hat from his head and bends to kneel before her. Essex's gallant action is recorded in history. Indeed, we know from an array of written and visual sources that Sir Walter Raleigh, Elizabeth's favoured courtier (who, like Essex, the favoured courtier in this film, was eventually beheaded), was famous for laying his cloak before the Queen. Essex's character, associated with an act that defines Raleigh's chivalry, acquires depth and narrative purpose because of this. As Thomas Fuller recounts in his 1662 *History of the Worthies of England I*,

> Captain Raleigh coming out of Ireland to the English Court in good habit (his cloaths being then a considerable part of his estate) found the Queen walking, till, meeting with a *plashy place*, she seemed to scruple going thereon. Presently Raleigh cast and spred his new plush cloak on the ground; whereon the Queen trod gently, rewarding him afterwards with many *suits*, for his free and seasonable tender of so fair a *foot cloath*.[32]

While Fuller's is the first description of this act, Michael Dobson and Nicola Watson have observed that 'Sir Walter's legendary courtesy to his queen became one of the nineteenth century's favourite images of the manly and Ruskinesque chivalry Elizabeth is supposed to have promulgated at her court.'[33] Dobson and Watson go on to note 'the popularity of such widely reproduced genre paintings as *The gallantry of Sir Walter Raleigh* (Samuel Drummond, 1828), *Sir Walter Raleigh spreads his cloak as a carpet for Queen Elizabeth* (William Theed, 1853), and *Sir Walter Raleigh laying down his cloak before Queen Elizabeth* (Andrew Sheerboom, 1875)'.[34] To these we might add *Sir Walter Raleigh laying down his cloak before Queen Elizabeth I* (circle of John Gilbert, 1817–97, n.d.), an 1854 graphite, ink and ink wash image of this same scene by Peter Frederick Rothermel, William Henry

10 The Earl of Essex (Lou Tellegen) kneels before Elizabeth I (Sarah Bernhardt) in *Queen Elizabeth* (*Les Amours de la Reine Elisabeth*, Henri Desfontaines and Louis Mercanton, 1912). National Film and Sound Archive of Australia.

Charles Groome's *Sir Walter Raleigh pulling his cloak out for Elizabeth I* (1880) as well as John Leech's more comical *Sir Walter Raleigh and Queen Elizabeth* (reproduced in Gilbert Abbott A'Beckett's 1864 *Comic History of England*, where Raleigh spreads his cloak over a puddle before a bemused looking Queen).

What is interesting is not just the way that film frames the characters in a manner similar to the pictures (in long shot, frontally, with none of the empty space that surrounds the characters on the live stage),[35] but the coincidence of costume, gesture and composition. On the right of the frame a chivalrous young man with a plumed hat kneels and lays down his cloak as the Queen walks towards him. In the photograph of the stage production this is inverted, so the Queen is shown walking onto the stage on the right as Essex kneels on the left with his cloak.[36] In this sense, film more closely reproduces the visual and compositional elements of the event already known to spectators through famous visual images.

On film, we see a famous gesture identifiable through visual images incorporated into a moving image. The legibility of Essex's simple gesture and the inclusion of it in a scene that runs for just a few minutes indicates that the moving

pictures were a form of visual literature newly available to popular audiences. Indeed, the transference of Raleigh's gallant gesture onto the character of Essex signals, at the film's outset, the importance given spectators as interpreters of character and narrative action. Similarly, the arrival of the Queen to a site of battle alludes to Elizabeth's famous visit to Tilbury on 7 August 1588. Bernhardt's address to the men who crowd the scene on the film – and we have in the background the long spears of infantry soldiers as well as their plumed helmets – is suggestive of the most famous speech of Elizabeth's reign. Famously, she said

> I have placed my chiefest strength and safeguard in the loyal hearts and good will of my subjects; and therefore come amongst you, as you see, at this time, not for my recreation and disport, but being resolved, in the midst and heat of the battle, to live or die amongst you all, and to lay down for God, and for my kingdom and for my people, my honour and my blood, even in the dust. I know I have the body of a weak and feeble woman, but I have the heart and stomach of a king, and of a king of England too.[37]

The film runs too fast for a speech of this length to be spoken. Nevertheless, Bernhardt does speak and gesture to her troops. Through her physical actions she indicates an event that was recorded for posterity and endured as recounted fact. The plumed hat that Bernhardt wears in this scene also reproduces Elizabeth I's costume on this visit. Ballads written at the time of Elizabeth's reign report her 'tossing her plume of feathers' and Thomas Heywood, in his later *Exemplary Lives and Memorable Acts of Nine the Most Worthy Women of the World*, speaks of her appearing 'in the head of her Troopes, and encouraging her Souldiers, habited like an Amazonian Queene, Buskind and plumed, having a golden Truncheon, Gantlet and Gorget'.[38]

Although there is no truncheon, gantlet or gorget in the film, there is reference to Elizabeth having the will to fight 'as a man' in the exchange we see with James VI. It is Essex, however, who encourages her and Essex who returns to announce victory just before Drake arrives. Elizabeth is thus at once a victorious Amazonian Queen, a Queen who enjoys the adoration of her subjects and a woman who is supported by the young man she later comes to love.

The opening scene concludes with Drake arriving dressed as a pirate to receive the Queen's embrace and to confirm victory. Drake then helps Essex and two soldiers lift the Queen in a litter. The men pause to receive the applause of the watching crowd. In this final moment of the film's opening scene we are

reminded of Elizabeth's triumph: arriving on foot, she is carried victoriously away. We are also reminded of another famous painting, *The Procession Portrait of Queen Elizabeth I* (after 1593, attributed to Robert Peake).[39] Once more, a famous painting is restaged on screen as a moving picture.

Horizontally disposed, Peake's painting shows Elizabeth in a canopied procession, accompanied by her court and watched by spectators who crowd around and lean from open windows high in the building behind her. While on film there is no canopy, no scenic hill and no building from which spectators watch (as though from boxes in a theatre), in both pictures we see the Queen borne aloft by her loyal subjects, women in attendance, men with halberds behind her, the four pall-bearers carrying her and the framing of all at full height. Indeed, the entire scene takes the same distance from its actors as the painter does to his subject. What this framing eliminates, conveying a sense of crowding to the spectator, is the top third of the painted picture (which is separated into a three-storey building on the right and rolling hills on the left).

We can presume that audiences at the turn of the twentieth century were familiar with this image. Imitated in George Vertue's engraving *Royal Procession of Queen Elizabeth* in 1740, it was still topical at the time of Queen Victoria's accession to the throne. In her 1844 *Lives of the Queens of England*, Agnes Strickland criticised the *Procession Portrait*, stating that it

> reminds us of the procession of a pagan goddess surrounded by her priests and worshippers, or the ovation of a Roman conqueror, rather than the transit of a Christian queen in civilized times. The semi-barbarous display of pomp and homage suited the theatrical taste of Elizabeth, who inherited the pride and vanity of both her parents, and understood little of the delicacy and reserve of an English gentlewoman.[40]

Written in homage to the rather more staid Queen Victoria, such criticism ironically indicates why Bernhardt might have referenced the *Procession Portrait* in her film. It allowed her to be pictured theatrically, as the 'Divine Sarah', surrounded by an applauding public. That a live audience would also be watching her as she was raised on screen is significant: Bernhardt was not just a queen, she was also one of global importance who travelled and was seen 'in carriage' abroad. Here another representational strategy implicit in the original painting is evident. Commissioned (arguably) by the Earl of Worcester, who used the Elizabeth cult to commemorate his own honour,[41] it nominally focuses on Queen Elizabeth in order to celebrate his relationship to this figure.

Consequently, in both painting and film, there is an oblique displacement. The real subject on view is, respectively, Worcester and Bernhardt's relationship to a queen, rather than the Queen herself.

In the final scene, the film stages a tableau of Paul Delaroche's 1828 painting, *Death of Queen Elizabeth, Queen of England, in 1603*. Here we see the clearest example of the licence Bernhardt takes with her portrayal of the Queen. Visually, the *mise-en-scène* is almost identical to Delaroche. Details are true, too, to recorded history: we know, for instance, that ermine was long an emblem of chastity and thus considered appropriate to the depiction of the Virgin Queen. We know that Elizabeth was painted with an ermine on her arm in 1585 (the 'Ermine' portrait, attributed to William Segar). We also know that during her final hours Elizabeth was surrounded by her closest female attendants, that she lay on cushions and that she did not name her successor until shortly before her death.

On film we have, however, rapid physical action. Hence, where Delaroche depicts the Queen lying in opulent splendour on an ermine cloak spread across a pile of cushions, Bernhardt instead proceeds rapidly to her demise. She walks into the room and is offered a sword (the sword of justice, itself prefigured in the 'Ermine' portrait). She discards this, stands before the pile of cushions and calls for a goblet from which she then drinks, and finally holds a mirror to her face. Discarding the mirror (which alludes not to vanity but to her awareness that her court had misrepresented her enduring beauty) she refuses support. Pulling herself straight, as though driven by a final burst of energy, she calls for the Earl of Nottingham. After naming her successor, she raises both arms upwards and, palms outstretched, falls forward.

May Agate, a former student of the actress, commenting on the stage production explains:

> [Bernhardt's] performance was one of a soul-seared woman who still loves the man she has put to death. She was regal, immensely dignified, terrible, and as a picture of remorse I can think of nothing more haunting. What is more, you felt here was a woman capable of putting people to death, for she was hard, inexorable, terrifying. Even in her last throes of suffering she made no appeal to pity. There was no truck with the pendants; she died standing up, falling forward on to a mass of cushions, not writhing, senile amongst them as is recorded historically.[42]

Agate's reference to the historic image of Queen Elizabeth's senile writhing invokes not only Delaroche's painting of the Queen but also its source, David

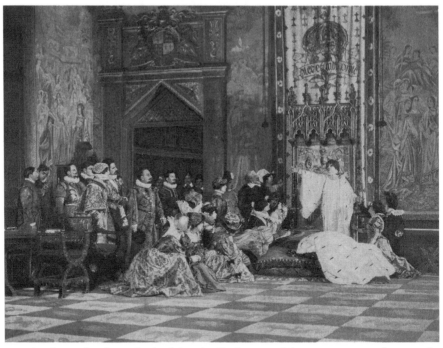

11 Sarah Bernhardt as Elizabeth I in the final scene of the 1912 stage production of *Les Amours de la Reine Elisabeth*. Bibliothèque national de France.

Hume's *House of Tudor* volume of his *History of England*, published in 1759. In this, Hume explains that for 'Ten days and nights she lay upon the carpet, leaning on cushions which her maids brought her; and the physicians could not persuade her to allow herself to be put to bed, much less to make trial of any remedies they prescribed to her.'[43]

There is evidence that Delaroche's painting had been used as reference for a previous stage tableau. As early as 1829 François Ancelot concluded a tragedy on Elizabeth's life with a deathbed scene similar to that depicted in Delaroche's work.[44] In 1867, when the playwrights Eugène Nus and Alphonse Brot opened their play *Testament de la Reine Elisabeth* at the Théâtre de la Gaité in Paris, a review in *Le Temps* stated 'Since the painting of Paul Delaroche, the dramaturgical painter who concerns himself much more with historical *mise-en-scène* than with philosophy, one can not but represent Elisabeth, old and dying, unless lying on cushions and railing through the golden lace of her bristling ruffles.'[45]

The *Testament de la Reine Elisabeth* called for such staging: the opening to the fourth tableau asks that Delaroche's *Queen Elizabeth* is explicitly recreated.[46] Viewed in this context, Bernhardt's adaption and Delaroche's *mise-en-scène* and historical gesture and action takes an added significance. In significantly changing and re-presenting Delaroche's painting, Bernhardt not only references a popular scene and accelerates its action, she also actively changes the character and meaning of the history depicted. In this way, an event was figuratively *and* rhetorically freed from the past.

Bernhardt's elaboration of how we might think about and understand Elizabeth I was part of the celebration of Gloriana in the early twentieth century. Whereas Victorian England had initially characterised Elizabeth as a vain and cruel queen, a pagan and uncivilised goddess, by the time Bernhardt played her, public sentiment had changed. As Leonée Ormond explains, by the 1880s the Elizabethans were no longer considered barbarians but were instead celebrated across the arts for their contribution to English history; the three-hundredth anniversary of the Armada saw public festivities as well as new poems, painting, sculptures and exhibitions. Bernhardt was thus portraying a Queen who loved Essex and a woman who could herself be loved as an empathetic, historical subject. The enduring irony of this is that *Queen Elizabeth* has been written into film history as a high-class failure. We would do well to remember, however, that the tale of Elizabeth and Essex is driven by the failure of a ring to deliver royal pardon. Transformed in the new empire of film, the royal touch was becoming associated with new customs and beliefs. It was the ability to move and be moved that, at the opening of the twentieth century, signalled Bernhardt's capacity to be queen.

NOTES

1 Marc Bloch, *The Royal Touch: Sacred Monarchy and Scrofula in England and France*, trans. J. E. Anderson (London: Routledge & Kegan Paul, 1973), especially 'Introduction', pp. 1–8.

2 *Ibid.*

3 David Mayer, *Stagestruck Filmmaker: D. W. Griffith and the American Theatre* (Iowa City: University of Iowa Press, 2009), p. 29.

4 Jon Burrows, *Legitimate Cinema: Theatre Stars in Silent British Films, 1908–1918* (Exeter: University of Exeter Press, 2003), p. 17.

5 Adolph Zukor bought the American rights to the film, paying US$360 a day plus 10 per cent of gross to Bernhardt and arranged a lavish opening at the Lyceum Theatre in New York. As Arthur Gold and Robert Fizdale state: 'A four reeler, it

reconciled exhibitors towards the longer film and earned $80,000 for Zukor on an investment of $18,000. With this money Zukor was able to make a distribution deal with Paramount Pictures, which he eventually took over.' Arthur Gold and Robert Fizdale, *The Divine Sarah: A Life of Sarah Bernhardt* (New York: Alfred A. Knopf, 1991), p. 310.

6 'L'indiretta partecipazione della grande tragica francese al sorgere delle fortune del fondatore della Paramount è uno dei casi più paradossali della storia dell'industria cinematografica.' *Enciclopedia dello spettacolo* (Rome: Casa Editrice le Machere, 1954), p. 371.

7 Besides *Camille* and *Queen Elizabeth*, Bernhardt appeared in a fifty-second excerpt from *Hamlet* (Clément Maurice, Phono-Cinéma-Théâtre, 1900), and other, longer-playing works: *La Tosca* (André Calmettes, 1908), *Adrienne Lecouvreur* (Louis Mercanton and Henri Desfontaines, 1913), *Sarah Bernhardt à Belle Isle* (*Sarah Bernhardt at Home*, Louis Mercanton, 1913), *Jeanne Doré* (Louis Mercanton with René Hervil, 1915), *Ceux de chez nous* (*Those at our House*, Sacha Guitry, 1915), *Les Mères françaises* (*Mothers of France*, Louis Mercanton and René Hervil, 1917), *It Happened in Paris* (David Hartford, 1919), *Daniel* (director unknown, 1921), and *La Voyante* (Louis Mercanton, 1923). Of these films, *La Tosca, Adrienne Lecouvreur, It Happened in Paris* and *La Voyante* are lost and only a short of excerpt of *Daniel* is available. See David W. Menefee, *Sarah Bernhardt: Her Films, Her Recordings* (Dallas: Menefee Publishing, 2012).

8 See Eileen Bowser, *The Transformation of Cinema* (New York: Scribners, 1990), pp. 204–5; and Richard Abel, *The Ciné Goes to Town: French Cinema 1896–1914* (Berkeley, Los Angeles and London: University of California Press, 1994), p. 316, for recent scholarship that endorses this view. Charles Musser, in his article 'Conversions and convergences: Sarah Bernhardt in the era of technological reproducibility, 1910–1913', *Film History* 25:1–2 (2013), p. 170, cites Terry Ramsaye, Adolph Zukor, Geoges Sadoul, Robert Sklar and Eileen Bowser to support this same point. Further sources could be cited to confirm the criticisms made about Bernhardt's acting. (Jay Leyda and Andre Bazin are also critical of her theatricality.) My point is that 'filmed theatre' has long been used as a term of critique in film studies.

9 See, for example, Abel, *The Ciné Goes to Town*, p. 316. See also Barbara Hodgdon, 'Romancing the Queen', in *The Shakespeare Trade: Performances and Appropriations* (Philadelphia: University of Pennsylvania Press, 1998), pp. 112–15.

10 See, for example, the *Ciné Journal* speaking of Bernhardt as 'THE GREATEST ARTIST OF THE WORLD in the Cinema' and offering the rights for the 'ENTIRE WORLD', marketing the film as 'the most magnificent ever presented.' 'Queen Elizabeth', *Ciné Journal* 230 (18 January 1913), pp. 72–3.

11 See Sander L. Gilman, 'Salome, syphilis, Sarah Bernhardt and the "modern Jewess"', in Sander L. Gilman (ed.), *Love + Marriage = Death and Other Essays on Representing Difference* (Stanford: Stanford University Press, 1998). See also Janis Bergman-Carton, 'Negotiating the categories: Sarah Bernhardt and the possibilities of Jewishness', *Art Journal*, 55:2 (Summer 1996), pp. 57–8, where it is explained that a caricature

Sarah Bernhardt: Her Majesty moves

published in 1884 in *La Vie Parisienne* entitled 'Théodora Puff' shows Victorien Sardou literally 'drumming support' for Bernhardt, who stands 'blowing her own horn' on the stage beside him. Here, Bernhardt's exaggeratedly large nose corresponds to one of the anti-Semitic physiognomic signs of Judaism. Visibly different from those physiognomies of the watching audience, Bernhardt is culturally separated from the crowd. Her thinness also reiterates this separation, suggesting a foreignness which the anti-Semitic imagination translated into sickness and disease.

12 See Sarah Bernhardt's comments about this 'band of students' called the 'Saradoteurs' in Paris in Sarah Bernhardt, *Ma Double Vie: Mémoires de Sarah Bernhardt* (Paris: Eugène Fasquelle, 1923), p. 290. See also Suze Rueff, who relates in her biography of Bernhardt that Bernhardt 'drew to the Odéon the students, the midinettes and the artisans of the *rive gauche*'. Suze Rueff, *I Knew Sarah Bernhardt* (London: Frederick Muller Ltd, 1951), p. 48.

13 See Stephen M. Archer, 'E pluribus unum: Bernhardt's 1905–1906 farewell tour', in Ron Engle and Tice L. Miller (eds), *The American Stage: Social and Economic Issues from the Colonial Period to the Present* (Cambridge: Cambridge University Press, 1993), p. 161.

14 See Frederick S. Boas, *Queen Elizabeth in Drama and Related Studies* (Freeport, NY: Books for Libraries Press, 1970), especially ch. 1 ('Queen Elizabeth in Elizabethan and later drama').

15 See David Beasley, *McKee Rankin and the Heyday of the American Theater* (Ontario, Canada: Wilfred Laurier University Press, 2002), pp. 379–80, for a discussion of this and the impact O'Neil had in Australia.

16 'Queen Elizabeth', *The Argus* (25 March 1901), p. 9.

17 'Amusements', *New York Times* (2 October 1866), p. 5.

18 Marvin A. Carlson, *The Italian Shakespearians: Performances by Ristori, Salvini, and Rossi* (Washington, DC: Folger Books, 1985), p. 34; Susan Bassnett, 'Adelaide Ristori', in Michael R. Booth, John Stokes and Susan Bassnett (eds), *Three Tragic Actresses: Siddons, Rachel, Ristori* (Cambridge: Cambridge University Press, 1996), p. 165.

19 F. G. W., 'Ristori', *American Art Journal* 5:26 (18 October 1866), pp. 407–8.

20 'Bernhardt as Queen Elizabeth', *New York Times* (12 May 1912), p. X9.

21 Bassnett, 'Adelaide Ristori', p. 121.

22 F. G. W., 'Ristori', pp. 407–8.

23 '[N]ous ne comprenons pas grand chose aux griefs qu'articule contre lui l'évêque de Worcester … Qu'importe! Nous regardons Sarah Bernhardt. Et Sarah est extraordinaire. La tragédie incomplète et confuse se concentre, se precise, dans son attitude, dans ses gestes, dans le frémissement de ses mains, dans l'angoisse de ses yeux, dans le tremblement de sa voix haletante et brisée. Nous ne nous intéressons nullement à Essex que nous connaissons fort mal. Mais la douleur de cette femme amoureuse et trahie, l'émoi de cette souveraine tiraillée entre l'élan de son coeur et les obstacles de la raison d'Etat nous remuent. Au dénouement, Sarah Bernhardt est plus admirable encore. … Elisabeth inconsolable, dévorée de remords. … Terribles, le visage de l'artiste, son égarement, son épouvante, et dans ses prunelles l'effroi des

127

récentes hallucinations. [...] Sarah de pousser de merveilleux cris de haine et de nous offrir le spectacle d'une sublime agonie [...] Elle traduit avec une extrême vérité la gamme entière des sentiments humains, elle exprime la véhémence aussi bien que la douceur; son jeu est sincère; il est même à l'occasion réaliste.' Adolphe Brisson, 'Chronique théatrale', *Le Temps* (15 April 1912), p. 1.

24 Gerda Taranow, *Sarah Bernhardt: The Art within the Legend* (Princeton, NJ: Princeton University Press, 1972), p. 169.

25 W. Stephen Bush, 'Queen Elizabeth', *Moving Picture World* (3 August 1912), p. 420.

26 See the photographs reproduced in the catalogue by Carol Ockman and Kenneth E. Silver (eds), *Sarah Bernhardt: The Art of High Drama* (New Haven and London: Yale University Press 2005), pp. 154 and 155. Here we see a reproduction of Hall's 1912 photograph, 'Sarah Bernhardt on caboose of her private Pullman car, "Le Sarah Bernhardt"', as well as the Moffett Studio's 'Sarah Bernhardt standing inside her train "Le Sarah Bernhardt"', 1912.

27 See *ibid.*, p. 84, for an illustration of this.

28 'Queen Elizabeth's ring', *The Times* (19 May 1911), p. 11.

29 'Elizabethan days', *Chicago Defender* (6 April 1912), p. 7.

30 Martin Meisel, *Realizations* (Princeton, NJ: Princeton University Press, 1983), p. 51.

31 As described in William Butler Yeats, 'Notes', *Samhain* (October 1902), p. 4.

32 Thomas Fuller, *The History of the Worthies of England I* (A New Edition with a few explanatory notes by John Nichols) (John Nichols & Son: London, 1811), p. 287.

33 Michael Dobson and Nicola J. Watson, *Elizabeth's England: An Afterlife in Fame and Fantasy* (Oxford: Oxford University Press, 2002), p. 140.

34 *Ibid.*

35 See the photographs of Bernhardt on the live stage in *Queen Elizabeth: Sarah Bernhardt dans 'La reine Elisabeth', pièce d'Emile Moreau: documents iconographiques* (Bibliothèque nationale de France, 1912).

36 *Ibid.*

37 Cited in Susan Bassnett, *Elizabeth I: A Feminist Perspective* (Oxford, New York and Hamburg: Berg, 1988), pp. 73, 74.

38 Winfried Schleiner, '"Divina Virago": Queen Elizabeth as Amazon', *Studies in Philology* 75:2 (Spring 1978), pp. 174–5, 176.

39 I do not want to go into the debates surrounding who painted this image and what it possibly represents. See David Armitage, 'The procession portrait of Queen Elizabeth I: a note on a tradition', *Journal of the Warburg and Courtauld Institutes* 53 (1990). Armitage links it to the 'isolable tradition of representing royal power' and states that because we can see the garter of Edward Somerset, Earl of Worcester, as he walks alongside Elizabeth in the portrait, we can date it to 25 June 1593 as this is when he received the Order of the Garter and became Elizabeth's Master of the Horse after the fall of Essex. See pp. 301 and 305.

40 Cited *ibid.*, pp. 306–7.

41 See discussion of the *Procession Portrait* in Louis Montrose, *The Subject of Elizabeth: Authority, Gender, and Representation* (Chicago and London: University of

Chicago Press, 2006), pp. 104–5, where he states that 'this splendidly festive image of the Elizabeth cult is made the occasion and the means to commemorate the honor and worship of one of Elizabeth's noble followers. By means of this oblique displacement, the Queen remains the nominal subject of the painting, but its real subject becomes the Earl of Worcester in his relationship to the Queen.'

42 May Agate, *Madame Sarah* (London: Home & Van Thal, 1945), p. 170.

43 David Hume, *The History of England*, vol. 1 (London: James S. Virtue, 1800), p. 543.

44 Norman D. Ziff, *Paul Delaroche: A Study in Nineteenth-Century French History Painting* (New York: Garland Publishing, 1977), p. 70.

45 'Depuis le tableau de Paul Delaroche, de ce peintre dramaturge qui s'est occupé de la mise en scène de l'histoire, beaucoup plus que de sa philosophie, on ne peut réprésenter Elisabeth, vieille et mourante, autrement que couchée sur des coussins, et râlant à travers la dentelle d'or de sa collerette hérissée.' Louis Ulbach, 'Revue théâtrale', *Le Temps* (20 May 1867), p. 1.

46 'Le théâtre représent le tableau de la mort d'élisabeth, par Delaroche. La Reine est étendue sur de riches tapisseries amoncelées sur le parquet et lui faisant une sorte de lit. Elle est fardée, mais son visage porte l'empreinte de la mort.' Eugène Nus and Alphonse Brot, *Le Testament de la Reine Elisabeth, drame historique a grand spectacle en cinq actes et huit tableaux* (Paris: Librairie Dramatique, 1867), p. 62.

SELECT BIBLIOGRAPHY

Abel, Richard, *The Ciné Goes to Town: French Cinema 1896–1914* (Berkeley, Los Angeles and London: University of California Press, 1994).

Agate, May, *Madame Sarah* (London: Home & Van Thal, 1945).

'Amusements', *New York Times* (2 October 1866), p. 5.

Archer, Stephen M., 'E pluribus unum: Bernhardt's 1905–1906 farewell tour', in Ron Engle and Tice L. Miller (eds), *The American Stage: Social and Economic Issues from the Colonial period to the Present* (Cambridge: Cambridge University Press, 1993).

Armitage, David, 'The procession portrait of Queen Elizabeth I: a note on a tradition', *Journal of the Warburg and Courtauld Institutes* 53 (1990).

Bassnett, Susan, *Elizabeth I: A Feminist Perspective* (Oxford, New York and Hamburg: Berg, 1988).

——'Adelaide Ristori', in Michael R. Booth, John Stokes and Susan Bassnett (eds), *Three Tragic Actresses: Siddons, Rachel, Ristori* (Cambridge: Cambridge University Press, 1996).

Beasley, David, *McKee Rankin and the Heyday of the American Theater* (Ontario, Canada: Wilfred Laurier University Press, 2002).

Bergman-Carton, Janis, 'Negotiating the categories: Sarah Bernhardt and the possibilities of Jewishness', *Art Journal* 55:2 (Summer 1996).

'Bernhardt as Queen Elizabeth', *New York Times* (12 May 1912), p. X9.

Bernhardt, Sarah, *Ma Double Vie: Mémoires de Sarah Bernhardt* (Paris: Eugène Fasquelle, 1923).

Bloch, Marc, *The Royal Touch: Sacred Monarchy and Scrofula in England and France*, trans. J. E. Anderson (London: Routledge & Kegan Paul, 1973).

Boas, Frederick S., *Queen Elizabeth in Drama and Related Studies* (Freeport, NY: Books for Libraries Press, 1970).

Bowser, Eileen, *The Transformation of Cinema* (New York: Scribners, 1990).

Brisson, Adolphe, 'Chronique théâtrale', *Le Temps* (15 April 1912).

Burrows, Jon, *Legitimate Cinema: Theatre Stars in Silent British Films, 1908–1918* (Exeter: University of Exeter Press, 2003).

Bush, W. Stephen, 'Queen Elizabeth', *Moving Picture World* (3 August 1912).

Carlson, Marvin A., *The Italian Shakespearians: Performances by Ristori, Salvini, and Rossi* (Washington, DC: Folger Books, 1985).

Dobson, Michael and Nicola J. Watson, *Elizabeth's England: An Afterlife in Fame and Fantasy* (Oxford: Oxford University Press, 2002).

'Elizabethan Days', *Chicago Defender* (6 April 1912), p. 7.

Enciclopedia dello spettacolo (Rome: Casa Editrice le Machete, 1954).

F. G. W., 'Ristori', *American Art Journal* 5:26 (18 October 1866).

Fuller, Thomas, *The History of the Worthies of England I* (A New Edition with a few explanatory notes by John Nichols) (London: John Nichols & Son, 1811).

Gilman, Sander L., 'Salome, syphilis, Sarah Bernhardt and the "modern Jewess"', in Sander L. Gilman (ed.), *Love + Marriage = Death and Other Essays on Representing Difference* (Stanford: Stanford University Press, 1998).

Gold, Arthur and Robert Fizdale, *The Divine Sarah: A Life of Sarah Bernhardt* (New York: Alfred A. Knopf, 1991).

Hodgdon, Barbara, 'Romancing the Queen', in *The Shakespeare Trade: Performances and Appropriations* (Philadelphia: University of Pennsylvania Press, 1998).

Hume, David, *The History of England*, vol. 1 (London: James S. Virtue, 1800).

Mayer, David, *Stagestruck Filmmaker: D. W. Griffith and the American Theatre* (Iowa City: University of Iowa Press, 2009).

Meisel, Martin, *Realizations* (Princeton, NJ: Princeton University Press, 1983).

Menefee, David W., *Sarah Bernhardt: Her Films, Her Recordings* (Dallas: Menefee Publishing, 2012).

Montrose, Louis, *The Subject of Elizabeth: Authority, Gender, and Representation* (Chicago and London: University of Chicago Press, 2006).

Musser, Charles, 'Conversions and convergences: Sarah Bernhardt in the era of technological reproducibility, 1910–1913', *Film History* 25:1–2 (2013).

Nus, Eugène and Alphonse Brot, *Le Testament de la Reine Elisabeth, drame historique à grand spectacle en cinq actes et huit tableaux* (Paris: Librairie Dramatique, 1867).

Ockman, Carol and Kenneth E. Silver (eds), *Sarah Bernhardt: The Art of High Drama* (New Haven and London: Yale University Press 2005).

'Queen Elizabeth', *The Argus* (25 March 1901).

'Queen Elizabeth', *Ciné Journal*, 230 (18 January 1913).

Queen Elizabeth: Sarah Bernhardt dans 'La reine Elisabeth', pièce d'Emile Moreau: documents iconographiques (Bibliothèque nationale de France, 1912).

Rueff, Suze, *I Knew Sarah Bernhardt* (London: Frederick Muller Ltd, 1951).

Schleiner, Winfried, ' "Divina virago": Queen Elizabeth as Amazon', *Studies in Philology* 75:2 (Spring 1978).

Taranow, Gerda, *Sarah Bernhardt: The Art within the Legend* (Princeton, NJ: Princeton University Press, 1972).

Ulbach, Louis, 'Revue théâtrale', *Le Temps* (21 May 1867).

Yeats, William Butler, 'Notes', *Samhain* (October 1902).

Ziff, Norman D., *Paul Delaroche: A Study in Nineteenth-Century French History Painting* (New York: Garland Publishing, 1977).

6

Elizabeth I: the cinematic afterlife of an early modern political diva

Elisabeth Bronfen and *Barbara Straumann*

In the American TV mini-series *Political Animals* (2012), Sigourney Weaver plays Elaine Barrish Hammond, a divorced former First Lady who serves as Secretary of State. In a trailer for the series, Hammond explains her own will to power by invoking a comparison to historical female politicians: 'I took this job as Secretary of State because I feel I can make a difference. Eleanor Roosevelt, Cleopatra, Elizabeth the First. That's the kind of company I want to keep.'[1] Because it traces the imaginary legacy of its protagonist not only to the tragic last pharaoh of ancient Egypt but also to the last of the Tudors, this recent TV drama serves as a useful point of departure for this essay, which aims to look at Elizabeth I in relation to cultural anxieties regarding women and public power in the twentieth century. Discussing Elizabeth I as an early modern political media diva may seem preposterous, and yet our claim is that she anticipates the very enmeshment between celebrity culture and political power that is so particular to the charisma of celebrities in the public arena in the twentieth and early twenty-first century. What is at stake in our discussion is, therefore, a self-consciously ahistorical reading of Elizabeth I through the lens of her subsequent recycling as a film icon.

In proposing to look at Elizabeth through her cinematic refigurations, we take our cue from Mieke Bal's notion of doing a preposterous history, by which she means reversing chronological order and looking at the past through the lens of its subsequent recyclings. Bal offers an ingenious spin on the term 'preposterous' as she foregrounds the notion of a reversal 'which puts what comes chronologically first ("pre") as an after-effect behind ("post") its later recycling'. Looking preposterously at the visual culture of the past through later refigurations that have coloured our conception of this past means drawing attention

to what remains hidden when one limits oneself to more conventional inter-
textual influences. In the case of Elizabeth I, a preposterous history entails
revisiting the portraits of this early modern queen, the anecdotes surrounding
her person, as well as memorable passages from her writings in relationship
to the way these have been reconceived on the silver screen. Such a revision
does not collapse past and present in what Bal calls 'an ill-conceived presentism',
nor does it 'objectify the past and bring it within our grasp, as in the problem-
atic positivist historicism'. Instead, the kind of 'preposterous reversal' which
she proposes refers to a way of doing history, of dealing with the past today.[2]
Applying Bal's notion of doing a preposterous history to the cultural survival of
Elizabeth I allows us to draw attention to the manner in which this Renaissance
queen can be discussed as the first political diva precisely because she is such a
resilient example for a complex gendering of sovereignty in the context of the
mass consumption of politics.

Elizabeth I is perhaps not the only early modern queen but certainly one of
the most memorable ones to use her public self-display – both her actual body
and its diverse representations – to strengthen and disseminate her political
power. The many portraits brought into circulation during her lifetime allowed
her both to control her public image and to cement her political power by mak-
ing it possible for her subjects to materially possess her image.[3] With her costly
summer progresses, furthermore, she also came to anticipate nineteenth- and
twentieth-century political mass entertainment. Above all, however, she is the
early modern queen who has had a particularly forceful cultural survival in
Anglo-American visual culture. This is not least because she can be read sub-
sequently as juggling the public persona with the private, that is, the natural
(feminine, ageing, dying) body with a symbolic body that needed to constantly
be reaffirmed as being eternal. As Ernst Kantorowicz famously writes in his
classic study on the king's two bodies in medieval and early modern culture,
it is the union of body natural and body politic that guarantees the continu-
ity and 'immortality' of the sovereign as a political institution.[4] Standing for
the symbolic mandate that the monarch occupies as the deputy of God in the
political landscape of his or her realm, the body politic needs to be embodied
by a body natural and, at the same time, also remedies the imperfections and
mortality to which the individual body is inevitably subjected. In the period
between the individual's death and the accession of the next monarch, the dec-
laration 'The king is dead, long live the king!' effectively affirms the survival
of the body politic.

In the case of Elizabeth I, Kantorowicz's model helps us understand how the cultural survival of this early modern queen has been inspired by the way in which her contemporaneous representations already turned her into a highly iconic figure, thus, ensuring the cultural circulation of her symbolic body to this present day. At the same time, the theory of the monarch's two bodies also refers us to the fact that in the case of the female sovereign, the body natural tends to be more foregrounded (because of her potential role as wife and mother but also because of her exceptional status as a feminine leader in a predominantly masculine world). What distinguishes Elizabeth I from many other female monarchs are the many seemingly contradictory positions that she brought together by gendering the symbolic body of the king and emphasising that she was a queen: namely that of the virgin, the mother only to England, the glorious warrior, and the distant lover, fascinating but also unreachable for all, except as a representation. As we shall see, Elizabeth's play with her myriad roles, but also her status as a public figure positioned between her symbolic body and her feminine natural body, is particularly pronounced in the cinematic recyclings of her figure.

So far seminal critical work has been done regarding the portraits of Elizabeth in the context of early modern portraiture, underscoring the alignment between religious and political allegory.[5] At the same time, Michael Dobson and Nicola Watson have also convincingly discussed the manner in which the changing representation of Elizabeth I in subsequent literary and visual culture can be seen to reflect various shifts in British national self-definition. Suggesting that Elizabeth I is 'the nearest thing England has ever had to a defining national heroine', Dobson and Watson trace how, for example, the early modern queen was turned into the plain-speaking and beef-eating figure of Queen Bess, who came to stand for a nostalgic recollection of an idyllic 'Merry Old England', how the first Elizabeth was invoked to celebrate the coronation of the second Elizabeth as the hopeful beginning of a new Elizabethan age in the aftermath of the Second World War, or how the early modern politician came to be imagined as a double of the first female British Prime Minister, Margaret Thatcher, who attempted to redefine England with her ideology of ambition, greed, new money, militarism and power-dressing.[6]

The allegorical relation between the Queen and the nation can, however, be traced as far back as her early modern portraiture. In fact, the status of Elizabeth I as a national icon is particularly prominent in the so-called 'Ditchley' portrait by Marcus Gheeraerts the Younger, where she can be seen to stand

on a map of England.[7] The sheer size of her superhuman figure, the anatomically improbable proportions delineated by the enormous sleeves as well as the virginal whiteness of her dress, face and hands, all underline that this is not a realistic portrait of an individual person, but a 'state portrait' foregrounding the symbolic body of the Queen, which serves as an abstract allegorical sign for her country. Indeed, visible beneath the figure of Elizabeth I is the territory of the different counties which she would have visited during her extended summer progresses in order to affirm her political sovereign power and which, in the portrait, she seems to protect with her enormous figure cloaked in its mantle. Like the Queen's theatrical self-display during her progresses, the portrait can be seen as an attempt to turn England not only into the stage where she performed her political power but also into a nation state unified by her allegorical figure.

In the 'Ditchley' portrait, Elizabeth I appears to be divided on many different levels. Her gigantic figure simultaneously touches the earthly ground and reaches up to heaven, thus evoking the notion of the sovereign as doubled by his or her human nature and divine status as a monarch anointed by God. At the same time, the figure of the Queen also marks the dividing line between the serene sunlight on the left and the dark stormy sky riddled by lightning on the right. Yet Elizabeth is, significantly enough, also represented as an androgynous figure. Her clothes symbolise her feminine chastity and purity by virtue of their dazzling whiteness, but they also look metallic, like the armour of a warrior prince. Indeed, while Dobson and Watson trace the cultural afterlife that Elizabeth I has enjoyed as a national icon, it is the complex relationship between gender and power in this afterlife that we want to highlight. As the quotation from the mini-series *Political Animals* at the beginning of this chapter indicates, contemporary political culture suggests that it is timely to revisit the issue of power and gender, precisely because the world of media and the world of politics have become ever more intertwined. To be more precise, this chapter explores the particular way in which, at three different historical moments, the body of Elizabeth I and the theatricalisation of her power intersect with the body of the modern film star. In order to do so, we focus on four actresses: Flora Robson in *Fire Over England* (William Howard, 1937) and *The Sea Hawk* (Michael Curtiz, 1940), Bette Davis in *The Private Lives of Elizabeth and Essex* (Michael Curtiz, 1939) and *The Virgin Queen* (Henry Koster, 1955), Jean Simmons in *Young Bess* (George Sidney, 1953) and finally Cate Blanchett in *Elizabeth* (Shekhar Kapur, 1998) and *Elizabeth: The Golden Age* (Shekhar Kapur, 2007).

Read in conjunction with each other, these films not only offer idiosyncratic enactments of an early modern political diva but also allow us to distinguish the diverse cultural needs and anxieties each refiguration of the past addresses and satisfies. For this reason, as we move from one historical period to the next, our discussion brings into play the double-voicing at issue in cinema's historical reimagination of Elizabeth I. As Robert Burgoyne notes, when epic cinema refigures history on screen, it inevitably deploys genre memory. By transporting recollections of the past into the present, history is to a degree always reimagined and reconceptualised from the position of the contemporary now.[8] This means that the cinema screen functions as a conceptual space, straddling a historical event with a present which it claims to speak to by having recourse to a past, but also to previous representations of this past. In the following, we will look at three historical moments in which Elizabeth I came to re-emerge in mainstream cinema so as to examine what ideological values were negotiated by virtue of a theatricalisation of her glamorous political self-representation.

After Sarah Bernhardt's melodramatic performance in *Les Amours de la Reine Elisabeth / Queen Elizabeth* (Henri Desfontaines, Louis Mercanton, 1912), revolving around her ill-fated love relationship with Robert Devereux, Earl of Essex, the first wave of films highlights the manner in which, during the rise of totalitarian governments in the 1930s, cinema engages with and reflects on authoritarian power regimes. While films such as *Gabriel Over the White House* (1933), *Young Mr Lincoln* (1939) and *Mr Smith Goes to Washington* (1939) offer various takes on the presidency, from Gregory La Cava's quasi-dictatorial leader, to John Ford's nostalgic politician and Frank Capra's benign figure of paternal authority, the costume melodramas of the late 1930s and early 1940s displace the struggles of male leaders such as Roosevelt and Churchill onto the figure of the Queen and her political adversaries.[9] Part and parcel of this displacement is the manner in which quasi-historical representations serve to support the war effort by moving into an earlier historical period in order to transcode current political concerns. The 1950s films emphasise how the last of the Tudors gives rise to a debate between the heart and the politics of a powerful sovereign in the context of the political imaginary of the period, including Cold-War paranoia, anxiety about women in the workplace and the coronation of Elizabeth II. The final examples from the late 1990s and the early twenty-first century explore the resuscitation not only of Elizabeth I on screen but also of the previous stars who embodied her. The cultural concerns at issue in this case involve

the manner in which the media have become the site where political battles are fought through as a battle of images.

How do these cinematic refigurations speak to the cultural issues and concerns that the re-enactment of Elizabeth I on screen is meant to address if not resolve? What aspects of this Queen are remembered? And why is it at the body of this Queen that the problematic of gendered sovereignty has come to be so resiliently debated? Our claim is that the Queen's two bodies bring together a feminine body natural with the symbolic mandate she assumes and fulfils. As the woman (mother, lover) is pitted against the politician, the mediality of her material embodiment also comes to be foregrounded. Moreover, these screen re-enactments thematically address the conflict between private person and public persona particular to female sovereignty because the Queen is both stateswoman and potential wife and mother (or virgin in the case of Elizabeth I). This raises the question of how each of the four film divas, by enacting the historical Queen, presents her own two bodies, that of a woman and that of a figure of celebrity culture. Even more important is the question how each of the four actresses brings her celebrity image to her performance of the Queen in a specific historical-cultural context.

It is important to note that all of the films discussed here make little use of narrative development. Both the portrait of the Queen that is brought to the screen as well as the particular story each film tells about her are fairly static. The scripts pick up on and rewrite one of several key historical anecdotes that have been handed down, notably the events leading up to the victorious battle against the Spanish Armada, Elizabeth's jealousy over her courtiers' romantic affairs with one or the other lady-in-waiting, the political volatility surrounding her ascension to the throne or the uprising of the Earl of Essex towards the end of her reign. If, then, there is little dramatic action and very little psychological development in these film narratives, we are instead presented with precisely those clichés with which Elizabeth has come to be identified, notably the tension between her duty as a sovereign and her desire as a woman; the emotional tension between her ageing and the agelessness of her as a queen; and thus the actual feminine body and its containment in the costumes and paraphernalia of political sovereignty.

In other words, the cinematic revisitation of Elizabeth I primarily entails a *mise-en-scène* of her embodiment of sovereign power, her performance of political spectacle. In so far as there is any narrative action, this involves the film heroes and their female lovers, both of whom function as satellites to her stationary

body. These men go into the world, either as soldiers or explorers, and bring the world back to their Queen. But precisely in that they are the ones to move outside the court, while we, as the spectators of this *mise-en-scène*, can both follow them and notice their absence, their mobility serves to underscore the static architecture of the court, which is built around Elizabeth at its centre. At the same time, while it is hard to keep the plots of the different films apart, each film is characterised by the specific star who embodies the Queen. Indeed, what makes these films so ideologically telling is the tacit equation between Elizabeth I and the stars Robson, Davis, Simmons and Blanchett, who preposterously resurrect the image we have of this early modern queen from her portraits and from the historical anecdotes surrounding her reign. Put another way, at issue in these films are less the stories they tell than the way in which they cast the Queen as a star, using reference to the historical figure as advertisement for a studio and its film, invoking her both as a commodity to be consumed, but also to sell the political narrative that she encapsulates. Our claim is that these films are not simply to be understood as historical costume melodrama, but instead as media images of power. Over and beyond the implicit or explicit usage that they make of actual portraits of Elizabeth, the function of these historical reimaginations of her is to create mediatised representations of political power that make this power consumable.

MODERN SOVEREIGNTY

The cinematic re-enactment of Elizabeth I in the context of 1930s geopolitics coincides with a general interest in charismatic queens. In 1933, Greta Garbo appeared in Rouben Mamoulian's *Queen Christina*. The following year Flora Robson played the Empress Elizabeth of Russia alongside Elisabeth Bergner in Alexander Korda's *The Rise of Catherine the Great*, Claudette Colbert brought Cleopatra to the screen in Cecil B. DeMille's monumental epic and Marlene Dietrich offered her impersonation of Catherine of Russia in Josef von Sternberg's *The Scarlet Empress*. Two years later, Florence Eldridge played Elizabeth I alongside Katherine Hepburn in John Ford's *Mary of Scotland*, while Anna Neagle performed Queen Victoria under the direction of Herbert Wilcox in *Victoria the Great* (1937) and then in *Sixty Glorious Years* (1938). Also in 1938, Norma Shearer played the fated French queen in W. S. Van Dyke's *Marie Antoinette*. In most cases the historical reimagination on screen equates the queen with the respective Hollywood star. Yet at the same time, these female

sovereigns also reflect on political leadership in more general terms. More specifically, as fascist governments in Germany, Italy and Spain gained power in the course of the 1930s, the preposterous gaze at earlier queens served to address a cultural present, namely the impending crisis of war. The two historical refigurations of Queen Victoria reflect on England's politics of appeasement, while the fatal demise of Marie Antoinette warns against blindness towards political unrest.

Most explicitly, however, the theatricalised politics of Elizabeth and her battle against the Spanish Armada are used to underline both the threat of and the necessary fight against a fascist takeover. The British production *Fire Over England* (1937) proposes a political allegory in which the defeat of the Armada figures as a determined reaction against Franco's Spain, with Elizabeth of England and Philip of Spain standing in for modern democracy and fascism respectively. In the pivotal scene of the film, before the actual battle begins, we see Flora Robson's Elizabeth spoon-feeding frail Lord Burghley with 'good English broth'. This underscores the Queen's self-fashioning as the mother of England. At the same time, we can already hear the drumbeats announcing war on the soundtrack. The editing then moves to a depiction of this warrior queen as she addresses her troops at Tilbury. The camera work positions Robson not apart from but in close proximity to her soldiers, as, dressed in full battle regalia, she rides to encourage them in their battle. Having reached the camp, Robson quotes parts of Elizabeth's well-known Tilbury speech. Most notably she calls out to her men – citing the historical speech verbatim – that she has 'the body of a weak and feeble woman' but 'the heart and stomach of a king, and of a king of England too' – and, in doing so, emphasises her political androgyny.[10] The visual argument is that because she is shown in the midst of her soldiers, she is one of them. Even on her white horse, which she rides side-saddle, she is hardly more elevated than her troops. Moreover, her bearing appears poised and calm (her horse does not move while she is speaking). The sequence closes with the burning of the Spanish ships. On the soundtrack we hear harps and the voice-over of Robson, invoking the divine force whose wind has scattered the nation's enemies. The disembodied voice seems to mark a divine position so that Robson's voice becomes the voice of the nation and perhaps even of divine providence.

Flora Robson began her career as a British theatre actress, and her public image is hardly one of glamour. During the Second World War, she moved back and forth between Hollywood and the London theatre to support the war effort on both sides of the Atlantic. More explicitly than in *Fire Over England*,

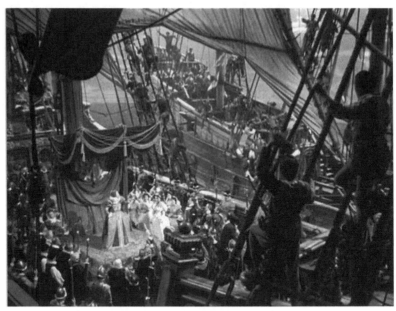

12 Flora Robson as Elizabeth I addressing her people aboard ship in
The Sea Hawk (Michael Curtiz, 1940).

her performance of Queen Elizabeth in the 1940 Hollywood film *The Sea Hawk* (whose director, Michael Curtiz, helmed *Casablanca* two years later) is explicitly aimed at rallying the American audience in its support for the Allies fighting overseas. Equally significant is the much-enhanced theatricality of this historical reimagination. In the final scene of the film, Robson's Elizabeth once again addresses her people, this time not on shore but on a ship. Set off by a canopy she stands on what looks like an elevated stage, thus turning the entire ship into a theatre. Compared to *Fire Over England*, there is more distance between her and her audience. In fact, she can be seen to tower over them. Curtiz's film language not only evokes Hollywood's more glamorous film techniques, but it also gives Robson more of a Hollywood star treatment. The editing moves from a long shot that establishes the scene of her political appeal to a medium shot as she explains to her loyal subjects that 'a grave duty confronts us all. To prepare our nation for a war that none of us wants, least of all your Queen.'

Gesturing toward the shift in President Roosevelt's stance regarding the war, Elizabeth proceeds to assure her ladies-in-waiting as well as the troops surrounding her that while she has tried by all means in her power to avert this war, a time to act has come: 'But when the ruthless ambition of a man

threatens to engulf the world, it becomes the solemn obligation of all free men to affirm that the earth belongs not to any one man but to all men.' By now the camera has seamlessly moved into a medium shot of Robson. While she claims freedom as the title and soil on which England, as a nation, exists, her gestures become more martial. As she pledges ships worthy of English seamen, the camera moves to a close-up of first Errol Flynn and Brenda Marshall, the two romantic leads, now shown to be the Queen's privileged addressees. They are also, however, the cinematic point of transition between the reimagined historical past and the contemporary audience. As Robson's Elizabeth invokes a 'navy foremost in the world, not only in our time but for generations to come', she speaks not only to her diegetic audience. The war effort she invokes is clearly directed at the American movie audience in the year 1940. The historical displacement works to underline the urgency of Roosevelt's own plea to the American people, to whom he had previously pledged that he would not go to war. Curtiz thus has recourse to Elizabeth's skill at political spectacle to suggest a cultural heritage and a cultural debt. With her speech, Robson, as a renowned British actress, is effectively calling upon her fans in America to support the British troops as allies.

One year earlier, Michael Curtiz had directed the historical costume melodrama *The Private Lives of Elizabeth and Essex*, in which Errol Flynn had also played the romantic lead. In this case, however, the role of Queen Elizabeth was performed by Bette Davis. *Private Lives* is one of the films which came out in Hollywood's *annus mirabilis* of 1939, when owing to a change in policy in the Hays Office, it had become possible to bring anti-Nazi sentiment explicitly to the screen. Thus, even if the film foregrounds the private life of the Queen, most notably the tension between her desire as a woman and her duty as a politician, it does so to transform an absolute monarch into a quasi-democratic leader. In a seminal dialogue between her and her favourite lady-in-waiting, she laments the constraint her queenship poses on her romantic desires. 'Thank heaven you're not a queen', she assures Lady Margaret, 'to be a queen is to be less than human, to put pride before desire, to search men's hearts for tenderness and find only ambition, to cry out in the dark for one unselfish voice and hear only the dry rustle of papers of state.' The camera remains in a medium close-up of Bette Davis, as she concludes, '[T]he queen has no hour for love, time presses, events crowd upon her, and for a shell, an empty glittering husk, she must give up all that a woman holds most dear.' Throughout this dialogue scene, the camera remains fairly static.

13 Bette Davis as the isolated Queen in *The Private Lives of Elizabeth and Essex* (Michael Curtiz, 1939).

Only once Elizabeth has asked Lady Margaret to fetch one of her council-lors does the camera move into a close-up of her face. Significantly enough, the close-up shows it reflected in a shard of the mirror she has broken just before the dialogue begins. For a brief moment she looks at herself in anguish and then turns over the reflection that gave us the Queen and the star as a vis-ual fragment. With this detail, the film evokes William Shakespeare's *Richard II*. However, in contrast to Shakespeare's history play, where the breaking of the mirror signals the separation of the two bodies of the king, Bette Davis's Elizabeth completely fuses with her symbolic mandate, thus emphasising the need for a sovereign in times of political threat to cast aside all romantic ambitions that might stand in opposition to national security. In 1936, Edward VIII famously abdicated in order to marry 'the woman I love'. In contrast, Davis's Elizabeth puts her duty as Queen above her personal happiness. She is wedded to her throne just as Bette Davis was committed to her professional ethos, which meant that she was not afraid of playing older women or unflat-tering roles, both of which were not conducive to a traditional Hollywood glamour image.

THE POSTWAR PROFESSIONAL WOMEN

The revisitation of Elizabeth I in the 1950s must be read in the context of the redomestication of the American female workforce at the end of the Second World War. It is important to recall that between 1941 and 1945, over 6 million women were working in defence plants to sustain the war effort, with over 20 million women in the workplace at large. Once the war was over, a great effort was made to persuade women to return to the home and give back their 'job to G.I. Joe'. (The scholarship on film noir has emphasised the cultural anxieties arising from this redistribution of gendered notions of work.) But many of the women stayed on. The 1950s are thus a highly ambivalent period, reintroducing the melodramatic positioning of women in the heart of the home. Yet the films of the decade attest to the fragility of this construction. Not only do many of the female stars relocated in the domestic space seem uncomfortable there, but other films also – even if only subtly – include women in white-collar work, often tragically negotiating their desire for love, family and maternity with the equally powerful desire for a career.

In this context of a cultural ambivalence regarding the re-emergence of working women which has not yet transformed into an active women's movement one might fruitfully place both of the historical reimaginations of Elizabeth I in the 1950s. In *Young Bess* (George Sidney, 1953), Jean Simmons, whom the Hollywood audience would have known from her performance of Ophelia in Laurence Olivier's *Hamlet* (1945), plays the young woman about to become England's queen. Significant for the violent passion she brings to her performance of this role is the fact that in 1952, she was the female star in Otto Preminger's film noir *Angel Face*, playing a war-traumatised young British woman, who kills first her parents, and then her husband when he decides to leave her. In *Young Bess* Simmons again brings a young woman's radical will to power on screen, recalling how, in Preminger's film noir, her eyes are able to shift seamlessly from innocent purity to demonic force whenever her desires are in danger of being thwarted.

In a pivotal scene in *Young Bess*, it is precisely this dangerous passion which is emphasised as she describes her imperial aspirations to Thomas Seymour (Stewart Granger), whom she wants to become the future admiral of her fleet. As she promises an opportunity that he has never dared to dream of, she stands in front of him, an ambitious young woman invoking the figure of the postwar working women of America. While she imagines where she would send

14 Jean Simmons as Elizabeth I in *Young Bess* (George Sidney, 1953).

him and how she would build up her navy, he is drawn into her passion. Yet as he brings into play the issue of romance, assuring her that he envies the man who will be her admiral, the tone of the scene changes, and we realise that her political ambition is shown to be in conflict with her romantic desire. The passion she has for her (future) empire transforms into a jealousy that she must contain as Seymour leaves her side to embrace his true beloved, Catherine Parr (Deborah Kerr), the last wife of her late father, Henry VIII (Charles Laughton). Her discussion of the possibilities open to an England with a grand fleet speak to the American imperialism of the early 1950s, the Cold-War obsession with cultural expansion, implicitly transcoding early modern England into postwar America. Simmons's performance is ominous in the way she speaks (namely with a childlike yet determined voice) but above all in the fiery look with which she beholds her rival, realising that, because she cannot win the battle for the heart of Thomas Seymour, all she has left are politics and war.

As in *The Private Lives of Elizabeth and Essex*, the *mise-en-scène* is fairly static throughout the dialogue between Elizabeth and Seymour. However, once Elizabeth realises that she is confined to her role as a political figure, the camera isolates her. It zooms into a close-up of her fiery eyes, thus foregrounding a cultural anxiety regarding women in power that recalls the anxiety that

Elizabeth evoked in early modern England as a female monarch. One might well speak about an uncanny viewing effect. It is as though we are drawn into a feminine gaze that becomes all-assuming and all-consuming. Unlike Audrey Hepburn in *Roman Holiday* (William Wyler, also 1953), she is not the docile princess who will quietly relinquish romance for her symbolic mandate. Instead there is something decidedly sinister about both her passion and her ambition.

Bette Davis returned to the role of Elizabeth in the 1950s, using her per-formance to comment on her own position as a politically engaged actress. Throughout the 1940s, Davis had firmly entrenched herself as one of the grand character actresses in Hollywood, and by 1950 was able to address the issue of the ageing star in *All About Eve*. Yet what the contemporary audience of *The Virgin Queen* (1955) would also have remembered was the fact that she had been a key supporter of anti-Nazi sentiment since 1933. After the attack on Pearl Harbor, Davis had become particularly energetic in supporting the war effort, known for her bond-drive work as well as founding with John Garfield the Hollywood Canteen, where stars entertained the troops (work which Delmer Daves commemorates in the eponymous film of 1944).[11] When she comes to play Elizabeth again in Henry Koster's costume epic, she is firmly installed as the older woman who has remained a powerful star in the Hollywood system, as well as a forceful political figure. She embodies the veteran professional woman in the American cultural imaginary. The scene portraying the early modern Queen in relation to mid-twentieth-century cultural anxieties regarding femin-ine rule comes at the end of the film. Her love interest, Walter Raleigh (Richard Todd), is about to embark with the woman of his heart (Joan Collins) on his voyage to America. Initially she does not want to be privy to his departure, but her adviser skilfully draws her to the window to see the ship sail off.

Her gaze through the spyglass first zeroes in on the romantic couple, the visual signifier for the romance she has to relinquish. Then, prompted by her adviser, she sees the flag under which the ship is sailing to the New World, namely hers. As in *Young Bess*, she is thus positioned between love and state power. Her poignant comment, 'I have to attend to business of state', as she turns back to her desk is significantly double in its meaning. Business of state is *all* she has, but business of state is also *what* she has. The spyglass with which she isolates first the romantic couple and then the insignia of her political power marks Davis's Elizabeth as the holder of the gaze. Not only can she thus survey her subjects, her gaze also determines what we see. She draws us back to herself, sitting at her desk, dealing with the business of state. Although she embodies

15 Bette Davis as the ageing Elizabeth I in *The Virgin Queen* (Henry Koster, 1955).

the cultural fantasies of Western hegemony during the Cold War, she does so as a woman. She may be frozen in her symbolic position, but she also inhabits it and its immense power.

CONSTITUTING A GENDERED SOVEREIGN

The third and last cultural moment we want to isolate is that of the late 1990s and the beginning of the new millennium. At stake in the preposterous cinematic appropriation of Elizabeth I in this period is a culture of political spin-doctoring, prominent first and foremost in the politics of Bill Clinton, Gerhard Schröder and Tony Blair. Because the task of the spin-doctor is to produce a media image, the politics of this time bring the politician closer to the movie star and thus closer to notions of glamour. In Shekhar Kapur's *Elizabeth* (1998), which propelled the Australian actress Cate Blanchett to international stardom and established her global fame and glamour, the spin-doctor is Elizabeth's spymaster Sir Francis Walsingham, played by Geoffrey Rush. After she has liquidated her political enemies, Elizabeth I thinks about possible ways of consolidating her power. In the decisive scene, as seminal to her understanding of her role as queen as Simmons's discussion with Seymour in *Young Bess*, Blanchett stands below a stone statue of the Virgin Mary as Walsingham suggests to her that since her subjects have found no one to replace the figure of the Virgin, she could turn herself into a living embodiment of this religious icon.

Later in this sequence, after her lady-in-waiting Kat has cut off her long hair, she will address her, while looking directly into the camera, and solemnly declare: 'I have become a virgin.' The wording is important; she does not say that she *is* but that she *has become* a virgin. The formulation underlines that what is at stake is a self-transformation in the course of which she, too, will turn herself into an icon. Like Bette Davis's Elizabeth in *Private Lives*, Cate Blanchett's has to make a sacrifice. But what is affirmed is not the symbolic position of the sovereign in a crisis of national security but rather the public image a political party needs to rally the nation's citizens. Kapur's take on the Renaissance queen is indicative of a certain depletion of the public space at the turn of the millennium. His film taps into a contemporary culture which is characterised by a loss of material substance in public debate. Instead, politics has turned into something that is conducted with media images.

The emphasis on a postmodern image culture is even more pronounced in Kapur's sequel *Elizabeth: The Golden Age* (2007). If, in *Fire Over England*, Flora Robson has to go into battle against a Spanish dictator closely resembling Franco, in *The Golden Age*, Philip of Spain recalls the Iranian leader Mahmoud Ahmadinejad. Once again we have a scene in which the Queen addresses her troops at Tilbury. The film language, however, is very different from that of *Fire Over England*. The *mise-en-scène* and camera angle Kapur chooses produce a far greater distance between Blanchett and her soldiers. Towering high above them, she is visually isolated against the cloud-riddled pale-blue sky. Moreover, in contrast to the fairly static position of Robson on horseback, her horse constantly keeps moving as she describes the enemy's prowess and the violence of the battle about to be unleashed.

Unlike Robson, who refers to the political androgyny of her queen by citing the historical speech of Elizabeth I, Blanchett does not refer to the 'weak and feeble' body she has as a woman and the 'heart and stomach' she has as a king. Instead she chooses to quote another passage from Elizabeth's famous Tilbury speech as she calls out to her soldiers that she is 'resolved in the midst and heat of the battle to live or die amongst you all'. Departing from the historical speech, she assures them that as long as they 'stand together, no invader shall pass', only to conclude to the loud cheering of her troops: 'and when this day of battle is ended, we meet again in heaven or on the field of victory'. It seems that she does not need to quote the passage regarding Elizabeth's political androgyny directly because it has become part of what one might call the quotable Elizabeth. Moreover, the Queen's martial identity is visually staged

in the way Blanchett, wearing a suit of armour and sitting astride her white horse, is posed above her men. Indeed, she is an iconographic hybrid of medieval and early modern warriors: her flowing loose hair and her plate armour are reminiscent of Joan of Arc, and the sequence also evokes Kenneth Branagh's cry to battle in *Henry V* (1989). Everything about this Elizabeth is citational, a postmodern pastiche. Unlike Robson, Blanchett does not make an appeal to an extra-diegetic audience. Instead her speech is oddly detached – perhaps because today the enemies of state are dispersed. But perhaps also because all that remains in Kapur's 'preposterous' appropriation of this early modern queen is pure cinematic image.

SHIFTS IN THE IMAGE

While each of the films discussed gives embodied life to a particular conception of Elizabeth I, they all end by transforming her into a final 'portrait'. These final tableaux freeze her moving image, and in so doing, pay homage to portraiture as the very art form which they have recast in the medium of the twentieth century. Placed next to each other, they offer a map of so-called pathos formulae, much along the lines of Aby Warburg's *Mnemosyne Atlas*. Defining these aesthetic formalisations of intense affects, Warburg was able to show not only how certain pathos formulae survive in cultural memory but also how they undergo shifts as they are rearticulated at various points in cultural history. Following his gesture, we juxtapose the different final 'portraits' of Elizabeth in the various films in order to render visible a cartography of both the visual and narrative implementation of the female star as queen.[12] Each of the final moments encapsulates the particular way in which the film in question thinks through the fascination and anxiety regarding gendered sovereignty. Also at issue is the manner in which the subsequent films rethink and refigure their predecessors, while their freezing of the Queen into a final 'portrait' reminds us of portraiture, the medium already used by Elizabeth I. In other words, what we want to highlight is how the films cite and reconceive previous representations of queenship according to the cultural concerns of their times. It is for this reason that it is useful to work with Robert Burgoyne's notion of double-voicing in order to address the political fantasies and anxieties of the current moment when the films were released. Placing these final image formulae next to each other means noticing the similarities as well as the thematic and aesthetic shifts that have taken place between the individual examples.

In the first wave of Elizabeth films, the historical reimagination served to speak *about* and *to* the world of totalitarian politics in the 1930s. The 1950s characterisations of this early modern queen allowed for an articulation regarding an anxiety about professional women. The recycling of clichés in Kapur's postmodern refigurations, finally, connects the pop iconography of celebrity culture to the spin-doctoring of politics at the end of the twentieth century. The cultural survival of the image formulae by which Elizabeth's legacy has taken hold of the contemporary imaginary can be seen as mainstream cinema's sustained engagement with queenship as a form of political celebrity. What the cinematic recyclings of Elizabeth I foreground is a politicisation of celebrity. The star brings her celebrity to her enactment of the historical queen. At the same time, cinema turns stars into political figures, and it does so in a world in which politicians present themselves ever more as stars.

At the end of *Fire Over England* we see Flora Robson praying among her people. She is a bit above them, yet also part of them. Although the camera focuses on her, she is together with her diegetic audience. Behind her we see the romantic couple that has formed under her auspices, played by the stars Laurence Olivier and Vivien Leigh (who themselves began an affair while acting as lovers in this film). The Queen is the mother of the couple as she is the mother of the nation. At the same time, she is also a Madonna to the people kneeling around her. In the final moments of *The Sea Hawk*, the *mise-en-scène* is far more theatricalised, and yet Flora Robson is still close to her people. She forms the centre of the image; she has the main light. The ship evokes a stage, with the audience grouped around her as she calls upon them to act politically, and implicitly to the audience in the movie theatre. Indeed, in her appeal to us she recalls Roosevelt's appeal to the American nation.

In the first of the two Bette Davis performances, it is significantly the gaze of Errol Flynn (playing Essex, who is about to be executed) that leads to the last scene. What we see, guided by Flynn's gaze, is the lonely figure of the Queen as she is sitting on her throne whilst Essex, her former favourite and love interest, is executed as a result of his political rebellion against her. The *mise-en-scène* of her solitary figure in the almost dark room underscores her isolation, but the scene also culminates in a final 'portrait' that shows her firmly wedded to her throne. The fact that the scene is introduced by Flynn's gaze indicates that the final image could be read both as the fantasy of Essex and as the actual experience of the Queen. While the drum roll on the soundtrack announces his imminent beheading, she moves nervously

and the camera becomes unsteady as it zooms to a medium shot of the Queen. Then, once the drums stop, signalling that he has been beheaded, she becomes static, as though frozen in her image. Implicitly, once his head has fallen, she becomes secure in her power, in her symbolic position. His head is the sacrifice necessary for her to remain on her throne. The *mise-en-scène* isolates her (no audience is visible as in the other films) but she is firmly positioned there as the camera moves to an extreme long shot, thus offering one final tableau of the Queen who has sacrificed romance for her duty as a stateswoman. In *The Virgin Queen*, when Bette Davis once more plays the part, she actually recycles herself. As in *Elizabeth and Essex*, she is isolated in space, sitting at her desk, and alone, after her courtier has left her to her work. She seems exhausted, perhaps weeping. As in the earlier film, her isolation is foregrounded, yet we also have the final cheerful music, which stands in stark contrast to her pose. As the camera tracks back, we see her as a figure of quiet despair, yet firmly emplaced in her symbolic position. The final image again affirms her in her power.

Young Bess installs yet another image formula, namely the birth of the Queen. We see Simmons, walking onto a balcony, about to accept her mandate to be queen, and hear her cheering subjects, although the crowd remains invisible. The camera focuses exclusively on her, zooming into a close-up of her face, as the actress holds her pose. Then an overlapping dissolve superimposes an image of the crown onto her face. (The release of the film coincided with the coronation of Elizabeth II, thought by many to usher in a so-called new Elizabethan era.) Like Bette Davis, though far less tragically, Simmons also becomes static, indicating that she has become a political icon. As in *The Virgin Queen*, her isolation marks the sacrifice that is necessary, in this case not for the Queen to maintain her power, but for the young Princess to become Queen. The most radical shift towards a frozen image can, however, be found in *Elizabeth*. Initially Blanchett emerges from white light, takes on shape and then invokes one of the many citations making up what we have come to call the quotable Elizabeth. As she turns towards one of her most eminent advisers, she declares: 'Observe, Lord Burleigh, I am married to England.' The throne she moves to is comparable to an altar, on which she, indeed, becomes an icon. The film ends with a freeze frame, transforming the body of the Queen into the fixed symbolic body of the Virgin but also into an image that reminds us of the early modern portraiture of Elizabeth.

In its declared passion for the aesthetics of postmodern pastiche, *Elizabeth: The Golden Age*, finally, works with even more quotable Elizabeths. Blanchett

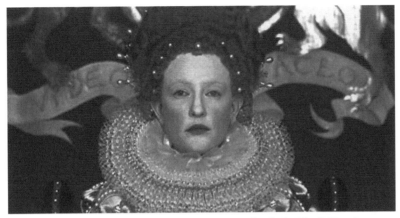

16 Cate Blanchett as the iconic Queen in *Elizabeth: The Golden Age*
(Shekhar Kapur, 2007).

17 Cate Blanchett as the Queen astride a map of Europe in *Elizabeth: The Golden Age*.

assumes the pose of the Madonna with Child, again enveloped in white light, as she declares 'I am your Queen, I am myself.' Kapur's Elizabeth is the first one to speak about her transformed state in terms of freedom. And as she makes her declaration of self-identity, she looks at us. She is isolated in her diegetic space and shifts her appeal to an extra-diegetic audience, thus recalling Robson in *The Sea Hawk*. White light then introduces the final image: a top

shot of Elizabeth standing on a map of Europe. By standing in the Channel and facing the continent, Blanchett visualises the imperialism Simmons invokes in *Young Bess*, while the map recalls the famous 'Ditchley' portrait, which shows Elizabeth, dressed in white, standing on a map of England. Adorned with transparent wing-like elements, Blanchett's dress also reminds us of the one in the 'Ditchley' portrait and, more generally, evokes the figure of a flying angel. At the same time, the translucence of Blanchett's ruff and the soft light in which this final scene is shot evoke the 'Rainbow' portrait also attributed to Marcus Gheeraerts the Younger. Painted in the very last years of Elizabeth's life, it represents the Queen as a beautiful young bride with an appearance much lovelier and softer than in her other portraits. As in the 'Ditchley' portrait, her cloak suggests the wings of an angel, bird or perhaps a butterfly. Part of the fabric is diaphanous, airy, almost like gossamer. The radiance and brilliance of the Queen in the 'Rainbow' portrait is precisely what is evoked by the luminous quality of Kapur's film language in this last scene. With this final example, we have arrived in the realm of a highly self-conscious reflexivity. The final sequence quotes portraits of Elizabeth as well as the previous film stars embodying her. So doing, it condenses these previous refigurations in order to produce Elizabeth I as a pure signifier.

We conclude with these final scenes in order to emphasise that at the end of each film, the movement of the Queen's body is frozen into an image, even if Kapur's *Elizabeth* is the only film to actually use a freeze frame. This is the final image, the 'portrait' in both senses of the word, namely the actual image and the image idea, with which the films install the Queen and her power by way of narrative closure. She is the one to survive as a queen (over political adversaries and romantic debacles). She is a survivor, and with her survive her portraits, handed down from one film to the next.

NOTES

1 *Political Animals*, TV mini-series written and directed by G. Berlanti, USA Network, aired from 15 July to 19 August 2012.
2 Mieke Bal, *Quoting Caravaggio: Contemporary Art, Preposterous History* (Chicago and London: University of Chicago Press, 1999), pp. 6, 7.
3 For a discussion of the ways in which Elizabeth I used her visual representation to consolidate her political power see Kevin Sharpe, *Selling the Tudor Monarchy: Authority and Image in Sixteenth-Century England* (New Haven and London: Yale University Press, 2009).

4 Ernst H. Kantorowicz, *The King's Two Bodies: A Study in Mediaeval Political Theology* (Princeton, NJ: Princeton University Press, 2nd edn, 1998).

5 See in particular Roy Strong, *Gloriana: The Portraits of Queen Elizabeth I* (London: Pimlico, 2003); David Fischlin, 'Political allegory: absolutist ideology and the "Rainbow Portrait" of Queen Elizabeth I', *Renaissance Quarterly* 50:1 (1997); Louis Montrose, *The Subject of Elizabeth: Authority, Gender, and Representation* (Chicago and London: University of Chicago Press, 2006); and again Sharpe, *Selling the Tudor Monarchy*.

6 Michael Dobson and Nicola J. Watson, *England's Elizabeth: An Afterlife in Fame and Fantasy* (Oxford: Oxford University Press, 2002), p. 1.

7 For reproductions of this and other portraits of Elizabeth I, see Strong, *Gloriana*.

8 Robert Burgoyne, *Film Nation: Hollywood Looks at U.S. History* (Minneapolis: University of Minnesota Press, rev. edn, 2010).

9 See Burton W. Peretti, *The Leading Man: Hollywood and the Presidential Image* (New Brunswick: Rutgers University Press 2012).

10 'Queen Elizabeth's armada speech to the troops at Tilbury, August 9, 1588', in Leah S. Marcus, Janel Mueller and Mary Beth Rose (eds), *Elizabeth I: Collected Works* (Chicago and London: University of Chicago Press, 2002), pp. 325–6.

11 See Elisabeth Bronfen's chapter on war entertainment in *Specters of War: Hollywood's Engagement with Military Conflict* (New Brunswick: Rutgers University Press, 2012).

12 Aby Warburg, *Der Bilderatlas Mnemosyne*, ed. Martin Warnke and Claudia Brink, in *Gesammelte Schriften: Studienausgabe* II 1.2, ed. Horst Bredekamp, Michael Diers, Kurt W. Forster *et al.* (Berlin: Akademieverlag, 3rd edn, 2008).

SELECT BIBLIOGRAPHY

Bal, Mieke, *Quoting Caravaggio: Contemporary Art, Preposterous History* (Chicago and London: University of Chicago Press, 1999).

Bronfen, Elisabeth, *Specters of War: Hollywood's Engagement with Military Conflict* (New Brunswick: Rutgers University Press, 2012).

Burgoyne, Robert, *Film Nation: Hollywood Looks at U.S. History* (Minneapolis: University of Minnesota Press, rev. edn, 2010).

Dobson, Michael and Nicola J. Watson, *England's Elizabeth: An Afterlife in Fame and Fantasy* (Oxford: Oxford University Press, 2002).

Fischlin, David, 'Political allegory: absolutist ideology and the "Rainbow Portrait" of Queen Elizabeth I', *Renaissance Quarterly* 50:1 (1997).

Kantorowicz, Ernst H., *The King's Two Bodies: A Study in Medieval Political Theology* (Princeton, NJ: Princeton University Press, 2nd edn, 1997).

Marcus, Leah S., Janel Mueller and Mary Beth Rose (eds), *Elizabeth I: Collected Works* (Chicago and London: University of Chicago Press 2002).

Montrose, Louis, *The Subject of Elizabeth: Authority, Gender, and Representation* (Chicago and London: University of Chicago Press, 2006).

Peretti, Burton W., *The Leading Man: Hollywood and the Presidential Image* (New Brunswick: Rutgers University Press, 2012).

Sharpe, Kevin, *Selling the Tudor Monarchy: Authority and Image in Sixteenth-Century England* (New Haven and London: Yale University Press, 2009).

Strong, Roy, *Gloriana: The Portraits of Queen Elizabeth I* (London: Pimlico, 2003).

Warburg, Aby, *Der Bilderatlas Mnemosyne*, ed. Martin Warnke and Claudia Brink, in *Gesammelte Schriften: Studienausgabe* II 1.2, ed. Horst Bredekamp, Michael Diers, Kurt W. Forster *et al.* (Berlin: Akademieverlag, 3rd edn, 2008).

7

Queens and queenliness: Quentin Crisp as
Orlando's Elizabeth I

Glyn Davis

Sally Potter's *Orlando*, an adaptation of Virginia Woolf's 1928 novel, first screened at film festivals in 1992, before being released in cinemas internationally in 1993. The film opens in 1600, with Orlando (Tilda Swinton) serving as a poet and page in the court of Queen Elizabeth I (Quentin Crisp). Crisp's appearance in *Orlando* is fleeting. The role, in its brevity, is comparable with Judi Dench's appearance as the same monarch in *Shakespeare in Love* (John Madden, 1998): somewhat infamously, Dench won an Academy Award for her performance, though she is only on screen for a few minutes.

Crisp's scenes as Elizabeth I – in keeping with other cinematic depictions of this particular monarch – are visually spectacular. The Queen arrives by longboat, at night, at a stately home which is decorated inside and out with bouquets and candles. At a banquet, Orlando recites a poem for the monarch, which she finds distasteful. On the following day, Orlando accompanies the Queen, wolfhounds and courtiers on a walk through formal gardens, where Elizabeth attaches a garter, venerable symbol of royal esteem, to Orlando's leg. Finally, Orlando visits the Queen in her bedroom; after Elizabeth has been undressed by her ladies-in-waiting and helped into bed, she and Orlando have an intimate conversation. During this encounter, Orlando is advised by the Queen: 'Do not fade; do not wither; do not grow old.' And so he doesn't: the remainder of the film depicts various episodes from Orlando's life over several centuries. Halfway through it, Swinton's character changes from male to female. Looking in a mirror, she declares 'Same person. No difference at all. Just a different sex.'

On 25 December 1993, the same year that *Orlando* attained widespread distribution in cinemas, Crisp appeared on British television's Channel 4, presenting the channel's first ever Alternative Christmas Message. Subsequently, this has become a mainstay of the channel's festive programming, scheduled

155

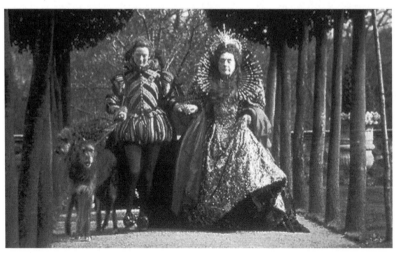

18 Elizabeth I (Quentin Crisp) is accompanied by Orlando (Tilda Swinton) on a walk in *Orlando* (Sally Potter, 1993).

head-to-head with Elizabeth II's own speech. Over the years, contributions to the programme have included the overtly political (Margaret Gibney, a schoolgirl from Belfast, made a plea for peace in 1997; controversially, Mahmoud Ahmadinejad, the president of Iran, was awarded the slot in 2008) and the more lightly comedic (Sacha Baron Cohen as Ali G in 1999, Marge Simpson of *The Simpsons* in 2004). Crisp's inaugural message overtly counterposed his role as a queer queen against Elizabeth II's status as monarch. If it is possible to say that the televised Crisp was 'playing' Elizabeth II – if only at the level of a satirical equivalence – then he shares a connection with Helen Mirren: they are the only two actors to play both Elizabeths. (Mirren took the titular role in the HBO miniseries *Elizabeth I* (Tom Hooper, 2005), and played Elizabeth II in *The Queen* (Stephen Frears, 2006) and the play *The Audience* (2013 and 2015).)

The programme opened with a red flag, embroidered with the letters 'QC', flapping in the wind. (Crisp's initials might also be read, of course, as 'Queen's Counsel'.) Slow-motion footage of Crisp being driven in a horse-drawn carriage around Central Park, New York, was sound-tracked by a clumsy attempt at 'God Save the Queen' played on a bugle. Delivered from an armchair in front of a fire, the speech was announced with a subtitle: 'QUENTIN CRISP, THE QUEEN'. Crisp was not dressed as Elizabeth II for his Alternative Message (more's the pity); rather, he wore a sensible combination of brown blazer, blue vee-necked

sweater and purple cravat. In a poker-faced *double entendre*, he connected his 'queen's speech' to his role in *Orlando*: 'A reginal theme has permeated my year.' Introducing a clip from Potter's movie, he commented that 'The film connects the many moments of English history with what, regrettably, I believe is called "gender-bending".' Most of the remaining Alternative Message advocated life in the United States, recommending that others in the UK should follow Crisp's lead and emigrate. Later on the same day, he also appeared on Channel 4's show *Camp Christmas*, alongside a roster of famous queer figures, including Melissa Etheridge, Derek Jarman, Ian McKellen, Armistead Maupin, Martina Navratilova – and Australian comedian Gerry Connelly, impersonating Queen Elizabeth II.

This chapter revisits the early 1990s, and Quentin Crisp's two brief performances as 'the Queen'. It explores three distinct but interrelated topics. In the first section, the 'fit' between Crisp's 'queenliness' and his roles as Elizabeth I and II are examined. Do aspects of the persona and life story of this 'stately homo' (a term Crisp used in reference to himself) make him an appropriate choice for either impersonation? Next, attention is turned to debates about queer cinema that circulated in the early 1990s, and the complicated position that Potter's *Orlando* and Quentin Crisp occupy in relation to these. Both 'gay' and 'queer', mainstream and marginal, Crisp's appearances as 'the queen' occurred at a significant turning point for gay / queer film and culture. Finally, the chapter examines Virginia Woolf's *Orlando* and asks whether it can be retrospectively categorised as a 'queer' text. If so, in what ways is this queerness manifested? And how is this related to Woolf's attitudes towards the monarchy? The significance of Crisp's role in Potter's film, I will suggest, is its yoking together of the queerness of Woolf's novel with the author's equivocal attitude towards royalty.

THE END OF AN ERA: CRISP'S REIGN AS QUEEN

Quentin Crisp was born in Surrey, England, on 25 December 1908. (His Alternative Message was aired on his eighty-fifth birthday.) He lived as an overt homosexual during decades in which male homosexuality was illegal. In 1968, the year after it was decriminalised in England, his autobiography *The Naked Civil Servant* was published. Crisp had intended, in a nod to Milton's *Paradise Lost*, to call his book *My Reign in Hell* – a title which would have framed his experiences as those of a netherworld monarch – but his agent insisted otherwise.[1] *The*

Naked Civil Servant details Crisp's childhood, his patchy periods of employment (most notably as a nude model for art classes) and his manifold sexual encounters with other men. The book was made into a television film in 1975, starring John Hurt and directed by Jack Gold; in 2009, Hurt reprised the role in a sequel, *An Englishman in New York*, directed by Richard Laxton. On the heels of the success of the 1975 film, Crisp began performing a one-man show, comprised of a mixture of personal anecdotes and reminiscences and a question-and-answer session with the audience. The show toured for many years. In 1981, Crisp emigrated to New York, where he remained until his death in 1999.

Throughout the 1970s and 1980s, Crisp became a renowned public figure, and was repeatedly interviewed on television. His stage show was broadcast on Channel 4 as *An Evening with Quentin Crisp* in 1980. Jonathan Nossiter's documentary *Resident Alien*, which follows Crisp around New York, was released in 1990, two years before *Orlando*. Although Crisp had made one or two minor appearances as an actor in films and television programmes, his role in *Orlando* was the first to garner any significant publicity and critical attention. And yet his love of cinema was substantial. Reflecting on the 1950s in *The Naked Civil Servant*, he writes:

> I managed to go to the pictures ... on an average once a week for many years; sometimes I went three times in three consecutive days and, very occasionally, twice in one day, thus spending seven hours out of twenty-four in the 'forgetting chamber'. Real life became for me like a series of those jarring moments when the screen goes blinding white, the jagged edge of a torn strip of film flicks one's eye-balls and there is a flash of incomprehensible numerals lying on their sides (like a message in code from Hades) before the dream begins again. [...] I was still a devotee of the divine woman. In my lifetime she changed her name three times, calling herself first Brigitte Helm, later Greta Garbo and finally Marlene Dietrich. I thought about her a great deal, wore her clothes, said her sphinx-like lines and ruled her kingdom.[2]

Crisp's idols, then, who had the status of powerful monarchs, were the larger-than-life screen queens of an era that was starting to fade from view. These were figures with whom his own identity melded, melted: it is feasible, in his dandy-with-*maquillage* attire, that he 'wore her clothes', or at least his own interpretation of them, but unclear exactly how he 'ruled her kingdom'. Crisp had little time for a new generation of stars such as Marilyn Monroe, or directors such as Antonioni, both of whom he criticises in *The Naked Civil Servant*.

However, he wrote a film column for the gay-orientated magazine *Christopher Street* throughout the 1970s and 1980s; a collection of these pieces, entitled *How to Go to the Movies*, was published in 1984.

Although Crisp was infatuated with a certain generation of silver screen royalty, he rarely commented on the English monarchy. Through his autobiography, subsequent books and public appearances he shaped an identity as a raconteur and entertainer, delivering carefully crafted and rehearsed epigrams and witticisms. Not unlike a member of the royal family, Crisp's answers were rarely spontaneous or off-the-cuff; he was always performing himself. The one member of royalty that Crisp did pass judgement on, negatively, was Diana, Princess of Wales (Diana Spencer). In an interview with Thom Nickels, he commented:

> I don't know how she became a saint. She was a Lady before she became Princess Diana so she knew the racket. Royal marriages have nothing to do with love. You stand beside your spouse and you wave and for that you never have a financial worry until the day you die and you are photographed whenever you go out … what more could she want?[3]

Crisp was compared to royalty by writers and journalists. John Walsh, in the *Independent*, referred to Crisp as 'England's first queen of hearts', an appellation also used of Diana.[4] For Guy Kettelhack, 'he was one of the seminal presences of the twentieth century – right up there with, and sharing many of the traits of Garbo, the Queen Mum, and Muhammad Ali'.[5] For these authors, then, Crisp's cultural position was comparable to those of both Diana Spencer and Queen Elizabeth the Queen Mother, the wife of King George VI. These are tantalising figures of comparison, as both had some cultural currency with (certain factions of) gay men – Diana in part for her work with people with HIV/AIDS, the Queen Mum for her alleged reputation as a fan of a party and a tipple.

For Sally Potter, however, Crisp's persona squared neatly with the role of Elizabeth I. In an interview with Penny Florence, she discussed her casting decisions:

> [W]ith Quentin, there are so many ways in which he's right for the part of Queen Elizabeth I, from physical resemblance onwards to the fact that he is the Queen of Queens, the true royal of England, and persecuted, the Englishman in exile *par excellence*. For me part of the secret pleasure of casting Quentin was restoring to him his true status as an iconic figure on the cultural scene.[6]

This quotation raises two provocative questions. First, what qualities account for 'true royalty'? Potter here dismisses the regular markers: bloodline, class position, family history. Crisp – born Denis Charles Pratt – grew up in a household which, though not in poverty, was far from wealthy. The phrase 'the Queen of Queens' configures an alternative regal lineage employing distinct criteria, avoiding considerations of wealth and heredity; it installs those gay men who have lived openly, brazenly and flamboyantly throughout history as royalty, with Crisp as their figurehead. Second, Potter associates persecution and exile with the monarchy. Elizabeth I experienced persecution early in life at the hands of her sister, Mary I, who had Elizabeth confined at the age of twenty in the Tower of London for allegedly plotting with Protestant rebels. After two months in the Tower, Elizabeth was moved to Woodstock, where she was placed under house arrest for almost a year. Crisp's *The Naked Civil Servant* details countless incidents of persecution, presenting a litany of abuse endured. However, the comparison falters. Elizabeth I returned from exile and, soon after, ascended to the throne. Crisp, in contrast, willingly chose exile from England, the country in which he experienced decades of difficulty. The last twenty years of his life, most of which he spent in New York, were arguably his 'golden age'. For both queens, however, their periods of suffering made them sympathetic to a broader public.

In relation to Crisp's Alternative Message, and the themes of persecution and sympathy, it is worth noting that 1992 was identified by Elizabeth II as her '*annus horribilis*': Prince Andrew and Sarah Ferguson separated; Anne, the Princess Royal, divorced her husband Mark Phillips; Charles and Diana separated; the Queen was pelted with eggs by protestors during a visit to Dresden; a fire broke out at Windsor Castle; the operations of the royal finances were reformed, with the Queen having to pay income tax for the first time; and the Queen sued the *Sun* newspaper for printing her Christmas speech before it aired. In 1993, then, when Crisp impersonated both Elizabeths, the royal family was at a low ebb, fragmented and falling apart. As Crisp's Alternative Message screened opposite Elizabeth II's speech, the viewing public had a difficult choice to make: to which ageing dame, suffering in adversity yet attempting to express some sort of hopeful sentiment, would they give their time and attention?

Potter implies that Crisp had a physical resemblance to Elizabeth I, which aided his casting in the role. Many portraits of Elizabeth I were produced

19 Cross-gender casting for the Queen (Quentin Crisp) in *Orlando*.

during her decades-long reign. The best-known is the 'Darnley' portrait, painted around 1575–76, which art historian Roy Strong attributes to the Italian artist Federico Zuccari.[7] The 'Darnley' portrait provided a 'face pattern' which was then used for many authorised paintings of Elizabeth into the 1590s. This not only freed the monarch from having to sit repeatedly for her portrait, but also prevented her likeness from ageing. Elizabeth I's distinctive 'look' is largely cosmetic: red hair; auburn, gold, black and orange clothing; negligible eyebrows; a prominent ruff. Although she and Crisp may have shared a strong nose, it is possible for numerous and diverse actors to impersonate Elizabeth I with the aid of costume designers and hair and make-up artists.

There are other ways in which the casting of Crisp in *Orlando* could be read as appropriate. Elizabeth I did not marry or have children, and was known as 'the Virgin Queen'. Christopher Haigh, in his biography of Elizabeth I, reveals that a Scottish emissary said to the Queen, '[Y]our Majesty thinks that if you were married you would be but queen of England, and now you are both king and queen!'[8] Crisp, despite the erotic exploits detailed in *The Naked Civil Servant*, lost interest in sex. In an interview late in life, he revealed that he had been celibate for almost fifty years.[9] In 1981, he published a second volume of autobiography entitled *How to Become a Virgin*. Elizabeth I's behaviour was often provocatively masculine: in a famous speech that she delivered to her troops at Tilbury in Essex, she said 'I know I have the body of a weak and feeble woman; but I have the heart and stomach of a king, and of a king of England too.' In

161

contrast, Crisp often acted in provocatively feminine ways. As the documentary *Resident Alien* makes clear, Crisp was familiar with the value and advantages of rehearsal and honing delivery in relation to performing his own persona. And yet, elsewhere, he was dismissive of his performance in *Orlando*:

> I don't really act. I say the words the way I would say them if I meant them. But I don't know how people act. I've never understood that. I asked a girl who came from America to England ... and she admitted she had been to a drama school. And I said, 'What did they teach you?' And she said, 'They taught me to be a candle burning in an empty room.' I'm happy to say she was laughing while she said it, but she meant it. I've never learned to be a candle burning in an empty room. So I go on the screen, and I say whatever I'm told to say.[10]

Of his appearance in *Orlando*, Crisp commented: 'It was hell to do. I wore a bonnet so tight it blistered my stomach. I wore two rolls of fabric tied around my waist with tape, and then a hoop skirt tied around my waist with tape, and then a quilted petticoat, and then a real petticoat, and then a dress. And I could never leave the trailer in which they were put on me without some-one lifting up the whole lot.'[11] Sometimes it's hard to be a woman: Crisp's statement, and the bed-chamber scene in Orlando, highlight the clothing toil that has been experienced by many members of the monarchy across the cen-turies – and, indeed, by many women in general. He was prepared, he said, to take 'two and a half hours' to 'reconstruct myself' in the morning, but Elizabeth I's layers of clothing still proved a formidable hurdle, a qualitatively distinct challenge.[12]

Crisp's scenes in *Orlando* are announced with two intertitles: '1600', 'DEATH'. Elizabeth I died in 1603: *Orlando*'s opening scenes take place at the end of the monarch's reign. In the early 1990s, Crisp, too, was nearing the end of his life. Elizabeth bequeaths Orlando a house, but orders him to embody an alterna-tive approach to time: 'do not wither; do not grow old'. As an heir of sorts, Orlando moves through time periods, genders, locations, all without ageing a day. Orlando acts as a successor, a changing of the guard. So too with the actors playing these roles: Crisp's drag gives way to Swinton's androgyny. Can this narrative and teleological manoeuvre be interpreted as a 'clearing of the ground', with one form of otherness (Crisp's homosexuality) replaced by some-thing fresh (Swinton's queerness)? How might *Orlando*'s gay/queer politics be unpacked, and how are these imbricated with its representation of royalty?

REVISITING THE QUEER CINEMA 'MOMENT'

The late 1980s and early 1990s, the time of *Orlando*'s production and release into cinemas, was a rich cultural period in terms of representations of gay/ queer sexuality, and one marked by debate, disagreement and dissent. Potter's *Orlando* became a key text in three distinct but overlapping discussions, concerning the relationship between heritage cinema and sexual difference, stereotyping and attempts to identify and define 'queer cinema'.

British heritage cinema in the 1980s and 1990s was most often associated with Merchant-Ivory Productions – the films of producer Ismail Merchant and director James Ivory, personal and professional partners who regularly worked with the screenwriter Ruth Prawer Jhabvala. The Merchant-Ivory stable became synonymous with adaptations of novels by E. M. Forster and Henry James – including *A Room with A View* (1985) and *Howards End* (1992) – although their output, produced across more than four decades, was more diverse than this characterisation admits. During the 1980s, the British heritage drama more broadly, with its emphases on repressed passions, actorly talent, realist attention to detail and spectacular depictions of grand architecture, had found some space for representations of homosexuality, most notably in *Another Country* (Marek Kanievska, 1984), *The Bostonians* (James Ivory, 1984) and *Maurice* (James Ivory, 1987). Although these films are notable for their analyses of the repression and conservatism of the times they depict – analyses which also had relevance for the years of Thatcher's rule in the UK during which they were produced – their narratives unfolded in a linear and realistic fashion, without formal or stylistic innovation.

Many theoretical considerations of heritage cinema have attempted to interrogate the political ramifications of a body of films that seems to revel in the spectacular pleasures of stately homes and 'authentic' costumes, which takes delight in the trappings of the well-to-do. Richard Dyer, in his essay 'Homosexuality and heritage', draws a valuable contrast between history and heritage:

> History is a discipline of enquiry into the past; heritage is an attitude towards the legacy of the past. Both have to deal with what comes down to us, what is left over, from the past. However, whereas historical enquiry uses an examination of the left-overs to try to understand what happened in the past and why, a heritage sensibility values them for their own sake, savours the qualities and presence of dwellings, costumes, artworks, objects.[13]

Heritage cinema, then, appears to wallow in the surface. However, as Andrew Higson and others have noted, heritage films are often riven with contradictions,

their pretty spectacle set off against elements of social critique.[14] For example, notes Dyer, despite 'its middlebrow respectability and focus on a homophobic past, heritage cinema in general has been surprisingly hospitable to homosexual representation'.[15] This serves to insert homosexual characters into the past, restoring them to history; it may also, as with films such as *Another Country* and *Maurice*, locate moments of lesbian and gay defiance, resistance and courage within these eras.

However, these titles benefit from comparison with a group of British period films made between the late 1970s and the early 1990s that revisited particular moments in history with explicit artifice and staginess, deploying a more complex form of queerness – films which lie outside the heritage canon. This group would include Derek Jarman's *Jubilee* (1978), in which Elizabeth I journeys from the period of her own reign to that of her namesake, *Caravaggio* (1986) and *Edward II* (1991), as well as Isaac Julien's *Looking for Langston* (1989). *Jubilee* and *Caravaggio* have personnel connections with *Orlando*: Tilda Swinton was a regular Jarman collaborator, and featured in several other films by the director, including *War Requiem* (1989), *The Garden* (1990) and *Edward II*. Further, *Caravaggio*'s costumes were designed by Sandy Powell, who also worked on *Orlando*. Powell has repeatedly designed costumes for film representations of royalty, including *The Other Boleyn Girl* (Justin Chadwick, 2008) and *The Young Victoria* (Jean-Marc Vallée, 2009).

The films by Jarman and Julien, in particular, offer alternative models of envisioning queer sexuality in earlier historical periods, different ways of understanding the relationships between sexual alterity and history. In a 2009 interview about *Orlando* at London's National Film Theatre, Tilda Swinton related Potter's film to British heritage cinema, and the difficulties that they faced in creating their own contribution to the genre:

> The only people who made costume films were Merchant-Ivory, and their kind of attitude to costume films was, generally speaking, nostalgic and hagiographic about a kind of traditional grid. ... We knew for sure that whatever we did ... we wanted to rock that – we wanted to keep some kind of present contact between the audience and the character.[16]

Julianne Pidduck, writing about *Orlando*'s design, highlights how the film marks its difference from the standard format of heritage cinema through its artificiality:

> [*Orlando*'s] historical moments are not produced ... through the conventions of realism (even as applied within more traditional costume drama), but rather

through the metonymic excess of elaborate set design and splendid overblown costume. The staged fantastical setting of each movement calls attention to the film's irreality. [...] The excess of the costumes and ridiculousness of the infinite ritual and pomp offer a kind of ongoing visual satire of the histori-cal conventions of bourgeois English manners, gender comportment and, less rigorously, empire.[17]

Indeed Potter herself, in an interview about making the film, has noted that she did not attempt to make a 'realistic' period drama:

I always said to the design teams: this is not a costume drama, this is not a his-torical film, it's a film about now that happens to move through these periods. Research and find out all the things we can and then throw them away. We're going to stylize, we're going to leave out, exclude certain colours or textures or shapes. The usual approach to costume drama is in the genre of realism, where a room is made to look like a room as it is thought to have looked then. But the premise of *Orlando* is that all history is imagined history and leaves out all the most important bits anyway.[18]

Orlando, then, aligned its approach to heritage cinema with those of Jarman and Julien. The problematic limits and conservative politics of the form led Potter, instead, to the deployment of a more playful postmodern aesthetic.

In addition to differences of opinion regarding the form of heritage cinema, and how it could accommodate – or be reconfigured by – queerness, a further topic of debate at the time of *Orlando*'s making related to cinematic stereo-typing. The year 1987 saw the publication of the revised, expanded edition of *The Celluloid Closet*, US gay rights activist Vito Russo's historical account of the limited stereotypes used by mainstream cinema to represent lesbian and gay characters. (A documentary of the same name, based on Russo's book and directed by Rob Epstein and Jeffrey Friedman, was released in 1995. One of the documentary's talking heads – who memorably compares homophobia with a distaste for green vegetables – is Quentin Crisp.) In the wake of this book's release, the ongoing debate relating to media employment of queer stereotypes escalated, with a variety of writers, activists and filmmakers contributing to the discussion.

Of direct relevance to this chapter's exploration of *Orlando*, and Quentin Crisp's performance in the film, the continued association of homosexuality with camp and drag was one such stereotype. For some commentators, camp had become an outmoded and unnecessary tactic, associated with a closeted

era before the birth of the gay rights movement. Daniel Harris, for instance, argued:

> As the forces of social stigma and oppression dissipate and the factors that contributed to the making of the gay sensibility disappear, one of homosexuals' most significant contributions to American culture, camp, begins to lose its shape. [...] Camp cannot survive our ultimate and inevitable release from the social burden of our homosexuality. Oppression and camp are inextricably linked, and the waning of the one necessitates the death of the other.[19]

Diva worship and effeminate behaviour were seen by such critics as relics of homosexuals' oppressed and miserable past. Furthermore, it was argued, camp had become increasingly mainstreamed since the 1960s, understood by a widespread percentage of the population and no longer solely the preserve of gay men. For other authors, however, camp's deployment by gay men persisted because of its critical and political charge. The contributors to the edited collection *The Politics and Poetics of Camp*, for instance, published in 1994, held to a hard-line argument that camp is an inherently political discourse and its deployment by straights a mere appropriation. Drag, like camp, was also subject to similar scrutiny, defended and pilloried in equal measure: an embarrassing relic to some, a deconstructive practice highlighting the performative nature of all gendered behaviour to others.

Orlando is a rich text in relation to these debates. What Crisp derogatorily referred to as the film's 'gender-bending' in his Alternative Message takes a number of forms, encompassing both camp and drag. Crisp's own scenes playfully highlight his association with feminine clothing and behaviour by placing him in the regal dress he so disliked, and he modulates his voice away from his regular deep, harsh drawl, making it higher and more gentle. The interactions between Elizabeth I and Orlando play across marked differences of status and age, and are additionally complicated by the fact that both Crisp and Swinton are cross-dressed. At other points in the film's diegesis, the fragility of gender as a performance is highlighted further. Elizabeth I's herald is played by musician Jimmy Somerville, who sings in falsetto (Somerville also made an appearance in *Looking for Langston*); Orlando attends a play in which a female character is obviously played by a man; Shelmerdine (Billy Zane), Orlando's lover, is portrayed in a notably feminine manner, with long hair and pouting lips.

It is tempting to read the death of Elizabeth I in *Orlando* as a comment on the place of camp and drag in queer culture of the early 1990s, as a 'clearing of the

ground'. This is partly related to casting decisions. Quentin Crisp may have been 'true royalty' for Potter, but not for some gay men. As John Walsh commented in an interview with Crisp, his 'relations with the American gay community are far from cordial. He is too old-style camp, he says, too bouffant and retrograde to be approved of in the clone zones of San Francisco and Greenwich Village. He's an embarrassing throwback, and an argumentative one.'[20] In contrast, Swinton's Orlando seems to put forward a possible new queer ideal – one that is slippery, hard to read, evades categorisation. Indeed, the character arguably personifies Eve Sedgwick's definition of queerness as 'the open mesh of possibilities, gaps, overlaps, dissonances and resonances, lapses and excesses of meaning when the constituent elements of anyone's gender, of anyone's sexuality aren't made (or can't be made) to signify monolithically'.[21]

The first encounter between Elizabeth and Orlando is fraught: the Queen objects to the content of Orlando's poem, which seems to be a comment on ageing. A rapprochement is quickly reached. However, there is perhaps a provocative comment being made here about an older form of gay culture and its relationship to youth. The Queen warns Orlando not to age or wither. Is the passing of youth the worst thing that a queen can envisage? The brief argument between Elizabeth and Orlando (which does not appear in Woolf's novel) invites comparisons with other cinematic representations of this monarch, in which she is depicted as aggressive, combative, even tyrannical. For instance, it is worth contrasting this relationship in *Orlando* with the rivalry in *The Virgin Queen* (Henry Koster, 1955) between Elizabeth (Bette Davis) and Beth Throgmorton (Joan Collins). For Elizabeth, Beth's relationship with Sir Walter Raleigh (Richard Todd) is a challenge on a number of levels: Beth is younger, able to bear children, healthier and arguably more able to do as she pleases. Although Beth does not wish to be queen, there are echoes in *The Virgin Queen*'s narrative of another Bette Davis movie, *All About Eve* (Joseph L. Mankiewicz, 1950). These films, of course – *All About Eve*, *The Virgin Queen* – are touchstones for an older gay male culture in thrall to the power of the diva, the form of gay culture that Daniel Harris (amongst others) denounced as outmoded. That it is possible to identify resonances of both, however fleeting and allusive, in *Orlando*'s opening scenes, contributes to a sense that Potter's film is concerned with searching for a queer alternative, a radical successor (and one who is not merely the next crowned sovereign).

Is *Orlando*, then, an instance of 'queer' cinema – in particular, of New Queer Cinema? In 1992, having attended a number of film festivals – Amsterdam,

Sundance and Toronto – at which *Orlando* was one of several independent lesbian and gay films screened – B. Ruby Rich penned an article for the *Village Voice*, arguing for the existence or coming-into-being of a new cinema movement which she termed 'New Queer Cinema'. Rich's essay was swiftly reprinted in *Sight and Sound*, accompanied by several additional short articles; a three-day international conference on New Queer Cinema also took place at the ICA. For Rich, the 'new queer films and videos' were 'united by a common style'. As she wrote:

> Call it 'Homo Pomo': there are traces in all of them of appropriation and pastiche, irony, as well as a reworking of history with social constructionism very much in mind. Definitively breaking with older humanist approaches and the films and tapes that accompanied identity politics, these works are irreverent, energetic, alternately minimalist and excessive. Above all, they're full of pleasure.[22]

Rich, then, claimed that the dominant connection between the New Queer Cinema films was a stylistic or aesthetic one, and that this style was to be understood as a 'homo' incarnation or variant of postmodernism; a concern with revisiting history was identified as a major preoccupation.

Rich's definition of New Queer Cinema's shared style seems to neatly summarise *Orlando*'s aesthetic, and to square with Pidduck's and Potter's comments on the film's artificial staging and design. In this regard, it is valuable to compare *Orlando* with some of the key films often named in relation to New Queer Cinema: *Poison* (Todd Haynes, 1991), *The Hours and Times* (Christopher Münch, 1991) and *Swoon* (Tom Kalin, 1992). Like *Orlando*, these films also feature reconstructions of particular periods in history: *Swoon* is set in the 1920s and focuses on the murderers Leopold and Loeb; *The Hours and Times* imagines an affair between Brian Epstein and John Lennon; *Poison* has three disparate narrative strands, including a Genet-influenced prison story and a sci-fi/horror tale about infection. In all of these examples, the historical authenticity usually associated with period drama is replaced by staged reconstruction which draws attention to its own fabrication, continually exposing its workings as fiction – and thus, 'history' as a fictional discourse.

Dennis Altman relates *Orlando* to *The Crying Game* (Neil Jordan, 1992), stating that both 'can be described as "queer"' because 'they unsettle assumptions and preconceptions about sexuality and gender and their inter-relationship'.[23] Altman is not the only author to connect these two films: at the time of

Orlando's release, many reviewers did the same, thanks to both featuring revelatory 'gender switch' moments. For Andrew Moor, *The Crying Game*'s queerness is productively imbricated with its handling of national politics:

> Jordan plays out his love plots within the conflict in northern Ireland. These 'Troubles' are the crying game the film addresses. The gender issues imaginatively allegorise the politics of the six counties. Sexual boundaries, the film suggests, are as artificial as the border dividing Ireland, and crises of category in the realm of sex and gender are connected to other crises in the realm of nationhood.[24]

Sophie Mayer has made a similar argument regarding *Orlando*'s status as a queer film:

> Making Somerville the Herald to Crisp's Virgin Queen was a bold statement that queer alternatives were right there in British history, and had always been part of British culture as a fierce and exciting undercurrent of difference *within* the mainstream. [...] *Orlando* makes a [subtle] argument for a redefinition of Britishness as queer, feminine, Eurocentric, downwardly mobile and experimental.[25]

Orlando, then, may be positioned as an instance of New Queer Cinema, in particular through its excessive and artificial aesthetic, its deconstructive approach to heritage cinema's *mise-en-scène*. More broadly, the film can be framed as queer as a result of its complex engagement with drag, camp, sexuality and gender performance, and the productive ways in which it connects these to specific moments in history – including the reign of Elizabeth I.

VIRGINIA WOOLF, QUEERNESS, ROYALTY

Having established the queerness of Potter's *Orlando*, does this retrospectively enable the identification of Woolf's source novel as queer, or proto-queer? Further, how might such an ascription be related to the book's handling of royalty – and, indeed, Woolf's broader attitudes towards the monarchy?

Virginia Woolf's position within the history of lesbian fiction is well established, and has been explored and dissected by a wide range of authors. *Orlando* is a key title here, as aspects of its content are based on the life of Vita Sackville-West, with whom Woolf had an affair lasting several years. The book was originally to be called 'Orlando: Vita'; though styled as a 'biography', Victoria Glendinning's description of *Orlando* as 'a phantasmagoria of Vita's

life spread over several centuries' is more accurate.²⁶ Specific characters are indebted to real-life individuals: Sasha, the Russian princess, is Violet Trefusis, another of Sackville-West's lovers; the transvestite Archduchess Harriet is Lord Lascelles, who had proposed to Vita; Shelmerdine is Sackville-West's husband Harold Nicolson. Orlando's poem 'The Oak Tree' is a veiled version of Vita's *The Land* (1926), and incorporates appropriated lines from the latter. Vita's son Nigel Nicolson famously called *Orlando* 'the longest and most charming love letter in literature'.²⁷

The first edition of *Orlando* contained eight illustrations, including a photo of Woolf's niece Angelica, portraits drawn from the Sackville-West family collection and three photographs of Vita. Each was falsely captioned, as though the images were of the book's characters: Vita became Orlando, Angelica was 'the Russian Princess as a child'. The painting that alleged to be 'The Archduchess Harriet' was actually Marcus Gheeraerts the Younger's portrait of Mary Curzon (1585–1645), Countess of Dorset, who was married to Edward Sackville, 4th Earl of Dorset. What is notable about this portrait is its resemblance to another by Gheeraerts: his painting of Queen Elizabeth I made around 1592, known as the 'Ditchley' portrait. The pose, styling and clothing of Countess and Queen are similar. This contributes an additional layer to *Orlando*'s complex blurring between 'real-world' personages and the book's characters. Elizabeth I appears fictionalised in the novel; an illustration 'informs' readers that Mary Curzon's likeness is 'of' the Archduchess Harriet (who turns out, in Woolf's story, to be a dissembling Archduke Harry in drag); the painting of Curzon resembles a well-known portrait of Elizabeth I. To put this more explicitly: Mary, who is dressed like Elizabeth, is announced as the character Harriet, who is really cross-dressing Harry. The choice of this image by Woolf, then, operates as playful recognition that the dress of the gentry – and, as a result of the resemblance to Elizabeth I, the stylings of the monarchy – can serve as a spectacular gendered performance that obscures the sexed body beneath. In Sally Potter's film, it is worth noting, Archduke Harry (John Wood) does not cross-dress, behaviour that might have manifested as a second 'drag Queen' and undercut the impact of Crisp's regal role.

This distinction between novel and film draws attention to one of Woolf's book's queerest elements: its panoply of unstable identities. Orlando's fantastical change of sex from male to female allows readings of the character as variously heterosexual, bisexual or transsexual. The book's narrator, discussing Orlando's new sex, reflects on the limitations of binaries and the imbrications of sex and gender: 'Different though the sexes are, they intermix. In every

human being a vacillation from one sex to the other takes place, and often it is only the clothes that keep the male or female likeness, while underneath the sex is the very opposite of what it is above. Of the complications and confusions which thus result everyone has had experience.'[28] These confusions are manifested in the narrative: when Orlando first sees Sasha, he notes her 'extraordinary seductiveness' but cannot identify her as male or female; Orlando and Shelmerdine, despite being engaged, both voice suspicions about the other's 'real' sex.[29] Indeed, *Orlando* is a novel which, as Merry Pawlowski notes, 'call[s] the whole notion of sexual fixity into question'[30] – a novel in which the hazy gendered and sexual identities of a significant number of characters operate as 'dissonances and resonances, lapses and excesses of meaning', to recall Eve Sedgwick's phrasing.

Woolf's book also unsettles other 'fixities'. *Orlando* poses as a 'biography' – a titling and generic act of misdirection which initially confused booksellers – but features an admixture of fictional material, real historical figures and fictionalised versions of actual individuals. Woolf intended the book to fall between genres, tones, registers. Whilst writing *Orlando* in 1927, she noted in her diary, 'It has to be half laughing, half serious: with great splashes of exaggeration.'[31] The book also troubled definitions of 'the historical novel' and 'the epic saga' by featuring a protagonist who traverses several hundred years within one relatively slim volume. For Elizabeth Freeman, it is the biographer-narrator's tracking and pursuit of Orlando across the centuries that gives the novel its queer charge:

> If we read *Orlando*'s biographer as historiographer, and his object Orlando as a figure for the past itself, then the writing of history is also figured as a seduction of the past and, correspondingly, as the past's erotic impact on the body itself. [...] Woolf's methodology, then, centres on an avowedly erotic pleasure: an *ars erotica* of historical enquiry that takes place ... between and across the bodies of lusting women.[32]

Orlando distributes its queerly sexed and gendered characters throughout and across numerous historical periods. In doing so, it effects a similar project to those New Queer Cinema films, mentioned above, which revisit particular eras in order to uncover the configurations of sexual alterity they enabled, abided, nurtured.

Elizabeth I's appearance in Woolf's *Orlando*, as with that in Potter's adaptation, is brief. The depiction of the monarch is ambivalent, mixing the respectful

with speculative sexual perversity. As Orlando bows before the Queen, offering her a bowl of rosewater, the biographer draws a sympathetic portrait:

> For she was growing old and worn and bent before her time. The sound of cannon was always in her ears. She saw always the glistening poison drop and the long stiletto. As she sat at table she listened; she heard the guns in the Channel; she dreaded – was that a curse, was that a whisper? Innocence, simplicity, were all the more dear to her for the dark background she set them against.[33]

And yet on the following page the teenage Orlando is seduced by the Queen, fifty years his senior. The description of this defloration interweaves abject detail with thinly veiled innuendo:

> [S]he pulled him down among the cushions where her women had laid her (she was so worn and old) and made him bury his face in that astonishing composition – she had not changed her dress for a month – which smelt for all the world, he thought, recalling his boyish memory, like some old cabinet at home where his mother's furs were stored. He rose, half-suffocated from the embrace. 'This', she breathed, 'is my victory!' – even as a rocket roared up and dyed her cheeks scarlet.[34]

Queen Elizabeth I's speech to her troops at Tilbury, referred to earlier, concluded with the phrase 'we shall shortly have a famous victory over those enemies of my God, of my kingdom, and of my people'. Woolf's use of the words 'This is my victory!' may be a comic allusion to this utterance, triumph in battle equated with conquest in the boudoir. As the Queen is stained with success, Orlando experiences Oedipal confusion, the monarch's 'astonishing composition' redolent of 'his mother's furs' – Woolf's evocative, multivalent phrases conflating the reginal and vaginal. Sally Potter's adaptation, despite its assortment of queer riches, shies away from showing sexual congress between Orlando and the Queen, Swinton and Crisp; no rockets roar up.

Woolf's engagement with the monarchy in *Orlando* echoes across her other writings, surfacing in novels, essays and diaries. A sustained reflection on the monarchy occurs in *Mrs Dalloway* (1925), for instance. Clarissa is buying flowers in Mulberry's on Bond Street when a car with window blinds passes by. 'But nobody knew whose face had been seen. Was it the Prince of Wales's, the Queen's, the Prime Minister's?' Clarissa decides it was 'probably the Queen'.[35] There follows a rumination on the power and longevity of the royal lineage:

> The face itself had been seen only once by three people for a few seconds. Even the sex was now in dispute. But there could be no doubt that greatness

was seated within; greatness was passing, hidden, down Bond Street, removed only by a hand's-breadth from ordinary people who might now, for the first time and last, be within speaking distance of the majesty of England, of the enduring symbol of the state which will be known to curious antiquaries, sifting the ruins of time, when London is a grass-grown path and all those hurrying along the pavement this Wednesday morning are but bones with a few wedding rings mixed up in their dust and the gold stoppings of innumerable decayed teeth. The face in the motor car will then be known.[36]

Clarissa here equates the monarchy with 'greatness' and 'endurance', and draws a distinction between 'ordinary people' and royalty: the attitude expressed is deferent, almost submissive. Published just three years later, *Orlando* is notably less reverential, less in awe of royalty, and prepared to take liberties in its depictions of real historical figures.

In 1934 Woolf expressed an alternative view of the monarchy in a review of *The Story of My Life* by the Romanian Queen Marie. This piece of writing was entitled 'Royalty', and opened by comparing the titular focus with animals:

Royalty to begin with, merely as an experiment in the breeding of human nature, is of great psychological interest. For centuries a certain family has been segregated; bred with a care only lavished upon race-horses; splendidly housed, clothed, and fed; abnormally stimulated in some ways, suppressed in others; worshipped, stared at, and kept shut up, as lions and tigers are kept, in a beautiful brightly lit room behind bars. The psychological effect upon them must be profound; and the effect upon us is as remarkable. Sane men and women as we are, we cannot rid ourselves of the superstition that there is something miraculous about these people shut up in their cage. [...] Now one of these royal animals, Queen Marie of Roumania, has done what had never been done before; she has opened the door of the cage and sauntered out into the street.[37]

Woolf praised Queen Marie's book, claiming it was well written. She argued that its significance lay in revealing royalty to be normal human beings, no different from anyone else. However, she identified that this could have disruptive, even potentially revolutionary potential:

But what will be the consequences if this familiarity between them and us increases? Can we go on bowing and curtseying to people who are just like ourselves? Are we not already a little ashamed of the pushing and the staring now that we know from these two stout volumes that one at least of the animals can talk? We begin to wish that the Zoo should be abolished; that the royal animals should be given the run of some wider pasturage – a royal Whipsnade.[38]

Woolf here identifies the fragility of the monarchy's meticulously crafted enclosure, and the ease with which 'the royal animals' might escape. The public face of the monarchy, she suggests, is merely an impassive cover for ordinary passions and quotidian concerns.

Woolf works through these ideas in more detail in her 1936 diary, regularly shifting her opinions towards the monarchy. On 27 January she describes George V's funeral procession:

> [W]e saw the coffins & the Princes come from Kings X: standing packed in the Square democracy, though held back by Nessa [Vanessa Bell, Woolf's sister], swarmed through; leapt the chain, climbed the trees. Then they came, the coffin with its elongated yellow leopards, the crown glittering & one pale blue stone luminous, a bunch of red & white lilies: after that 3 undertakers in black coats with astrachan [sic] collars: 'our King' as the woman next to me called him, who looks blotched & as if chipped by a stone mason: only his rather set wistful despair marked him from any shopkeeper – not an ingratiating face: bloated, roughened, as if by exposure to drink life grief & as red as a fisherboys. Then it was over. & I shall not try to see more. But the whole world will be afoot at dawn tomorrow.[39]

In line with Clarissa Dalloway's sense of reverential awe, Woolf here documents the spectacle of 'democracy', 'the whole world', clamouring to witness the dead King. She also draws attention to extravagant detail, to leopards and lilies. And yet Woolf inserts an honest critique of the appearance of the new monarch, Edward VIII, undercutting the passage's recognition of the moment's historical import.

Later in 1936, Woolf detailed the revelation of Edward VIII's relationship with Wallis Simpson, and his abdication. Across several diary entries, her vacillating attitudes towards the affair and the monarchy were set down. On 7 December, she wrote:

> All London was gay and garrulous – not exactly gay, but excited. We cant [sic] have a woman Simpson for Queen, that was the sense of it. She's no more royal than you or me, was what the grocer's young woman said. But today, before the PM makes his announcement to the House, we have developed a strong sense of human sympathy; we are saying Hang it all – the age of Victoria is over. Let him marry whom he likes. In the Beefsteak Club however only Lord Onslow & Clive take the democratic view. Harold [Nicolson] is glum as an undertaker, & so are the other nobs. They say Royalty is in Peril. The Empire is divided. In fact never has there been such a crisis. That I think

is true. [...] Things – empires, hierarchies – moralities – will never be the same again. Yet today there is a certain feeling that the button has been pressed too hard: emotion is no longer so liberally forthcoming. And the King may keep us all waiting, while he sits, like a naughty boy in the nursery, trying to make up his mind.[40]

Riven with contradictions, this entry variously positions Woolf with two strands of general public opinion, a collective 'we' – Simpson can't be Queen, the King should marry as he desires – and with 'the nobs', who believe that 'Royalty is in Peril'. Three days later, Woolf writes:

Meanwhile 'the people' have swung round to a kind of sneering contempt. 'Ought to be ashamed of himself' the tobacconists [sic] young woman said. [...] He could have gone on with Mrs S. as mistress till they both cooled: no one objected. Now he has probably lost her, & thrown away the Kingdom & made us all feel slightly yet perceptibly humiliated. Its [sic] odd, but so I even feel it. Walking through Whitehall the other day, I thought what a Kingdom! England! And to put it down the sink ... Not a very rational feeling. Still it is what the Nation feels.[41]

It is possible to detect in these entries aspects of *Mrs Dalloway*'s reverence, *Orlando*'s mixture of respect and glee-at-disruption and of the 'Royalty' review's consideration of the possibility that monarchs are everyday folk with quotidian concerns. The diary entries also add to this mixture insight into the opinions of different classes regarding the monarchy, and a recognition of the way in which the status of royalty is bound up with nationalism, a nation's understanding of its own power, position and status.

Orlando – Woolf's queer, genre-defying fantasia – was her first written expression and exploration of an equivocal attitude towards the monarchy. Beginning the tale of her gender-switching protagonist with an encounter between Orlando and an ageing, lusty Queen inserted Elizabeth I into a tapestry of characters whose identities are wavering, opaque, unsettled. One of the major innovations of Potter's screen adaptation is a purposeful blurring between the source book's roster of ambiguous, vacillating characters and Woolf's ambivalent attitude towards the monarchy. Casting Quentin Crisp as Elizabeth I enabled Potter to queer the Queen, and thus to highlight that issues of class, gender and sexuality are always necessarily interrelated. Woolf's ambivalence about royalty is transformed into an evanescent revelling in the potential queenliness of Queens.

175

NOTES

1 Nigel Kelly, *Quentin Crisp: The Profession of Being – A Biography* (Jefferson, NC: McFarland, 2011), p. 73.

2 Quentin Crisp, *The Naked Civil Servant* (Glasgow: Fontana/Collins, 1981), p. 202.

3 Thom Nickels, 'His homosexual holiness', archived at http://crisperanto.org/interviews/nickels1.html.

4 John Walsh, 'England's first queen of hearts was always Quentin Crisp', *Independent* (15 June 1996), www.independent.co.uk/arts-entertainment/englands-first-queen-of-hearts-was-always-quentin-crisp--now-at-86-resident-in-manhattan-where-he-is-one-of-the-few-famous-people-listed-in-the-telephone-directory-1337088.html.

5 Guy Kettelhack, quoted on the Quentin Crisp Archives website, www.crisperanto.org/bio/index.html.

6 Penny Florence, 'A conversation with Sally Potter', *Screen* 34:3 (Autumn 1993).

7 Roy Strong, *Gloriana: The Portraits of Queen Elizabeth I*. London: Thames and Hudson, 1987.

8 Christopher Haigh, *Elizabeth I* (Harlow, Essex: Pearson, 2nd edn, 1998).

9 Nickels, 'His homosexual holiness'.

10 Keith Phipps, 'Englishman in New York: legendary author and wit Quentin Crisp talks with *The Onion*', archived at http://crisperanto.org/interviews/phipps.html.

11 *Ibid.*

12 *Ibid.*

13 Richard Dyer, 'Homosexuality and heritage', in *The Culture of Queers* (London and New York: Routledge, 2002), p. 206.

14 Andrew Higson, 'Re-presenting the national past: nostalgia and pastiche in the heritage film', in Lester Friedman (ed.), *Fires Were Started: British Cinema and Thatcherism* (London: UCL Press, 1993).

15 Dyer, 'Homosexuality and heritage', p. 204.

16 Swinton makes this statement in 'Orlando + In Conversation with Sally Potter and Tilda Swinton', 2 December 2009, www.bfi.org.uk/live/video/261.

17 Julianne Pidduck, 'Travels with Sally Potter's *Orlando*: gender, narrative, movement', *Screen* 38:2 (Summer 1997), p. 175.

18 Florence, 'A conversation with Sally Potter', pp. 276–7.

19 Daniel Harris, *The Rise and Fall of Gay Culture* (New York: Ballantine, 1997), p. 34.

20 Walsh, 'England's first queen of hearts'.

21 Eve K. Sedgwick, *Tendencies* (Durham, NC and London: Duke University Press, 1993), p. 8.

22 B. Ruby Rich, 'New Queer Cinema', *Sight and Sound* 2:5 (September 1992), p. 32.

23 Dennis Altman, 'On global queering', *Australian Humanities Review* (July 1996), www.australianhumanitiesreview.org/archive/Issue-July-1996/altman.html.

24 Andrew Moor, 'Beyond the pale: the politics of Neil Jordan's *The Crying Game*', in Robin Griffiths (ed.), *British Queer Cinema* (London and New York: Routledge, 2006), p. 159.

25 Sophie Mayer, *The Cinema of Sally Potter: A Politics of Love* (London and New York: Wallflower, 2009), p. 2.

26 Victoria Glendinning, *Vita: The Life of V. Sackville-West* (New York: Quill, 1983), p. 203.

27 Nigel Nicolson, *Portrait of a Marriage* (New York: Atheneum, 1973), p. 202.

28 Virginia Woolf, *Orlando: A Biography* (Ware, Hertfordshire: Wordsworth Editions, 2003), pp. 92–3.

29 *Ibid.*, pp. 17, 124.

30 Merry Pawlowski, 'Introduction', in Woolf, *Orlando*, p. xiv.

31 Virginia Woolf, *The Diary of Virginia Woolf*, vol. 3, *1925–1930*, ed. Anne Oliver Bell (London: Hogarth Press, 1980), p. 168.

32 Elisabeth Freeman, *Time Binds: Queer Temporalities, Queer Histories* (Durham, NC and London: Duke University Press, 2010), p. 106.

33 Woolf, *Orlando*, p. 10.

34 *Ibid.*, p. 11.

35 Virginia Woolf, *Mrs Dalloway* (London: Penguin Books, 1996), pp. 17, 19.

36 *Ibid.*, p. 19.

37 Virginia Woolf, 'Royalty', in Michèle Barrett (ed.), *Women and Writing* (New York: Harvest, 2003), p. 139.

38 *Ibid.*, p. 142.

39 Virginia Woolf, *The Diary of Virginia Woolf*, vol. 5, *1936–1941*, ed. Anne Oliver Bell (London: Hogarth Press, 1984), pp. 12–13.

40 *Ibid.*, pp. 39–40.

41 *Ibid.*, pp. 40–1.

BIBLIOGRAPHY

Altman, Dennis, 'On global queering', *Australian Humanities Review* (July 1996), www.australianhumanitiesreview.org/archive/Issue-July-1996/altman.html.

Crisp, Quentin, *The Naked Civil Servant* (Glasgow: Fontana/Collins, 1981).

Dyer, Richard, 'Homosexuality and heritage', in *The Culture of Queers* (London and New York: Routledge, 2002).

Florence, Penny, 'A conversation with Sally Potter', *Screen* 34:3 (Autumn 1993).

Freeman, Elisabeth, *Time Binds: Queer Temporalities, Queer Histories* (Durham, NC and London: Duke University Press, 2010).

Glendinning, Victoria, *Vita: The Life of V. Sackville-West* (New York: Quill, 1983).

Haigh, Christopher, *Elizabeth I* (Harlow: Pearson, 2nd edn, 1998).

Harris, Daniel, *The Rise and Fall of Gay Culture* (New York: Ballantine, 1997).

Higson, Andrew, 'Re-presenting the national past: nostalgia and pastiche in the heritage film', in Lester Friedman (ed.), *Fires Were Started: British Cinema and Thatcherism* (London: UCL Press, 1993).

Kelly, Nigel, *Quentin Crisp: The Profession of Being – A Biography* (Jefferson, NC: McFarland, 2011).

Kettelhack, Guy, 'Ancient, glittering & gay', archived at http://crisperanto.org/memories/kettelhack2005a.html.

Mayer, Sophie, *The Cinema of Sally Potter: A Politics of Love* (London and New York: Wallflower, 2009).

Moor, Andrew, 'Beyond the pale: the politics of Neil Jordan's *The Crying Game*', in Robin Griffiths (ed.), *British Queer Cinema* (London and New York: Routledge, 2006).

Nickels, Thom, 'His homosexual holiness', archived at http://crisperanto.org/interviews/nickels1.html.

Nicolson, Nigel, *Portrait of a Marriage* (New York: Atheneum, 1973).

Pawlowski, Merry, 'Introduction', in Woolf, *Orlando: A Biography*.

Phipps, Keith, 'Englishman in New York: legendary author and wit Quentin Crisp talks with *The Onion*', archived at http://crisperanto.org/interviews/phipps.html.

Pidduck, Julianne, 'Travels with Sally Potter's *Orlando*: gender, narrative, movement', *Screen* 38:2 (Summer 1997).

Rich, B. Ruby, 'New Queer Cinema', *Sight and Sound* 2:5 (September 1992).

Russo, Vito, *The Celluloid Closet: Homosexuality in the Movies* (New York: Harper, rev. edn, 1987).

Sedgwick, Eve K., *Tendencies* (Durham, NC and London: Duke University Press, 1993).

Strong, Roy, *Gloriana: The Portraits of Queen Elizabeth I* (London: Thames and Hudson, 1987).

Walsh, John, 'England's first queen of hearts was always Quentin Crisp', *Independent* (15 June 1996), www.independent.co.uk/arts-entertainment/englands-first-queen-of-hearts-was-always-quentin-crisp--now-at-86-resident-in-manhattan-where-he-is-one-of-the-few-famous-people-listed-in-the-telephone-directory-1337088.html.

Woolf, Virginia *The Diary of Virginia Woolf*, vol. 3, *1925–1930*, ed. Anne Oliver Bell (London: Hogarth Press, 1980).

——*The Diary of Virginia Woolf*, vol. 5, *1936–1941*, ed. Anne Oliver Bell (London: Hogarth Press, 1984).

Woolf, Virginia, *Mrs Dalloway* (London: Penguin Books, 1996).

——*Orlando: A Biography* (Ware, Hertfordshire: Wordsworth Editions, 2003).

——'Royalty', in Michèle Barrett (ed.), *Women and Writing* (New York: Harvest, 2003).

Part III

Images of empire

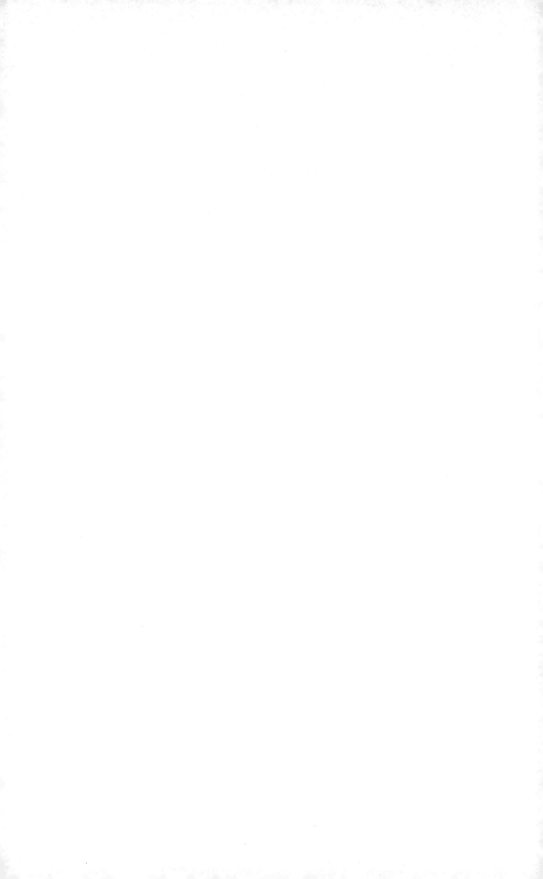

Renewing imperial ties: *The Queen in Australia*

Jane Landman

'The Southern Cross has vanished in the dawn. Over the city of Sydney, the brilliance of a summer's day has broken. It is the third of February 1954. A day of high summer – and of high history for Australia.'

So opens the narration of the Australian government film *The Queen in Australia* (1954), describing the triumphal entrance into Sydney Harbor of the recently crowned Queen Elizabeth II. For the first ascendant monarch bearing the title of head of the Commonwealth, the grand tour of 1953–54 is best understood as a new Commonwealth progress, 'the like of which had never previously been seen', as Winston Churchill announced to the House of Commons.[1] This tour marked the 'apogee of the Windsor Monarchy's world repute' following soon after the coronation and the Commonwealth conquest of Everest, an event broadly reported as a royal tribute.[2] These events bracket a period of Commonwealth optimism, a temporary pause between the imperial 'implosions' of the late 1940s (the independence of India, Pakistan, Ceylon / Sri Lanka and Burma) and the next round of Empire-diminishing events (e.g. Suez in 1956–57, followed by African decolonisation starting in the early 1960s).[3]

It had been a long wait for this first visit to Australia by a ruling monarch, a tour delayed twice by those factors – her father George VI's illness and death – that led to Elizabeth's accession to the throne in 1952.[4] This patience was well rewarded: the fifty-seven-day Australian leg was the longest stopover of this longest-ever royal progress. The party crisscrossed Australia by car, train, plane and ship, visiting seventy country towns as well as capital cities, and along the way making a hundred speeches.[5] The film commentary attributing to Elizabeth's arrival the dawning of the day is entirely consonant with the hyperbolic royal discourse of the time: memorialisation started before the tour with the sale of scrapbooks for souvenirs. Commentators exhausted stocks of superlatives in

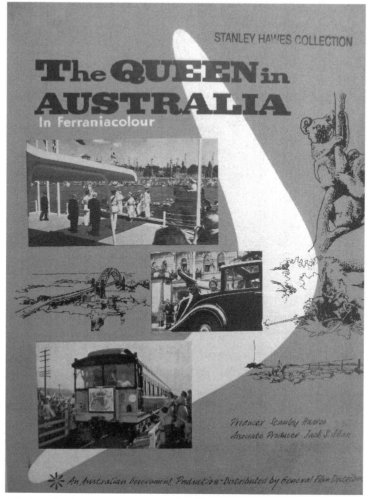

20 An Elizabethan progress: poster for *The Queen in Australia* (produced by Stanley Hawes, 1954).

attempting to convey the tour's magnificence and the sincerity of the waving and cheering crowd's celebration. An estimated 75 per cent of the population came to see the Queen, filling stadia, lining city streets and assembling in remarkable numbers at remote whistle-stops during Australia's so-called 'royal summer'.[6]

Departing in November 1953, the royal party travelled first to Bermuda, Jamaica and Panama before sailing to the Pacific. The Pacific stops commenced in the 'friendly isles' of Tonga with a side trip to the Crown Colony of Fiji,

followed by the longer-stay visits in the settler nations of Aotearoa-New Zealand and finally Australia (from February to April).[7] On the westward return, the party dropped in at the Cocoas Islands, a private fiefdom granted in perpetuity to the Clunies-Ross family by Queen Victoria, before sailing to the newly independent Sri Lanka.[8]

This was a tour that repurposed the British Crown, from head of Empire to head of a multiracial family of nations. Gratified to be amongst the chosen and alert to possibilities for their own touristic exposure, the sites on the route furnished an exotic global backdrop for royal dramaturgy. Venues and events were prepared for a year in advance. In Suva the 'enterprising officer of the public works Department' who cheaply and cunningly disguised unsightly damage from a recent cyclone and drought was awarded with a 'Royal Victorian Order Medal for this outstanding service'.[9] In this way the massive costs were defrayed by the host sites: The small colony of Fiji spent over £20,000, while Australia contributed £A200,000 to the refit of the *Gothic* alone and more than £A310,000 for the tour itself.[10] These costs included subsidising the large international – though effectively British – press contingent, with the Australian government covering their transport, communication needs and accommodation.

While maintaining a consistent public welcome required extensive preparation and negotiation, and more complex behind-the-scenes manoeuvring in some more sensitive locations (such as Ceylon and Gibraltar), the Pacific itinerary virtually guaranteed warm royal welcomes, and underlined deep and diverse historical ties: in Fiji and again in Cairns, for example, the Queen dined with descendants of the *Bounty* mutineers; visiting Queen Sālote in Tonga, she was photographed with a turtle that was once Captain Cook's pet.[11] In her Christmas broadcast from Gisborne, New Zealand, she simply said: 'I find myself completely and most happily at home.'[12]

The young mother was an exemplary vehicle in which to condense messages about continuity as well as postwar restoration and renewal. The tour's rituals and speeches enacted a 'new' commonwealth semiosphere. This reimagining foregrounded the ties of 'affection and loyalty' binding territories to Britain, ties formed by sovereignties freely ceding to Empire, in order to shelter under the protection of democratic Westminster practices. Though her patrimony, youth and fertility, Elizabeth combined tradition and a promise of the new, the 'everyday' femininity of wife and mother, and that of fairy-tale princess privilege. She was, at once, Queen of the 'free world' of Commonwealth and of Empire, and she came bringing messages of unity in 'troubled times'.[13]

183

This chapter concerns the interactions of the tour and national public communications agencies in the production of messages of loyalty and unity, examining both what was at stake in securing signs of loyalty in the Pacific, and the way that Australian cultural producers imagined and depicted social unity in this transitional historical period. It focuses on the prestige government film, *The Queen in Australia* – the first feature-length colour documentary made in Australia, and a project representing the public relations 'opportunity ... of the century'.[14]

REBRANDING THE COMMONWEALTH IN THE PACIFIC

Legislatively, the 'new commonwealth' came into being in the interests of securing an ongoing relationship with independent India. It was a means to retain a monarch as head of a multiracial family – 'a worldwide brotherhood of nations' with republican members.[15] This shift anticipated broader waves of decolonisation, from which inclusion in the British Commonwealth would buffer newly independent member states, particularly against the 'political encroachment of communism'.[16] Relations within the British Commonwealth at this time were radial, with London at the hub: the Commonwealth association was a means for Britain to maintain central influence despite its waning power. While the new commonwealth implicitly acknowledged such change, Britain also sought to reassert its colonial power in the 1950s, seeking not just to 'hold the line' at the current losses, but to 'revitalize its empire by reestablishing its moral authority and economic and strategic interests as a Great Power'.[17]

As Simon Firth demonstrates, the partial and/or incomplete outcomes of decolonisation in the Pacific suggest that the term better describes a historical period of international political enthusiasm, rather than any standard political process. In Australia and Aotearoa-New Zealand, decolonisation continues into present-day struggles over Indigenous land rights and treaty obligations for example, while international enthusiasm has passed over secessionist struggles in West Papua in favour of appeasing post-colonial Indonesia.[18]

The formal processes granting independence largely took place in a later wave than most African states; Fiji and Tonga in 1970, and the Australian Territory of Papua, and Trust Territory of New Guinea, in 1975 (hereafter TPNG). However, after the Second World War, as Priya Jaikumar notes, 'colonialism had become embarrassing'.[19] Continuing to hold colonial possessions, and administering populations of dispossessed and disenfranchised peoples within colonial

settler nations under race-based and discriminatory regulation, were areas of vulnerability in the Western alliance's self-presentation as the lands of the free. Evidence for this claim abounds in the records of the Australian Department of Territories, where policy delays and missteps are decried as providing opportunities for the Soviets to embarrass Australia at the United Nations.[20]

The tour's Pacific itinerary risked little in terms of embarrassing anti-colonial unrest: the government history of the royal visit to Fiji makes the point:

> Fiji seldom attracts the attention of the overseas press. ... It is a peaceful Crown Colony not yet associated with any of the topical colonial demands for constitutional reform or national self-determination, and not producing alarming reports of racial strife, economic distress, communist infiltration, or threats against the established order of government.[21]

However, Chinese and Indian indentured labourers (and descendants in Singapore and Malaya as well as Fiji), were influenced by anti-colonial movements in erstwhile homelands, and South East Asia was far from peaceful.[22] The Dutch withdrawal from Indonesia in 1949 (after recolonising attempts were rebuffed by nationalist forces) had left unresolved the status of West Papua, which for the first part of the 1950s remained as Dutch New Guinea. The French withdrawal from Indochina in 1954, along with threats to British rule in Malaya and Singapore, threatened to isolate white Australia, facing a future without the 'security blanket' of British military backup.[23] Anti-communist conservative Prime Minister of Australia, Robert Menzies, was generally considered unsympathetic to the aspirations of Asian nationalists.[24] Christopher Waters notes that Australian politicians more broadly were swimming defensively and fruitlessly 'against the tide' of postwar decolonisation throughout the turbulent 1960s and even into the early 1970s.[25]

Charged with communicating state policy, government information offices were in some instances deployed in managing adverse commentary on colonial policy and conduct. In the early 1950s, the Australian film division, for example, was commissioned to produce a series of reporting films justifying developmental policies and showing progress, and hurdles to progress, in TPNG, during a time when independence was imagined as an event for a still-distant future.[26] Stanley Hawes, producer-in-chief of the Australia government film unit and producer of *The Queen in Australia*, prepared a report in 1950 for the Malayan film unit, to ready it to produce propaganda films aimed at persuading Chinese communist rebels to renounce their armed independence struggle.[27]

185

By virtue of its public service restructures, the Australian film unit has had many names, but was at this time one of the divisions in the Australian News and Information Bureau (NIB), whose services also included 'Editorial' (print productions), an international film distribution service with primary hubs in London and New York and the supply of information officers to selected international trade posts and embassies that were proliferating as part of Australia's increasingly independent approach to foreign policy. The new bureau's responsibilities included making Australia better and more favourably known internationally: to this end the division negotiated commercial exhibition for major productions where possible, and also supplied 16mm films to various cohorts of 'opinion leaders' (such as diplomatic circles and universities), as well as to schools and community groups.[28]

Simon Potter notes a broad pattern of institutionalised inter-connection in the Commonwealth media/information field that played a role 'in sustaining a sense of Britishness around the empire' into the 1950s.[29] With informal and formal networks of staff training and exchange, such information services can be loosely considered as part of a shared imperial/Commonwealth apparatus, with film agencies owing varying debts to the British Documentary Movement (hereafter BDM) and the advocacy of influential key figure John Grierson, an 'institutional entrepreneur on behalf of documentary'.[30] In the Australian film unit Grierson's influence was directly felt though the recruitment of the British producer-in-chief Stanley Hawes, who had worked with Grierson at the Canadian Film Board during the war. Before the war, Hawes had Grierson's support in seeking entry into British documentary circles, and he remained throughout his career a 'Grierson man'. *The Queen in Australia* is best understood as homage to Grierson, in its conception, style and mode of production, as well as in its world-view.[31]

Scholarly accounts of this period in the film unit tend to focus on the 'political and stylistic orthodoxy' of output from this key cultural institution during a historical period of conservative hegemony from 1953 into the mid-1960s.[32] During this time hostile restructures diminished the status and independence of the film division, corralling it to the service of government ministers and removing its capacity to initiate its own production under the guidance of a national board independent of the public service hierarchy.[33] This hostility was focused primarily on concerns that the film division harboured communists and fellow-travellers (including amongst the crew making *The Queen in Australia*), raising issues about its fitness for the government's purposes. The government

also was sympathetic to the rival claims of the commercial sector.[34] Yet despite three reviews in this decade, the government largely maintained the film division's budget and staff.

Hawes accused the government of 'reducing Government film production to mediocrity by masterly indecision'.[35] But from its own deliberations, it would seem that primary stake-holding ministries in the mid-1950s (Territories, External Affairs and Migration) were quite clear in wanting a film information *service department*, not one producing art documentary auspiced by an independent board.[36] Such concerns were not purely localised: Grierson complained of a similar diminution in the UK, writing to Hawes that 'The grand old principle, which we have done so much to establish, of having overall national themes and integrating to that end the demands of the departments disappeared from policy and procedure.'[37] Ian Aiken notes a disinclination in the Hong Kong Film Unit to employ 'Griersonians' as they were thought to be inappropriately committed to the craft of film, which, along with their liberal impulses, reduced their fitness for the kind of instrumental and budget filmmaking desired by the Colonial Office and local administration.[38]

Moreover, these reviews were also responses to the broader changing priorities and contexts for government information policy. While investigations into the Australian film and print divisions/units were driven by local budgetary, structural and productivity concerns, they mirror to some extent ongoing policy adjustment in Britain in view of the growing costs of servicing overseas information needs and their strategic significance in international relations. In sensitive information-alliance meetings held with New Zealand, Britain and the US 1958–59, it was acknowledged that 'anti-colonial sentiment' in South East Asia brought together a community of discontent, and these nations were united in their goal of keeping South East Asia out the 'Sino-Soviet orbit'.[39] Meetings prepared extensive wish-lists of issues on which Asians needed to have their views clarified, such as on the Western role of bringing 'peace and stability' to the region, and that association with the West 'does not mean domination by it'.[40]

During the 1950s then, Anglo-sphere political interests were aligned in approaching decolonisation though a Cold War lens, and in investing in informational strategies as part of the arsenal of the struggle for decolonising 'hearts and minds'. Promoting a racially inclusive and egalitarian Commonwealth was one approach to countering hostile anti-colonial alliances. In his concluding report, Australian press relations officer Oliver Hogue concludes that the royal tour 'has been a significant indication to the world of the unity of the peoples

187

of the Commonwealth of nations'.[41] Subsequent hopes for the international influence of a film distilling such a potent expression of Commonwealth loyalty were similarly tied up in Cold War rhetoric. While a Glasgow newspaper review's claims that 'if *The Queen in Australia* could be thrown on the inside of the Iron Curtain for a week, future conferences might shape up very differently' may seem absurdly zealous in hindsight, similar hopes are found throughout the NIB's files on the film's distribution, for example in Hawes's views that the film would not only serve to make Australia better known in Asia, but be of particular value in the anti-communist 'psychological campaign' in Malaya.[42]

PRODUCTION

Hawes unwaveringly believed in the progressive role of documentary film in a civic education project tailored to the needs of complex modern societies, and there is no sign that this view changed over the long years of his tenure as producer-in-chief (1946–69). He held also to Grierson's view that information service is 'not simply ancillary to other activities of government':

> It is the chosen instrument by which a nation gives account of its stewardship. It is the instrument through which it secures the co-operation of the people to national and international ends. It is the instrument by which a nation contributes to the international pool of understanding in matters of common interest.[43]

The unit, then, also had a considerable stake in the success of this project, and ambitions set aloft by the loosening of standard budgetary parsimony.[44] Hawes aimed to have *The Queen in Australia* completed for the monarch's return home in May – a tight deadline also reflecting his need to get the film into distribution before the tour had faded from public memory.[45] As the 35mm Ferrania colour stock could not be processed in Australia, he decided to manage the shoot and postproduction from London, a plan that also allowed him to work with former BDM colleagues. He communicated with the crew in the field – who were working without any other feedback – by cable and letter. In this and every other respect this was an epic production.

Hawes was determined that in its artistry and efficiency the film would showcase Australian creative talent (for example, in the original music and lyrical script), as well as the unit's production competence (such as in planning and communications), and technical expertise. In a more minor key, artistry

would showcase Commonwealth ties. The bulk of the film spend was to be in Australia with only 'unavoidable editing and recording expenses' to be incurred in the UK, where Hawes could also access a pool of Australian creative talent – he later estimated that as many Australians worked on the film in London as did in Australia.[46]

Pre-planning included reconnaissance of key locations, with some preliminary shooting taking place some four months before the tour started, after which Hawes wrote a 'prescript'. The very stuff of this protracted progress – ritual reiterations of parliamentary openings and so on that symbolically united the disparate sites visited – resisted interesting treatment. Further, Hawes quite rightly was concerned that the cycle of Commonwealth royal progress films around this time, along with the New Zealand film unit production that would precede his, risked market saturation. These included the *Royal Tour of South Africa* (1947), the *Royal Tour of Canada* (1951) both made when Elizabeth was still a princess, along with *A Queen is Crowned* (1953).[47]

Hawes decided to order his film thematically, to avoid repeating the chronological approach of these others, and sought script assistance from BDM alumnus Stuart Legg for his 'expertise on the Commonwealth'.[48] Written by Australians Tom Hungerford and George Johnston, as well as the British author Laurie Lee, the script was to be merged and polished by Legg. In January Legg wrote:

> My hunch is to point the cameras as much at what the Queen sees (and through that, to the perspective of the country beyond) as at the Queen herself. 'Australia on Parade' – happy, laughing, humorous, and good-humoured, gusty, excited and exciting. Wonderful faces, places. Plenty of candid close-ups. The U.K., as ever, is ignorant of the Commonwealth of which it is a member: and if you made real rip-roaring, lovable picture about Australia and Australians – about the spirit the Queen sensed but could not see – you might not just wake people up a bit here and make them cry, but have a pretty saleable commodity as well.[49]

While nowhere mentioned, this 'portrait of a nation' approach is close to that taken in the Canadian film. Fortuitously it also lent creative and national credibility to what turned out to be a practical approach to logistical challenges. Even at the planning stage Hawes admitted that 'sequences which I had relied on to give some human interest are collapsing one by one'.[50]

Although the film crew were making the *official* film, their access was under the jurisdiction of state and municipal bodies: senior cameraman Jack Allan

complained 'All sorts of things keep cropping up which did not exist when you and I traveled around together and at nearly every function we got to there is some little tin-pot dictator for the day who just has to wield his authority.'[51] In London, Hawes received continuous exculpatory accounts from the men in the field about the errors, misadventures and even outright deception (on the part of civic bodies determined to be included) that undermined well-laid plans for interesting footage.[52] Spontaneous moments were missed because of the time taken for setting up bulky cameras, and casual, humorous or intimate footage of the Queen proved impossible in light of royal protocols and priorities. Even formal occasions were often difficult: the Queen disliked the intrusion of glaring lights and often favoured interactions with the public over camera exposure. The head of the NIB concluded that the Queen's press secretary, Commander Richard Conville, failed to understand the need to 'promote' the Queen as well as protect her. Negotiations with Conville broke down so completely that the crew took to setting up dummy cameras to misdirect 'the man with the built-in sneer'.[53]

Nevertheless, on completing, Hawes was content with the balance and fit between nation and Crown saying, 'it has emerged, as I planned it, as a film not only of the Royal couple, but of Australia itself and of the people of the country'.[54]

PRODUCING SETTLER SPACE AND TIME IN
THE QUEEN IN AUSTRALIA

A structuring convention in BDM films addressing social issues is explaining their improvement though some policy or innovation. While Ian Aiken considers British interwar documentary as a movement of genuine social reform, Brian Winston has critiqued the 'social amelioration' film as enacting a flight from their own social meanings in its foreclosing on investigation or critique.[55] Hawes's calling-card film for the Australian unit, *School in the Mailbox* (1947), exemplifies the approach: It explains the isolation of rural children, and demonstrates the improving role of the correspondence school, with an educative account of how the component parts operate to fit or incorporate the isolated outback family into the operationally inclusive and improving whole of the nation. It is a neat, disciplined and well-received project, that also bears out colleague Ron Maslyn Williams's account of the impact of 'English training. They were all going to reform the world, make it better by showing how things worked, how a workman [for example] was part of whole state machinery.'[56]

The royal tour film was a far messier and grander project than *School in the Mailbox* logistically and ideologically, but motivated by the same spirit of 'propaganda for good'. While, as would be expected in a record of national celebration, the narrative avoids social problems, nevertheless the history, character and future of the nation organise the film's discourse, in a project that came with its own ready-made 'amelioration', that is, the Queen and all she conveyed about collective belonging. While 'unity in diversity' was a key theme associated with the tour, many commentators have understood this in national rather than broader Commonwealth terms. Ewan Morris, for example, considers that the tour's popularity is better understood as escapist entertainment, and the Queen as national surrogate, 'the visible sign of nation', such that loyal crowds who comprised the nation were cheering and celebrating themselves. In a similar vein, Ina Bertrand notes in the division's film, the 'daring ... lack of pomp' and emphasis on ordinary people's experience of the tour.[57]

In various talks and papers, Hawes accorded documentary a special capacity for revealing meanings 'beneath the surface of things'. In this homage to Grierson, Hawes enacts BDM ideas about documentary as a kind of social technology to the extent that it not only reflects, but putatively enacts the unities of the settler nation.

Morris claims that in the tour, Aborigines and external territory subjects were given 'star billing as model loyal citizens as [they were] the least assimilated groups' and thus required the most work to make them appear part of the 'big happy family'.[58] If this visibility is true of the tour generally, it does not carry over into the film. The film division had done little work about Aboriginal peoples, and none specifically for them, or about intercultural contact.[59] Those Hawes calls 'original Australians' in his script needed to be fitted into orderly relations in the national narrative – the 'original', the 'new' (those non-British European migrants sought in increasing numbers after the war) and the Australians without modifiers, i.e. British settlers. Aside from any other role in the national narrative, he needed the Indigenous population to visually enact Australia's distinctiveness:

> The touchstone selected as the test of whether a sequence should be eliminated or drastically reduced ... was whether the events included in any particular sequence were distinctively Australian. By this test sequences like the Flying Doctor, Bondi Surf Carnival, the children's display, the dance of the Torres Strait Islanders, and so on, were selected for the full treatment; while Garden Parties, Universities, Ballet, Women's organizations ... which ... could be seen in other countries, were regretfully given scanty treatment.[60]

Grierson's approach to 'representative typicality' shapes this strategy. Echoing Winston, Anna Grimshaw complains that BDM 'films appear to be about people and yet we encounter types ... they are located in the modern world and yet deny both history and politics'.[61] The denial in this case concerns the film's indifference to the racial politics of its national assemblage, in the face of much countervailing evidence encountered in the production. Hawes, for example, requested an image of an Indigenous stockman for one of the film's national montages and was told from the field: 'You may miss out on the aborigines [*sic*] listening at the homestead, as ... they will not employ them when they have to pay them the same money as white stockmen.'[62]

The dependence on demotic Indigenous cultural signs to index Australian settler distinctiveness is far more extensive in the film than the outline of key events suggests.[63] Appropriated signs abound in the footage: from the giant boomerang archway under which the cavalcade pass in Sydney to the all-white Australian Ballet royal performance of *Corroboree*, composed by John Anthill, whose works also feature in the film, and performed in blackface. Those few Indigenous Australians who are featured are always performing their difference – by throwing boomerangs or dancing. A popular shot in royal reportage generally is that of crowds improvising viewing positions – climbing trees, flagpoles or onto roofs to catch a royal glimpse. Such modest disorder indexes loyal and spontaneous enthusiasm, but not one such crowd shot includes an Indigenous Australian. This is assimilative appropriation – where Aboriginal Australians are evacuated from the incidental or natural landscapes of the film – Australia as *terra nullius* – yet everywhere visible in these contained registers. This fraught interplay of dependency and disavowal is part of settler colonialism's ongoing cultural labour, in reproducing and tweaking racial constructs to ensure the 'reproduction of historical relations into the present'.[64]

The commentary accompanying the themes stitches together the building blocks of tour films – laying of wreaths, planting of trees, openings and command attendances, tours of inspection, review and admiration, with the narrative threads of emergent nationhood made from interlocking tropes of modernity (such as the rocket range), development ('wresting increase' from a quiescent land) and the human assemblage of assimilation. This combination generates the film's 'chronotope', its construction of the 'intrinsic connectedness' of space and time, as Mikhail Bakhtin notes.[65] Opening in the east-coast morning and closing in the west-coast evening at Fremantle, the film moulds space to the movements of time and plot, creating a history of the present of the settler nation.[66]

The tour covered 10,000 miles, and the crew generated close to 60,000 feet of footage – of which Hawes was able to use less than 10 per cent.[67] This compression further concentrates events that were themselves densely symbolic and finely calibrated. To give tighter coherence to the overlapping and exceeded themes, he bookends the film chronologically in the commentary, and this day-in-the-life device slows time, thickening the fifty-seven consecrated days of the royal summer, in this layered temporality. The structural conceit of paused time is reiterated though various aural and visual devices, such as a moment of anticipatory quiet before the explosion of maritime horns, toots and whistles that welcome the *Gothic* into Sydney harbour. Then leading into the words of welcome from the Lord Mayor and Prime Minister are the words of the commentary which accompanies a welcoming scenic introductory montage:

> They [those welcoming the Queen] speak for giant Queensland beneath its Capricorn skies; for Victoria where channel, dam and sluice have wrested increase from the tawny soil. They speak for a continent amongst the oldest in its being, amongst the freshest and most fruitful in its modern doing. ... They speak above all for a new nation, flexing its muscles, filling its spaces, inheriting its own.

Nowhere in the film is the settler chronotope stated more explicitly than in this cultural construction of colonialism as divine 'destiny', where the quiescent ancient land awaits for modernising energy of the settler.[68] The scale of the opening crowd scenes, along with distant geographic reaches of the montage, demonstrates the extent to which the 'small band of Englishmen' who first settled in Sydney have gone forth to multiply.

This emphatic settler discourse distinguishes the Australia tour from other Pacific sites destinations, including Aotearoa-New Zealand. A partial exception, which is one of the most successful sequences, takes place in northern Queensland. Cameraman Jack Allan wrote to Hawes: 'Touching on Cairns – Undoubtedly this is going to be one of highlights of your film so start cheering':

> David Eastman flew up to Cairns ... and ... selected a little unpainted weatherboard house, whose owner had a wife, some kids and a battered old car. David gave them a balloon and some flags and shot a nice sequence of them leaving to go to see the Queen. Next he buried the car deep in the jungle and had it come crashing through the very thick undergrowth out on to the road where our party drives past a magnificent field of cane with some beautiful mountain scenery in the background ... undoubtedly the best part will be

the Torres Strait Islanders as all their rehearsal was shot in close up ... [we] shot the whole sequence of this very interesting re-enactment of Torres Strait Islands' history. I have never seen H.M. more animated or interested, and even blasé me got a kick out of these fellows; they were truly magnificent.[69]

The vectors converging in this scene – settler, Islander, colonial Crown – provide the moment in the film that comes closest to acknowledging the Pacific location of settler Australia. Arriving at the helm of a pearling lugger, the Islanders seem to be free agents of their own voyage, although they 'lived under the rigid control of a government-appointed Protector and ... were required to obtain permits to visit the mainland or to travel within the islands'.[70] Their dance points to a time before and outside settler time, but even in this far-north location, the performance remains touristic spectacle, with no Islanders or mainland Indigenous peoples visible among the watching crowds.

Following the dance are a few seconds of the Queen and Duke moving down a line of delegates from Australian territories. These men were the chosen representatives of Paul Hasluck, Minister for Territories, and architect of Australia's assimilation policy.[71] Hasluck set the 'appropriate' level of territories' peoples to meet the Queen – this is the wording of his report – and arranged the writing of their vows of loyalty.[72] Of the Northern Territory (NT) party of eight, six were white Australians – the administration and two 'pioneering couples' – along with 'two outstanding aborigines' [sic]. One of these was the self-taught landscape artist Albert Namatjira. His granddaughter later reported that 'Albert ... didn't really speak to her at all. Back then, she gave him a medal and he quickly walked away.'[73] In a play about Namatjira's life written and performed by his family, the Queen figures as a remote, quaint icon of an alien empire, immeasurably divorced from the imposed assimilation that blighted Indigenous lives.[74]

In Cairns, in remote north Queensland, the Minister arranged a two-day visit for a larger delegation.[75] This group – again all men – was chosen for its leadership in driving development policies and / or loyal war service. The travel notes of Ron Williams give some indication of what the visit signified for Simagun, one of the delegates whom Williams met when researching his film series for the Department of Territories. Simagun was nominated member of the TPNG legislative council (an early structure in the territories' guided political development), an ex-coast watcher and member of the constabulary.

Williams first describes his surprise at seeing Simagun 'lounging at ease across the table from the district officer ... probably the only native to sit in

a European's office in the Territory'. He was a small business entrepreneur – running a truck business and sluicing for gold, and, unusually, he owned a rifle and used cigarette papers rather than newspaper. Despite this relative affluence, he could not afford to live in the capital, Port Moresby (which is the location of the legislative council on which he sat). The story about this trip that Simagun related on two separate occasions to Williams concerns a night of drinking with Namatjira, where Simagun said he demonstrated the greater stamina of his race.[76] This fleeting connection occurred in the face of their mutual subjection. At this time both were subject to protectionist racial modes of legislation that mandated the forms of development to be attained in order to achieve citizenship: in TPNG policies for social, economic and political development aimed to prepare and equip subject peoples for their future place in the world; in the NT, the benchmarks were personal. Aborigines in the NT had almost without exclusion become wards of the state under the 1953 welfare ordinance. Wardship would be revoked, 'in the case of individuals whom the authorities deemed capable of managing their own affairs', entitling full citizenship rights.[77] At this time Namatjira was a ward of state, and Simagun was 'legally incompetent', a citizen of neither TPNG nor Australia, and his Australian tour was exceptional. Soon after this visit, Namatjira was granted citizenship, which was later revoked when he was imprisoned for the crime of supplying alcohol to other wards.[78]

Williams's travel notes contain this paraphrased translation of what Simagun discerned from his royal visit:

> Some of us believe that the spirits will bring European goods to us in ships and planes. I myself believed this at one time but now I know that this is not true … you know … when I visited Australia what I saw there was very different from what I expected to see. I found that a man who did not work did not eat … unless we work hard too and listen carefully to the agricultural officer … our children might become labourers working for others.[79]

The minister, and Territories administration, may well have found the development goals of the visit achieved by Simagun's substitution of the magical thinking of the 'cargo cult' for a properly modern understanding of the market economy, but been less comfortable with his concerns about the disenfranchisement of his children in a cash economy.

Senior British politicians visited Australia in unprecedented numbers in the months leading up to the tour, concerned to maintain the Commonwealth

character of the so-called 'young' nation in light of postwar development and change. David Lowe recounts the British High Commissioner's hope that the Queen's physical presence would 'provide a strong source of definition for the two groups he identified as central to Australia's future, children and immigrants'.[80] Postwar fertility is everywhere evident in the film and nineteen events about or for white children were held, including a display in Sydney where massed bodies spelt out loyalty in dance. Yet only two Indigenous children are seen – those whose father demonstrates how to throw a boomerang.

The floral tribute is a privileged moment in the progress, and late colonial sentiment is finely calibrated in the discursive distinctions and local inflections attending this ritual renewal of ties across the Pacific. The obeisance of flower girls is linked to royal renewal though the elaborate coronation dress, which accompanied Elizabeth on tour and was worn to open various parliaments. It was stitched with floral motifs forming 'an atlas of the Queen's realms [with] flowers of the eleven Commonwealth countries ... intertwined in a floral garland, each flower or leaf nestling around the Tudor rose'.[81] Floral tributes from the Commonwealth's most youthful actualise these atlas embroideries, figuring submission in innocence. For little settler girls in Australia– mostly daughters of civic dignitaries – being a flower girl was a moment of fleeting celebrity, a chance to 'participate in a dream ... of a fairy tale Queen come to life' in the words of the *Women's Weekly*.[82] Hawes's prescript mentions an Indigenous flower girl, but she does not eventuate in the film, visually playing out Indigenous assimilation into white culture. Mirroring these gestures are the wreaths everywhere laid for the fallen, creating a life-cycle of gendered Commonwealth service. The analogue of the genuflecting girl is the ever-helpful boy scout 'ready with a pair of hands' to plant trees after a preliminary spade or two by the Duke.

CONCLUSION

When the *Gothic* finally set sail from Fremantle, no one cheered louder than the hard-worked official film crew, each of whom received the royal commemorative medal given to those members of the press who lasted four states or more.[83] Neither the scale of nor the widespread national enthusiasm for the 1954 tour was to be repeated in Australia, and in this light the tour has been described as a 'last gasp of empire'. Staging and producing such an extended royal show exhausted audience attention, too, and Hawes – still tied up in postproduction in London – was told by one of his

correspondents 'now that the Queen is on her way home she seems practically to have slipped out of public consciousness. ... Sydney is talking of the Petrov affair and nothing else.'[84]

Released by May the film was highly praised within government and commercial circles. The Head of Information at the Commonwealth Relations Office declared it the 'very best thing I have ever seen in the true interests of Commonwealth'.[85] It is a film, as Hawes wrote to Grierson, that bears out the Griersonian 'grand scheme', marrying tourist and migration promotion to a story of modern nation-within-Commonwealth, presenting a mythic history of the present, wherein a harmonious white community confidently defines the space and time of the nation, and basks in the Crown's reflected glory. This is not a film about an Australia of Asia or the Pacific: As Hawes wrote about its opening: 'the cross section of the country has some very lovely material in it. It makes Australians want to go home, and makes the English want to emigrate.'[86] Australia's internal colonisation and Pacific imperialism are as marginal as it is possible to imagine in the national story, and in this way the film signals forthcoming Australian antipathy to the multi-racial hues of the new Commonwealth. I leave the last words to the US reviewer who aptly describes the film as 'an expanded love story ... between a new sovereign and a new people in an old and durable political arrangement'.[87]

NOTES

1 'Royal Tour: nothing like it in history says Churchill', *Fiji Times and Herald* (13 November 1954), p. 1.

2 Ben Pimlott, in Klaus Dodds, David Lambert and Bridget Robison, 'Loyalty and royalty: Gibraltar, the 1953–54 Royal Tour and the geopolitics of the Iberian Peninsula', *Twentieth Century British History* 18:3 (2007), p. 375; Peter Hansen, 'Coronation Everest', in Stuart Ward (ed.), *British Culture and the End of Empire* (Manchester and New York: Manchester University Press, 2001).

3 John MacKenzie, 'The persistence of empire in metropolitan culture', in Ward (ed.), *British Culture*.

4 Australian royal visits proposed for 1949 and early 1952 were cancelled on account of the ill health of George VI, and a substitute planned visit by Princess Elizabeth and Prince Philip in 1952 was cancelled during an early stage in its itinerary following the King's death. Kate Cumming, *Royalty and Australian Society: Records Relating to the British Monarchy Held in Canberra* (Canberra: Commonwealth of Australia, 1998), p. 112.

5 *Ibid.*, p. 125.

6 National Film and Sound Archive, Canberra, Stanley Hawes collection (hereafter SHC), box 5, *The Queen in Australia* script.

7 The map of the tour published in accounts such as that of the Fijian government shows the Queen travelling from Fiji to Tonga: the dates above are sourced from government information office plans suggesting an unreported change; it is unclear which version is definitive. See National Archives of Australia, Canberra (hereafter NAA), A9711 PRO 39, Royal visit Fiji and Tonga.

8 NAA, A1838, 555/10/1, Publicity royal tour, 1954.

9 J. W. Sykes, *Royal Visit 1953* (Suva: Government Printing and Stationary Department, 1954).

10 NAA, A6895, N1956/312, News and Information Bureau film production programme.

11 In Ceylon, for example, considerable behind-the-scenes correspondence negotiated the balance between respectful observance of Hindu ritual (removing her shoes to enter the temple) and her standing fully shod in Protestant and regal dignity. See The National Archives (United Kingdom), Kew, DO 121/213, Queen's tour of commonwealth countries 1953–1954. She visits Uganda, Tobruk, Malta and Gibraltar on the way back to London, arriving 15 May 1954.

12 Kenneth Bourne (ed.), *The Royal Tour of Australia and New Zealand in Pictures* (Melbourne: Herald Gravure Printers for *Herald and Weekly Times*, 1954), unpaginated.

13 Such statements are made all along the Pacific route and repeatedly cited, for example in the film script, various newspaper stories and in stories collected in commemorative volumes such as the one cited above.

14 SHC, box 9, memo from Kent Hughes, Minister, Department of the Interior, to Hawes, 17 March 1954.

15 Peter Marshall, 'Shaping the "New Commonwealth"', *Round Table* 350 (1999), pp. 185–6; Dodds, Lambert and Robison, 'Loyalty and royalty', p. 373.

16 Marshall, 'Shaping the "New Commonwealth"', p. 191.

17 Caroline Elkins, 'The reassertion of the British Empire in Southeast Asia', *Journal of Interdisciplinary History* 19:3 (Winter 2009), p. 365; also see David Reynolds, 'Empire region, world: the international context of Australian foreign policy since 1939', *Australian Journal of Politics and History* 51:3 (2005), p. 348.

18 Simon Firth, 'The rise and fall of decolonisation in the Pacific', in Donald Denoon (ed.), *Emerging from Empire? Decolonisation in the Pacific* (Canberra: Australian National University, 1997); also see Roger Thompson, *The Pacific Basin since 1945* (London and New York: Longman, 1994).

19 Priya Jaikumar, *Cinema at the End of Empire: A Politics of Transition in Britain and India* (Durham, NC: Duke University Press, 2006), p. 10.

20 See, for example, National Archives of Papua New Guinea, Port Moresby, AN 247, SN 367, FNCA 11/4/1/14, Production of films in the Territory for use by administrative departments, 1950–1953; NAA, A518, 0141/3/1, Films – Papua and New Guinea – Australian Territories Exhibition 1952 – proposed film on Papua and New

Guinea, 1951–1953; NAA, A452, 61/7890, Production of films recording Australian administration in Papua and New Guinea, 1958–1962.

21 Sykes, *Royal Visit 1953*, p. 2.

22 See Ali Ahmed, 'Political change, 1874–1960', in Brij Lal (ed.), *Politics in Fiji* (Sydney: Allen and Unwin, 1986); Andrea Benvenuti, 'Australia, the "Marshall experiment" and the decolonisation of Singapore 1955–56', *Journal of Southeast Asian Studies* 43 (2012); Frank Cain (ed.), *Menzies in War and Peace* (St Leonards, NSW: Allen and Unwin, 1997), p. 156.

23 David Goldsworthy, *Losing the Blanket: Australia and the End of Britain's Empire* (Carlton South, Victoria: Melbourne University Press, 2002).

24 Gregory Pemberton, 'An imperial imagination: explaining the post-1945 foreign policy of Robert Gordon Menzies', in Cain (ed.), *Menzies in War and Peace*, p. 156.

25 Christopher Waters, 'Against the tide', *Journal of Pacific History* 48:2 (2013). Some political historians point to the ways in which national politics 'decolonised' (or 'de-dominionised') in relation to Whitehall in the 1950s. In such departures from the compliant agreement still sought by London from its Commonwealth allies, Australia was likely to be even more intractably hostile to decolonising aspirations. See, for example, Reynolds, 'Empire region, world', p. 349.

26 Jane Landman, 'Visualising the subject of development: Australian government films made during the trusteeship of New Guinea', *Journal of Pacific History* 45:1 (2010).

27 SHC, box 42, Malayan film unit.

28 Landman, 'Visualising the subject'.

29 Simon Potter, 'Strengthening the bonds of the Commonwealth: the Imperial Relations Trust and Australian, New Zealand and Canadian personnel in Britain 1946–1952', *Media History* 11:3 (2005).

30 Albert Moran, *Projecting Australia: Australian Government Film Since 1945* (Sydney: Currency Press, 1991), p. 2; Jo Fox, 'John Grierson, his "Documentary Boys" and the British Ministry of Information 1939–42', *Historical Journal of Film, Radio and Television* 25:3 (2005).

31 Ian Aitken discusses the shifting meanings of "Griersonian' in 'The development of the official film-making in Hong Kong', *Historical Journal of Film, Radio and Television* 32:4 (2012), pp. 590–1.

32 Moran, *Projecting Australia*, pp. 54, 55–80.

33 Graham Shirley and Brian Adams, *Australian Cinema: The First Eighty Years* (Sydney: Angus and Robertson, 1983).

34 Moran, *Projecting Australia*; David McKnight, 'Australian film and the cultural cold war', *Media International Australia* 111 (May 2004).

35 John Grierson Archive, Stirling University (hereafter JGA), GAA, 16:23, letter from Hawes to Grierson, 11 August 1953.

36 This account unfolds in the large file on the abolition of the Department of Information and the creation of the NIB: NAA, A65619 (A5619/1), C762.

37 JGA, GAA, 16:12, letter from Grierson (UNESCO, Paris) to Hawes, 6 October 1947.

38 Ian Aitken, *Film and Reform: John Grierson and the Documentary Film Movement* (London and New York: Routledge, 1992); Aitken, 'Development of the official film-making in Hong Kong'.

39 NAA, A5619/1, C762, Conference on the co-operation in information activities in South-East Asia Canberra, marked 'Secret', June 1958 and November 1959.

40 *Ibid.*

41 NAA, A9711PRO, Hogue, undated.

42 SHC, box 51, general, review cited in letter, K. Murphy to R. Williams, 28 May 1954; Hawes comments on Asia *ibid.*, report, Hawes to the Director, NIB, 28 May 1954.

43 JGA, GAA, 4 21, articles, speeches and broadcasts, pp. 39–45; GAA, 4:21:7, the nature and form of a government information service.

44 The film had an initial budget of £A8.000, though further funds were made available. NAA, A6895, N1956/312, NIB Film production programme.

45 SHC, box 88, letter from Hawes to Ted Hunter, 17 January 1954.

46 SHC, box 51, progress report, April 20 1954; letter from Hawes to Grierson, 10 December 1953.

47 All except *A Queen is Crowned* are available online; *A Queen is Crowned* (UK, Rank, 1953); *The Royal Tour New Zealand* (New Zealand National Film Unit, 1954), www.nzonscreen.com/title/royal-tour-1953-54-1954; *The Royal Tour of Tonga* (New Zealand National Film Unit, 1954), www.nzonscreen.com/title/royal-visit-to-the-kingdom-of-tonga-1954; *The Royal Tour of Canada* (Canada, National Film Board, 1952), www.nfb.ca/film/royal_journey.

48 SHC, box 51, general, letter from Hawes to Stuart Legg, 21 January 1954.

49 SHC, box 51, early correspondence with the film centre (London), letter from Legg to Hawes, 21 January 1954.

50 *Ibid.*, letter from Hawes to Legg, 10 January 1954.

51 SHC, box 51, general, letter from Jack Allen to Hawes, 16 March 1954.

52 *Ibid.*, letter from Allan to Hawes, 16 March 1954.

53 *Ibid.*, letter from Allan to Hawes, 17 March 1954.

54 *Ibid.*, letter from Hawes to Peter Morrison, editor of *Film Weekly*, 30 April 1954.

55 Brian Winston, *Claiming the Real: The Griersonian Documentary and its Legitimations* (London: BFI, 1995), pp. 37–8; Aitken, *Film and Reform*.

56 Cited in Moran, *Projecting Australia*, p. 42.

57 Ewan Morris, 'Forty years on: Australia and the Queen, 1954', *Journal of Australian Studies* 4 (1994) p. 13; Ina Bertrand, 'Stanley Hawes: a Grierson man', *Metro* 120 (1999), p. 42.

58 Morris, 'Forty years on', p. 6.

59 Moran, *Projecting Australia*, p. 39.

60 SHC, box 51, general, 'Progress report', 20 April 1954.

61 Anna Grimshaw, *The Ethnographer's Eye: Ways of Seeing in Anthropology* (Cambridge: Cambridge University Press, 2001), p. 62.

62 SHC, box 51, general, B. Gandy to Hawes, 26 March 1954.

63 Zoe Druik, 'International cultural relations as a factor in postwar Canadian cultural policy: the relevance of UNESCO for the Massey Commission, *Canadian Journal of Communication* 32 (2006), p. 189.

64 Patrick Wolfe, 'Race and trace of history: for Henry Reynolds', in F. Bateman and L. Pilkington (eds), *Studies in Settler Colonialism: Politics, Identity and Culture* (Houndmills, Basingstoke: Palgrave Macmillan, 2011), p. 289; for a seminal overview of the politics of Indigenous representation, see Marcia Langton, *'Well, I Heard It on the Radio and I Saw It on the Television'* (Sydney: Australian Film Commission, 1993).

65 David Lowe, '1954: the Queen and Australia in the world', *Journal of Australian Studies* 46 (1995), discusses modernity and technology as development, Moran, *Projecting Australia*, also observes the insistent discourse of development in the film division documentaries.

66 Mikhail Bakhtin, 'The dialogic imagination: four essays', trans. Michael Holquist and Caryl Emerson, in Pam Morris (ed.), *The Bakhtin Reader* (London: Edward Arnold, 1994), p. 184.

67 SHC, box 51, 'Progress report', April 20 1954.

68 Deborah Rose Bird, *Reports from a Wild Country: Ethics for Decolonization* (Sydney: University of New South Wales Press, 2004), p. 37.

69 SCH, box 51, general, letter Allan to Hawes, 16 March, 1954.

70 David Lawrence and Helen Reeves Lawrence, 'Torres Strait: the region and its people', in Richard Davis (ed.), *Woven Histories, Dancing Lives: Torres Strait Islander Identity, Culture and History* (Canberra: Aboriginal Studies Press for the Australian Institute of Aboriginal and Torres Strait Islander Studies, 2004), p. 27.

71 Russell McGregor, 'Wards, words and citizens: A. P. Elkin and Paul Hasluck on assimilation', *Oceania* 69 (1999), p. 243.

72 NAA, A9708, RV/Q, Territorial representation.

73 Cited at www.theguardian.com/commentisfree/2013/nov/28/my-message-to-queen-elizabeth-ii-aboriginal-art-needs-support.

74 *Namatjira*, written by Scott Rankin, created with the Namatjira family, Malthouse Theatre and Big hART, Melbourne, August 2012; *Michael James Manaia*, a Maori biographical play, also references the 1953/54 tour as a moment of cultural alienation and disjunction. *Michael James Manaia*, written by John Broughton, Taki Rua Production, Melbourne 12–28 October 2012.

75 In addition to theses delegations, some self-funded groups of scouts also attended. NAA, A9708, RV/Q, Territorial representation.

76 National Library of Australia, Canberra, Maslyn Williams Papers (hereafter MWP), MS 3936, box 1, folder 2, travel notes.

77 McGregor, 'Wards, words and citizens', p. 243.

78 This story is related in the play about his life, also see *ibid*.

79 MWP, MS 3936 box I, folder one, travel notes.

80 Lowe, '1954: the Queen and Australia in the world', p. 6.

81 Peter Trepanier, 'Some visual aspects of the monarchical tradition', *Canadian Parliamentary Review* 27:2 (2004), p. 27.
82 'Flowers for a royal lady', *Women's Weekly* (27 January 1954), p. 32.
83 SHC, box 51, general, letter, D. Mason to Hawes, 2 April 1954.
84 This compelling story concerned the defection of a Soviet embassy staffer and his wife. SHC, Box 51 general, letter from Tom Gurr, Associated Newspapers, Sydney, to Hawes, 9 April 1954.
85 SHC, box 51, general, 18 May 1954.
86 SHC, box 51 general, letter, Hawes to S. Brown, Canberra, 27 March 1954.
87 SHC, box 51, reviews, film review, *Evening Star* (Washington), 24 June 1954.

SELECT BIBLIOGRAPHY

Ahmed, Ali, 'Political change, 1874–1960', in Brij Lal (ed.), *Politics in Fiji* (Sydney: Allen and Unwin, 1986).

Aitken, Ian, *Film and Reform: John Grierson and the Documentary Film Movement* (London and New York: Routledge, 1992).

——'The development of the official film-making in Hong Kong', *Historical Journal of Film, Radio and Television* 32:4 (2012).

Bakhtin, Mikhail, 'The dialogic imagination: four essays', trans. Michael Holquist and Caryl Emerson, in Pam Morris (ed.), *The Bakhtin Reader* (London: Edward Arnold, 1994).

Benvenuti, Andrea, 'Australia, the "Marshall experiment" and the decolonisation of Singapore 1955–56', *Journal of Southeast Asian Studies* 43 (2012).

Bertrand, Ina, 'Stanley Hawes: a Grierson man', *Metro* 120 (1999).

Bird, Deborah Rose, *Reports from a Wild Country: Ethics for Decolonization* (Sydney: University of New South Wales Press, 2004).

Bourne, Kenneth (ed.), *The Royal Tour of Australia and New Zealand in Pictures* (Melbourne: Herald Gravure Printers for *Herald and Weekly Times*, 1954).

Cain, Frank (ed.), *Menzies in War and Peace* (St Leonards, NSW: Allen and Unwin, 1997).

Campbell, Ian C., *Island Kingdom: Tonga Ancient and Modern* (Christchurch, New Zealand: Canterbury University Press, 1992).

Cumming, Kate, *Royalty and Australian Society: Records Relating to the British Monarchy Held in Canberra* (Canberra: Commonwealth of Australia, 1998).

Denoon, Donald, *A Trial Separation: Australia and the Decolonisation of Papua New Guinea* (Canberra: Pandanus Books, 2005).

Dodds, Klaus, David Lambert and Bridget Robison, 'Loyalty and royalty: Gibraltar, the 1953–54 Royal Tour and the geopolitics of the Iberian Peninsula', *Twentieth Century British History* 18:3 (2007).

Druik, Zoe, 'International cultural relations as a factor in postwar Canadian cultural policy: the relevance of UNESCO for the Massey Commission', *Canadian Journal of Communication* 32 (2006).

Firth, Simon, 'The rise and fall of decolonisation in the Pacific', in Donald Denoon (ed.) *Emerging from Empire? Decolonisation in the Pacific* (Canberra: Australian National University, 1997).

Fox, Jo, 'John Grierson, his "documentary boys" and the British Ministry of Information 1939–42', *Historical Journal of Film, Radio and Television* 25:3 (2005).

Goldsworthy, David, *Losing the Blanket: Australia and the End of Britain's Empire* (Carlton South, Victoria: Melbourne University Press, 2002).

Grimshaw, Anna, *The Ethnographer's Eye: Ways of Seeing in Anthropology* (Cambridge: Cambridge University Press, 2001).

Hansen, Peter, 'Coronation Everest: the Empire and the Commonwealth and the second Elizabethan age', in Stuart Ward (ed.), *British Culture and End of Empire* (Manchester and New York: Manchester University Press, 2002).

Jaikumar, Priya, *Cinema at the End of Empire: A Politics of Transition in Britain and India* (Durham, NC: Duke University Press, 2006).

Landman, Jane, 'Visualising the subject of development: Australian government films made during the trusteeship of New Guinea', *Journal of Pacific History* 45:1 (2010).

Langton, Marcia, *'Well, I Heard It on the Radio and I Saw It on the Television'* (Sydney: Australian Film Commission, 1993).

Lawrence, David and Helen Reeves Lawrence, 'Torres Strait: the region and its people', in Richard Davis (ed.), *Woven Histories, Dancing Lives: Torres Strait Islander Identity, Culture and History* (Canberra: Aboriginal Studies Press for the Australian Institute of Aboriginal and Torres Strait Islander Studies, 2004).

Lowe, David, '1954: the Queen and Australia in the world', *Journal of Australian Studies* 46 (1995).

——'Brave new liberal: Percy Spender', *Australian Journal of Politics and History* 51:3 (2005).

MacKenzie, John, 'The persistence of empire in metropolitan culture', in Ward (ed.), *British Culture and the End of Empire*.

Marshall, Peter, 'Shaping the "New Commonwealth"', *Round Table* 350 (1999).

McGregor, Russell, 'Wards, words and citizens: A. P. Elkin and Paul Hasluck on assimilation', *Oceania* 69 (1999).

——'Avoiding "Aborigines": Paul Hasluck and the Northern Territory Welfare Ordinance 1953', *Australian Journal of Politics and History* 51:4 (2005).

McKnight, David, 'Australian film and the cultural cold war', *Media International Australia* 111 (May 2004).

Moran, Albert, *Projecting Australia: Australian Government Film Since 1945* (Sydney: Currency Press, 1991).

Morris, Ewan, 'Forty years on: Australia and the Queen, 1954', *Journal of Australian Studies* 4 (1994).

Pemberton, Gregory, 'An imperial imagination: explaining the post-1945 foreign policy of Robert Gordon Menzies', in Cain (ed.), *Menzies in War and Peace*.

Potter, Simon, 'Strengthening the bonds of the Commonwealth: the Imperial Relations Trust and Australian, New Zealand and Canadian personnel in Britain 1946–1952', *Media History* 11:3 (2005).

Reynolds, David, 'Empire region, world: the international context of Australian foreign policy since 1939', *Australian Journal of Politics and History* 51:3 (2005).

Shirley, Graham and Brian Adams, *Australian Cinema: The First Eighty Years* (Sydney: Angus and Robertson, 1983).

Sykes, J. W., *Royal Visit 1953* (Suva: Government Printing and Stationary Department, 1954).

Thompson, Roger, *The Pacific Basin since 1945* (London and New York: Longman, 1994).

Trepanier, Peter, 'Some visual aspects of the monarchical tradition', *Canadian Parliamentary Review* 27:2 (2004).

Waters, Christopher, 'Against the tide', *Journal of Pacific History* 48:2 (2013).

Winston, Brian, *Claiming the Real: The Griersonian Documentary and its Legitimations* (London: BFI, 1995).

Wolfe, Patrick, 'Race and trace of history: for Henry Reynolds', in Fiona Bateman and Lionel Pilkington (eds), *Studies in Settler Colonialism: Politics, Identity and Culture* (Houndmills, Basingstoke: Palgrave Macmillan, 2011).

The King's Speech: an allegory of imperial rapport

Deirdre Gilfedder

In March 2014 to the surprise of many in Australia, the Prime Minister, Tony Abbott, announced the reintroduction of the titles of Knight and Dame into the Australian honours list. The titles, given in recognition of public service in various domains, hark back to an imperial tradition that was eliminated in 1986 by the Australian government and replaced with a national system of honours called the Order of Australia. With Abbott's reform, Knights and Dames are once again to be appointed by the monarch, presently Elizabeth II, who is not only Queen of the United Kingdom but also Queen of Australia, on the advice of the Prime Minister.[1] The reversion to knighthoods was greeted with bemusement throughout the country, with critics bemoaning a return to a 'colonial frame of mind', or the establishment of what has long been termed in Australia, a 'bunyip aristocracy'.[2] It also revealed the complexity of an entirely independent Australia's relationship to the British monarchy.

This return to royal honours comes in the wake of a series of mediated public relations 'successes' for the British royal family in the twenty-first century. In Britain the wedding of Prince William and Kate Middleton, the Queen's Diamond Jubilee of June 2012 and the live telecast event of Prince George's christening were slick media events that contributed, according to many commentators, to the 'rebranding' of the royal family. Claire Wardel and Emily West demonstrate that already for the Golden Jubilee of 2002 one could observe a new co-operative tone in the British tabloid press.[3] In Australia the 2014 tour of Kate and Wills seemed also to have been followed by 'fawning' coverage,[4] with live television crosses to the couple's activities and reports naming baby Prince George the 'Republican-slayer'. Meanwhile little coverage of this royal tour addressed the real constitutional issues of Australia's relation to Britain,

the question of whether Australia should retain the British monarch as head of state into the twenty-first century. The republican debate that drew ample media attention in the 1990s, including a fully televised constitutional convention broadcast by the Australian Broadcast Commission, seemed to have ceded media space to celebrity culture. At the time of William and Kate's 2014 tour the press reported a ReachTEL poll indicating that republican sentiment was at its lowest point in twenty-three years, with only 35 per cent of 18–34-year-olds supporting a republic. In Britain, also, republican sentiment has declined, according to a ComRes poll showing that from 2011, when 25 per cent of Britons expected the emergence of a republic within fifty years, the number dropped to a tiny 7 per cent in 2013. This shift in both countries is framed by new configurations in global media patterns where circulating icons clearly enhance the soft power of monarchy. Within this landscape, films about royals also have their role to play.

Two major commercial releases of the years 2000 map this change in opinion in Britain and Australia, and stand out as contemporary narrative explorations of the legitimacy of the British monarchy: *The Queen* (Stephen Frears, 2006) and *The King's Speech* (Tom Hooper, 2010). Coming as they do four years apart, it is possible to read the dynamic these films have produced as powerful visual arguments. While *The Queen* traces troubled times for Her Majesty and even dangles the threat of republicanism as the political stakes of her public relations failure, the Oscar-crowned *The King's Speech* appears to restore the monarch as cinema hero and indeed as a legitimised, dignified heir to the British throne. One could argue that *The King's Speech*, with its insistence on the triumphant reconstruction of the monarch, seeks to repair what *lèse-majesté* the film of 2006 may have stirred up. In the final scene of *The Queen*, Elizabeth II and Tony Blair take a walk in the gardens of Buckingham Palace, and Peter Morgan's script has her ask him, 'Don't you think what affection people used to have for this institution is diminished?' Blair rejects such a claim, but the doubt does hang in the air as the essential political query posed by *The Queen*. On the other hand, by the end of Tom Hooper's film of 2010 the audience is cheering for their hero, not an underdog from the popular classes, but no less than Britain's King George VI.

Both films feature the monarch as protagonist following Shakespearean tradition, and employ the narrative device of a reflection character whose function is to help reconquer the elusive 'majesty' of rightful monarchy. Elizabeth II is saved by her Prime Minister, her rival in popularity but loyal admirer, Tony Blair, who engineers the tabloid and televisual media to create a space for Her Majesty, side-lined and criticised during the drama of Princess Diana's death.

Meanwhile, Bertie (the Duke of York) in *The King's Speech* is aided by his speech therapist, the unorthodox colonial Lionel Logue, who transforms the stuttering, younger brother of Edward VIII into a confident George VI. The plot turns on a familiar dramatic tradition where social opposites are paired to generate both drama and comedy, evoking such figures as Shakespeare's 'trusted fools' or 'wise companions'.

However, the debate about monarchy which provides the context of these two films raises interesting political questions about the idea of loyalty: in *The Queen*, the conservative monarch relies on the support of the Labour leader, in the case of *The King's Speech*, a 'bromance' develops between King and colonial Other. Recent cinema around the British monarchy demands thus a critical cultural studies approach to the kind of representations the industry is circulating. While *The Queen* is about the special relationship in the United Kingdom between the sovereign and the Prime Minister, *The King's Speech* raises a postcolonial problematic of the peculiar status of a Commonwealth realm. In both films, the codes are both ancient and modern: the loyal helper is required to manage the monarch's prestige within the new-fangled complexities of media power, while at the same time engaging in traditional chivalric codes of lord and vassal.

The trope of chivalry is at the narrative heart of these films about twentieth-century modern monarchs. According to tradition, the vassal, locked into feudal ties of loyalty, rushes to the aid of his lord sovereign and is rewarded or protected for this fealty. In *The Queen*, the chivalric relation between Blair and Queen Elizabeth II is constructed both narratively (Blair indeed manages to save the Queen's public image) and iconographically. One of the most powerful shots occurs during an early scene showing the newly elected Blair bent on one knee kissing the Queen's hand, the traditional 'hands kissed on appointment'.[5] A similar relationship is set up in John Madden's 1997 film about Queen Victoria, *Mrs. Brown*, with the bearded Glaswegian comic Billy Connolly playing the role of Her Majesty's loyal Scottish servant, Mr Brown. A controversial blow against Scottish nationalism perhaps, the peripheral subject of Her Majesty is represented as a life-giving force for an institution in crisis. In *Mrs. Brown*, the Scot heals an English monarch in mourning, while in Hooper's *The King's Speech*, the future monarch suffers from the crippling condition of a speech impediment. Life-blood is needed from somewhere in the realm, and in *The King's Speech*, it is drawn from the Empire. The question of representing monarchy spreads beyond Britain's metropolitan borders, and this film pictures the sovereign's 'help' as an Australian.

The relationship between two men, Bertie (the Duke of York, played by Colin Firth) and his therapist, Lionel (played by Geoffrey Rush), is the main focus of the film. Lionel Logue is taken into the trust of the King, or, rather, in the shift the film proposes, the King is taken into the trust of his vassal, Logue, not at court but in the inner realm of the therapist's subterranean medical rooms. The tensions around the inequality of their status are emphasised by the *mise-en-scène*: lengthy exchanges are filmed in the intimacy of the decaying, patina-walled offices using a series of close-ups, short-sided shots and other quirky camera angles and lenses. Cinematographer Danny Cohen explained that under Hooper's direction he placed his camera very close to the actors and shot with wide-angle lenses (using ARRI Master Prime lenses), his strategy being to not only produce large character portraits but to also bring in the background.[6] Others have noted the unconventional framing in the scene where Bertie and Lionel discuss Bertie's unhappy childhood – reverse shots displace both characters to opposite edges of the frame, emphasising the social distance between them. For Jason Haggstrom, there is indeed an overuse of 'interesting' camera angles, which he perceives as a directorial distraction from the action, the canted angles and short-siding overpowering the acting.[7] This rhetorical cinematography, the 'distressed' set design with peeling wallpaper and bare furniture, as well as the sagging pin-striped suit worn by Logue transports the viewer into a theatrical world conceived to highlight what is played out as the psychological melodrama of the Prince's speech problem. The low lighting and smoggy scenes atmospherically suggest a Depression era plagued with uncertainty and crisis: Bertie's speaking problem is clearly a metonymic reference to the faltering kingship of Edward VIII that resulted in his abdication. In *The King's Speech*, the lighting is oppressive, the war is approaching and the throne threatens to remain empty.

The abdication is the central historical drama that the film skirts around in favour of George VI's personal tale. The constitutional crisis of 1936 was critical: Europe was in turmoil with Spain in civil war, Hitler remilitarising the Rhineland, while Mussolini drew closer to Nazi Germany. The British monarch's role was supposed to represent symbolically the unity not only of Britain but also the Empire, itself drawn into incipient conflicts of decolonisation. The anxiety produced by the threat of a vacant throne cannot be overestimated and the core narrative of *The King's Speech* is to instate a moral authority, a figure to unite all British subjects, both in the United Kingdom and in the dominions and colonies. *The Times* echoed this anxiety in its editorial of 4 December 1936,

stating that, 'the need for national calm and national unity was never greater'. With Edward VIII's abdication, Prince Albert emerged as hope for the Crown in a troubled Europe. While his early reign was marked by the policy of appeasement, this is one of the many political realities missing from Hooper's film. Much of the politics seems to have been edited out, save towards the end, when Anthony Andrews's Stanley Baldwin and Timothy Spall's Winston Churchill support Albert for monarch, while the real-life Churchill actually supported Edward VIII.

The focus on the relationship between the King and his therapist, however, carries a rich subtext along the themes of social equality and imperial rapport. The *Economist* journalist who signs her/himself Bagehot (after the Victorian defender of constitutional monarchy)[8] points out that the film's success in the United Kingdom is partly due to its theme of equality, always dear to British hearts: 'At the heart of the film lie two linked themes. One involves Britain's ideas of hierarchy, the other its wartime heroism and rejection of fascism.'[9]

The social divide between the main characters is referenced by the depiction of Logue's shabby rooms as well as a shot of the street where he lives with his family, figured as a slum littered with refuse and street urchins. The Yorks meanwhile live in a grand house. The dialogue constantly raises social difference through Lionel's casualness and Albert's stiff-upper-lip aristocratic manner. The problem of hierarchy, however, stretches beyond the British class system to the tiered relations of Empire. Lionel Logue is an Australian called to help his King and their relationship has historical resonance. Their rapport can be analysed on several levels: the narrative structure and dialogue of Bertie and Lionel's story, the performance of Geoffrey Rush as Lionel Logue as well as what we know of the real-life historical Logue, speech therapist to King George VI. *The King's Speech* also raises the question of film as social allegory: is it possible to interpret the drama of Bertie and Lionel as a framed argument relating to a wider historical context, that of relations between Britain and Australia in the 1930s as well as now?

In David Seidler's screenplay the duo function according to some classic Proppian narrative rules.[10] Lionel Logue is recruited to aid the fragile hero to overcome his 'impediment' and a series of difficult tasks to attain a prized regal dignity. Logue is the actantial supporter[11] whose main function is to advance the hero's story. (The dialogue makes this explicit, when Bertie says to the therapist, 'I came here as I was under the illusion you might help me perform this function.') His role naturally engages the question of equality.

In the beginning of the film, Prince Albert seeks aid from someone he will consider a 'servant'. Social hierarchy is initially raised by his wife, Elizabeth York, who has come to Logue's offices in Harley Street to ask for help. When Logue suggests rather casually that her 'hubby' pop over for treatment for his stutter, she commands, 'You must come to us.' This is the beginning of a struggle between Albert and Lionel around their status. On his first visit the Prince admonishes Logue, 'When speaking with a royal one waits for the royal to start the conversation and choose the topic.' Yet, the established hierarchy is complicated by the therapist's role as a teacher who must make demands of the royal. Logue resolves the difficulties of the situation, through his demands for a circumscribed equality. This point is repeatedly made – refusing to call his patient 'Your Royal Highness', Logue insists that, 'We must be true equals.' He begs the Prince to 'Call me Lionel' not 'Dr Logue' and is generally undaunted by the status of his patient.

It would seem then that Logue is ambivalent: on the one hand, he is the King's vassal, locked into a relationship of mutual trust and service, and on the other, he resists this subservient role. Indeed, the character is marked by a quasi-republican refusal to recognise royalty (calling the Prince 'Bertie', insisting on his professional prerogatives, making a cup of tea with his back turned to him). However, Logue's story in the film is one of learning his place, as we will see, while in the meantime Rush's performance plays liberally with imperial hierarchy.

The film opens at the closing ceremony of the British Empire Exhibition of 1925 at what was originally called the Empire Stadium.[12] While most critics focus on the Bertie character as King of Britain, this setting reminds us that George VI was in fact the last British Emperor,[13] and Australia in the period depicted still what was called a Dominion.[14] Australia had officially gained Dominion status at the 1907 Colonial Conference, though it had been a self-governing nation since 1 January 1901. By 1926 the Balfour report defined this status as being on an equal footing to Britain and the word 'colony' was soon dropped by the Statute of Westminster in 1931, the founding document of the Commonwealth. Following the Second World War, Australia, like Canada, New Zealand and others, was known officially as a Commonwealth *realm* (rather than *dominion*), and continued to retain the British monarch as its head of state. This situation continues today, except that the Australia Act of 1986 removed the final legal ties to Britain's courts and states that the Commonwealth of Australia is entirely 'a sovereign and independent nation'.

Australians, like other imperial subjects, had participated in the First World War, sending hundreds of thousands of volunteers to fight and die for the Mother Country. While their sacrifice was behind the push to make Britain abolish colonial status for its Dominions,[15] imperial belonging coloured Australian politics for the whole of the interwar period. Torn between conservative imperial loyalty and growing nationalism, Australia was scarred by the events of the war and some began to doubt the wisdom of a citizenship so directly linked to Britain.[16] The hegemonic ideology of the early decades of the twentieth century, however, remained loyalism. Defined as personal allegiance to the sovereign, it was conceived as the uniting thread of the British Empire, as it was supposed to override religious or ethnic affiliation.[17] A British subject in the 1930s was still defined as one who 'recognized the King as his Lord', and owed allegiance to the King's person (a different status was reserved for 'British Native subjects'). Empire Day was observed in Australia as of 1905, an occasion on which school children were enjoined to swear their allegiance to the Crown. Fighting for 'King and Country' had been the central propaganda of the First World War for Australians, Irish, Canadians, New Zealanders, Indians and others locked into an imperial *pro patria mori*.

The dependence in the film of the King on the Australian is reminiscent of this ideology of loyalism. In the dialogue Lionel Logue mentions how he had come to England specifically to cure the young men whose speech had been affected by shell shock during the Great War. The narrative suspense is constructed around the final speech, *the* King's speech of the title, which will be delivered on the radio to rally not only the nation but also the Empire to another war. George VI's broadcast declaration is in fact an appeal to Empire: 'For the second time in the lives of most of us, we are at war. ... It is to this high purpose that I now call my people at home and my people overseas who will make our cause their own.' The First World War had put the chivalric contract between colonial subject and monarch to the test. We can recall the speech delivered by a Labor Party member in Australia at the outbreak of war in 1914, that Australia would help Britain, 'to the last man and the last shilling'.[18] On the brink of another European conflict, the King in Hooper's film asks the Australian Lionel, 'Are you willing to do your part?'

The inner tensions of the screen relationship between the monarch and his subject owe much to the performance of Geoffrey Rush, who also co-produced the film. Rush plays Logue less as a loyal vassal than as a colonial upstart, disregarding hierarchy, treating the Prince/King as any other.[19] While his wife, Myrtle (Jennifer Ehle), performs a respectful curtsy to Elizabeth, Lionel's

egalitarianism is seen as seditious. When Lionel attempts to pat his shoulder, the Prince warns him, 'Don't take liberties! You're a dangerous man, Logue.' At a later point in the film, Logue criticises Bertie's brother, David, who is on the point of being crowned King Edward VIII. The Prince denounces him as 'a wicked man. Trying to get me to commit treason!' 'Oh dear, perhaps he's a Bolshevik', sighs Elizabeth York, going up in the creaky lift with her husband. When Logue quizzes her for more information on his client, she taunts, 'You will be treated as an enemy if you are not obliging.' The characterisation mixes obligation and rebellion, with Logue's constant attempts to flatten out imperial order. For the first half of the film, Bertie plays along (more or less) with this egalitarian game, but at one stage he indignantly closes ranks. In the argument filmed with Steadicam as they walk through foggy Regent's Park, the exasperated Prince shouts, 'I'm the brother of a King, the son of a King, back through untold centuries. ... You are a jumped-up jackaroo from the Outback.' Like the dominion nation, Australia, in the interwar years, Lionel Logue is not quite sure of his place – he considers himself equal but is regarded as inferior.

Logue's colonial status is further underscored by the theme of his dubious credentials. It is soon revealed that he has no formal training in speech therapy and is in reality an actor from Perth, the peripheral subject struggling to make a place for himself in the metropolitan centre. From the outer reaches of Empire, he has dreamed of performing Shakespeare in Britain and auditions for the role of that other king with a disability, Richard III, in an amateur London playhouse. Rush gives a *mise-en-abyme* performance – an Australian actor playing a ham Australian actor – after which he is laughed out of the audition as a poor-cousin, colonial sham. 'I didn't realize Richard III was King of the colonies', taunts the director. The many references to Richard III in the film have been seen as an allusion to George VI's disability, but it should be remembered that it is Logue who plays Richard III, the usurper of royal power. In doing so he poses the threat of the colonial 'mimic'. Homi Bhabha traces the colonial subject's opportunistic desire to succeed in the metropolitan culture by copying its behaviour, dress and language, resulting in what he calls an ambivalent hybridity. Geoffrey Rush's audition scene produces this ambivalent effect, and the derision the Australian actor suffers fuels a growing sense of resentment. Bhabha also claims that mimicry can be an unconscious subversion of colonial power in revealing the hollowness of the codes that are imitated.[20] Thus mimicry can register both the stain of inadequacy and a threat to power. All this begs the question, is Rush's Logue a subversive performance?

If we take this perspective, much of the character's dialogue can be read as slanted references to republicanism. In addition to Logue's constant calls for equality, he repeatedly claims self-determination, impertinently answering Elizabeth York's demands with 'My game, my turf, my rules.' While they are in his offices, Logue answers Bertie's protests about the therapy again with 'My castle, my rules.' The theme of equality is also evident in the cinematography, with large-framed two-shots punctuating the film. In the scenes filmed in the Harley Street rooms, the two characters are juxtaposed and given equal screen-space. In the Regent's Park scene they are framed in medium long shots so the viewer sees the bodies of the two men who are dressed almost identically, with dark coats and hats, two friends walking in the park. While much of the film involves cross-cutting between close-ups, and point-of-view shots from behind the King's microphone to emphasise his nervousness, the longer two-shots establish a neat homology between the two main characters. Similarly, promotional posters released by the Weinstein company vary between a shot featuring Rush standing behind Firth, the attendant acolyte, and a more balanced two-shot of Firth and Rush.

A far more obvious republicanism is expressed in the pivotal coronation rehearsal scene when Logue provocatively (and very unrealistically) dares to sit on the throne, the 700-year-old King Edward's Chair. This is an anxious moment, once again emphasised by the cinematography – a slightly shaky hand-held camera and more short-sided shots. At this point, the still-vacant throne of England seems to have been usurped by a colonial mimic, evoking the anxiety of 'hollowness' theorised by Homi Bhabha. To add insult to injury, Logue quips, 'I don't care how many royal arse-holes have sat on this chair.' This outrage is intended to spark the therapeutic anger of the soon-to-be George VI, who achieves self-realisation when he shouts 'I have a voice.' However, the symbolism is tangible and was favourably commented on by the deputy of the Australian Republican Movement, John Warhurst, who calls the film's version of Logue a 'republican hero': 'He recognises authority but will not bow to it. He insists that his professional work with the Duke of York/George VI is conducted on a no frills, first name basis. He might be somewhat eccentric, but his humanity and humour are enormously appealing. Jack is as good as his master.'[21] Rush's performance involves a doubling effect characteristic of allegory, indexing both the identity crisis of a British Dominion in the interwar years and, indirectly, the republican values espoused by a large number of Australians, particularly of Rush's generation, today. The argument is made somewhat heavy-handedly,

21 Colonial mimicry? Australian speech therapist Lionel Logue (Geoffrey Rush) dares to sit on King Edward's Chair in *The King's Speech* (Tom Hooper, 2010).

both audibly and visually – Rush's cultivated Australian accent (as opposed to English Received Pronunciation or broad Australian) recalling early recordings from the ABC (Australian Broadcasting Commission) and his challenging gaze when he is seated on the Coronation Chair suggesting the familiar figure of the King's fool and the anti-authoritarian sentiment of Australian republicanism.

Nevertheless, in the dénouement after the emotional climax of the rally to War speech, Logue finally recognises George VI's authority and the master–servant relationship reverts to the status quo. 'Thank you. Well done, my friend', says the King in a belated bid for egalitarianism, 'Thank you, Your Majesty', replies Logue (albeit with a rather ambiguous intonation). It is at this point that the stories of the two men concur and the film's conservatism re-emerges. Lionel learns his place, his rebellion is tamed and he is rewarded, as vassals in days of old, with a knighthood.[22] George VI gains that sacred quality of kings theorised by Ernst Kantorowicz[23] in his work on European monarchy, the aura of imperial majesty that has been threatened by crisis. He does so both through the recognition accorded by his subject, and through the pseudo-mystical power of the media. Speech therapy is the instrument to the King's aural presence through radio. His domain is addressed through broadcasting, visually referenced in the final scene with cross-cuts to the BBC studios (filmed at Battersea Power Station), with all the dials and what look like frequency transmitters marked with destinations within the British Empire – Bechuanaland, Kenya, Bahamas, Australia. These are interspersed with the establishing shots of people around

Britain listening to the speech – soldiers preparing equipment, working-class customers in a pub, gentlemen in a London club and so forth – creating the effect of a global British community. Thus the King's media presence is also the channel of his imperial authority: 'I send to every household of my peoples, both at home and overseas, this message, spoken with the same depth of feeling for each one of you as if I were able to cross your threshold and speak to you myself.' This is the triumph of the King, to be able to incarnate authority ('I have a voice') and to disseminate this disembodied authority from Buckingham Palace (from where the speech was broadcast) across the Empire. In real life, the call was answered by Australia. On the same day as the King's Call to Arms, 3 September 1939, Australian Prime Minister Robert Menzies delivered his famous radio broadcast declaring his country's commitment to Britain: 'Fellow Australians, it is my melancholy duty to inform you officially that ... Great Britain has declared war upon her [Germany], and that, as a result, Australia is also at war.'

The *Economist*'s Bagehot is correct to point out that the film's success in Britain is partly about the public's narcissism: 'If British cinema-goers have taken this tale of a reluctant king to their hearts, it is because it faithfully reflects their sense of themselves.'[24] This social imaginary works also for an Australian audience in this Anglo-Australian production. Australians are invited to see themselves in this irreverent, egalitarian character full of 'colonial ingenuity', suggesting the old Australian nationalist cliché formulated by Russell Ward in the 1950s: 'The Australian believes that Jack's not only as good as his master but probably a good deal better.'[25] Australian audiences, well versed in the history and cultural memory of the World Wars, recognise their former colonial selves. The republican question is raised, but in a typically Australian way remains unresolved. The film lingers in the half-light of postcolonial ambivalence with a final shot of Geoffrey Rush standing literally on the threshold between two rooms of Buckingham Palace.

From an Australian point of view the pitting of a local 'working-class' hero against the British aristocratic system is hardly new cinema material. Graeme Turner mentions it as a well-worn routine of Australian nationalist film fiction citing such productions of the 1980s as *Gallipoli* (Peter Weir, 1981), *Breaker Morant* (Bruce Beresford, 1980) as well as the television series *Bodyline* (1984), in which the 'heroic' Australian challenges British authority.[26] Such national fictions draw on familiar stereotypes such as the 'cheeky, resourceful larrikin' that go as far back as the 1890s literature of Henry Lawson and C. J. Dennis's *The*

Sentimental Bloke and *Ginger Mick*, both made into popular silent films in 1919 and 1920. The 'Australian type' in this tradition is invariably white and masculine and was particularly skilfully incarnated by Paul Hogan in his film *Crocodile Dundee* (Peter Faiman, 1986). Both Turner and Tom O'Regan discuss the role of 1970s and 1980s so-called national cinema in creating a 'social bond' through narratives that both unite and exclude Australians, and note the persistence of the theme of postcolonial rivalry with Britain.[27] Yet they also signal its declining relevance in an increasingly multicultural society with the narrow focus on the 'Anglo' white male dissipating in the films of the 1990s and beyond. Felicity Collins and Therese Davis demonstrate the rupture that the Mabo decision of 1992 (a High Court decision that allowed Indigenous Australians to claim their land rights) brought to Australian cinema,[28] introducing a renewed set of national narratives linked to the political recognition of indigenous Australia, and a new set of heroes like the young female runaways of *Rabbit-Proof Fence* (Philip Noyce, 2002). The post-Mabo films deal with the country's own internal colonising past and traumatic memories, rather than the identity struggle between Australia and Britain. Hooper's film signals the return of the imperial dynamic and the white male democratic hero, with the original approach of bringing the Australian into the intimate circle of the monarch. Rush's Lionel Logue avoids the larrikin stereotype, presenting us with a relatively fresh characterisation of the cultivated Australian, a type he had already played in his Oscar-winning performance in the film *Shine* (Scott Hicks, 1996). He still represents a challenge to aristocratic power, but rather than roam free in the Bush or on the streets of Sydney like Ginger Mick, he is absorbed into the heart of the court.

The King's Speech was marketed to a variety of audiences, in a context where narratives of 'national cinema' are no longer clear-cut. Rush's performance serves to entertain the generation of Australians who recognise the old chestnut of Anglo-Australian relations, and British viewers who fantasise about Australian class iconoclasm. Yet, for obvious budgetary reasons, the film was primarily aimed at North Americans, not necessarily versed in this specific postcolonial issue, yet sensitive to its tension. Distributed by the Weinstein Company, it met with unexpected and sustained success in the USA, largely as a result of its inclusion of an older cinema-going target. The feel-good tale of an ordinary monarch's symbolic transformation was then 'crowned with success' at the 2010 Academy Awards, enacting a kind of resacralisation through transnational media.[29]

But contrary to Rush's performance, the diaries of the real Lionel Logue reveal a story of true loyalty. In 2010, grandson Mark Logue published them

in a book modestly entitled, *The King's Speech: How One Man Saved the British Monarchy.*[30] He also gave several interviews about his discovery of the diaries in the family attic. Explaining that the relationship between Logue and George VI was far more formal, he states that in the film 'there's artistic license in the breaking through of the royal etiquette'. He adds that Lionel Logue was far from impertinent: 'I'm not sure if the Bertie thing was real. I personally believe he was more deferential and would have called him Your Majesty. That's consistent in the diaries.'[31] The class difference conjured up in the film by the dirty streets and poor furnishings of the Logue residence is also a fabrication. Mark Logue paints the portrait of a prosperous bourgeois living in a mansion in Sydenham called Beechgrove:

Beechgrove had twenty-five rooms, five bathrooms, five acres of garden, a tennis court and a cook; it was probably bigger than the Piccadilly house his patient moved into when he and his duchess were married. Logue had never been poor – he was a respectable middle-class Australian who delighted in his intimate access to the monarchy and gladly deferred to its members.[32]

The diaries portray a perfectly loyal imperial subject with no shading of the Aussie egalitarianism suggested by Geoffrey Rush. When George VI thanked Logue, his typical response was, 'The greatest thing in my life, Your Majesty, is being able to serve you.' Possibly chosen to assist the King because he was a practising Freemason,[33] Logue seems to illustrate the official and hegemonic loyalism of the Australian upper class in the interwar years, underwritten by the firm allegiance of Australian Freemasonry to the sovereign. With its rewriting of its vassal as a radical egalitarian, *The King's Speech* demonstrates how media culture participates in a society's shifting self-image. For contemporary Australian spectators, Rush's Logue personifies the indecisiveness of their republican dream.

NOTES

1 The honours are not imperial; recipients become Knights and Dames of the Order of Australia.

2 A term coined by early Australian republican Daniel Deniehy in the nineteenth century when the New South Wales government tried to introduce a local peerage system. A *bunyip* is an aboriginal mythological creature.

3 Claire Wardle and Emily West, 'The press as agents of nationalism in the Queen's Golden Jubilee: how British newspapers celebrated a media event', *European Journal of Communication* 19:2 (2004).

4 Mark Day, opinion editor for *The Australian*, criticised media coverage of the event in 'Cheer Kate, but don't confuse celebrity with constitution', *The Australian* (28 April 2014), .www.theaustralian.com.au/media/opinion/cheer-kate-but-dont-con-fuse-celebrity-with-constitution/story-e6frg9tf-1226897652898#.

5 The tradition of appointing the United Kingdom's Prime Minister is explained on the website of the British monarchy, www.royal.gov.uk/MonarchUK/Queenand-Government/QueenandPrimeMinister.aspx.

6 Danny Cohen interviewed in Beth Marchant, 'Cinematographer Danny Cohen on *The King's Speech*', *Studio Daily* (17 February 2011), www.studiodaily.com/2011/02/cinematographer-danny-cohen-on-the-kings-speech.

7 Jason Haggstrom, 'The miserable ugliness of *The King's Speech*', *Reel 3* (31 December 2012), http://reel3.com/the-miserable-ugliness-of-the-kings-speech.

8 In 1867 William Bagehot published *The English Constitution*, in which he defined the role of the constitutional monarch in Great Britain.

9 'Bagehot', '*The King's Speech*, a preposterous film but oddly shrewd about Britain', *The Economist* (14 January 2011), www.economist.com/blogs/bagehot/2011/01/british_monarchy.

10 Vladimir Propp, *Morphology of the Folk Tale*, trans. American Folklore Society (Bloomington: Indiana University Press, 1968).

11 Narratological term developed by A. J. Greimas in 'Éléments pour une théorie de l'interprétation du récit mythique', *Communications* 8:8 (1966).

12 The aim of the Empire Exhibition was to 'stimulate trade and strengthen bonds that bind mother Country to her Sister States and Daughters'. See Mark Logue and Peter Conradi, *The King's Speech: How One Man Saved the British Empire* (London: Quercus, 2010), p. 36.

13 George VI was the last 'Emperor of India' (a title the British borrowed from the Mughals), witnessing the independence of India in 1947. He signed himself 'G.R.I.' (*rex imperator*) for the last time on 15 August 1947. The Irish Free State had already written the monarch out of its constitution at the abdication and by 1948 was a republic refusing even to join the British Commonwealth. The Commonwealth itself withdrew the concept of common allegiance to the Crown, with the King placed as the symbolic head of a free association of states. Burma also gained independence from Britain in 1948 while George VI was King.

14 Thus, Australia was technically a dominion from 1907 to 1948, after which it was called a 'realm'.

15 The Statute of Westminster abolished the term 'colony' for those countries of the Empire which had largely independent parliaments. However, the Government of Australia did not ratify the Statute of Westminster till 1942, when the threat of Japanese invasion forced a change in foreign policy.

16 The main political debate in Australia was around economic policy to combat the disastrous effects of the Depression. The left of the Labor party opposed imperial financial policies as well as the conservative culture of loyalism.

17 See Daniel Gorman, *Imperial Citizenship: Empire and the Question of Belonging* (Manchester: Manchester University Press, 2006), p. 21.

18 Andrew Fisher delivered an impassioned speech in favour of the Empire's war effort on 6 July 1914: 'Australians will stand behind our own, to help and defend her, to the last man and the last shilling.' Australian Federal Election speeches, Museum of Australia, http://electionspeeches.moadoph.gov.au/speeches/1914-andrew-fisher.

19 This seems to have also been the choice of Tom Hooper and Geoffrey Rush, though Hooper explains they were at pains to avoid stereotyping. 'Geoffrey was very keen he didn't want to make a York-versus-snob movie. I think if Geoffrey hadn't been Australian and I hadn't been Australian, we probably would have lapsed into a much broader cliché.' In John Lopez, '*The King's Speech* director Tom Hooper on the King's stammer, Colin Firth, and the royal family, *Vanity Fair* (8 December 2010), www.vanityfair.com/online/oscars/2010/12/the-kings-speech-director-tom-hooper-on-the-kings-stammer-colin-firth-and-the-royal-family.

20 Homi Bhabha, 'Of mimicry and man: the ambivalence of colonial discourse', in *The Location of Culture* (London: Routledge, 1994).

21 John Warhurst, 'Lessons about Australian identity from "The King's Speech"', *Eureka Street* 21:1 (25 January 2011), www.eurekastreet.com.au/article.aspx?aeid=24802#.UqXSLqWqOmw.

22 The extra-diegetic note explains this before the final credits: 'Lionel Logue was made a knight of the Royal Victorian Order in 1944 – This high honour from a grateful King made Lionel part of the only order of chivalry that specifically rewards acts of personal service to the Monarch.'

23 The German historian Ernst H. Kantorowicz, writing in the 1930s, theorised the sacredness of medieval kings and the persistence of their rituals in his work, *The King's Two Bodies: A Study in Mediaeval Political Theology* (Princeton, NJ: Princeton University Press, 2nd edn, 1998).

24 'Bagehot', '*The King's Speech*'.

25 Russel Ward, *The Australian Legend* (Melbourne: Oxford University Press, 1958), p. 2.

26 Graeme Turner, 1994, *Making it National: Nationalism and Australian Popular Culture* (Sydney: Allen and Unwin, 1994), p. 48.

27 Tom O'Regan, *Australian National Cinema* (London: Routledge, 1996), pp. 17–27.

28 Felicity Collins and Theresa Davis, *Australian Cinema after Mabo* (New York: Cambridge University Press, 2004).

29 For more on media sacralisation see Nick Couldry, *Media Rituals: A Critical Approach* (London: Routledge, 2002).

30 Logue and Conradi, *The King's Speech*.

31 Stephen Krutz, interview with Mark Logue, 'The real story behind "The King's Speech"', Speakeasy Blog, *Wall Street Journal* (4 December 2010), .http://blogs.wsj.com/speakeasy/2010/12/04/the-real-story-behind-the-kings-speech/.

32 Krutz, 'The real story behind "The King's Speech"'.

Deirdre Gilfedder

33 According to Suzanne Edgar's entry for Lionel George Logue in the *Australian Dictionary of Biography* (published by the National Centre of Biography at the Australian National University, Canberra), adb.anu.edu.au/biography/logue-lionel-george-10852, he was also speech therapist to the Royal Masonic School.

SELECT BIBLIOGRAPHY

Ashcroft, Bill, Gareth Griffiths and Helen Tiffin, *Post-Colonial Studies: The Key Concepts* (London: Routledge, 2000).

'Bagehot', '*The King's Speech*, a preposterous film but oddly shrewd about Britain', *The Economist* (14 January 2011), www.economist.com/blogs/bagehot/2011/01/british_monarchy.

Bhabha, Homi, 'Of mimicry and man: the ambivalence of colonial discourse', in *The Location of Culture* (London: Routledge, 1994).

Collins, Felicity and Theresa Davis, *Australian Cinema after Mabo* (New York: Cambridge University Press, 2004).

Couldry, Nick, *Media Rituals: A Critical Approach* (London: Routledge, 2002).

Day, Mark, 'Cheer Kate, but don't confuse celebrity with constitution', *The Australian* (28 April 2014), www.theaustralian.com.au/media/opinion/cheer-kate-but-dont-confuse-celebrity-with-constitution/story-e6frg9tf-1226897652898#.

Edgar, Suzanne, entry for Lionel George Logue, *Australian Dictionary of Biography* (published by the National Centre of Biography at the Australian National University, Canberra), adb.anu.edu.au/biography/logue-lionel-george-10852.

Fisher, Andrew, speech of 6 July 1914, Australian Federal Election speeches, Museum of Australia, http://electionspeeches.moadoph.gov.au/speeches/1914-andrew-fisher.

Gorman, Daniel, *Imperial Citizenship: Empire and the Question of Belonging* (Manchester: Manchester University Press, 2006).

Greimas, A. J. 'Éléments pour une théorie de l'interprétation du récit mythique', *Communications* 8:8 (1966).

Haggstrom, Jason, 'The miserable ugliness of *The King's Speech*', *Reel3* (31 December 2012), http://reel3.com/the-miserable-ugliness-of-the-kings-speech.

Hennessy, Patrick, 'Confidence in British monarchy at all-time high, poll shows', *Telegraph* (27 July 2013), www.telegraph.co.uk/news/uknews/theroyalfamily/10206708/Confidence-in-British-monarchy-at-all-time-high-poll-shows.html.

Kantorowicz, Ernst H., *The King's Two Bodies: A Study in Mediaeval Political Theology* (Princeton, NJ: Princeton University Press, 2nd edn, 1998).

Krutz, Stephen, Interview with Mark Logue, 'The real story behind "The King's Speech"' (4 December 2010), Speakeasy Blog, *Wall Street Journal*, blogs.wsj.com/speakeasy/2010/12/04/the-real-story-behind-the-kings-speech/.

Logue, Mark and Peter Conradi, *The King's Speech: How One Man Saved the British Empire* (London: Quercus, 2010).

Lopez, John, 'The *King's Speech* director Tom Hooper on the King's stammer, Colin Firth, and the royal family', *Vanity Fair* (8 December 2010), www.vanityfair.com/online/oscars/2010/12/the-kings-speech-director-tom-hooper-on-the-kings-stammer-colin-firth-and-the-royal-family.

Marchant, Beth, 'Cinematographer Danny Cohen on *The King's Speech*', *Studio Daily* (17 February 2011), www.studiodaily.com/2011/02/cinematographer-danny-cohen-on-the-kings-speech.

Morris, Meaghan, 'Tooth and claw: tales of survival and "Crocodile Dundee"', *Social Text* 21 (1989).

O'Regan, Tom, *Australian National Cinema* (London: Routledge, 1996).

Propp, Vladimir, *Morphology of the Folk Tale*, trans. American Folklore Society (Bloomington: Indiana University Press, 1968).

Turner, Graeme, *National Fictions: Literature, Film and the Construction of Australian Narrative* (Sydney: Allen and Unwin, 1993).

———*Making it National: Nationalism and Australian Popular Culture* (Sydney: Allen and Unwin, 1994).

Ward, Russel, *The Australian Legend* (Melbourne: Oxford University Press, 1958).

Wardle, Claire and Emily West, 'The press as agents of nationalism in the Queen's Golden Jubilee: how British newspapers celebrated a media event', *European Journal of Communication* 19:2 (2004).

Warhurst, John, 'Lessons about Australian identity from "The King's Speech"', *Eureka Street* 21:1 (25 January 2011), www.eurekastreet.com.au/article.aspx?aeid=24802#.UqXSLqWqOmw.

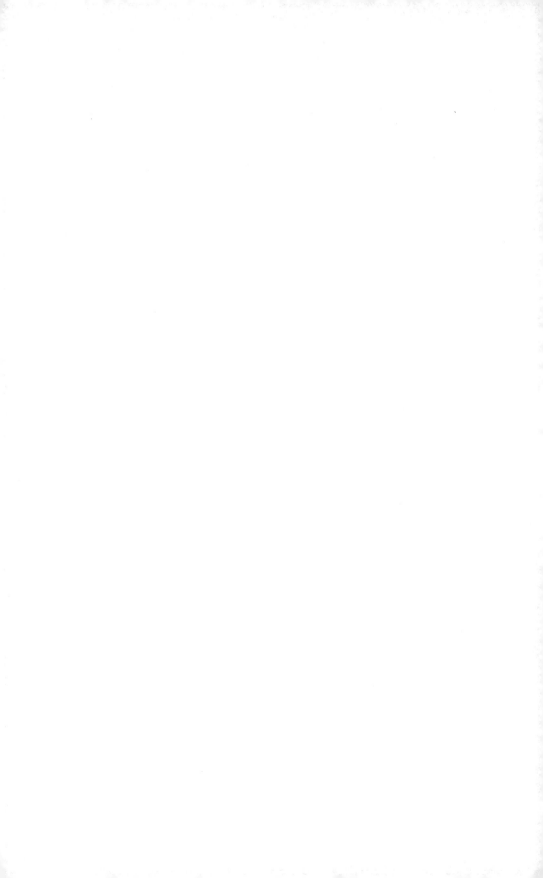

Part IV

Popular participation in royal representation

10

The Queen has two bodies: amateur film, civic culture and the rehearsal of monarchy

Karen Lury

'Well, this is grand!' said Alice. 'I never expected I should be Queen so soon – and I'll tell you what it is, your Majesty', she went on in a severe tone (she was always rather fond of scolding herself), 'it'll never do for you to be lolling about on the grass like that! Queens have to be dignified you know!'[1]

This chapter will explore a range of amateur rather than professional film production: in this context, 'amateur film' serves as a broad category which includes a diverse number of films made by individual hobbyists, cine clubs and the more commercially minded directors of various 'local topicals'.[2] While the majority of amateur films (as home movies) are essentially private, featuring people and events emerging from the domestic context of the filmmaker (such as a birthday party, a christening or a holiday) there are many others made by non-professionals that concentrate on accessible, predictable and explicitly public events. In the British context, many of these public events are civic festivals and gala days, or royal visits to cities, schools and large sporting competitions. In the context of an anthology exploring the representation of the British monarchy on screen, the coincidence of these symbolic performances of monarchy in amateur film is particularly interesting. In the argument that follows, the amateur filmmaker's capturing of the real monarchy, as in the representatives of the British Crown, or the fabricated monarchy, as in the gala queen or princess, provide a fascinating comparative case study. Of particular interest is the role of the child who will be seen to have a central – if surprisingly ambiguous – function, with his or her presence both confirming and satirising the institution of the monarchy. In the looking-glass world invented by Lewis Carroll, the little girl Alice becomes queen and, as we shall discover, amateur films provide many similar instances where children function as a mirror or temporary surrogate for royalty.

The apparent preoccupation of amateur filmmakers with versions of monarchy is partly determined by the accessibility of the subject matter for the opportunistic camera operator. Yet they are also pervasive because these films have met with the needs and fascinations of the archivist and historian. From the extensive, diverse and often bewilderingly mundane range of amateur cinema, a specific value or interest can be assigned to a film when it records something (intentionally or unintentionally) that provides access to 'history', whether this is a ritual repeated over many years, or a photographic record of a known historical figure. There are therefore many real and fabricated queens in amateur film collections across the UK. Some of the earliest films held by the Scottish Screen Archive (SSA), for instance, record either actual monarchy (such as the *Duke of York visits Mavor and Coulson Limited: 12th October 1932*, bw/silent, 4.25 minutes) or they depict public rituals in which monarchy is faked or performed by the community (as in the many films recording the Bo'Ness Children's Fair Festival, including *Bo'Ness Public School: Queen Anne Petrie* (1923, bw/silent, 55 minutes).[3] While these kinds of film are pervasive across the UK, this chapter is particularly concerned with the Scottish context of the films under discussion, incidentally exposing the complexity of the relationship of Scottish communities to the British monarchy and their imagining of a coherent civic history.

GLASGOW WELCOMES THE QUEEN

This film – 1953, colour/silent, 14.41 minutes – is entirely typical of the work of advanced amateurs such as the Scottish Association of Amateur Cinematographers, who are funded, in this instance, by the Scottish Film Council.[4] The film features a young Queen Elizabeth II and her husband, the Duke of Edinburgh, on a post-coronation civic visit to Glasgow and is one of a number of similar films grouped together as *Scotland Salutes the Queen*. The film begins with the titles on a colourful tartan background, suggesting that George Square (the main public square in Glasgow, directly in front of the impressive buildings of the City Chambers) is 'transformed'. Certainly, there are many banners and flowers to be seen, and later in the sequence it is clear that an impressive crowd has gathered. The Queen and the Duke of Edinburgh arrive in an open-top car. The Queen is dressed conservatively, if fashionably, in a dark swing coat and small white hat, with white gloves and white shoes. Unlike many of the city dignitaries she meets, who are wearing long, dark ceremonial gowns decorated with gold brocade and white fur, the Queen is not wearing anything

that speaks specifically of her royal status, such as a crown or a more formal gown. The smaller numbers of women who are directly introduced to the Queen wear – like the Queen herself – smart coats or dresses, hats and gloves. About 50 metres from the Queen, policemen, some on horses, struggle to contain the surges of the crowd in the Square. The Queen then inspects a line-up of soldiers in formal dress – a small group of Scots Guards – who are wearing red military jackets and bearskin hats. Accompanied by an officer, she walks briskly up and down the lines of soldiers, as photographers hover at the end of the lines themselves. There is a clear distinction between people who come close to the Queen and those who are on the fringes of the event. Individuals or groups of people who are directly introduced or who are inspected by the Queen mirror her posture and attire, act stiffly and dress formally. In contrast, other individuals, such as the photographers and crowd members, are dressed informally and are much more relaxed and active in their behaviour. For instance, the film shows the photographers running around the royal grouping for a better shot, and there are many sequences in which individuals in the crowd chat to each other, peer over each other's shoulders, look at the camera or generally shuffle their feet, shoving each other and excitedly waving at the royal party.

For someone like myself – a British citizen who has grown up in the UK – the posture of the Queen, the behaviour and the dress of the dignitaries and onlookers seems entirely conventional, although there is an interest in seeing a younger Queen betray, at this early point in her reign, a stiffness matched with a manner that is both alert and brisk. This very individual performance of dignity has remained consistent and was still visible in the many televised news items featuring the Queen's royal visits and openings during the celebrations for her Diamond Jubilee in 2012, almost sixty years after this film was made. The reason for detailing this particular sequence, however, is to note how closely it follows the model that Ilse Hayden has identified in her anthropological study of the British royal family, in which she suggests that in these kinds of civic encounters, the Queen must balance precariously between appearing ordinary (accessible) and extraordinary (royalty).[5] She suggests, 'Much of the appeal of the Queen as a symbol derives from her personhood, but the messiness of being a person must not be allowed to intrude upon the dignity of the institution of Queenship.'[6] The Queen's peculiar status – as both person and symbol – is related to kingship (or, here, queenship) as an institution, as well as a biological inheritance that must be indelibly tied to the actual body of her person. As Joseph Roach suggests, in his historical study of processions, rituals

and other civic performance, this kind of balancing act is derived from, and a manifestation of,

> the legal fiction that the king had not one but two bodies – *the body natural* and *the body politic* – [which] developed out of medieval Christology … and into an increasingly pragmatic and secular principle of sovereign succession and legal continuity.[7]

Since in these events the Queen is not costumed to display her extraordinary qualities and, as Hayden suggests, since she appears superficially like any other 'upper-middle-class matron',[8] she is required to signal her uniqueness and her institutional status through her posture and behaviour, which manifest as 'dignity'. Indeed, as Hayden comments, referring specifically to Elizabeth II, 'Her dignity, deriving in part from the almost suprahuman control of that body, is more impressive than if she were made of cast iron.'[9]

Equally important is the manner in which those physically closest to the Queen (her consort, her ladies-in-waiting and the various civic officials and soldiers she meets) conform to an explicit choreography. The men bow, the women curtsy and the soldiers stand rigidly to attention or salute. In a situation such as this event – where there is evidently huge general public interest – onlookers act as if the Queen, her immediate retinue and those she meets and greets all operate behind a theatrical 'fourth wall' in which the royal party's interactions with a limited number of privileged individuals are clearly staged and are 'to be looked at'. The work of the policemen is surely to establish this boundary. The significance and rather peculiar character of this fourth wall becomes even more evident in the following section of the film in which the Queen and Duke of Edinburgh visit the Scottish Veterans' Garden City Cottages at Ralston near Glasgow.

In this sequence, the Queen and the Duke of Edinburgh arrive again in a large open-top car. The filmmaker is clearly positioned more closely to events than in the previous sequence and would appear to be just over the other side of the street from the royal party, so that the Queen is presented at a more intimate distance than before, through a series of mid- to long shots. The more ad hoc nature of the choreography at this smaller scale event means that the Queen herself is occasionally blocked from view as one or more dignitaries take their place alongside her. From this initial position, the filmmaker attempts to pan the camera to follow the royal party as they make their way down the street. Edits in the final film – there is a notable insertion of a sequence of children waving flags excitedly – suggest that additional sequences were captured by another camera

operator (or at a different time by the same filmmaker) and were used to bridge breaks in continuity as the filmmaker (or filmmakers) tried to keep up with the royal party as they made their journey down the street. Along the street, small groups of people stand on the pavement in front of low garden walls: these people are formally dressed. Directly behind these garden walls are other groups of people who are dressed much more informally. The distinction between the two groupings of individuals – behind or in front of the walls – is clear: those people who are presumably standing in their own front gardens (and behind the walls) are not presented to the Queen directly. Those people who are situated in front of the walls – and who are perhaps less likely to be actually resident in the street – are lined up to bow and curtsy to the Queen, who pauses to speak briefly to each of them in turn. The men are in smart suits, some wearing the chains of civic office, the women wear conservative formal coats and both the men and women wear hats. In contrast, the people standing in their gardens are much more informally dressed: they do not wear hats and several of the women appear to have stepped directly away from their work as they are wearing informal 'house coats' (thin cotton pinafores, often with a floral design, characteristically worn by housewives in the 1950s). These individuals do not greet the Queen directly and she does not appear to make eye contact with them. As she proceeds down the street the number of spectators becomes larger and the distinction between being in front or behind the wall begins to erode, and here the Queen no longer stops to greet anyone specifically, although she seemingly acknowledges the onlookers' presence with smiles and a slight lowering of her head.

This sequence therefore repeats the careful choreography of the royal visit, where a tangible, if often invisible boundary is established between the Queen and the unselected majority who attend. In the earlier sequence in George Square, this boundary was established by the work of the police. In this later sequence, this boundary is initially realised by low brick walls that separate the majority of spectators from the privileged few who actually get to meet the Queen. As the cameras capture the Queen's progress, the impression is of a conveyor belt (the Queen works her way in a straight line greeting people one after the other) but her close proximity to the onlookers also provides an unusual composition in which the on-stage of the royal visit – the meeting and greeting, the bowing and curtsying – is nearly undermined by the visibility of the off-stage, where the spectators talk to one another, take photographs, wave their hankies, smoke and fidget at a distance of only 2 or 3 metres from the Queen as she passes by.

Despite this unusual capture or inclusion of the off-stage activities, the event as pictured is entirely as would be expected from a royal visit and there is no anxiety or apparent confusion manifested either by the Queen or by the spectators as to how they should behave. However, filmed in a way that exposes the clumsiness and artificiality of the formal choreography, it also appears rather ridiculous, a fragile dance of *politesse* sustained almost entirely by convention and the performance of the Queen herself – something that becomes much more marked toward the end of her journey down the street. Indeed, as the superiority and special status of the Queen is not manifest in her dress or appearance, or through other expressions of power, her position might seem to be precarious.[10]

However, the film incorporates another familiar encounter commonly orchestrated to prop up the etiquette required by this kind of occasion. At a point that appears to be almost half-way down the street, the Queen is approached by a little girl, dressed in a white lacy dress, white shoes and socks, with a large white bow in her hair, holding a formal bouquet of pink roses. Introduced to the Queen, the little girl curtsies and presents her with the flowers. The Queen bows slightly (graciously) to receive them, at which point, the little girl curtsies again. The surrounding spectators applaud and cheer. The Queen – as recipient of the gift – should be indebted to the giver.[11] Yet, as Hayden suggests, as in this and many other royal visits, the Queen 'gives nothing' but her presence, yet apparently remains undiminished by this refusal to conform to a 'gift economy'.[12]

The apparently unproblematic quality of this refusal suggests that the role of the child within this banal encounter may be significant. The giving child, here appearing as an idealised, mute, diminutive other, is clearly not a threat to the status of the Queen, specifically, to Her Majesty. It seems plausible to suggest, as Hayden does, that this child or any child will not be a threat because they are always less powerful than any adult they meet. Despite the twentieth century's obsession and anxiety concerning the importance of childhood and the continuing idealisation of the child since the Romantic period, politically, socially and even biologically, children (since they are generally small, inarticulate, without rights, lacking money or physical strength) occupy the lowest or most deviant social and cultural status in Western culture of any other living being aside from non-human animals.[13] The child's symbolic gift giving thus serves to reinforce rather than undermine the Queen's natural (biological and institutional) superiority. As Hayden suggests:

> The few pictures that I have seen that contrast the socially superior (i.e. the similarly attired Queen, royal retinue and hosts) with the socially inferior (i.e. the contrastingly attired rank and file) involve children. On these occasions,

the privileged individuals can be shown in proximity to the Queen because the distinctions between the *hoi ogloi* and the *hoi polloi* would not be easily recognised as those of class. Rather, they appear to be the difference of child and adult. Children are so deviant that all adults outrank them.[14]

The child's deviancy and inferiority mirrors and bolsters the extraordinary and superior status of the Queen herself. In this film, in terms of their composition, child and monarch present an inverted symmetry: the adult Queen in a long, dark coat, performing graciousness and dignity despite the intense scrutiny of the on-looking crowd; the little girl dressed all in white, petite, similarly suppressing any possible exuberance or inappropriate body language, rigidly repeating her formal curtsy to the acclaim of an appreciative audience. Primped, prettified and obedient, the little girl is performing a version of childhood in the same way that the Queen performs a version of monarchy. They are individuals but also representatives of highly visible institutions or mythologies. As captured on this film and in many similar encounters, the child and the Queen have real bodies while, at the same time, they function as if they were inanimate emblems, sites for the projection of history and memory, acting as screen and mirror for social convention and hierarchy. As such, although Hayden here refers only to the monarchy, she might also be referring to the child:

> They are both persons and symbols; and because they are persons they cannot be used as can inanimate symbols. But this intractableness does not distract from their symbolism. It intensifies it, for the power of symbols emanates from their ability to reconcile the irreconcilable.[15]

In the following section I want to further explore the symbolic aspect of the monarchy and the similarly two-bodied aspect of the child by addressing a number of amateur films in which children – mostly young adolescent girls – become queens.

DUMFRIES GUID NYCHBURRIS DAY: THE INSTALLATION OF THE
'QUEEN OF THE SOUTH'

Dumfries is to celebrate its Guid Nychburris Festival on Friday, 22nd July and Saturday, 23rd July, when the programme will include the riding of the marches, a procession and pageant representative of historical incidents and personages, a pageant of the seasons by school children, and prizewinners of

sports and horse racing. There has been a generous expenditure of money to ensure the success of the festival and between 700 and 800 people will participate in the procession and pageant.[16]

In the films of Dumfries Guid Nychburris Day, the living representatives of the British monarchy are absent. Instead the films capture a series of repeated and fictional coronations, civic processions and make-believe queens. Although there are many similar events across Scotland and there are many films capturing festivals and gala princesses over a long period of time (notably perhaps the previously cited Bo'Ness films), here I concentrate on the films held by the SSA depicting the Dumfries 'Guid Nychburris Day' as an entirely fabricated civic festival that has been filmed almost from its first inception – in 1932 – and which is still running today.[17] One of the earliest films the SSA holds picturing the festival is *Dumfries Guid Nychburris Day: Riding of the Marches and Pageant* (1933, director unknown, sponsored by the ABC cinema, black and white/silent, 13.46 minutes). As the credits for the film suggest, it is a good example of what is now termed a 'local topical' – a film sponsored by a local cinema recording something of apparently intense local and historic significance but not co-incidentally also capturing many local individuals, including those participating in the ceremony and many others who feature as spectators to the event itself.

This film, like others of its type, features several long sequences in which the camera pans across gathered crowds. It was clearly made with the explicit ambition of encouraging people to attend its exhibition at their local cinema, since having been filmed as part of the crowd they might hope to see themselves on the big screen. Indeed, in one sequence, a man can be seen handing out leaflets to a crowd, who are waiting for the 'Queen of the South' (the festival's queen) and her retinue to arrive. The man wears a long overcoat advertising the fact that the 'Pageant film' can be seen in the Regal Cinema. Not only is this a rather neat self-reflexive image for the film historian (the film has incorporated its own promotional intent which will then inevitably be rescreened as part of the final product) it also confirms there are directly commercial motivations as well as mythical/historical conceits that underpin the festival. Indeed, later films of the festival, from the early 1950s, include parades of lorries from a number of local businesses, more or less imaginatively dressed as carnival floats, further confirming the festival's commercial importance as opposed to its apparent historic significance for the town. In relation to my previous argument, the focus on the crowd suggests that in this film the conventions of recording an actual royal visit or event have been subverted. Here the off-stage activities and those

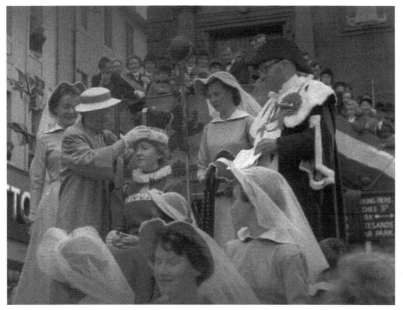

22 The crowning of the 'Queen of the South' on Guid Nychburris Day
1952 in Dumfries, Scotland.

individuals behind the fourth wall are not captured *accidentally* while the film-maker is attempting to capture the significant figures in the foreground: rather, the spectators, as much as the fabricated queens, *are* there 'to be looked at', a fact which they seem (un)comfortably aware of, as many of the crowd members present self-conscious smiles, or wave and point at the camera.

In her study of a similar Scottish Borders festival – the Peebles Beltane Festival – Susan J. Smith notes that this kind of event should not be seen as akin to the carnival, which in the famous study by Bakhtin is seen as an opportunity for resistance.[18] 'Rather than providing a programme of confrontation and change, it seems akin to those elements of the Medieval and Renaissance Festival which represent through procession, competition and performance, a ritual of stability and continuity for an old order.'[19]

To further reiterate the conservative and law-abiding aspects of the festival it can be noted that 'Guid Nychburris' can be interpreted as 'good citizens', implying that the community is being celebrated as both civilised and 'neighbourly'. Like the Beltane festival that Smith describes, Guid Nychburris is held in the summer months (June or July) but in this instance, in Dumfries, a small town in Galloway near the border between England and Scotland.[20] The day itself – now part of a

week-long festival – was conceived by the town's librarian, G. W. Shirley – who also penned the festival song 'Queen of the South'. Primarily celebrating the town becoming a Royal Burgh (in 1186 under the aegis of the Scottish king, Robert III), the events incorporated into the festival include the 'Riding of the Marches', a reading of the declaration, the crowning of the Queen of the South, the singing of the song and various ceremonial parades around the town, as well as a ball.[21]

Smith suggests that the centrality of the coronation of a 'virgin' queen in these festivals testifies to the sense of security attained when people 'reaffirm the rightness of the moral rules by which they live or feel they ought to live' in a society 'held together by its internal agreement about the sacredness of certain fundamental moral standards'.[22] The 'Queen of the South' as a title or as a position has no historical basis, although its legitimacy may appear rather confusingly confirmed by the existence of the local football team, Queen of the South, a name derived from a poem by local poet David Dunbar (1828–73) which pronounces the town of Dumfries 'Queen of the South'. It is entirely likely that Shirley adopted the title for his festival queen for the same reason, and in that sense this ceremonial queen fulfils a key function of perhaps any monarch, which is to represent the both the land (here the town) and the community. She also symbolises the ambition of the festival itself, which 'is the moment which secures the attachment of local history, shared meanings and common aspirations to a bounded space, through a pastiche of ritual formality and festive frivolity'.[23]

As Smith indicates, the employment of a young girl to fulfil this role possibly represents the community's desire to imply and uphold a particular moral order and to establish a strictly gendered choreography in which the queen is generally passive, surrounded and supported by men, including the 'cornet', the (usually young) man elected to lead the 'Riding of the Marches'. The queen's elaborate dress is, unlike the conservative but contemporary wardrobe of the actual Queen in the previous films, closer in appearance to the ceremonial dress of royalty, and is therefore a mish-mash of different periods and fabrics. Notably however, as seen in the films, there is a distinct shift from the earlier mode of dress in the 1930s and the 1950s films, where the relatively simple medieval style of the earlier queens is later replaced by a much more elaborate (and obviously uncomfortable) Tudor look, including a fixed collar, a corset and wide skirts, presumably in keeping with the emerging and popular conception of a new 'Elizabethan Age' with the coronation of Queen Elizabeth II in 1953.

The crowning and ceremonial function of the Queen of the South is therefore much like Alice's own ascension: at once obvious, uncomfortable and surprisingly

complicated at the same time. In Lewis Carroll's fantasy, Alice moves – in accordance with the rules of a game that she seems largely to be unaware of – across a chess-board and is finally crowned queen once she reaches the right square; in the festival and films, the close association between the Queen of the South and her territory (whose boundaries, like the chess squares in Alice's world, are carefully policed) reveals that this crown is also secured as much by geography as by biology. Yet, like Alice's, this 'queenliness' is also produced through the performance of dignity. Among the most charming and inadvertently comical aspects of these films are the different ways in which the various queens manage their posture, the weight of the crown, the length of their dress and the attention of the crowds and camera. In one particular sequence from the 1952 film, the queen arrives – in what would seem to be a further extension and elaboration of the ceremony – by boat.[24] She then proceeds carefully up the street with an elderly gentleman accompanying her. As they walk together, her hand is held by this gentleman at a ridiculously awkward angle, with her arm tilted upwards and across her body, clearly making her progress even more difficult. It is in moments such as this that terms such as grace and poise in relation to the performance of monarchy are revealed as necessary skills and not just window-dressing, since the amateurish aspects of the choreography recorded here reiterate and unintentionally deride the elaborate *politesse* that we have seen is essential to the maintenance of royalty in public.

At the end of *her* journey Alice discovers, much to her dismay, that she has to contend with two queens at once, as both the Red Queen and the White Queen tire of teaching manners or playing riddles and fall asleep. Alice remarks to herself, 'I don't think it ever happened before, that anyone had to take care of two Queens asleep at once! No, not in all the History of England – it couldn't, you know, because there never was more than one Queen at a time.'[25] The Queen of the South generates similar tensions – most obviously in the 1952 film. While we see the young Queen of the South being crowned, elsewhere in the film there is another queen depicted – sitting on a throne – on one of the carnival lorries with a large sign on the front proclaiming 'Elizabeth is Queen' – a clear reference to the new (but not yet crowned) Elizabeth II. She is not present of course, but her presence is implied. So in a sense the 1952 film contains three queens – the proudly local Queen of the South; a proxy for Queen Elizabeth II; and the monarch herself, implied but held just out of frame. At one and the same time, therefore, the film contains performances of loyalty to the locality and a performance of loyalty to the (British) Crown. In essence the film allows

us to ask which queen is the real queen or to suppose (like Alice), that anyone can be a queen if they are in the right place at the right time. What the films reveal about the festival and thus about its central figure are the mixed motivations and contested histories that are manifest in the marginalised Borders cultural identity. As Smith suggests, for instance, in relation to Beltane, 'The Borders are neither Highland nor Lowland in character, and they are spatially marginal to, and socially marginalised by, both the "high" cultural image of Edinburgh ... and (to a lesser extent) the revival of an urban enterprise culture in Glasgow.'[26]

In line with Smith's argument, the conflation of histories in the Guid Nychburris festival reflects the position of Dumfries as a Border town. Dumfries is in Scotland but it is not necessarily defined by the dominant signifiers of Scottishness. In itself the title the 'Queen of the South' is rather indeterminate: it neither refers directly to the Queen of Scotland or the Queen of England but it could be either. At the same time the queen (and the body and performance of the costumed young girl) are used to represent an intensely local and closely bounded space that as a community is actually quite incoherent and porous – in terms of the border between Scotland and England, in terms of its actual historical legacy and increasingly, as made evident in the films, through the community's exposure to other cultural myths and narratives relayed through broadcast media such as television. Although at least one of the Guid Nychburris films makes specific reference to Robert the Bruce and the festival itself celebrates the award of Burgh status to the town from another Scottish king, and the Riding of the Marches is a wider Scottish tradition, other elements in the festival draw on associations and popular terms of reference that have broader and less specifically Scottish characteristics. One way in which this distinction from the Highlands and Central Belt tradition of Scottishness can be seen, for instance, is in the conspicuous absence of tartan in the dress of any of the participants in the festival; as a material strongly associated with Scottish aristocracy and the British monarchy's association with Scotland, its absence is especially significant since, as we have seen, it features prominently in the amateur record of the actual monarch's visit to Glasgow in 1953.

Other less localised and non-Scottish associations are also evident in the earlier films, showing many of the town's children involved in the celebrations. In these films (for example the film from 1934) there are extensive scenes of boys and girls dancing around maypoles and performing practised routines dressed as nymphs, pirates and birds. In the later films from the 1950s, these larger-scale displays seem to be less frequent and the fancy dress has become competitive,

with children dressed up as mythical characters and contemporary celebrities –
including Elizabeth II, Little Bo Peep, Edmund Hillary and a little boy dressed
(with sign attached) as Gilbert Harding's 'Char Lady'.[27] In these charades,
parades and competitions, the community would appear to acknowledge and
celebrate its universal attributes (the changing of the seasons and representa-
tion of fantastic figures) and equally its modernity as the children's appearance
makes knowing references to the wider contemporary popular culture available
through the mass media.

Dressing-up is familiar practice occurring in many civic occasions, village
fêtes and in school-sponsored events across the United Kingdom. Captured on
film, however, and across so many films – in terms of their historical and geo-
graphic spread – the motivation for this dressing-up of children is cumulatively
more peculiar and more multi-layered in its effect than it at might first appear.
In the films many of the children appear bewildered and bedraggled – partic-
ularly when it rains, as it so often does in the summer in Scotland – and they
very often appear bored. Hunched together in the downpour during straggling
parades, milling about in halls, awkwardly controlling their elaborate dresses
in the wind, or desperately clasping the more ambitious costumes together,
the children in these films frequently stare at the camera, fidget and sometimes
cry. As is frequently an issue in the presentation and performance of children
on film, their appearance prompts questions about consent, agency and inten-
tion: simply put, while it is evident that some children appear delighted to
take part, other children's behaviour makes the viewer conscious that in many
instances there may have been considerable coercion involved.

The purpose of the dressing-up in these films must surely be mixed since,
while it may allow the child to take part in a celebration with their peers, it
may also be to win the competition, or serve as an opportunity for the knowing
parent to make a contemporary 'in-joke'. In this sense, then, the child's appear-
ance is not about restoring or reaffirming a coherent sense of Scottishness or a
straightforward celebration of the status quo. Costumed as royalty or as celeb-
rity, the appearance of children in these events and later on film reflects their
potential to operate or act as an effigy. As Joseph Roach has explained, 'effigy'
implies several things at once:

> Normal usage employs the word *effigy* as a noun meaning a sculpted or pic-
> tured likeness. More particularly it can imply a crudely fabricated image of a
> person, commonly one that is destroyed in his or her stead, as in hanging or

burning *in effigy*. When *effigy* appears as a verb, though that usage is rare, it means to evoke an absence, to body something forth, especially something from a distant past *(OED)*.[28]

By dressing up their children, adults may oblige the child to fulfil one aspect of the effigy, presenting a 'crude likeness' of celebrities or royalty. However, as the films demonstrate, the child's appearance also speaks to the wider resonance of the effigy, in which the child is used both as a potentially vulnerable surrogate for some other (and usually powerful) person and also to 'body something forth'. A child performing the monarch through events such as the mock coronation reflects a tradition that is perhaps more ancient than many other aspects of the festival itself, as child performers dressed as nobility and monarchs are known to have appeared in medieval and early modern pageants, such as the Chester Midsummer Show in the decades before and after 1600.[29] In the Scottish context there is a similar history of child actors in early modern plays and pageants, with the ambiguous nature of the child's presence allowing the expression, if not necessarily resolution, of different communities' mixed emotions and frustration about their shared local history and the authority of the various monarchs they were subject to. As Meradith T. McMunn suggests, in her study of child performers in early Scottish drama and ceremony:

> The symbolism of these child characters – innocence or its opposite, satire made more trenchant by the use of youths in roles of respect, such as kings, popes, or priests, reinforced the message of the speeches and dialogues. Thus, the child who spoke such parts helped to bring together the meaning of the pageant.[30]

In the twentieth-century pageants and parades that these films depict, we can see that this tradition continues and that the children operate as

> performed effigies – those fabricated from human bodies and the associations they evoke – provid[ing] communities with a method of perpetuating themselves through specially nominated mediums or surrogates: among them, actors, dancers, priests, street maskers, statesmen, celebrities, freaks, children, and especially, by virtue of an intense but unsurprising paradox, corpses.[31]

I am not suggesting that the representation of the child as a more ghastly version of effigy was the (mostly unknown) filmmakers' intent in picturing Guid Nychburris (or other festivals). Rather, it is an effect generated or amplified by the amateur quality of the filming (which features odd compositions, abrupt edits and poorly constructed narratives) along with the frequent lack of sound, the stilted

nature of the performers and the uncontrolled intervention of the weather, which accumulate to disrupt the viewer's understanding and unconscious acceptance of the ordinary conventions of this kind of civic event. The uncanny or rather grue-some alliance to which Roach refers – between the child figure in fancy dress and the corpse, or between the freak and the child – is also a very familiar trope in professionally executed fictional and documentary films, and its naive execu-tion here is haunted by these other modes of representing children on film. In their capturing of the contingent contexts for the event (the wind, the rain, the boredom and fidgeting of children and crowds) amateur films may be seen to undermine the more conservative ambitions that otherwise motivate these civic festivals and expose, via their awkward representation and in the capturing of its amateur choreography, the peculiar mechanics and consensual suspension of disbelief that elsewhere serve to maintain and sustain the illusion of royalty. The use of the child or young adolescent girl as a substitute for the monarch may not seem problematic – since it is so common, so 'past remarkable'. Yet the messi-ness of the child's body and the charming inadequacy of the child performer fre-quently upset the illusion, belittling the institution they seek to promote.

CONCLUSION

The child and the monarch and the child *as* the monarch perform specific roles in civic rituals. While the child's presence may appear to either bolster or cele-brate the institution of the monarchy, amateur films frequently capture a less certain or coherent display and portray a more ambivalent investment in that authority. What these amateur films specifically capture – indeed, what the film-makers seem drawn to again and again – is the ambiguity of the animated child. Animated in that they are lively, vigorous, fidgety; animated too in that are akin to marionettes, puppets, motivated not from within but under the instruction of their parents or teachers. These animated children expose a tension between repression and order (doing as they're told, being civilised, successfully repro-ducing the past and the future of the community) and tension and disruption (the slippages in their performances, the excess of their real bodies as they are exposed to the vagaries of the climate, reminding us of their potential to satirise as well as to exemplify 'noble' qualities such as innocence and virtue).

The films themselves generate similar tensions. This is because as amateur films they are, in one sense, 'copies' – the amateur filmmaker is standing in for the professional news camera operator for the royal visit; in the recording of a

civic festival, the filmmaker records an invented civic ceremony as if it were a significant and coherent historical event when in fact it is no more than a fabrication of this kind of ritual. In their focus on the child – who may appear as mirror or surrogate for the monarch – the films, of course, adhere to the tradition of using children as lively, animated subjects both for film and in live performance. What they can't quite contain, however, is the way in which the child's presence reflects and exposes the precarious being of the monarch herself, who, like the child, has not one, but two bodies.

NOTES

1 Lewis Carroll, *Through the Looking Glass* (London: Puffin Books, 2010) p. 134.
2 See for instance Snowden Becker's short intervention for *In Media Res*, 'I love a parade', mediacommons.futureofthebook.org/imr/2012/10/17/i-love-parade, and Andrew Prescott, 'We had fine banners: street processions in the Mitchell and Kenyon Films', in Vanessa Toulmin, Simon Popple and Patrick Russell (eds), *The Lost World of Mitchell and Kenyon: Edwardian Britain on Film* (London: BFI, 2004).
3 More details of these films, including clips and selected full-length films – including many of the Bo'Ness Fair Days – can be accessed via the Scottish Screen Archive's online catalogue, ssa.nls.uk.
4 The actual director of the film is uncertain as it is likely that there were various filmmakers involved. The film and further details as to its content and origins can be accessed via the SSA website.
5 This distinction between ordinary/extraordinary mirrors the work of the film star as described by Richard Dyer in his book *Stars* (London: BFI, 1979).
6 Ilse Hayden, *Symbol and Privilege: The Ritual Context of British Royalty* (Tucson: University of Arizona Press, 1987), p. 10.
7 Joseph Roach, *Cities of the Dead: Circum-Atlantic Performance* (New York: Columbia University Press, 1996), p. 38. Roach is referring to the concept originally identified by Ernst H. Kantorowicz, *The King's Two Bodies: A Study in Mediaeval Political Theology* (Princeton, NJ: Princeton University Press, 1957).
8 Hayden, *Symbol and Privilege*, p. 7.
9 *Ibid.*, p. 10.
10 In fact the Queen is accompanied by an older man in uniform who carries a ceremonial sword. Nonetheless, she herself has no evident weaponry on her person and carries only a handbag.
11 See Marcel Mauss, *The Gift: The Form and Reason for Exchange in Archaic Societies* (New York and London: W. W. Norton, 1990).
12 Hayden, *Symbol and Privilege*, p. 103.
13 See Chris Jenks, *Childhood* (London: Routledge, 2005).
14 Hayden, *Symbol and Privilege*, p. 101.
15 *Ibid.*, p. 77–8.

16 *Scotsman* (13 July 1932), p. 13.
17 See the website guidnychburris.co.uk/output/home.asp and video of the festival in 2013 on YouTube: www.youtube.com/watch?v=162n4Z8mE_0.
18 Mikhail Bakhtin, *Rabelais and his World* (Cambridge, MA and London: MIT Press, 1965).
19 Susan J. Smith, 'Bounding the Borders: claiming space and making place in rural Scotland', *Transactions of the Institute of British Geographers* 18:3 (1993), p. 295.
20 In a letter to the *Scotsman* (21 January 1932), p. 9, 'G.W.S' (presumably G. W. Shirley) writes: 'There is a sound historical basis for the name. We now use the word neighbor to denote a person living next door, but in the 16th Century it meant citizen, or fellow townsman.'
21 'Riding of the Marches', usually conducted on horseback, refers to a ritual re-enactment of the guarding and marking of the boundaries of the royal burgh from neighbouring landowners, that was conducted by the Provost, Baillies, Burgesses and others in the town.
22 Smith, 'Bounding the Borders', p. 295.
23 *Ibid.*, p. 293.
24 The SSA catalogue suggests that the date for this film (cat. no.: 0878) is provisionally 1951; however, a reference in the film, 'Elizabeth is Queen', would seem to suggest that in fact it was 1952 – George VI, Elizabeth II's father died on 6 February 1952, so while she was not crowned until 1953, Elizabeth was Queen by the summer of 1952.
25 Carroll, *Through the Looking Glass*, p. 143.
26 Smith, 'Bounding the Borders', p. 301.
27 Though from New Zealand Edmund Hillary was a member of the British expedition that reached the summit of Mount Everest in 1953. Gilbert Harding was a well-known panellist on British television in the 1950s, known as the 'rudest man in Britain'. The reference to his 'char' is obscure but this may have been an oblique reference to the fact that Harding – a closet homosexual during a period when male homosexuality was still illegal in the UK – did not appear to have other women, aside from his cleaning-lady, in his life.
28 Roach, *Cities of the Dead*, p. 36.
29 See, for instance, Susannah Crowder, 'Children, costume and identity in the Chester Midsummer Show', *Early Theatre* 10:1 (2007).
30 Meradith T. McMunn, 'Children as actors and audience for Early Scottish drama and ceremony', *Children's Literature Association Quarterly* 10:1 (1985), p. 23.
31 Roach, *Cities of the Dead*, p. 36.

BIBLIOGRAPHY

Bakhtin, Mikhail, *Rabelais and his World* (Cambridge, MA and London: MIT Press, 1965).
Becker, Snowden, 'I love a parade', *In Media Res*, mediacommons.futureofthe-book.org/imr/2012/10/17/i-love-parade.

Carroll, Lewis, *Through the Looking Glass* (London: Puffin Books, 2010).

Crowder, Susannah, 'Children, costume and identity in the Chester Midsummer Show', *Early Theatre* 10:1 (2007).

Dyer, Richard, *Stars* (London: BFI, 1979).

Hayden, Ilse, *Symbol and Privilege: The Ritual Context of British Royalty* (Tucson: University of Arizona Press, 1987).

Jenks, Chris, *Childhood* (London: Routledge, 2005).

Kantorowicz, Ernst H., *The King's Two Bodies: A Study in Mediaeval Political Theology* (Princeton, NJ: Princeton University Press, 1957).

Mauss, Marcel, *The Gift: The Form and Reason for Exchange in Archaic Societies* (New York and London: W. W. Norton, 1990).

McMunn, Meradith T., 'Children as actors and audience for early Scottish drama and ceremony', *Children's Literature Association Quarterly* 10:1 (1985).

Prescott, Andrew, 'We had fine banners: street processions in the Mitchell and Kenyon films', in Vanessa Toulmin, Simon Popple and Patrick Russell (eds), *The Lost World of Mitchell and Kenyon: Edwardian Britain on Film* (London: BFI, 2004).

Roach, Joseph, *Cities of the Dead: Circum-Atlantic Performance* (New York: Columbia University Press, 1996).

Smith, Susan J., 'Bounding the Borders: claiming space and making place in rural Scotland', *Transactions of the Institute of British Geographers* 18:3 (1993).

FILMOGRAPHY

Bo'Ness Public School: Queen Anne Petrie (1923, black and white / silent, 55 minutes).

Duke of York visits Mavor and Coulson Limited: 12th October 1932 (black and white / silent, 4.25 minutes).

Dumfries Guid Nychburris Day: Riding of the Marches and Pageant (Sponsor: ABC Cinema, Dumfries, 1933, black and white / silent, 13.46 minutes).

Dumfries Guid Nychburris Day (Sponsor: ABC Cinema, Dumfries, 1934, black and white / silent 8.28 minutes).

Glasgow Welcomes the Queen (members of the Scottish Association of Amateur Cinematographers, 1953, colour / silent, 14.41 minutes).

Guid Nychburris Celebrations (Sponsor: Lyceum Cinema, Dumfries, 1951* (1952), black and white / silent, 11.20 minutes).

Guid Nychburris Festival (Sponsor: Lyceum Cinema, Dumfries, 1956, black and white / silent, 13.04 minutes).

11

The regal catwalk: royal weddings and the media promotion of British fashion

Jo Stephenson

In 2011, Kate Middleton[1] was 'reportedly worth £1 billion to the British economy'.[2] The huge international interest in her wedding that year to Prince William was greeted as a major opportunity to boost British trade by promoting British fashion both at home and abroad. On 9 March 2012 on ITV's morning television show *Daybreak*, British fashion expert Caryn Franklin said of Middleton, by then dubbed the Duchess of Cambridge, 'she certainly does generate an enormous amount of money for the fashion industry. Anything she wears sells out instantly, and certainly some of her favourite high-street designers have posted record profits.'[3] Soon after this *Stylist* magazine reported that the website of the British fashion chain Reiss had crashed for two hours after Middleton was shown wearing their '£175 taupe Shola dress to meet the Obamas'.[4]

The royal family is a central feature of Britain's projected identity and a unique selling point of the national brand created to promote its exports. The relationship between the Windsors and the fashion industry can be seen in a number of British Fashion Council (BFC) initiatives. Following the death of Princess Diana in 1997, the BFC set up the Princess of Wales Charitable Trust in 1998 'in recognition of her loyal support of British fashion designers', to provide British fashion graduates with scholarships to further their fashion education.[5] In the lead-up to the Queen's Diamond Jubilee in 2012, London's central shopping thoroughfare 'launched a Great British Fashion Flag Showcase' in which 147 Union Jack flags, 'including 10 dedicated fashion flags' were hung above the major retail stores in Bond Street, Regent Street and Piccadilly, stretching for 1.5 miles.[6] These 'dedicated fashion flags' were created by high-profile British designers including the House of Alexander McQueen (whose creative director Sarah Burton became 'Designer of the

Year' at the British Fashion Awards 2011 for her work on Middleton's wedding dress) and Stella McCartney (designer of the Team GB kit for the London 2012 Olympic Games, and winner of the BFC 'Designer of the Year' award 2012).[7] BFC chair Harold Tillman and John Penrose MP, Minister for Tourism and Heritage, were both in attendance at this Jubilee celebration launch, illustrating its significance for British commerce, as well as its role as a national celebration with political undertones.[8] Fashion exhibitions at Kensington Palace over the years, including the 2013 'Fashion Rules' exhibition, also highlight the historical connection of British fashion to the history and tradition of the royal palaces.[9] On 16 March 2012 a reception for the British clothing industry was held at Buckingham Palace, hosted by the Queen and the Duke of Edinburgh.[10] These examples show how the British royal family is linked with the business of British fashion, through the work of the BFC, and alongside both the city politics of London and the national politics of Great Britain.

Although fashion film criticism is increasingly becoming more established, it has so far clung closely to fiction film. Fashion has traditionally been seen as a partner of storytelling rather than documentary or live broadcasting, and yet both the latter are also narrative media. Referring to Mary Ann Doane's theories of the 'event', this chapter will consider the fascination with royal fashion and its subsequent use in national promotion campaigns, showing the links between past and present media strategies.[11] I will begin by looking at the social and cultural significance of a filmed 'event', before tracing the developments in royal wedding coverage since the beginning of the twentieth century. Working forward to the present day, I will examine the promotional use of live wedding broadcasting and DVD highlight compilations. Throughout these sections, I will consider how the reportage of broadcast television and earlier newsreels employ the storytelling devices that work as brand narratives for the royal family, the British fashion industry and a London-centric Britain. Focusing on selected royal fashion 'moments' throughout history, this chapter asks what these 'moments' mean, and why they acquire such force in popular culture and cultural memory. Among these considerations are the issue of national production advertised as quintessentially British in order to be sold abroad and the contradictions between British tradition, the forward-looking drive of the fashion industry and live broadcasting. Also in question is the peculiar combination of fairy-tale references and a growing accessibility of the British royal family as presented by the media – a necessary element in persuading audiences that a royal lifestyle is achievable through consumption.

TIME, PLACE AND THE 'EVENT'

In a discussion of British fashion promotion it is important to look at the presentation of fashion 'moments' projected on global media platforms. What comes first? Is an event of intrinsic significance captured on film, or does it become a fashion moment by being filmed? Doane's writing on cinematic time provides a useful approach by reviewing early cinema and its ability to fix moments of time.[12]

The actuality films of the late nineteenth and early twentieth century were often recordings of everyday life, of subjects as ordinary as workers leaving at the end of the day in the 1895 Lumière brothers' film *La Sortie des usines Lumière à Lyon* (*Workers Leaving the Lumière Factory in Lyons*).[13] Although narrative soon entered cinema, the initial fascination of the medium came from its simple ability to record movement. In *The Emergence of Cinematic Time*, Doane discusses the early preoccupation with cinema as a technology capable of 'fixing life and movement, providing their immutable record'.[14] She maintains that 'any moment can be the subject of a photograph; any event can be filmed',[15] but most of them are not. In choosing what to film, the filmmaker decides which moments viewers will be most interested in, or entertained by. This links with the idea of the event, which we can see played out in royal wedding coverage. Doane asserts: 'The act of filming transforms the contingent into an event characterized by its very filmability, reducing its contingency. The event was there to be filmed.'[16] In this way, early actuality films fixed moments of history by privileging them over other, un-filmed moments. These privileged moments would then feed into future cultural memory, acting as our only moving-image record. Not only were these moments fixed in film, they were fixed in history, and in memory.

To explain this Doane offers a commentary on the afterimage that sparks an interesting debate about the use, purpose and effect of promotional film and media built up through time. In this analogy,

> an external object annihilates the retinal imprint in order to make room for its own impression. The retina *retains* impressions, but only briefly, long enough to merge with succeeding impressions and make a pure present inaccessible. ... The theory of the afterimage presupposes a temporal aberration, an incessant invasion of the present moment by the past, the inability of the eye to relinquish an impression once it is made and the consequent superimposition of two images.[17]

This, I would suggest, is the figurative way promotional media operate through time. The chronological build-up of royal wedding coverage augments itself as

a narrative, meaning that the present material cannot be wholly distinguished from the footage of the past. The cultural memory of these images, brought up time and time again in contemporary footage (early newsreel footage of previous royal weddings is shown as clips in contemporary broadcasts), means that the images exist all together, at the same time. Past royal wedding coverage is as influential to our viewing of today's royal wedding coverage as the contemporary material itself, because it establishes traditions and expectations that today's material consciously draws on for maximum impact.

In the creation of fashion moments such as Kate Middleton's arrival at her wedding to reveal her dress to the world, we see an obsession with the instant, with anticipation and revelation, and with the accessibility of the present. Live coverage has a lot of waiting time to fill, what Doane refers to as 'dead time'. Discussing the early actuality film, she states:

> In an actuality, the time that is excluded or elided is constituted as 'dead time' – time which, by definition, is outside of the event, 'uneventful.' But such an explanation assumes that the event is simply 'out there' and dead time a by-product of grasping the event's clear-cut and inherent structure. It would be more accurate, I think, to assume that an understanding of 'dead time' – time in which nothing happens, time which is in some sense 'wasted,' expended without product – is the condition of a conceptualization of the 'event.' From this point of view the documentary event is not so far from the narrative event. The event may take time, but it is packaged as a moment: time is condensed and becomes eminently meaningful.[18]

In live television coverage of the 2011 royal wedding, dead time (or the time between 'eventful' happenings) is continuously filled with a discursive focus on the following themes: London as an iconic city, the size of the international audience, anticipation of the bride's wedding dress, revelation of the bride's wedding dress and guest wardrobe choices. Doane goes on to state: 'Although the term *event* implies the fortuitous, the accidental, transience, and unpredictability … it also can be used to connote a high degree of constructedness, as in notions of a media event or social event.'[19] Royal coverage is made meaningful by its purposeful construction. Despite being documentary/live broadcasting, it is not spontaneous but very much planned, organised and fitted into a storyline. This story is acting as a brand narrative for British export.

In their advice book on advertising, *What's Your Story?*, Ryan Mathews and Watts Wacker ask, 'what's really important to the branders who want to effectively communicate with their customer? … We think the answer to that

question is a good story.'[20] In more detail they recommend that 'a brand's story must engage an audience at a human level to be effective'.[21] This provides a useful way of looking at the increasing sense of royal accessibility conveyed by this body of media texts. Matthews and Wacker also suggest keeping to familiar narratives, to prevent complicating the message: 'Stick to basic plots ... [and] [a]void mixed messaging.'[22] Throughout analysis of royal wedding coverage we can see these guidelines in use through the construction of narrative and the use of fairy-tale conventions to engage with audiences and sell the British image. In *Place Branding*, Robert Govers and Frank Go connect the construction of brand stories with the promotion of actual or imaginary locations: 'the narrative of place as it is told and retold in history books, literature, the media and popular culture, with often corresponding heroes, great leaders and great events'.[23] The stories told in these films are stories of royal weddings, but also the stories of London, Britain and British identity.

The newsreel footage of early twentieth-century royal weddings is part of a constructed narrative of British history and the British fashion industry. This story is still being written in the film and media coverage of royalty today. As historical artefacts, this collection of royal wedding coverage forms part of various archives, now held by the British Film Institute (BFI), Pathé and the BBC. In 2011 Pathé digitised a selection of historical royal wedding coverage and made it available as a DVD compilation titled *British Royal Weddings of the 20th Century*.[24] This is the DVD from which I am accessing most of the newsreels referred to in this chapter. As archive film, this material needs to be acknowledged not only as the product of a film company, but also as the product of an archive.

There are problems inherent in framing a discussion of national storytelling through the institution of the archive. Circulation of and access to texts is as important a part of national storytelling as the films themselves. As David Hesmondhalgh writes:

> [M]uch of the work of cultural industry companies attempts to match texts to audiences, to find appropriate ways of circulating texts to those audiences and to make audiences aware of the existence of texts. [...] The upshot of these processes is that cultural industry companies keep a much tighter grip on the *circulation* of texts than they do on their production.[25]

The archives that now hold these films impose a level of censorship on national stories through the selection process determining which films should be digitised and circulated.

Historiographers acknowledge this process in speaking about archives as power structures, created by those with authority and constructed to give an official presentation of the past. As Jacques Derrida observes:

> [T]he technical structure of the *archiving* archive … determines the structure of the archivable content even in its very coming into existence and in its relationship to the future. The archivization produces as much as it records the event. This is also our political experience of the so-called news media.[26]

In this way archives act as storytelling devices, creators of historical narratives. Thus the claim of Michel Foucault that history is not only found in but is written through the archive: '[H]istory, in its traditional form, undertook to "memorize" the *monuments* of the past, [and] transform them into *documents* … in our time, history is that which transforms *documents* into *monuments*.'[27] Looked at from this perspective, the archive presents a constructed narrative of history, subjectively created by institutions in power to tell a particular story.

Doane describes Foucault's vision of time in early cinema as 'offering its spectator an immersion in *other* spaces and times'.[28] The material covered in this chapter offers a dual immersion in time to give contemporary viewers the sense of 'being there', transporting viewers back to the day of the 'event'. Geographically, this material allows immersion in another place (the capital city) for non-London audiences. London audiences are also allowed access to a further place, which Mark Cousins refers to as 'Royal London':

> Royal London, a space of state occasions governed to the minutest details by pre-ordered codes of protocol of the British establishment. … Only on prescribed royal and state occasions does Royal London become visible, and it does so not as an architecture but as a processional route which links church (Westminster Abbey) and state (Parliament) with the monarch (Buckingham Palace).[29]

According to Cousins, London uncovers its identity as a royal place on days of royal celebration. A sense of occasion is implied here, of rare happenings, events, but also of deposits into the national archive of moving images. In this way, such material allows a further immersion into other times and places. Time is used through these moving images to curate a cultural memory and to write a history of places – in this case London and Britain. Those places, along with their brand narrative, are then used to promote trade, in this case fashion, to international markets.

As well as the promotion of London in relation to projected ideals of historical British moments, this media coverage also highlights the links made between British fashion and London. London as a place has a strong presence throughout the wedding footage covered in this chapter, owing to the historical connection between the royal family and London in traditional and tourist images of Buckingham Palace, the Changing of the Guard, carriage processions on the Mall, and weddings, funerals and coronations in St Paul's Cathedral and Westminster Abbey. This royal panoply is frequently connected to images of British fashion in the iconography of the Swinging Sixties, a brightly coloured Union Jack cityscape that situates the Windsors in the capital city with its leading fashion houses, national fashion weeks and flagship retail stores.

FASHIONING ROYAL NEWS

One of the earliest examples of British royal wedding coverage on screen is the wedding of Princess Mary and Henry George Charles, Viscount Lascelles, in 1922. The DVD *British Royal Weddings of the 20th Century* compiles a selection of short British Pathé newsreels covering different aspects of the wedding and its preparations. A newsreel titled 'Princess Mary to Marry an English Nobleman' was released in 1921 to celebrate their engagement. The newsreel frames Viscount Lascelles in an iris shot as a 1920s pin-up, a suggestion of fill lighting giving him a dreamy quality and connecting him with film stars of the time.[30] The glamorous portrait of Princess Mary's prospective groom offers an early example of the treatment of British royalty as cinematic celebrities. However, visual access to royal figures was still limited. In the subsequent newsreel of the ceremony in 1922, a great effort has been made to hide the wedding dress from the public.[31] An annex has been set up in front of the entrance to the Abbey for this purpose, so that the bride can arrive at the Abbey unseen. As the carriage pulls up to the entrance we have only a brief glimpse of the bride's veil through the carriage window before she disappears from sight. When the couple leave the Abbey after the ceremony they again enter the carriage through the annex, meaning that our only views of the pair are images of their heads through the carriage window, taken at a distance and difficult to make out. At the end of the newsreel there is a shot of the couple standing on the balcony of Buckingham Palace. However, it remains at a distance, and shows them only from the waist up. There is no full-length image of the bride in her dress. This distancing of the bride and her apparel from spectators is enhanced by the cinematography,

often using aerial shots of the carriage to preserve the couple's privacy. The use of images that are almost, but not quite, close enough to give a detailed view emphasises the discretion of early royal wedding coverage.

In the Pathé newsreel of the 1934 marriage of Prince George, Duke of Kent, and Princess Marina of Greece, a shot of the crowd shows a spectator brandishing a contraption covered in mirrors to enable him to see what is going on from varying angles.[32] This is followed later in the film by shots of others in the crowd holding up mirrors to enhance their view. Contemporary images of spectators at the 2011 royal wedding holding smartphones and digital cameras aloft suggest that, although the technology has changed, the audience's relationship with royal celebrity has not. Both groups seek to access the best image (however fleeting), and to have a sense of ownership over the historical 'moment'.

As part of its coverage of the 1935 wedding of Prince Henry, Duke of Gloucester to Lady Alice Scott, another Pathé newsreel offers an early example of media-constructed anticipation about a royal wedding dress.[33] The film employs a present-tense commentary, but one which has been recorded after the ceremony, narrating it in the style later adopted for a live broadcast. The commentator states: 'And now, everyone is waiting for the bride. Here she is!'[34] At this point the bride looks at the camera, giving a quick smile and a nod before getting into the car, suggesting the acknowledgement of her public persona and celebrity status. The inclusion of this shot in the edited film, together with the commentary, is an early example of the media's attempt to engage viewers in the day's event. With this unusually (for the time) intimate insight, the impression is of a unique occasion, one that is special enough to break down the usual barriers between the royal family and the general public to allow a nationwide celebration.

One abiding trope evident at this time is the commentator's remark on the scale of the international audience. He declares: 'All London, in fact, all the world, rejoices in the happiness of our royal family. ... This crowd is only a minute part of the great public all over the Empire who will today be wishing joy to the bride and bridegroom.'[35] Significantly cashing in on this export opportunity is a Pathé fashion film made to supplement the coverage of the day.[36] It shows a mannequin modelling outfits that Lady Alice has packed for her honeymoon, describing the clothes and naming the designer, British royal couturier Norman Hartnell. Again, present-tense commentary is used to convince the audience that they are experiencing a royal fashion show firsthand, an event that brings consumers and British fashion commodities closer together.

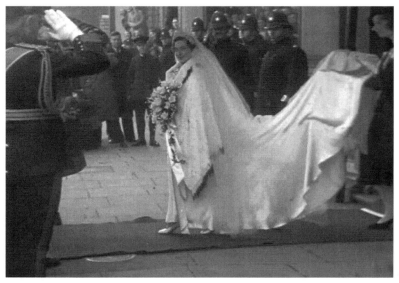

23 The wedding dress of Lady Alice Scott, British Pathé 1935. *British Royal Weddings of the 20th Century* DVD (British Pathé, 2011).

The relationship between the royal family and the British fashion industry has been set in place prior to the Second World War, ready to be resumed once the war is over.

The late 1940s saw heightened interest in Princess Elizabeth as heir to the British throne. Mendes and De La Haye note that her wedding in 1947

> attracted widespread media attention and led to a flurry of clothes shopping in establishment circles. Her embroidered gown, by Norman Hartnell, was not ration-free and required 100 coupons. The dress was much admired and so efficient was the Seventh Avenue copying network that a replica was ready eight weeks before the wedding, though in the interests of international harmony it was not put on sale until the day itself.[37]

A collection of short newsreels was made surrounding Princess Elizabeth's wedding to Prince Philip. In Pathé newsreel footage titled 'The Princess Weds' we see visual references to iconic London landmarks such as Big Ben.[38] The bridal gown is also a subject of interest: 'Inside the Palace, the cameras were able to capture the exquisite workmanship of the bridal gown.'[39] Although this commentary contains none of the speculation of contemporary coverage, another short film made by British Pathé focused on its making. 'Wedding Dress Silk

Made in Essex' is part of a DVD collection released by the Royal Collection titled *Happy and Glorious: The Royal Wedding (1947) and The Coronation (1953) from Original Newsreels*.[40] It follows the progress of the Princess's wedding dress from the weaving of its fabric:

> At Braintree in Essex, Peggy Lyn will prepare the silk and threads which will be used for Princess Elizabeth's wedding dress. ... Greatest secrecy covers the preparations, and the final design will not be ready for public viewing until the November wedding day. ... The Princess's gown will set a new fashion for brides. Orders for the design will crowd in from many countries.[41]

Use of the future tense in this commentary creates excitement, building the event up in advance. Filming in a textile factory forges an association for the viewer between the royal wedding dress and British manufacturing, connecting an important national event with images of national industry. The accessibility of the royal family through fashion becomes stronger in this period, as the postwar continuation of rationing motivates images of national unity. Despite her choice of royal couturier Norman Hartnell, Princess Elizabeth needed to be seen saving ration coupons for her wedding dress in the same way as other British brides in order to create a feeling of solidarity and shared experience. Her saving was emphasised in press reports of the time, to persuade viewers that the Princess was just like them.[42] The impression of accessible fashion was also enhanced in the 1940s when Hartnell began to design ready-to-wear collections for the benefit of women who aspired to follow the royal style but could not afford the *haute couture* price-tags. However, as Andrew Marr explains, frugality had its limits:

> Already, towards the end of 1947 and despite a torrent of reforming social legislation, people were becoming weary of the shortages and red tape Labour was coming to represent. As preparations for the wedding gathered speed, it began to be clear that outside the eager platoons of the socialists, there was little enthusiasm for a puritanical, frugal event. The country wanted colour and it wanted fun. And that, after all, is the job of the monarchy.[43]

The opposition between solidarity and morale-boosting spectacle was clearly one that needed carefully balancing at this economically unstable time.

One of the most significant changes to British royal wedding coverage occurs with Pathé's coverage of Princess Margaret's wedding to fashion photographer Anthony Armstrong-Jones in 1960.[44] 'May Wedding' is the first example of Pathé

royal wedding coverage that is presented in colour – in this case, Technicolor. This in itself is significant – Pathé are using a new cinematic technique to present the news. As well as being shot in Technicolor, the film is much more cinematic in terms of its structure, narrative and (what can arguably be called) performance. The opening titles are designed like those of a fictional film of the day, with pink roses in the background, romantic music and ornate typography. The commentary is much more emotional than the sombre efforts for previous weddings and in this sense sounds much more 'acted', a theatrical quality furthered through its narration by British stage and screen actor Michael Redgrave. But it is the evocative nature of the constructed narrative of the film that really sets it apart from its predecessors.

Poetic recitation throughout the film of the lines 'Sing a Song of London' and 'May Wedding' is not required for journalistic purposes. Such emotive techniques are designed to enhance the audience's responses, pointing forward to the more subtle use of live speculation in 2011 to intensify interest in the 'event'. 'London' is repeated frequently throughout this poetic narration, connecting it to romance and patriotism. Reference to the city as 'the heart of the world' speaks to the country's still cherished imperial identity and its new push for export markets.[45]

THE FAIRY-TALE PRINCESS

Lady Diana Spencer, later to become Diana, Princess of Wales, has often been cited as a British fashion icon. Diana's dress, designed by David and Elizabeth Emmanuel, is described by biographer Nicholas Courtney as an

> apt creation with its blend of the theatrical and the romantic. Made of ivory pure silk taffeta with an over-layer of pearl-encrusted lace, the dress had a bodice with a low frilled neck-line and full sleeves gathered at the elbow. In keeping with tradition, the bride wore something old – the Carrickmacross lace that made up the panels had once belonged to Queen Mary and had now been dyed a slightly lighter shade of ivory than the dress; something new – the dress itself; something borrowed – her mother's diamond earrings and the Spencer tiara and something blue – a tiny blue bow had been stitched into the waist band. … The silk shoes had a central heart motif made of nearly 150 pearls and 500 sequins.[46]

The blend of traditional wedding lore and aristocratic finery described here condenses the royal wedding narrative played out in the media. The borrowed

lace connects the dress with a narrative of British history, tying the various strands and chapters of the British brand together. Despite the more contemporary approach to designers, the dress is constructed as a spectacle to dazzle audiences, rather than as an attainable model for the audience's imitation. The design links the royal family with the wedding traditions observed by many of its viewers, while at the same time distancing Diana as special in its excess of precious elements and handcrafted details. Courtney goes on to highlight further relatable elements of the day:

> Just like any other family wedding, the bridegroom's mother came down the aisle with the bride's father and the bride's mother with the Duke of Edinburgh. [...] Another fun touch, to show that it was a family wedding and not a state occasion, was the helium-filled balloons emblazoned with Prince of Wales's Feathers and the sign, 'Just Married' with hearts, written in lipstick on a piece of old cardboard on the back of the landau that took them to Waterloo Station.[47]

In making these points, the media is setting up the wedding dress as representative not only of regal fashion, but of a national industry. Diana's dress is presented as the centrepiece of the event, a showcase for the contemporary artistry of British fashion, while the lace once worn by Prince Charles's great-grandmother affirms the continuity of the British monarchy and – by extension – the British state. Although there was live television commentary on the day (an earlier version of what we saw in 2011), the Pathé newsreel commentary is still in the form of edited highlights, presented in present-tense commentary. And here, the newsreel of 'The Wedding of Prince Charles and Lady Diana Spencer', the commentary makes the fairy-tale narrative explicit:

> The world gets its first full glimpse of the fairytale princess, demure behind her veil, and the wedding dress that has been a carefully guarded secret, resplendent ivory silk taffeta, trimmed with antique lace and a long, long train, all 25 feet hand-embroidered. As bewitching and romantic a bride as ever touched the heart of the world.[48]

The fairy-tale princess is traditionally an aspirational figure, whose life and status is transformed by a powerful man. Diana's arrival into public consciousness as an unknown *ingénue*, much younger than her husband, taps into the Cinderella fantasy of an unregarded girl whose beauty wins the love of a handsome prince. The now conventional assertion that the dress 'has been a carefully

guarded secret' again creates an aura of excitement and curiosity about an event watched by a worldwide audience of over 750 million viewers – 'the most popular programme ever broadcast' at that time.[49] In turn, the focus on Diana's wardrobe set up a discussion of her fashions that continued throughout the rest of her life and long after.

CONTEMPORARY ROYAL WEDDINGS

The 2011 royal wedding was broadcast live in Britain on BBC and ITV. Viewed by 'around a third of the world's population',[50] the coverage stretched from early in the morning until well into the afternoon, adding up to almost eight hours of live broadcast on each channel. The first element of British fashion promotion running throughout this coverage is that of London as an iconic fashion city. The 2011 BBC broadcast opens not with images of the prospective bride and groom, but with iconic images of London, encompassing the London Eye, Big Ben, St Paul's and Westminster.[51] The numerous shots of crowds waving Union Jack flags along the Mall – a trope that has persisted since the very first Pathé newsreel mentioned in this chapter – locates the celebration as a specifically British event. As Andrew Marr later observed:

> It was filmic. The richly coloured uniforms of the male Windsors and the glamorous, British-made dresses of the bride and her new family added to the Harry Potter effect of swooping television shots in the gothic, leafy and stained-glass illuminated Abbey.[52]

These opening images of London work further to cement the event within the capital consumer city. Numerous references are also made throughout the coverage to Savile Row, linking fashion with a specific London fashion street. The link between fashion, London and politics is accentuated in the BBC coverage in an interview with Boris Johnson, Mayor of London, who is told by BBC presenter Fiona Bruce that he looks very smart in his morning suit. He replies, 'This comes from, I'm delighted to say, from Moss Bros in Fenchurch Street, and I'm indebted to Pam of Moss Bros in Fenchurch Street for her hard work to get me as smart as she could.'[53] Moss Johnson is a high-street chain that rents formal menswear. By mentioning an affordable London outfitter Johnson jokes that he is one of the people. This reference also makes the point that London fashion is accessible to all, not only those who can afford bespoke tailoring.

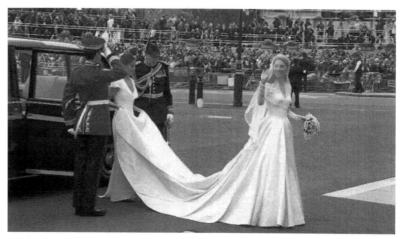

24 The wedding dress of Kate Middleton, 2011. *The Royal Wedding* DVD
(Formative Productions, 2011).

For the first half of live television coverage on both channels, dead time is filled with speculation about the bride's wedding dress and its designer. She – Sarah Burton of Alexander McQueen – is not identified until Kate Middleton steps out of the car at Westminster Abbey at approximately 11 a.m. The constant repetition of the dress question, coupled with the enthusiastic and excited responses of the guests on screen, is reminiscent of 'Wedding Dress Silk Made in Essex', building an interest in the dress that may not have existed pre-coverage. When its designer is finally named, the use of spontaneous (yet surely scripted) live commentary allows this identity to be delivered in a mode of revelation, adding to the excitement of Middleton's arrival at the Abbey as a national fashion moment. Thus created, it is available for endless rescreenings, part of the event but also justifiable as a moment in its own right. The immediacy of this information is also highlighted, with the global public contributing to the coverage with tweets and emails read out on screen. Later, when Middleton departs for her honeymoon in a blue Zara dress priced at £49.99, the promotion of accessible royal fashion culminates in Zara's selling out of duplicate dresses within hours.[54]

This royal reporting has an even more emphatic Cinderella theme than that of Diana's wedding, owing to Kate's status as a 'commoner'. A daughter of first-generation party-favours millionaires becoming a princess is tied into her combination of couture and ready-to-wear, concluding an aspirational message

of social transformation. Marr captures this feeling when he writes: 'Girls in the crowd waving signs reading "Harry's mine" were (mostly) joking but could go home afterwards and feel the joke was not absurd.'[55] Cue ITV commentator Philip Schofield's observation of the bridal gown: 'So if you imagined a fairy-tale princess and her dress, is that the picture you had in your mind? I think perhaps it might have been.'[56] The 2011 ITV1 coverage takes time to focus on the Britishness of the wedding dress's manufacture, as well as its design: 'the dress epitomises timeless British craftsmanship by drawing together talented and skilled workmanship from across the United Kingdom.'[57] Live promotion has the added bonus of seeming less like promotion because it feels spontaneous, but it raises the question as to whether we are so inundated by advertising in our daily lives that we simply stop noticing it.

Both the ITV and BBC 2011 live wedding broadcasts contain a running commentary on the wardrobe decisions of significant guests as they enter the Abbey. Mother of the bride Carol Middleton wears a dress designed by the fashion house of the London designer Catherine Walker. The live commentaries on ITV and BBC both highlight the fact that Catherine Walker was a favourite of Princess Diana and dub the choice both astute and appropriate. On ITV1 Celia Walden (fashion and society writer for the *Telegraph*) describes it as a 'quintessentially British choice'.[58] Similarly, the wife of the British Prime Minister, Samantha Cameron – herself ex-creative director and current consultant for the British accessories firm Smythson – is wearing Burberry. As Paula Reed, style director of *Grazia* magazine, announces on BBC: 'Of course she's flying the flag – that's one of our biggest and most successful fashion houses. It looks fantastic on her.'[59]

There are at least three DVD compilations of highlights from the wedding (BBC, ITV and Formative Productions), all about three hours in length. Despite their limited airing time, the compilations find time to include key fashion 'moments' in their commentaries, therefore classing them as 'eventful'. All three DVDs include at least one fashion reference, some of them choosing to make it a focus of the whole DVD. The BBC Souvenir DVD includes only Middleton's arrival at the Abbey, revealing both the dress and its designer to the world, but its inclusion in the highlights places this moment at the same level as official moments in the event's schedule and routine, emphasising its national significance.[60]

The Formative Productions souvenir DVD focuses the majority of its commentary on fashion, and comes with a fashion guide booklet.[61] The chronology

of the wedding day is altered from the beginning, starting with the couple's Buckingham Palace balcony kiss after the ceremony. Its distancing from the event allows it to be more critical. As well as praise for British designers there are also scathing remarks on guests' wardrobe choices, added for entertainment value. Less news, more gossip column, the commentary points out that film director Guy Ritchie's coat is unbuttoned, although 'The Queen has let it be known … she rather likes morning coats to be buttoned.'[62] Socialite Tara Palmer-Tomkinson's dress is deemed inappropriate as it 'really is off the shoulder', unlike the dress of former Harry girlfriend Chelsea Davey, which is only 'almost off the shoulder'.[63] As we are informed, 'almost is acceptable, off the shoulder is absolutely not, in particular for Westminster Abbey'.[64] Samantha Cameron is also criticised for going 'hatless', while the hat-wearing Miriam Clegg, wife of the Deputy Prime Minister, is said to have 'played it safe'.[65] Despite its critical tone, this DVD still falls under the promotional banner. The commentator declares: 'I defy any woman to say that a man doesn't look very handsome in a morning coat, especially if it's cut by Savile Row.'[66] The Mayfair headquarters of London's elite tailors, Savile Row is mentioned again here in the description of brother of the bride James Middleton's suit.

The British manufacture of Kate Middleton's dress is also highlighted in the Formative Productions DVD, with more detail than in the ITV live commentary:

> It's very interesting … to look at the details that as much of it was made in England as possible. The lace work on the bodice and on the hem is made by the Royal School of Needlework and apparently Sarah Burton set up a design studio next door to the Royal School of Needlework in Hampton Court Palace and a lot of the fittings were executed there because obviously the designer of the dress had to be kept top secret.[67]

Again, this coverage is setting itself up within the tradition of British film and media coverage to promote Britain not only as a fashion centre, but also as a manufacturing nation, a centre of craftsmanship endorsed by royal appointment.

The historical relationship drawn out in the media between royalty and fashion was established long before 2011. Dazzled by its afterimage, we not only accept but expect it. British media tradition has created the popular desire for a fashion-based royal events commentary that means if it is not included, we are disappointed. We are, in essence, waiting for the adverts. Commercial promotion has become entertainment, and, even more concerningly, news. Audience anticipation has been built up through the cross-generational use of tropes from

the 1920s to the present day, giving British media coverage of royal weddings a standard formula that develops, but doesn't change.

More striking in the live coverage of the 2011 royal wedding is the use of dead time to allow more broadcasting space for a discussion of British fashion. However, one could also argue that the commentary focuses on seemingly frivolous fashion moments to give a feeling of immediacy and accessibility, both to the time of the event itself and to its royal figures. This was an early technique to make royal coverage feel as live as possible, at a time when live broadcasting was not an option. In the 2011 coverage, it is the use of fashion that permits audience identification with the royal family. But the opposite is also true, that the fashion elements of the day have become privileged as exceptional moments, not only fashion 'moments', but 'events' in themselves.

The history of screen media's reports of royal weddings brings together a number of different aspects of Britishness that all cluster around the theme of fashion, namely industry, commerce, craftsmanship, pageantry, tradition, innovation and international importance. It is as though each is attempting to hold together the past and present within Britain, with fashion as the tie that binds them. Fashion paradoxically both looks back and refreshes. In the 2011 coverage of the royal wedding there is much talk of a new generation of royalty, embodied by the modern relationship of William and Kate. They met at university and lived together before marriage. Minibuses conveyed their lesser relations from the Palace to the Abbey. Their wedding was viewed world-wide on contemporary social media sites, smartphones and tablets. It is as though the royal family were undergoing a makeover in the British media – a new look – a phenomenon fundamental to fashion itself.

NOTES

1 Catherine Middleton, now formally titled the Duchess of Cambridge, is often referred to in celebrity style by her familiar name 'Kate' in magazines and on television. Both the BBC and ITV live television coverage of the 2011 Royal Wedding called her 'Kate'.
2 'Why we all want to believe in Kate', *Stylist* (18 April 2012), p. 45.
3 Caryn Franklin on *Daybreak* (ITV 1, 9 March 2012).
4 'Why we all want to believe in Kate', p. 46.
5 British Fashion Council, 'BFC Princess of Wales Charitable Trust' (no date given), www.britishfashioncouncil.co.uk/content.aspx?CategoryID=1615&ArticleID=1383.
6 British Fashion Council, 'Great British fashion flags' (1 May 2012), www.britishfashioncouncil.co.uk/news_detail.aspx?ID=416.

7 *Ibid.*

8 *Ibid.*

9 Historic Royal Palaces, 'Fashion Rules exhibition – royal glamour at Kensington Palace', Historic Royal Palaces (no date given), www.hrp.org.uk/KensingtonPalace/stories/palacehighlights/FashionRules/default.aspx.

10 Julia Neel, 'British clothing industry reception', *Vogue* (17 March 2010), www.vogue.co.uk/spy/celebrity-photos/2010/03/17/clothing-industry-reception-at-buckingham-palace.

11 Mary Ann Doane, *The Emergence of Cinematic Time: Modernity, Contingency, the Archive* (Cambridge, MA and London: Harvard University Press, 2002).

12 *Ibid.*

13 Referred to *ibid.*, p. 23.

14 *Ibid.*, p. 1.

15 *Ibid.*, p. 10.

16 *Ibid.*, p. 23.

17 *Ibid.*, p. 76. Emphasis as in original.

18 *Ibid.*, pp. 159–60.

19 *Ibid.*, p. 140. Emphasis as in original.

20 Ryan Matthews and Watts Wacker, *What's Your Story?* (Upper Saddle River, NJ: FT Press, 2008), p. 136.

21 *Ibid.*, p. 149.

22 *Ibid.*

23 Robert Govers and Frank Go, *Place Branding: Glocal, Virtual and Physical Identities, Constructed, Imagined and Experienced* (Basingstoke: Palgrave Macmillan, 2009), p. 20.

24 *British Royal Weddings of the 20th Century* (British Pathé; Cherry Red Records Limited Trading as Strike Force Entertainment, 2011), DVD.

25 David Hesmondhalgh, *The Cultural Industries* (London: Sage, 2nd edn, 2007), p. 6. Emphasis as in original.

26 Jacques Derrida, *Archive Fever: A Freudian Impression*, trans. Eric Prenowitz (Chicago and London: University of Chicago Press, 1996), pp. 16–17. Emphasis as in original.

27 Michel Foucault, *The Archaeology of Knowledge*, trans. Alan M. Sheridan Smith (London and New York: Routledge, 1989), p. 8. Emphasis as in original.

28 Doane, *The Emergence of Cinematic Time*, p. 3. Emphasis as in original.

29 Mark Cousins, 'From royal London to celebrity space', in Mandy Merck (ed.), *After Diana: Irreverent Elegies* (London: Verso, 1998), pp. 77–8.

30 'Princess Mary to marry an English nobleman' [Princess Mary weds Henry Charles George, Viscount Lascelles], British Pathé, 1921. Accessed on *British Royal Weddings of the 20th Century*.

31 'Wedding of HRH Princess Mary and Viscount Lascelles, D.S.O at Westminster Abbey', [Princess Mary weds Henry Charles George, Viscount Lascelles], British Pathé, 1922. Accessed on *British Royal Weddings of the 20th Century*.

32 'The Royal wedding' [Prince George, Duke of Kent weds Princess Marina of Greece], British Pathé, 1934. Accessed on *British Royal Weddings of the 20th Century*.

33 'The Royal wedding' [Prince Henry, Duke of Gloucester weds Lady Alice Scott], British Pathé, 1935. Accessed on *British Royal Weddings of the 20th Century*.

34 *Ibid.*

35 *Ibid.*

36 Fashion Film Supplement to the Wedding of Prince Henry, Duke of Gloucester and Lady Alice Scott [Prince Henry, Duke of Gloucester weds Lady Alice Scott], British Pathé, 1935. Accessed on *British Royal Weddings of the 20th Century*.

37 Valerie Mendes and Amy De La Haye, *Fashion since 1900* (London: Thames & Hudson, new edn, 2010), pp. 140–1.

38 'The Princess weds' [Princess Elizabeth weds Philip Mountbatten, Duke of Edinburgh], British Pathé, 1947. Accessed on *British Royal Weddings of the 20th Century*.

39 *Ibid.*

40 'Wedding dress silk made in Essex', 1947. Accessed on *Happy and Glorious: The Royal Wedding (1947) and The Coronation (1953) from Original Newsreels* (London: The Royal Collection, 2007), DVD.

41 *Ibid.*

42 Drusilla Beyfus, 'Royal wedding dresses', *The Royal Wedding Official Souvenir and Programme* (London: The Royal Jubilee Trusts, 1981), p. 18.

43 Andrew Marr, *The Diamond Queen: Elizabeth II and Her People* (London: Macmillan, 2011), p. 110.

44 'May Wedding' [Princess Margaret weds Anthony Armstrong-Jones], British Pathé, 1960. Accessed on *British Royal Weddings of the 20th Century*.

45 *Ibid.*

46 Nicholas Courtney, *Diana Princess of Wales* (London: Park Lane Press, 1982), p. 40.

47 *Ibid.*, pp. 45–7.

48 'The Wedding of Prince Charles and Lady Diana Spencer 29 July 1981 St Paul's Cathedral' [Prince Charles weds Lady Diana Spencer], British Pathé, 1981. Accessed on *British Royal Weddings of the 20th Century*.

49 'Prince Charles and Lady Diana Spencer's wedding 29 July 1981', BBC, www.bbc.co.uk/history/events/prince_charles_and_lady_diana_spencers_wedding.

50 Marr, *The Diamond Queen*, pp. 363–4.

51 *The Royal Wedding: H R H Prince William & Catherine Middleton 29th April 2011* (BBC1, 29 April 2011), live coverage.

52 Marr, *The Diamond Queen*, p. 364.

53 *The Royal Wedding*, BBC.

54 'Why we all want to believe in Kate', p. 46.

55 Marr, *The Diamond Queen*, p. 368.

56 *The Royal Wedding* (ITV1, 29 April 2011), live coverage.

57 *Ibid.*

58 *Ibid.*

59 *The Royal Wedding*, BBC.

60 *The Royal Wedding – William and Catherine* (BBC, 2011), DVD.

61 *The Royal Wedding: William and Kate 29th April 2011*, Collectors Edition double DVD set (Formative Productions, 2011), DVD.
62 *Ibid.*
63 *Ibid.*
64 *Ibid.*
65 *Ibid.*
66 *Ibid.*
67 *Ibid.* The Royal School of Needlework is a charity that provides courses in hand embroidery for all abilities. The school describes itself as 'the International Centre of Excellence for the Art of Hand Embroidery', www.royal-needlework.org.uk/content/10/about_the_royal_school_of_needlework.

BIBLIOGRAPHY

Beyfus, Drusilla, 'Royal wedding dresses', *The Royal Wedding Official Souvenir and Programme* (London: The Royal Jubilee Trusts, 1981).
British Fashion Council, 'BFC Princess of Wales Charitable Trust' (no date given), www.britishfashioncouncil.co.uk/content.aspx?CategoryID=1615&ArticleID=1383.
British Fashion Council, 'Great British fashion flags' (1 May 2012), www.british-fashioncouncil.co.uk/news_detail.aspx?ID=416.
Courtney, Nicholas, *Diana Princess of Wales* (London: Park Lane Press, 1982).
Cousins, Mark, 'From royal London to celebrity space', in Mandy Merck (ed.), *After Diana: Irreverent Elegies* (London: Verso, 1998).
Derrida, Jacques, *Archive Fever: A Freudian Impression*, trans. Eric Prenowitz (Chicago and London: University of Chicago Press, 1996).
Doane, Mary Ann, *The Emergence of Cinematic Time: Modernity, Contingency, the Archive* (Cambridge, MA and London: Harvard University Press, 2002).
Foucault, Michel, *The Archaeology of Knowledge*, trans. Alan M. Sheridan Smith (London and New York: Routledge, 1989).
Govers, Robert and Frank Go, *Place Branding: Glocal, Virtual and Physical Identities, Constructed, Imagined and Experienced* (Basingstoke: Palgrave Macmillan, 2009).
Hesmondhalgh, David, *The Cultural Industries* (London: Sage, 2nd edn, 2007)
Historic Royal Palaces, 'Fashion Rules exhibition – royal glamour at Kensington Palace', Historic Royal Palaces (no date given), www.hrp.org.uk/KensingtonPalace/stories/palacehighlights/FashionRules/default.aspx.
Marr, Andrew, *The Diamond Queen: Elizabeth II and Her People* (London: Macmillan, 2011).
Marx, Karl, *Capital: An Abridged Edition*, ed. David McLellan (Oxford: Oxford University Press, 1995).
Matthews, Ryan and Watts Wacker, *What's Your Story?* (Upper Saddle River, NJ: FT Press, 2008).

Mendes, Valerie and Amy De La Haye, *Fashion since 1900* (London: Thames & Hudson, new edn, 2010).

Neel, Julia, 'British clothing industry reception', *Vogue* (17 March 2010), www.vogue.co.uk/spy/celebrity-photos/2010/03/17/clothing-industry-reception-at-buckingham-palace.

'Why we all want to believe in Kate', *Stylist* (16 April 2012).

12

The Queen on the big screen(s): outdoor screens and public congregations

Ruth Adams

Since the Queen's Golden Jubilee in 2002, big screens in public places relaying live broadcasts to large crowds, often very near to the 'real' action, have become an increasingly important and visible element of royal celebrations. It might be expected that in our current era of media fidelity, diversity and ubiquity, these mass congregations would lose their appeal but the opposite would seem to be the case. An estimated 1 million people watched the Golden Jubilee 'Party at the Palace' concert on screens in the Mall, 90,000 watched the royal wedding in Hyde Park and Trafalgar Square in 2011 and many of the million people who lined the River Thames for the 2012 Diamond Jubilee pageant watched the event on the fifty screens along the route, with a further 90,000 watching in Battersea Park.

This arguably represents a reversal of the dominant trend during the second half of the twentieth century, when the primary means by which public events were transmitted and received was by television in domestic contexts, leading to anxieties that public culture and public life had been displaced by a more atomised, private mode of engagement. However, as Scott McQuire observes, 'the explanatory value of such a narrative is declining', and 'the current expansion of media screens from predominantly fixed and private locations to mobile and public sites has introduced a new set of questions'.[1] How, for example, should we understand this new type of public occasion, the transmissions which are their focus and their 'not-quite-liveness'?[2] What motivates people to travel and congregate to view events on proximate screens rather than watching at home? Are such events a means of compensating for a fragmentation of community and audience in a postmodern age of media proliferation? Do they represent the reinvention of public space? Barker suggests that 'We might say that a new notion

264

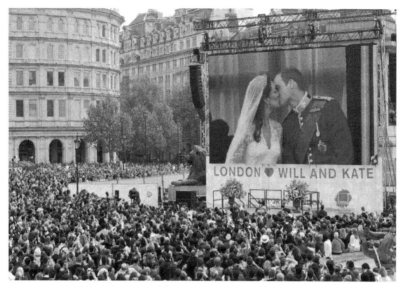

25 Spectators in London's Trafalgar Square view the royal couple's post-nuptial kiss on the big screen, 2011 (AP Archive).

is emerging from this, which we could call *eventness*: that is, the creation of and participation in senses of heightened cultural togetherness.'[3] Does the content determine the nature of these phenomena? Are public broadcasts of royal celebrations qualitatively different from, for example, sporting, theatrical or political events transmitted in a similar fashion? This chapter seeks to answer some of these questions in relation to live public screenings of royal ceremonial and celebration. The novelty and popularity of these screenings make them, I would argue, a legitimate area of research, and one that has not yet been explored in relation to royal events, although work has been done on live broadcasts in sporting, theatrical and other cultural environments. This omission might be understood in the context of a more widespread neglect of topics relating to the British monarchy by academia, an inattention that is perhaps 'perplexing',[4] given its prominence in British culture and society, and the strong emotional attachment demonstrated by a significant proportion of the population. Tom Nairn argues that it is a mistake for scholarly analysis to dismiss popular interest in the royals as 'mass idiocy',[5] and that it should instead be recognised as a significant element of the UK's rather complex and paradoxical national identity.

In this chapter I examine British royalty's relationship with the media, particularly since the advent of television, and review existing research on media

technology, on the concept of 'liveness' and the uses of public screenings in a variety of contexts. In doing so I try to identify some conceptual frameworks that illuminate these more recent developments. I also introduce some findings from a small empirical research project, which canvassed the experiences of people who watched royal events on big screens in London in 2011 and 2012, namely the wedding of Prince William and Kate Middleton, and the celebrations for the Queen's Diamond Jubilee. This research is far from comprehensive or conclusive, but it does, I believe, flag up some key themes and issues, and gestures towards possibilities for future research.

Ten respondents completed long-form open-ended questionnaires, and in four cases this was followed up by semi-structured face-to-face interviews lasting between thirty minutes and one hour. The respondents were recruited through a variety of means, including personal recommendation, social media and university research calls. Among this group the Jubilee river pageant on 3 June 2012 was the most popular event, with eight of the ten attending. Four had attended the screenings of the Jubilee concert the following day, but only one had watched the final day of the weekend celebrations, the more traditional Thanksgiving Service at St Paul's Cathedral and procession to Buckingham Palace. Six of the respondents had also watched the wedding of Prince William and Kate Middleton on public screens in April 2011.

Only one respondent identified as male, and all but two were under thirty. Most were educated to degree level, and a number had or were studying for postgraduate qualifications. Four were not native to the UK, but all were living in the UK when they attended the events in question. The relatively international nature of the group reflects the demographic of the student body of my university, but is also indicative of the British royal family's global appeal. Several respondents commented on the relatively high proportion of foreigners they perceived at the events they had attended. Although this would appear to challenge Tom Nairn's assessment that '[v]isitors and outsiders may not understand this "irrational" identification, because they do not share the community inwardness it represents',[6] a number of my respondents from overseas stated that their motivation for attending was at least partly 'anthropological', that they wanted to 'see how British people experience this kind of event'.[7]

The gender (im)balance within this sample group reflects wider trends. MORI research from 1987, for example, found that 'twenty-five percent of women are prepared to describe themselves as "very interested" in the Royal

Family, as compared with eleven percent of men'.[8] The lone male respondent demonstrated the least interest in and engagement with royal events, claiming to have attended only at the behest of friends. Because of the small size of the sample group, it is problematic to suggest that they are representative of audiences for royal events, but they may constitute an indicative 'snapshot' of opinion and experience.

Popular interest in the monarchy is, Ben Pimlott suggests, largely media-generated, and 'Since the Monarchy and media are today so closely enmeshed ... it has become impossible to imagine modern royalty except in the context of a spotlight.'[9] As Michael Billig asserts, the British monarchy 'does not survive as an embarrassing relic, shuffling along like an elderly relative, conscious of being in the way of the younger generation. Quite the contrary, it survives by being noticed, over and over again.'[10] Buckingham Palace actively constructs royal media coverage and image-marketing, employing professional press secretaries and publicity agents, generating press releases and photo opportunities and, in the digital age, producing official websites. Despite some anxieties in the early years of broadcasting that too much publicity might 'stain the mystery, even the dignity of the Crown',[11] the necessity of modern technology and media coverage in facilitating the royal family's function of 'perpetuating the national community through the provision of unifying symbols and rituals',[12] came to be accepted, and eventually embraced, by both Crown and country. David Cannadine recounts that

> the B.B.C.'s first director general, Sir John Reith, himself a romantic devotee of pageantry and the monarchy, rapidly recognised the power of the new medium to convey a sense of participation in ceremonial which had never been possible before. So, from the time of the Duke of York's wedding in 1923, 'audible pageants' became a permanent feature of the B.B.C.'s programmes, as each great state occasion was broadcast live on the radio, with special microphones positioned so that the listener could hear the sound of bells, horses, carriages and cheering. In a very real sense, it was this technical development which made possible the successful presentation of state pageants as national, family events, in which everyone could take part.[13]

The Queen's coronation in 1953 was the first major international event to be broadcast on television, with an estimated 20.4 million viewers in the UK alone, 56 per cent of the adult population. The coronation was the first media event seen by the majority of the population, and was for many their first experience of 'watching the box'. It is an event that has become a touchstone

in the mythology of the nation and the memories of millions. This history supports the assertion by Dayan and Katz that successful media events have three partners:

> the organizers of the event who bring its elements together and propose its historicity [in this instance, the Crown]; the broadcasters who re-produce the event by recombining its elements; and the audiences, on the spot and at home, who take the event to heart. Each partner must give active consent and make a substantial investment of time and other resources if an event is to be successfully mounted for television. Indeed, it is useful to think of such events as constituting a kind of 'contract' among the three parties whereby each side undertakes to give something to the others in order to get something in return.[14]

It has been argued that media ubiquity 'democratised' the British monarchy, citing, for example, the force of public opinion that led to the televising of the coronation, overcoming the resistance of Crown, church and government. While John Balmer's suggestion that this led to a shift in power, with the British public now controlling the destiny of the royal family, is undoubtedly overstating the case, we can none the less argue that in the media age, 'the function of royal events is to entertain and provide a spectacle for consumption'.[15] Apparently paradoxically, the more modern and sophisticated broadcast technology has become, the more important it becomes that the 'ancient' and 'traditional' form a part of the ceremonial. As David Cannadine observes: 'If, for example, the queen had travelled to St Paul's Cathedral in a limousine [rather than the horse-drawn state coach] for her Jubilee Thanksgiving Service, much of the splendor of the occasion would have been lost.'[16] Balmer argues that we can perceive the British monarchy as a 'corporate brand', the survival of which is dependent on 'accommodating political, economic, social, and technological change'.[17] As a brand, the British royal family, Otnes and Maclaran suggest, offers 'tangible benefits. These include providing consumers with a respected and shared symbol of nationalism, helping them engage in national "togetherness" and fostering a sense of identity based on shared history, culture and traditions.'[18] We might categorise the royal media events and the 'live' experiences arranged round them examined here as part of the 'plethora of industries', that 'produce goods, services and experiences specifically designed to enhance consumers' knowledge and enjoyment of the B[ritish] R[oyal] F[amily]'.[19]

While to some extent the British monarchy can be thought of as global celebrities, Billig warns against making glib or misleading comparisons because

> Royals are uniquely different from other show business celebrities. ... In the first place ... the stars of the entertainment industries ... are [not] held to embody a national heritage and the future of a nation. There is a second crucial factor which confirms the uniqueness of royal fame. In contemporary life, there are no other figures who are guaranteed a lifetime of celebrity from the moment of birth. Indeed the interest of the media guarantees fame from the moment of possible conception. This fame is transmitted across generations. The sons and daughters of today's film stars and sporting heroes will fade into anonymous obscurity, unless they manage to gain celebrity in their own right. But it is not so with the royals – they, their unborn children and grandchildren are known to be famous, whatever they do.

In a world of obsolescence, the transmission of royal celebrity across the generations has special significance.[20]

One of my interviewees, who joked that she enjoyed 'waiting outside in the cold', also regularly attended film premieres and other 'red carpet events', but stated that there was a distinct difference between these and royal occasions. Apropos the royal wedding, the event with perhaps the most evident 'movie star glamour', she said:

> As much as there was a celebrity factor to it, I think it was first and foremost about patriotism and what it represented to the country, and being a historical event, and ... all of that was just much more important. I think just because it was William's wedding, and Kate became such a celebrity, there were a lot of different factors that played in. The celebrity, the Diana factor, and just everything that goes with the two of them that made it a little bit special in that sense, but I think in general that it's always going to be more about the country and the royal family and what it represents.[21]

This supports Blain and O'Connell's assertion that while it 'may be true that the phenomenon of monarchy in the media is primarily economic and secondarily political ... it seems to have acquired economic and political importance *because* it is originally of cultural and psychological importance'.[22] Although popular veneration for royalty does fluctuate somewhat, only a very small proportion of the British population identify as republican, and MORI polls and the British Social Attitudes Surveys demonstrate that support for the monarchy is found among all social groups.[23]

Although, as we have seen, the notion that the mass media have the potential to create communities of interest and imagination is not a new one, the experience of watching live, mediated happenings in public and *en masse* is certainly novel. Until recently, the dominant conceptual framework for understanding large media events was that advanced by Daniel Dayan and Elihu Katz. They defined 'media events' as live television broadcasts, organised by establishment bodies, which 'stand for consensual values and have the authority to command our attention'.[24] These can generate vast audiences, and although facilitated by technology, this is achieved by a 'norm of viewing',[25] which portrays it as valuable, even mandatory to watch, and demands an element of active participation from the audience, such as watching in groups, dressing for the occasion and in doing so constructing their own celebrations around the event. Broadcasts of royal celebrations, such as coronations, jubilees and weddings, are paradigmatic of such a model. Dayan and Katz assert that media events *privilege the home* and observe that:

> This is where the 'historic' version of the event is on view, the one that will be entered into collective memory. Normally the home represents a retreat from the space of public deliberation. ... Yet the home may become a public space on the occasion of media events, a place where friends and family meet to share in both the ceremony and the deliberation that follows.[26]

This account chimes with John Ellis's characterisation of the broadcast television viewer as 'a bystander in very specific circumstances, those of the home'.[27] Live public screenings challenge this assumption, however, and raise questions about what happens to the nature of both broadcasts and their audiences as a consequence of this translation.

A mutual characteristic of both public and domestic consumption of media events is that they are usually shared with 'special' people, and are treated as occasions to reactivate family bonds, friendships and neighbourhoods. Representatively, all but one of my respondents, who had been unable to find her friends on the day, had attended the royal screenings with at least one friend or family member, and the shared nature of the experience was evidently an important aspect. In some cases the royal event seemed to be a pretext for a social occasion. One wrote, 'We thought it would be fun to make an event of it – friends came from Oxford and we had a picnic.'[28] However, media events can also 'create their own constituencies'[29], generate temporary communities and social networks who share an experience, a historical moment together.

Another of my respondents said, for example: 'It felt like everybody had come together as a group of friends even though none of us knew each other.'[30] These alliances serve, argue Dayan and Katz, to reinforce the status quo: '[B]roadcasts *integrate* societies in a collective heartbeat and evoke a *renewal of loyalty* to the society and its legitimate authority.'[31]

> Thus, the *event connects center and periphery*, not only through the experience of communitas, but through direct communion with central symbols and values, through the assumption of ritual roles in a ceremony conducted by establishment leaders, and through the presence of small groups of known and valued others.[32]

Again, although this is an analysis that can clearly be extended to sporting, military or cultural spectacles, these characteristics are most literally and profoundly expressed, I would argue, by broadcasts of royal ceremonial.

Media events have a complex relationship with the 'live' and the 'real'. Philip Auslander observes that the 'live' is a *consequence* of the mediated, rather than the reverse; prior to the development of recording technologies, there would have been no concept of the 'live' event, 'for that category has meaning only in relation to an opposing possibility'.[33] Through its intervention, argue Dayan and Katz, television itself 'becomes the primary performer in the enactment of public ceremonies'.[34] Consequently it becomes meaningless to ask whether 'this type of broadcast offers a "true" rendition of the original event. Given the openly "performative" nature of television's role, the problematics of "truth" and "falsehood" become almost irrelevant here.'[35] Auslander argues that television has become the dominant form that the live event seeks to resemble, rather than vice versa, while Steve Wurtzler goes so far as to suggest that the live event has come to be seen as a 'degraded' version of the mediatised.[36] However, Auslander asserts too that 'liveness and mediatization must be seen as a relation of dependence and imbrication rather than opposition'[37] and questions whether there remain 'clear-cut ontological distinctions between live forms and mediatized ones'.[38] Dayan and Katz propose that we should regard the media event as *sui generis*: 'Neither reproduction nor access, it offers an experience in its own right, different from the original, and probably more important.'[39] Perhaps paradoxically though, media events continue to fetishise the 'real'; television claims to give its viewers a sense of 'being there'. Having generated the concept of the live, broadcast media

must compensate for its lack, by offering intimacy, apparent proximity and equality of access.

Media events 'institutionalize a cinematographic model of "publicness" ',[40] a characteristic emphasised by the emergence of public screenings.

> With electronic communication, the reconstituted performance can be simultaneous, within a temporal frame shared by all protagonists and by the audience. These are 'live' broadcasts, which means that simulation of a performance has reached a state of near-perfection: it has become temporally indistinguishable from the performance itself. This live dimension of the broadcast ostensibly returns us to theater and church. But shared time conceals another dimension of the cinematographic model: that public reaction is no longer a reaction to the original performance, but to its simultaneous substitute.[41]

In June 2009, the National Theatre in London initiated a popular phenomenon when it broadcast by satellite a live theatrical production to 70 cinemas in the UK and a further 210 around the world. An estimated 50,000 people saw the play as it was performed. These audiences may have been geographically distant from that in the theatre, but they none the less witnessed the show at the same time, and were spatially co-present to the others in the cinema where they watched. Bakhshi and Throsby's research suggests that the expectations and experiences of the audiences in the theatre and the cinemas had more in common than not, and the 'experiential aspects', the sense of occasion and 'the buzz' of the performance were valued by both. In both cases, the chance to see the actors 'up close' was reported as an important factor, and significantly, nearly 85 per cent of the cinema audiences 'reported feeling "real excitement" because they knew the performance they were watching was taking place "live" at the National Theatre'. As Bakhshi suggests: '[t]his finding suggested that there are limits to the "anywhere, anytime" attitude towards the consumption of cultural content. It would seem that there does exist a "right time" (live, as it happens) and a "right place" (a cultural venue, whether a theatre or a cinema) to enjoy some cultural experiences.'[42]

This could be seen as an exemplar of what John Urry conceptualises as a particular 'kind of travel to place, where timing is everything'.

> This occurs where what is experienced is a 'live' event programmed to happen at a very specific moment. Co-presence involves 'facing-the-moment'. Examples include political, artistic, celebratory, academic and sporting occasions. ... Each of these generates intense moments of co-presence. These

events cannot be 'missed' and they set up enormous demands for mobility at very specific moments.[43]

Clearly my respondents who attended public broadcasts of royal events were responding to these demands, and appear to substantiate Mike Weed's assertion that the 'need for proximity is not for proximity to the event, but to others sharing in the experience of watching the event'.[44] Deirdre Boden and Harvey L. Molotch likewise identify a 'compulsion of proximity',[45] and observe that 'When we are in copresence, we have some evidence that the other party has indeed made a commitment, if nothing else than by being there.'[46] This sense of 'fellow feeling' was greatly valued by the majority of my respondents; one said that they 'wanted to be around people to experience the sense of community and shared excitement'.[47] Thus it would seem that if, as Dayan and Katz assert, media events initially 'shifted the locus of ceremoniality from the piazza and the stadium to the living room',[48] then live screenings have shifted it right back. This contradicts many earlier assumptions about the perceived benefits and likely consequences of domestic media. Television was touted as a way of avoiding the stress and discomfort of travel and mass outdoor events, of crowds and the risk of 'social contamination', but it appears that these are 'risks' that many are willing to take. A significant constituency evidently welcomes opportunities for communality and engagement and, in this context, as Haferburg, Golka and Selter observe, big screens can have 'an important impact on public space and life'.[49] Simone Arcagni concurs, proposing that the media event 'reinstates the function of public space as a place of public use, and above all, defines the spectator who wants to see but also participate'.[50]

Watching live screenings in public places could be argued to be, and in many cases seemed to be experienced as, a sort of 'win-win' situation. David Rowe, writing about sporting contexts, observes that while the viewer of an event on television must forgo the atmosphere and excitement of the live experience, they are compensated with '[e]xpert commentary, multi-camera angles (from panoramas to extreme close-ups), split screens, "wired" officials, directional microphones, action replays, super-slow motion, and so on'.[51] Audiences who are present at live events get to enjoy the atmosphere and excitement from being part of a like-minded crowd, and the sense that they are part of history in the making, but may find that as a result of a variety of restrictions, they actually get to see little or nothing of the event itself, often a partial view of a fleeting moment at best. But as Rowe observes, the 'insertion of televisual infrastructure into the event itself' can overcome these problems 'for an "in-person audience … unsure about whether it should not be

at home, watching TV" for fear of only "attending part of the event", when with television "everybody can attend the whole event" '.[52] This has the effect of reversing the 'spectatorial dynamic', because 'instead of transmitting images of unique spatio-temporal events to remote locations, the attending spectator is provided with multiple versions of what they have seen (or have not or could not) *as if they were absent*'.[53] Other commentators, however, are more sceptical about the advantages or pleasures of such a set-up. Auslander argues that 'The spectator sitting in the back rows of a Rolling Stones or Bruce Springsteen concert … is present at a live performance, but hardly participates in it as such since his/her main experience of the performance is to read it off a video monitor.'[54] Goodwin goes so far as to suggest that 'attending a live performance … these days is often roughly the experience of watching a small, noisy TV set in a large, crowded field'.[55] Even if this were true, 'the enforced scarcity of the in-person experience, as opposed to the automatic plenitude of its living room equivalent, seems to still tip the balance in favour of "being there" ',[56] suggests David Rowe. Several respondents said they were motivated by the opportunity to experience a 'once-in-a-lifetime event', to 'feel the atmosphere and be able to say, "I was there!" '.[57] As one said, 'I think there are very few circumstances in which you can be part of something that you know for sure will be part of History, and I guess many people went for that reason.'[58] Related to this is the desire, perhaps unconscious, to accrue cultural and social capital. Auslander suggests that a 'dimension to the question of why people continue to attend live events in our mediatized culture is that live events have cultural value: being able to say that you were physically present at a particular event constitutes valuable symbolic capital.'[59] One of my respondents spoke about the 'human need for this authentic experience',[60] although she acknowledged that such experiences could be amplified in the recalling and the retelling, 'so even if they see the top of one flag, which is literally all I saw, that's going to be "Oh, we watched the Jubilee flotilla" '.[61] Another, who had arrived early at the riverside to guarantee a view of the live action, stressed why this was important: 'I think the idea of seeing it in person makes it something memorable. You have to actively seek out the event to participate – wake up early, stake a spot out, sit in the rain, etc. – that it becomes something that you have done rather than something others have merely watched.'[62] But none the less we see similar claims made for both mediated and immediate experiences, which reflects Auslander's questioning of whether there remain 'clear-cut ontological distinctions'[63] between them.

It is important for media events to attract a live crowd, so that something of the atmosphere and significance of the event can be conveyed to the audience

watching at home. As Rowe observes: '[I]t is unlikely that global media events founded, however imperfectly, on the premise of recording history, can readily dispense with the audible and visible witness of a large attending crowd.'[64] In the context of royalty, streets thronged with flag-waving subjects give the continued presence of the monarchy in public life a sense of legitimacy, and audiences attending live screenings of events may find themselves simultaneously spectator and spectacle. Rowe notes that

> the use of televised 'reaction shots' of screen spectators in public (or quasi public) spaces outside the event is a device that extends the spectacle of the crowd beyond the ... [event proper]. ... Television in this way seeks to compensate those who did not or could not attend by giving them a 'bit part' in the festival, while implicitly reinforcing for the wider viewership the aura of the event and the ultimate desirability of seeing it three-dimensionally and of 'feeling it' through all available senses.[65]

In sporting contexts this is illustrated by the coverage of 'Murray Mound' at Wimbledon, and 'Park Live' at the London Olympics, and is increasingly the case at royal events also. Rowe makes the further observation, supported by my findings, that audiences at screenings behave much as those at live events might be expected to. He writes that: 'The experiential synthesis occurring at public "screenings" was evident in forms of crowd interaction – chanting before the screen and applauding the two-dimensional images of athletes.'[66] One of my respondents recalled seeing a group of Jamaican spectators watching Usain Bolt during the Olympics on public screens in London: 'people were glued to the screen and looked beside themselves with excitement'.[67] Intensity of experience, then, can be a consequence as much of the emotional engagement of spectators as of their location, a characteristic common to both royal and sporting occasions, it would seem.

The emotional engagement created by communal viewing was recalled by a respondent who had attended the screening of the Diamond Jubilee concert:

> You have a thousand other people with you who are dancing and singing and screaming, and it just becomes like a festival, community experience, which you wouldn't have otherwise. I know in the past we've had, I don't know, Eurovision Song Contest parties and things like that, where you all watch it on a TV ... but seeing it in a public space like Hyde Park just takes it to a whole new level.[68]

Another said that the atmosphere in the crowd 'was incredible. I don't think I've ever experienced being among so many people where everyone was so visibly

happy and excited.'[69] She recalled that she and her friends had considered going to a pub to watch the concert, because they thought

> it would have been pretty much the same thing, and probably more comfortable because we wouldn't have to go through the crowds to get to a park and just sit on the ground, but by that point we had been to all the other events and we were just so excited to be around everyone, and we realised what a fun experience it was, and it was really just the sense of community that was happening while we were there.[70]

This supports Mike Weed's observation that with the advent of live screenings the key question becomes

> not 'being there' but 'being where?' – that is, what places or venues are going to provide the best communal … experience? Because the 'there' in 'being there' has become so fluid, as has the range of experiences available, the question that fans may now ask each other is less likely to be 'were you there?' but rather 'where did you watch?' and 'what was it like?'[71]

One respondent said that being part of a crowd made the live screening seem 'more realistic, it feels more like you're actually at the event if there's other people screaming and cheering and wearing British flags and that kind of thing'.[72] Another, who had watched the royal wedding on screens in Hyde Park, claimed that she and her friends had actually felt 'closer to the action watching it as part of a crowd than squashed by the side of the road watching a glimpse of it. I have never regretted not going to try and see them in the flesh'.[73] A third recalled the (perhaps surprising) intimacy that the event generated:

> There was actually a moment when Kate was walking down the aisle … up to Prince William, and when the actual ceremony took place and they exchanged the rings, and there was a really kind of 'goosebump' moment, because all of Hyde Park just went silent for quite a while, which was really emotional. I remember the girl next to me, who was British, started crying as well, which was really peculiar to see because we were in this huge space, with this whole bunch of people, and you have these screens up and people really are feeling raw emotions, and that was special, I guess. You felt like you were part of it in Westminster Abbey, you were kind of there with them in a way.[74]

These reports would seem to reflect Nairn's observation that '[c]rowd emotion is notoriously communicable, and hard to resist; people speak of being "carried away". The point of this sort of popular coming-together ("crowd"

hardly seems to fit) is that the participants are sustained by the feeling of *doing* something.'[75]

Interestingly, this sense of the crowd as a unified collectivity was felt just as acutely by the one respondent who had been a reluctant attendee; he, however, experienced it more as an oppressive uniformity. He reported that at both the royal concert and the Olympics screening he had attended, for him, the 'fervent nationalist tone undermined the positive aspects of the occasion', because 'when flags are involved I feel it becomes less about inclusion, more about cultural territorialism'.[76] He recalled that his

> intention for going ... [to the Jubilee concert] was more to do with the music than anything else, but when we got there it was clear that the crowd was more of a royalist fan than a pop music fan. I think it was that crowd element that made me ... that upped the discomfort level. ... It's kind of the general atmosphere of feeling that you're then a part of that is very ... I found it a mixture of distaste and alienation, because you are in that environment, and you're not just watching it, you're actually physically a part of it. So there's a certain really affective element there ... the alienating aspect was very tangible and almost physiological. You could feel your muscles tense and breath shorten a bit. I don't want to over-egg it ... but you're bounded by conventions, and in St James's Park you are surrounded by very lovely people, lots of families, young children, older people, all having a lovely time, at least that's the sense you get, and you don't want to start ... not that I would anyway, outwardly dissenting and protesting. ... And also with my friends who were a lot more ... I got the impression from them they were a lot more able to just enjoy themselves, I think.[77]

The difficulty of dissenting in such circumstances, even for those with the stomach for it, was indicated by another respondent, an enthusiastic royalist, who recalled seeing a group of about twenty republicans at the Jubilee pageant; she reported that they turned up

> with some posters and everything, and every time they started chanting, the whole crowd just started chanting 'God Save the Queen' together, to completely drown out their sound. After a while they just gave up, because there was no point in even trying. They wouldn't be able to show their posters, they wouldn't be able to get anything across.[78]

However, respondents also reported less intense modes of engagement, resembling the mode identified by Haferburg *et al.* in their research on screenings during the 2010 football World Cup. They propose that big screen

transmissions have a capacity to create a more 'laid-back' form of spectator-ship, a consequence of the distance that the screens impose between the audi-ence and the action. They suggest that this 'detached' type of viewing could be 'more like a pub experience or even a picnic with some entertainment in the background'.[79] Reflecting this, one of my respondents reported that the atmos-phere amongst the crowd watching the Jubilee concert was 'excited, relaxed, easy-going, like being at a festival'.[80] Another recalled: 'So ... we had our picnic with us, we had our blankets with us, it was a warm sunny day and I was there with a set of friends. ... Half of it was going to see the concert, half of it was "let's have a nice day in Hyde Park because it's sunny outside" kind of thing.'[81]

Of all the events discussed, my respondents reported the greatest satisfaction with the Jubilee concert. One reason appeared to be that this was a spectacle that could, by the general public at least, *only* be watched on screens. Because there was no hope of seeing the action live, expectations were fulfilled. All spoke of a party atmosphere, and good views and sound from screens and speakers. One recalled that

> as soon as the concert kicked off, everyone stood up and it was literally like a festival. People were dancing, and you kind of forgot, because again the concert was taking place at Buckingham Palace and it was so close to Hyde Park, I think all of Hyde Park pretended that we were watching the concert live instead of on the screens, because that's how people engaged with it. ... People forget that you're not actually watching it live, well you are watching it live, but you're not at the event.[82]

The majority of respondents stated that the proximity of the screens to the live action was none the less an important contributor to the atmosphere, their enjoyment and the sense of uniqueness of the event. One recollected that

> it felt ... like the screen was almost like a tunnel through the trees, because there were loads of trees around the Palace and St James's Park, that get in the way, so maybe it felt like it was just a little portal, I suppose, whereas if it had been in some other distant location maybe it would have been a bit more ... it could have been just a recording.[83]

Several remarked on the excitement of seeing the post-concert fireworks on both the screen and in the sky above them, and that this made it 'that much more special to have that proximity'.[84] Similarly, a respondent who watched the royal wedding on screens in Hyde Park enjoyed the fact that during the RAF

flyover 'as soon as the planes flew over the balcony [at Buckingham Palace, on which the newlyweds were standing] and they lifted their heads, that moment, then the planes ... flew over us, which ... made it special too because you felt the proximity to the whole event'.[85] Proximity can also afford other unexpected advantages. An American visitor to London during the Queen's Golden Jubilee in 2002 witnessed a public appearance by the Queen and Prince Philip after watching the screening of the 'Prom at the Palace' classical concert in the Mall. He recalled that he 'saw them in the flesh for the first time which was thrilling, although the crowd was so thick that it was hard to get a good view'.[86]

These recollections illustrate Billig's observation that: 'Present royal moments, whether those of the great televised occasions or the moment when an ordinary person receives the touch of a royal hand-shake, are construed as being inherently memorable.'[87] The last quotation, however, does perhaps point to the limitations of mediated experiences, and what Ziegler calls 'the almost magical significance'[88] attached by many to seeing royalty in person. One respondent reflected that:

> What I really got from these events was that I can't imagine the Royal family ever not existing, because there was such an outpouring of love and support and loyalty, that it's really difficult to explain to people who have never experienced this and haven't grown up with this, to understand what happens to people when the Queen passes by, and how people completely lose themselves, and they're so happy, and can't wait to show their support.[89]

Consequently, although casual royal watchers' priorities may be comfort and sociability, more engaged fans will aim for an experience as close to the intensity of the 'live' show as possible. One respondent had camped out on the street for a glimpse of royalty in the flesh at both the royal wedding and the Jubilee Thanksgiving Service.

Whether a sense of 'presentness' was achieved varied amongst respondents and between events. While satisfaction was reported in instances where the screen was the only available mode of spectatorship, responses were more ambivalent about the Jubilee river pageant, where it was theoretically possible to watch both screened and live action. Some enjoyed the dual experience, being able to both compensate for a restricted view and to feel that they were getting a more 'rounded' view of the event. One said, '[I]t was really nice, because we were watching the small boats coming through ... and then every once in a while you'd have the Duchess of Cambridge popping up on the big screens.'[90]

While several respondents reported that there seemed to be little difference in the responses of the crowd to live or screened action, with the nature of the action and personnel on view apparently the primary determinant of levels of noise and enthusiasm, others complained that engagement was impeded by the poor placing of some screens and technical difficulties with defective sound and vision. As Barker suggests, 'the whole point for audiences of livecasting appears to be its capacity to be invisible as technology. Enthusiastic audiences for a livecast don't want to be reminded of the fact that it is being transmitted … blips in transmission … disrupt concentrated participation.'[91] Some identified a problem of 'disconnect' between the screened content (the BBC's programming consisting of a mixture of event footage and related features) and what could sometimes be glimpsed in front of them. One said that:

> If it had been there as sort of a guide, so you knew when she [the Queen] was passing by, that might have been a bit more useful. … So, if we had seen the screen and gone 'okay, so she's just passed the Albert Bridge, we know where she is' … because there was a point when everyone started cheering and we're like, 'Okay, was that her?', because we didn't know.[92]

Although this respondent also acknowledged that 'it was actually just neat to be there with all the other people decked out in Jubilee gear and very excited about the event',[93] most who had only been able to see the screens expressed disappointment, and regarded their experience as second best. It seemed to be the very immediate proximity of the screens to the action that prompted this disenchantment. One mused:

> When you're faced between the option of 'Oh, there's a screen right here, I can watch it on the screen' or it's actually going on right behind me, it didn't really work and it's sort of hedging your bets as to whether you're actually going to see anything on the river as opposed to just stopping and watching the screen. Watching the screen kind of felt like cheating out on it, in that sense, it's sort of like 'Oh! I'm just going to go for this', when really you're right there anyway, so you might as well just try to see it.[94]

Certainly the respondents who had attended the Jubilee river pageant screenings in parks rather than by the Thames appeared to have enjoyed themselves more, but factors such as bad weather and other forms of physical discomfort perhaps need to be taken into account here, too.

One interesting finding of the research was that a high proportion of respondents, whether or not they had enjoyed a satisfactory experience and a good view

of the action at the events themselves, stated that they watched the event on television or online when they got home. It seems that domestic television is still regarded as the optimum medium for conveying information, if not atmosphere. This respondent offered a representative recollection:

> I remember going home and then watching the whole thing again on television as well, because ... when you are in the park there is so much emotion to it, and you were distracted by other people as well and their reactions were kind of beautiful, but you did kind of want to have that moment when you watched the highlights on TV to make sure you saw every single minute of it because it was really nice.[95]

For this and other reasons, it is important, as Scott McQuire asserts, to 'demarcate these public rituals [generated by the introduction of live coverage on big screens] from the older social function of television'.[96] In the context of a fragmenting and globalising media landscape, and a more diverse and geographically mobile audience, the increasing ubiquity and popularity of large screens as a focal point for public gatherings in public space may be taken to represent a desire for new forms of collectivity. These occasions differ from their more traditional counterparts because 'the screen does not so much substitute for a public gathering as become the occasion for one'.[97] My research suggests that in attending these public screenings, people seek not only communality but also, and apparently paradoxically, the 'live' experience, a sense of 'being there' and the chance to claim themselves witnesses to history.

Although beyond the scope of this paper, there is evident potential for future research to examine not just the impact of big screens, but how these combine with other types of new media, in particular the Internet and mobile devices. As McQuire observes, the 'cumulative impact of these developments on the relation between media and public space has been profound'.[98] We live in an era of 'media platforms which move so fast that they no longer merely "represent" events, but become part of them, foreshadowing the role of near instantaneous feedback loops in shaping contemporary experience of public space'.[99] Examples of this include live tweeting from public events, and videos, hosted on YouTube, which capture the responses of the crowds watching the televised relay of the 2011 royal wedding on the big screen in Trafalgar Square.[100] As an explanatory framework Barker offers 'the idea of "intermediality" ... a world of increasingly interpenetrative media which constantly cross-refer'.[101]

As we have seen, the British monarchy themselves are active participants in this brave new media world. Conscious that their survival depends to a large part on popular support, they have embraced social media and the digital, and boast Facebook, Flickr and Twitter accounts. Although, as Billig suggests, the 'appearance of antiquity might be appealing to something genuinely old within the psyche of monarchy's subjects', it is perhaps more likely that 'present times are producing states of mind which are drawn to the appearances of tradition. Monarchy, thus, fits today's modern, perhaps post-modern, times.'[102] Royalty meets contemporary needs through representing an apparently timeless heritage via the newest forms of media. While an encounter with royalty 'in the flesh' has lost none of its thrill, this compulsion for proximity will continue to be generated primarily through the reproduction of their image on an ever-growing diversity of screens.

NOTES

1 Scott McQuire, 'Rethinking media events: large screens, public space broadcasting and beyond', *New Media and Society* 12:4 (2010), p. 569.

2 Michael Barker, *Live to Your Local Cinema: The Remarkable Rise of Livecasting* (Basingstoke: Palgrave Macmillan, 2013), p. 10.

3 *Ibid.*, p. 57.

4 Michael Billig, *Talking of the Royal Family* (London: Routledge, 1992), p. 12.

5 Tom Nairn, *The Enchanted Glass: Britain and Its Monarchy* (London: Verso, 2011), p. 11.

6 *Ibid.*, p. 106.

7 Respondent 1.

8 Cited in Billig, *Talking of the Royal Family*, p. 173.

9 Ben Pimlott, 'Monarchy and the message', *Political Quarterly* 69:B (1998), p. 106.

10 Billig, *Talking of the Royal Family*, p. 1.

11 Philip Ziegler, *Crown and People* (London: Collins, 1978), p. 155.

12 Clifford Stevenson and Jackie Abell, 'Enacting national concerns: Anglo-British accounts of the 2002 royal Golden Jubilee', *Journal of Community & Applied Social Psychology* 21 (2011), p. 126.

13 David Cannadine, 'The context, performance and meaning of ritual: the British monarchy and the "invention of tradition", *c.* 1820–1977', in Eric Hobsbawm and Terence Ranger (eds), *The Invention of Tradition* (Cambridge: Cambridge University Press, 2013), p. 142.

14 Daniel Dayan and Elihu Katz, *Media Events: The Live Broadcasting of History* (London: Harvard University Press, 1994), p. 54.

15 Stevenson and Abell, 'Enacting national concerns', p. 126.

16 Cannadine, 'The context, performance and meaning of ritual', p. 156.

17 John M. T. Balmer, 'A resource-based view of the British monarchy as a corporate brand', *International Studies of Management & Organization* 37:4 (2007–8), p. 36.

18 Cele C. Otnes and Pauline Maclaran, 'The consumption of cultural heritage among a British royal family brand tribe', in Bernard Cova, Robert V. Kozinets and Avi Shankar (eds), *Consumer Tribes* (Oxford: Butterworth-Heinemann / Elsevier, 2007), p. 52.

19 *Ibid.*, 52.

20 Billig, *Talking of the Royal Family*, pp. 220–1.

21 Respondent 5 in interview.

22 Neil Blain and Hugh O'Donnell, *Media, Monarchy and Power* (Bristol: Intellect, 2003), p. 60.

23 The most recent British Social Attitudes Survey finds that while the UK is still a long way from levels of royal support in the 1980s, when 65 per cent said it was 'very important' for Britain to continue to have a monarchy, there has none the less been a turnaround in opinion – from 27 per cent expressing strong support for the royal family in 2006 to 45 per cent in 2013. See www.bsa-30.natcen.ac.uk / read-the-report / key-findings / trust,-politics-and-institutions.aspx.

24 Dayan and Katz, *Media Events*, p. 6.

25 *Ibid.*, p. 8.

26 *Ibid.*, p. 22.

27 John Ellis, *Visible Fictions: Cinema, Television, Video* (London: Routledge, 2000), p. 160.

28 Respondent 2.

29 Dayan and Katz, *Media Events*, p. 15.

30 Respondent 3.

31 Dayan and Katz, *Media Events*, p. 9.

32 *Ibid.*, p. 196.

33 Philip Auslander, *Liveness: Performance in a Mediatized Culture* (London: Routledge, 1999), p. 51.

34 Dayan and Katz, *Media Events*, p. 78.

35 *Ibid.*

36 Steve Wurtzler, 'She sang live, but the microphone was turned off: the live, the recorded, and the subject of representation', in Rick Altman (ed.), *Sound Theory, Sound Practice* (London: Routledge, 1992), p. 92.

37 Auslander, *Liveness*, p. 53.

38 *Ibid.*, p. 7.

39 Dayan and Katz, *Media Events*, p. 79.

40 *Ibid.*, p. 210.

41 *Ibid.*

42 Hasan Bakhshi, 'Measuring cultural value', Keynote speech delivered at 'Culture Count: Measuring Cultural Value' forum, Customs House, Sydney, Australia, 20 March 2012, www.nesta.org.uk / areas_of_work / creative_economy / assets / features / measuring_cultural_value, p. 5.

43 John Urry, 'Mobility and proximity', *Sociology* 36:2 (2002), p. 262.

44 Mike Weed, 'The pub as a virtual football fandom venue: an alternative to "being there"?', *Soccer & Society* 8:2–3 (2007), p. 411.

45 Deidre Boden and Harvey L. Molotch, 'The compulsion of proximity', in Roger Friedland and Deidre Boden (eds), *NowHere: Space, Time and Modernity* (London: University of California Press, 1994), p. 258.

46 *Ibid.*, p. 263.

47 Respondent 3.

48 Dayan and Katz, *Media Events*, p. 211.

49 Christoph Haferburg, Theresa Golka and Marle Selter, 'Public viewing areas: urban interventions in the context of mega-events', in Udesh Pillay, Richard Tomlinson and Orli Bass (eds), *Development and Dreams: The Urban Legacy of the 2010 Football World Cup* (Cape Town: HSRC Press, 2009), p. 175.

50 Simone Arcagni, 'Media architectures and urban screens as new media: forms, places and spectatorship', in P. Zennaro (ed.), *Colour and Light in Architecture. Proceedings of the First International Conference on Colour and Light in Architecture* (Verona: Knemesi Editori, 2010), http://rice.iuav.it/211/1/05_arcagni.pdf., pp. 253–4.

51 David Rowe, 'Global media events and the positioning of presence', *Media International Australia* 97 (2000), p. 16.

52 *Ibid.*

53 *Ibid.*

54 Auslander, *Liveness*, p. 24.

55 Andrew Goodwin, 'Sample and hold. Pop music in the digital age of reproducing', first published in *Critical Quarterly* 30:3 (1988), repr. in Simon Frith and Andrew Goodwin (eds), *On Record. Rock, Pop, and the Written Word* (London: Routledge, 1990), quoted Auslander, *Liveness*, p. 26.

56 Rowe, 'Global media events', pp. 18–19.

57 Respondent 4.

58 Respondent 5 from questionnaire.

59 Auslander, *Liveness*, p. 57.

60 Respondent 6 in interview.

61 *Ibid.*

62 Respondent 7.

63 Auslander, *Liveness*, p. 7.

64 Rowe, 'Global media events', p. 16.

65 *Ibid.*

66 *Ibid.*, p. 17.

67 Respondent 6 from questionnaire.

68 Respondent 8 from questionnaire.

69 Respondent 5 from questionnaire.

70 Respondent 5 in interview.

71 Mike Weed, 'Sport fans and travel: is "being there" always important?', *Journal of Sport & Tourism* 15:2 (2010), p. 106.

72 Respondent 6 in interview.

73 Respondent 2 from questionnaire.
74 Respondent 8 in interview.
75 Nairn, *The Enchanted Glass*, p. 79.
76 Respondent 9 from questionnaire.
77 Respondent 9 in interview.
78 Respondent 5 in interview.
79 Haferburg *et al.*, 'Public viewing areas', p. 175.
80 Respondent 8 in interview.
81 *Ibid.*
82 *Ibid.*
83 *Ibid.*
84 *Ibid.*
85 *Ibid.*
86 Theodore Harvey, 'The Queen's Golden Jubilee weekend: a personal account', www.royaltymonarchy.com/opinion/jubilee.html.
87 Billig, *Talking of the Royal Family*, p. 221.
88 Ziegler, *Crown and People*, p. 107.
89 Respondent 5 in interview.
90 *Ibid.*
91 Barker, *Live to Your Local Cinema*, p. 54.
92 Respondent 6 in interview.
93 Respondent 6 from questionnaire.
94 Respondent 6 in interview.
95 Respondent 8 in interview.
96 McQuire, 'Rethinking media events', p. 574.
97 *Ibid.*
98 *Ibid.*, p. 571.
99 *Ibid.*
100 See, for example, www.youtube.com/watch?v=iLXg8lhi8LM. Interestingly, in the context of this discussion, this video is titled 'Royal Wedding 29 Apr 2011, Live at Trafalgar Square, London, UK'.
101 Barker, *Live to Your Local Cinema*, p. 43.
102 Billig, *Talking of the Royal Family*, p. 56.

BIBLIOGRAPHY

Altman, Rick (ed.), *Sound Theory, Sound Practice* (London: Routledge, 1992).
Arcagni, Simone, 'Media architectures and urban screens as new media: forms, places and spectatorship', in P. Zennaro (ed.), *Colour and Light in Architecture. Proceedings of the First International Conference on Colour and Light in Architecture* (Verona: Knemesi Editori, 2010), http://rice.iuav.it/211/1/05_arcagni.pdf.

Auslander, Philip, *Liveness: Performance in a Mediatized Culture* (London: Routledge, 1999).

Bakhshi, Hasan, 'Measuring cultural value', Keynote speech delivered at 'Culture Count: Measuring Cultural Value' forum, Customs House, Sydney, Australia, 20 March 2012, www.nesta.org.uk/areas_of_work/creative_economy/assets/features/measuring_cultural_value.

Balmer, John M. T., 'A resource-based view of the British monarchy as a corporate brand', *International Studies of Management & Organization* 37:4 (2007–8).

———'Scrutinising the British monarchy: the corporate brand that was shaken, stirred and survived', *Management Decision* 47:4 (2009).

Barker, Michael, *Live to Your Local Cinema: The Remarkable Rise of Livecasting* (Basingstoke: Palgrave Macmillan, 2013).

Billig, Michael, *Talking of the Royal Family* (London: Routledge, 1992).

Blain, Neil and Hugh O'Donnell, *Media, Monarchy and Power* (Bristol: Intellect, 2003).

Boden, Deidre and Harvey L. Molotch, 'The compulsion of proximity', in Roger Friedland and Deidre Boden (eds), *NowHere: Space, Time and Modernity* (London: University of California Press, 1994).

Cannadine, David, 'The context, performance and meaning of ritual: the British monarchy and the "invention of tradition", c. 1820–1977', in Eric Hobsbawm and Terence Ranger (eds), *The Invention of Tradition* (Cambridge: Cambridge University Press, 2013).

Cova, Bernard, Robert V. Kozinets and Avi Shankar (eds), *Consumer Tribes* (Oxford: Butterworth-Heinemann/Elsevier, 2007).

Dayan, Daniel and Elihu Katz, *Media Events: The Live Broadcasting of History* (London: Harvard University Press, 1994).

Ellis, John, *Visible Fictions: Cinema, Television, Video* (London: Routledge, 2000).

Friedland, Roger and Deidre Boden (eds), *NowHere: Space, Time and Modernity* (London: University of California Press, 1994).

Goodwin, Andrew, 'Sample and hold. Pop music in the digital age of reproducing', *Critical Quarterly* 30:3 (1988).

Haferburg, Christoph, Theresa Golka and Marle Selter, 'Public viewing areas: urban interventions in the context of mega-events', in Udesh Pillay, Richard Tomlinson and Orli Bass (eds), *Development and Dreams: The Urban Legacy of the 2010 Football World Cup* (Cape Town: HSRC Press, 2009).

Harvey, Theodore, 'The Queen's Golden Jubilee weekend: a personal account', www.royaltymonarchy.com/opinion/jubilee.html.

Hobsbawm, Eric and Terence Ranger (eds), *The Invention of Tradition* (Cambridge: Cambridge University Press, 2013).

McQuire, Scott, 'Rethinking media events: large screens, public space broadcasting and beyond', *New Media and Society* 12:4 (2010).

Nairn, Tom, *The Enchanted Glass: Britain and Its Monarchy* (London: Verso, 2011).

Otnes, Cele C. and Pauline Maclaran, 'The consumption of cultural heritage among a British royal family brand tribe', in Bernard Cova, Robert V. Kozinets and Avi Shankar (eds), *Consumer Tribes* (Oxford: Butterworth-Heinemann/ Elsevier, 2007).

Pillay, Udesh, Richard Tomlinson and Orli Bass (eds), *Development and Dreams: The Urban Legacy of the 2010 Football World Cup* (Cape Town: HSRC Press, 2009).

Pimlott, Ben, 'Monarchy and the message', *Political Quarterly* 69:B (1998).

Rowe, David, 'Global media events and the positioning of presence', *Media International Australia* 97 (2000).

Stevenson, Clifford and Jackie Abell, 'Enacting national concerns: Anglo-British accounts of the 2002 royal Golden Jubilee', *Journal of Community & Applied Social Psychology* 21 (2011).

Urry, John, 'Mobility and proximity', *Sociology* 36:2 (2002).

Weed, Mike, 'The pub as a virtual football fandom venue: an alternative to "being there"?', *Soccer & Society* 8:2–3 (2007).

Weed, Mike, 'Sport fans and travel: is "being there" always important?', *Journal of Sport & Tourism* 15:2 (2010).

Wurtzler, Steve, 'She sang live, but the microphone was turned off: the live, the recorded, and the subject of representation', in Rick Altman (ed.), *Sound Theory, Sound Practice* (London: Routledge, 1992).

Ziegler, Philip, *Crown and People* (London: Collins, 1978).

Part V

Television's contested histories

13

Television's royal family: continuity and change

Erin Bell and *Ann Gray*

INTRODUCTION

British television has had a long, and not always happy, relationship with the Crown, but since Richard Cawston's documentary *The Royal Family* (BBC, 1969) the Windsors have acknowledged the necessary evil of allowing the cameras in to record less formal aspects of their life and work. The Queen herself has since been the subject of three such observational documentaries: Edward Mirzeoff's *Elizabeth R* (BBC, 1992) marking the fortieth anniversary of her reign, Matt Reid's *Monarch: The Royal Family at Work* (BBC, 2007) and Michael Waldman's *Our Queen* (ITV, 2013). These documentaries are often unsatisfactory experiences for their royal subjects and the filmmakers alike. Reid's film created controversy when the veracity of its trailer was called into question, resulting in the resignation of the then BBC1 controller Peter Finch. *Our Queen*, a rare offering in this genre from ITV, revealed a tension between the filmmaker, Waldman, who wanted to observe the monarchy, and the advisers, who sought to conserve its reputation and therefore wished to limit his access.[1] As the latter unsurprisingly triumphed, an almost inevitable celebratory mode was conveyed. The royal family seems much more comfortable with cameras that are kept at an appropriate distance as on formal occasions covered by broadcasters. As these brief examples suggest, such televised representations are potentially fraught with implicit questions about the legitimacy of monarchy in the twenty-first century, or on the other hand, the suitability of the younger royal generations to replace the Queen.

In this chapter, we therefore focus on the ways in which two British broadcasters, the BBC and Channel 4, handled coverage of the monarchy during a particularly sensitive period for the Windsor family of ageing and generational

change. These events culminated in the commemoration of Queen Elizabeth's sixtieth year on the throne, the speculation surrounding Prince Charles as the oldest heir apparent in British history, the marriage of Prince William and Catherine Middleton and the birth of their son, George, now third in line to the throne. What various examples of this television coverage reveal are the delicate negotiations necessary on the part of the broadcasters in dealing with the continuity of the monarchy, traditional symbol of the stability of the nation and the inevitability of change. In addition to speculation surrounding Prince Charles's suitability to take over as monarch and the possible abdication of the Queen, the marriage of Prince William to a 'commoner' provoked much discussion about her genealogy and her assimilation into the royal family. The latter, of course, is overshadowed by still vivid public memory of William's mother, the late Princess Diana.

Such anniversaries and state occasions are opportunities for broadcasters, especially the BBC, to commission documentaries and to construct 'media events', and are the keystones of much historical programming, as we have noted in detail elsewhere.[2] BBC television has covered royal events since 1939 when the departure of the King and Queen for Canada was televised[3] and has in the intervening decades positioned itself as the holder of the nation's archives, from which it regularly produces documentary programmes about national history, including the monarchy. In contrast, Channel 4, set up in 1982 to offer alternative and innovative programming, has been less concerned with the nation's past and especially celebratory accounts of its monarchy. Commemorative programming on the BBC often seeks to represent a historical national identity and in doing so create a sense of community within a culturally disparate nation. The rise of commemorative programming in nations across Europe over the past two decades has been noted by scholars: anniversaries offer programme makers and national broadcasters such as the BBC an opportunity to air material which conveys knowledge of significant national and international events, whilst also cementing the broadcasters' role as part of the same national history and heritage. For the BBC especially, commemorative programming emphasises its role in creating and maintaining a memory of, in this instance, the royal past, whilst satisfying audience expectations that such events be marked. Most recently, the sixtieth anniversary of the Queen's accession to the throne (2012), the wedding of Prince William and Catherine Middleton (2011) and the birth of their first child (2013) have prompted depictions of royal history on a number of channels as well as broadcasters' websites.[4]

In 1953 the coronation of Elizabeth II was televised and viewed by an imaginary collective of citizens engaging in the national calendar with the royal family at its core. Analysis of the commemoration of this event, alongside other royal occasions, demonstrates how national identity continues to be key to UK terrestrial channels' accounts of the royal family and the nation, past and present. The Diamond Jubilee of the accession saw the BBC especially offer a multi-dimensional account both of royal but also broadcasting history, with its website drawing together a range of relevant recorded material from the 1950s to the twenty-first century, most of which, such as 1965 footage of the Queen visiting Berlin, originated from the BBC's own archives, and some of which was itself commemorative material from earlier jubilees.[5] By layering royal and institutional commemoration in this manner, as is also done in *The Diamond Queen* (2012) series, in which a reference to the televising of the coronation in 1953 is accompanied by colour footage from the BBC's own archives, the corporation can lay claim to being central to the national marking of such events.

JUBILEE COVERAGE

In February 2012 the BBC aired *The Diamond Queen*, a three-part series led by the current affairs presenter Andrew Marr, which included contributions from other members of the royal family. In using the noted journalist Marr – in BBC2 Controller Janice Hadlow's description, a 'familiar and trusted guide' – as an ambassador 'for the idea of history' the series stressed its, and the BBC's, credibility and authority.[6] Although an unsurprisingly celebratory account of the Queen's life and actions in the present, it nonetheless through significant silences and editing seems to offer some degree of criticism of other members of the royal family and their, it is inferred, desire to take the Queen's place on the throne, presumably through her abdication.

The first episode of the three-part series begins with Marr addressing the audience, over footage of waving flags and a blue sky, reminding them of the importance of the monarchy to Britain. Soon afterwards, Prince William, one of the Queen's grandsons and next in line to the throne after his father Charles, the Prince of Wales, is interviewed and comments on his grandmother's professionalism in her role, describing himself as a 'young upstart' who recognises the importance of watching her in order to determine 'how it's done'. Whilst this certainly does not suggest that he wishes her to abdicate, it nevertheless reminds the audience that the Queen will, eventually, be replaced by a younger

member of the royal family. Significantly, though, it is William and not Charles who makes these comments. Indeed, two minutes further into the episode, over footage of the Queen meeting her subjects at an event in Wales in April 2010, Marr asserts that, unlike elected heads of state who, in the relatively short term, campaign for votes, 'this is the real endless, perpetual campaign … she's here one week after her eighty-fourth birthday but retirement, never mind abdication, seem to be words never mentioned in her presence'. Indeed, this is the only explicit reference to her potential abdication in the series, although the comments of Prince Henry, William's younger brother and at the time third in line to the throne, may perhaps be viewed as ambivalent: 'these are the things that at her age she shouldn't be doing. And yet she's carrying on and doing them.' While almost certainly intended as praise for his grandmother and her refusal to rest despite her advanced years, the editing of Prince Henry's interview may lead the viewer to question not the legitimacy, but the safety of continuing for the Queen.

Although such quotations are revealing in their own light, so too are the absences. Princess Anne, the Queen's only daughter and at the time tenth in line to the throne, appears in episode one; Prince Andrew, the Queen's second son and then fourth in line to the throne, appears in the second episode, and Prince Edward, the Queen's third son and youngest child and then eighth in line to the throne, appears in the third. The absence of the Queen's eldest child is marked: other than a brief reference in the second episode to 1992 as a difficult year for the Queen, because of a massive fire at Windsor Castle in the November and the announcement by the then Prime Minister John Major of the separation of Charles and his wife Diana the following month – although interestingly the separation of Prince Andrew and his wife Sarah in the March of 1992 is not referenced – only in the final episode is interview material from 2008 showing Charles used, and in revealing ways.

Indeed, the interview is used only in the last few minutes of the final episode, marked tellingly as 'interviewed in 2008', unlike the material gathered from the other children and several grandchildren of the Queen. It appears in the context of Marr's drawing together of the final episode and of the series as a whole, in which he concludes: 'So sixty years on the throne. Quite an achievement for this small woman, with a world-familiar face, a thousand years of history at her back, who since a twist of fate at the age of ten has known her destiny.'

Using claims to tradition to justify the continuation of the monarchy, yet somehow also suggesting that fate, rather than a centuries-old monarchical

structure, led to Elizabeth's crowning, Marr is at this very important point unseen, although seen elsewhere in the series. He therefore occupies the role of 'Voice of God' narrator, identified by Bill Nichols as the expository mode of documentary. Such a mode has tended to foster 'the professionally trained, richly toned male voice of commentary',[7] which further emphasises Marr's authority and legitimacy as presenter. He speaks over footage of himself meeting the Queen and at one point is heard apologising to her for 'stalking' her over the past eighteen months of filming, certainly emphasising his legitimacy and proximity to the elite subjects of the series he has fronted. However, he also adds what might be interpreted as a reminder of the thorny issue of the Queen's potential abdication, mirroring that first raised in episode one: 'For her children and grandchildren, it's a different story [from that of the Queen's continuing activity]. Next in line of succession, the Prince of Wales is the oldest heir apparent in British history at the age of 63.' Initially off screen, Charles can then be heard adding, as if in response to Marr's assertion, 'Half the battle, isn't it, is how to adapt in the best way, without losing that element of continuity. Not easy – you feel your way gently, you know.' The response, and the interview in general, seem to deal with the question of change to and within the monarchy, an issue of some interest at the time the interview was recorded (2008) because discussion of what was to become the 2013 Succession to the Crown Act was underway, encouraged by backbench MPs such as Evan Harris, whose Royal Marriages and Succession to the Crown (Prevention of Discrimination) Bill 2008–9 represents an attempt to modernise royal succession.[8] Eventually such sentiment led to the legal enshrinement of the principle that age rather than gender would determine who should succeed to the throne.

Rather oddly in this context, then, Marr's voice-over continues, as he notes that: 'and her legacy also of course lies in the hands of her eight grandchildren', with no reference to her children and particularly to the next in line to the throne, Charles. This is reflected in the last few minutes of interview material, in which William talks about the pressure on him to perform well, given the example the Queen has set, and noting that: 'while she's still there and providing such a good example, it allows me to learn and be able to develop'. His brother Henry adds that 'at the end of the day... she has put this country way before anything. ... I would love to see anyone else handle [it] and I don't think they would as well as she has.' While again intended as praise for his grandmother's efforts during her reign, his comment also seems to suggest the unworthiness of any descendant, including his own father, and therefore the

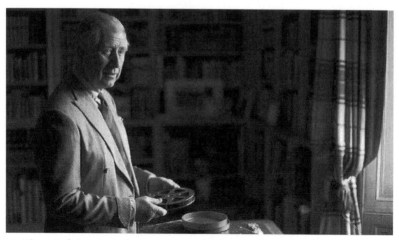

26 The wistful senior relative? Prince Charles views Windsor home movies in
A Jubilee Tribute to the Queen by the Prince of Wales (BBC, 2012).

illegitimacy of any desire that the Queen should abdicate. As Marr concludes, in a vein which seems to support this interpretation while also reminding the audience of the elderly Queen's mortality: 'We've taken her rather for granted. And after 60 years, perhaps its time we stopped.'

Prince Charles's reflections on the Queen's period on the throne were, however, transmitted on BBC1 on 1 June 2012 as a prelude to the live coverage of the celebrations that marked the Jubilee. The programme *A Jubilee Tribute to the Queen by the Prince of Wales* (BBC1) was billed as a 'personal' tribute and included 'private cine film' and 'home movies' taken, for example, behind the scenes on Coronation Day which show the Queen juggling the duties of monarch and mother and on family seaside holidays in Norfolk. Caroline Davies, previewing the programme for the *Guardian*, suggests that this 'footage is similar to that stored in boxes in millions of homes across Britain'.[9] In the programme Charles is seen viewing the old footage and is visibly moved to see the 1952 film of his mother shot by the Duke of Edinburgh in Kenya, where she received news of her father's death and her effective succession, and family film of his great-uncle Lord Louis Mountbatten, killed by an IRA bomb in 1979. Looking through this archive Charles appears as a wistful senior relative, the custodian of the 'family album' who has been overtaken by more recent events and left to sit at home with his memories. Referring to the sovereign he speaks admiringly of the longevity of her reign and her adherence to tradition, which he says has helped

'anchor things a bit and give reassurance that something is there which is perhaps a little more timeless than other things which are changing all the time'.

While representations of the monarchy appear across a number of television genres, they are significantly present in those programmes that commemorate what are considered to be important events in a nation's past. Programmes that coincide with and celebrate the anniversaries of such historic occasions can be understood as historical event television. Dayan and Katz refer to the importance of 'media events' in what they call the 'live broadcasting of history' for national and, increasingly, international broadcasting and their intended audiences. They identify the form of these event types as 'contest', 'conquest' and 'coronation', examples of which respectively would be major sporting events, state funerals and what they call 'the festive viewing of television', for example Bastille Day in France.[10] These media events interrupt the routines of scheduled broadcasting and involve live coverage. Increasingly the broadcasters are active partners in their preparations. In the UK these types of event often focus on the royal family, a seemingly endless source of weddings, funerals, birthdays and 'jubilees' for blanket 'live' national broadcasting. The 'live' elements, e.g. state occasions, parades, concerts, etc., which make up these programmes are supplemented and supported by other genres, such as documentaries which provide background to the main events and which are scheduled across a weekend or which are aired as lead-up to the live coverage.

The 2012 Jubilee celebrations covered three days – Saturday, Sunday and a national holiday on Monday – and took the form of a 'Thames Pageant', a live concert in front of Buckingham Palace, a Service of Thanksgiving in St Paul's Cathedral and a procession to Buckingham Palace. The BBC was central to all events, leading the pooled broadcast of the river pageant, as producer and exclusive rights holder for the live concert and lead pool broadcaster of the procession. As lead broadcaster, the BBC inevitably bore the brunt of the criticism of the coverage that was considered too populist, shallow and, unusually for the BBC, lacking in factual accuracy. Much of the criticism focused on the BBC's choice of presenters better known for their work in children's programming, charity telethons and magazine shows rather than news and current affairs. In a typically English way, the weather could be and was blamed for some of the shortfalls. The live broadcast of the 7-mile route on the river of the 1,000-boat flotilla, requiring 90 cameras including remote-controlled pan and tilt HD cameras on the royal barge itself,[11] was practically washed out by constant heavy rain. Undeterred by the criticism the then Director General, Mark Thompson,

rallied his troops in an internal email saying: 'By capturing the spectacle of the Thames pageant and yesterday's ceremonies alongside smaller local celebrations we reflected reaction from up and down the country. Our role in creating and staging Monday's incredible diamond jubilee concert also meant we made our own contribution to a special moment in our nation's history.'[12]

The procession 'set-piece', the finale of the celebrations, was organised through the pooling of BBC, ITN and Sky outside broadcasting facilities. In contrast, the Channel 4 coverage of the anniversary was largely through news and current affairs programming, and might be seen as implicitly critical of the BBC's far more celebratory approach. The Channel 4 website offered a news report on the anniversary, which seems to contrast 1950s and contemporary Britain by emphasising how 'communities were strong', with 'the royal thread woven through six decades of profound change, in Britain'. Channel 4 news presenter Jon Snow went 'out and about' to garner the views of a number of people, interlaced with a 'voice from the time', Richard Dimbleby, a 'professionally trained, richly toned male voice of commentary' in Nichols's terms, whom we hear speaking over black and white footage of crowds gathering in 1953 for the coronation. As Snow interjects, over recent images of a crowd amassing for the celebrations, 'we don't even talk like that anymore'. Over footage both of the 1953 event and its anniversary in 2013 he continues:

> Then she was in the imperial pomp of carriage and horse. Today, the more prosaic Roller. We were six years on from ruling India. Today we're hoping she'll do more trade with us, not least in these Rollers. Then the ladies in waiting and maids of honour arrived in style. Today, there was just one, packed into a transit behind. [Footage of interior of Westminster Abbey.] One thing hasn't changed – the music.

By offering contrasts, the account is very different from the BBC's, which instead emphasises continuity. With reference to 'Vivat Regina', Snow continues 'Sung then by the probably all-white Westminster scholars. Today, from the same school, pupils despatched from China, India, Araby [sic] and beyond, the new life-blood of British private education.' It is difficult not to read this as a veiled criticism by the channel of the choice of children for the choir: all male, from very privileged backgrounds, international consumers of elite education. Perhaps to counterbalance this, Snow goes on to interview people at a 'London street market' near Westminster, with their accounts of sleeping on the pavement near the Abbey in 1953, to be there in good time for the coronation

procession. However, after two accounts from elderly women, a Northern Irish man adds that 'I'm afraid it was all a big disappointment to me, cos I didn't really know what was going on. My mum was all excited.' The inclusion of a Northern Irish voice is intriguing; aside from suggesting that not everyone in the crowds appreciated the spectacle, it demonstrates the migration of people from different parts of the British Isles to London. It also, perhaps, reminds the viewer of the delicate political balance still being maintained in the province. Returning to the gap between 1953 and the present, Snow notes that 'the content of the state [is] profoundly changed', with an elderly woman claiming that 'everyone was kind, and friendly, and there wasn't the horrible things going on … we might have been short of things [during rationing] but we didn't really go hungry'. Instead of offering continuity, then, the account seems to identify both positive and negative forms of change. Unlike the BBC, Channel 4's coverage of the Jubilee depicts it as part of wider British and world history, positioning the royal family as carried on a tide of wider change, rather than instigators of it, and with regular references to economic and business developments.

Channel 4 is of course a very different broadcaster from the BBC. Founded in 1982 with aim of having simultaneously two 'faces' or logics, the 'public service' tradition of broadcasting inaugurated by John Reith at the BBC and the 'private services' or 'cultural entrepreneur' tradition, embodying a more corporate and commercial ethos, its dual mission was foundering by the 1990s.[13] We have emphasised the importance of broadcaster and channel branding elsewhere.[14] The move from Channel 4's explicit embracing of a public service ethos to a more problematic model, in the media historian Simon Blanchard's view, in which a 'private service's "face"', specifically the '[m]arket-corporate expansion of television as "just another business"',[15] brought financial gains for a minority but may have led it to distance itself from other broadcasters who still, like the BBC, align themselves at least in part with a public service ethos. The need to do so is further evidenced in our analysis of representations of royal genealogy, particularly that of the Duchess of Cambridge.

ASSIMILATING THE 'OUTSIDER'

With the recent royal wedding and royal birth it seems hardly surprising that there should have been discussion of the origins of the Duchess of Cambridge, formerly Catherine Middleton, future queen and, later, mother of the future King George VII. The BBC and Channel 4 versions of the Middletons' family

history suggest different roles on the part of the broadcasters, and different preconceptions of their audiences, as much as they offer rival interpretations of the royal baby's ancestry. A focus upon genealogy is, though, hardly surprising given the wider public interest in family history research, mirrored in the hugely successful BBC series *Who Do You Think You Are?* (2004–). Offering insights into family history research but also, perhaps more importantly, into the genealogy of a range of celebrities from sportspeople and actors to politicians and comedians, the format has been sold overseas and arguably forms part of the BBC's flagship output, core to its channel identity. By offering a similar account of the Middleton family past, then, the BBC were drawing upon this authority, while Channel 4's version of Catherine's family history both online and in broadcast material may have been attempting to rival it and offer an alternative interpretation. Such alternative versions reveal desires to position the future queen in ways palatable to different viewers and therefore to add to ongoing discussions of the role of the royal family, past and present.

One of the earliest television documentary series to consider the history of royal marriage to commoners was Channel 4's *Monarchy* fronted by David Starkey, one of the faces of Channel 4 and, as we have suggested elsewhere, a contentious presenter-historian who is an intellectual 'brand' himself and is part of the broadcaster's branding.[16] In December 2007 'The Windsors', the final programme in the seventeen-part series, aired. In it Starkey acknowledged briefly the move during the First World War to encourage monarchs to marry English commoners, part of an attempt to maintain public support for a monarchy with close family ties to the German Kaiser. This thread was not discussed at length in the series and was only returned to in the context of an impending wedding, in Starkey's 2011 documentary *Romance and the Royals*. 'The Windsors', however, offered telling insights into the royal family, particularly the Queen, including her thorny relationship with her daughter-in-law Diana, Prince William's mother, in whose memory a concert had been held earlier in the year to mark the tenth anniversary of her death, and thereby into the politics of succession, royal marriages and births.

Starkey initially discusses the 'rebranding' of the British royal family from Saxe-Coburg to Windsor in response to anti-German feeling in the First World War. To further appease the public, he notes, the possibility of allowing monarchs to marry British commoners was also mooted at that time. Then, over aerial footage of Windsor Castle, which had been devastated by fire in 1992, Starkey refers to 'unprecedented change' through a 'firestorm of scandal', as

'the heir to the throne and his wife paraded their mutual adultery'. Such assertions are certainly not part of the BBC's *Diamond Queen*, and demonstrate how the choice of such a contentious figure as presenter led to a rather different form of royal history, less celebratory and more castigating. Starkey's introduction of the episode summarises it as 'the rise, triumph, and eventual humiliation of the house of Windsor', but it tries to do so in the measured voice of the historian. He lays claim to something approaching Nichols's expository mode, and yet his commentary has already conveyed moral judgments of many of the individuals in his account. In this sense Starkey is perhaps also reflecting the dual faces of Channel 4; his tone suggests a public service element, emphasising ethics and morality, and yet both this 2007 episode and the 2011 *Romance and the Royals* seem calculated to profit, via advertising at the very least, from their subject matter. Certainly, from his initial work with the channel Starkey has offered, in the view of Peter Grimsdale, the then Commissioning Editor for history, a counter-intuitive alternative to the BBC[17] and the example of the series considered here certainly seems to confirm this.

'The Windsors' also raises issues about the personal relationships of existing members of the royal family. For example, Starkey specifically considers Prince Charles, remarking that the Queen's family have been 'unable or unwilling' to keep to her 'iron code of duty'. Charles's wedding to Diana in 1981 is particularly focused upon, as, Starkey asserts, it 'started a chain of events which shook ... the House of Windsor to its foundations'. He also highlights Charles's ambivalence over the idea of marrying Diana, until his father told him he was honour-bound to do so. In addition, Starkey suggests, the births of their sons seemed to exacerbate their problems, although he does not give details. Offering alternative accounts of the marital breakdown, and sympathy to Charles for returning to his mistress rather than to Diana because of her affairs 'with all and sundry', Starkey argues that the Queen was forced to guide the family through a political and media minefield.[18] Although Charles is certainly depicted as a less 'professional' choice of monarch than his mother, the possibility of abdication is implicitly negated. Indeed, as Starkey asserts over footage of Charles dancing and admiring penguins on a royal visit overseas, 'barring an act of God, [he] will be, must be, king'.

While series such as *Monarchy* offered a rather critical interpretation of the Queen's descendants, Starkey's, and Channel 4's, later work moved even further towards an explicit statement of the need for the royal family to recognise its British roots and, if necessary, to reject marriage to members of an elite in

favour of 'commoners'. References to Catherine's family history began to be made in 2011, with Channel 4's *Romance and the Royals*. Screened a few days before her wedding to Prince William, in April 2011, the documentary identified precedents for the marriage of a Prince and a commoner, and most interestingly, the channel's website linked this to wider national issues: 'By putting William and Kate's marriage in its historical context, David Starkey reveals it as the logical next step in a century-long struggle to return our monarchy to its native roots, preserving it as a focus of national identity.'[19] Despite these claims the programme was criticised by several reviewers, including Benji Wilson of the *Telegraph*, who considered it 'Channel 4 cashing in on the royals',[20] ignoring Starkey's credentials as a historian and as presenter of the *Monarchy* series on the same channel, although perhaps expressing some of the uneasiness felt by viewers when forced to reflect on the impermanence of a family depicted as an unchanging fixture of British history and identity.

In addition to creating television programmes representing royal history and politics, broadcasters have increasingly published texts about the monarchy on their websites. This has been particularly the case in recent years, with the marriage of William and Catherine, and the birth of their son George in 2013, and has often taken the form of genealogical tables and accounts. For example, a day before her wedding the Channel 4 website declared Catherine 'the middle-class princess', emphasising both her maternal ancestors' work as miners in north-east England, as well as her father's solicitor ancestors. Perhaps this identification of Catherine as middle class was intended as praise for a more inclusive monarchy, although the channel was keen to note on its website that '[f]rom an anti-monarchist viewpoint, however, she is marrying – notwithstanding her origins – into an unelected institution at the top of a social and political system that is ossified, unrepresentative and undemocratic',[21] thereby offering also a criticism of the institution of monarchy and perhaps, therefore, of Catherine's desire to join it. During a period of economic downturn, the activities of an elite, whether economic or royal, may be particularly open to criticism.

However, despite Starkey's assertion in *Romance* of the Britishness, or at least Englishness, of royals when marrying commoners before the early eighteenth century – a point contradicting to some degree an assertion he made, albeit briefly, in the final episode of *Monarchy* – and the channel's website defining Catherine as middle class, alternative accounts such as that published in the *Daily Mail* newspaper claimed Catherine as distantly royal, and even as a 'distant

cousin' of her husband.[22] William's parents, too, were distantly related, and unsurprisingly, at the birth of William's son, the channel asked 'How royal is the royal baby?'[23] Unlike Channel 4, though, the BBC emphasised Catherine's 'humble roots' without reference to royalty or middle-class identity, with coal-miners, carpenters and labourers the main focus, rather than the solicitors on her father's side of the family.[24] These two different approaches to the future Queen may be interpreted as reflecting the two channels' identities, as much as those of the royal family and those marrying into it. As we have already noted, while the BBC's account of the Queen's life was keen to celebrate her achievements and the specialness of the royal family, with which Catherine was contrasted, the Channel 4 news account of the same year (2012), identified the relative privilege of Catherine's ancestors.

In the light of such varied depictions of family history, it is pertinent to consider whether this suggests a pro- or –anti-abdication position on the part of broadcasters. For several years and particularly in 2013, which saw the abdication of the Dutch Queen Beatrice and the Belgian King Albert in favour of their children, the UK press, and current affairs series such as *Question Time*, discussed the possibility, and used both past and present examples to support their arguments. Focusing, as the *Diamond Queen* did, on the age of Prince Charles, commentators such as Harry Mount, writing in the *Telegraph*, have noted that 'Prince Charles must sometimes wish he could go Dutch'.[25] However, this press discussion was little reflected in BBC coverage or even in that of Channel 4, which tended instead to consider the ethics of maintaining a monarchy or the genealogy of those marrying into it. Admittedly, the BBC's *Diamond Queen* does, through the absence of Prince Charles, seem to suggest that his sons would be more likely to take the throne, and certainly, by discussing the 'royalty' of William's son George, Channel 4 seems to draw a direct line between the Queen and William, bypassing Charles almost entirely.

Commemorative historical coverage aside, the BBC has acknowledged debates over abdication. In a BBC News broadcast of 30 April 2013 that began by discussing the historical significance of monarchy across Europe, the problems of the Spanish royal family and related allegations of embezzlement were featured. Moving to footage from the British Jubilee celebrations, the commentator asked if any of the world's other monarchs would consider abdication, although 'at 87, she [Elizabeth] shows no sign of leaving her throne'. Some months earlier, on 31 January 2013, the panel of the BBC current affairs programme *Question Time* grappled with the same debate when one audience

member asked 'Should Prince Charles ask the Queen to go Dutch?' In reply the comedian Dom Joly likened Prince Charles to former Prime Minister Gordon Brown, who after years shadowing Tony Blair achieved less than a term in office before being losing the general election, and overall was, in Joly's words, a 'terrible disappointment'. Joly's argument that Charles should step aside for his son William received audience applause. Another panellist, James Delingpole of the *Spectator*, was also applauded when he added that, whilst the Queen does not make 'provocative, outspoken remarks', Charles has over the past decades taken 'explicitly political positions' and therefore might be seen to compromise the role of constitutional monarch. However, the more careful line taken by Baroness Warsi stressing Charles's work on community cohesion as well as the ongoing work of the Queen also received applause.[26] Such debates in news and current affairs programming are examples of television's function of 'working through'[27] aspects of national concern. Whether they have really affected the depiction of the royal family in history programming seems a moot point.

The broadcast coverage of the birth of Prince George (born 22 July 2013) is interesting to consider in relation to the issue of royal succession. Media crews camped outside St Mary's Hospital, and once again the BBC was criticised, this time for 'too much coverage', but fought back by reminding the press of the 'major historical event – the birth of a new heir to the throne' and reporting that BBC News Online had 19.4 million unique browsers globally and 10.8 million from the UK on Monday 22 July, the day the Duchess went into labour.[28] The christening of Prince George took place on 23 October 2013 at St James's Palace and the official photographs included a photograph of the Queen with the 'three future kings', Charles, William and George. As of May 2014 this remained on the BBC News website[29] alongside the last such official photograph taken in 1894 picturing Queen Victoria at the christening of the future Edward VIII with the future kings George V and Edward VII. The iconic image of the Windsor monarch and her successors seems to anchor the monarchy while also securing the future in rough seas ahead.

CONCLUSION

Television coverage of the royal family, past and present, reflects the different intentions and remits of the broadcasters involved. For the BBC, balancing accusations of popularisation against a need to have a sizeable audience in order to justify its position as the only licence-fee-receiving broadcaster, and to maintain

its status as self-declared archivist of national history, this has led to a variety of attempts to represent the royal family and its history, from Jubilee coverage to a range of documentaries. For Channel 4, offering an alternative view has meant drawing on a news- and current affairs-related agenda particularly central to its identity. The websites of both broadcasters highlight areas of conflict, particularly over those joining the royal family.

Arguably, then, the 360°[30] online and televised coverage of such events as royal weddings and jubilee celebrations has the potential to offer more viewpoints across official broadcasting sites. However, as we have noted elsewhere of history programming,[31] this potential is often not realised. In the coverage of the monarchy the possibilities are limited by constraints placed upon broadcasters by the royal family with regard to access and the nature of their participation in specific programmes. These concerns are part of the delicate negotiations with a centuries-old institution, the representatives of which may not always agree to their involvement, as the absence of Prince Charles from *The Diamond Queen* suggests. Similarly, the BBC itself is concerned to maintain good relations with the royal family in order to uphold the institution's self-defined role as the primary national broadcaster, thus shaping and to some extent limiting the ways in which it depicts the monarchy. However, both the BBC and Channel 4 are engaged in competition for audiences which itself engenders something of a polarisation in representation as each network attempts to reinforce its own identity and ethos to attract its target audiences.

The differing coverage of the Duchess of Cambridge's ancestry by the BBC and Channel 4, which includes website material, demonstrates alternative interpretations of her ancestry reflecting the preconceived audiences for the channels. Catherine is, according to Channel 4, of middle-class origin, while the BBC emphasises her 'humble roots'. The former is a narrative of increasing privilege, the latter a more romanticised 'rags to riches' story. Interestingly, however, both broadcasters stayed within the confines of a version of royal genealogy rather than attempting an entirely different means of representing Catherine's heritage, for example the DNA analysis employed by a number of popular television programmes. British television coverage of royal celebrations does more than offer opportunities to make covert statements about the institution of monarchy and its future. As part of its 'alternative' ethos, Channel 4 can and does make explicit and critical statements about the institution, its privilege and its place within British society. Nonetheless, conscious of its claims to public service broadcasting, it too does not stray far from the national narrative of the monarchy.

NOTES

1 Mark Lawson 'Our Queen: the latest royal TV to tell us almost nothing', *Guardian* (15 March 2013), www.theguardian.com/tvandradioblog/2013/mar/15/our-queen.

2 For example, Ann Gray and Erin Bell, *History on Television* (Routledge: London, 2013), pp. 100–29.

3 See Joe Moran, *Armchair Nation* (Profile Books: London, 2013), p. 42.

4 See for example the BBC sites on the history of royal weddings: www.bbc.co.uk/history/royal_weddings; the history of royal births: www.bbc.co.uk/history/0/22623324; and the Queen's reign and Jubilee: www.bbc.co.uk/history/people/queen_elizabeth_ii. Channel 4 sites include those on the wedding: http://blogs.channel4.com/snowblog/royal-wedding-history-pantomime/15160; and the Jubilee: www.channel4.com/news/jubilee.

5 See BBC History, 'The Queen', www.bbc.co.uk/history/people/queen_elizabeth_ii#p00t3pry.

6 Gray and Bell, *History on Television*, p. 51.

7 Bill Nichols, *Introduction to Documentary* (Bloomington: Indiana University Press, 2001), p. 105.

8 For additional information see 'Royal Marriages and Succession to the Crown (Prevention of Discrimination) Bill', House of Commons library research paper 09/24 (2009).

9 Caroline Davies, 'BBC documentary shows poignant images of a queen in the making', *Guardian* (1 June 2012), www.theguardian.com/uk/2012/jun/01/bbc-documentary-images-queen-making.

10 Daniel Dayan and Elihu Katz, *Media Events and the Live Broadcasting of History* (Cambridge, MA, Harvard University Press, 1992), p. 1.

11 Adrian Pennington, 'Diamond Jubilee: by Royal Appointment', *Broadcast* (24 May 2012), www.broadcastnow.co.uk/techfacils/production-feature/diamond-jubilee-by-royal-appointment/5042633.article.

12 Ben Dowell, 'Queen's Diamond Jubilee: BBC bosses dodge criticism of TV coverage', *Guardian* (6 June 2012), www.theguardian.com/media/2012/jun/06/queens-diamond-jubilee-bbc.

13 Simon Blanchard, 'Two faces of Channel Four: some notes in retrospect', *Historical Journal of Film, Radio and Television* 33:3 (2013), p. 365.

14 Gray and Bell, *History on Television*, pp. 44–5.

15 Blanchard, 'Two faces of Channel Four', p. 374.

16 Gray and Bell, *History on Television*, pp. 80–1.

17 *Ibid.*, p. 78.

18 See Mandy Merck's chapter in this collection for further examples.

19 See summary of *Romance and the Royals* on Channel 4 website: www.channel4.com/programmes/kate-and-william-romance-and-the-royals/episode-guide/series-1/episode-1.

20 Benji Wilson, 'Kate and William: Romance and the Royals, Channel 4, review', *Telegraph* (28 April 2011), www.telegraph.co.uk/culture/tvandradio/8478054/ Kate-and-William-Romance-and-the-Royals-Channel-4-review.html.

21 See 'Kate Middleton: the middle-class princess', www.channel4.com/news/ kate-middleton-the-middle-class-princess.

22 See 'Wills and Kate: kissing cousins', *Daily Mail* (3 August 2010), www.daily-mail.co.uk/femail/article-1299794/How-Prince-William-Kate-Middleton-relate d-thanks-Tudor-tyrant.html.

23 See 'How royal is the royal baby?', www.channel4.com/news/how-royal-is-the-royal-baby-kate-william.

24 See 'Royal wedding: family tree', www.bbc.co.uk/news/uk-13050232.

25 Harry Mount, 'Why the Queen is never going to abdicate', *Telegraph* (29 January 2013), www.telegraph.co.uk/news/uknews/queen-elizabeth-II/9834829/Why-the-Queen-is-never-going-to-abdicate.html.

26 *Question Time*, BBC1, 31 January 2013.

27 John Ellis, *Seeing Things: Television in the Age of Uncertainty* (London and New York: I.B.Tauris, 2000), pp. 91–101.

28 www.bbc.co.uk/complaints/complaint/bbcnewsroyalbabycoverage.

29 www.bbc.co.uk/news/uk-2461019.

30 See Gray and Bell, *History on Television*, p. 223, n. 26.

31 *Ibid.*, pp. 17–25.

SELECT BIBLIOGRAPHY

Blanchard, Simon, 'Two faces of Channel Four: some notes in retrospect', *Historical Journal of Film, Radio and Television* 33:3 (2013).

Davies, Caroline, 'BBC documentary shows poignant images of a Queen in the making', *Guardian* (1 June 2012), www.theguardian.com/uk/2012/jun/01/ bbc-documentary-images-queen-making.

Dayan, Daniel and Elihu Katz, *Media Events and the Live Broadcasting of History* (Cambridge, MA: Harvard University Press, 1992).

Dowell, Ben, 'Queen's Diamond Jubilee: BBC bosses dodge criticism of TV coverage', *Guardian* (6 June 2012), www.theguardian.com/media/2012/jun/06/ queens-diamond-jubilee-bbc.

Ellis, John, *Seeing Things: Television in the Age of Uncertainty* (London and New York: I.B.Tauris, 2000).

Gray, Ann and Erin Bell, *History on Television* (London: Routledge, 2013).

Lawson, Mark, 'Our Queen: the latest royal TV to tell us almost nothing', *Guardian* (15 March 2013), www.theguardian.com/tvandradioblog/2013/ mar/15/our-queen.

Moran, Joe, *Armchair Nation* (London: Profile Books, 2013).

Mount, Harry, 'Why the Queen is never going to abdicate', *Telegraph* (29 January 2013), www.telegraphco.uk/news/uknews/queen-elizabeth.-II/9834829/why-the-Queen-is-never-going-to-abdicate.

Nichols, Bill, *Introduction to Documentary* (Bloomington: Indiana University Press, 2001).

Pennington, Adrian, 'Diamond Jubilee: by Royal Appointment', *Broadcast* (24 May 2012), www.broadcastnow.co.uk/techfacils/production-feature/diamond-jubilee-by-royal-appointment/5042633.article.

Thody, Philip, *Europe since 1945* (London: Routledge, 2000).

Wade, Judy, *Diana: The Intimate Portrait* (London: Blake, 2007).

Wilson, Benji, 'Kate and William: Romance and the Royals', Channel 4, review', *Telegraph* (28 April 2011), www.telegraph.co.uk/culture/tvandradio/8478054/Kate-and-William-Romance-and-the-Royals-Channel-4-review.html.

The Tudors and the post-national, post-historical Henry VIII

Basil Glynn

The Tudors (2007–10) is a prime example of a relatively new type of post-national and post-historical television series that has become an established global alternative to BBC costume drama. Drawing on international rather than specifically British ideals of nationhood, it often runs counter to received history[1] while the use of computer-generated imagery (CGI) gives it a contemporary rather than historical aesthetic. It also constitutes, as Ramona Wray contends, 'an extraordinarily detailed take on the reign'[2] of Henry VIII and is 'with a total of thirty-eight episodes and a combined running time of almost thirty-five hours', as Sue Parrill and William B. Robinson observe, 'by far the longest filmic event ever to deal with the Tudor dynasty'.[3]

SCREENING HENRY BEFORE *THE TUDORS*

As England's most famous (or infamous) monarch, Henry VIII has featured prominently throughout the history of British national cinema, and his various on-screen incarnations could be argued to have revealed much about Britain and its national character. Raymond Durgnat famously suggested that national cinema serves as a window onto the society from which it arises[4] and Deborah Cartmell and I. Q. Hunter, considering British historical drama as such a window, claim that it has long been obsessed with periods associated with national greatness such as the Tudor, Jacobean and Victorian eras. The persistent representation of such eras, they argue, reflects 'both a British desire to revisit history in the wake of new definitions of Britishness' and the need to reassess 'the meaning of Englishness in a devolved nation now that England's myths have been degraded by revisionism'.[5] Such a case could be made for certain British heritage productions such as *Chariots of Fire*, *Brideshead Revisited* and

A Room with a View, all of which Tana Wollen identifies as being 'nostalgic in that their pasts were represented as entirely better places'.[6] This 'splendid' past, presented also in many BBC costume dramas such as *Middlemarch* (1994) or *Pride and Prejudice* (1995), is usually represented as refined and sophisticated and, as Robin Nelson suggests, invites audiences to 'take pleasure in the cultural myth of "Englishness," of tradition, stability and fair play'.[7]

Yet in many important respects Henry VIII on film and television has seldom held up this mirror for England, partly because the screen monarch has not been presented as an ambassador for cultural myths of Englishness such as 'fair play', nor as a representative example of English sophistication nor as the ruler of an era that was an entirely better place. Furthermore, he has rarely offered a mirror for England because he has infrequently been 'English' on screen. Indeed, from the earliest years of cinema Henry has proved a popular subject for filmmakers outside Britain, particularly with continental filmmakers. In 1912 he appeared in the French production *Henry VIII et Jane Seymour* for Pathé Frères (director unknown) and again in 1913 in *Anne de Boleyn* (director unknown). In 1920 he featured in a particularly lavish German film, *Anna Boleyn*, which was released in America as *Deception*. Directed by Ernst Lubitsch, it starred Emil Jannings as Henry and reportedly cost '8.5 million marks' to make and had '4,000 extras'.[8] Since this prestigious picture, Henry has continued to appear in continental productions, such as the French 1937 films *François premier* (Christian Jaque) with Alexandre Rignault as Henry, and *Les Perles de la couronne* (Sacha Guitry) with Lyn Harding as the King.

In addition to his continental characterisations, Henry has appeared in numerous and varied American productions. In 1935 he featured as a miniaturised monarch in *The Bride of Frankenstein* (James Whale, 1935), with A. S. 'Pop' Byron playing Henry. He was a female-obsessed cartoon character voiced by Mel Blanc in the Looney Tunes cartoon *Book Revue* (Robert Clampett, 1946). A half century later, in the 'Margical History Tour' episode from the fifteenth season of *The Simpsons* (Mikel B. Anderson, 2004, 20th Century Fox Television) he was played by Homer Simpson (Dan Castellaneta). He even turned up in the pornographic film *The Undercover Scandals of Henry VIII* (Charlton De Serge, 1970) with Steve Vincent as a lustful liege. Unusual renditions aside, Henry has also appeared in more traditional manifestations in US film and television productions. He featured in Vitagraph's 1912 *Cardinal Wolsey* (Laurence Trimble) with Tefft Johnson as Henry and in 1933 when Richard Cramer played him in the Mack Sennett comedy film *Don't Play Bridge*

with Your Wife (Leslie Pearce). Rex Harrison took on the part in 'The Trial of Anne Boleyn' episode in the television drama series *Omnibus* (1952, CBS) and in 1953 Charles Laughton played the role in the film *Young Bess* (George Sidney). In 1969 Richard Burton won an Oscar nomination for best actor for his performance as the King in *Anne of the Thousand Days* (Charles Jarrott).

Henry has also featured in different versions of the same story. Charles Major's novel, *When Knighthood was in Flower*, was filmed in 1922 (Robert G. Vignola) with Lyn Harding as Henry (a part he would again play in *The Pearls of the Crown*, 1937) and also in 1953 by Disney under a new title, *The Sword and the Rose* (Ken Annakin), with James Robertson Justice playing the King. Philippa Gregory's novel *The Other Boleyn Girl* was adapted by the BBC in 2003 (Philippa Lowthorpe) with Jared Harris as Henry and was made into a feature film in 2008 (Justin Chadwick) with Eric Bana portraying the King. After being broadcast as a BBC radio play in 1954, Robert Bolt's *A Man for All Seasons* was screened as a live BBC television drama in 1957 (directed by Peter Dews) with Noel Johnson as Henry, followed in 1966 by Robert Shaw's rendering of the King in a film adaptation (Fred Zinnemann) for which he won an Oscar nomination. In 1988 Martin Chamberlain also played Henry in a filmed stage play version that was directed by Charlton Heston.

Heston himself took the role of Henry in the 1977 film *Crossed Swords* (Richard Fleischer), an adaptation of *The Prince and the Pauper*, and this Mark Twain novel has hugely contributed to the appearances of the monarch on screen. In 1909 an Edison version (J. Searle Dawley) featured Charles Ogle as the King,[9] followed in 1915 by another American version (Hugh Ford and Edwin S. Porter), in which Robert Broderick played Henry. In 1920 an Austrian version (*Prinz und Bettelknabe*, Alexander Korda) cast Albert Schreiber as the King, followed by a US version in 1937 (William Keighley) that saw Montagu Love in the role. A Russian adaptation appeared in 1943 (*Prints i Nishchiy*, Erast Garin) and 1957 witnessed Douglas Campbell playing Henry in *The Dupont Show of the Month* version of *The Prince and the Pauper* (Daniel Petrie, CBS). After performing the King in a 1956 episode of the BBC Sunday Night Theatre, Paul Rogers played Henry for a second time in the *Walt Disney's Wonderful World of Color* episode 'The Prince and the Pauper: The Pauper King' (Don Chaffey, 1962). In 1976 Ronald Radd acted Henry in a BBC series version (Barry Letts) and Alan Bates played the King in 2000 for Hallmark's take on Twain's tale (Giles Foster).

Not surprisingly, Henry has appeared in numerous British productions. On television he was played in 1947 by Arthur Young in *The Rose without a Thorn*

(Desmond Davis, BBC) and by Basil Sydney in 1952 in a *BBC Sunday Night Theatre* episode of the same story, again entitled 'The Rose without a Thorn' (Michael Barry). Paul Rogers took on the role of the King in a different episode in the *BBC Sunday Night Theatre* series in 1956 called 'The White Falcon' (Rudolph Cartier). In 1970 Keith Michell played the King for the BBC's six-part television series *The Six Wives of Henry VIII* (and would do so again for the BBC in 1996 for yet another television version of *The Prince and the Pauper* (Andrew Morgan)). John Stride was Henry in the BBC's 1979 version of Shakespeare's *The Famous History of the Life of King Henry the Eighth*. In 1999 Henry appeared again in *The Nearly Complete and Utter History of Everything* (Dewi Humphreys, Paul Jackson, Matt Lipsey, BBC) played by Brian Blessed and 2003 saw Ray Winstone taking on the role in ITV's two-part television drama, *Henry VIII* (Pete Travis). In 2015 Damian Lewis appeared as Henry in an Anglo-American television adaptation of Hilary Mantel's Man Booker Prize-winning novel *Wolf Hall*.[10]

British films featuring the King include *Henry VIII and Catherine Howard* (1910, director unknown). The following year Arthur Bourchier took the title role in a version of Shakespeare's *Henry VIII* (William Barker), described by historian Rachael Low as Britain's 'first really important feature film'.[11] Not only did it bring Shakespeare to British film production, allowing exhibitors, as James Park puts it, to 'attract a better class of customer',[12] but it also ran at half an hour when most films prior to it were no more than 10 minutes in length. Henry appeared next in 1926 in *Hampton Court Palace* (Bert Cann) with Shep Camp as Henry and again in 1933 with Charles Laughton as the King (a part he would reprise in 1953 in *Young Bess*) in *The Private Life of Henry VIII* (Alexander Korda), a Henry production that for the second time was dubbed the most important British film made up to that date. It was, as Roy Armes states, 'a phenomenon' in the 1930s, 'immensely popular in the United States'[13] and, as James Chapman reports, 'the first British talking picture to become a significant commercial success in the international market'.[14] Greg Walker proclaims it 'probably the most important film produced in Britain before the Second World War'.[15]

Yet the divisions between continental, British and American productions in this, by no means exhaustive, catalogue of screen Henrys are not always easy to justify. *Crossed Swords*, for instance, was a multinational co-produced 'Europudding', partly financed with American money and filmed in the UK and Hungary. *The Private Life of Henry VIII*, despite being, as Chapman asserts, 'the film that is seen as making the breakthrough for British films in the American market',[16] actually had multiple international dimensions from the outset, not

the least being that it was 'written and produced largely by European émigrés'. As Armes points out, it had 'a Hungarian producer-director (Korda himself), designer (his brother Vincent) and co-scriptwriter (Biro), a French cinematographer (Perinal) and an American editor (Harold Young). The only Englishman to play a major production role in this archetypically British film was Arthur Wimperis, who was largely responsible for the dialogue.'[17] From the outset, producer-director Alexander Korda saw the project as an 'international film', one that would 'appeal and succeed abroad'.[18] British films featuring Tudor monarchs have often featured such international dimensions. Robert Murphy, for example, excluded films such as *A Man for All Seasons* (1966) and *Mary, Queen of Scots* (Charles Jarrott, 1971) from his history of British cinema, attributing them to an international, American-dominated style of filmmaking.[19]

As Parrill and Robinson argue, '[T]he sensational elements of Tudor history have been appealing to British, American, and continental movie makers and audiences from the early days of film.' Initially, this was because '[I]n silent films no language barrier existed to prevent films about Henry VIII's excesses and Mary Stuart's plight made in Italy, France, and Germany from finding audiences in England and North and South America.'[20] Yet even with language barriers, the 'sensational elements' of the story of the King and his six wives have ensured to this day that they remain global subjects of film and television. Henry has proven particularly suitable for sensation because he is largely free of the mythical significance of his daughter Elizabeth or Queen Victoria in relation to the status of the English monarchy or Anglo-British culture and fully free of their virtuous reputations. He holds a place in history for murder, multiple marriages and (selfishly) laying the foundations with the Reformation for the Protestant country that Elizabeth (unselfishly) built into a great nation. He is a figurehead belonging to the other side of the coin to the cultural idol that is 'the quasi-religiously adored virgin Queen Bess'.[21] Elizabeth is memorialised on screen as a queen who placed the needs of her nation above her sexual and reproductive desires, sacrificing 'the "natural" destiny of a woman, marriage and children, trading personal happiness for public power'.[22] Her self-negation is linked to a glorious reign 'of imperial and creative supremacy'[23] in films such as *Fire Over England* (William K. Howard, 1937) and *The Sea Hawk* (Michael Curtiz, 1940). In *Jubilee* (Derek Jarman, 1978) and *Shakespeare in Love* (John Madden, 1998) she firmly stands 'for the era of Shakespeare, Marlowe and Spencer, the Golden Age of English culture'.[24] In contrast to such a golden age, Henry's reign is popularly

remembered as one in which he personally sacrificed nothing except his waist-line and his wives in his quest for power and pleasure. It is not his reign but Henry himself who colourfully dominates in the popular consciousness and so it is hardly surprising that 'King Bluebeard'[25] has been the subject of so many screen biographies from so many countries.

Nat Cohen (head of production at EMI when the BBC TV series *The Six Wives of Henry VIII* was adapted for the cinema) described the potential prof-itability of Henry's global stardom when he declared that he remains 'a sub-ject for the world market',[26] and in the case of the TV series he was right. It 'was sold to countries as diverse as Japan, Australia, Canada, Sweden, Finland, Belgium and West Germany, and was bought by the CBS network which broadcast it on American television'.[27] To underscore this global popularity, it is worth noting how seldom England's most famous king has been played by an Englishman, even in Anglophone productions, being portrayed by the Australian-born Keith Michell, American Charlton Heston, Irish Robert Shaw, Welsh Richard Burton, South African Syd James and, in *The Tudors*, the Irish Jonathan Rhys Meyers.

The international dimensions of British historical film and television produc-tion are actually unsurprising because they both depend on international dis-tribution and exhibition. The financing of expensive BBC costume dramas on television, as Nelson points out, has long been possible only because of their 'world sales' potential.[28] The same is the case with cinema, where, as Chapman explains, 'the historical film has generally been among the most expensive British productions and is therefore dependent upon overseas markets for its ultimate profitability. The British production sector as it currently stands is too small and unstable to support the consistent production of large-scale histor-ical films.'[29] In order to assure international demand, international appeal has become built into the British historical production itself with non-British stars proving a crucial aspect. By way of illustration, Julianne Pidduck cites Tudor-set films like *Elizabeth* (Shekhar Kapur, UK/US, 1998, Polygram/Working Title/Channel Four Films) and *Shakespeare in Love* (US, 1998, Universal) which bene-fited from the marketability of American stars like Gwyneth Paltrow and Ben Affleck, Australians such as Geoffrey Rush and Cate Blanchett and French ones such as Vincent Cassel and Eric Cantona. 'Aside from commercial motivations', she further suggests an aesthetic function in the inclusion of such actors as 'this mélange of accents, star personas and acting styles suggests the pleasures of make believe so central to costume drama and historical fiction.'[30]

The Tudors

The Tudors and the internationally co-produced historical TV drama in general similarly integrate international appeal in order to accommodate a modern international audience. In addition to making use of internationally known stories and stars, they also foreground new technology, exploit explicit sex and violence, take advantage of tax incentives and relatively cheap shooting locations such as Ireland (*The Tudors*), Hungary (*The Borgias*) and Belgium (*The White Queen*), and dwell on the fictional aspects of historical fiction.

In *Television in Transition*, Shawn Shimpach explores television's constantly changing nature and, in particular, the new structures of production and distribution in today's 'new, international, multi-channel universe', suggesting that it is white 'futuristic' heroes such as Doctor Who and Superman who are at the forefront, constantly featuring in stories in which they are being 'asked again and again to help save the day'. Yet while these futuristic heroes have become globally successful, other protagonists from the past have also become hugely significant in this 'new international, multi-channel universe'.[31] Spartacus (*Spartacus: Blood and Sand* (2010, Starz)), Julius Caesar (*Rome* (2005–7, BBC/HBO)), King Arthur (*Camelot* (2011, Starz/Take 5/CBC/Ecosse/Octagon)), Alexander Borgia (*The Borgias* (2011–13, Showtime/Take 5/Octagon/Mid Atlantic Films)), Leonardo da Vinci (*Da Vinci's Demons* (2013–, Starz/BBC Worldwide)), Elizabeth of York (*The White Queen* (BBC/Company/Czar Television, 2013)) and Henry VIII (*The Tudors* (2007–10)) have become the central characters of internationally produced and distributed television series in the last decade.

Unlike Superman and Dr Who, these white historical figures tend to be less interested in 'saving the day' than seizing the day in their quests for personal power, vicious retribution and passionate sex. They also feature in series that are notably 'international' in aspects such as production company partnerships, filming locations, financing and casting. *The Tudors*, for example, has a complex national status. It is the creation of the British Working Title Films (whose parent company is the American NBC Universal), Octagon Films, Canadian Peace Arch Entertainment, American-based Reveille Productions (which was taken over in 2008 by Elisabeth Murdoch's Shine Group) and Showtime (which is a subsidiary of CBS). It has an international cast including the English Henry Cavill, Northern Irish/New Zealander Sam Neill, Canadian Henry Czerny and Swedish Max von Sydow, and it was filmed in Ireland. Like many other such international productions, it took advantage of tax inducements offered by

more than one country, investment incentives provided by the Government of Ireland with the participation of the Irish Film Board and the Canadian Film or Video Tax Credit.

It is advantageous to consider *The Tudors* within the context of this recent flourishing in internationally produced historical television drama because these productions share important features. One is that they make little claim to historical fidelity and overtly fictionalise the past. Another is that they also regularly use computer generation or locations that look suitable but have little or no relation to the actual sites of historical events. (Tudor England in *The Tudors*, when not computer-generated, is largely recreated at Ardmore Studios near Dublin.) The past in these dramas is populated with characters who are lustful, devious and pathologically brutal and the productions are immensely explicit in showing their sexual activities and bloody exploits. A glimpse at any one of the numerous scenes of torture that occur throughout *The Tudors* serves to signal this violent past as a much worse place than today. The show brings us, among other scenes, the spectacle of a prisoner about to be boiled alive 'mercifully' offered the option of jumping into a scalding vat of water head first to minimise his suffering (series 2, episode 1–2.1). It also offers the burning of Simon Fish (1.10), a view of Bishop Fisher's beheading from the subjective camera perspective of the basket into which his head will fall (2.5), the botched beheading of Thomas Cromwell with the drunken executioner repeatedly hacking his back with his axe (3.8), George Boleyn's head graphically severed from his body (2.9), George Smeaton being stretched on the rack after having his eye crushed (2.9), the hanging of Robert Aske from the battlements (3.4), John Constable having a red-hot poker thrust up his rectum (3.3), and so on.

In this graphic depiction of violence, historical series such as *The Tudors*, *Spartacus Blood and Sand* and *The Borgias* distinguish themselves from restrained historical and costume dramas such as *Pride and Prejudice* and *Downton Abbey* (UK, 2010–, Carnival), the likes of which also continue to be produced and exported by British television companies very successfully. In contrast to the anachronistic propriety in series such as these, in which simmering desire remains largely unspoken and 'foreplay is basically hanging your clothes properly',[32] *The Tudors* and its ilk offer a diametrically opposed approach. Character behaviour is explicitly up-to-date rather than elegantly out-of-date. Unlike those period dramas which have tended to present a bygone sensibility to modern television audiences, series like *The Tudors* choose to infuse a bygone era with a modern sensibility. As its costume designer Joan Bergin declares, *The Tudors*

was never intended to be respectable because its producers 'didn't want a rigid BBC costume drama',[33] a point echoed by the executive producer Morgan O'Sullivan, who adds that it 'has a contemporary feel about it. It's not stiff and starchy in the way they normally do period dramas.'[34]

In the budget-limited world of British television, the 'rigid' and 'starchy' dramatic reconstruction of the past has more often than not been conveyed through modest sets and costumes, with the word rather than the visual style privileged. This verbal emphasis has contributed to British television costume drama's reputation for literariness and restraint, and has helped imbue it with a theatrical quality, served as it has been by an unobtrusive '"flatness" in the depiction and construction of space, as if the camera' is 'afraid to move through the fourth wall and interrupt an established environment'.[35] In spite of the merits of script, performance and dramatic effect, such stylistic conservatism with dialogue to the forefront and camerawork to the background is certainly evident in the BBC Tudor dramas *The Shadow of the Tower* (1972), *Elizabeth R* (1971) and *The Six Wives of Henry VIII* (1970).

Yet, perhaps surprisingly, it is not only in BBC historical dramas that the Tudors have been presented in such a conservative style. They have also appeared via many of the same conventions on the big screen. In some cases this is understandable when Tudor-set films have been heavily influenced by television source material, as in the case of the film *King Henry VIII and His Six Wives*. Yet even when not drawing on television directly for inspiration, the presentation of the Tudors in the cinema has often evoked the theatrical. Chapman, for example, locates the Tudor-set film *Anne of the Thousand Days* within the theatrical tradition of British television drama as a result of its 'cultural and aesthetic conservatism: respectable, literate, wordy' script and 'sober visual style of sensitive colour cinematography and predominantly frontal staging'.[36] Such theatricality was explicable in this case because *Anne of the Thousand Days* was an adaptation of a stage play by Maxwell Anderson. Indeed, numerous films depicting Tudor monarchs have been based upon Anderson's plays including *Mary of Scotland* (John Ford, 1936), *The Private Lives of Elizabeth and Essex* (Michael Curtiz, 1939) and the US television movie *Elizabeth the Queen* (George Schaefer, 1968, Hallmark). Shakespeare's *Henry VIII* and Robert Bolt's *A Man for All Seasons* are other obvious theatrical sources for Tudor-set film and television adaptations.

Yet, as well as referencing television and the theatre, reference, and to a certain extent deference, to the past itself has also contributed immensely to the

conventional style in which the Tudor period has customarily been conveyed in the cinema. In addition to generic conventions established by previous renditions, it has been governed by the use of historical locations when recreating the period. Bleak weather-worn exteriors and dank ancient interiors of actual (if not always the correct) castles, cathedrals and manor houses feature as the major settings in films such as *Anne of the Thousand Days* (which made use of Hever Castle in Kent, home to the Boleyns during Anne's lifetime), *Mary, Queen of Scots* (Alnwick Castle in Northumberland), *Henry VIII and His Six Wives* (Allington Castle in Kent) and *Elizabeth* (Durham Cathedral, Haddon Hall in Derbyshire and York Minster). In spite of the colourful costumes and glamorous stars decorating these films, an unappealing sense of the past pervades. Pidduck describes how the castles and cathedrals in *Elizabeth* 'ooze an inky gloom'.[37] A bleak dreariness pervades the exterior shots of films such as *Mary, Queen of Scots* with its repeated presentation of darkened cloud-covered landscapes and the interiors of *Anne of the Thousand Days* with its cold, drab, stone inner walls cheered only by tapestries and flickering candlelight.

In stark contrast to the real castles and cathedrals that situated its predecessors within authentic stone and mortar, *The Tudors* paradoxically depicts its historical world through computer generation. Rather than using extant buildings constructed hundreds of years ago, its post-production castles and cathedrals are evidently constructed not 'then' but 'now'. Bloody, yet far from gloomy, this pixellated past is vibrantly new. As *Variety* proclaimed upon *The Tudors*' initial broadcast, 'Showtime has freshened up mouldy history.'[38] In addition to creating a kingdom 'spritzed with Febreze',[39] as Ginia Bellafante described it, a post-produced past helps prioritise the televisual over the wordy or theatrical with its emphasis on the computer-generated picturesque. Unlike Hollywood historical epics which often spend millions of dollars to recreate history, a budget out of reach for most film and all television production, millions of pixels instead provide the spectacular vistas of Victorian London in *Ripper Street* (2012–, UK/Canada/Ireland, BBC/Tiger Aspect/Look Out Point/Element) and *Penny Dreadful* (2014–, US/UK, Showtime/Desert Wolf/Neal Street), Renaissance Rome in *The Borgias* or Florence in *Da Vinci's Demons*.

Just as 'the arrival of colour broadcasting at the end of the 1960s opened up new possibilities' for historical drama, transforming it into 'one of the significant production trends over the next decade … exemplified by *The First Churchills* [David Giles, 1969, BBC], *The Six Wives of Henry VIII* [Naomi Capon and John Glenister, 1970, BBC], *Elizabeth R* [Claude Whatham, Herbert Wise,

Richard Martin, Roderick Graham, Donald McWhinnie, 1971, BBC] and *I, Claudius* [Herbert Wise, 1976, BBC]',[40] so too has the contemporary historical series benefited from advances in CGI. Computer generation is serving to disconnect the period drama from 'actual' history because, without being overtly self-reflexive, it foregrounds each show's artificiality. It provides the perfect inauthentic backdrop for each inauthentic account. *The Tudors*, for example, clearly relies on effects rather than location-shooting at historical sites and in the very first episode treats viewers to CGI renderings of Whitehall Palace and Hampton Court as well as panoramic shots of London and Paris. These non-existent settings offer precisely what cannot be offered by the concretised actuality of locations such as Haddon Hall and Durham Cathedral. No longer dominated by what survives of the past, shows like *The Tudors* are now untethered from the stylistic and production requirements of previous film and television historical drama.

However, abandoning authenticity has come at some cost to the reputation of contemporary international historical dramas. By jettisoning long-established principles for representing the past, series like *The Tudors* have also rejected the belief that historical drama should perform a pedagogical function. Required to convey the period they are depicting authentically to a contemporary audience, historical dramas have seldom been immune to accusations of distorting the past, getting facts wrong or producing 'groan-inducing howlers'.[41] Sue Harper, for example, argues that historical drama has a duty to the historical record that other genres, such as costume drama, simply do not have. While 'both reinforce the act of social remembering, costume dramas and historical films are different from each other. Historical films deal with real people or events: Henry VIII, the Battle of Waterloo, Lady Hamilton. Costume film uses the mythic and symbolic aspects of the past as a means of providing pleasure, rather than instruction.'[42]

By making no such claims to instruction, *The Tudors* was immediately attacked for its unapologetic use of history for drama instead of presenting drama as history. Rather than merely picking holes in it, many critics shredded the entire series as historical drama with no historical value. For example, in his co-authored book *The Tudors on Film and Television*, William Robinson protests that the series offers little more than 'shock value'[43] and complains that 'the history is so mangled it might have been simpler to just tell it straight with intermittent gratuitous sex scenes'.[44] Anticipating this assessment, *New York Times* critic Mary Jo Murphy observed that 'you watch *The Tudors* for the history the way you read *Playboy* for the articles'.[45]

This kind of condemnation should have been ruinous if Ramona Wray is correct in her description of the show's ambitions as 'intimately connected to contemporary notions of audience' and 'must-see television'. Drawing on conceptions of 'quality television' she observes that shows like *The Tudors* are 'designed to attract not so much a volume audience as highly educated consumers who value the literary qualities of these programmes' and as a result are 'able to acquire and boast a greater cultural legitimacy'.[46] Yet the series avoided the quality pigeonhole to attract a much larger and more lucrative audience. It proved the biggest draw for Showtime since 'the service premiered *Fat Actress* in March 2005'[47] and scored 'well above'[48] the ratings figures for the debut of Showtime's *Dexter*, despite Showtime undertaking with *The Tudors* 'the bold move of taking on the Sunday night programming of HBO at the exact period when HBO ... [flexed] ... its muscles with new seasons of *The Sopranos* and *Entourage*'.[49] Following such initial achievements, *The Tudors* went on, as Sue Parrill and William Robinson put it, to become 'for better or worse, a genuine cultural phenomenon'.[50] As they explain, as well as being broadcast on Showtime it

> appeared on BBC2 in the United Kingdom, CBC Television in Canada, Tele TV3 in Ireland ... has been released through a variety of digital outlets, and is available all over the world on DVD and Blu-Ray, both as individual seasons and in a boxed set containing the complete series. Many of its stars have become international celebrities. It has its own rather sophisticated website and has spawned fan sites, fan clubs, and fan fiction, as well as keeping Tudor blogs abuzz with commentary.[51]

As well as appealing to a mass audience outside and beyond the 'highly educated consumer' of quality television, *The Tudors* happily abandoned any attempt at 'literary quality'. Perceived by *Variety* as at best middlebrow since it had 'the potential to bring together ... critics and elites who might be partial to period pics, and broader commercial aud[ience]s drawn to the sex and shenanigans',[52] it was similarly identified by Alessandra Stanley of the *New York Times* as being lowbrow but fun, 'a captivating romp, *Ocean's Eleven* in ruffs and doublets',[53] In the *New Statesman* Rachel Cooke guiltily admitted to being a fan, while stating that if 'in Tudorland terms' Hilary Mantel's novel *Wolf Hall* 'is like having lunch at Le Gavroche', *The Tudors* is like having 'dinner at Chicken Cottage. ... It's as if your dimly remembered school textbook had been rewritten by someone who used to work on *Falcon Crest*.'[54]

Much of the reimagining of *The Tudors*, and consequent commercial success and critical mauling that followed, can be credited to its writer, Michael Hirst, who has recently made his reputation, for good or bad, 'rewriting school textbooks' in a historical genre in which historical accuracy is secondary. Hirst has played a large part in the current direction the internationally co-produced historical drama has taken because he has been centrally involved in several of them. As Parrill and Robinson explain, he 'created and wrote all the episodes for *Camelot* (Starz 2011); served as executive producer for *The Borgias* (Showtime 2011) ... and is the creator and executive producer of *Vikings* (2013), the History Channel's first scripted drama series'.[55] He was also in a position of great creative power when it came to *The Tudors* because it was, as its executive producer called it, 'a writer's movie'[56] (in spite of being, of course, television).

Hirst, already something of a 'period drama specialist'[57] following his historically set screenplays for *The Deceivers* (Nicholas Meyer, UK, 1988), *Fools of Fortune* (Pat O'Connor, UK, 1990) and *Elizabeth*, remarkably wrote all four seasons of *The Tudors* single-handed. He was on set 'almost all the time'[58] and himself points out how highly unusual this was 'in that most television series are written by a staff of writers'. It was very much his 'baby', he maintains. 'When they started filming, I still hadn't finished episodes 9 and 10. I was literally the only person who knew what was going to happen.'[59] From this position of control, Hirst argues for a 'need' for the 'historical material to resonate ... and for its themes to be relevant to our own lives'.[60]

In achieving resonance and relevance, *The Tudors* provoked numerous critics to complain of what they saw as deplorable historical inaccuracies. Ginia Bellafante, for example, objected to the 'historical hopscotch' she detected as a result of the fact that 'timelines are abbreviated' and 'papacies are rearranged. ... Henry VIII was a man of extreme faith who attended Mass five times a day', she said, but 'watching *The Tudors* you'd think he spent most of that time shaving'.[61] Indeed, the clean-shaven 'young, buff and lusty Henry VIII',[62] as Mary Jo Murphy of the *New York Times* described him, was clearly a shock to many. 'In contrast to most depictions of an old, fat, detestable king', Brian Lowry wrote in *Variety*, *The Tudors* 'introduces Henry as a bright-eyed young man with washboard abs',[63] such 'perfectly demarcated abdominals', as Bellafante added, that he looked 'like someone you would hire to be your live-in personal trainer'.[64]

Such condemnation for 'wonky'[65] history is nothing new for Hirst, who as a writer had already received abundant criticism for disregarding received history with *Elizabeth* alongside the film's director, Shekhar Kapur (who proclaimed

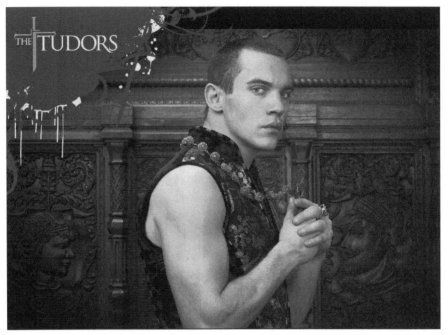

27 Henry VIII (Jonathan Rhys Meyers) as a 'punk-rock' ruler in
The Tudors (Showtime, 2007–10).

that 'historical facts are only a constraint if you stick to them').[66] Renée
Pigeon accused them both of expressing 'no interest in historical veracity' and
denounced their 'invented or grossly misrepresented events and characters'.[67]
Robinson gave them the barest of credit in his appraisal, stating that Elizabeth
'starts and ends well but is nonsense in between'.[68] Susan Doran judged the film
with its 'deliberate trampling over historical fact' to be 'profoundly unhistor-
ical',[69] while Christopher Haigh invited viewers to 'by all means enjoy *Elizabeth*'
with the proviso that they just 'don't suppose that it's telling you anything much
about history'.[70] *Elizabeth: The Golden Age*, which Kapur also directed and Hirst
co-wrote, fared little better amongst critics, with Vivienne Westbrook objecting
to the fact that the film made 'tenuous claims to being fact whilst paying its chief
respects to fiction. Put more simply, what is presented as fact is, in fact, fiction.'[71]

The disregard for historical veracity in Hirst's two accounts of Elizabeth's
reign is also apparent in *The Tudors*, much of whose narrative did not happen
to the particular people presented in the drama, did not occur in the particu-
lar ways depicted or did not occur at all. Yet does this necessarily indict him

as a sloppy researcher who deems history a mere inconvenience? Discussing Hirst's attitude to his source material on *Elizabeth*, Haigh made the important point that 'the errors in *Elizabeth* are not accidental, they are quite deliberate adjustments of history to meet the requirements of a drama. ... *Elizabeth* was not made in ignorance. You have to know a lot of Elizabethan history to make these mistakes; you have to know what really happened (or probably happened) before you can turn it into this particular story. Real characters are adjusted, real events are amended and relocated, plausible incidents are invented – all to serve the drama.'[72]

Hirst himself justifies his measured approach to rewriting history by arguing that 'in a film you have to push things a bit. It's not like writing a history book in which you can stand back and be cool and say perhaps or perhaps not.'[73] His admission suggests that criticising *The Tudors'* historical errors is akin to forcing a door that Hirst himself is holding open. While he maintains that 'everything I wrote was based on historical research and historical "fact" (as reported, that is, by historians!)',[74] he qualifies this by stating that only 'about 85 per cent of *The Tudors* is true'.[75]

Part of his reason for rewriting history is to avoid confusion, as with his decision to merge Henry's two sisters, Mary and Margaret, into the single character of Margaret. There was already another Princess Mary in *The Tudors*, Henry's daughter by Catherine of Aragon, and Hirst 'didn't want two Princess Marys on the call sheet because it might have confused the crew. "Which one do you mean, Michael? Who do we dress?"'[76] As a result *The Tudors* (1.4.) features Margaret (when it was in fact Mary) going to Portugal (Mary went instead to France) to marry the King of Portugal (Mary actually married King Louis XII of France, whereas Margaret travelled to Scotland to marry James IV). Although a convoluted rewriting of history, the use of Margaret and the introduction of Portugal instead of France and/or Scotland did avoid misunderstanding because '*The Tudors* had shown a French king in a different context in Season 1 ... so he just chose another European country.'[77] While the wrong sister going to the wrong country to marry the wrong king may have perplexed those familiar with the period, such distortion has little negative impact on the narrative sweep of the series. In dramatic terms the King's sister is sent abroad to marry a decrepit king, has sex on the way with Henry's best friend Charles Brandon, suffers an unpleasantly comical form of humiliation and sexual assault at the hands of her royal husband, suffocates him in disgust and revenge for this outrage and returns happily remarried to the aforementioned best friend (although

historically speaking it was Mary and not Margaret who married Brandon). The result is therefore both dramatic and dramatically unhistorical.

Such major, and more importantly, conscious tampering with 'historical truths' marks *The Tudors* out as undeniably inauthentic and Hirst himself clearly expected the backlash that indeed came later, when he admits he had to shore himself 'up against the inevitable hostility of – I should imagine – mainly British academics and historians, who will find (to their secret delight) many errors of fact and detail in the work'.[78] Yet he endorses his methods on the grounds that even while deliberately rewriting history for dramatic purposes, one can still care deeply about the history one is rewriting because it was only written by someone else in the first place – and not necessarily truthfully. For instance, in relation to Elizabeth bedding Dudley in *Elizabeth*, he argues that while there is no evidence that they did, there is also no evidence that they did not. 'There's plenty of circumstantial evidence that she did sleep with Dudley', he claims, and justifies his decision to have her sleep with him in the film to be little more than 'a small nudge in the direction of romanticism'.[79] In *The Tudors*, a similar logic towards received history presides. For example, in the drama Cardinal Wolsey takes his own life, contrary to the historical account that he died of an illness. Yet significantly, within the drama, Wolsey makes it clear that 'nobody must ever know' about his suicide (1.10). Viewers, therefore, are offered a privileged view of a hidden moment of history that historians themselves have not had. 'Hirst defends this depiction, contending that this might have been the way things really happened, and that Henry would have covered it up. Wolsey certainly had motive. "He was going to come back to a show trial" ', Hirst said, ' "and the best that he could get would have been a public beheading in front of all his enemies and a jubilant crowd." ' Hirst 'also wanted to give an acclaimed actor, Sam Neill, a powerful scene: "I didn't want him to go out with a whimper. I wanted him to go out with a bang." '[80]

Such an approach is possible because there are certain historical events that audiences tend to be aware of and so long as these are 'ticked off' they will not feel that what they are watching is untethered from historical reality. Thomas More must be executed, for example, and Anne Boleyn cannot be pardoned at the last minute and go on to live a happy life if any dramatisation is going to be seen as authentic. Observing the 'scant respect for actuality' in *Elizabeth*, Moya Luckett claims that it got away with it because 'few viewers' were likely 'to know much more about her reign than a vague connection with Sir Walter Raleigh, Mary Queen of Scots and the Spanish Armada'.[81]

Even the scantiest general knowledge can be problematic for historical drama, because unlike fiction it has to contend with the fact that its audience may at the very least know the ending. Many would be aware, for example, that the rebel army would be defeated in the *Spartacus* series and that Cleopatra would take her own life in *Rome*. So too in *The Tudors* would the audience apprehend that ultimately Henry would die and make way for his children, with Elizabeth eventually ascending to the throne. Hirst's rather ingenious way of making use of this biographical knowledge is to bring to a pleasing union the conjectural history we have been viewing and the official history we had been familiar with beforehand. For example, perhaps the greatest surprise of both *Elizabeth* and *The Tudors* had been that the monarchs looked nothing like we had expected, with a young and beautiful Elizabeth and a thin and beardless Henry. The final moments of both dramas rectify this by presenting the official history as not fact but just that, 'official' history. Pamela Church Gibson points out that at the end of *Elizabeth* 'in order to become an idol, venerated by her people, Elizabeth must lose her innocence, deny her humanity and reject her sexuality'.[82] For the greater part of the drama we had witnessed not the idol projected through history but the young woman discovering herself, but the drama ends with a performance by the Queen as she transforms herself into 'the pearl-encrusted icon of later memory'.[83] It is a film, as James Leggott points out, that explores 'the machinery of myth-making'.[84]

Henry, in the final episode of *The Tudors* when he poses for his portrait, assumes, like Elizabeth, the iconic bearing that will carry his image to his people and his memory throughout the ages. The ending shows that the historical alterations that have been so criticised are not unsuitable after all, because they simply counter an already fabricated historical record. 'The unknown story' is contrasted in the finale with the 'official' conception that will become the known story. We therefore witness the erasure from history of the story we have just watched and the authorised history created to replace it. Just as Elizabeth transforms herself into the image of the Queen passed down to us in Nicholas Hilliard's and Marcus Gheeraerts's portraits, so Henry recognises that he has to generate an image that will live on through the ages and demands in the final episode that his defining portrait be painted by a true master, Hans Holbein. He rejects Holbein's first attempt as making him look too weak and is only content with the image that we know today. As Thomas S. Freeman explains, it is this painting that not only preserved the features of the King but also 'partially shaped Henry's historical reputation ... the king, standing like a defiant

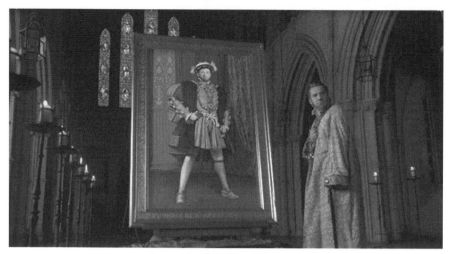

28 Creating the myth of Holbein's Henry in *The Tudors*.

colossus, with his legs wide apart, supporting his massive torso, embodies pride, arrogance, authority, resolution and indomitable will'.[85] Creditably, Hirst took issue with such historical PR:

> I think that all the portraits, all the images of rulers are usually lies. The way they present themselves to their public is a calculated way. ... The images of kings that we see are often certainly tampered with. ... Henry VIII had a very strong sense of how he wanted to promote his kingship and himself. So the images of kings that we see are often certainly tampered with. ... This big picture of Henry when he looks completely commanding is how he wanted to see himself and how he wanted others to see him. What I wanted to do at the end, when you see the classic version, I wanted people to say 'well, I see that but we've watched something else. We've watched a man going through all these stories and we've been interested in this. And that was his story.' And the formal ending, the other thing, that's a sort of, that's a piece of propaganda, Tudor propaganda, you know. And I wasn't doing that story.[86]

The story Hirst did, while imaginative and purposeful, was not necessarily novel or original. Kara McKechnie, among others, has observed that dramas about the monarchy make up a significant area of British film production and that the lives of kings and queens have been reimagined again and again 'according to the needs of the age'.[87] In these various reimaginings, depictions that run contrary to the popular image of famous kings and queens are nothing new. 'Iconoclastic or deliberately "inauthentic" approaches to history' range 'from

the avant-garde contributions of Derek Jarman and Peter Greenaway to the "vulgar" work of Ken Russell.'[88] Others have shown kings and queens in their youths. Films such as *Young Bess* and *Young Victoria* (Jean-Marc Vallée, 2009), for example, present their famous and sexually abstinent queens as young, romantically, and even sexually, active. Both *Elizabeth* and *The Tudors*, like these works, constructed 'countermyths' to 'demythologise the past', and take their place in a tradition of 'retrovisions',[89] to borrow Cartmell and Hunter's term.

Ultimately, though, *The Tudors* is inimitable in that it sustains its 'retrovision' for four seasons and deliberately aims for controversy over respectability in its depiction of Henry VIII throughout. As Wray states, it stands as 'an unprecedentedly ambitious attempt to televise history'.[90] It questions not just how we see Henry VIII, but monarchs in general. Robinson, one of many to take issue with the depiction of Henry, complained that Rhys Meyers looked 'more like a cross between a punk rocker and a soccer player than a king',[91] but *The Tudors* challenges this very assumption – just what should a king look like? Should on-screen depictions adhere to custom-designed legacies just because they are powerful in the public consciousness? Hirst certainly thinks not, asserting that nobody had departed from the established image of Henry before 'because of the iconography'.[92]

The challenges to the King's 'established image' in *The Tudors* exemplify the scant respect paid by the post-national and post-historical drama to received history. The multinational financing, companies, casts, crews and locations combined with modern CGI engender historical creations that are designed to appeal to mass modern international audiences for whom particular national histories are far from sacrosanct. Favouring the extreme, the visual and the sensational, they also cast off the wordy literary/theatrical tradition that had hitherto bolstered British historical and costume drama. Not surprisingly this newly perceived strain of disrespect and excess in a genre associated with a conservative literary respectability led critics to critically downgrade *The Tudors* from 'Le Gavroche' to 'Chicken Cottage'. Yet one might question why such excess should be so objectionable when telling the story of Henry VIII. The accepted image of the King, indeed perhaps the reason for his long-lived fame, is that he was a man given to massive excesses. He worked his way through a veritable army of wives and mistresses and, as portrayed by Holbein, also ate enough to feed one.

Holbein's portrait memorably evokes a monarch who, as Hirst states, 'was no matinee idol. ... He was square-headed, bearded and seriously overweight.'[93] Despite this, the painter's powerful interpretation helped make the King, if not

a matinee idol, then at least a matinee favourite, garbing 'every cinema Henry' in 'the flat hat with plumes, the medallion and the dagger'.[94] Holbein's bulky figure, seized upon and developed by numerous productions, perhaps most influentially in *The Private Life of Henry VIII*, has been forged into the popularly perceived image of the 'ermine-garbed, overweight monarch with a turkey drumstick in one hand'.[95] It is this semi-comical image that *The Tudors* contests with its dangerous, athletic and lustful protagonist.

In *The Tudors* the monarch lords over a very different kingdom than that of Laughton's Henry, a difference perhaps best illustrated in comparable scenes from both versions. In *The Private Life of Henry VIII* the royal palace is depicted as a happy place where, when Henry tells a joke, the camera follows the infectious laughter rolling through the corridors, past soldiers and guests, and into the kitchen where the cooks join in the merriment. In contrast, in the opening episode of *The Tudors*, it is the sounds of the King's passionate lovemaking that reverberate around the palace. It is not happiness but the sovereign's sexual desires that dominate his court and the grunts and moans of intercourse that echo down the corridors as the camera tracks past impassive servants and soldiers who remain stony-faced while listening to his pleasure.

Over the course of its four seasons *The Tudors* explores in detail Henry's domination of his wives, his court and his people as well as his captivatingly contradictory nature. It depicts his affection for friends and lovers and also his brutality towards them and the consequent fear in which he is held. It portrays his love for his wives accompanied by his monstrous desire to kill them and above all focuses upon his self-centredness and egotism as a man who indulges in every advantage kingship can offer. It also rescues the King from the conservatism of prior depictions. In this regard Robinson's appraisal of *The Tudors* as presenting a 'punk-rock' Henry is not entirely unsuitable. It is, after all, a counter-cultural depiction that *The Tudors* offers and one that in many respects does this particular monarch a favour.

NOTES

1 I refer throughout to Christopher Lockett's definition of received history that 'refers to the aggregate of stories, images, caricatures, and qualities associated with' a period or figure 'that come to define our expectations in the cultural imaginary'. Christopher Lockett, 'Accidental history: mass culture and HBO's *Rome*', *Journal of Popular Film and Television* 38:3 (2010), p. 102.

2 Ramona Wray, 'The network king: recreating Henry VIII for a global television audience', in Mark Thornton Burnett and Adrian Streete (eds), *Filming and Performing Renaissance History* (Basingstoke: Palgrave Macmillan, 2011), p. 18.

3 Sue Parrill and William B. Robinson, *The Tudors on Film and Television* (Jefferson, NC: McFarland, 2013), p. 248.

4 Raymond Durgnat, *A Mirror for England: British Movies from Austerity to Affluence* (London: Faber & Faber, 1970).

5 Deborah Cartmell and I. Q. Hunter, 'Introduction. Retrovisions: historical makeovers in film and literature', in Deborah Cartmell and I. Q. Hunter (eds), *Retrovisions: Reinventing the Past in Film and Fiction* (London: Pluto, 2011), p. 3.

6 Tana Wollen, 'Over our shoulders: nostalgic screen fictions for the 1980s', in John Corner and Sylvia Harvey (eds), *Enterprise and Heritage: Crosscurrents of National Culture* (London: Routledge, 1991), p. 186.

7 Robin Nelson, 'Costume drama (Jane Austen adaptations)', in Glen Creeber (ed.), *The Television Genre Book* (London: BFI, 2001), p. 39.

8 Parrill and Robinson, *The Tudors on Film and Television*, p. 14.

9 William B. Robinson, 'Introduction', in Parrill and Robinson, *The Tudors on Film and Television*, p. 7.

10 In addition to dramas, Henry has also appeared frequently in documentaries featuring performed reconstructions of events that occurred during his reign, such as David Starkey's series *Six Wives of Henry VIII* (2001, Channel 4) (in which both Andy Rashleigh and Chris Larkin played the King) and *Henry and Anne: The Lovers Who Changed History* (2014, Channel 5) (in which Jack Hawkins played the part).

11 Rachael Low, *The History of British Film (1906–1914)* (London: Allen and Unwin, 1949), p. 209.

12 James Park, *British Cinema: The Light that Failed* (London: B. T. Batsford, 1990), p. 44.

13 Roy Armes, *A Critical History of the British Cinema* (London: Secker & Warburg, 1978), pp. 116–17.

14 James Chapman, *Past and Present: National Identity and the British Historical Film* (London: I.B.Tauris, 2005), p. 13.

15 Greg Walker, *The Private Life of Henry VIII* (London: I.B.Tauris, 2003), p. ix.

16 Chapman, *British Cinema*, p. 8.

17 Armes, *A Critical History of the British Cinema*, p. 116.

18 Quoted in Stephen Watts, 'Alexander Korda and the international film', *Cinema Quarterly* 2:1 (1933), pp. 13–14.

19 Robert Murphy, *Sixties British Cinema* (London: BFI, 1992), p. 6.

20 Parrill and Robinson, *The Tudors on Film and Television*, p. 1.

21 Eckart Voigts-Virchow, 'History: the sitcom, England: the theme park – *Blackadder's* retrovisions as historiographic meta-TV', in Gaby Allrath and Marion Gymnich (eds), *Narrative Strategies in Television Series* (Houndmills: Palgrave Macmillan, 2005), p. 223.

22 Renée Pigeon, '"No man's Elizabeth": the Virgin Queen in recent films', in Cartmell, Hunter and Whelehan (eds), *Retrovisions: Reinventing the Past in Film and Fiction*, p. 8.

23 James Leggott, *Contemporary British Cinema: From Heritage to Horror* (London: Wallflower, 2008), p. 77.

24 Susan Doran, 'From Hatfield to Hollywood: Elizabeth I on film', in Susan Doran and Thomas S. Freeman (eds), *Tudors and Stuarts on Film: Historical Perspectives* (Basingstoke: Palgrave Macmillan, 2009), p. 102.

25 Hilary Mantel, 'Royal bodies', *London Review of Books* 35:4 (2013), www.lrb.co.uk/v35/n04/hilary-mantel/royal-bodies.

26 *Today's Cinema* (27 October 1971), p. 9.

27 Chapman, *Past and Present*, p. 257.

28 Robin Nelson, *TV Drama in Transition: Forms, Values and Cultural Change* (Basingstoke: Macmillan, 1997), p. 150.

29 Chapman, *Past and Present*, p. 324.

30 Julianne Pidduck, '*Elizabeth* and *Shakespeare in Love*: screening the Elizabethans', in G. Vincendeau (ed.), *Film/Literature/Heritage: A Sight and Sound Reader* (London: BFI, 2001), p. 133.

31 Shawn Shimpach, *Television in Transition: The Life and Afterlife of the Narrative Action Hero* (Oxford: Wiley-Blackwell, 2010), p. 7.

32 'No sex please, we're British', *Live* supplement of *Mail on Sunday* (16 September 2012), p. 16.

33 Quoted in Alan Riding, 'When Henry VIII was young, beardless, even thin', *New York Times* (11 October 2006), www.nytimes.com/2006/10/11/arts/television/11tudo.html?pagewanted=all.

34 *Ibid.*

35 Stephen Lacey, 'Too theatrical by half? *The Admirable Crighton* and *Look Back in Anger*', in I. MacKillop and N. Sinyard (eds), *British Cinema of the 1950s: A Celebration* (Manchester: Manchester University Press, 2003), p. 160.

36 Chapman, *Past and Present*, p. 255.

37 Pidduck, '*Elizabeth* and *Shakespeare in Love*: screening the Elizabethans', p. 131.

38 Brian Lowry, 'Showtime leaps into bed with Henry VIII', *Variety* (26 March 2007), p. 22+, http://go.galegroup.com/ps/i.do?id=GALE%7CA161750671&v=2.1&u=mmucal5&it=r&p=AONE&sw=w&asid=4a96a40b437a29635f40544431d3b2fb.

39 Ginia Bellafante, 'Nasty, but not so brutish and short', *New York Times* (28 March 2008), www.nytimes.com/2008/03/28/arts/television/28tudo.html?_r=0.

40 Chapman, *Past and Present*, p. 257.

41 Peter Marshall, 'Saints and cinemas: *A Man for All Seasons*', in Doran and Freeman (eds), *Tudors and Stuarts on Film*, p. 51.

42 Sue Harper, 'Bonnie Prince Charlie revisited: British costume film in the 1950s', in Robert Murphy (ed.), *The British Cinema Book* (London: BFI, 2nd edn, 2001), p. 127.

43 Robinson, 'Introduction', p. 11.

44 *Ibid.*, p. 6.

45 Mary Jo Murphy, 'Dear Anne, not ready to kill you yet', *New York Times* (6 May 2007), www.nytimes.com/2007/05/06/weekinreview/06read.html.

46 Wray, 'The network king', p. 18.

47 ‘ "Tudors" reign in premiere on Showtime', *Multichannel News* (9 April 2007), p. 25, http://go.galegroup.com/ps/i.do?id=GALE%7CA161747723&v=2.1&u=mmucal 5&it=r&p=AONE&sw=w&asid=f0532d8d31f824d48dd01e6390567567.

48 Josef Adalian, ‘Royalty rules: *Tudors* bow makes cabler history', *Daily Variety* (4 April 2007), p. 1+, http://go.galegroup.com/ps/i.do?id=GALE%7CA162300723&v=2.1& u=mmucal5&it=r&p=AONE&sw=w&asid=3c0f82dfcabee5a04be51763e9fd54df.

49 Steven Zeitchik, ‘Net's royal plush: it's Showtime as pay cabler places big bet on *Tudors*', *Variety* (19 March 2007), p. 13+, http://go.galegroup.com/ps/i.do?id=GAL E%7CA161395802&v=2.1&u=mmucal5&it=r&p=AONE&sw=w&asid=4b657741 40f7256c34dbcf7e6fe387d3.

50 Parrill and Robinson, *The Tudors on Film and Television*, p. 248.

51 *Ibid.*

52 Zeitchik, ‘Net's royal plush'.

53 Alessandra Stanley, ‘Renaissance romping with Henry and his rat pack', *New York Times* (30 March 2007), www.nytimes.com/2007/03/30/arts/television/30tudo. html.

54 Rachel Cooke, ‘King Henry, Lady Jane and Hugo Boss', *New Statesman* (24 August 2009), p. 49.

55 Parrill and Robinson, *The Tudors on Film and Television*, p. 248.

56 Riding, ‘When Henry VIII was young, beardless, even thin'.

57 Eva Hall, ‘Ireland's Gabriel Byrne joins cast of Morgan O'Sullivan's *Vikings*', *The Irish Film & Television Network* (22 May 2012), www.iftn.ie/news/?act1=record&onl y=1&aid=73&rid=4284958&tpl=archnews&force=1.

58 Riding, ‘When Henry VIII was young, beardless, even thin'.

59 Quoted *ibid.*

60 Michael Hirst, ‘Foreword', in *The Tudors: It's Good to Be King – Final Shooting Scripts 1–5 of the Showtime Series* (New York: Simon &Schuster, 2007), p. xi.

61 Bellafante, ‘Nasty, but not so brutish and short'.

62 Murphy, ‘Dear Anne, not ready to kill you yet'.

63 Lowry, ‘Showtime leaps into bed with Henry VIII'.

64 Bellafante, ‘Nasty, but not so brutish and short'.

65 Cooke, ‘King Henry, Lady Jane and Hugo Boss'.

66 D. Brook, ‘Elizabeth I is known as the Virgin Queen. So why does a new film show her having sex with a courtier?', *Mail on Sunday* (13 September 1998), quoted in Thomas S. Freeman, ‘Introduction: it's only a movie', in Doran and Freeman (eds), *Tudors and Stuarts on Film*, p. 7.

67 Pigeon, ‘ "No man's Elizabeth", p. 8.

68 Robinson, ‘Introduction', p. 9.

69 Doran, ‘From Hatfield to Hollywood', p. 103.

70 Christopher Haigh, ‘Kapur's *Elizabeth*', in Doran and Freeman (eds), *Tudors and Stuarts on Film*, p. 134.

71 Vivienne Westbrook, ‘*Elizabeth the Golden Age*: a sign of the times', in Doran and Freeman (eds), *Tudors and Stuarts on Film*, p. 167.

72 Haigh, 'Kapur's *Elizabeth*', p. 128.
73 Hirst, quoted in Haigh, 'Kapur's *Elizabeth*', p. 127.
74 Hirst, 'Foreword', p. xiii.
75 Hirst, quoted in Riding, 'When Henry VIII was young, beardless, even thin'.
76 Hirst, quoted in Anita Gates, 'The royal life (some facts altered)', *New York Times* (23 March 2008), www.nytimes.com/2008/03/23/arts/television/23gate.html.
77 Gates, 'The royal life (some facts altered)'.
78 Hirst, 'Foreword', pp. xiv–xv.
79 Hirst quoted in Haigh, 'Kapur's *Elizabeth*', p. 127.
80 Hirst quoted in Gates, 'The royal life (some facts altered)'.
81 Moya Luckett, 'Image and nation in 1990s British cinema', in Robert Murphy (ed.), *British Cinema of the 90s* (London: BFI, 2000), p. 90.
82 Pamela Church, 'Fewer weddings and more funerals: changes in the heritage film', in Murphy (ed.), *British Cinema of the 90s*, p. 122.
83 Pidduck, '*Elizabeth* and *Shakespeare in Love*: screening the Elizabethans', p. 134.
84 Leggott, *Contemporary British Cinema*, p. 7.
85 Thomas S. Freeman, 'A tyrant for all seasons: Henry VIII on film', in Doran and Freeman (eds), *Tudors and Stuarts on Film*, p. 30.
86 'Farewell to the King: Michael Hirst on *The Tudors* finale', in *The Tudors: The Complete Fourth Season*, DVD (Sony Pictures Home Entertainment, 2012).
87 Kara McKechnie, 'Taking liberties with the monarch: the royal bio-pic in the 1990s', in Claire Monk and Amy Sargeant (eds), *British Historical Cinema: The History, Heritage and Costume Film* (London: Routledge, 2002), p. 226.
88 Leggott, *Contemporary British Cinema*, p. 82.
89 Cartmell and Hunter, 'Introduction', p. 2.
90 Wray, 'The network king', p. 18.
91 Robinson, 'Introduction', p. 6.
92 'Special Features: 11 cast and crew interviews', in *The Tudors: The Complete First Season*, DVD (Sony Pictures Home Entertainment, 2007).
93 Quoted in Riding, 'When Henry VIII was young, beardless, even thin'.
94 Freeman, 'A tyrant for all seasons', p. 30.
95 David Mermelstein, 'Emmy contender: Jonathan Rhys Meyers', *Variety.com* (7 June 2007), http://variety.com/2007/scene/news/emmy-contender-jonathan-rhys-meyers-1117966480.

BIBLIOGRAPHY

Adalian, Josef, 'Royalty rules: *Tudors* bow makes cabler history', *Daily Variety* (4 April 2007), http://go.galegroup.com/ps/i.do?id=GALE%7CA163300723&v=2.1&u=mmucal5&it=r&p=AONE&sw=w&asid=3c0f82dfcabee5a04be51763e9fd54df.
Armes, Roy, *A Critical History of the British Cinema* (London: Secker & Warburg, 1978).

Bellafante, Ginia, 'Nasty, but not so brutish and short', *New York Times* (28 March 2008), www.nytimes.com/2008/03/28/arts/television/28tudo. html?_r=0.

Cartmell, Deborah and I. Q. Hunter, 'Introduction. Retrovisions: historical makeovers in film and literature', in Deborah Cartmell, I. Q. Hunter and Imelda Whelehan (eds), *Retrovisions: Reinventing the Past in Film and Fiction* (London: Pluto, 2011).

Chapman, James, *Past and Present: National Identity and the British Historical Film* (London: I.B.Tauris, 2005).

Cooke, Rachel, 'King Henry, Lady Jane and Hugo Boss', *New Statesman* (24 August 2009).

Doran, Susan, 'From Hatfield to Hollywood: Elizabeth I on film', in Susan Doran and Thomas. S. Freeman (eds), *Tudors and Stuarts on Film: Historical Perspectives* (Basingstoke: Palgrave Macmillan, 2009).

Durgnat, Raymond, *A Mirror for England: British Movies from Austerity to Affluence* (London: Faber & Faber, 1970).

'Farewell to the King: Michael Hirst on *The Tudors* Finale', in *The Tudors: The Complete Fourth Season*, DVD (Sony Pictures Home Entertainment, 2012).

Freeman, Thomas S., 'Introduction: it's only a movie', in Susan Doran and Thomas S. Freeman (eds), *Tudors and Stuarts on Film: Historical Perspectives* (Basingstoke: Palgrave Macmillan, 2009).

———'A tyrant for all seasons: Henry VIII on film', in Susan Doran and Thomas S. Freeman (eds), *Tudors and Stuarts on Film: Historical Perspectives* (Basingstoke: Palgrave Macmillan, 2009).

Gates, Anita, 'The royal life (some facts altered)', *New York Times* (23 March 2008), www.nytimes.com/2008/03/23/arts/television/23gate.html.

Gibson, Pamela Church, 'Fewer weddings and more funerals: changes in the heritage film', in Robert Murphy (ed.), *British Cinema of the 90s* (London: BFI, 2000).

Haigh, Christopher, 'Kapur's *Elizabeth*', in Susan Doran and Thomas S. Freeman (eds), *Tudors and Stuarts on Film: Historical Perspectives* (Basingstoke: Palgrave Macmillan, 2009).

Hall, Eva, 'Ireland's Gabriel Byrne joins cast of Morgan O'Sullivan's *Vikings*', *The Irish Film & Television Network* (22 May 2012), www.iftn.ie/news/?act1=r ecord&only=1&aid=73&rid=4284958&tpl=archnews&force=1.

Harper, Sue, 'Bonnie Prince Charlie revisited: British costume film in the 1950s', in Robert Murphy (ed.), *The British Cinema Book* (London: BFI, 2nd edn, 2001).

Hirst, Michael, 'Foreword', in *The Tudors: It's Good to Be King – Final Shooting Scripts 1–5 of the Showtime Series* (New York: Simon & Schuster, 2007).

Lacey, Stephen, 'Too theatrical by half? *The Admirable Crighton* and *Look Back in Anger*', in Ian MacKillop and Neil Sinyard (eds), *British Cinema of the 1950s: A Celebration* (Manchester: Manchester University Press, 2003).

Leggott, James, *Contemporary British Cinema: From Heritage to Horror* (London: Wallflower, 2008).

Lockett, Christopher, 'Accidental history: mass culture and HBO's *Rome*', *Journal of Popular Film and Television* 38:3 (2010).

Low, Rachael, *The History of British Film (1906–1914)* (London: Allen and Unwin, 1949).

Lowry, Brian, 'Showtime leaps into bed with Henry VIII', *Variety* (26 March 2007), http://go.galegroup.com/ps/i.do?id=GALE%7CA161750671&v=2.1&u=mmucal5&it=r&p=AONE&sw=w&asid=4a96a40b437a29635f40544431d3b2fb.

Luckett, Moya, 'Image and nation in 1990s British cinema', in Robert Murphy (ed.), *British Cinema of the 90s* (London: BFI, 2000).

Mantel, Hilary, 'Royal bodies', *London Review of Books* 35:4 (2013), www.lrb.co.uk/v35/n04/hilary-mantel/royal-bodies.

Marshall, Peter, 'Saints and cinemas: *A Man for All Seasons*', in Susan Doran and Thomas S. Freeman (eds), *Tudors and Stuarts on Film: Historical Perspectives* (Basingstoke: Palgrave Macmillan, 2009).

McKechnie, Kara, 'Taking liberties with the monarch: the royal bio-pic in the 1990s', in Claire Monk and Amy Sargeant (eds), *British Historical Cinema: The History, Heritage and Costume Film* (London: Routledge, 2002).

Mermelstein, David, 'Emmy contender: Jonathan Rhys Meyers', *Variety.com* (7 June 2007), http://variety.com/2007/scene/news/emmy-contender-jonathan-rhys-meyers-1117966480.

Murphy, Mary Jo, 'Dear Anne, not ready to kill you yet', *New York Times* (6 May 2007), www.nytimes.com/2007/05/06/weekinreview/06read.html.

Murphy, Robert, *Sixties British Cinema* (London: BFI, 1992).

Nelson, Robin, *TV Drama in Transition: Forms, Values and Cultural Change* (Basingstoke: Macmillan, 1997).

——'Costume drama (Jane Austen adaptations)', in Glen Creeber (ed.), *The Television Genre Book* (London: BFI, 2001).

'No sex please, we're British', *Live* supplement of *Mail on Sunday* (16 September 2012).

Park, James, *British Cinema: The Light that Failed* (London: B. T. Batsford, 1990).

Parrill, Sue and William B. Robinson, *The Tudors on Film and Television* (Jefferson, NC: McFarland, 2013).

Pidduck, Julianne, '*Elizabeth* and *Shakespeare in Love*: screening the Elizabethans', in Ginette Vincendeau (ed.), *Film/Literature/Heritage: A Sight and Sound Reader* (London: BFI, 2001).

Pigeon, Renée, '"No man's Elizabeth": the Virgin Queen in recent films', in Deborah Cartmell, I. Q. Hunter and Imelda Whelehan (eds), *Retrovisions: Reinventing the Past in Film and Fiction* (London: Pluto, 2011).

Riding, Alan, 'When Henry VIII was young, beardless, even thin', *New York Times* (11 October 2006), www.nytimes.com/2006/10/11/arts/television/11tudo.html?pagewanted=all.

Robinson, William B., 'Introduction', in Sue Parrill and William B. Robinson, *The Tudors on Film and Television* (Jefferson, NC: McFarland, 2013).

Shimpach, Shawn, *Television in Transition: The Life and Afterlife of the Narrative Action Hero* (Oxford: Wiley-Blackwell, 2010).

'Special features: 11 cast and crew interviews', in *The Tudors: The Complete First Season*, DVD (Sony Pictures Home Entertainment, 2007).

Stanley, Alessandra, 'Renaissance romping with Henry and his rat pack', *New York Times* (30 March 2007), www.nytimes.com/2007/03/30/arts/television/30tudo.html.

Today's Cinema (27 October 1971).

'"Tudors" reign in premiere on Showtime', *Multichannel News* (9 April 2007), http://go.galegroup.com/ps/i.do?id=GALE%7CA161747723&v=2.1&u=mmucal5&it=r&p=AONE&sw=w&asid=f0532d8d31f824d48dd01e6390567567.

Voigts-Virchow, Eckart, 'History: the sitcom, England: the theme park – *Blackadder*'s retrovisions as historiographic meta-TV', in Gaby Allrath and Marion Gymnich (eds), *Narrative Strategies in Television Series* (Houndmills: Palgrave Macmillan, 2005).

Walker, Greg, *The Private Life of Henry VIII* (London: I.B. Tauris, 2003).

Watts, Stephen, 'Alexander Korda and the international film', *Cinema Quarterly* 2:1 (1933).

Westbrook, Vivienne, '*Elizabeth the Golden Age*: a sign of the times', in Susan Doran and Thomas S. Freeman (eds), *Tudors and Stuarts on Film: Historical Perspectives* (Basingstoke: Palgrave Macmillan, 2009).

Wollen, Tana, 'Over our shoulders: nostalgic screen fictions for the 1980s', in John Corner and Sylvia Harvey (eds), *Enterprise and Heritage: Crosscurrents of National Culture* (London: Routledge, 1991).

Wray, Ramona, 'The network king: recreating Henry VIII for a global television audience', in Mark Thornton Burnett and Adrian Streete (eds), *Filming and Performing Renaissance History* (Basingstoke: Palgrave Macmillan, 2011).

Zeitchik, Steven, 'Net's royal plush: it's Showtime as pay cabler places big bet on *Tudors*', *Variety* (19 March 2007), http://go.galegroup.com/ps/i.do?id=GALE%7CA161395802&v=2.1&u=mmucal5&it=r&p=AONE&sw=w&asid=4b65774140f7256c34dbcf7e6fe387d3.

Part VI

Monarchy in contemporary anglophone cinema

15

From political power to the power of the image: contemporary 'British' cinema and the nation's monarchs

Andrew Higson

From Kenneth Branagh's *Henry V* Shakespeare adaptation in 1989 to the story of the final years of the former Princess of Wales, in *Diana* in 2013, at least twenty-six English-language feature films dealt in some way with the British monarchy.[1] All of these films (the dates and directors of which will be indicated below) retell more or less familiar stories about past and present kings and queens, princes and princesses. This is just one indication that the institution of monarchy remains one of the most enduring aspects of the British national heritage: these stories and characters, their iconic settings and their splendid *mise-en-scène* still play a vital role in the historical and contemporary experience and projection of British national identity and ideas of nationhood.

These stories and characters are also of course endlessly recycled in the present period in other media as well as through the heritage industry. The monarchy, its history and its present manifestation, is clearly highly marketable, whether in terms of tourism, the trade in royal memorabilia or artefacts, or images of the monarchy – in paintings, prints, films, books, magazines, television programmes, on the Internet and so on. The public image of the monarchy is not consistent across the period being explored here, however, and it is worth noting that there was a waning of support for the contemporary royal family in the 1990s, not least because of how it was perceived to have treated Diana. Support waxed again in the 2000s, bolstered by the ceremonial surrounding the death of the Queen Mother and the Golden Jubilee of Queen Elizabeth II in 2002, the marriage of Prince William and Kate Middleton in 2011 and the Queen's Diamond Jubilee in 2012.

At least sixteen different monarchs appeared in 'British' films of the 1990s and 2000s, charting the history of the nation from the decline of the Roman era to the present-day, from the legendary King Arthur in the film of the same name to the present Queen Elizabeth II in *The Queen*. Kings and queens from various periods appear in films as diverse as *Braveheart* and *Hyde Park on Hudson*, *Robin Hood: Men in Tights* and *Mrs. Brown*, *Elizabeth* and *W./E.*, *The Madness of King George* and *The Young Victoria*, *To Kill a King* and *The King's Speech*. While all of these films engage with history, they are also creative products designed to work as profitable entertainment commodities. They are to that extent part of the imaginative construct that is heritage. As such, historical accuracy is not the interest here, but rather the way that films from the late twentieth and early twenty-first centuries present the British monarchy to contemporary global audiences, the way they imagine the monarchy, and in so doing forge a particular sense of British national identity.

Heritage is not politically neutral – heritage artefacts, events and representations always carry with them particular ideas about how we might view the past, and how the past might be used in the present. One of the most vital features of Britain's royal heritage is the sense of longevity and tradition; to mobilise it is in part to establish a sense of continuity between past and present, to insert the national present into a national tradition. Paradoxically, if the royal films at one level align their celluloid monarchs with the ideologies of tradition and continuity, at another they play a vital role in modernising the contemporary image of the British monarchy. Thus they tell relatively familiar stories in new ways, variously drawing on the conventions of romantic drama, action adventure and family drama, and on the conventions of both historical drama and contemporary drama.[2]

They weave together images from historical paintings and contemporary star images, stories from history books and iconography borrowed from other films. They present a seductive and alluring *mise-en-scène* of enormous wealth, luxury and privilege that is very much the product of inheritance and historical legacy. But they also tell stories that are shot through with present-day concerns, anxieties and reference points. Thus in the films set in the late eighteenth century and later, the spectacle of heritage is countered by scenes from modern, domestic, middle-class family life. The blurring of past and present almost by definition colours the way in which these royal films work – as historical dramas, they take us back to an earlier period, and sometimes to a pre-industrial space, and rely heavily on a sense of tradition and

convention. But as films, they are part of the modern industrialised culture of consumption.

How then do these various films function in contemporary culture? To tackle this question it is necessary to situate these films firstly as products of the entertainment business, created for particular markets, drawing on varying generic models, and consumed by a range of different audiences. In this context, the fact that the films feature monarchs is almost incidental. At the same time, these films do represent those monarchs as characters in particular types of drama, and a second set of questions then concerns the nature of the portrayal of the British monarchy for contemporary audiences. In particular, depictions of monarchs from different historical periods demonstrate changes in the nature of royal power and authority. These changes can be seen in the differing degrees of narrative agency afforded to different monarchs, and in the representation of the monarch as national figurehead, the spectacle of pomp and ceremony, the depiction of the royal body and the image of the royal family.

A third set of questions concern the extent to which these films not only represent the historical monarchy but also help maintain the institution of the monarchy by making it seem relevant and attractive to contemporary audiences. Given that these films play to international audiences, it is also important to ask about the role that the filmic heritage of monarchy plays in the construction of British national identity in a globalised world. These three approaches are closely interrelated: if we are to understand the part these films might play in maintaining and modernising the monarchy, we need to look at how these films work as films, the cinematic function they perform and the types of entertainment and engagement they offer.[3]

'BRITISH' FILMS ABOUT THE ROYALS, 1989–2013

This analysis will concentrate on the circumstances under which and the ways in which several of the English-language, UK/US fiction films of the 1990s and 2000s have engaged with the royals. Most of these films were transnational productions, often dependent on American involvement, in terms of the circumstances of their financing, their production and distribution and the creative team behind them. Some of them are classified as UK productions, some as US productions and some as UK/US productions. The national is therefore *not* a key concept for all involved parties – hence the inverted commas around the word 'British' in my title.

341

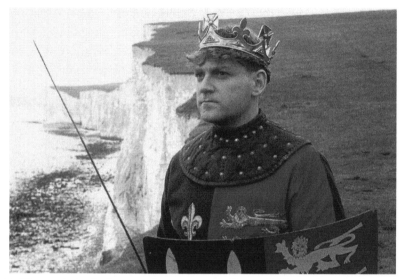

29 The mythologised pre-modern monarch: Henry V (Kenneth Branagh) in the Shakespeare adaptation directed by Branagh in 1989.

Films released between 1989 and 2013 about the British monarchy can be assigned to three historical periods: the pre-modern monarchy; the early modern monarchy of the Tudors and the Stuarts; and the late modern monarchy from the Hanoverians to the Windsors.

Films in the first category depict the real and legendary monarchs of medieval times and earlier, all of them heavily mythologised, most dealing with warrior kings and thus working with the conventions of the action-adventure film as it cross-breeds with the epic, the parody and the Shakespeare adaptation. While these films and monarchs will not figure large in what follows, it is worth noting the range of films that fall into this category, organised chronologically in terms of the historical period depicted in the films:

- *King Arthur* (Antoine Fuqua, 2004), dealing with the legendary King Arthur
- *Braveheart* (Mel Gibson, 1995), Edward I
- *Edward II* (Derek Jarman, 1991), Edward II
- *Robin Hood: Prince of Thieves* (Kevin Reynolds, 1991), Richard I
- *Robin Hood: Men in Tights* (Mel Brooks, 1993), Richard I
- *Robin Hood* (Ridley Scott, 2010), Richard I, John
- *Henry V* (Kenneth Branagh, 1989), Henry V
- *Richard III* (Richard Loncraine, 1995), Richard III.

The films that fall into the second category depict the early modern monarchs, the more or less absolutist kings and queens of the Tudor and Stuart periods, from Henry VIII to Charles II, with Elizabeth I very much at the centre of attention. Instead of warriors, these kings and queens become elaborately ornamentalised rulers, who do pretty much as they please, in public and in private – although such behaviour costs Charles I his head in *To Kill a King*. The films and monarchs that fall into this category include:

- *The Other Boleyn Girl* (Justin Chadwick, 2008), dealing with Henry VIII
- *Elizabeth* (Shekhar Kapur, 1998), Elizabeth I
- *Elizabeth: The Golden Age* (Shekhar Kapur, 2007), Elizabeth I
- *Shakespeare in Love* (John Madden, 1998), Elizabeth I
- *Anonymous* (Roland Emmerich, 2011), Elizabeth I
- *Orlando* (Sally Potter, 1992), Elizabeth I
- *To Kill a King* (Mike Barker, 2003), Charles I
- *Restoration* (Michael Hoffman, 1995), Charles II
- *Stage Beauty* (Richard Eyre, 2004), Charles II
- *The Libertine* (Laurence Dunmore, 2005), Charles II.

The third and final category includes those films that depict the constitutional monarchy of the late modern period, from 'mad' King George to the present Queen Elizabeth. These films are much more focused on the private sphere: romance, family and the life of the royal household. The public sphere of politics and events outside the royal household tends to function as a backdrop, only intruding on the drama in so far as it is the consequence of what happens in the private sphere. Films and monarchs that fall into this category, again ordered by the date of their setting, include:

- *The Madness of King George* (Nicholas Hytner, 1994), dealing with George III
- *The Young Victoria* (Jean-Marc Vallée, 2009), Victoria
- *Mrs. Brown* (John Madden, 1997), Victoria
- *W./E.* (Madonna, 2011), Edward VIII
- *The King's Speech* (Tom Hooper, 2010), George V, Edward VIII and George VI
- *Hyde Park on Hudson* (Roger Michell, 2012), George VI
- *The Queen* (Stephen Frears, 2006), Elizabeth II
- *Diana* (Oliver Hirschbiegel, 2013), dealing with Diana, Princess of Wales, and with the fall-out from her close relationship to the monarchy.

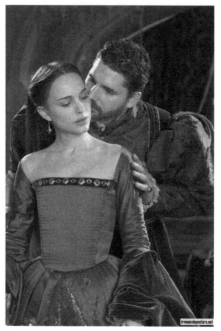

30 The ornamentalised early modern monarch: Henry VIII (Eric Bana) with Anne Boleyn (Natalie Portman) in *The Other Boleyn Girl* (Justin Chadwick, 2008)

If the first category of films is closely related to one of the archetypal boy's genres, the action-adventure film, then this final category is much more closely related to what used to be called the woman's film; it is also much more closely related to the middlebrow quality film, the art-house film or, more likely, the crossover film that can straddle both the specialised art-house market and the multiplex mainstream. The films in the second category hover between the more masculinist and bigger-budget action-adventure film and the lower-budget, more female-orientated, romance-laden costume drama in its middlebrow quality-film guise.

MARKETING MONARCHY: ROYAL FILMS AND THE FILM BUSINESS[4]

None of these films would have been made if they hadn't at some level been understood as entertainment commodities, addressed to particular audiences. As already noted, their varying genre attributes mean they occupy very different places in the market, in terms of their target demographic. This is partly a

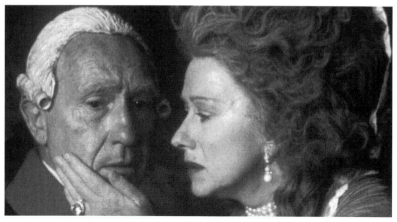

31 The domesticated late modern monarch: King George III
(Nigel Hawthorne) and Queen Charlotte (Helen Mirren) in
The Madness of King George (Nicholas Hytner, 1994).

question of genre and style, it is partly about production budgets and aspirations, it is partly about marketing and promotion and it is partly about modes of distribution and dissemination.

All eight of the films listed above as depicting the late modern British monarchy were modestly budgeted by Hollywood standards, but several proved very successful with audiences at the box-office and subsequently in all the ancillary markets of video, DVD, television, video-on-demand services and so on. Most of the films were pitched at the quality end of the market, and designed to make a mark with critics but also with middle-class and middle-aged audiences attached to particular notions of taste and particular types of cultural capital. However, they were also designed to appeal beyond that tightly defined segment. As such, they were conceived as crossover products that might move between small specialist or art-house cinemas and mainstream multiplexes – and most of them more or less made their mark in this way.

Indeed, *The Madness of King George* and *Mrs. Brown* became important touchstones for the industry and how it thinks about what it calls the boutique end of the business, or the specialised market, and how films made with that market in mind could become significant money-spinners and reputation enhancers. Profit and prestige were thus understood as working hand in hand. It's worth noting in this context that five of the late modern monarchy films listed above were Oscar winners, garnering awards for art direction, for costume design, for

acting and, in the case of *The King's Speech*, for best film. In other words, the focus was very much on the image, on visual presentation.

This particular discourse of quality shapes the way that such films function in the market-place, but crucially it also shapes the way the late modern monarchy is represented and understood – in terms of 'good' taste and a particular class-bound cultural sensibility. *The Young Victoria* is slightly different, in that it is one of those costume dramas that was deliberately designed to attract a younger audience – although it wasn't actually very successful at the box-office for a film of its budget size. *W./E.* and *Diana*, both dealing with characters who were seen as deviant in relation to the monarchy, and both rather different from the other royal films in this list, fared even worse.

Several of the films about earlier monarchs, both medieval and early modern, are also pitched at the quality end of the market. Some of them were distinctly auteur-led, art-house films, like Derek Jarman's *Edward II* and Sally Potter's *Orlando*. Some were crossover films that hovered between the art-house and the mainstream, such as the two *Elizabeth* films, which, like *The Young Victoria*, were designed to reach wider audiences, male as well as female, and the young as well as the middle-aged. *Elizabeth* in particular was very successful in reaching out to those wider audiences. *Braveheart*, directed by and starring Mel Gibson, the various versions of Robin Hood and the Jerry Bruckheimer production of *King Arthur*, all action-adventure films, were intended for quite different audiences, and in most cases employed much larger budgets designed to achieve success in the multiplex mainstream market.

As a storehouse of relatively familiar stories and characters that can be exploited by the global creative industries, the British monarchy is a worldwide brand. The films which depict it are designed to appeal to both domestic and international audiences, and especially to engage with the US fascination with the British royal family and the 'old country' more generally. Note in this context the ambivalence of *The Madness of King George* in relation to America. On the one hand, at the level of the narrative, it details in passing America's historical break with the British monarchy in the late eighteenth century. As a production with US investment, however, it plays on a more recent American re-engagement with the spectacle of tradition, the allure of the British monarchy and a culturally sanctified Anglophilia, thereby renewing and reaffirming the tie with Britain at a different level.

Hyde Park on Hudson (2012), which involves King George VI and his wife Queen Elizabeth's visit to Franklin D. Roosevelt's estate in Hyde Park, New York, in

1939, again emphasises the distance between the USA and the British monarchy at this point in history. There is almost no ceremonial spectacle; indeed, the formality of the monarchy is more the subject of ridicule. But the King is portrayed as a sympathetic, flawed character who is drawn out of his shell by Roosevelt's down-to-earth Americanness. The effect is to diminish the mystique of the royals, which is in many ways typical of the way the British monarchy has been modernised through the twentieth and early twenty-first centuries. It is perhaps not insignificant, however, that the film did not fare particularly well at the American box-office, especially by comparison with *The Madness of King George*, or indeed with *The King's Speech*, which portrayed King George VI as a much more engaging, emotionally rounded but still deeply flawed character.

THE QUESTION OF GENRE

In terms of how these various royal films function as products of the entertainment industry, designed for particular markets, the question of genre and style is clearly significant. Yet the monarchy film is not in itself a generic category that the industry uses, and it's not particularly important in promotional discourses and practices – even if the royal connection may be important to some audiences. More significant is the way that these films draw on more established genres such as the action-adventure film and the quality costume drama in order to address different market segments, and in the case of certain films, notably *Elizabeth*, the way they are able to mix those genres and bring those segments together around the same viewing experience.

Many of the royal films – and especially those about early and late modern monarchs – are period dramas in which lavish costumes play a vital role. As such, this genre underlines the link between the role of dress and the formation of the public image of monarchy. The spectacle of costume is one means of establishing the pomp and splendour of the monarchy on film. In the case of the Tudors, the extravagance of costume enables the royals not simply to inhabit but to dominate absolutely the theatre of power. Note the way in which Henry VIII's costume in *The Other Boleyn Girl* dramatically enhances his stature, for instance, and the way Elizabeth I uses costume in the final scene of *Elizabeth* to become an almost divine national figurehead. For the more modern monarchs, on the other hand, costume is one of the ways of maintaining the semblance of power, but it is now the soft power of the public image rather than genuinely political or military power.[5] This process of costuming the monarch

to achieve the semblance of power is particularly evident in *The Madness of King George*, especially in its opening and closing scenes.

Costume is in this sense just one aspect of the fetishisation of material culture in the quality heritage film, with its display of loosely period-appropriate objects, decor, architecture and man-made landscapes. This particular way of developing the *mise-en-scène* of so many of the royal films is designed to establish both an experience of realism and historicity, and a sense of spectacle. But of course there are many other period films that play with costumes and the spectacular *mise-en-scène* of pastness but don't feature monarchs.

Several of the costume dramas that do feature monarchs also draw on the generic conventions of the biopic, the romantic drama or the family saga – and again the fact that they are about monarchs is almost incidental. Depicting a part or the whole of the life of a monarch is just one way of telling the sort of engaging, character-centred stories that the quality film audience seek out. Films such as *Mrs. Brown* or *The Young Victoria* may present scenes from the life of Queen Victoria, but for some audiences they will simply be well-made, character-driven dramas. Other royal films function as dramas about characters facing extraordinary crises in their personal lives: Elizabeth in the film of the same name, for instance, or George III in *The Madness of King George*, or Bertie, George VI, in *The King's Speech*.

Thus, if for some viewers all these films are indeed films about the monarchy, for other viewers and for industry stakeholders, the royals are simply characters in a drama, elements of the *mise-en-scène*. Perhaps this is the most important role these films play in modernising the monarchy, in updating the royal heritage. They situate the royals as narrative protagonists in stories about romance, they dress them up in costumes that appeal to a particular idea of spectacle, they insert them into a particular *mise-en-scène* of the national past and they sell those stories to global audiences. By situating the royals within relatively conventional genres of popular and middlebrow culture, the various types of films that feature the monarchy treat them both as banal, taken for granted, an undeniable part of contemporary culture and as a special brand of celebrity, a particular type of cultural icon, a cipher for national identity and even nationhood in a global world. By exploiting a fascination with the British royal families, and almost regardless of whether they represent the royals in a sympathetic manner, such films play a role in maintaining the monarchy as a contemporary cultural presence and help shape the way contemporary audiences perceive the monarchy.

THE MONARCH AS NATIONAL FIGUREHEAD: POWER
AND AUTHORITY

If from one perspective, the films under discussion are simply genre pieces in which British royal personages happen to appear, the presence of those royals clearly does have an impact on how the monarchy is viewed by late twentieth- and early twenty-first-century audiences. The following sections of this chapter therefore examine in more detail the different ways in which these films imagine the royal heritage and depict the monarch as national figurehead. In particular, they examine how power and authority are exercised through the royal body, through spectacular representation and through the insertion of the monarch within an image of the royal family.

All of the royal films in their different ways negotiate the idea of the monarch as national figurehead. That status may be well established, as in the supreme self-confidence and larger-than-life stature of Henry VIII in *The Other Boleyn Girl*, or in Charles II's equally assured embodiment of the powerful monarch in *Restoration*. In other films, that status of national figurehead may still be in the process of being established, as in *Elizabeth*, where the ascent to absolute power of the eponymous queen is imaginatively reconstructed; or in *The King's Speech*, where George VI must overcome his stammer to win the affection of his people. Or the status of the monarch as national figurehead may be thrown into crisis and need to be re-established, as it is in *To Kill a King*, in which Charles I is beheaded during the English Civil War; or in *The Queen*, where Elizabeth II loses the support of her people over the way she responds to the death of Diana, the People's Princess.

The authority of the national figurehead is represented in various ways and takes various forms. Firstly, it can be represented in terms of naked power – the power that the monarch wields, the power to make things happen, to issue demands that are acted upon, to use physical force. A second means by which national and even global authority and respect is achieved in these films is through the strategic creation of an awe-inspiring image by surrounding the monarch with pomp and ceremony, adorning the royal body and inserting it into a *mise-en-scène* of majesty. A third means by which the authority of the national figurehead is represented on film is through the idea of the royal family as a metaphor for the national family and a model for the nation. The idea of the British royal family as a key national icon is relatively new, suggesting that if representations of royalty at one level function to establish a sense of tradition and continuity, they are also at the same time about change.

One of the central issues in the filmic representation of monarchy, then, is the representation of power, something that all of these films tackle in one way or another. The films about medieval and early modern monarchs show them as able to wield more or less absolute power and establish themselves as national figureheads by force. These medieval warrior kings and queens and the often ruthlessly powerful Tudor and Stuart monarchies gradually give way to the increasingly constitutional monarchies of the late modern period. In the films that depict this period, the celluloid monarchs are really only able to wield power within the much more heavily circumscribed space of the private sphere, within their own family or the royal household. Unable to secure their status as national figurehead by force, they must do so by other means.

At one extreme, then, are those monarchs who rule, those who govern, those who have executive authority unbound by the laws of the land, by a constitution or by convention, those who have the ability to override politicians, officials and advisers and make their own decisions that affect the well-being of the nation. Both Henry VIII in *The Other Boleyn Girl* and Elizabeth in the two eponymously named films at times exercise this version of power in the public sphere of the court, while in *Henry V* it is exercised on the battlefield. At the other extreme, in the words of the constitutional historian Vernon Bogdanor, is the 'sovereign who reigns but does not rule'.[6] This is precisely the fate of the late modern monarchs on film: they are ceremonial monarchs who merely reign, whose actions *are* limited by constitution and convention, whose political power is severely circumscribed. These are monarchs, then, who accede executive power to the elected politicians, the prime minister and the government. Obliged by constitutional law to stand above politics, their power is thereby restricted to the private sphere and they are only able to make decisions that affect the members of their families and royal households, rather than the nation as a whole.

In *The Madness of King George*, the elected politicians are constantly seeking to curtail George III's attempts to intervene in political affairs. In *The Young Victoria*, they negotiate with the young queen about how she is able to behave in relation to political affairs. By the time of *The King's Speech*, the focus is almost resolutely on George VI's private life, and his efforts to control his stammer; his interventions in the public sphere are primarily intended to voice the will of the Prime Minister and his cabinet, without question.

This shift away from monarchs who both wield immense political power and appear as spectacularly majestic figureheads is at the same time a shift to the representation of the late modern monarchy as possessing very little political

power and influence but still playing a crucial symbolic or ideological role as national figurehead. This symbolic power – this power of the image – is vital to the maintenance of the institution of monarchy. As historian David Cannadine has argued, 'as the real power of the monarchy waned, the way was open for it to become the centre of grand ceremonial once more'.[7] As he and others demonstrate, much of the monarchical ritual of the period since the late nineteenth century is invented or at least renovated tradition, designed precisely to bolster the monarchy through ceremonial activities, bodily adornment and public appearances, including appearances mediated by cinema, radio and television.[8] Both the actual forms of ceremonial and their representation in films construct links with the absolute power of earlier monarchs by playing on the heritage of royalty, creating a strong sense of tradition and continuity. This can be seen in particular in the military-style uniforms worn by George III in *The Madness of King George*, Prince Albert in *The Young Victoria* and George VI in *The King's Speech*, which implicitly link them to the power of the warrior monarchs of earlier times.

PUBLIC AND PRIVATE VERSIONS OF THE ROYAL BODY

All of these royal films construct a relationship between the public and the private spheres. Regardless of the period they are depicting, they represent kings and queens in terms of power, influence and authority. But that power is played out differently in the public and the private spheres according to the period being depicted. In going behind closed doors and situating the monarchs in the private sphere, these films also create romantic entanglements and personal crises for their monarchs, thereby conferring another set of traits that produce them as the emotionally rounded but flawed characters of film drama.

Much of the drama of the late modern films plays out a tension between private life and public duty, a tension between domesticity, romance and family life on the one hand and the obligations of public appearances and ceremonial occasions on the other. That tension is less evident in the early modern films. First, the private is hardly domesticated in these films; rather, it is constructed almost entirely in terms of romantic and/or sexual liaisons, which themselves spill over into the public sphere. And those liaisons are frequently developed in terms of selfish irresponsibility rather than familial responsibility. Secondly, in the public sphere, there is a blurring between responsible public duty and what again might be seen as an irresponsible, absolutist wielding of power. In the

private sphere, in both the early and the late modern films, the royal body is wracked by the full range of human emotions and feelings, it manifests disabilities, it becomes ill, it dies. In the public sphere, in the form of ceremonial occasions, the body is adorned in rich costumes, it is ornamentalised, something to be gazed at, as the spectacular embodiment of majestic difference.

In the early modern films, notably in *Elizabeth*, *The Other Boleyn Girl* and *Restoration*, the private body of the monarch is often eroticised and engaged in sexual activity. This is much less likely to be the case in the late modern films. From the late eighteenth century of *The Madness of King George* onwards, the royals are situated in a safe familial and increasingly domestic space where they have comfortable life partners rather than lovers. The shift is never complete, however. Thus in *The Madness of King George*, the royal couple are presented as charmingly sweet when they are on their own together, but when the King's 'madness' takes over, he makes crude sexual advances towards other women. As his illness abates, however, this deviance is once more contained by his de-eroticised royal self. A few decades later, Queen Victoria is depicted at either end of her reign in romantic mode. In *The Young Victoria*, her youthful body is to some extent eroticised. The older version of the Queen in *Mrs. Brown* enjoys a sentimental, even romantic relationship with the commoner John Brown, but her body is not eroticised in any way. The twentieth-century royals of *The King's Speech*, *Hyde Park on Hudson* and *The Queen* are also carefully de-eroticised, but again there are exceptions in the bodies of deviant royals – Edward VIII/the Duke of Windsor in *The King's Speech* and *W./E.* and Diana, Princess of Wales, in *Diana*. Indeed, in all of these cases, we might argue that the actually or potentially eroticised royal body is presented as a deviant body, whose deviance spills over into the public sphere, causing some sort of constitutional crisis which must then be resolved.

The late modern films in various ways work to contain those deviant bodies and demonstrate the averting of crisis in the public sphere. The 'perfect' conclusion in this respect is the reappearance of the properly contained body in public. In such moments, it is possible to restore the symbolic power of the monarchy. The image of the royal family at the end of *The Madness of King George* is one such example, inserting the King back in his rightful place at the heart of the family and of the nation; another is the appearance of the royal family on the balcony at Buckingham Palace at the end of *The King's Speech*, after George VI has managed to contain his stammer for his first wartime radio speech; another is the long-awaited public walkabout by Elizabeth II to see the flowers left by

the mourners of Diana, Princess of Wales, in *The Queen*. In such moments of royal public presence, a vital bond is created between the body of the monarch, the royal family and the national family. What are negotiated in these stories are the power of popularity, and the symbolic status of the monarch as national figurehead.

There is also an implicit renegotiation of the medieval concept of 'the king's two bodies', the 'body politic' and the 'body natural'.[9] The body natural is the monarch's earthly body, the human body, the vulnerable body. The body politic transcends the merely earthly body and is a spiritual state which affords the monarch the divine right to rule and symbolises majesty. The body politic also precisely embodies and therefore represents the nation as a whole, the community of the realm. In the films of the 1990s and 2000s, the body natural has become the unruly body of the private sphere, while the body politic has become the ceremonial body of the public sphere. It is still an extraordinary body, a body set apart, a body whose divinity is now the divinity of celebrity, but it is now in constant tension with the body natural, rather than effortlessly transcendent. It is the ceremonial body that appears in public, in court, on the balcony, with the deviancy of sexual activity, illness or speech disorder temporarily under control. It is a body whose rectitude allows the monarch once again to assume the status of national figurehead, to represent the community of the realm.

<div align="center">THE THEATRE OF POWER: THE *MISE-EN-SCÈNE* OF MAJESTY</div>

When the early modern theatre of power is represented in films of the 1990s and 2000s such as *Elizabeth*, *The Other Boleyn Girl* and *Restoration*, the monarchy is often shown as cruel, tyrannical, ruthlessly wielding absolutist power. At the same time, it is represented as majestic, as magnificent in its spectacle. The theatre of power itself is re-created in the staging of courts, costumes and colonnades, of political manoeuvring and crowd control, of royal posture and expansive camerawork. In filmic terms, this is the *mise-en-scène* of majesty. If the despotism of the monarchy is shocking in its untrammelled power, the spectacular presentation of the monarchy and its court is still sufficiently awe-inspiring to win the admiration of the onlookers – in this case, the films' audiences.

We also see the private lives of the monarchs, their personal foibles, their sexual activity, even on occasion their vulnerability – in *The Other Boleyn Girl*, we witness Henry VIII's reaction when his sexual advances are resisted by Anne

<div align="center">353</div>

Boleyn; in *Elizabeth*, we witness the young queen's anxiety as she prepares for a crucial speech. Seeing the monarchs in private like this humanises them and turns them into flawed characters in a drama that is at times beyond their control, characters who can win not just the awe-struck admiration but the affection of their audiences. It is an attractive and beguiling mythology of tradition, power and humanity.

In the films about the late modern period, there is still a theatre of monarchy, a theatre of ceremonial spectacle, a projection of public splendour, grandeur and majesty in the display of palaces and grand houses, luxurious interiors and formal costumes. The late modern monarchs may be presented as having very little power and influence outside their families and their households, and as the pawns of the politicians, but they are still spectacular creatures who command awe. This late modern *mise-en-scène* of majesty is thus a means of securing the monarch's status as national figurehead, and it is here that the monarchy is most clearly cloaked in the trappings of heritage and inserted into a long tradition that secures a sense of continuity with the past.

The Madness of King George playfully represents the ways in which this spectacle is constructed precisely as a theatrical display of symbolic power in the late modern period. The extraordinary final scenes of *Elizabeth* equally demonstrate the extent to which the *mise-en-scène* of majesty is a theatrical construction in the early modern period as well, but in this case there is a clear link to political authority and agency that is absent from *The Madness of King George*. The late modern theatre of power is then a performance without political substance, although it still has a symbolic charge in its very performativity.

In films set in the mid-Victorian period and later, however, the scenes of ceremonial spectacle are downplayed, replaced by a sense of the middle-class normality of the royal families and their homes. In *The King's Speech*, we enter the private spaces and see the off-duty clothes of George V and his sons, the future Edward VIII and George VI; in *The Queen*, we enter the paradoxically mundane Balmoral of Elizabeth, Philip and Charles; in *Hyde Park on Hudson*, the royal couple are away from home and the world of British ceremonial and become just another posh, repressed British couple in formal wear. If most of these films project a certain degree of royal spectacle, there is also a strong element of banal ordinariness, stretching from the scenes in the royal bedchamber in *The Madness of King George*, via Victoria's visit to the Grants' cottage in *Mrs. Brown*, to the bickering royal couple in their bedrooms in *Hyde Park* ... and *The Queen's* Prince Philip calling Elizabeth 'Cabbage' as they get into bed in Balmoral. This

may still be an exceedingly class-bound idea of ordinariness, but its mundane qualities are still very striking.

How does this banality of the private sphere relate to the question of power? The later modern monarchs are presented on film as still *attempting* to wield the power of unquestioned authority, of privilege, of inheritance, even of divine right, rather than abide by the conventions of good manners, civil relationships and reasonable behaviour. There is then still a despotic aspect to the late modern cinematic monarchs, but their tyranny is now contained primarily within their own families, with their spouses and their offspring, and within their personal households, with servants, advisers and the like. Victoria shouts at her staff and her sons and daughters and their spouses in *Mrs. Brown*; George V and his son Edward tyrannise Edward's brother Bertie, the future George VI, about his stammer in *The King's Speech*; Elizabeth puts Philip firmly in his place in *The Queen*.

This despotic behaviour rarely ventures in to the public sphere. Public political power and influence is thus much less in evidence in these late modern films; indeed, as already noted, several of the films, including *The Madness of King George*, *The Young Victoria*, *Mrs. Brown* and *The Queen*, chart the efforts of their screen monarchs to come to terms with the waning of political power and influence, while still hanging on to the crown. They may *try* to pull rank in their relations with the elected and/or professional politicians, and attempt to influence events and social relations outside their own family and household. But they rarely succeed, with the politicians shown in delicate, diplomatic negotiation, seeking to resist monarchical influence and to shape the monarch's will to their own political design – and what is perceived as the will of the people, in terms of popularity and assent.

Although this behaviour, this struggle to wield power and authority, takes place primarily in the private sphere, it does have ramifications in the public sphere, and can even trigger constitutional crisis. Hence the so-called Bedchamber Crisis in *The Young Victoria*; the abdication of Edward VIII in *The King's Speech*; and the loss of respect for the monarchy when the Windsors fail to recognise the strength of popular feeling around the death of Diana in *The Queen*. In such circumstances, the monarchs are invariably required to modify their behaviour – which generally means they must make appropriate public appearances, they must perform authority correctly, they must adopt the rectitude of ceremonial splendour or empathise with the plight of the national family. The monarchs of *The Young Victoria*, *Mrs. Brown* and *The King's Speech* are also shown struggling to maintain their popularity, to look and sound the

part, to stand above the political fray. This is very much writer Alan Bennett's central theme in *The Madness of King George*, and it is very much the fate of the post-political monarchy, the decorative, ceremonial monarchy, if it is to maintain its status and authority as national figurehead.

The problem to be resolved in *The Queen* is precisely this relationship between the private and the public. How can Elizabeth re-engage with her people, with society? How can she regain her popularity? And what sort of public image should she project, what sort of ceremonial response is appropriate for the Queen in relation to Diana's death? To put it another way, how much of the private should be brought into the public sphere? How much should the Queen emote in public (as in the walkabout outside the palace)?

THE PRIVATE SPHERE, THE ROYAL FAMILY AND THE FEMINISATION OF THE MONARCHY

By playing out so much of their drama in the private sphere, these films also contribute to the perceived feminisation of the monarchy. Various historians have argued that, over the last two centuries, the monarchy has become feminised in terms of those who have sat on the throne for most years, but also in terms of the domestication of the institution, the way it has become bound to the idea of the royal *family*, its association with philanthropy and welfare, and the erosion of real political power.[10]

There has certainly been a preponderance of cinematic interest in female monarchs during the 1990s and 2000s, with two films about Elizabeth I and three others in which she appears; two about Victoria; and one about Elizabeth II. Even Elizabeth I's ruthless culling of her enemies and her militarism is offset by the feminine, romantic role she adopts for much of the two Shekhar Kapur-directed versions of her life, *Elizabeth* and *Elizabeth: The Golden Age*.

The image of the royal family is also central to filmic representations of the late modern monarchs, and to some extent bolsters the idea of the royal family as a metaphor for the national family and a model for the nation. The image first comes to the fore in *The Madness of King George*, but is particularly evident in the films about twentieth-century monarchs, where the *mise-en-scène* of majesty is played down and the iconography of the royal family played up. In *The King's Speech*, for instance, the paternalistic head of the royal family is by extension also the benevolent head of the national family, his people. But that

paternalistic head, George VI, is constructed very much as a vulnerable character who depends enormously on the support of his wife, but also his two young daughters, whose approval he seeks after his climactic radio speech at the end of the film. To this end, the figure of the King is feminised and domesticated, genially paternalistic rather than oppressively patriarchal.

Given the important role of the royal wives in *The Madness of King George* and *The King's Speech*, and given the way that Victoria holds sway over her very grown-up family in *Mrs. Brown*, as does Elizabeth II in *The Queen*, the late modern royal family is as much female-led as it is patriarchal. This is reinforced by the fact that the narrative space of these films is primarily the private sphere of the family. That space and those families are also represented in terms of a particular idea of ordinariness; indeed, the model of the family on display is akin to a respectable middle-class ideal of family life that hardly seems distant from at least the core target audience for the film. Through such representations of ordinariness and domesticity, the idea of the monarchy as extraordinary and powerful is once again diminished.

This sense of relatively powerless ordinariness is further secured by the fact that most of the films from the 1990s and 2000s about the late modern monarchy represent the royal family as dysfunctional. In public, George III tries to ensure his family appears as ideal in *The Madness of King George*, but in private, we witness its conflicts and failings, whether in the form of his sons challenging his authority or his own illness and its effects on those around him. In *The King's Speech*, it is suggested that Bertie's stammer derives from the bullying oppressiveness of his father and his elder brother. Even George VI's own family, which may be presented in the same film as the ideal national model, bequeaths the Diana problems that are depicted in *The Queen* and *Diana* as the product of yet more familial dysfunctionality.

In the early modern films, the private sphere is a site for royal sexual activity on the one hand and for plotting the monarch's next move in the public sphere on the other. These may often be closely related, as in *The Other Boleyn Girl*, where Henry VIII's desire to bed Anne Boleyn becomes the motivation for his schism with the Catholic church. In the late modern films, however, as the monarchy loses any real political power, it retreats into a private sphere that is now represented less as a site for sexual activity and political scheming and more as the domestic space of the family. This de-politicisation and domestication of the monarchy is to some extent matched in the films by the performance of monarchical benevolence and an engagement with philanthropic and humanitarian causes.

Andrew Higson

In *The Madness of King George*, George III gleefully embraces the moniker 'Farmer George', which he sees as indicative of his concern for the welfare of the nation. In *The Young Victoria*, Victoria and her husband Albert push various philanthropic causes. George VI is seen as attending to the welfare of the nation in relation to impending war in both *The King's Speech* and *Hyde Park on Hudson*. Diana's espousal of humanitarian missions in *Diana* and the way that both that film and *The Queen* cite her nomination as the 'queen of hearts' and the 'people's princess' again link the monarchy in a broad sense to philanthropy. On the other hand, these two films can also be read as using these same tropes to advance an implicit critique of the monarchy for its distance from the concerns of ordinary people and its failure to engage with the emotional life of the nation – and thereby, it might be argued, its failure to engage sufficiently with a feminine sensibility.

Some of the representations of early modern monarchs also embrace the idea of a benevolent monarchy – in the figure of Elizabeth I in the two eponymously named films, for instance; or in Charles II's interest in science, technology, medicine and innovation in *Restoration*. But in such cases, this benevolence is always tempered by what today seem like wilful abuses of power – at times violently wilful. Such monarchs have not yet become the domesticated figureheads of the late modern films – but even those monarchs occasionally abuse their power within the private sphere. Indeed, if any of these monarchs appears to represent a benevolent, welfare monarchy, even a democratic monarchy, there is still a huge gap between their lifestyles and those of most of their subjects. The late modern films may undermine the sense of difference and exclusivity that surrounds the monarchy by representing the royal family as in some ways 'ordinary', but they also present the monarchy as retaining an element of extraordinariness which demands admiration, respect, even reverence. The representation of social relations in these films is still marked by a huge sense of difference, and the spectacle of enormous wealth and privilege in particular – the *mise-en-scène* of majesty – speaks to an intensely hierarchical, class-based social structure, with the wealth and exclusivity of the royal family situating it at the top of that hierarchy.

CONCLUSION: PROJECTING THE BRITISH ROYAL HERITAGE FOR CONTEMPORARY GLOBAL CULTURE

These various films from the late twentieth and early twenty-first centuries are at one level conventional entertainment commodities. But they are also

indicative of the way in which the British royal family, the world's most prominent national monarchy, has become a global cultural commodity, a brand that embraces particular types of stories and images, and a particular sense of British identity that can be marketed to audiences around the world. They make a clear distinction between the politically and narratively powerful monarchs of the pre-modern and early modern periods, and the politically powerless constitutional monarchs of the late modern period. These representations help to modernise and democratise the image of monarchy. On the one hand, there is the ordinariness and humanity of the royal family; on the other hand, this is offset by the extraordinary cinematic spectacle of monarchical ritual, ceremonial occasions, palatial settings and majestic costumes.

Cinema thus plays a part in the reinvention and renewal of pomp and pageantry around the monarchy, situating the monarchy firmly within the society of the spectacle, reinforcing its public image, its visual presence. The full regalia of monarchy, the *mise-en-scène* of majesty, may not represent political power but it still has an important ideological function, maintaining the symbolic authority of the British monarchy and the status of the monarch as national figurehead in a globalised world.

The divorce of political power from the soft power of the image is vital, but the remaining symbolic charge of this public image is equally vital. The cinema of monarchy is one of the ways in which the lustrous majesty of monarchy is maintained, but also refurbished for a democratic era in which kings and queens become more like ordinary people. At the same time, these films collectively situate the monarchy in relation to a rich and often spectacular version of national heritage, presenting the monarchy as a distinctive and attractive symbol of nationhood and tradition that is somehow timeless and stands above politics and private interests. The relative success of the various films enables the reproduction of this heritage and normalises the monarchy as a more or less awe-inspiring feature of contemporary global culture. In this way, a spectacle of wealth, privilege and exclusivity is made to seem attractive to audiences around the world.

This spectacle renders the royals as extraordinary, set apart from ordinary people, aloof and detached. That sense of extraordinariness is to some extent reinforced by the casting of carefully chosen film stars – Emily Blunt, Judi Dench, Colin Firth, Helen Mirren – and brilliant character actors – Nigel Hawthorne, Sam West – all of whom create charismatic and engaging royal characters. This is in effect the merging of two cults of celebrity. But the films

about the late modern constitutional monarchs also present them to some extent as ordinary, familiar and familial, mundane, like us. The earlier monarchs are also to some extent humanised by their representation as the flawed characters of drama whose vulnerabilities we witness when we see them in private. But there are still important differences between the way they are represented and the way more recent monarchs are represented. The medieval and early modern celluloid monarchs generally enjoy both political power and narrative agency. Where they have the capacity to make things happen, however, things happen to or around the monarchs in the late modern period, and it is really only in their private lives that they are able to act, to demonstrate agency, to emote.

The endings of the films about the late modern monarchs tend to see these characters finally triumph over adversity, and reach a position in which they feel comfortable with their duties and responsibilities and at ease with their bodies, their desires and their emotions. Thus George III is able to seem himself again and to present that self publicly to his people at the end of *The Madness of King George*, appropriately costumed, and at the heart of the royal family; George VI is able to overcome his stutter enough to make a crucial speech – and then present himself publicly to his people, again surrounded by the royal family; and it is precisely in appearing in public outside Buckingham Palace that Elizabeth II in *The Queen* is able re-establish her class certainty and her symbolic authority.

Each of those films also plays an important part in the presentation of the late modern monarchy as domestic, ordinary and feminine, the monarch's authority represented as much by their status as head of the royal family, and by extension the national family, as by the spectacle of majestic imagery. The soft, persuasive power of these images of family headship and royal splendour lies in their ability to win popular approval for the institution of monarchy. Through the stories it tells, the way it tells them and especially the way it visualises the monarchy, the cinema of the 1990s and 2000s presents the post-political royals as in the end unthreatening and benevolent, but also as charismatic and narratively significant. They may not be politically significant figures, they may not be able to command an army or command the nation, but they are certainly able to command attention as socially and culturally significant figures. That significance is in part an assertion of national distinctiveness in an increasingly globalised world. Cinema may have played a part in refurbishing this image of the post-political British monarchy but, like it or not, its reign is not over yet.

NOTES

1 Historically the English monarchy governed England and Wales prior to the 1707 Act of Union with Scotland. Thereafter it is referred to as the British monarchy.

2 On the relationship between heritage and cinema, see Andrew Higson, *English Heritage, English Cinema: Costume Drama since 1980* (Oxford: Oxford University Press, 2003); on the relationship between film genres, the film industry and the representation of the past, see Andrew Higson, *Film England: Culturally English Filmmaking since the 1990s* (London: I.B.Tauris, 2011).

3 In developing the arguments below, the following were particularly useful: Andrzej Olechnowicz (ed.), *The Monarchy and the British Nation, 1780 to the Present* (Cambridge: Cambridge University Press, 2007); David Cannadine, 'The context, performance and meaning of ritual: the British monarchy and the "invention of tradition", *c.* 1820–1977', in Eric Hobsbawm and Terence Ranger (eds), *The Invention of Tradition* (Cambridge: Cambridge University Press, 1983); Kara McKechnie, 'Taking liberties with the monarch: the royal bio-pic in the 1990s', in Claire Monk and Amy Sargeant (eds), *British Historical Cinema: The History, Heritage and Costume Film* (London: Routledge, 2002); and Jeffrey Richards, 'The monarchy and film 1900–2006', in Olechnowicz (ed.), *The Monarchy and the British Nation*.

4 This section draws on arguments developed in Higson, *English Heritage*, and Higson, *Film England*; box-office details are from *Box Office Mojo*, www.boxofficemojo.com/.

5 See Joseph Nye, *Soft Power: The Means to Success in World Politics* (New York: PublicAffairs, 2004).

6 Vernon Bogdanor, 'The monarchy and the constitution', *Parliamentary Affairs* 49 (1996), p. 407.

7 Cannadine, 'Context, performance and meaning', p. 121; see also Andrzej Olechnowicz, 'Historians and the modern British monarchy', in Olechnowicz (ed.), *The Monarchy and the British Nation*, pp. 25–7; and David Chaney, 'A symbolic mirror of ourselves: civic ritual in mass society', *Media, Culture and Society* 5 (1983).

8 See Olechnowicz, 'Historians and the modern British monarchy', pp. 31–3; and Richards, 'The monarchy and film'.

9 See Ernst Kantorowicz, *The King's Two Bodies: A Study in Mediaeval Political Theology* (Princeton, NJ: Princeton University Press, 1957).

10 See Clarissa Campbell Orr, 'The feminization of the monarchy 1780–1910: royal masculinity and female empowerment', in Olechnowicz (ed.), *The Monarchy and the British Nation*, and Olechnowicz, 'Historians and the modern British monarchy', pp. 27–31.

SELECT BIBLIOGRAPHY

Bogdanor, Vernon, 'The monarchy and the constitution', *Parliamentary Affairs* 49 (1996).
Box Office Mojo, www.boxofficemojo.com/.
Campbell Orr, Clarissa, 'The feminization of the monarchy 1780–1910: royal masculinity and female empowerment', in Andrzej Olechnowicz (ed.), *The*

Monarchy and the British Nation, 1780 to the Present (Cambridge: Cambridge University Press, 2007).

Cannadine, David, 'The context, performance and meaning of ritual: the British monarchy and the "invention of tradition", *c.* 1820–1977', in Eric Hobsbawm and Terence Ranger (eds), *The Invention of Tradition* (Cambridge: Cambridge University Press, 1983).

Chaney, David, 'A symbolic mirror of ourselves: civic ritual in mass society', *Media, Culture and Society 5* (1983).

Higson, Andrew, *English Heritage, English Cinema: Costume Drama since 1980* (Oxford: Oxford University Press, 2003).

————*Film England: Culturally English Filmmaking since the 1990s* (London: I.B.Tauris, 2011).

Kantorowicz, Ernst, *The King's Two Bodies: A Study in Mediaeval Political Theology* (Princeton, NJ: Princeton University Press, 1957).

McKechnie, Kara, 'Taking liberties with the monarch: the royal bio-pic in the 1990s', in Claire Monk and Amy Sargeant (eds), *British Historical Cinema: The History, Heritage and Costume Film* (London: Routledge, 2002).

Nye, Joseph, *Soft Power: The Means to Success in World Politics* (New York: PublicAffairs, 2004).

Olechnowicz, Andrzej, 'Historians and the modern British monarchy', in Andrzej Olechnowicz (ed.), *The Monarchy and the British Nation, 1780 to the Present* (Cambridge: Cambridge University Press, 2007).

Olechnowicz, Andrzej (ed.), *The Monarchy and the British Nation, 1780 to the Present* (Cambridge: Cambridge University Press, 2007).

Richards, Jeffrey, 'The monarchy and film 1900–2006', in Andrzej Olechnowicz (ed.), *The Monarchy and the British Nation, 1780 to the Present* (Cambridge: Cambridge University Press, 2007).

16

Melodrama, celebrity, *The Queen*

Mandy Merck

In 1955 the *New Statesman* published an article by the pundit Malcolm Muggeridge with a headline that would become a cliché of British political commentary. Republished in May 2012 for the Queen's Diamond Jubilee, 'The Royal Soap Opera' compared newspaper coverage of Princess Margaret's romance with Royal Air Force Group Captain Peter Townsend to that bestowed on Rita Hayworth. 'The application of film-star techniques to representatives of a monarchical institution is liable to have', it warned, 'disastrous consequences':

> The film star soon passes into oblivion. She has her moment and then it is all over. And even her moment depends on being able to do superlatively well whatever the public expects of her. Members of the royal family are in an entirely different situation. Their role is to symbolize the unity of a nation; to provide an element of continuity in a necessarily changing society. This is history, not *The Archers*,[1] and their affairs ought to be treated as such.[2]

Thirty years passed before Judith Williamson challenged Muggeridge by claiming that this celebrity melodrama could actually *serve* the Crown and the ideology of national unity that it represents. Writing just after the protracted strike that failed to halt the closure of Britain's coal mines in 1984, Williamson observed that the pitmen's wives sought the Queen's support for their cause in the belief that she *cared*, that the ambiguous 'concern' about the strike expressed in a palace press release indicated a royal regard for ordinary Britons' welfare not shared by the elected government of Conservative Prime Minister Margaret Thatcher. That belief, Williamson argued, has been bolstered by the British monarchy's cultivation of a middle-class domestic image since the reign of Victoria. In 'incorporating both affection (based on identification) and obedience (based on difference)', it has employed a canny populism to foster both: 'There is the

intimate and casual private moment on the one hand; the spectacle of State occasions, the glamour of wealth and national tradition on the other.'[3] Royal privilege and ceremonial display have increasingly been combined with publicity focused on the ordinary interests of romance, marriage, children and the home – the basic materials of melodrama – with considerable political success. And thus, when Muggeridge's 'orgy of vulgar and sentimental speculation' about whether Princess Margaret would renounce her title to marry a divorced man was echoed half a century later by similar speculation about whether her nephew would marry a divorced woman, both romance and royal status, desire and duty, were upheld. Prince Charles married Camilla Parker Bowles, the former wife of a Commander of the Household Cavalry, in 2005, the year before the release of an actual melodrama with a real-life film star commemorating (and, by many accounts, furthering) the Crown's survival of its greatest modern crisis.

Discussing the melodramatic concentration on 'family relationships, star-crossed lovers and forced marriages' in the direct predecessor of the genre, the eighteenth-century bourgeois tragedy, Thomas Elsaesser discerns a strong anti-feudalism in its portrayal of the villains. 'Often of noble birth', they 'demonstrate their superior political and economic power invariably by sexual aggression.'[4] Although that storyline would serve very well for the 1997 contretemps provoked by the British royal family's cynical betrothal of the heir to the throne to a naive teenager, *The Queen*'s restaging of these conflicts in the domestic life of the Windsors makes the monarch the heroine, albeit a monarch portrayed as a beleaguered working woman in the Hollywood melodramatic mode, with even more pathos given her advanced age: the concerned Chief Executive of the royal 'firm,' torn in the crisis after Diana's death between her lifelong reserve and her anointed obligations to her symbolically childish subjects. This transfer of spectatorial sympathy represents a political *coup de théâtre*, and has been acknowledged as such. Not untypically, royal biographer William Shawcross maintains that *The Queen* rebutted allegations of the monarch's 'uncaring' attitude to Diana's death, capturing its subject's 'moral courage' and eliciting many letters from members of the public 'saying that before the film they had never quite understood what she had been through, others saying how glad they were that the film had finally tried to tell the truth they had always accepted'.[5] As film critic David Thomson succinctly concludes, the film is 'the most sophisticated public relations boost HRH had had in 20 years'.[6]

Princess Diana would seem the more likely heroine of this melodrama, the beautiful young innocent deceived by a powerful older man. Thwarted in love,

spurned by her husband's family, harried by the press, she became a figure of female suffering and resistance, pointing the finger of accusation à la Lillian Gish in the 1995 BBC *Panorama* interview viewed by the Queen in the film: 'There were three of us in this marriage.' The cinematic character of Diana's celebrity was redoubled by the sense that this shy young woman had been 'discovered'[7] by her husband, painfully wrenched from private life to mass exposure and early death like the doomed Norma Jean whose ballad was rewritten for her funeral. As journalist Allan Massie argues, Diana, although the daughter of an earl, was 'unquestionably' the star of 'the Royal soap opera' and the 'child of her age':

> Not long after Diana's death, Tony Blair, as prime minister, called for the release of Deidre Rachid, a fictional character fictionally imprisoned for a fictional offence in Coronation Street.[8] Many mocked his intervention, but in this confusion of real life and television, he represented the spirit of the times. ... When Diana was killed, and Blair pronounced her 'the People's Princess', it was hard to remember that she was actually a member of one of the great Whig aristocratic families. The image, only partly manufactured, had all but obliterated the reality.[9]

But if *The Queen* is a melodrama attempting to replace this generic hero-ine with the living monarch, it was initially devised as a docudrama, with that form's fidelity to actual events and the employment of both television and press quotation. Real and simulated footage from British newscasts is interspersed with a fictional narrative of both the royal family and the Labour government's response to Diana's death. Written by Peter Morgan, *The Queen* is the centrepiece of his New Labour trilogy in which Michael Sheen plays Tony Blair, and it was also destined for the small screen before continental co-production expanded its budget. The two television productions which bracket it are *The Deal* (directed by Stephen Frears, 2003) on the power-sharing negotiations between Tony Blair and Gordon Brown prior to their government's first election, and *The Special Relationship* (directed by Richard Loncraine, 2009) on Blair's dealings with US presidents Clinton and Bush.

In many ways *The Queen* follows the formula of *The Deal* as closely as its two-syllable title. Both were directed by Stephen Frears and both focus on real-life political contests in which a frontrunner is defeated by a rival. Real-life Labour spin doctors (Peter Mandelson, played by Paul Rhys in *The Deal*, and Alastair Campbell, played by Mark Bazely in *The Queen*) take key supportive roles. Footage of an actual funeral appears at the climax of both narratives and

both end with an ironic coda. The difference between the two productions is significantly that of their medium, which 'opens out' *The Queen* to the production values of the feature film, while confining *The Deal* to the cheaper *mise-en-scène* of television. In the latter there is consequently little visible difference between the low-resolution image of its dramatic sequences and that of the video news archive. Although *The Deal* does employ scenes of people watching television to bridge the two, it also cuts directly between them with no ostensible breach of image quality or narrative continuity.[10] Significantly the deceased politician in the archive sequence of the funeral, the Scottish Labour leader John Smith, is portrayed earlier by actor Frank Kelly. Conversely Diana – even in the opening of *The Queen* when she is still alive – is represented only by actuality footage. Belén Vidal has called attention to the 'different temporalities'[11] signalled by the film's textual – and textural – variation, observing both its insertion of Mirren's enacted Queen into the documentary record and the Crown into a belated engagement with twentieth-century communications. But this division has a further import, one of character, genre and ontology, since the Queen is entirely portrayed by an actor and seen mostly in the fictional melodrama filmed by Frears, while Diana is confined to the archive of her indexical image. While avoiding what Giselle Bastin has described as the 'low-quality' impersonations of the Princess in the many television biopics of the 1980s and 1990s,[12] this strategy makes Diana history, in both the literal and figurative sense, while paradoxically enlivening the very traditional genre which it deploys to vindicate the Queen.

Throughout *The Queen* news broadcasts on television screens and photographic images are counterposed to the paintings in the royal residences and Downing Street. Their thematic purposes are multifold, but they mark a dramatic progress in which Diana – effectively portrayed as pretender to the throne – is supplanted in the televisual frame by the Queen, who is initially identified with the milieu and iconography of fine art. Only when this process has been completed can Diana's funeral begin and the Princess be laid to rest, and with her the threat she presents to the Queen's authority. To make this happen, melodrama, with its pathos, its appeal for moral recognition and its highly expressive *mise-en-scène*, must, in both a political and an aesthetic sense, dominate the docudrama. The DVD cover of *The Queen* announces this generic contest with an eloquent image absent from the actual film. In it Helen Mirren – costumed for the title role in funereal black, with discreet pearls at her neck and a white rose brooch – stands frowning in front of a gigantic photograph of the

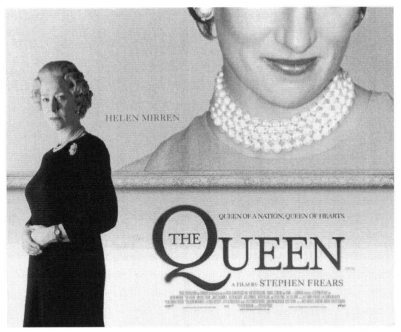

32 'Queen of a Nation, Queen of Hearts': the DVD cover image for
The Queen (Stephen Frears, 2006).

real-life Diana. In a markedly competitive pose, Mirren's Queen has turned her
back to the photograph. It is cropped just below Diana's eyes, masking her gaze
at the spectator, but emphasising its subject's smile, as well as her more youth-
ful complexion. Yet the photograph is toned a ghostly grey, while the figure in
the foreground is in colour. A caption reads (in conservative blue) QUEEN OF
A NATION, (and in radical red) QUEEN OF HEARTS.

Stephen Heath's term 'narrative image'[13] suggests how this illustration
anticipates the film's abiding contrast of photographic publicity with private
existence. For much of its running time, the nation's Queen is out of the pub-
lic eye, at Balmoral, her Scottish hunting estate. Meanwhile, the Queen of
hearts is montaged in the cascade of images with which her life culminated,
watched repeatedly on television, pursued to her death by the paparazzi and
memorialised by her photographs on thousands of mourners' placards. The
medial frame, it is suggested, has been usurped by the Queen's rival, her former
daughter-in-law. In the tradition of Friedrich Schiller's 1800 play *Mary Stuart*
(whose sympathetic treatment of both Mary of Scotland and Elizabeth I makes

it a more obvious precedent for this melodrama than the royal villain plays cited by Elsaesser), this is a drama about two ambitious queens, one romantic, one worldly, in a contest for power. Although Diana's death is announced soon after the film begins, her threat to the Crown cannot be averted until the anointed monarch reoccupies her rightful place within the frame and broadcasts a statement of regret to the nation. And even then the ghostly pretender lingers on, her archive image twice inserted into that of the mourners at her own funeral, the second time in a confrontational turn toward the camera that matches the Queen's at the film's opening.

Both Vidal and Bastin have rightly stressed this spectrality. Diana's representations throughout the film are figured as both posthumous (at its 2006 debut she had been dead for nine years and she dies again at its beginning) and ghost-like, reconfigured in (mostly) silence, slow motion and the lower resolution and desaturated colours of television news. These enhance the haunting effect of her image in the present absence so often remarked upon by theorists of photography. Throughout the film this documentary footage of the dead Princess is watched by the film's characters, played by actors filmed in the higher resolution, deeper hues and synchronised sound of the feature film. Thus we are given two realities in two different registrations – that of the fictional world of melodrama and that of the actual world of documentary. But here, enhanced by cinema's larger gauge, lighting, set design, casting and sheer scale (in both financial and figural terms), the symbolic world of the melodrama is more vivid, more audible and apparently more alive than the indexical images of the real-life Diana. The Queen of Hearts is dead. Long live the Queen of a Nation (who will become, through the sympathetic agency of the melodrama, the next Queen of Hearts).

As well as the images framed by the television screen, gilt-framed paintings adorn the more formal settings of this film. Like the harpsichord passage that introduces the Palace in the scene in which the newly elected Blair is confirmed Prime Minister, these works of art synedochise the aesthetics of tradition, wealth and offices of state. The conflict between the two media is introduced in its title scene, when the Queen watches the news as she poses in the ceremonial robes of the chivalric Order of the Garter for an artist in a Buckingham Palace state room.[14] It is Election Day, 1997, and the first shot of the film is a televised one of a contemporary Labour Party supporter, as indicated by the 'Britain deserves better' slogan on his red T-shirt. Yet the era of Muggeridge's article persists, since the Queen's pose and costume are designed to recall her most

famous portrait, painted by Pietro Annigoni in 1954–55, when she was in her late 20s. The grey hair and West Indian accent of the film's fictional painter, Mr Crawford, also recall the bygone heyday of immigration from the Caribbean. Moreover, the character is portrayed by Earl Cameron, best known for the 1950s and 60s film and television melodramas in which he so often played the virtuous victim of racist violence (*Sapphire*, Basil Deardon, 1959) or exploitation (*Flame in the Streets*, Roy Ward Baker, 1961). The name Crawford is itself an allusion to 1950, the year when the former nanny of Elizabeth and Margaret, Marion Crawford or 'Crawfie', outraged the royal family by publishing her memoir *The Little Princesses*. But the ease with which Mr Crawford converses with his sovereign also suggests the ethnic 'diversity' championed in the Blair era. Combined with the casting of Mirren (playing the then seventy-one-year-old monarch at the age of sixty-one) the effect is to make the Queen both venerable and youthful – a veteran of ten prime ministers as she will later remind Blair – and yet in her pose for this portrait strikingly elegant, a star.

In the narrative device that structures the entire film, the situation of the title scene is announced by the television. As the painter works, the news in the background is of Tony Blair's arrival, aged forty-three, to cast his vote at his constituency's polling station. This provokes an amiable discussion in which the presumptive hierarchies of race, gender, politics and portraiture are put into question. Playing on the role of the Queen as the artist's subject, and the artist as subject of the Queen (Britons are not citizens but 'subjects' of the Crown), the scene manoeuvres them into equilibrium. As sovereign, the Queen points out, she has no vote. Conversely, Crawford has risen early to cast his ballot against the Labour leader whose commitment to modernisation, we infer, the Queen would also oppose if she could only – like so many of melodrama's mute characters – say so. Speaking on her behalf, Crawford protests that 'We're in danger of losing too much that's good about this country as it is.' Their exchange underlines the elderly artist's traditionalism as a portraitist in paint – counterposed to the electronic images flickering in the background. It also establishes the limited powers of the constitutional monarch – deprived, she complains, 'of the sheer joy of being partial'. But if this deprivation, as well as the threat pronounced in the word 'moderniser', introduces the Queen as the victimised heroine traditional to melodrama (a victim who can confide in the traditionally victimised figure of the Caribbean immigrant) Mirren's performance of the role in full diva mode adds a contrasting note of humour. Reminded by Crawford that, although she cannot vote, it *is* her Government, she raises

a regal eyebrow to observe drily, 'I suppose that is some consolation.' A cut to black enables Mirren's credit to punctuate this ethnic dialogue in contrasting white. Then, with Alexandre Desplat's theme tune swelling to its fanfare, the craning camera rises to conclude the scene – past the stately figure in the white brocade, the golden tassels, the midnight-blue mantle and the star-shaped emblem of the Order to fix on the face of the film's star in three-quarter profile. As she slowly turns toward the camera, her left eyebrow still aloft, another white title announces THE QUEEN, joining Mirren to her character in syntactical equivalence.

The celebrity culture of the nineteenth century is often credited with turning theatre stars into royalty, as the power of Europe's ruling families was increasingly curtailed and that of prominent entertainers increased. In the classical tragedies and historical dramas then performed, actors played monarchs, and offstage they socialised and sometimes coupled with them. The epitome of this phenomenon was Sarah Bernhardt, who consolidated her own stardom with the role of the victimised Spanish queen in Victor Hugo's romantic melodrama *Ruy Blas* and whose noble lovers are thought to include Elizabeth II's great-grandfather, who became Edward VII. One of *The Queen*'s many ideological masterstrokes is its contemporary identification of the star actor (Mirren) with the world's most prominent living monarch as 'celebrities', in a highly reflexive narrative in which that term and its implications are explicitly discussed.

As with successor melodramas casting Colin Firth as George VI (in *The King's Speech*, 2010) and Meryl Streep as Margaret Thatcher (in *The Iron Lady*, 2011), Helen Mirren's casting as Elizabeth II identifies the political figurehead with a leading actor, rather than a lesser-known lookalike in the contemporary biopic tradition that casts Angela Bassett as Tina Turner or the young Cate Blanchett as Elizabeth I. Moreover, Mirren is an aristocrat among film stars, who has played classical queens like Cleopatra and Phèdre on the stage, whose supposed descent from the actual Russian aristocracy was remarked on the film's debut and who was dubbed a Dame of the British Empire soon afterwards. In 1994 she portrayed Queen Charlotte in *The Madness of King George* and in the 2005 HBO series, *Elizabeth I*, she joined a long line of star actresses, including Bernhardt, Bette Davis, Flora Robson, Glenda Jackson and Judi Dench, in portraying the first Queen Elizabeth. But Mirren's star persona has also retained the vein of rebellious sexiness embodied in her early stage roles as Shakespeare's Cressida (1968) and Strindberg's Miss Julie (1971), as well as an offscreen identification with progressive causes also manifest in her long-running police series *Prime*

Suspect (1991–2006). Her rendition of its ageing, vulnerable and undoubtedly caring Detective Chief Inspector was clearly appropriated to make the monarch a sympathetic heroine, a female manager struggling to combine authority and virtue.[15] The low-key grittiness of Mirren in that role also bolsters the televisual realism with which the docudrama elements of *The Queen* support its melodramatic fiction.

With but a few significant exceptions, the analysis of film melodrama now takes its historical cues from Peter Brooks' canonical study *The Melodramatic Imagination.* Brooks argues that the theatrical form originated in the aftermath of the revolutionary overthrow of political and religious authority, and by revolution he means the French revolution of 1789–95.[16] But two key scenes in *The Queen* clearly refer to an earlier revolution, the English revolution that climaxed with the execution of Charles I in 1649. The emphatic 'Anglitude' of this film and its actors is ideological as well as historical, and it prompts a reconsideration of that other revolution and its relation to this dramatic mode. Here it is worth recalling that the intellectual developments signalled by the English revolution (religious scepticism, political contractarianism, scientific empiricism and an interest in what would now be called social psychology) included a sustained philosophical discussion of fame, variously articulated as 'honour', 'reputation' and 'esteem' by Thomas Hobbes, David Hume and Adam Smith.

Hobbes was an English royalist forced to flee the revolution to the Stuart stronghold in Paris. From exile in 1651, he published his political treatise *Leviathan,* in which he argues that a naturally quarrelsome humanity does so for three main motives – gain, safety and reputation. Although a monarchist, Hobbes was also an incipient materialist, and his analyses of both royal power and reputation are historically and analytically pertinent to *The Queen.* 'Reputation of power, is Power',[17] *Leviathan* declares, in the apparent tautology which critics of the 'famous for being famous' formulae of contemporary celebrity culture wrongly imagine to be new. Honour in Hobbes's view derives not from personal worthiness but from public valuation, and it thus requires public acknowledgement: 'To be Conspicuous, that is to say, to be known, for Wealth, Office, great Actions, or any eminent Good, is Honourable. ... Obscurity, is Dishonourable.'[18] Similarly, in advocating the restoration of the English monarchy, Hobbes employs an extended theatrical metaphor to justify the sovereign's power. By his representative function, the monarch is said to 'personate' his subjects as the actor his role. In the interest of peace and prosperity, *Leviathan* urges the English to grant a new sovereign the '*Right* to *Present* the Person of them

all'.[19] Here Hobbes exploits the ancient trope of the world-as-theatre invoked by his contemporary, the poet Andrew Marvell, who stages the execution of the theatre-loving Charles I as a play in his 'Horatian Ode', probably written in the year that *Leviathan* was published:

> That thence the *Royal Actor* borne
> The *Tragick Scaffold* might adorn:
> While round the armed bands
> Did clap their bloody hands.[20]

The stag scenes in *The Queen* are suffused with this memory of English history. They combine direct allusions to those events and their contemporary iconography with more recent references to the idealised representation of animals and the countryside painted by the Victorian Edwin Henry Landseer and animated by Disney. All of this rests on the ancient symbolism of the stag, from the horned god of the Celts to Christian representations of Jesus as a martyred deer to the animal's medieval association with the monarchs who monopolised its hunting by royal licence. The most obvious of these iconographic references is to the Roman goddess Diana, about whom Charles Spencer declared in his funeral eulogy to his sister, 'of all the ironies about Diana, perhaps the greatest was this – a girl given the name of the ancient goddess of hunting was, in the end, the most hunted person of the modern age'. Although the final words of Spencer's eulogy are included in one of the film's many insertions of television news footage, they do not include those just quoted. *These cannot be spoken in the film*, because its project is to secure the spectator's sympathy by substituting the Queen for Diana as the victim of the hunt.

This task is achieved by, first of all, tapping into the longtime association of the British monarchy with the natural world. As in its espousal of 'ancient' traditions and ceremonies (often devised in the nineteenth and twentieth centuries), this royal investment in the nation's 'rurality and imagined roots' identifies the Crown with what Tom Nairn calls a 'contrived timelessness',[21] as manifested in the country pastimes of a folkloric public. (A similar invocation of the physical powers of sport ensures a royal attendance at every major competition.) Again, the modern version of this natural association was a Victorian creation, by the monarch herself in notable collaboration with Landseer, from whom she commissioned portraits of royal pets, royal gamekeepers, royal babies with their favourite pets and a life-size portrait of herself on horseback. Landseer often painted humans and animals in the Highlands, illustrated Walter Scott's

Waverley novels, and most famously painted his widely reproduced study of a Highland stag, *Monarch of the Glen*, in 1851. The art direction of *The Queen* borrows shamelessly from these Victorian landscapes, toning the Balmoral costumes in their heather shades. Antlers hang from the walls and retrievers join the corgis on holiday from Buckingham Palace. Notably present is the cross-species identification that prompted Landseer to paint an entire series of dogs credited with rescuing people without human assistance and the French playwright François-René Guilbert de Pixérécourt to pen one of the greatest successes of early stage melodrama about another faithful hound, *The Dog of Montargis*.[22]

The Queen herself is emotionally rescued by a deer when she drives her Land Rover up to the moor where Prince Philip has taken her grandsons to escape their grief for their mother's death by stalking and killing animals. The irony of this inverted consolation begins when her vehicle breaks down fording a picturesque stream and she is forced to telephone her estate staff for help. As the troubled woman waits by the water the first stag scene opens, its intimate tone signalled by a medium close-up of her removing her headscarf, with its Gucci bridle design on white silk. Standing bareheaded in atmospheric birdsong, she turns away from the camera and begins to weep. An orchestration of harp and high strings fades in, with the majestic stag's sudden approach signalled by a poignant woodwind melody. On seeing it the melancholy monarch is transfixed, fervently exclaiming 'You beauty'. Then, at the sound of the approaching estate workers, she reciprocates the rescue, shooing the stag away to an equally magical disappearance synchronised to a Disney chime.

The second stag scene is announced when Philip informs the Queen that the one she saw has been killed by a 'commercial guest' on a neighbouring estate. Despite the increasing urgency of the week's events, she immediately drives there and is welcomed by the gamekeeper, who takes her to an octagonal stone outbuilding with a tiled floor and shuttered windows. Again birdsong yields to non-diegetic music, but now the woodwind theme is a wistful memory. In a descending shot that reverses the crane past the Queen in the opening scene, the hanging stag is revealed to be decapitated. Its large head, with its vast rack of antlers, rests on a sideboard. With his cap doffed, the gamekeeper identifies it as an 'imperial ... a fourteen-pointer'. The unusually long-lived specimen has been shot by a London banker who has failed to achieve a clean kill, subjecting the animal to lengthy suffering before its final dispatch. The now timely allusion to the investment banker who can't shoot straight, a vacation stalker

out of touch with the organic community represented in the gamekeeper's evident familiarity with the Queen, recalls the supposed antagonism between the new rich and the nobility, one that was also inferred from the reported hostility displayed by Elizabeth Windsor toward Margaret Thatcher (the wife of an oil executive) during her premiership. (*The Iron Lady*'s ostensible feminism rules out the representation of that intra-female conflict, attributing the aristocratic Tory opposition to Thatcher to male privilege.)

In the tradition of melodrama this second stag scene is one of recognition, the monarch drawing near to her impressively crowned counterpart to behold it in the kinship and foreboding telegraphed by the film's opening epigraph from Henry IV, Part II: 'Uneasy lies the head that wears the crown.' Her scarf in this scene is blood-red and replacing the hunter's bridle is a motif of gamebirds similar to those seen hanging behind the stag. These images of prey decorate the head of a queen whose reign has been exceptionally long and whose predecessor Charles I was deprived of his head by the victorious parliamentarians of the English revolution. (In the melodramatic muteness dramatised in *The King's Speech*, that of the moral man unable to speak, Charles I was also said to have overcome his stammer when denouncing his execution from the scaffold.) The stag hangs upside down like a deposed tyrant in a cooling room that resembles a mortuary – or the chapel in which the imprisoned Charles was pictured in the Guillaume Marshall portrait circulated by his supporters in a volume entitled *Eikon Basilike: The Pourtraiture of his sacred maiestie in his solitarie suffering*. With her mind concentrated wonderfully by the fate of one or both monarchs, and the gamekeeper's 'God bless you, Ma'am' ringing in her ears, another suffering monarch rapidly proceeds to propitiate her unhappy subjects, flying to London, communing with the mourners gathered at the gates of Buckingham Palace and – most importantly – broadcasting a tribute to the deceased princess.

In a film whose central issue is the power of mass media in public life, television screens are watched constantly, mostly by groups of people – kitchen staff, civil servants, the crowds in the park during Diana's funeral – following the news in figures of national attention. This vigilance commences in the title sequence with the Queen's viewing of the election report and continues with the announcement of Diana's crash, seen at Balmoral in the early hours of the morning by her, Prince Philip (James Cromwell), the Queen Mother (Sylvia Sims) and Prince Charles (Alex Jennings). Where a 1969 BBC documentary set a PR precedent by permitting the British public to witness the domestic life of the *Royal Family*,[23] including a Highland barbecue gently parodied in *The*

Queen, the film reverses the angle to make the Windsors the spectators. In their dressing-gowns and slippers, with the Queen clutching her hot-water bottle, the royal family could be the working-class *Royle Family* of British sitcom fame,[24] passively gripped by public events, confused and irritable, unable to hear the telly over the conversation.

The Victorian social commentator Walter Bagehot observed that the notion of a 'family on the throne ... brings down the pride of sovereignty to the level of petty life'.[25] Such is the scale of melodrama, Geoffrey Nowell-Smith writes, which typically 'supposes a world of equals ... exercising local power or suffering local powerlessness, within the family or the small town'.[26] 'Familyness', Tom Nairn declares, is 'crucial for the sort of national-popular identity the Windsors purvey.'[27] Its varying generations and genders offer the public a contending cast of characters compared by Nairn in his 1989 study of the monarchy to that of the TV soap *Dallas,* while the inheritance of the throne through the bloodline represents both the organic continuity of the state and the retention of private property by the kin group. For this double function the virtue of the mother is crucial, and to best her rival the Queen must become a better one. Demonstrably cold to the son whose unhappy marriage she 'signed off on', she is distressed when he protests that Diana was loving to *her* children. Both they and the Queen's other offspring are never seen with the monarch. Instead, in this markedly matriarchal dynasty,[28] she seeks advice from her own elderly 'Mummy', who bracingly reminds her of the vow she took to the lifelong service of her country.

To retain her crown and become the good mother that the film requires, the Queen must establish a parental relation with her *subjects,* one that her Prime Minister is eager to enable.[29] The Oedipality of Blair's filial devotion to the monarch is laughingly observed by his wife Cherie (Helen McCrory), portrayed in the film as a convinced republican, while his press secretary hails him as 'Mr Father of the Country'. And indeed the young Prime Minister and the older sovereign are the couple created by the film, united in their renewal of the British monarchy. But the Queen achieves a more conventional maternity when, returning at last to London, she halts her car at the gates of Buckingham Palace to order to inspect the tributes brought by Diana's mourners. As a startled reporter points out that such unscheduled encounters with the public are 'extremely unusual', Blair and his Downing Street staff watch its live broadcast on a bank of monitors. 'It really is', one TV commentator observes, 'as if the public and the royal family, the monarchy, have had a bit of a quarrel this

week and now it is being healed.' 'Like a family spat', another helpfully explains. When Campbell interrupts with his revisions to 'the old bat's' eulogy of Diana, Blair rises in anger. Pointing to the screen, he shouts 'That woman has given her whole life in service to her people, fifty years doing a job she never wanted, a job she watched kill her father ... and now we're all baying for her blood.'

A cut to the Queen shows her pained perusal of a succession of commemorative messages in which Diana is portrayed as a religious martyr, her eyes uplifted and her head veiled, with captions declaring 'You were too good for them' and 'They have your blood on their hands.' The crowd is silent, with the clicking of cameras and the rustling of paper the only audible sounds. Turning away from the angry placards, the Queen asks a little girl behind the barricade if she would like her to place her bouquet. When the child declines, a close-up reveals Mirren's wounded expression, which is then transformed when the child explains 'These are for you.' As the relieved monarch carries her flowers past the mourners, the denunciations disappear and the women in the crowd silently begin to curtsey, one after another genuflecting to the Queen. In a sensation scene traceable to the pioneering melodramas of Pixérécourt,[30] her own virtue is belatedly acknowledged, the public acknowledgement that Hobbes declared essential to honour.

The scene that follows is clearly designed to match the one which opens the film. Again the Queen is in dark clothing and again she looks directly into the camera, with the crowd visible in the window behind her. Her reprised stillness as she composes herself is that of the tableau traditional to melodrama, halting the action to seal the symbolic import of the scene. But her pose is not for a flattering depiction in oils but a live broadcast, and she is dressed in day wear and reading glasses, not the panoply of her Garter robes. Instead of a ceremonial portrait, the Queen is now the subject of a command performance over which she does not have, as she admits, 'a choice'. In reluctantly acceding to the popular demand for a televised tribute to Diana, not only does she take up the Princess's place in the pixelated frame, she also experiences the involuntary intimacy of a much less formal relation of regard, that of celebrity culture. She is, she proclaims, 'speaking as your Queen', but in Campbell's added phrase she continues, *'and as a grandmother'*, asserting her familial communality with the people she 'personates'.

Mass mediation is unsurprisingly associated with celebrity status in this film, and celebrity with Diana – the most prominent of global celebrities honoured at the film's end by the real-life Hollywood celebrities Tom Hanks, Steven

Spielberg, Nicole Kidman and Tom Cruise in the footage of her funeral. Half a century after Muggeridge's warning, it is as though one member of the royal family had indeed become Rita Hayworth, or more grandly, the original 'Candle in the Wind', Marilyn Monroe. In a comic scene in *The Queen*, the c-word is actually spoken by her private secretary (Roger Allam) when he hesitantly reveals that Diana's funeral has had to be modelled on that planned for the Queen Mother, but with monarchs and heads of state replaced by 'a sprinkling of actors of stage and screen, fashion designers and other ... celebrities' – at which point Sylvia Sims's Queen Mother echoes 'celebrities' with an expression of incredulous distaste worthy of Edith Evans. But Sims is, of course, an actor of stage and screen. Notwithstanding her portrayal of royal disdain, the film is preoccupied by the same vulgar popularity that drives the narrative of its melo-dramatic ancestor, *Mary Stuart*.

In Schiller's 1800 play, the first Queen Elizabeth is forced to avert the claim to her throne posed by her cousin, Mary of Scotland, by imprisoning her. When her supporters' plotting continues, she reluctantly signs a warrant for Mary's execution. The speculation that Diana's death might have been similarly arranged is acknowledged in *The Queen* by Campbell's joking suggestion that Blair ask the Queen 'if *she* greased the brakes'. A further parallel between the play and the film is evident in a courtier's complaint that Mary's 'influence upon the human heart is too supreme'.[31] After her love-struck supporter attempts to assassinate Elizabeth, the anti-Papist crowd calls for the Scottish queen's death. In a remarkable anticipation of the events portrayed in the film, Elizabeth is told 'it is thy people / who, round the palace ranged, impatient / demand to see their sovereign'.[32] As her counsellors debate whether the public mood will turn again in favour of Mary, the beleaguered Queen asks:

> when
> Shall I once more be free upon this throne?
> I must respect the people's voice, and strive
> To win the favour of the multitude,
> And please the fancies of a mob, whom naught
> But jugglers' tricks delight.[33]

The fluctuation of the people's fancies was not only a pervasive dramatic theme in the post-revolutionary moment in which Schiller wrote *Mary Stuart*. It returns in a coda to *The Queen* which darkens the final exchange between the Prime Minister and his monarch when their weekly audiences at Buckingham Palace recommence in the autumn after Diana's death. As Blair glibly attempts

to reassure the sovereign that the republican rumblings of the summer have died away, she listens stonily and suddenly declares that the British public will one day turn against *him* – an anticipation of the dramatic loss of popularity which Blair had indeed experienced by the time of the film's production for his complicity in the invasion of Iraq. Like the final intertitle of *The Deal*, which notes that by its broadcast in 2003 Blair's promised handover of prime ministerial office to Gordon Brown had still not happened, this coda performs the ironic updating that often concludes the docudrama. But within this final sequence, the film stages a far more revealing acknowledgement of its own devices, an acknowledgement performed by denial.

Suggesting that they continue their discussion in the Palace gardens, the Queen leads Blair down a corridor. Suddenly she stops, removes her glasses and returns to the traumatic events of the summer. 'One in four?', she quietly asks, 'wanted to get rid of me?' Again Blair insists that this opposition was only momentary. 'I've never been hated like that before', the chastened monarch replies. Visible behind her is one of several marble statues in this scene. Presumably chosen to represent the neoclassical decor of Buckingham Palace, they lead to an extensive display of statuary in the formal garden in which the two are seen walking as the film's credits roll. Given the hitherto sustained opposition of painting and television, this sudden turn to the sculptural seems difficult to ignore.

As the Queen anxiously questions Blair she stands before a classical nude who looks modestly downward as she clasps a veil to her nether regions. But the naked intimacy suggested by this figure is soon dispelled as the Queen raises her voice and continues down the hallway: 'Nowadays', she declares, 'people want glamour and tears, the grand performance. I'm not very good at that.' At this point she passes a second statue, of an upright Victorian gentleman with his right hand tucked into his waistcoat and his left steadying a sheaf of papers. 'I prefer to keep my feelings to myself', she continues, 'and, foolishly, I believed that was what the people wanted from their queen – not to make a fuss, nor wear one's heart on one's sleeve. Duty first, self second.' As the Queen concludes her complaint, another classical statue briefly comes into view, of a sexually ambiguous figure whose short tunic is draped over a single shoulder.

If the woman averting exposure suggests Diana (the classical goddess furious to be seen bathing, the contemporary princess shielding her face from the paparazzi), does the frock-coated dignitary represent statesmanship and the third statue androgyny? Is this the film's final word on the dialectics of female

rule? Or those of the phallic grandmother? Or does this marble, like the pre-vious allusions to pixels and paint, refer to the varied media of dramatic per-sonation? In the theatre of the eighteenth and early nineteenth centuries, the striking of 'attitudes' or dramatic poses based on those of classical sculpture was a familiar device. The English tragedienne Sarah Siddons and her French successor Rachel were both praised for the statuesque gravity of their pos-ture and expression, while Henry James referred to the 'solidity' of Schiller's Mary when commending Helena Modjeska's 'exquisite and pathetic Queen of Scots'.[34] Mirren's own performances of stage tragedies readily link the film to this tradition.

If these statues invoke the 'classiness' of classicism, and the prestige sought from Mirren's casting, their cold whiteness may likewise suggest an era long before the modernising moment into which the film opens. Looking back to it the Queen defends her aversion to emotional display by saying 'that's how I was brought up'. But the catch in her voice as she recalls her coronation when 'just a girl' neatly subverts her protestation, signalling that her modesty about the grand performance is as false as that which veils the figure behind her. Rather than reading this scene as a final reversion to classical decorum and restraint, we should take it at face value, as still more evidence of the very emotional genre this leading lady has affirmed by her negation. For this is a film that truly does wear its melodramatic heart on its docudrama sleeve – its movie star monarch performing, *pace* Muggeridge, 'superlatively well whatever the public expects of her', the glamour and the tears that have brought us to an age of unparalleled royal celebrity.

NOTES

1 *The Archers* is a radio soap opera about rural British life broadcast on BBC Radio 4 since 1950. With the cancellation of the US *Guiding Light* in 2009, it has become the world's longest-running soap opera in any medium.
2 Malcolm Muggeridge, 'The royal soap opera' (first published in the *New Statesman*, 22 October 1955), republished by the *New Statesman* (30 May 2012), www.newstates-man.com/lifestyle/2012/05/back-royal-soap-opera.
3 Judith Williamson, 'Royalty and representation', in *Consuming Passions: The Dynamics of Popular Culture* (London and New York: Marion Boyars, 1986), p. 80.
4 Thomas Elsaesser, 'Tales of sound and fury: observations on the family melodrama', in Christine Gledhill (ed.), *Home Is Where the Heart Is: Studies in Melodrama and the Woman's Film* (London: BFI, 1987), p. 45.
5 William Shawcross, 'Portrait in majesty', *Vanity Fair* (June 2007), p. 106.

6 David Thomson, 'Biographical dictionary of film number 99 (Stephen Frears)', *Guardian* (3 September 2010), p. 14.

7 See Graeme Turner, 'The cultural function of celebrity', in *Understanding Celebrity* (London: Sage, 2006), p. 96.

8 First broadcast in 1960, *Coronation Street* is a British television soap opera set in a fictional suburb of Manchester. In 1998, a character in it called Deidre Rachid was wrongfully imprisoned after a relationship with a con man. A national media campaign to free her ended the storyline with her 'release' three weeks later. In 2000, the Prince of Wales appeared on the show playing himself in a fictional news bulletin.

9 Allan Massie, 'Why Diana is still the spirit of the age', *Telegraph* (12 April 2008), www.telegraph.co.uk/news/uknews/1584774/Why-Diana-is-still-the-spirit-of-the-age.html.

10 Derek Paget, 'Making mischief: Peter Kosminsky, Stephen Frears and British television docudrama', *Journal of British Cinema and Television* 10:1 (2012), p. 188.

11 Belén Vidal, *Heritage Film: Nation, Genre and Representation* (London: Wallflower, 2012), p. 44.

12 Giselle Bastin, 'Filming the ineffable: biopics of the British royal family', *Auto/Biography Studies* 24:1 (Summer 2009), p. 42.

13 Stephen Heath, *Questions of Cinema* (Bloomington: Indiana University Press, 1981), p. 21.

14 For a reading of this scene and its relation to other heritage films' use of portraiture, see Vidal, *Heritage Film*, pp. 42–3.

15 The public identification of Mirren with the role of Elizabeth II was arguably furthered by her toast to the monarch when accepting the 2007 Best Actress Oscar for the role: 'Ladies and gentlemen, I give you the Queen.' In 2013 and 2015, she again 'gave' theatre goers the Queen in Peter Morgan's *The Audience*, portraying the monarch's weekly private discussions with prime ministers ranging from Churchill to Cameron. Remarking on the play's 'two-hour exercise in propaganda for Elizabeth Windsor', *Guardian* journalist Jonathan Freedland observed, 'These days, in which our own favoured celebrities are those who have triumphed over adversity, it's not enough that we admire the monarch, we must feel sympathy too. ... Partly down to Mirren's ability to convey a sense of inner longings repressed, we believe this Queen when she sighs at "the unlived lives within us all".' Jonathan Freedland, 'After a night at the theatre with the Queen, I worry about democracy', *Guardian* (22 March 2013), www.theguardian.com/commentisfree/2013/mar/22/theatre-queen-worry-democracy-politicians.

16 Peter Brooks, *The Melodramatic Imagination* (New Haven and London: Yale University Press, 1995), pp. 14–20.

17 Thomas Hobbes, *Leviathan* [1651], ed. Richard E. Flathman and David Johnston (New York and London: W. W. Norton, 1997), p. 48.

18 *Ibid.*, p. 53.

19 *Ibid.*, p. 96.

20 Andrew Marvell, 'An Horatian Ode upon Cromwel's Return from Ireland', in Helen Gardner (ed.), *The Metaphysical Poets* (London: Penguin Books, 1961), p. 258.

21 Tom Nairn, *The Enchanted Glass: Britain and Its Monarchy* (London: Verso, updated 2nd edn, 2011), p. viii.

22 First staged in 1814, *The Dog of Montargis* was based on a fourteenth-century legend in which the faithful dog of a murdered knight finds the sash of the murderer and later keeps him from escaping.

23 Made by the BBC to publicise the Investiture of the Prince of Wales at Caernarvon in 1969, *Royal Family* was directed by Richard Cawston. Although its behind-the-scenes informality was controversial at the time, the programme's success prompted the Palace to ask Cawston to take over the production of the Queen's Christmas television broadcast from 1970 to 1985.

24 Produced by Granada Television for the BBC, *The Royle Family* is a situation comedy portraying a working-class family living in Manchester. It ran for three series between 1998 and 2000, with further special episodes in 2006, 2008, 2009 and 2010. The series reunited actors Ricky Tomlinson and Sue Johnston, the stars of the 1980s Channel 4 soap opera *Brookside*.

25 Walter Bagehot, *The English Constitution* [1867] (London: Fontana Library, 1963), p. 85.

26 Geoffrey Nowell-Smith, 'Minnelli and melodrama', in Gledhill (ed.), *Home Is Where the Heart Is*, p. 71.

27 Nairn, *The Enchanted Glass*, p. 37.

28 See David Cannadine, 'From biography to history: writing the modern British monarchy', *Historical Research* 77:197 (2004), p. 303.

29 Confirming his own view of this maternal theme, director Stephen Frears has observed, 'Making a movie about the Queen is almost like making a movie about your mother and in England, the Queen really does serve as a kind of symbolic, emotional mother of the country.' Quoted in Emanuel Levy, 'The Queen according to Frears', *Emanuel Levy: Cinema 24/7*, www.emanuellevy.com/interview/the-queen-according-to-frears.

30 In *The Melodramatic Imagination* (p. 27), Brooks argues that melodrama 'is about virtue made visible and acknowledged, the drama of recognition'. His example is Pixérécourt's 1819 *La Fille de l'exilé*, in which a band of fierce Tartars fall to their knees before a young woman who has heroically forgiven the persecutor of her father.

31 Friedrich Schiller, *Mary Stuart: A Tragedy*, trans. Joseph Mellish, Project Gutenberg ebook, last updated November 2012, Act I, Scene 8 (no pagination), www.gutenberg.org/files/6791/6791-h/6791-h.htm.

32 *Ibid.*, Act IV, Scene 7.

33 *Ibid.*, Scene 10.

34 Henry James, 'The London theatres' [1880], in Allan Wade (ed.), *The Scenic Art: Notes on Acting and Drama* (London: Rupert Hart-Davis, 1949), p. 161.

BIBLIOGRAPHY

Bastin, Giselle, 'Filming the ineffable: biopics of the British royal family', *Auto/Biography Studies* 24:1 (2009).

Bagehot, Walter, *The English Constitution* [1867] (London: Fontana Library, 1963).

Brooks, Peter, *The Melodramatic Imagination* (New Haven: Yale University Press, 1995).

Cannadine, David, 'From biography to history: writing the modern British monarchy', *Historical Research* 77:197 (2004).

Elsaesser, Thomas, 'Tales of sound and fury: observations on the family melodrama', in Christine Gledhill (ed.), *Home Is Where the Heart Is: Studies in Melodrama and the Woman's Film* (London: BFI, 1987).

Freedland, Jonathan, 'After a night at the theatre with the Queen, I worry about democracy', *Guardian* (22 March 2013), www.theguardian.com/commentisfree/2013/mar/22/theatre-queen-worry-democracy-politicians.

Heath, Stephen, *Questions of Cinema* (Bloomington: Indiana University Press, 1981).

Hobbes, Thomas, *Leviathan* [1651], ed. Richard E. Flathman and David Johnston (New York and London: W. W. Norton, 1997).

James, Henry, 'The London theatres' [1880], in Allan Wade (ed.), *The Scenic Art: Notes on Acting and Drama* (London: Rupert Hart-Davis, 1949).

Levy, Emanuel, 'The Queen according to Frears', *Emanuel Levy: Cinema 24/7*, www.emanuellevy.com/interview/the-queen-according-to-frears.

Marvell, Andrew, 'An Horatian Ode upon Cromwel's Return from Ireland', in Helen Gardner (ed.), *The Metaphysical Poets* (London: Penguin Books, 1961).

Massie, Allan, 'Why Diana is still the spirit of the age', *Telegraph* (12 April 2008), www.telegraph.co.uk/news/uknews/1584774/Why-Diana-is-still-the-spirit-of-the-age.

Muggeridge, Malcolm, 'The royal soap opera' (first published in the *New Statesman*, 22 October 1955), republished by the *New Statesman* (30 May 2012), www.newstatesman.com/lifestyle/2012/05/back-royal-soap-opera.

Nairn, Tom, *The Enchanted Glass: Britain and Its Monarchy* (London: Verso, updated 2nd edn, 2011).

Nowell-Smith, Geoffrey, 'Minnelli and melodrama', in Christine Gledhill (ed.), *Home Is Where the Heart Is: Studies in Melodrama and the Woman's Film* (London: BFI, 1987).

Paget, Derek, 'Making mischief: Peter Kosminsky, Stephen Frears and British television docudrama', *Journal of British Cinema and Television* 10:1 (2012).

Schiller, Friedrich, *Mary Stuart: A Tragedy*, trans. Joseph Mellish, Project Gutenberg ebook, last updated November 2012, www.gutenberg.org/files/6791/6791-h/6791-h.htm.

Shawcross, William, 'Portrait in majesty', *Vanity Fair* (June 2007).

Thomson, David, 'Biographical dictionary of film number 99 (Stephen Frears)', *Guardian* (3 September 2010), p. 14.

Turner, Graeme, 'The cultural function of celebrity', in *Understanding Celebrity* (London: Sage, 2006).

Vidal, Belén, *Heritage Film: Nation, Genre and Representation* (London: Wallflower, 2012).

Williamson, Judith, 'Royalty and representation', in *Consuming Passions: The Dynamics of Popular Culture* (London: Marion Boyars, 1986).

17

When words fail: *The King's Speech* as melodrama

Nicola Rehling

In his review of *The King's Speech* (Tom Hooper, 2010), *Guardian* critic Peter Bradshaw remarks that the Oscar-winning film shows 'some cheek at presenting an English monarch as the underdog'.[1] However, although melodrama traditionally 'sides with the powerless',[2] it has become a common mode through which the British monarchy is represented in contemporary British cinema, primarily to evoke sympathy for the strain the royal role places on the monarch as private individual. George VI (Colin Firth) in the film is without doubt a melodramatic figure, the victim of his severe speech impediment and the demand that he speak publicly – the violent imposition of duty over private desires that characterises the melodramatic terrain. The film can also be read as a 'family melodrama' thanks to its relentless focus on the personal and domestic realm – evident in the diminutive 'Bertie' by which the young Prince Albert who becomes King is called for much of the film. In the father–son melodrama tradition, his stammer is attributed to trauma enacted by his stern, dominating parent (Michael Gambon) and an inability to live up to paternal expectations.

The King's Speech is also exemplary of Peter Brooks's formulation of melodrama as a mode that seeks moral legibility in what he terms a 'post-sacred era', one without universal religious conviction.[3] Moral imperatives, Brooks argues, can now only be expressed in personal terms and are often orchestrated by generating pathos for a virtuous but wronged figure, whose suffering is often literalised physically.[4] Bertie is such a figure, his tortured body and agonising stammer bespeaking not only the burden of monarchy, but most importantly his unrecognised goodness. While the film is willing to reference some of the ideological conflicts about Britain's constitutional monarchy that prevailed in the 1930s, its insistence on Bertie's victimisation and integrity forcefully inscribes not only

his personal virtue but also, by extension, the virtue of the monarchy as institution – provided, the film suggests, individual monarchs undertake the role with the commitment and duty entrusted in them.

MELODRAMA, FILM STUDIES AND THE MONARCHY BIOPIC

I primarily use the term melodrama with Brooks's sense of it as 'an imaginative mode', a way of seeing and conveying moral truths rather than a stage or screen genre with a clear set of conventions.[5] However, the debates around melodrama in film studies in the early 1970s, when film theorists actively constructed the family melodrama as a genre, are highly pertinent to *The King's Speech*. Adopting Marxist, feminist and psychoanalytic approaches, and taking capitalism, ideology, patriarchy and repression as their main topics of investigation, scholars such as Thomas Elsaesser, Geoffrey Nowell-Smith, Laura Mulvey, Chuck Kleinhans and David Rodowick, among others, focused on the 1950s family melodrama, typified by the work of Douglas Sirk.[6] While differing in emphasis, this cycle of films explored intergenerational conflicts and repressions within middle-class families, most often through the suffering of a victim (rarely the father) who served as the primary figure of identification. These films, it was argued, could voice a critique of patriarchy and capitalism by revealing internal tensions and ideological incoherencies.

Crucial in staking out the family melodrama as a genre is Elsaesser's essay 'Tales of sound and fury: observations on the family melodrama' (1972). There he argues that the persistence of melodrama as a popular cultural form is symptomatic of a stubborn refusal 'to understand social change in other than private contexts and emotional terms'.[7] Despite his criticism of melodrama's escapism from political crises through its unremitting focus on the personal realm, Elsaesser suggests that the screening of impotent, victimised individuals, subjected to external forces that find no release but drive relentlessly and destructively inwards, can 'serve to formulate a devastating critique of the ideology that supports [such alienation]'.[8] Elsaesser has been influential in his attention to melodrama's pathos, or sympathetic feeling, and its role in conveying psychological and sexual repression, as well as to the expressive *mise-en-scène* of the family melodrama – the oppressive bourgeois home whose clutter seems to entrap the protagonists, evoking a latent but ever-lurking hysteria.[9] Many of his observations on melodrama as a style expressing impotent suffering can be applied to *The King's Speech*, as we shall see.

Along similar lines, Geoffrey Nowell-Smith, in his brief essay 'Minnelli and melodrama' (1977), also fused Marxist and Freudian approaches, analysing the psychic and social determinations at work in the bourgeois melodrama. For Nowell-Smith, the castrating power of patriarchal dominance constitutes melodrama's main thematic concern; hence, the oppression of female protagonists or males whose masculinity is 'impaired' – since what melodrama dramatises, he argues, are 'forms of a failure to be male – a failure from which patriarchy allows no respite'.[10] With the father responsible for the perpetuation of this symbolic sexual division, the family melodrama is centrally concerned with paternity and succession (a key concern of the monarchy film, of course), as well as

> the child's problems of growing into a sexual identity within the family, under the aegis of a symbolic law which the Father incarnates. What is at stake (also for social-ideological reasons) is the survival of the family unit and the possibility of individuals acquiring an identity which is also a place within the system, a place in which they can both be 'themselves' and 'at home', in which they can simultaneously enter, without contradiction, the symbolic order and bourgeois society. It is a condition of the drama that the attainment of such as place is not easy and does not happen without a sacrifice, but it is very rare for it to be seen as radically impossible.[11]

The happy end in melodrama, he notes, often feels impossible and contrived, achieved at the cost of repression, resulting in an excess which cannot always be accommodated into a classic realist narrative, but is 'siphoned off' – expressed in the 'hysterical' moments when realist conventions break down, such as intrusive music or excessive *mise-en-scène*. For Nowell-Smith, the importance of melodrama is precisely this laying bare of the contradictions that most Hollywood forms smooth over.[12] While his assumption that only non-realist aspects of a text can voice social critique is problematic (a distrust of realism that characterises many of these 1970s ideology theorists), his framework is useful in thinking through not only Bertie's relationship with his father, but also the non-realist stylistics that occasionally punctuate the film, most often to generate sympathy for Bertie, who seems entrapped by the demands of the institutions of both the family and monarchy. However, as Laura Mulvey noted, writing in the same year, while the textual 'fissures' of melodrama can highlight the incoherencies of bourgeois ideology, they might also function as a 'safety valve for ideological contradictions'.[13]

Another approach to melodrama, which has been highly influential in film studies, and greatly informs my own analysis of *The King's Speech*, is the framing

386

of melodrama not so much as a distinct form but rather a 'mode of representation with a particular moralizing function operating across many genres'.[14] As Linda Williams aptly summarises, '[i]f emotional and moral registers are sounded, if a work invites us to feel sympathy for the virtues of beset victims, if the narrative trajectory is ultimately concerned with a retrieval and staging of virtue through adversity and suffering, then the operative mode is melodrama'.[15] Her paradigm stems from Peter Brooks's seminal work *The Melodramatic Imagination: Balzac, Henry James, Melodrama, and the Mode of Excess* (1976). Brooks explores how melodrama was initially a theatrical form that emerged with the French Revolution's abolition of the licensing restrictions on theatres and the need to find new ways to address uneducated audiences about moral values at a time when the Church had lost much of its power and influence. In this 'post-sacred' era, there was still an ongoing craving for moral certainty, but it was only conceivable in personal terms.[16] Melodrama, for Brooks, is thus 'a peculiarly modern form' that responds to the loss of pre-Enlightenment values by 'making the world morally legible', often through a distinct polarisation of good and evil in order to reassure us of 'their presence and operation as real forces in the world'.[17] For this reason, melodrama is often structured around the path of unacknowledged, wronged and suffering virtue, and the staging of its ultimate triumph and/or recognition.[18] In this Manichean universe, Brooks argues, characters rarely have interior depth; rather, since 'melodrama exteriorizes conflict and psychic structures', they embody ethical imperatives or psychic signs.[19] These ethical imperatives or emotional states may be rendered in somatic terms, allegorising them through extreme physical conditions.[20] The most common example in melodrama is that of the 'mute role' – not only metaphorically, such as a character unable to speak as a result of familial or structural relations or one sworn to a vow of silence, but also cases of literal physical muteness.[21] This muteness often results in characters being unable to show their true virtue, or being wrongly accused and unable to defend themselves, such as Pixérécourt's *Le Chien de Montargis* (*The Dog of Montargis*, 1814), in which a mute servant is falsely accused of murder and struggles to prove his innocence. The failure of words or language is also evident in the 'heightened dramatization' of the mode, such as gestures, music or other expressionistic devices, which are symptomatic of this failure of words to be 'wholly adequate to the representation of meanings'.[22]

Many of the recent biopics about the modern monarchy, such as *Mrs. Brown* (John Madden, 1997), *The Queen* (Stephen Frears, 2006),[23] *The Young Victoria*

(Jean-Marc Vallée, 2009), as well as *The King's Speech* can be read in terms of melodrama if we adopt Brooks's paradigm. These 'quality films', which show-case British stars whilst using the monarchy as a global commodity to court international as well as domestic audiences, depict monarchs who suffer unjustly under the strain imposed by royal life. One of the prime attractions of such films, as Belén Vidal notes, is the 'star-as-performer', notable examples being Judi Dench's and Helen Mirren's controlled performances in *Mrs. Brown* and *The Queen* respectively, in which close-ups dramatise emotional restraint through small, subtle gestures or facial expressions, and the voice is slightly modulated to convey pent-up feelings, resulting in 'nuanced psychological portraits of the otherwise inaccessible figures they embody'.[24] Much like the quality literary film, which takes pleasure in screening self-possession, stifled feelings, fleeting glances, the failures of speech, the unarticulated and the frus-tration of intentions,[25] the monarchy film foregrounds repression, the thematic concern *par excellence* of melodrama. These films also orchestrate 'the feeling of righteousness achieved through the sufferings of the innocent',[26] in this case the victimised monarchs whose private lives are ravaged by the public role they are forced to bear. Thus they construct a benign representation of constitutional monarchy, while politics only enters the picture in terms of its impact on the monarch's private lives. This focus on the personal is essential in an era in which only individual virtue can legitimise the monarchy as an institution.[27]

THE MONARCHY IN CRISIS: *THE KING'S SPEECH* AS MELODRAMA

From its opening, *The Kings Speech* presents Bertie as a victim and the pri-mary point of the spectator's identification. A title card informs us that the King asked Prince Albert to give the opening address to the Empire Exhibition in 1925 – his 'inaugural broadcast to the nation and the world', the BBC announcer tells his audience. This is then followed by a series of close-ups of the microphone, a repeated motif throughout the film that con-veys the Prince's dread of public speaking, and then a series of close-ups of a panic-stricken Bertie muttering the speech to himself. The asymmetrical framing of this moment, with the Prince on the extreme left of the frame (a technique used throughout the film), suggests he has been thrown off bal-ance by the daunting task ahead and psychologically retreats – an example of the many overtly expressionistic moments in the film that foreground his alienation and punctuate the realist mode in ways that recalls Elsaesser's,

Nowell-Smith's or Mulvey's readings of the family melodrama. After shots of Bertie's wife Elizabeth (Helena Bonham-Carter) comforting him, and a montage sequence of equipment for broadcasting to the colonies that shows the immensity of the audience – the entire Empire, no less – Hooper again overtly eschews classic realism by using a tracking shot filmed with a slightly distorting wide-angled lens to lead the funereal Prince to the dreaded microphone, a directorial choice that forges the spectator's identification while separating Bertie from his environment and underscoring his isolation. The microphone itself looms large, creating a barrier between Bertie and the crowd in a way not dissimilar to Sirk's prevalent use of barriers, frames and constrictions as part of his domestic *mise-en-scène* of entrapment – the non-verbal, heightened expressionism that for Elsaesser and Brooks characterises the melodramatic form. While the melancholic tones of Alexandre Desplat's haunting soundtrack accompanied Bertie to the microphone, now a painfully long silence ensues, broken only by a horse neighing, followed by close-ups of the Prince as he battles to speak, intercut with shots of puzzled technicians, his pained wife and embarrassed members of the crowd turning away as he struggles to utter the 'k' at the beginning of 'king' – an overdetermined refusal of the role from the very outset of the film. Bertie is thus silenced, similar to Pixérécourt's mute stage characters, unable to reveal his true worth, which none the less is immediately made known to the spectator.

As the film jumps to 1934, Bertie continues to suffer such indignities. Consulting a leading speech therapist of the time, he is encouraged to fill his mouth with marbles and 'enunciate' (an intertextual reference to *Pygmalion*), which, the therapist cheeringly informs the Prince, 'cured Demosthenes', the Athenian orator who suffered from a speech impediment as a boy (evoking the ironic comment from his wife that 'That was in Ancient Greece. Has it worked since?'). Filmed in an overpowering, suffocating, low-angled close-up, again with a distorting wide-angled lens, the therapist is represented from Bertie's point of view as a threatening figure, whose assaults on Bertie's self-respect prompt the irascible Prince to expel the marbles angrily, storm out in a violent outburst and refuse further treatment. Such cinematic language might function as a means of articulating the unbearable pressures of royalty, in the way that Elsaesser and Nowell-Smith, for example, interpret the 'excessive' or 'hysterical' moments of the family melodrama as oblique social critique, but its primary function is 'to generate emotion'[28] and secure sympathy for the demoralised, repressed Bertie as an *individual* facing adversity.

That said, the film's main source of melodrama – Bertie's distressing unsuitability for the public role he is forced to play – allows the film to explore the consequences for the monarchy of the reterritorialisation of the public/private spheres by mass media under modernity, since the Prince's predicament is only exacerbated by the new requirements of radio broadcasts. As his father George V – the first monarch able to broadcast to his subjects – states of the radio (which he terms a 'devilish device'): 'In the past all a king had to do was look respectable in uniform and not fall off his horse. Now we must invade people's homes and ingratiate ourselves with them.' Such ingratiation, which signifies a constitutional monarchy that has to struggle to retain its popularity,[29] he obviously find particularly distasteful, even though the real George V has been credited by some with modernising and thereby saving, even, the British monarchy.[30] This emphasis on the import of performance in modern leadership is made more heavy-handedly when Bertie and his family watch footage of Hitler addressing the crowd at the Nuremberg rallies; when his daughter Elizabeth asks what Hitler is saying, Bertie replies, rather wistfully, 'I don't know but he seems to be saying it very well.' This demand for public performance makes the film's George V disdainfully remark that the royals have become the 'lowest, basest of all creatures' – 'actors' – actors who had to perform very well indeed to avoid being 'out of work', a reference to the very real threats posed by republicanism and socialism at this time. Indeed, for historian David Cannadine, it is precisely the 'invention' and performance of royal rituals and traditions, perfected at the end of the nineteenth and beginning of the twentieth century, which prevented the British monarchy from suffering the same fate as its Austrian, Prussian and German equivalents.[31] None the less, in evoking sympathy for Bertie, the film at times seems to join George V in expressing nostalgia for a monarchy that retained its mystique and privacy (still just possible at this time, the film suggests, when speech therapist Lionel Logue (Geoffrey Rush) doesn't recognise Princess Elizabeth) and no longer possible with the mass media, the Internet, mobile phones and the media construction of the Windsors as celebrities.

Scenes with George V also stage a father–son melodrama, screening a Bertie who fails to live up to his father's demands and thus struggles to find a place where he can be 'himself' and be 'at home', to rephrase Nowell-Smith.[32] During the 1934 Christmas broadcast, when George V impels his son to try out the microphone, he impatiently bellows: 'Sit up, straight back, face boldly up to the bloody thing and stare it square in the eye, as would any decent Englishman. Show who's in command.' Then, condemning Bertie's socialite brother David,

the future Edward VIII (Guy Pearce), and his scandalous relationship with the American divorcée Wallis Simpson (Eve Best), he sternly predicts (in a way typical of the contemporary monarchy biopic's self-reflexivity about narratives of history and nation):[33] 'When I'm dead, that boy will ruin himself, this family and this nation within 12 months. Who will pick up the pieces; hmm? Herr Hitler, intimidating half of Europe, Marshall Stalin the other half? Who'll stand between us, the jackboots, and the proletarian abyss? You?' This final questioning 'You?' conveys a lack of confidence in Bertie, with public and political antagonisms articulated as personal conflict in the melodramatic tradition. When the Prince again attempts to speak in the microphone, his muscles clench, his jaw locks and his stammer is at its most violent, causing his father, filmed from a threatening, higher camera angle to roar: 'Get it out boy!' 'Just try it!' 'Do it!' Bertie, though, like the mute figures Brooks discusses, cannot speak or prove his worth to his father. Positioning Bertie as a 'boy' whose masculinity is 'impaired',[34] the film adopts the classic Oedipal paradigm of the castrating father,[35] with melodrama's obsession with paternal legacy, the survival of the family and the reconsolidation of patriarchy rendered more pressing through Bertie's future role not merely as head of a family, but as future King and Emperor. While he discovers after the King's death that his father had actually deemed him to have had 'more guts than all his brothers put together', this merely compounds the film's melodramatic operation, since it screens the typical 'too late' motif of emotional revelation, with the psychic damage already done.

This Oedipal drama is further played out through the Prince's therapy-style confessions to Lionel Logue, an Australian-born, self-taught, often irreverent speech therapist, irrepressible to Bertie's repressed.[36] If the doctor is most often a pivotal figure in melodrama who 'serv[es] to identify and cure the physical and psychic maladies of femininity',[37] here Logue's function is to interrogate the physical and psychic maladies of monarchy and privileged masculinity. Having worked with shell-shock victims in the First World War, he is convinced that speech impediments are rooted in psychological traumas and locates Bertie's stammer not so much in the burden of royalty, but his dysfunctional relationship with his stern father, cold mother and bullying elder brother. The Prince is initially unwilling to confide in Lionel and is dismissively contemptuous of his 'modern' methods – a point underscored cinematically in their first meetings when both characters occupy the extreme edges of the frame; however, once Logue gains Bertie's trust after his father's death, now in a tightly framed shot connoting intimacy, the Prince confesses how the teasing he endured as a child

was encouraged by his father, who declared: 'I was afraid of my father and my children are damned sure going to be afraid of me.' Bertie further reveals the painful memory of a sadistic nanny who pinched him and refused him food – a memory so painful he cannot speak but can only sing to the tune of 'Swanee River' (one of Lionel's unorthodox methods) – noting that it took his parents three years to notice. Lionel also asks Bertie why he thinks his stammering is worse around his brother David, whom we see bullying Bertie and mimicking his stammer, reducing Bertie to an inarticulate, crumpled heap.

These instances of cruelty reinforce the Prince's own belief that the Windsors are not a family but a 'firm' – a reference to the beginning of the royal family circulating as a brand in the global marketplace. The pressures of the nuclear family and the impossibility of reconciling private desires with patriarchal power and duty – that is, the stuff of family melodramas – are rendered more acute for royals since, as we see with Edward VIII's abdication and the constitutional crisis it evoked, pursuing private desires can have very public consequences – a common theme to all monarchy films.[38] However, the film also shows tender scenes of Bertie's supportive wife and children, suggesting that he will be a very different father. This follows the common trend in British and American films of casting benign masculinity as sensitive paternity, as a corrective to the traditional model of a repressed, non-emotional patriarch, such as that embodied by George V.[39] In this respect, the film adds to the common construction of the royal family as a typical bourgeois family that was initiated by Queen Victoria[40] and continues in current media representations, including the soap opera coverage of the Windsors as a dysfunctional family during the royal divorce scandals in the mid-1990s.

The film's overt foregrounding of the trauma and pain at the heart of the royal nuclear family, with Bertie and his father (who is given little psychological depth) representing psychic signs of psychological conflict, is highly illustrative of the convergence between melodrama and psychoanalysis that Brooks identifies: 'psychoanalysis is a kind of modern melodrama, conceiving psychic conflict in melodramatic terms and acting out the recognition of the repressed, often with and on the body'.[41] For Brooks, what is key both to both discourses is the hysterical body, 'a body preeminently invested with meaning – a body that has become the place for the inscription of highly emotional messages that cannot be written elsewhere, and cannot be articulated verbally'.[42] The task of Logue, then, who directs the responses of spectators much better versed in Freudian discourse than his intra-diegetic contemporaries, is to interpret

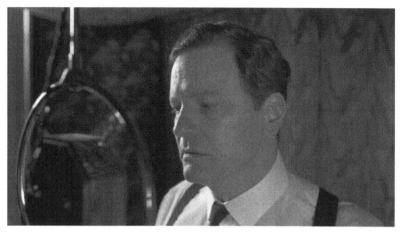

33 The monarch as the virtuous victim of melodrama: Colin Firth as George VI in
The King's Speech (Tom Hooper, 2010).

Bertie's stammering body, which he does by constantly commenting not only on the Prince's childhood traumas, but also on his unrecognised courage and potential brilliance, telling his wife that his unnamed client 'could really be somebody great, but he's fighting me'.

Bertie's stammer therefore, like the muteness of virtuous victims in nineteenth-century stage melodramas, makes the world 'morally legible'[43] at a time when the monarchy derives its power from the people rather than God. This enables the film to screen some of the challenges to the institution whilst reassuring us that it is a benign influence in British modern life. In this respect, the film shares the ambivalences of the British heritage film since it fetishises the spectacle of royalty and valorises its role in forging national unity while drawing attention to the gulf between the lives of the Windsors and their subjects.[44]

The challenges posed to the modern monarchy are played out in the personal sphere through the dynamics of Bertie's friendship with Logue, which stages a gentle class and culture clash when Bertie's pompous belief in his superiority is debunked by the lower-middle-class Australian in ways that court audience enjoyment, such as when Logue insists on equality, calls his patient 'Bertie' ('only my family call me that', the outraged Prince utters) and forbids his smoking with the edict 'my castle, my rules'. His therapeutic exercises result in undignified royal displays when Elizabeth sits on her husband's chest, or when Bertie is rolled around the room by Logue, or sings and dances his speech

or punctuates it with profanities, as do the Windsors' clumsy negotiation with the lift cage in the building where Lionel has his consulting room. This gentle debunking of the royals' sense of superiority makes them more accessible, portraying them as private individuals with normal longings and weaknesses – a project similar to the monarchy films *Mrs. Brown* and *The Queen*. It also, however, underscores the validity of the Prince's own confession that he is painfully out of touch with the 'common man' – a problem facing the constitutional monarch in many royal biopics of recent years, most notably *The Queen*, which revolves around Elizabeth II's lack of media savviness compared to her young Prime Minister, Tony Blair.

While Logue demands respect, he is no republican or rebellious imperial subject. He might well sit in St Edward's Chair during the coronation rehearsals, an act of impudence that so outrages the combustible Bertie that he invokes Divine Right in his claim to the throne; however, his actions do not constitute a political challenge, but rather his attempt, as a therapist, to force his patient to assert his desire to be King. Indeed, Logue's actions prompt Bertie to shout out in a melodramatic moment of psychological unblockage: 'I have a right to be heard! I have a voice!' In other words, the therapist's concern is not the monarchy as institution, but Bertie's absence of self-belief. It could also be argued that this relationship between the future King and Emperor and his colonial subject works in the way Paul Dave notes of the patrician/plebeian couple – to offer a unifying 'representations of essential Englishness rather than evidence of class [or, I would add, colonial] struggle'.[45] The same could be said of the contrasting shots of the lavish royal residences with the dilapidated, Depression-hit setting of Lionel's modest home and grungy consulting room. The film's insistent focus on Bertie's struggle with adversity circumvent even this fleeting recognition of the vast suffering of the general populous during this time – laying the film open to common criticisms levelled at the conservatism and elitism of the heritage film.

That said, the film does engage on some level with political challenges of republicanism and the spectre of socialism that plagued the monarchy at this time, such as when George V tells Bertie 'at any moment, some of us might be out of work', while the Prince reminds his errant brother, 'Kinging is a precarious business, these days. Where is the Russian Tsar? Where's cousin Wilhelm? [...] [T]here are people marching across Europe singing the Red Flag', only to be told by David that he is being 'dreary' and Herr Hitler will sort them out. Moreover, while little is made of the crisis of public faith in the monarchy

caused by the Abdication, resistance to Prince Albert ascending to the throne and the Blackshirt support for the Nazi-sympathiser Edward VIII is noted through background shots of British Union of Fascists posters declaring 'God Save the King' – posters which, Bertie acknowledges to Lionel, do not refer to him. However, one could also argue that such transitory recognition of the contradictions and tensions of the monarchical system configure a means by which the monarchy sustains itself – similar to the ways Laura Mulvey reads 1950s melodrama's representation of patriarchy.

The stark opposition the film constructs between Bertie, the good King, and David, the bad King – blatant embodiments of the moral polarisation in which melodrama trades – also allows the film to suggest the problem is not the monarchical system *per se*, but by whom and how it is executed. In complete antithesis to our opening glimpse of Bertie, the confident, dashing and highly eloquent David is first seen piloting himself into the Sandringham estate, described as 'a sun god descended from the skies' in the screenplay.[46] David, of course, is also a melodramatic figure, struggling with the conflict central to the mode – 'the impossibility of an individual reconciliation of the law and desire',[47] forced to choose between 'what he wants, or … what the people expect him to do', as Stanley Baldwin puts it. While at times David is treated with some sympathy for his predicament, such as his melodramatic collapsing into tears on his father's death as he ascends the throne, his behaviour is also characterised as selfish on account of his failure to carry out kingly duties, his profligacy, his socialite lifestyle and his insistence on marrying an unsympathetically painted Wallis Simpson. The film also references, though rather briefly, his support of Hitler, with George VI and Elizabeth's own initial support of appeasement conveniently side-lined by the way the film skips almost directly from the abdication to the outbreak of the Second World War.[48]

In contrast to his brother, the Prince is rendered heroic for forsaking his personal desires for public duty, continuing 'the monarchy film's traditional theme of self-sacrifice'.[49] This martyrdom is foregrounded when he offers his religious oath to the accession council in a scene that shares some of the oppressive *mise-en-scène*, camerawork and stylistic excess that characterised the 1950s family melodrama, though here it evokes not women's imprisonment in domestic confinement but Bertie's entrapment in kingship. His dread of this overpowering ritual is conveyed through a low-angled, hyper-symmetrical point-of-view shot of the accession chamber, filmed with a wide-angle lens to emphasise depth of field and evoke Bertie's total alienation. Such shots of the

lavish spectacle of the chamber might well evoke awe and fetishise British customs – the much-criticised 'nostalgic gaze' at 'heritage space' of the heritage film, which for Andrew Higson undercuts 'the social critiques so often suggested narratively by these films';[50] however, the ornate ceiling also seems about to cave in on Bertie, adding to an ongoing sense of constriction evoked in a film dominated by claustrophobic, interior settings.[51] This is followed by a series of disconnected shots of paintings of previous monarchs that Bertie sees hanging on the wall, the last being that of his father, which suggests the future King's rising panic and fear of failing to measure up to his predecessors. Unable to utter a word, he is reduced to what the screenplay terms 'a complete muscle-locked halt. He bows his head in humility. And shame.'[52] Here again, excessive cinematic language as well as Bertie's hysterical body bespeak the entrapment and resistance that he cannot articulate, while 'the literal suffering of [his] agonized body' 'orchestrate[s] the moral legibility crucial to the [melodramatic] mode',[53] his victimisation confirming his virtue.

Bertie's failings in the accession chamber only highlight his later triumph when he delivers his radio broadcast to rally his subjects' support for war, a scene that is melodrama at its purest. The stakes could not be higher. As the Prince complains, recognising his decorative role and political impotence, but simultaneously the importance of his symbolic function in forging national unity, 'If I am to be King ... where is my power? May I form a Government, levy a tax or declare a war? No! Yet I am the seat of all authority. Why? Because the Nation believes when I speak, I speak for them. Yet I cannot speak!' This, as Cynthia Fuchs notes, is one of the film's direct allusions to its multi-faceted title: 'as the act of speaking, as the extra-significant speech he must make to announce England's 1939 entry into war against Germany, and as the more metaphorical notion: speech as a means of communicating and so constructing national identity'.[54] Bertie's fumbled rehearsals exploit our fears that he might fail the nation in this grave hour, as does the deployment of similar techniques to the opening scene, such as the motif of the tracking shot to the microphone down tight, narrow corridors and close-ups of the looming microphone. As the speech scene begins, he is initially shown seemingly imprisoned by the microphone, and once broadcasting begins, an awkward silence ensues, creating a palpable tension evoked through intercutting shots of Elizabeth, terrified for her husband, and puzzled broadcasters. After a shaky beginning, Bertie, literally conducted by Logue, gains confidence, and while not delivering a perfect performance, which the director Tom Hooper rejected for being too much of

'a Hollywood ending',[55] reaction shots as well as the stirring accompaniment of Beethoven's Seventh attest to its success. This rather intrusive, but none the less extremely moving soundtrack provides the moral legibility and emotional pitching that for Brooks is the essential role of excessive 'melos' (music) in melodrama.[56]

As the King's confidence increases, and the music swirls, longer, side-on shots of Bertie are used in which he no longer seems trapped by the microphone, intercut with shots of his huge audience hanging on his every word. This includes working-class men in a pub, factory hands, servants at Buckingham Palace, soldiers serving abroad, the dignitaries at Buckingham Palace, David and Wallis Simpson in France (shot against an expansive window suggesting both their freedom from Bertie's oppressive role and their exile), Logue's wife and son, as well shots of the equipment broadcasting the speech to the entire Empire, and a very relieved Elizabeth. Bertie, the montage sequence implies, has indeed succeeded in using radio to collapse the public and private distinction and deliver his speech with what he calls 'the same depth of feeling for each one of you as if I were able to cross your threshold and speak to you myself'. His body is now healed, allegorising the reinvigorated national body that had been ailing from his brother's abdication, but triumphantly emerges reunified behind its King, whose virtue has finally been recognised, just in time for the forthcoming war.

By ending with this highly moving speech, real-life chronology is very much compressed, since it is documented that Prince Albert's stammer had considerably improved as early as 1927 when he opened the Australian parliament.[57] The film thus adopts the 'subjective and selective' postmodern approach to history that for McKechnie also characterises *Mrs. Brown*, with ' "facts" subordinated to the needs of the narrative'.[58] This also stages the 'in the nick of time' motif of melodrama, allowing Bertie to incarnate goodness to Hitler's evil and thereby inscribe the moral polarisation essential to the mode. This montage sequence, intensely poignant as a result of our extra-textual knowledge of the atrocities the war would bring,[59] represents the 'imagined community' of the 'nation', to use Benedict Anderson's term,[60] one in which class relations and inequalities are harmonised and wartime Britain is represented as 'one large family whose common concerns ride above any sectional interests'.[61] The melodramatic mode of address, in other words, builds on cultural representations of the Second World War as 'our finest hour', a time of unparalleled national unity. Inevitably, we read this scene with our extra-textual knowledge of the Allies' victory, of George

VI's and Queen Elizabeth's popularity (their refusing to leave London during the Blitz now well established in cultural mythology), the imminent break-up of the British Empire and the future loss of the alleged postwar consensus. Thus, to deploy Svetlana Boym's two typologies of nostalgia, this scene is less exemplary of 'reflexive nostalgia,' a forward-looking nostalgia that creates spaces for critical thinking and foregrounds the contradictions of modernity, than that of 'restorative nostalgia', a backward-looking nostalgia which attempts to reconstruct a lost 'truth' and tradition.[62] Indeed, this triumphant sequence fosters a conservative view of a former Britain that appears unified, despite rigid class hierarchies (which for the film seems more to index 'Britishness' than suggest any entrenched national division), culturally uniform (conforming to the all-white norm of the heritage film)[63] and an unrivalled imperialist power.

This image of Britain has perhaps become more necessary to construct now that traditional markers of national identity, as well as the notion of national cinema itself, are under erasure; as Belén Vidal puts it, the heritage film is gradually changing into a '"post-" phenomenon: post-nation, post-quality and post-modern', whether that refers to multinational funding sources, globalised production processes or a stylistic diversity that eludes national or auteurist specificity.[64] Indeed, *The King's Speech* was partly US funded, despite the self-congratulation in the British press concerning its innate Britishness in the wake of its Oscar successes.[65] This sense of *The King's Speech* as quintessentially British stems largely from the subject matter of the monarchy as a prototypical British icon, but none the less one intended for global consumption,[66] with the film aptly dubbed '[a] picnic for Anglophiles' by Hoberman.[67]

If, as Kara McKenchie argues, the royal biopic responds to conceptions of the monarchy dominant at the time of production,[68] then, released just before Prince William and Kate Middleton's royal wedding, *The King's Speech* played well into the resurging popularity of the royal family after it had reached its lowest ebb in the 1990s with the royal divorces and the disastrous handling of Princess Diana's death. The film's melodramatic discourse of 'monarch in crisis' certainly meditates on the impossibility of royals reconciling private desires and public duty, but far from giving space to ideological challenges to the monarchical system, the spectre of the real historical threats of republicanism and socialism are raised only to be deflected. Indeed, the primary function of the film's melodramatic address, I would argue, is to foreclose overt political critique, with threats to the monarchy played out on the personal terrain, treated as personal conflicts and traumas against which Bertie, in his individual struggle

against adversity, ultimately triumphs. Taking not only *The King's Speech*, but also other monarchy films such as *The Queen*, *Mrs. Brown* and *The Young Victoria* into account, it would seem that the melodramatic mode and its appeals to victimhood, as the Queen herself seems to have learnt when she dubbed 1992 her *'annus horribilis'*,[69] constitute an essential means through which the British monarchy is currently rendered an accessible and necessary British product (with international appeal, as the global success of the film verifies), enabling it to reaffirm its legitimacy in postmodernity.

NOTES

1 Peter Bradshaw, 'Oscars 2011: the Academy and the elderly genuflect to *The King's Speech*', *Guardian* (28 February 2011), www.guardian.co.uk/film/2011/feb/28/oscars-2011-the-kings-speech1.
2 Martha Vicinus, '"Helpless and unfriended": nineteenth-century domestic melodrama', *New Literary History* 13:1 (1981), p. 130.
3 Peter Brooks, *The Melodramatic Imagination: Balzac, Henry James, Melodrama and the Mode of Excess* (New Haven: Yale University Press, 2nd edn, 1995), pp. 42–3.
4 *Ibid.*, p. 46.
5 *Ibid.*, p. vii.
6 For an excellent account of these debates, as well as the Sirkian melodrama, see John Mercer and Martin Shingler, *Melodrama: Genre, Style, Sensibility* (London: Wallflower, 2004).
7 Thomas Elsaesser, 'Tales of sound and fury: observations on the family melodrama', in Christine Gledhill (ed.), *Home Is Where the Heart Is: Studies in Melodrama and the Woman's Film* (London: BFI, 1987), p. 47.
8 *Ibid.*, pp. 47, 62.
9 *Ibid.*, pp. 67, 61–2.
10 Geoffrey Nowell-Smith, 'Minnelli and melodrama', in Gledhill (ed.), *Home Is Where the Heart Is*, p. 72.
11 *Ibid.*, p. 73.
12 *Ibid.*, p. 74.
13 Laura Mulvey, 'Notes on Sirk and melodrama', in Gledhill (ed.), *Home Is Where the Heart Is*, p. 76. Mulvey's crucial feminist intervention into these debates was to argue that melodramas with a male protagonist tend to arrive at a more satisfactory conclusion than those with a female point of view – a narrative trajectory that *The King's Speech* follows. For criticisms of these theorists of family melodrama see Christine Gledhill, 'The melodramatic field: an investigation', in Gledhill (ed.), *Home Is Where the Heart Is*, and Steve Neale, *Genre and Hollywood* (London: Routledge, 2000), ch. 5.
14 Linda Williams, *Playing the Race Card: Melodramas of Black and White from Uncle Tom to O.J. Simpson* (Princeton, NJ: Princeton University Press, 2001), p. 15.

15 *Ibid.*

16 Brooks, *Melodramatic Imagination*, p. 16.

17 *Ibid.*, pp. 14, 42, 13.

18 *Ibid.*, p. 27.

19 *Ibid.*, p. 35.

20 *Ibid.*, p. 56. Brooks speculates that different kinds of dramas have different corresponding physical conditions: for tragedy, which is concerned with a lack of knowledge and insight, it is blindness; for comedy, which pivots around misunderstanding and a lack of communication, it is deafness; for melodrama, characterised by a desire to express everything but also the inability to do so, it is muteness (Brooks, *Melodramatic Imagination*, p. 57).

21 *Ibid.*, pp. 56, 31.

22 *Ibid.*, pp. xiii, 56.

23 See Mandy Merck's analysis of *The Queen* in this volume, in which she argues that the film's melodramatic mode ends up dominating the docudrama genre, with the victimised heroine *par excellence* – Princess Diana – gradually being replaced by Queen Elizabeth II, who is represented as a beleaguered, misunderstood working woman.

24 Belén Vidal, *Heritage Film: Nation, Gender and Representation* (London: Wallflower, 2012), p. 38.

25 E. Sonet, cited in Vidal, *Heritage Film*, p. 26.

26 Linda Williams, 'Melodrama revised', in Nick Browne (ed.), *Refiguring American Film Genres: Theory and History* (Berkeley: University of California Press, 1998), p. 62.

27 This goes some way towards accounting for the patronage of charities and 'highly visible, public-spirited social service' of the modern British monarchy, which some historians believed saved it from republicanism and socialism in the twentieth century – Prochaska, cited in Andrzej Olechnowicz, 'Historians and the modern British monarchy', in Andrzej Olechnowicz (ed.), *The Monarchy and the British Nation, 1790 to the Present* (Cambridge: Cambridge University Press, 2008), p. 28.

28 Williams, 'Melodrama revised', p. 44. Here Williams is taking issue with the 'so-excessive-as-to-be-ironic model' of 1970s and 80s anti-realist, ideological critics of melodrama (Elsaesser, Nowell-Smith, Mulvey, etc.) that read any such 'excessive', non-realist expressionism as an ironic comment on bourgeois ideology and/or a 'siphoning off' of characters' repressed emotion, overlooking the crucial affective impact of such techniques on audiences.

29 For David Cannadine, this signifies an 'emasculated' and 'feminised' monarchy, resulting in 'greater stress on family, domesticity, maternity and glamour'. David Cannadine, 'From biography to history: writing the modern British monarchy', *Historical Research* 77:197 (2004), p. 303.

30 See, for instance, the BBC2 documentary *King George and Queen Mary: The Royals Who Rescued the Monarchy* (2012).

31 David Cannadine, 'The context, performance and meaning of tradition: the British monarchy and the "invention of tradition", *c.* 1820–1977', in Eric Hobsbawm and

Terence Ranger (eds), *The Invention of Tradition* (Cambridge: Cambridge University Press, 1983.

32 Nowell-Smith, 'Minnelli and melodrama', p. 73.

33 Vidal, *Heritage Film*, p. 37.

34 Nowell-Smith, 'Minnelli and melodrama', p. 72.

35 Indeed, George VI has been termed 'the ultimate castrated male' by Prochaska (cited in Olechnowicz, 'Historians and the modern British monarchy', p. 29).

36 J. Hoberman, *The King's Speech*: how therapy saved monarchy', *Village Voice* (24 November 2010), www.villagevoice.com/2010-11-24/film/the-king-s-speech-ho w-therapy-saved-monarchy.

37 Marcia Landy, 'Melodrama and femininity in Second World War British cinema', in Robert Murphy (ed.), *The British Cinema Book* (London: BFI, 2nd edn, 2001), p. 123.

38 Pamela Church Gibson, 'From dancing queen to plaster virgin: *Elizabeth* and the end of English heritage', *Journal of Popular British Cinema* 5 (2002), p. 135.

39 See Susan Jeffords, *Hard Bodies: Hollywood Masculinity in the Reagan Era* (New Brunswick, NJ: Rutgers University Press, 1994), ch. 7; Fred Pfeil, *White Guys: Studies in Postmodern Domination and Difference* (London: Verso, 1995), ch. 2; Nicola Rehling, *Extra-Ordinary Men: White Heterosexual Masculinity and Contemporary Popular Cinema* (Lanham, MA: Lexington Books, 2009), ch. 2.

40 Cannadine, 'From biography to history', p. 303.

41 Brooks, *Melodramatic Imagination*, p. xi.

42 *Ibid.*

43 *Ibid.*, p. 42.

44 For a useful summary of debates concerning the heritage film, see Vidal, *Heritage Film*, ch. 1.

45 Paul Dave, *Visions of England: Class and Culture in Contemporary Cinema* (Oxford: Berg, 2006), p. 5.

46 David Seidler, *The King's Speech*, Screenplay, *Deadline* (14 January 2011), www-deadline-com.vimg.net/wp-content/uploads/2011/01/TheKingsSpeech-DL.pdf, p. 35.

47 David Rodowick, 'Madness, authority and ideology: the domestic melodrama of the 1950s', in Gledhill (ed.), *Home Is Where the Heart Is*, p. 273.

48 Peter Bradshaw, '*The King's Speech* – Review', *Guardian* (21 October 2010), www. guardian.co.uk/film/2010/oct/21/kings-speech-review-colin-firth.

49 Kara McKechnie, 'Taking liberties with the monarch: the royal bio-pic in the 90s', in Claire Monk and Amy Sargeant (eds), *British Historical Cinema: The History, Heritage and Costume Film* (London: Routledge, 2002), p. 227.

50 Andrew Higson, 'Re-presenting the national past: nostalgia and pastiche in the heritage film', in Lester Friedman (ed.), *Fires Were Started: British Cinema and Thatcherism* (London: Wallflower, 2006), p. 99.

51 Roger Ebert observes that the film 'is largely shot in interiors, and most of those spaces are long and narrow. … I suspect [Hooper] may be evoking the narrow, constricting walls of Albert's throat as he struggles to get words out.' Roger Ebert, '*The*

King's Speech', RogerErbet.Com (15 December 2010), www.rogerebert.com/reviews/the-kings-speech-2010.

52 Seidler, *The King's Speech*, p. 63.

53 Williams, *Playing the Race Card*, p. 29.

54 Cynthia Fuchs, 'The King's Speech: a little more concentration'. *PopMatters* (24 November 2010), www.popmatters.com/pm/review/134071-the-kings-speech.

55 David Gritten, 'Tom Hooper interview for *The King's Speech*', *Telegraph* (23 December 2010), www.telegraph.co.uk/culture/film/filmmakersonfilm/8219733/Tom-Hooper-interview-for-The-Kings-Speech.html. Hooper stated in the same interview:

> Originally, it had a Hollywood ending. … Bertie was cured. His final speech was faultless. I finally came to understand that wasn't truthful. If you hear the real speech (made by the King on the outbreak of war in 1939), he's clearly coping with his stammer. But it's not a perfect performance. He's managing it.
>
> I felt wary of making a film about a miracle cure. For most people [who stammer], it's not about a cure; it's about living with it. Also, there was a massive dramatic return on this change. Because the greatest problem in any movie like this is that you need to believe in the capacity of your hero to fail in the final act.

56 Brooks, *Melodramatic Imagination*, pp. 48–9. The Beethoven soundtrack in this finale has prompted this scene to be labelled 'the official Rocky moment' by Hoberman (Hoberman, 'The King's Speech'). Hoberman's response, which mirrors that of many other reviewers, is indicative of what Brooks, p. ix, terms 'our postmodern sophistication' in that 'we don't quite take melodrama "straight" anymore – maybe no one ever did – but always with a certain ironic detachment. Yet, remarkably, as spectators we can demur from the melodramatic – find it a hoot, at times – and yet still be seriously thrilled by it.'

57 Steve Meacham, 'king's voice calmed a nation', *Sydney Morning Herald* (10 November 2010), www.smh.com.au/entertainment/movies/kings-voice-coach-calmed-a-nation-20101109-17m2x.html?skin=text-only.

58 McKechnie, 'Taking liberties with the monarch', p. 227.

59 Tara Judah, 'The King's Speech', *Liminal Vision* (25 December 2010), http://liminalvision.wordpress.com/2010/12/25/the-kings-speech/.

60 Benedict Anderson, *Imagined Communities: Reflections on the Origin and Spread of Nationalism* (London: Verso, rev. edn, 1991).

61 Andrew Higson, *Waving the Flag: Constructing a National Cinema in Britain* (Oxford: Clarendon, 1995), p. 171.

62 Svetlana Boym, *The Future of Nostalgia* (New York: Basic Books, 2001), p. xviii.

63 John Hill, 'Contemporary British cinema: industry, policy, identity', *Cineaste* 26:4 (2001), p. 33.

64 Vidal, *Heritage Film*, p. 75.

65 The film was also the last film to be funded by the now disbanded UK Film Council, dubbed its 'Swan Song' by Bradshaw. Bradshaw, 'Oscars 2011'.

66 Vidal, *Heritage Film*, p. 19.

67 Hoberman, *'The King's Speech'*.

68 McKechnie, 'Taking liberties with the monarch', p. 218.

69 Queen Elizabeth II, *'Annus horribilis* speech', 24 November 1992, *Official Website of the British Monarchy*, www.royal.gov.uk/ImagesandBroadcasts/Historic%20 speeches%20and%20broadcasts/Annushorribilisspeech24November1992.aspx.

BIBLIOGRAPHY

Anderson, Benedict, *Imagined Communities: Reflections on the Origin and Spread of Nationalism* (London: Verso, rev. edn, 1991).

Boym, Svetlana, *The Future of Nostalgia* (New York: Basic Books, 2001).

Bradshaw, Peter, *'The King's Speech* – review', *Guardian* (21 October 2010), www. guardian.co.uk/film/2010/oct/21/kings-speech-review-colin-firth.

———'Oscars 2011: the Academy and the elderly genuflect to *The King's Speech*', *Guardian* (28 February 2011), www.guardian.co.uk/film/2011/feb/28/ oscars-2011-the-kings-speech1.

Brooks, Peter, *The Melodramatic Imagination: Balzac, Henry James, Melodrama, and the Mode of Excess* (New Haven: Yale University Press, 2nd edn, 1995).

Cannadine, David, 'The context, performance and meaning of tradition: the British monarchy and the "invention of tradition", *c.* 1820–1977', in Eric Hobsbawm and Terence Ranger (eds), *The Invention of Tradition* (Cambridge: Cambridge University Press, 1983).

———'From biography to history: writing the modern British monarchy', *Historical Research* 77:197 (2004).

Church Gibson, Pamela, 'From dancing queen to plaster virgin: *Elizabeth* and the end of English heritage', *Journal of Popular British Cinema* 5 (2002).

Dave, Paul, *Visions of England: Class and Culture in Contemporary Cinema* (Oxford: Berg, 2006).

Ebert, Roger, *'The King's Speech'*, *RogerErbet.Com* (15 December 2010), www.rog-erebert.com/reviews/the-kings-speech-2010.

Elsaesser, Thomas, 'Tales of sound and fury: observations on the family melo-drama', in Christine Gledhill (ed.), *Home Is Where the Heart Is: Studies in Melodrama and the Woman's Film* (London: BFI, 1987).

Fuchs, Cynthia, *'The King's Speech*: a little more concentration', *PopMatters* (24 November 2010), www.popmatters.com/pm/review/134071-the-kings-speech.

Gledhill, Christine, 'The melodramatic field: an investigation', in Christine Gledhill (ed.), *Home Is Where the Heart Is: Studies in Melodrama and the Woman's Film* (London: BFI, 1987).

Gritten, David, 'Tom Hooper interview for *The King's Speech*', *Telegraph* (23 December 2010), www.telegraph.co.uk/culture/film/filmmakersonfilm/ 8219733/Tom-Hooper-interview-for-The-Kings-Speech.html.

Higson, Andrew, *Waving the Flag: Constructing a National Cinema in Britain* (Oxford: Clarendon, 1995).

——'Re-presenting the national past: nostalgia and pastiche in the heritage film', in Lester Friedman (ed.), *Fires Were Started: British Cinema and Thatcherism* (London: Wallflower, 2006).

Hill, John, 'Contemporary British cinema: industry, policy, identity', *Cineaste* 26:4 (2001).

Hoberman, J., '*The King's Speech*: how therapy Saved monarchy', *Village Voice* (24 November 2010), www.villagevoice.com/2010-11-24/film/the-king-s-speec h-how-therapy-saved-monarchy.

Jeffords, Susan, *Hard Bodies: Hollywood Masculinity in the Reagan Era* (New Brunswick, NJ: Rutgers University Press, 1994).

Judah, Tara, '*The King's Speech*', *Liminal Vision* (25 December 2010), http://liminalvision.wordpress.com/2010/12/25/the-kings-speech/.

Landy, Marcia, 'Melodrama and femininity in Second World War British cinema', in Robert Murphy (ed.), *The British Cinema Book* (London: BFI, 2nd edn, 2001).

McKechnie, Kara, 'Taking liberties with the monarch: the royal bio-pic in the 90s', in Claire Monk and Amy Sargeant (eds), *British Historical Cinema: The History, Heritage and Costume Film* (London: Routledge, 2002).

Meacham, Steve, 'King's voice calmed a nation', *Sydney Morning Herald* (10 November 2010), www.smh.com.au/entertainment/movies/kings-voice-co ach-calmed-a-nation-20101109-17m2x.html?skin=text-only.

Mercer, John and Martin Shingler, *Melodrama: Genre, Style, Sensibility* (London: Wallflower, 2004).

Mulvey, Laura, 'Notes on Sirk and melodrama', in Christine Gledhill (ed.), *Home Is Where the Heart Is: Studies in Melodrama and the Woman's Film* (London: BFI, 1987).

Neale, Steve, *Genre and Hollywood* (London: Routledge, 2000).

Nowell-Smith, Geoffrey, 'Minnelli and melodrama', in Christine Gledhill (ed.), *Home Is Where the Heart Is: Studies in Melodrama and the Woman's Film* (London: BFI, 1987).

Olechnowicz, Andrzej, 'Historians and the modern British monarchy', in Andrzej Olechnowicz (ed.), *The Monarchy and the British Nation, 1790 to the Present* (Cambridge: Cambridge University Press, 2008).

Pfeil, Fred, *White Guys: Studies in Postmodern Domination and Difference* (London: Verso, 1995).

Rehling, Nicola, *Extra-Ordinary Men: White Heterosexual Masculinity and Contemporary Popular Cinema* (Lanham, MA: Lexington Books, 2009).

Rodowick, David, 'Madness, authority and ideology: the domestic melodrama of the 1950s', in Christine Gledhill (ed.), *Home Is Where the Heart Is: Studies in Melodrama and the Woman's Film* (London: BFI, 1987).

Seidler, David, *The King's Speech*, screenplay, *Deadline* (14 January 2011), www-deadline-com.vimg.net/wp-content/uploads/2011/01/TheKingsSpeech-DL.pdf.

Vicinus, Martha, '"Helpless and unfriended": nineteenth century-domestic melodrama', *New Literary History* 13:1 (1981).

Vidal, Belén, *Heritage Film: Nation, Gender and Representation* (London: Wallflower, 2012).

Williams, Linda, 'Melodrama revised', in Nick Browne (ed.), *Refiguring American Film Genres: Theory and History* (Berkeley: University of California Press, 1998).

———*Playing the Race Card: Melodramas of Black and White from Uncle Tom to O.J. Simpson* (Princeton, NJ: Princeton University Press, 2001).

INDEX

Note: page numbers in *italic* refer to illustrations. Titles of films, paintings and publications are in *italic*.